*Susan McGahist*
*june 2014*

# LASTING IMPRESSIONS
*Celebrated Works from the Art Gallery of Hamilton*

# IMAGES INOUBLIABLES
*Œuvres célèbres de l'Art Gallery of Hamilton*

ART GALLERY OF HAMILTON

ITINERARY / ITINÉRAIRE

Art Gallery of Hamilton
May 28 – September 5, 2005

Art Gallery of Nova Scotia
May 5 – September 4, 2006

The Beaverbrook Art Gallery
September 21 – November 20, 2006

MacKenzie Art Gallery
January 13 – March 18, 2007

Mendel Art Gallery
April 6 – June 3, 2007

Museum London
June 23 – September 16, 2007

Musée national des beaux-arts
du Québec
October 11, 2007 – January 6, 2008

# LASTING IMPRESSIONS
*Celebrated Works from the Art Gallery of Hamilton*

# IMAGES INOUBLIABLES
*Œuvres célèbres de l'Art Gallery of Hamilton*

*Catalogue edited by / Catalogue préparé sous la direction de*

TOBI BRUCE

*curator of the exhibition / commissaire de l'exposition*

*Essays by / Essais par*

TOBI BRUCE

DEBRA DALY HARTIN

ESTHER TRÉPANIER

JOYCE ZEMANS

*Entries by / Notices par*

JANICE ANDERSON I KAREN ANTAKI I LOUISE D'ARGENCOURT

MICHAEL BELL I ALICIA BOUTILIER I MAURA BROADHURST I TOBI BRUCE

LISA CHRISTENSEN I ANN DAVIS I BRIAN FOSS I FRANÇOIS-MARC GAGNON

ALISON GARWOOD-JONES I ARLENE GEHMACHER I MICHÈLE GRANDBOIS

IHOR HOLUBIZKY I ANNA HUDSON I KRISTINA HUNEAULT I ANDREW HUNTER

GRACE INGLIS I JAMES KING I LAURIER LACROIX I IAN LUMSDEN I CONSTANCE MARTIN

BARBARA MEADOWCROFT I JOYCE MILLAR I GERTA MORAY I JOAN MURRAY

SANDRA PAIKOWSKY I IAN THOM I ESTHER TRÉPANIER

CHRISTOPHER VARLEY I LAURAL WEINTRAUB

**Art Gallery of Hamilton**

123 King Street West
Hamilton, Ontario   L8P 4S8
www.artgalleryofhamilton.com

Distributed by:
ABC Art Books Canada Distribution
www.ABCartbookscanada.com

Printed in Canada

This exhibition was organized and circulated by the Art Gallery of Hamilton. This project has been made possible in part through a contribution from the Museums Assistance Program, Department of Canadian Heritage.

L'exposition a été organisée et mise en circulation par l'Art Gallery of Hamilton. Ce projet a été rendu possible en partie grâce à une contribution du Programme d'aide aux musées du ministère du Patrimoine canadien.

Exhibition Tour sponsored by PACART

Tournée de l'exposition commanditée par PACART

The Art Gallery of Hamilton wishes to thank the City of Hamilton, its members and friends. As well, it is grateful for the generous assistance of the Canada Council for the Arts and the Ontario Arts Council.

L'Art Gallery of Hamilton remercie la Ville de Hamilton de même que ses membres et ses amis. Sa gratitude va également au Conseil des Arts du Canada et au Conseil des arts de l'Ontario pour leur appui constant.

**Library and Archives Canada Cataloguing in Publication**

Art Gallery of Hamilton
   Lasting Impressions: Celebrated Works from the Art Gallery of Hamilton / Tobi Bruce ... [et al.] = Images inoubliables. Œuvres célèbres de l'Art Gallery of Hamilton / Tobi Bruce ... [et al.]. Includes 4 essays, and 33 entries, each in the original English or French, and each with English or French translation by Danielle Chaput and Judith Terry.

Catalogue of a travelling exhibition of Canadian historical art work (1884-1957), first held at the Art Gallery of Hamilton, May 28-Sept. 5, 2005 and travelling to other galleries.

Includes bibliographical references and index.

ISBN 0-919153-84-4

   1. Art, Canadian--Exhibitions. 2. Art, Canadian--Ontario--Hamilton--Catalogs. 3. Art Gallery of Hamilton--Catalogs. I. Bruce, Tobi, 1965- II. Title. III. Title: Images inoubliables.

ND245.A678 2005    709'.71    C2004-905395-7E

**Catalogage avant publication de Bibliothèque et Archives Canada**

Galerie d'art de Hamilton
   Lasting Impressions: Celebrated Works from the Art Gallery of Hamilton / Tobi Bruce ... [et al.] = Images inoubliables. Œuvres célèbres de l'Art Gallery of Hamilton / Tobi Bruce ... [et al.]. Comprend 4 essais et 33 notices, en anglais ou en français, chacun avec sa traduction dans l'autre langue par Danielle Chaput et Judith Terry

Catalogue d'une exposition itinérante d'art historique canadien (1884-1957), présentée en premier lieu à la Art Gallery of Hamilton, 28 mai-5 sept. 2005 et visitant ensuite d'autres galeries.

Comprend des références bibliographiques et un index.

ISBN 0-919153-84-4

   1. Art, Canadian--Exhibitions. 2. Art Gallery of Hamilton--Exhibitions. I. Bruce, Tobi, 1965- II. Titre. III. Titre: Images inoubliables.

ND245.A678 2005    709'.71    C2004-905395-7F

To

the memory of Thomas Reid MacDonald (1908–1978)

and

the dedication of the Women's Committee

~ ~ ~

À la mémoire de

Thomas Reid MacDonald (1908–1978)

et en hommage

au dévouement du Comité féminin

# CONTENTS / SOMMAIRE

*Q*uand j'ai lu l'essai de Tobi Bruce et revécu à travers ce texte tout aussi intéressant qu'instructif les premières années de notre musée, je me suis rendu compte que nous étions parvenus à recréer aujourd'hui à l'Art Gallery of Hamilton l'esprit et l'essence de ces débuts. Ainsi, nous avons atteint un de nos principaux objectifs.

Nous sommes bien sûr extrêmement fiers de notre nouvel édifice. Quand ils sont réussis, les édifices traduisent les valeurs de l'organisation qu'ils abritent. Dans le nôtre, les percées dans l'enveloppe architecturale et le spacieux foyer témoignent de notre volonté d'ouverture sur une communauté vaste et diversifiée. Mais c'est la nouvelle intégrité des aires d'exposition qui fait vraiment honneur au précieux héritage qui nous a été transmis et que nous célébrons par ce livre et l'exposition qui l'accompagne.

Les musées nous parlent de la vie et de la société telles que vues et interprétées par les artistes et les savants. La version éclairée que Tobi Bruce nous donne de nos premières années met en évidence le génie d'un homme dont l'exemple nous inspire. Beaucoup de gens ont les moyens d'acquérir des œuvres d'art, mais peu sont capables de bâtir des collections durables. L'intérêt que T. R. MacDonald portait à l'art qui lui était familier, sa capacité de forger de solides relations avec ses collègues artistes et ses concitoyens – en particulier les membres du Comité des bénévoles – et son talent unique pour reconnaître les œuvres qui résisteraient au temps, tout cela a fixé de très rigoureux critères pour constituer la collection de l'AGH. Plus tard, sa décision de situer la collection dans un contexte en faisant l'acquisition d'œuvres britanniques et américaines contribua à donner à l'AGH une envergure internationale.

Cette exposition, donc, rappelle l'histoire des premières années du musée et salue le legs de T. R. MacDonald au Canada. Mais elle démontre aussi l'influence que T. R. MacDonald continue d'avoir à ce moment crucial de notre histoire. À la veille de rouvrir nos portes au public canadien, il ne fait aucun doute pour nous que nos objectifs reflètent les siens. Nous avons encore pour priorités de mieux connaître et comprendre notre collection, d'en faire profiter d'autres gens en tenant des expositions, et de la situer dans un contexte grâce aux partenariats avec des musées et galeries. Tout comme *Ciel et terre dévoilés : Trésors européens de la collection Tanenbaum* et la présentation d'une série d'acquisitions récentes et majeures en art contemporain, *Images inoubliables. Œuvres célèbres de l'Art Gallery of Hamilton* signale l'orientation que nous voulons donner à nos futures activités.

J'aimerais exprimer ma plus profonde gratitude à Tobi Bruce, qui mérite nos éloges pour cette exposition et ce catalogue remarquables, ainsi qu'à tous les spécialistes qui ont écrit des textes pour cet ouvrage. Nous leurs sommes très reconnaissants de leurs réflexions et de leur intérêt pour la collection. J'aimerais également dire un merci tout spécial aux bénévoles et aux donateurs qui ont connu T. R. MacDonald et travaillé avec lui à créer ce qui deviendrait pour notre ville et notre pays un tel trésor. Notre reconnaissance va aussi à l'artiste Alex Colville, qui a collaboré de près avec nous pour la restauration de sa magnifique peinture *Cheval et train*, ainsi qu'à toutes les autres personnes qui ont contribué de diverses manières à la réalisation de ce projet.

Le ministère du Patrimoine canadien nous a apporté son appui pour la recherche, la production, la restauration et la mise en tournée de l'exposition, et nous l'en remercions vivement. Nous remercions également l'Institut canadien de conservation pour sa collaboration et son généreux soutien.

Enfin, nous sommes ravis que des œuvres de notre collection puissent être vues dans diverses localités du pays, et nous disons merci à chacun des établissements qui les accueillera.

*Louise Dompierre*
*Présidente et directrice générale*

hen I first read Tobi Bruce's essay, re-living through her engaging and informative text the early years of our institution, I realized that the new AGH has managed to re-capture the spirit and the essence of the Gallery's beginnings. In doing so, we have achieved one of our main goals.

We are, of course, immensely proud of our new building. At their best, buildings reflect an organization's values. The opening out of the architectural envelope and the spaciousness of the foyer emphasize our determination to engage with a broad and diverse community. But it is the new integrity of the exhibition spaces that truly does credit to the gift that was passed down to us and that we celebrate with this book and the accompanying exhibition.

Galleries are about life and society as seen and interpreted through the eyes of artists and scholars. Tobi Bruce's enlightened version of our early years focuses on the collecting genius of a man whose example is inspirational. Many are in a position to acquire artworks, but few are able to build collections that endure. T. R. MacDonald's focus on art that was familiar to him, his ability to forge strong relationships with fellow artists and members of the community – especially the Volunteer Committee – and his unique capacity to identify artworks of lasting significance clearly set the high collecting standards of the institution. Later on, when he decided to contextualize the collection through the acquisition of British and American works, he did much to raise the Gallery's international stature.

This exhibition, then, conveys the story of the Gallery's early years and acclaims T. R. MacDonald's legacy to Canada. But it also speaks of his continuing influence at this crucial time in our history. On the eve of the re-opening of our doors to the Canadian public, there is no question that our goals reflect his. Our key priorities remain those of further understanding and researching our collection, of sharing it with others through exhibitions, and of contextualizing it through partnerships with other museums and galleries. Like *Heaven and Earth Unveiled: European Treasures from the Tanenbaum Collection* and the

presentation of a series of recent major contemporary acquisitions, *Lasting Impressions: Celebrated Works from the Art Gallery of Hamilton* signals the thrust of our future activities.

In addition to Tobi Bruce, who deserves praise for this remarkable exhibition and publication, I would like to extend my deepest appreciation to all the scholars who have provided texts for the catalogue. We are truly grateful for their insights and interest in our collection. I would also like to extend a special thank you to those volunteers and donors who knew T. R. MacDonald and worked with him on the creation of what would prove to be such a great legacy to this city and this country. Special gratitude is also due to artist Alex Colville, who worked closely with us to restore his magnificent painting *Horse and Train*, and to all the other individuals who contributed in various ways to make this project possible.

The support of the Department of Canadian Heritage for the research, production, conservation and circulation of the exhibition is most gratefully acknowledged. We are also indebted to the Canadian Conservation Institute for its generous support and collaboration.

Finally, we are delighted to share our collection with a national audience, and I thank each of the hosting institutions for bringing this exhibition to their respective communities.

*Louise Dompierre*
*President and C.E.O.*

ACKNOWLEDGMENTS

The exhibition *Lasting Impressions: Celebrated Works from the Art Gallery of Hamilton* and its publication have been four years in the making. Neither would have been realized without the assistance and participation of many people. I must first acknowledge all the publication's contributing authors, each of whom approached their particular subject with enthusiasm and insight. They have enriched our understanding of this collection in new and meaningful ways, and have allowed us to present a document that speaks from multiple perspectives. Special thanks must be extended to Esther Trépanier and Joyce Zemans, both of whom took on an especially broad theme, spending time with our collection and reflecting deeply on specific works and ideas. Debra Daly Hartin and the Canadian Conservation Institute (CCI, Ottawa) are also due particular gratitude for undertaking and generously sponsoring the conservation of Alex Colville's *Horse and Train*, and for presenting their findings here. We thank Alex Colville for his ready co-operation with all aspects of this project, including travelling to Ottawa to meet with the CCI team. We are also indebted to Stephen Gritt and the National Gallery of Canada for undertaking and sponsoring the conservation of Emily Coonan's *Girl in Dotted Dress*.

Several people gave generously of their time in hours of interviews for this project. I am indebted to Paul Duval, the late Jean Keogh and Miriam Lebow, for their memories, insights and generosity of spirit. Two other individuals deserve special mention in this regard: Katherine MacDonald and the late Ruth McCuaig. Both have a lifetime of involvement with the AGH, and their willingness to answer my constant questions with patience and intelligence during regular visits over many years helped to paint a rich picture of our institution and its holdings. For this, and for their love and understanding of the collection, I am exceedingly grateful. Several other loyal Gallery supporters have also made significant contributions, recalling people, places and events. I here acknowledge and thank Helen Hadden, Grace Inglis and Frances Waters.

This publication offers the results of a good deal of new research concerning the dating, provenance and exhibition history of the works included. Our accomplishment of much of this work – confirming existing records while adding new data – would not have been possible without the assistance of many colleagues and researchers across the country. For this, and assistance with other aspects of this exhibition and publication, we extend our thanks to Shannon Anderson, Oakville Galleries; Pierre Arpin and Mary-Ellen Threadkell, Art Gallery of Greater Victoria; Danièle Archambault and Danielle Blanchette, The Montreal Museum of Fine Arts; Daryl Betenia, Quyen Hoang and Lindsay Moir, Glenbow Museum; Marisa Bourgoin, Corcoran Gallery of Art; François Cartier, McCord Museum; Jacquie Cartwright, Lefevre Fine Art Ltd.; Kenlyn Collins, Winnipeg Art Gallery; David R. Collens, Storm King Art Center; Katherine Degn, Kraushaar Galleries; Lucie Dorais; Bruce Dunbar, Edmonton Art Gallery; Jane Edmonds, Stratford Festival of Canada Archives; Catherine Elliot-Shaw, McIntosh Gallery; Barry Fair, Museum London; Eleanor Friedl, Fairleigh Dickinson University; Michele Gallant, Dalhousie Art Gallery; Arlene Gehmacher, Royal Ontario Museum; Andrew Gent, Tate Library and Archive; Cassandra Getty, Art Gallery of Windsor; Lu Harper, Memorial Art Gallery of the University of Rochester; Charles Hill, Tanya Richard and Rosemarie Tovell, National Gallery of Canada; Jean Holland, Albright-Knox Art Gallery; Margaret Houghton, Hamilton Public Library; Anna Hudson, York University; Linda Jansma, Olexander Wlasenko and Barb Duff, Robert McLaughlin Art Gallery; Ann Kitz; Alan Klinkhoff, Galerie Klinkhoff; Cheryl Leibold, Pennsylvania Academy of the Fine Arts; Katharine Lochnan and Amy Marshall, Art Gallery of Ontario; Sarah McMaster, Tom Thomson Memorial Art Gallery; Kim Ness and Gerry Loveys, McMaster Museum of Art; Brian Oickle; Dawn Owen, Macdonald Stewart Art Centre; Michèle Paret, Wildenstein Institute; Brent Raycroft; Kevin Rice, Confederation Centre Art Gallery;

10

Nicole Rivette and Julie McMaster, Toledo Museum of Art; David Somers, Art Gallery of Peel; Robert Steven, Kitchener-Waterloo Art Gallery; Illi-Maria Tamplin, Art Gallery of Peterborough; David G. Taylor, Gallery Lambton; Ian Thom, Vancouver Art Gallery; and Deborah Wythe, Brooklyn Museum of Art. Cyndie Campbell, Head, Archives, National Gallery of Canada, deserves special mention for her considerable assistance.

This is one of the most ambitious publications ever undertaken by the AGH, and the skills of editor/translators Danielle Chaput and Judith Terry are to be commended. Working with over thirty contributors, Judith and Danielle managed to retain the authors' individual voices while editing and translating the whole into a coherent and consistent document. Branka Vidovic of Neographics was equally masterful in her ability to take an unwieldy amount of text and images and shape it into the elegant publication you now hold.

Louise Dompierre, President and C.E.O., and Shirley Madill, Vice President and C.O.O., supported the exhibition and publication wholeheartedly from the outset, envisioning a project as ambitious and unique in scope as the collection itself. I am indebted to both for their support and trust. The staff of the AGH has, as usual, risen to the occasion. Julie Bronson, Special Projects Co-ordinator, deserves special mention, for she has shown herself to be a consummate master of detail, coordinating every aspect of the publication's production, and of the exhibition and its subsequent tour. I am exceedingly grateful to her. Christine Braun, Registrar, worked seamlessly with the exhibition team assisting in the areas of conservation, copyright and cataloguing details, while Barbara Carter, Exhibitions Coordinator, helped with copyright research. Thanks are also due to Greg Dawe, Chief Preparator, Paula Esteves Mauro, Preparator, and their team for their expertise and the sensitivity of their installation. My greatest thanks go to Alicia Boutilier, Assistant Curator for this exhibition, who came to this project as a research assistant and left as equal partner. Her complete participation on every aspect of the project – at both conceptual and logistical levels – was invaluable. I thank her for the excellence of her work, her professionalism and, above all, her intelligence. The AGH staff is a most co-operative and creative group of individuals, and each one has contributed to some degree to this project, be it within the Finance, Marketing/Communications or Programming departments. I extend my sincere appreciation to each of them.

I also wish to acknowledge here the foundational work undertaken by former AGH curator Ross Fox and art writer and historian Grace Inglis, who co-authored *The Art Gallery of Hamilton: Seventy-Five Years (1914–1989)* on the occasion of our 75th anniversary in 1989. The research set out in that catalogue was of great assistance to me during the initial phases of this project, and I am indebted to both for their pivotal contribution to our understanding of the history of this institution and its collection. Ihor Holubizky, former AGH Senior Curator, also deserves special thanks. Having worked extensively with this collection and knowing it as he does, he was a stimulating, thoughtful and invaluable resource. For this, and so much more, I thank him.

Sadly, during the research and preparation of this project we lost two of our oldest and dearest friends, Ruth McCuaig (1915–2004) and Jean Keogh (1919–2004). Both women (as founding members of the Women's Committee and beyond) made very significant and tangible contributions to this institution, and their sustained commitment and devotion was exemplary. I relied on them heavily, as vital links to the past and as models of integrity and dedication for the present. I am personally and professionally grateful to have known these extraordinary women, and I hope this publication will go some way towards paying tribute to their lasting contributions.

*Tobi Bruce*
*Senior Curator*

'exposition *Images inoubliables. Œuvres célèbres de l'Art Gallery of Hamilton* et la publication qui l'accompagne ont mis quatre ans à se réaliser. Ni l'une ni l'autre n'aurait vu le jour sans l'aide et la participation de nombreuses personnes. Je remercie d'abord tous les auteurs qui ont contribué à la rédaction du catalogue de l'enthousiasme et du discernement qu'ils ont apportés à l'étude de leur sujet. Ils ont jeté un nouvel éclairage sur la collection de l'AGH et nous ont permis de présenter un document où s'expriment de multiples points de vue. Je remercie tout spécialement Esther Trépanier et Joyce Zemans, qui ont toutes deux accepté de traiter d'un thème particulièrement vaste, pris le temps d'explorer nos réserves et poussé la réflexion sur certaines œuvres et idées. Debra Daly Hartin et l'Institut canadien de conservation (ICC, Ottawa) méritent aussi notre reconnaissance pour avoir effectué et généreusement subventionné la restauration de *Cheval et train* d'Alex Colville et présenté ici leurs constatations. Je remercie Alex Colville qui a collaboré avec empressement à tous les aspects de ce projet et a bien voulu se rendre à Ottawa pour rencontrer l'équipe de l'ICC. Notre gratitude va aussi à Stephen Gritt et au Musée des beaux-arts du Canada qui ont effectué et financé la restauration de *Jeune fille en robe à pois* d'Emily Coonan.

Plusieurs personnes ont donné généreusement de leur temps en heures d'entrevues pour ce projet. Je remercie Paul Duval, feu Jean Keogh et Miriam Lebow de leurs souvenirs, de leurs idées et de leur esprit généreux. Deux autres personnes dont la vie fut intimement liée à celle de l'AGH méritent une mention spéciale : Katherine MacDonald et feu Ruth McCuaig. Des années durant, je leur ai régulièrement rendu visite; la patience et l'intelligence avec lesquelles elles ont répondu à mes constantes questions m'ont aidée à brosser un tableau plus fouillé de notre institution et de ses avoirs. De cela, ainsi que de leur amour et de leur compréhension de la collection, je leur suis extrêmement reconnaissante. D'autres fidèles du musée ont réveillé pour moi leurs souvenirs des gens, des lieux, des événements; je tiens à souligner, à cet égard, l'importante contribution de Helen Hadden, Grace Inglis et Frances Waters, et je les en remercie.

La publication que voici contient pour une bonne part les résultats de nouvelles recherches sur la datation des œuvres, leurs précédents propriétaires et les expositions où elles ont déjà été présentées. Nous n'aurions pas pu accomplir un tel travail – confirmer les données existantes et en ajouter de nouvelles – sans le concours de nombreux collègues et chercheurs de tous les coins du pays, qui nous ont également apporté leur aide pour d'autres aspects de l'exposition et du catalogue. Nous remercions Shannon Anderson, Oakville Galleries; Danièle Archambault et Danielle Blanchette, Musée des beaux-arts de Montréal; Pierre Arpin et Mary-Ellen Threadkell, Art Gallery of Greater Victoria; Daryl Betenia, Quyen Hoang et Lindsay Moir, Musée Glenbow; Marisa Bourgoin, Corcoran Gallery of Art; François Cartier, Musée McCord; Jacquie Cartwright, Lefevre Fine Art Ltd.; Kenlyn Collins, Winnipeg Art Gallery ; David R. Collens, Storm King Art Center; Katherine Degn, Kraushaar Galleries; Lucie Dorais; Bruce Dunbar, Edmonton Art Gallery; Jane Edmonds, Stratford Festival of Canada Archives; Catherine Elliot-Shaw, McIntosh Gallery; Barry Fair, Museum London; Eleanor Friedl, Fairleigh Dickinson University; Michele Gallant, Dalhousie Art Gallery; Arlene Gehmacher, Musée royal de l'Ontario; Andrew Gent, Tate Library and Archive; Cassandra Getty, Art Gallery of Windsor; Lu Harper, Memorial Art Gallery of the University of Rochester; Charles Hill, Tanya Richard et Rosemarie Tovell, Musée des beaux-arts du Canada; Jean Holland, Albright-Knox Art Gallery; Margaret Houghton, Hamilton Public Library; Anna Hudson, York University; Linda Jansma, Olexander Wlasenko et Barb Duff, Robert McLaughlin Art Gallery; Ann Kitz; Alan Klinkhoff, Galerie Klinkhoff; Cheryl Leibold, Pennsylvania Academy of the Fine Arts; Katharine Lochnan et Amy Marshall, Musée des beaux-arts de l'Ontario; Sarah McMaster, Tom Thomson Memorial Art Gallery; Kim Ness et Gerry Loveys, McMaster Museum of Art; Brian Oickle; Dawn Owen, Macdonald Stewart Art Centre; Michèle Paret, Wildenstein Institute; Brent Raycroft; Kevin Rice, Centre des arts de la Confédération; Nicole Rivette et Julie McMaster, Toledo Museum of Art; David Somers,

Art Gallery of Peel; Robert Steven, Kitchener-Waterloo Art Gallery; Illi-Maria Tamplin, Art Gallery of Peterborough; David G. Taylor, Gallery Lambton; Ian Thom, Musée des beaux-arts de Vancouver; et Deborah Wythe, Brooklyn Museum of Art. Nous avons une dette spéciale de reconnaissance envers Cyndie Campbell, chef des Archives du Musée des beaux-arts du Canada, dont l'aide fut considérable.

Ce catalogue est l'un des plus ambitieux jamais publiés par l'AGH, et nous devons saluer l'excellent travail accompli par les traductrices et réviseures Danielle Chaput et Judith Terry. Collaborant avec plus de trente auteurs, Judith et Danielle ont réussi à conserver le ton que chacun a donné à son texte, tout en assurant la cohérence et l'unité de l'ensemble. Branka Vidovic, de Neographics, a tout aussi habilement réussi à transformer cette volumineuse quantité de textes et d'images en l'élégant volume que vous avez maintenant entre les mains.

Louise Dompierre, présidente et directrice générale de l'AGH, ainsi que Shirley Madill, vice-présidente et directrice de l'exploitation, ont dès le début appuyé sans réserve l'exposition et le catalogue qui l'accompagne, et cru en ce projet aussi ambitieux et unique que la collection même. Je les remercie toutes deux de leur soutien et de leur confiance. Le personnel de l'AGH s'est, comme à son habitude, montré à la hauteur de la tâche. Julie Bronson, coordonnatrice des projets spéciaux, mérite ici une mention spéciale pour avoir coordonné, avec une parfaite maîtrise des détails, tous les aspects de la production du livre, de l'exposition et de la tournée qui suivra; je lui en suis extrêmement reconnaissante. Christine Braun, archiviste, s'est magnifiquement intégrée à l'équipe de l'exposition pour régler des questions sur la restauration, les droits d'auteur et le catalogage, alors que Barbara Carter, coordonnatrice des expositions, a participé à la recherche sur les droits d'auteur. Ma gratitude va aussi à Greg Dawe, préparateur en chef, à Paula Esteves Mauro, préparatrice, et à leur équipe : l'accrochage des œuvres de l'exposition témoigne de leur compétence et de leur sensibilité. J'ai une dette toute spéciale de reconnaissance envers Alicia Boutilier, conservatrice adjointe de l'exposition qui, arrivée à ce projet en tant qu'assistante à la recherche, est devenue ma complice. Son entière participation à tous les aspects, tant conceptuels que logistiques, fut inestimable. Je la remercie de l'excellence de son travail, de son professionnalisme et, surtout, de son intelligence. Le personnel de l'AGH est formé de gens remarquablement coopératifs et créatifs, et chacun – aux services des Finances, du Marketing et des Communications, de la Programmation – a fait sa part pour que ce projet se concrétise. À tous, j'adresse mes plus sincères remerciements.

J'aimerais également souligner ici le travail fondamental entrepris par l'ancien conservateur de l'AGH, Ross Fox, ainsi que par l'auteure et historienne d'art Grace Inglis qui, à l'occasion de notre 75ᵉ anniversaire en 1989, ont cosigné *The Art Gallery of Hamilton : Seventy-Five Years (1914-1989)*. La recherche présentée dans leur catalogue m'a été particulièrement utile aux premières étapes de mon projet, et je leur dois beaucoup; qu'ils soient tous deux remerciés de leur apport essentiel à la compréhension de l'histoire de l'AGH et de sa collection. Ihor Holubizky, ancien conservateur principal de l'AGH, a longuement travaillé sur la collection et la connaît par cœur; il fut pour moi une inspiration et un précieux guide; pour cela, et tant d'autres choses encore, je le remercie.

Depuis que nous avons entrepris ce projet, deux de nos plus fidèles et plus chères amies, Ruth McCuaig (1915–2004) et Jean Keogh (1919–2004), nous ont hélas quittées. Toutes deux (à titre de membres fondatrices du Comité féminin, et bien longtemps après) ont participé de manière significative et tangible à l'essor de l'AGH, et fait preuve d'une persévérance et d'une loyauté exemplaires. J'ai beaucoup compté sur elles, car elles étaient tout autant des liens vitaux avec le passé que des modèles d'intégrité et de dévouement pour le présent. Ce fut pour moi un honneur et une joie de connaître ces femmes extraordinaires, et j'espère que cette publication contribuera à leur rendre hommage pour tout ce qu'elles ont accompli.

*Tobi Bruce*
*Conservatrice principale*

On ne peut résumer les quatre-vingt-dix années d'histoire d'une institution. C'est tout simplement impossible. Il y aurait trop d'histoires à raconter, trop de souvenirs et de voix – et autant de stratégies parmi lesquelles choisir. L'objectif de cette publication est de raconter la fondation de l'Art Gallery of Hamilton et la constitution de sa collection permanente, et de proposer des réflexions sur certains parcours personnels, thèmes et objets qu'elles recoupent.

Cela semble d'abord assez simple, mais la complexité de l'entreprise apparaît très vite. Bien que la collection soit celle d'un musée et qu'elle soit perçue comme telle, son développement est le résultat tangible de décisions et de volontés humaines – celles des artistes, des conservateurs, des collectionneurs, des directeurs, des bénévoles. Sa croissance et sa composition rendent compte des choix et des jugements faits, au fil des ans, par le personnel et les fidèles de l'AGH, qui ont employé leur temps, leur énergie et leurs idées à bâtir quelque chose d'unique à Hamilton et d'apprécié partout au Canada. Cette collection est devenue beaucoup plus impressionnante qu'on ne pouvait l'imaginer à ses débuts en 1914. Trouver comment aborder son histoire, comment donner une juste idée de ce qu'elle représente, de la manière dont elle s'est formée, et de ce qu'elle signifie aujourd'hui n'était pas une mince tâche.

Plusieurs personnes ont contribué à bâtir la collection, des personnes qui ont eu le bonheur de travailler avec des objets qui sont – c'est le moins qu'on puisse dire – inspirants. Il est important de les nommer et de leur exprimer notre gratitude : Thomas Reid (T. R.) MacDonald (sur qui porte le premier essai du catalogue), Glen Cumming, Andrew Oko, Ross Fox, Ihor Holubizky, Robert Swain, Ted Pietrzak, Jennifer Watson et, plus récemment, Shirley Madill et Louise Dompierre. Chacun – et je m'inclus dans ce groupe – a certainement reconnu qu'il lui incombait d'aider à développer le caractère particulier de ce corpus tout en cherchant à le *voir* pour ce qu'il est réellement. Mais nous ne sommes, par définition, « gardiens » d'une collection que pour une courte période; notre contribution s'inscrit dans le cours des événements, elle n'a rien d'arrêté. Les objets ne se prêtent à nous que brièvement – nous passons, et eux demeurent. Par conséquent, « connaître » une collection ne peut jamais qu'être une question de degré, une rencontre passagère avec quelque chose de trop complexe pour qu'on puisse entièrement le saisir – une incessante recherche, un constant forage.

Et c'est là la véritable beauté de toute collection.

Dès le début, nous avons voulu que ce projet soit le fruit d'une collaboration : plusieurs histoires requièrent plusieurs conteurs. Ce que nous souhaitions, c'était faire de la collection un champ d'investigation et amener d'autres personnes à l'explorer, à l'étudier, à la voir de leurs yeux. Nous avons invité des historiens d'art, des universitaires et des conservateurs à réfléchir à différents aspects de ce corpus, et à aborder leur sujet comme des observateurs bien informés, mais impartiaux. Nous ne leur avons donné que quelques indications générales et n'avons fixé aucune « règle » (hormis celle, très frustrante pour eux, d'un nombre maximum de mots); chacun était libre d'adopter le point de vue qu'il jugeait le plus approprié. Nous sommes fiers de vous présenter ici leurs réflexions et leurs judicieux commentaires.

On l'a souvent dit : Hamilton peut s'enorgueillir de posséder l'une des meilleures collections d'œuvres d'art du Canada. Nous croyons que cela est vrai. Cette collection n'est pas affaire de quantité, mais de qualité et de diversité – elle est le résultat tangible de la prévoyance, du discernement, de la sagesse et de la persévérance de ceux et celles qui, à l'intérieur comme à l'extérieur du musée, l'ont bâtie. Pour cela, nous avons beaucoup de gens à remercier.

Bienvenue à l'AGH.

*Tobi Bruce*
*Conservatrice principale*

*H*ow do you tell the story of ninety years of institutional history? The answer is simple: you don't. There are many stories to be told, many memories and voices – and as many strategies appropriate to the challenge. The main aim of this publication is to recount the founding of the Art Gallery of Hamilton and the building of its permanent collection, and to offer reflections on some of the individual narratives, themes and objects they encompass.

While this may appear to be a straightforward enough endeavour, the complexity of the enterprise soon began to manifest itself. Although the profile and identity of the collection is institutional, its development has been essentially human: it is the tangible result of *people* – artists, curators, collectors, directors and volunteers. Its particular growth and composition reflect years of choices and judgments on the part of Gallery staff and supporters, who have devoted their time, energy and insights to the building of something unique to Hamilton and esteemed across Canada. This impressive collection has attained greater stature than would have been imagined possible at the time of its inception in 1914. The weighty question we faced was how best to address this collection's history, how to formulate some kind of picture of what it represents, how it came to be, and what it means today.

The collection has had several "makers," individuals who have had the good fortune to work with objects that are, to say the least, inspirational. It is important to name and acknowledge them here: Thomas Reid (T. R.) MacDonald (subject of the first essay), Glen Cumming, Andrew Oko, Ross Fox, Ihor Holubizky, Robert Swain, Ted Pietrzak, Jennifer Watson, and most recently, Shirley Madill and Louise Dompierre. Each – and I include myself here – has undoubtedly come to recognize their responsibility in helping to shape the collection's unique character while attempting to *see* the corpus for what it is. But we are, by definition, "keepers" only for a time, our contributions organic and anything but definitive. The objects indulge us only briefly – keepers are transient, they, permanent. Consequently, "knowledge" of a collection can only ever be a matter of degree, a passing encounter with something too complex to be fully grasped, an ongoing and never-ending excavation.

And that is the real beauty of any collection.

From the outset this project was conceived as a collaborative endeavour – many stories require many storytellers. What we have attempted to do is to open the collection as a site of investigation, to have others explore, investigate, see it for themselves. We invited art historians, scholars and curators to reflect on different aspects of the collection, approaching their subjects as informed but impartial participants. We established no "rules" and provided few guidelines (other than what proved for the writers to be a very frustrating word count limit), allowing each author the freedom to adopt the vantage point they deemed most appropriate. We are proud to present you with their thoughtful and illuminating perspectives.

It has often been said that Hamilton boasts one of the best art collections in Canada. We believe this to be true. It is not a question of numbers, but of quality, depth and breadth – the tangible result of the foresight, discernment, wisdom and perseverance of individuals both inside and outside the Art Gallery of Hamilton. For this, we have many to acknowledge and thank.

Welcome to the collection.

*Tobi Bruce*
*Senior Curator*

With a rare combination of taste, thrift, knowledge and Scottish will, he has built a remarkable collection of art from scratch.[1]

<div align="right">

Paul Duval, speaking of the Art Gallery
of Hamilton's first director, T. R. MacDonald.

</div>

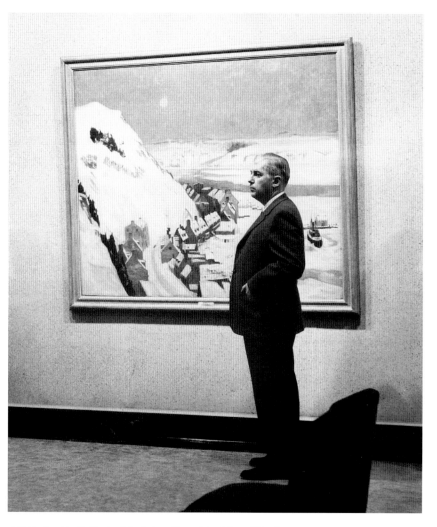

T. R. MacDonald with Maurice Cullen's *Cape Diamond*. Art Gallery of Hamilton

# Modern Ambition
# A Canadian Collection Comes of Age

*Tobi Bruce*
*Senior Curator*
*Art Gallery of Hamilton*

This is a story about a particular time and place, about a community of people who came together with the great ambition of building something of substance: an art gallery and a permanent collection of quality and stature, for the city of Hamilton. In my view it is a rather remarkable story, one of quiet and sustained determination, ingenuity and commitment, of creative and resourceful strategies and inspired visions. The players – artists, curators, volunteers, collectors, dealers and patrons – are all protagonists in a narrative that moves through decades, across provinces, and in and out of the lives of several people. Of course, it is not fundamentally a unique story but one that has been played out in many cities across this country over the past one hundred and fifty years, each situation bearing the particular mark of its makers, each institution a child of its time. Accordingly, the Art Gallery of Hamilton (AGH) collection has a complexion of its own, and it is the purpose of this essay to consider this particular character and how it came to be.

The building of the AGH's collection of modern Canadian art is unquestionably a success story, and like all such stories it has its heroes. In November of 1947, Thomas Reid (T. R.) MacDonald (1908–1978), an astute, self-effacing and determined artist from Montreal, became the Art Gallery of Hamilton's first full-time director/curator. His appointment marked a turning point in the AGH's collecting history, for with the man came the creative vision and the resolve to transform an institution and a collection in a manner that, to this day, serves to distinguish them in Canada.

## Foundations: The Ambitious City and an Ambitious Artistic Son

A popular writer described Hamilton in 1858 as "the ambitious and stirring little city," the name stuck; only "little" she is no longer, being the third city in the Dominion, having a population of over 50,000, and her critics have missed out the "stirring," so if you seek for news of Hamilton in the general newspapers, you must look for it under the heading "The Ambitious City."[2]

Ishbel Gordon, the Countess of Aberdeen,
wife of the Governor General of Canada, 1893

The "ambitious" moniker, applied early to the city of Hamilton, is an apt leitmotif for the telling of this story, as it is ambition that has, in large measure, defined the history of the Art Gallery of Hamilton and its collections.[3] Founded and incorporated in 1914, the AGH is one of this country's oldest art institutions.[4] Upon the premature death in 1906 of painter William Blair Bruce – who, though an expatriate for most of his career, was considered at the time to be Hamilton's most ambitious and successful artistic son – his widow, sculptor Caroline Benedicks-Bruce, his father William and his sister Bell Bruce-Walkden bequeathed twenty-nine of his paintings to the city, with the proviso that a properly equipped art gallery be established to house and present the collection.[5] While this event was by no means the first step in establishing a municipal gallery for the city of Hamilton, it did serve to galvanize and focus the many disparate efforts to

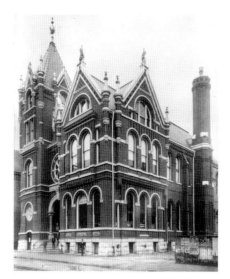

found a cultural centre that had been underway since the latter part of the nineteenth century.[6] The city was more than ripe for such an undertaking, and having experienced several false starts, community leaders were determined not to let this opportunity slip through their grasp. It took eight long years to select and consolidate a permanent gallery space (due largely to the lack of an appropriate building to house the collection), and the Art Gallery of Hamilton was officially opened on 30 June 1914. By all accounts it was an affair to remember that heralded home the Bruce collection and presented alongside it an impressive loan exhibition of Canadian oils, watercolours, prints and drawings. The latter assembly was realized largely through the efforts of photographer Alexander M. Cunningham, newly appointed chairman of the Gallery Board, and Hamilton artist John Sloan Gordon (see cat. 22), its newly named secretary,[7] in collaboration with the Royal Canadian Academy, the Ontario Society of Artists and the Canadian Art Club, and augmented by loans from local artists and collectors.[8] That Hamilton's inaugural exhibition was comprised almost entirely of Canadian works[9] was not lost on local audiences; indeed, for one city reviewer who applauded the opening show, this served as evidence of advancements in the field of Canadian art:

> Pessimistic thoughts on the future of Canadian art will not mature after a visit to the art gallery of Hamilton, opened during the week by the lieutenant governor. In this gallery the collection of pictures ... is a credit to the city, and a surprise awaits the visitor to this nest of art which has developed and achieved success through the untiring efforts of several public-spirited citizens. The exhibition is wholly representative and cosmopolitan, every school of painting is hinted at in the many works shown, but in all there is a decided originality of conception which marks the progress of a new note in the world of art – a Canadian school.[10]

The privileging and promotion of local, regional and national talent in the inaugural exhibition would prove prophetic of later AGH collection and exhibition strategies and priorities. Among the many artists exhibiting who would later come to form the very core of the Gallery's collection of modern Canadian art were William Brymner, George Agnew Reid, Maurice Cullen, A. Y. Jackson, Arthur Lismer, Lawren Harris and Albert Robinson.[11] A healthy mix of local and national, historical and contemporary, the presentation included works by several of the day's more modern painters.

The Gallery opened on the second floor of Hamilton's first Public Library building (fig. 1), but the space quickly proved cramped and inadequate. Tight quarters and a policy of hosting touring and loan exhibitions from other Canadian galleries and the various art societies at first discouraged the building of a permanent collection. At the opening, A. M. Cunningham established immediate prospects for collection building in no uncertain terms: "The question as to the best means to secure pictures for the remaining rooms was debated and it was decided that so long as the space was as limited as at present and one third of that space given over to the Bruce collection, a permanent collection was not desirable and it would soon lose interest."[12] It was the general feeling that the Bruce collection could well bring renown to the city and its young Gallery. A strong and representative cross-section of the artist's work, the collection reflected Bruce's activities in Hamilton, France and Sweden, encompassing landscapes, seascapes, portrait and figure works, and ranging from intimate sketches to large canvases. The Bruce acquisition, certainly an auspicious beginning for any municipal collection, bore witness to the talents of a local boy made good on the international stage. His European achievements, including his participation in the highly prestigious Salons of Paris, were regularly reported in Hamilton's papers, establishing his stature and reputation locally. As Arlene Gehmacher has shown, Bruce and his activities came to personify the city's ambition, paralleling Hamilton's own aspirations in the early years of the twentieth century.[13] His paintings represented the ambitious spirit made real and tangible, and for the next thirty-odd years they became Hamilton's signature images, synonymous with the AGH and its collection.

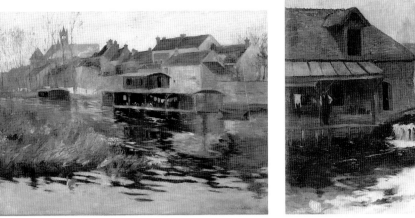

Fig. 2
MAURICE CULLEN (1866–1934)
*Wash Houses on the Seine*
c. 1894
oil on canvas
58.7 x 80 cm
Long and Bisby Memorial, 1923

Fig. 3
MAURICE CULLEN (1866–1934)
*The Dam, Passy* 1894
oil on canvas
63.8 x 80.3 cm
Long and Bisby Memorial, 1923

Bruce's activities and work also provide an appropriate point of departure for a consideration of Hamilton's collection of modern art, reflecting as they do the movements and sensibilities of an ambitious painter in the late nineteenth century. Leaving Hamilton for Paris in July 1881, Bruce was one of the first Canadian-born artists to make the pilgrimage to the cultural centre of the Western world in search of education and exhibition opportunities. He enrolled at the Académie Julian and had his first submission accepted for the 1882 Salon.[14] Such immediate validation was a great encouragement to the young painter, and his desire to absorb and adapt new painting approaches to landscape soon took him further afield, to the artistic communities centred in the French villages of Barbizon, Grez-sur-Loing and Giverny. His immersion in these communities – particularly Giverny, where in the summer of 1887 he was one of a group of North American painters to establish an art colony – developed and directed both his eye and sensibilities.

Two sketches from this period in the AGH collection, *Giverny, France* (1887, cat. 3) and *Giverny* (c. 1887, cat. 2), reflect Bruce's adoption of several Impressionist techniques, including working *en plein air* with a view to capturing light effects, a high-key palette and broken brushwork. They also show us Bruce at his most modern. It is in these intimate essays that we see the artist loosen his brushwork, play with colour and experiment with composition – in essence, relax the self-imposed formal rules prescribed for a grand Salon picture and lose himself, if only a little. This duality of purpose – experimentation on the one hand and controlled statement on the other – accounts in part for the polarities of Bruce's practice; both aspects were admirably present in the Bruce family donation to Hamilton. Indeed, the artistic heights to which Bruce aspired coalesced in the realization of his masterpiece, *The Phantom Hunter* (1888, cat. 6). Accepted for the 1888 Paris Salon, the painting is unequivocally Bruce's *chef-d'œuvre*. Its inclusion in the 1914 Bruce collection gave the corpus – from the very beginning – a mark of distinction. It was a Canadian theme painted and exhibited abroad, its subject was enigmatic, captivating and, very importantly, executed on a large scale. But above all it was *heroic*. The work, which captured the spirit of the young Hamilton artist seeking fame and fortune abroad, was the perfect showpiece in an already impressive collection. To the degree that the labours of one artist could carry the weighty expectations of a community, a new gallery and a permanent collection, William Blair Bruce proved equal to the task. In form and purpose Bruce's work was a most inspired and appropriate cornerstone for Hamilton's burgeoning holdings, setting the standard by which the larger collection would be measured for many years to come.

In keeping with Cunningham's remarks at the opening, however, interest in the active building of a collection for Hamilton was minimal following the inaugural exhibition. This, together with the declaration of war in August 1914, relegated most acquisition efforts to the back burner. This is not to say that some significant works did not enter the collection. Chief among these were two early works by Maurice Cullen – *Wash Houses on the Seine* (c. 1894, fig. 2) and *The Dam, Passy* (1894, fig. 3), acquired in 1923 – paintings that Cullen's friend William Blair Bruce had had a hand in placing in an important private collection in Hamilton.[15]

> It is rather late that I write information in regard to Cullen's pictures, but it is not so easy to do when on the railway train or boat – I think we had better have the article for the newspaper run something in this way – "The two pictures which have been on exhibition for some days past in Mr. Blanchfords [sic] windows, we have discovered to be the excellent examples of one of our best native landscape painters, Mr. Maurice Cullen of Montreal, who has this year had the great honour of being elected as an Associate of the "Société Nationale des Beaux-Arts," Salon des Champs de Mars, Paris, France where the above mentioned excellent examples of modern landscape painting were exposed last year and have now been added to the numerous collection of Mr. W. D. Long of this city."[16]

As part of the bequest of Jane Long Bisby, sister of the late William Dubart Long,[17] the two works were a strong

complement to the existing Bruce collection, building as they did on the nucleus of work by the first generation of Canadian artists to execute paintings overseas. As Canadian artists abroad the two men knew one another, having met in Paris in 1892[18] and consolidated their relationship in Cullen's meetings with the Bruces in Grez-sur-Loing between 1892 and 1895.[19] Cullen's *Wash Houses on the Seine* shows affinities to Bruce's work, especially passages in his painting *Agreeable Meeting* (fig. 4), exhibited at the 1893 Salon. Both pictures are characterized by a palette of mauve and pink, and a tonalist handling that creates luminous effects. We also see a similar treatment of the trees in the distance – spindly suggestions delicately perched and positioned to maximum effect. But in the Cullen there is a distinct looseness to the paint application, the artist having allowed the imprecise and the suggestive to dominate his treatment of the river scene. This manner can be distinguished from Bruce's more naturalistic and academic handling of his subject. The two Cullen paintings provided a firm footing for what would ultimately become a select but significant collection of the artist's work in Hamilton.

Another early acquisition of note was A.Y. Jackson's *Near Canoe Lake* (1914, cat. 35), purchased for the Gallery by A.M. Cunningham from the Patriotic Fund exhibition, presented in Hamilton from 23 April to 1 May 1915.[20] The work, painted the year of Jackson's first trip to Algonquin Park with Tom Thomson and future members of the Group of Seven, represents an important moment in his development.[21] The painting marks the collision of Jackson's European training[22] with his first experience of the Canadian North. In this assured and broadly painted picture, executed in a range of blues, pinks and mauves, Jackson depicts the variable colour shifts in the snow-covered landscape, adapting lessons learned abroad to the Canadian landscape.[23] That such an early northern Canadian subject by Jackson would be acquired so early in the institution's history is fitting, given the leading and, indeed, formative role Jackson would later play in the building of Hamilton's collection during T.R. MacDonald's directorship.

Nevertheless, Cunningham's discouraging words regarding the building of a permanent collection held true for many years, certainly with respect to the AGH's collection of modern painters. While important historical bequests were received in the years between the two wars,[24] it was only following the end of the Second World War that any significant cultural advances were made in Hamilton. By 1947 Hamiltonians had been campaigning for a new, adequately funded and fireproofed gallery for many years – almost from the day the Gallery opened in 1914. Now, however, these demands were voiced loudly and collectively, as part of a general citywide movement concerned with Hamilton's cultural and intellectual betterment. A vocal leader of this movement was Freda Waldon, chief librarian of the Hamilton Public Library. In May of 1947 she opened the 15th Annual Exhibition of The Art Club of Hamilton, delivering a talk aptly titled "The Recurring Dream of a Cultural Centre for Hamilton." Waldon summarized the cultural development of the city, locating present efforts in an historical context and closing with a call to arms of sorts: "I urge you to think of yourselves as part of a general movement, which some people call Recreation and some call Adult Education and some would like to call the birth of a distinctive Canadian culture, but which is essentially a movement to bring the good things of life, the enjoyment of the things of the mind and the creative spirit to everybody ... [I] hope with you that a new day is dawning." [25]

Waldon's words were predictive: six months later T.R. MacDonald arrived, and a new day did indeed dawn on the Art Gallery of Hamilton. Following the allocation of an unprecedented grant of $8,500 from the City of Hamilton to the AGH, with explicit provision for the hiring of the first full-time curator,[26] MacDonald made the move to Hamilton. On 12 November 1947 he reported for work.[27] As time would prove, it was the right time, the right place and – without question – the right man.

## T. R. MacDonald: An Artist First

First things first. Before we consider T. R. MacDonald the curator, we must understand T. R. MacDonald the painter, because at the very core he was – and always remained – an artist; it was the mainstay of his identity. In fact, it is this aspect of his biography that provides us with the clearest insights into the particular vision and sensibility, both aesthetic and philosophical, that formed the foundation of Hamilton's permanent collection. From the beginning, art was MacDonald's central reference point, the locus around which he built his life's work. The fact that his identity as a painter was overshadowed by his activities as curator and director served only to heighten the crucial role his painting practice played in his curatorial vision. It was the painter's eye, the instincts of an artist that were brought to bear on Hamilton's collection for over a quarter century.

Thomas Reid MacDonald was born in Montreal on 28 June 1908 to Scots parents – Thomas Fraser MacDonald and Katherine MacLean. The young boy lost his mother five years later, and his aunt, Katherine's sister Grace MacLean, came from Scotland to assist in his upbringing.[28] MacDonald took an early interest in art, studying under Adam Sherriff Scott at his private school between 1928 and 1930, and with Edmond Dyonnet at the Art Association of Montreal's life classes between 1930 and 1933. Both teachers were academically trained figurative painters, solid draftsmen whose work was traditional in execution and sensibility. MacDonald's particular artistic vision thus developed from a sound academic training, but it was invigorated by ready access to Montreal's more vibrant modern painters of the 1930s.

The decade in which MacDonald came of age artistically was unquestionably a vital one in Montreal. Seasoned and senior artists exhibiting regularly during the 1930s included such leaders of Montreal's modern school of painting as Edwin Holgate, Adrien Hébert, John Lyman, Lilias Torrance Newton, Marian Scott, Goodridge Roberts, Prudence Heward and Philip Surrey. All were prominent figurative painters, and MacDonald's sustained immersion in Montreal's strong figurative tradition established the foundation from which the artist would never stray. In terms of subject matter and treatment, MacDonald's Montreal rearing had far-reaching consequences for the artist, affecting both his own development as a painter and the kind of art he would later privilege – indeed seek out – in the building of Hamilton's collection. Many of Montreal's artists of the 1930s, largely uninterested in the wilderness landscapes long celebrated by Toronto's Group of Seven (1920–1932), turned to their immediate surroundings and the people inhabiting them for the subjects of their paintings. The urban environment, the figure and the portrait became central and recurring themes.[29] MacDonald, a child of his time, worked with this vocabulary from the very beginning, developing a lifelong predilection for portraits and figure studies and finding in them endless pictorial challenges and opportunities.

MacDonald's steady exhibition activity in Montreal throughout the 1930s points to an artist of some ambition, certainly one immersed in the daily activity of art. The twenty-year-old painter made his debut at the Art Association of Montreal's Annual Spring Exhibition in 1929, and exhibited each year thereafter through 1938. He also exhibited with the Royal Canadian Academy when their exhibitions were held in Montreal (1931, 1933, 1935, 1937), and participated in their *Canadian Art* exhibition organized under the direction of the National Gallery of Canada and presented at New York's World's Fair in 1939.[30] Apart from these group showings, MacDonald also sought out opportunities to present larger bodies of work; this was achieved through Montreal's Arts Club, where he exhibited in 1932, in a two-man show with Leslie Smith, and in 1935, in a solo show.

The Arts Club, a private men's club founded in 1912 and opened the following year by the city's cultural elite, provided MacDonald with an artistic "brotherhood" that included many of his close friends and painting associates. His application for membership, dated 11 October 1937, records Leslie Smith and James Crockart as proposer and seconder respectively, while Robert Pilot and Adrien Hébert were both supporting signatories.[31] Pilot, with whom

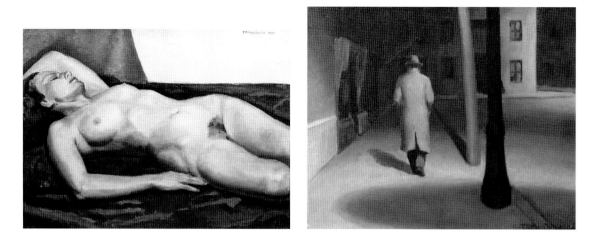

Fig. 5
T. R. MacDONALD (1908–1978)
*Nude* 1937
oil on canvas
Private collection

Fig. 6
T. R. MacDONALD (1908–1978)
*One A.M.* 1936
oil on canvas
33.3 x 40.8 cm
Private collection, Collingwood

MacDonald shared studio space in the 1930s, was among his closest lifelong friends and an artist who would play an important role in building Hamilton's collection after MacDonald's arrival there. David Morrice (nephew of painter James Wilson Morrice), whose application for membership was submitted only ten days after MacDonald's, was another good friend who retained ties with MacDonald after his departure from Montreal and who, together with his aunt Margaret Rousseaux, would be largely responsible for building the Gallery's collection of works by J. W. Morrice (including cats. 13, 26 and 31). But apart from the camaraderie and social network offered by the Club, it also gave MacDonald access to a steady stream of member exhibitions, which, for a period he had a hand in organizing. By November of 1946, the Club's exhibition committee was comprised of MacDonald, Pilot (as chairman), Smith, Hébert and Morrice.[32]

The work of two artist members in particular, Adrien Hébert and Edwin Holgate, appears to have provided MacDonald with viable means of loosening his approach while maintaining the form and structure central to his painting practice. In a 1937 nude (fig. 5), MacDonald's debt to Holgate is evident in the building of form through coloured planes and the emphasis on the structural whole of the composition. Formally and compositionally, however, it was Hébert's canvases that offered the most interesting touchstone for MacDonald. The spatial treatment of his interiors depends on visual strategies that became central to MacDonald's own practice. And while we see MacDonald experimenting during the 1930s with a loose painterly approach, it is in his small and highly successful *One A.M.* (1936, fig. 6) – which the artist reworked in a 1956 composition included in the present exhibition (cat. 86) – that we are presented with signature MacDonald. In this compositionally tight and direct picture, the restrained paint handling and muted palette establish an atmosphere of hushed quiet. Here, formal and chromatic control heightens atmospheric effect. MacDonald's interest in the structure of things, in the methodical build-up of form and the careful construction of shape and mass, is both evident and central to his approach. This evocative work reflects MacDonald's

primary concern with establishing an effective visual framework for his narratives. A sense of detachment and anonymity, of the individual's relationship with his environment, speaks directly of MacDonald's lifelong preoccupation with exploring the human condition. Whether in his acutely observed portraits and nudes or his seemingly detached urban scenes, a sustained objectivity coupled with a quiet introspection produced canvases that are simultaneously intimate and universal.

This particular aspect of MacDonald's painting practice has also been linked to the works of the American Realists,[33] most notably members of the Ashcan School and Edward Hopper. Hopper's compelling and melancholic night paintings were particularly appealing to MacDonald's own sensibilities. We need look no further than his *Drug Store* of 1965 (fig. 7) and compare it to Hopper's work of the same title from 1927 (fig. 8) – which MacDonald included in his 1961 *American Realists* show in Hamilton – to recognize his debt to his American colleague.[34] This essentially American tradition also found voice in Montreal, most prominently in Philip Surrey's urban street scenes (see cat. 87).

MacDonald's early life in Montreal was followed by several years of active duty in the Second World War. After enlisting in March 1941, he was sent overseas to England the following August with the rank of sergeant. In May of 1944 he was commissioned as a war artist and spent the majority of his remaining service in Italy.[35] His activities overseas consolidated many of the relationships he would maintain upon his return to Canada, including those with artists Charles Comfort and Will Ogilvie.

What becomes clear from a consideration of T. R. MacDonald's early years and his development as an artist is the degree to which his own aesthetic vision, both as painter and collector, subsequently defined Hamilton's collection during the period of building under his guidance. But there was another, equally important aspect of MacDonald's formative years that would also have an impact on Hamilton's collection: the rich network of artist-colleagues that he had developed and would maintain and nurture throughout his tenure in Hamilton. As we shall see, it was largely through MacDonald's connections in Montreal

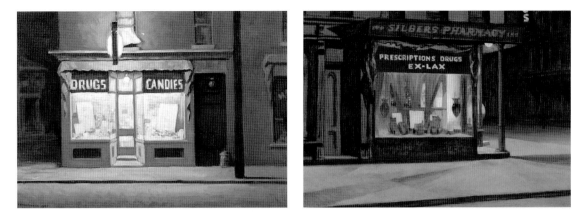

Fig. 7
T. R. MacDONALD (1908–1978)
*Drug Store* 1965
oil on canvas, 61.0 x 91.5 cm
Collection of Mary and John
Rutherford, Toronto

Fig. 8
EDWARD HOPPER
(American; 1882–1967)
*Drug Store* 1927
oil on canvas, 73.66 x 101.92 cm
Museum of Fine Arts, Boston
Bequest of John T. Spaulding,
48.564

and the artists whom he also called friends that Hamilton became home to many of its most prized canvases.

## Fifty-two Stairs

> It is entirely unnecessary to elaborate on the inadequacy of the present dilapidated and antiquated [art gallery] building more than to say that it is a disgrace to a city where culture amongst people of all conditions of life is soaring to new heights.[36]
>
> E. Howard Beynon, Vice-President,
> The Art Club of Hamilton, December 1946

When T. R. MacDonald reported to work on 12 November 1947 and climbed the infamous fifty-two stairs to the second floor of the Public Health Building – formerly the Public Library – which housed the gallery, his surroundings were by all accounts anything but inspirational; it was a gallery fallen into disrepair, in serious need of physical improvements and a cosmetic facelift. Of course, the situation in Hamilton was not unique: there were other rather dismaying directorial debuts in Canada. Eric Brown's arrival at the National Gallery of Canada, for example, was equally memorable. "When Eric Brown came to Ottawa in 1910 as Curator of the National Gallery of Canada, although this institution had been in existence for thirty years, it still occupied a small and dingy upstairs gallery above the exhibition hall of the Department of Fisheries on O'Connor Street. Eric liked to tell the story of his first day there when a small boy poked his head around the doorway and called out, 'Say mister, where's the whale?'"[37] The rather stagnant state of many Canadian cultural institutions persisted through the Second World War. By 1950 the National Gallery of Canada's status had improved only nominally; with a professional staff of four, the gallery continued to be housed in temporary quarters.[38] The situation in Hamilton was mirrored by George Swinton's virtually contemporaneous arrival as curator at the Saskatoon Art Centre.[39] Writing to his old friend "Mac," Swinton engagingly describes his first day on the job: "I arrived upstairs and the situation that I found myself in defies description ... This was my new threshold – and

I at once started to clean up the trash it held ... I was able to start building from scratch. Unfortunately, I found out that both financially and artistically the resources were – to say the least – low and extremely insecure."[40]

Naturally, the state of affairs varied from city to city and institution to institution, but only a handful of Canadian cities – Montreal, Quebec, Toronto and Vancouver – could boast gallery facilities designed specifically as such. Most institutions made do with premises that were neither properly equipped nor conceived as exhibition spaces, let alone fireproofed or climate controlled. The Winnipeg Art Gallery, founded (just two years earlier than the AGH) in 1912 – and thus one of the country's oldest galleries – was housed in the Civic Auditorium building from 1932 to 1971, while the Edmonton Museum of Art occupied space in the Edmonton Motors building between 1945 and 1955, before moving to the Secord House in 1955 and officially changing its name to the Edmonton Art Gallery the following year.[41]

Postwar reconstruction programs had a widespread impact on the feasibility and realization of cultural projects, and there is no question that this period witnessed an acceleration of collection building in Ontario. The new London Public Library and Art Museum (now Museum London) opened in the Elsie Perrin Williams Building in October 1940,[42] and the Willistead Art Gallery (now the Art Gallery of Windsor) was incorporated in 1944; both began their ascensions in the late 1940s. Under the respective leaderships of Clare Bice and Kenneth Saltmarche, the two institutions began actively programming and assembling collections in suitably equipped exhibition spaces. Like MacDonald, both men were artists who devoted their entire professional careers to the development of their respective institutions through dynamic programming and sustained collection building. It was this commitment to one place and one endeavour, moreover, that ultimately resulted in an identification between individual and gallery. These men – Bice in London from 1940 to 1972, Saltmarche in Windsor from 1946 to 1985, and MacDonald in Hamilton from 1947 to 1973 – became synonymous with their institutions, casting their respective galleries and collections in the moulds of their choosing.

However disillusioned MacDonald was with his new surroundings, they were clearly not sufficiently discouraging to deter him from his mission. In fact, with a staff of three that included a secretary and a superintendent, MacDonald embraced what he must have perceived as a remarkable opportunity in Hamilton. He certainly hit the ground running, redefining exhibition and programming activities, and making his ambition to develop the collection known from the start. In his first interview with *The Hamilton Spectator*, he is quoted as saying: "We are doing the best that we can with the very inadequate facilities we have at present and we hope, before too long, to have a more modern place and a collection which will be quite important."[43] The article goes on to outline MacDonald's plans for holding monthly exhibitions, beginning with a showing of seventeen paintings by Randolph Hewton[44] brought by MacDonald from The Arts Club, in Montreal (fig. 9).[45] From the very beginning of his tenure MacDonald knew his mind and how to effect his institutional strategies: establish an active exhibition program (one that relied heavily on his Montreal connections) with, more importantly, a view to building a collection of significance. For MacDonald, exhibitions were largely a means to an end. In a talk to Gallery members in March 1959, MacDonald said: "I think nothing takes the place in a community of a growing and vital collection, particularly if this can be supplemented by good, and when possible, related exhibitions. I believe much of the pleasure and benefit of exhibitions is missed when there is no fixed point of reference such as a permanent collection."[46] MacDonald wasted no time; within two months of his arrival in Hamilton he purchased his first painting for the collection – Albert Robinson's 1926 work *Falling Snow, Les Éboulements*, convincing the Gallery's Board to spend what little money they had in the bank on the work.[47] He realized early on that he needed to put art in front of people, as much of it as possible, for them to *see* it, if he hoped to develop both an audience for the Gallery and a taste for collecting art in the city. He succeeded roundly at both.

MacDonald also wasted little time in forging strong relations with one of Canada's most significant art patrons at the time. In February 1948, MacDonald travelled to Ottawa with the express purpose of calling on Harry Stevenson Southam, publisher of *The Citizen* and Chairman of the National Gallery's Board of Trustees, who had grown up in Hamilton. The young curator came away from his visit having secured four paintings for the AGH, including the spectacular *Icebergs and Mountains, Greenland* (c. 1930, cat. 62) by Lawren Harris, which arrived in Hamilton the following week. Shortly after the visit, then director of the National Gallery H. O. McCurry wrote to MacDonald: "I hope your people in Hamilton were properly impressed with the success of your expedition and will let you come again."[48] This beneficial and friendly association lasted for the rest of Southam's life. He donated thirteen more Canadian and European works to his hometown gallery, as well as bequeathing a further twenty-two on his death in 1954.

MacDonald also immediately set the pace and tenor of his exhibition program. Within three months of his arrival in Hamilton, he had organized a large exhibition of painting by Toronto and Montreal artists that offered a comparative view of these two important schools of painting. The show was enthusiastically received and heralded as a sign of things to come. One reviewer commented: "T. R. MacDonald, curator of the Hamilton Art Gallery … where the exhibition is being held, is largely responsible for bringing together the works which form the finest exhibit of its kind seen in Hamilton for many years."[49] It was an exhibition framework and formula that worked – for the Gallery, its patrons and the artists – and it set the model for what would become an important annual event at the Art Gallery of Hamilton: the Annual Winter Exhibition.

## Setting the Tone: The Annual Winter Exhibitions, 1948–1973

MacDonald's first long-term initiative was to inaugurate the Annual Winter Exhibition, a loan exhibition held every year from 1948 to 1955 during the month of December and thereafter in February until 1973, the years coinciding almost exactly with the span of his tenure in Hamilton. MacDonald had a range of aspirations for this juried show,

Fig. 11
PHILIP SURREY (1910–1990)
*Variation on a Theme by Poussin*
1962
oil on canvas
39.7 x 59.9 cm
Patron's Purchase Fund, 1963

not the least of which was assembling good work for potential acquisition, as well as providing another exhibition venue for artists. Outlining his initial purpose for the Winter Exhibition in a 1965 letter to William Withrow, then director of the Art Gallery of Toronto, MacDonald wrote: "I had in mind, I suppose, the old Spring show in Montreal, which prior to the war offered an opportunity for almost anyone of any ability at all to show their work in an exhibition with established artists. I believe this served a very useful purpose and I hope our exhibition here, in its own way, serves such a purpose."[50] The Winter Exhibition did serve this purpose, bringing together amateur and professional artists in a single exhibition forum.

But the Winter Exhibitions had even greater significance. They were, in effect, the first sign of the city and its Gallery's artistic maturation, brought about by the vision of T. R. MacDonald. Engendering a sense of pride amongst Hamiltonians, the initiative was hailed in the local press. "Show is a Landmark" ran *The Hamilton Spectator* headline that announced the first Winter Exhibition.[51] And indeed it was. "From the doldrums in which it struggled only a year ago, Hamilton Art Gallery has risen steadily in achievement and significance, and it can now hold its own independent exhibition. The First Annual Winter Exhibition of the Art Gallery of Hamilton is open in a few days time."[52] While the unidentified writer perhaps overstates the case, the Annual Exhibition certainly marked an important turning point for the institution.

The first Annual Winter Exhibition was a fair indicator of things to come: Hamiltonians were regularly presented with a solid, if not avant-garde, cross-section of Canadian painting (in oil and watercolour), printmaking and sculpture. Generally averaging around one hundred works, the Winter Exhibition consistently privileged the work of Hamilton, Montreal and Toronto artists. Regular Montreal contributors in the early years included Adrien Hébert, Philip Surrey, Ghitta Caiserman, Robert Pilot, Kathleen Morris, Goodridge Roberts, Frederick Taylor, Louis Muhlstock and Anne Savage.[53] Toronto and Ontario mainstays were Charles Comfort, A. Y. Jackson, Jack Bush, Paraskeva Clark, Carl Schaefer, Peter Haworth, Bobs Cogill

Haworth, A. J. Casson, George Pepper, Kathleen Daly Pepper, Rowley Murphy and John Alfsen. Hamilton talent was often represented by the work of sculptor Elizabeth Bradford Holbrook, Hortense Mattice Gordon, Ray Mead and other members of the Contemporary Artists of Hamilton.[54] There was unquestionably a coherence and consistency to the Winter Exhibitions, in terms of participating artists, jurors and aesthetics, particularly during the 1950s. Most of the artists (although not quite all) were figurative, and for those who formed the backbone of these annual exhibitions, continual exposure over more than a decade served to confirm and legitimize their work among the Hamilton audience.[55]

From the beginning, jurors were artists of reputation and, with very few exceptions, figurative painters.[56] Jury composition was usually a mix of local, regional and national talent; for the first Annual, for example, the jurors were A. Y. Jackson, Charles Comfort and Hortense Gordon. Later adjudicators included Carl Schaefer (1949), Will Ogilvie (1950, 1954, 1965), Kenneth Saltmarche (1951, 1959), Clare Bice (1949, 1957, 1962), Jack Nichols (1952, 1954), George Pepper (1951, 1958), Yvonne McKague Housser (1955), Jock MacDonald (1958), Philip Surrey (1960), Goodridge Roberts (1963) and Robert Pilot (1964) (fig. 10). With catalogues produced and funds raised locally to offer purchase prizes, the Winter Exhibition quickly became an *event*. Attendance rose consistently higher as Hamiltonians gathered yearly in increasing numbers to see a large body of contemporary painting, often simply for pleasure, often to purchase. The works shown annually were also a rich source of potential gallery acquisitions. Each year a purchase prize was solicited from a local patron or business, and a work selected by the acquisitions committee was added to the collection. Several important works entered the collection in this way: A. J. Casson's *First Snow* in 1952 (1947, cat. 82); the AGH's only Lilias Torrance Newton, *Keith MacIver* in 1955 (n.d., fig. 35); Jock MacDonald's *Iridescent Monarch* (1957) in 1960; John Lyman's *Femmes sur la Plage* in 1961 (1948, fig. 36); Philip Surrey's *Variation on a Theme by Poussin* in 1963 (1962, fig. 11); and Paraskeva Clark's

# *Fine Pictures At The Winter Show -- But Prize-winner Isn't One Of Them*

Fig. 12
Headline from *The Hamilton Spectator* review of the 8th Annual Winter Exhibition from which *Horse and Train* was acquired.
Spectator Collection, Special Collections, Hamilton Public Library

*Rain on Window* (n.d.) and Goodridge Roberts' *Reclining Nude No. 2* (1961), both in 1964.

Without question the most notorious prize selection was Alex Colville's *Horse and Train* (1954, cat. 85), purchased from the 1957 exhibition, for which Charles Comfort, Clare Bice and Henry Walter Smith served as jurors. The choice was not a popular one at the time, at least with one arts writer (fig. 12). Critic Mary Mason opened her review of the exhibition by questioning the validity of the acquisition: "There are undoubtedly some very fine paintings out at the Art Gallery of Hamilton in this year's Winter Show, but the winner of the purchase prize is not, alas, one of them."[57] As Joyce Zemans shows elsewhere in this catalogue, *Horse and Train* soon ascended to icon status, but at the time of acquisition it was, curiously enough, a rather provocative choice. That this painting would even slightly confound one critic speaks directly of the public's general comfort level, in 1957, with more contemporary forms of artistic expression.

## "I'm not a gambler. We're spending public money." T. R. MacDonald

The Winter Exhibitions provide us with an important artistic gauge for the period under review. During the 1950s, the work of many of the artists included in these shows came to form Hamilton's collection of contemporary art. The majority were working within a figurative framework, arguably out of step with the day's artistic vanguard. In decades when abstraction and non-objective art were at the forefront of the artistic discourse, Hamilton's acquisition program remained resolutely figurative, and the new curator was unequivocal on this issue from the start. While MacDonald was prepared to organize, and indeed ensure, a balanced exhibition program, one that incorporated presentations of both figurative and more avant-garde art,[58] he made his feelings towards the latter known publicly. A year into his administration, MacDonald brought to Hamilton the most "contemporary" exhibition the city had ever seen;[59] organized by the University of Toronto's Hart House, it included the work of six contemporary

Montreal painters: Gordon Webber, Jacques de Tonnancour, Albert Dumouchel, Alfred Pellan, Pierre Gauvreau and MacDonald's good friend Goodridge Roberts. With the exception of Roberts, all were working within an abstract idiom. In a review of the exhibition, MacDonald is quoted as saying: "Whether you like it or not, it is here in existence, and it's widespread – not just the work of a few cranks. Mind you, I'm not prepared to say it's art. Time will take care of it. If it is not art it won't last."[60] Not surprisingly, this distancing from non-figurative art manifested itself in acquisition matters. From the outset MacDonald perceived his role as collector for a public institution to be a conservative one. This is not to suggest that he was anti-modern; according to associate and friend Paul Duval, they often discussed abstract painting, and Duval remembers the curator being particularly interested in the work of Borduas.[61] However, MacDonald's approach to the building of a public collection was predicated on the belief that the core holdings should consist of an historical collection of works by artists of proven ability and reputation. It was a mandate to which he remained steadfast throughout his years in Hamilton. Retrospectively assessing his methods at the time of his retirement, MacDonald said: "I've had a very good time here considering we're conservative. But I'm not a gambler. We're spending public money. It's not up to a gallery like ours to gamble. I think it's up to the collectors to do that."[62] MacDonald had been true to his vision, and over the course of a twenty-six year period only a handful of abstract works entered the collection.[63] Given that his acquisition activities coincided with the rise and reign of abstract art in Canada, this fact offers indisputable evidence of MacDonald's collecting bias.

The 1950s actually became the proverbial battleground for a nationwide debate waged between the advocates of representational and abstract art. Much ink was spilled across the country concerning the "new" art and its legitimacy, as well as its relevance to the broader public.[64] Hamilton was no exception. From the beginning, abstraction was received with a mix of responses that ranged from qualified acceptance, to bemused concern, to outright condemnation. The public's discomfort was both

incited by and reflected in the debates that played out in the city's daily papers. The tone was established early on. In his review of the Montreal painters exhibition of 1948, *Hamilton Spectator* writer Eric Williams opens with the provocative question: "'But what on earth are they getting at?' That will be the worried query of many a Hamiltonian visiting the city's Art Gallery during the next few weeks. For the main exhibition on view there consists largely of abstract studies." And while overall the review attempts to treat the work in an even-handed manner, attending largely to its formal and decorative qualities, Williams closes his argument much in the manner he had begun: "This group of paintings represent a hypersensitive development of just one aspect of art, to the effacement of all others. Whether it can achieve real greatness is open to considerable doubt."[65]

The dialogue surrounding the rise and value of abstract art remained at a fairly undeveloped level, with writers conducting all-out assaults on the one hand and expressing conciliatory bemusement on the other. In a country where art education was still in its nascent stages, the public's dismay and confusion was to be expected. However, MacDonald's open misgivings about abstraction did little to entice interest in it, or to validate it among the local audience. Moreover, while ensuring that the public had access to abstraction through exhibitions, MacDonald remained resolute in his decisions regarding collection building. In his 1959 talk to AGH members, following over a decade of collection building, MacDonald's conviction remained steadfast.

> A question which has been asked from time to time is – why does the Art Gallery not A) concentrate entirely on contemporaries whose work can be purchased for relatively low prices, B) at least purchase more contemporary work? In answering for the Acquisitions Committee I would say that we have tried to do two things. First to try to assure that the Gallery will have as fine and representative as possible a collection of all periods of Canadian art ... We are trying to acquire these early works while there is still

> a chance to do so. With the increase of art galleries and private collectors we are in a highly competitive field. There are many artists whose work if not acquired now, or at least in the near future, will soon be impossible to find even at much higher prices than those prevailing today. I think it should be borne in mind that in a sense we are handling public monies and I think that it is our duty to invest it as soundly and wisely as possible. I am not prepared to say that it is the first duty of an art gallery to support younger artists, I wonder if this is not more properly the field of the private collector who by purchasing their works for his own collection and presentation to public galleries, will be affording young artists that recognition and solid encouragement so necessary.[66]

Essentially, what MacDonald had set out to do was establish strategies to educate the public about art, create a sense of enthusiasm, and develop a community of collectors. The Winter Exhibitions, as a form of visual education in contemporary representational Canadian painting, served this purpose in part. They provided Hamiltonians with a steady diet of quality work, initially from Ontario and Quebec and later from across the country, developing public appreciation and appetite for those artists that showed regularly. At this early juncture, we begin to see signs of what would prove to be a remarkably consistent and coherent approach to Gallery activities, which built upon itself, reinforcing and reiterating the importance of certain artists and a certain aesthetic. And so the various threads of Gallery activities – exhibitions, acquisitions, lectures, fundraising – were woven together early in MacDonald's tenure, coalescing into a well-defined strategy whose character became increasingly clear as the years passed.

Although it could be argued that this approach was unbalanced, serving neither the avant-garde artist nor contemporary art discourse, it did build on MacDonald's knowledge and connections. And while it was debatable at the time, there is little question today that MacDonald's strategy served Hamilton's collection remarkably well.[67]

Fig. 13
The Art Gallery of Hamilton's
second home opened
December 12, 1953.
Special Collections, Hamilton
Public Library

## A Community Comes Together

While MacDonald remained the guiding force behind all Gallery activities, the conception, execution and refinement of many initiatives were regularly the fruit of the indefatigable efforts of the Women's Committee (renamed the Volunteer Committee in 1977). The Annual Winter Exhibition was the first in the series of strategies set in motion by MacDonald, but when it came to ancillary Gallery activities geared at further building Hamilton's art audience, the Women's Committee was a force to be reckoned with. Formed in March 1950, the Committee (known initially but briefly as the Women's Auxiliary) came together at the request of the Board of Directors, who had first envisioned its role as simply to oversee the music for Sunday afternoon concerts at the Gallery.[68] Little did anyone know how pivotal this group would become to the Gallery's success on so many levels. Similar groups were already active in several other Canadian institutions. The Art Gallery of Toronto, the London Public Library and Art Museum, and the Winnipeg Art Gallery all boasted Women's Committees, reflecting a social and cultural dynamic that was taking shape in the postwar years, when large numbers of educated women with increased leisure time and a desire to contribute to their communities began devoting their energies to a range of causes. At a time when professional gallery staffs were minimal, their contributions were indispensable.[69]

From the beginning the mandate was clear: "The Auxiliary will have two main objectives: to create new interest in the Gallery by gaining new members, to help and instigate money raising schemes for the Gallery. The Auxiliary will also be responsible for entertaining and providing refreshments for the Openings of the Exhibitions, and on any other occasions when asked to do so by the Board of Directors."[70] Plans unfolded quickly and successfully, and the importance of the group's role within the organization was soon recognized. Particularly adept at mobilization and motivation, the Women's Committee numbered seventy within three months of its formation. And so the schemes began. Most significant among its members' many activities was their success at generating income for the institution while simultaneously building and educating an audience for art in Hamilton. Initially, their efforts were aimed at raising funds for a new gallery building, an objective that was fully achieved when the new Art Gallery of Hamilton opened in December of 1953 (fig. 13).[71]

Once formed, the Women's Committee immediately set to work, organizing the landmark *Mile of Pictures* exhibition in the short span of six months (fig. 14). At the suggestion of Mrs. C. W. Murphy (sister-in-law of artist Rowley Murphy), who had witnessed a similar event in the French capital,[72] the Committee embarked on its ambitious and novel exhibition concept: led by Janet Barber, the Committee's first president, the women approached every storeowner operating a commercial business along the city's two main commercial arteries[73] with the request to exhibit artwork in their store window. They succeeded in securing every window but three. The exhibition, which ran for a week in late September 1950, consisted of modestly priced works – nothing marked at over one hundred dollars, with fifty percent of the proceeds going to the Gallery's Building Fund. Soliciting work from over ninety artists across Canada, the Committee managed to secure over a hundred paintings and sculptures for display. Local and national artists alike participated, with the result that work by the likes of Arthur Lismer, A. Y. Jackson, Charles Comfort, Goodridge Roberts, Fritz Brandtner, Carl Schaefer and Paraskeva Clark were made available, at reasonable prices, to an emerging group of Hamilton collectors. The buzz surrounding the endeavour was considerable, as the event was expertly promoted by the Committee through the local press[74] and radio, as well as in Toronto's *Globe and Mail*. It was the kind of event the community could not help but support. After decades of hearing and reading about the need for a new gallery in Hamilton and witnessing various fundraising attempts, Hamiltonians were finally seeing a tangible effort that was also serving the broader community. Writing an advance notice in her column, *The Globe and Mail*'s Pearl McCarthy astutely noted:

Fig. 14
(l to r) Kate Steiner, Jean Keogh and Janet Barber at the Mile of Pictures information booth in Gore Park.
Courtesy, *The Globe and Mail*

Fig. 15
Art Rental in 1965
Spectator Collection, Special Collections, Hamilton Public Library

Hamilton is going to spring a surprise in the autumn, and do something really novel for Ontario. A committee transcending all group interests ... is organizing a gigantic sale of pictures by Canadian artists. Rumours ... indicate that the paintings will be displayed in several stores ... This is all very shrewd as well as helpful. Hamilton needs a gallery and public art policy, but public policies arise out of private enthusiasms, and there is no stimulus to art interest like personal ownership of a picture or small sculpture bought with your own savings. A theory turns into a love.[75]

And so the Women's Committee started turning theory into practice, assisting in the steady process of building a community of art enthusiasts and collectors. This first event successfully brought art to the streets and into people's everyday lives, exposing them to the work of contemporary Canadian artists and allowing them to participate in the Gallery's fundraising efforts in a personal and meaningful way. When all was said and done, the project had raised over nineteen hundred dollars, with half the works sold. And demonstrating the soundness of the Gallery's overall strategy of developing a community of collectors who would ultimately gift work to the institution, some of the works did indeed become part of the permanent collection.[76]

Another equally successful Women's Committee initiative was its Sale of Fine Arts series, held in 1954, 1957, 1959 and 1961.[77] These exhibitions were by invitation, and like the Winter Exhibition they provided a range of quality work for would-be collectors while dovetailing with the idea of further educating the public in contemporary art by established artists. But it was in 1955 that the Women's Committee launched one of its most impressive and important civic achievements: the Art Rental program (fig. 15). Both the Vancouver and London galleries had already developed rental programs, and it was felt that a similar scheme in Hamilton would further the Gallery's goals. It was this initiative, above all others, that served to bring original artwork into people's homes, developing their eye through the experience of living with art and inspiring renters to become collectors. While raising funds

was always a primary concern, early organizers of the rental program also held much loftier aspirations: "The project's real success has been through its emphasis on aesthetics and the education of the public ... The women responsible in the project's early days were determined that only the best work available by established Canadian artists would be shown, and they felt certain that such a policy could not help but be of benefit to those renting the works of art and to the artists themselves."[78]

In order to ensure quality, MacDonald was consulted in drawing up the list of artists to be contacted, and he continued to play an advisory role on an ongoing basis. As Ruth McCuaig, one of the Gallery's most significant patrons and a guiding member of the Women's Committee from its inception, remembers: "We didn't want to have anything [in art rental] that wouldn't be good enough for Tom to think worthy of renting ... After a Winter Exhibition or the Sale of Fine Arts, we would ask him to go around with us and [we would] say 'Do you think this would be suitable for the Picture Rental?'"[79] This recollection confirms the extent of MacDonald's influence over all matters of artistic concern connected with the Gallery. Developing a community of collectors was of paramount importance to him and to the future success of the Gallery. The concept was both simple and sound. Bring as much good work as possible to the community and establish a range of opportunities for its acquisition.

Apart from these more organized and formal mechanisms aimed at selling artwork, MacDonald himself functioned discreetly as an informed intermediary between various artists and Hamilton collectors. His constant search for work for the collection had him in regular contact with artists, while his familiarity with local collections enabled him to direct work to sympathetic households. Often, if a work arrived for consideration but funds were unavailable for acquisition by the Gallery, MacDonald would create the optimum conditions for its viewing by a potential collector. Hanging the work in one of the galleries and lighting it to advantage, he would contact a potential buyer and present it for their consideration. Many works entered Hamilton collections in this way, and the enterprise served both the

Fig. 16
REGINALD MARSH
(American; 1898–1954)
*Grand Windsor Hotel* 1939
tempera on paper mounted
on plywood
76.1 x 55.5 cm
Gift of Mr. and Mrs. J. A. McCuaig
in memory of her father,
H. B. Hall, 1963

community and the artists. In 1950, MacDonald's close friend Goodridge Roberts, who provided the curator with a steady stream of work from Montreal for local Hamilton collections, wrote to him: "Your skill in translating my things into cash fills me with wonder and exultation – and is most timely now that I have moved into an unfurnished place and have to get even such basic things as window-blinds, chairs and a kitchen stove."[80] Both Adrien Hébert and Edwin Holgate, other old friends from Montreal, also enjoyed ongoing patronage in Hamilton through MacDonald's good offices. Following receipt of a cheque for a number of drawings sent to Hamilton, Holgate wrote: "I am quite awed by the reception of the drawings ... Thank you for the cheque and the opportunity."[81] MacDonald's strategy was successful, since works he had had a hand in placing in Hamilton private collections often came to rest in the AGH's permanent collection, and continue to do so to this day. Albert Robinson's *Quebec Village* (1923, cat. 49), acquired by Mr. and Mrs. David Barber during MacDonald's tenure, is a perfect case in point: gifted to the Gallery in 1980, the work remained with the couple before entering the AGH in 2000.

### "There is always the problem of getting money to buy pictures for a collection. But when people know you want things, they help."[82] T. R. MacDonald

He made it sound so very simple. But the modesty of MacDonald's understatement belies the resolve and perseverance required to purchase work for the collection during the 1950s and 1960s, when there was no fixed acquisition budget or guaranteed purchase funds. In a few exceptional instances, the project of building a community of collectors served the Gallery's own acquisition goals directly. Placing utter faith in MacDonald's knowledge and judgment, Hamilton collectors Ruth and John McCuaig enabled the curator to build an important collection of American art, at a time when works by members of the Ashcan School and the Social Realists were still within

financial reach. An American by birth, Ruth McCuaig felt the association was an appropriate one and together with her husband funded many of MacDonald's regular New York jaunts to select work for Hamilton.[83] Through the McCuaigs' sustained philanthropy several important canvases entered the collection, including John Sloan's *Stein and Press* (1906, cat. 16); Reginald Marsh's *Grand Windsor Hotel* (1939, fig. 16) and George Bellows' *Portrait of Meredith Hare* (1921, fig. 17). Of course, there were others who contributed to the American cause, including Herman Levy, Mrs. Murray Proctor, Mrs. F. F. Dalley, Mrs. C. H. Stearn, and Mrs. C. W. Robinson, all close members of the Gallery "family" and (with the obvious exception of Levy) members of the Women's Committee. Following the important *American Realists* exhibition organized by MacDonald in 1961,[84] the director's strategy of educating and then building an audience for a particular school of painting through exhibition had certainly persuaded a handful of loyal Gallery patrons to assist him in broadening his collecting vision. And it happened quickly. By the summer of 1968 MacDonald had acquired enough good American paintings to prompt art critic Paul Duval to write an article in *The Hamilton Spectator* highlighting the fact: "Hamilton's ownership of such a splendid cross-section of American painting represents more than a cultural gesture of international goodwill. It also represents the goodwill and determination of a group of Hamilton citizens that the local gallery should stand second to none in certain basic fields of art. Virtually every American painting has been presented privately by a Hamilton Gallery supporter, with the guidance of the Gallery's director, T. R. MacDonald."[85] The American Realists had affinities to MacDonald's own painting practice, but he also saw their work as providing a rich contextual framework for the consideration of Canadian painting. "I think by surrounding the Canadians with Americans, British and Europeans, we can see our own art in its proper setting and perspective. I think the Americans are especially valuable. We're all North Americans and we share much the same experience.

Fig. 17
GEORGE BELLOWS
(American; 1882–1925)
*Portrait of Meredith Hare* 1921
oil on canvas
96.6 x 76.3 cm
Gift of Mr. and Mrs. J. A. McCuaig
in memory of her father,
H. B. Hall, 1968

Fig. 18
WALTER SICKERT
(British; 1860–1942)
*Hubby and Marie* 1914
oil on canvas
46.9 x 38.1 cm
Gift of the Women's Committee,
1960

Yet the U.S. artists were more socially conscious than our artists of the same period. So they complement each other very nicely."[86]

Of course, the collection was first and foremost Canadian; MacDonald had been clear about this from the start. In his 1959 speech to the Gallery membership, MacDonald retrospectively assessed the situation. "It seemed most natural and desirable that our first object should be the formation of the best possible collection of Canadian paintings, drawings, sculpture and prints."[87] In the same year, however, as MacDonald and the Board deliberated over the formalization of an official acquisitions policy, the decision was taken to collect modern British art, specifically painters associated with the Camden Town Group. This decision was certainly dictated in part by financial resources, as works by these painters were at the time "affordable," but the choice was nonetheless wise. In March of 1960 the Women's Committee sponsored a two-month European trip for MacDonald. Travelling to, among other places, Paris, Amsterdam, Rotterdam and Edinburgh,[88] he also spent considerable time in London, and on his return to Hamilton presented four works for acquisition that included Spencer Gore's *The Bedroom* (1908, cat. 18) and Walter Sickert's *Hubby and Marie* (1914, fig. 18). Women's Committee funds subsequently proved indispensable to the burgeoning British collection, their support permitting the acquisition of several important canvases and sculptures during MacDonald's tenure.

The other important player in the building of the British collection, and to a lesser degree the American collection, was the aforementioned Paul Duval, writer and arts editor for *Saturday Night* magazine from 1944 to 1963 and a close associate of MacDonald's. When the New York-based International Business Machines Company (IBM), which had built sizeable nation-specific collections in the 1930s, slowed its collecting activity, Duval, familiar with their holdings, approached the company about their ultimate intentions for the works and expressed an interest in purchasing.[89] Within a few years, Duval had succeeded in acquiring large portions of both the Canadian and British collections.[90] His close association with MacDonald and his respect for the manner in which the director was steadfastly building the AGH collection resulted in MacDonald being given right of first refusal – at cost.[91] No fewer than seven works from IBM's British holdings entered the collection, including Tristram Hillier's *L'Arrêt de Villainville* (1939, cat. 75), Paul Nash's *Monster Shore* (1939, cat. 76) and Edward Wadsworth's *Sussex Pastoral* (1941, cat. 80).[92]

A frequent visitor to Hamilton, where for a time in the 1960s he became art critic for *The Hamilton Spectator*,[93] Duval developed relationships with several of the city's top private collectors, often placing important work in their hands. It was through Duval, for example, that prominent collector Roy Cole, a Hamilton businessman who was a leading Board member and governor of the Gallery for many years, as well as being a member of the acquisitions committee between 1968 and 1970, acquired two significant Canadian canvases – Emily Carr's *Yan, Q.C.I.* (1912, cat. 27) and Lawren Harris's *Hurdy Gurdy* (1913, cat. 32).[94] Duval had purchased the Carr from IBM in December of 1961 for one hundred and fifty dollars. Some thirty years later, Cole would gift both works to the AGH, strengthening the modern Canadian collection in a significant and enduring manner.

In retrospect, the decision to collect modern British and early twentieth-century American art was a sagacious one, as these collections served to define and distinguish Hamilton's holdings in a manner totally unique in Canada. The relationship between these schools and Canadian painting was as yet unexplored, and no other mid-sized regional institution in Canada, with the exception of the Beaverbrook Art Gallery, opened in 1959 (the result of Lord Beaverbrook's modern British collection), was actively collecting in these areas. The move to introduce international schools to complement the AGH's Canadian holdings and thereby raise the stature of the collection was a confident one. Still relatively modest in size but now ambitious in scope, the collection was unquestionably coming of age.

Fig. 19
CHARLES COMFORT (1900–1994)
*Chuhaldin* 1931
watercolour on paper
91.4 x 106.7 cm
Gift of the Women's Committee,
1954

## "One of Them": The Artists' Network

It is largely through the perspicacious and canny buying of artwork that we obtain a clear view of a curator's taste and judgment. The willful and skillful shaping of the collection was accomplished by MacDonald in a fluid and determined manner. As the only reliable source of acquisition funds, monies raised by the Women's Committee were essential to MacDonald in achieving his curatorial vision for the collection. But their involvement ended there: from the beginning it was made clear that acquisition decisions lay exclusively with the curator/director and the acquisitions committee.[95] In retrospect, this renunciation of control was crucial to the overall success of the Gallery's purchase program – and the quality of the resulting collection – because it allowed MacDonald to pursue his vision unimpeded. However, while curatorial visions inevitably do, and should, have an impact on any permanent collection, the issue of unilateral control has long been a matter for debate.

In an article published in the 1950 summer issue of *Canadian Art*, senior Canadian artist Lawren Harris and E. R. Hunter, then director of the High Museum of Art in Atlanta, Georgia (and a Canadian who had worked in galleries in Ottawa, Toronto and Montreal), debated precisely this matter of individual versus committee control over curatorial decisions. Harris argued for a democratic model in matters of Canadian art gallery policy, believing that galleries should be run "strictly under the control and direction of councils and committees made up of both laymen and artists, elected by the gallery membership, and art bodies with the director and curator subject to the decisions of these gallery councils and committees."[96] Hunter countered: "Selection by committee almost always results in compromise, and while it may be safe enough in politics, compromise is invariably dull in art … collections formed by one man, while often not so well rounded, usually have more sparkle, more really fine paintings than are to be found in collections which have been selected by committee."[97] Both, however, agreed on one point: if the curator/director also "paints" then he is more likely to work in harmony with the artist, to better understand the

artistic process. Though MacDonald the artist worked with an acquisitions committee, the vision was undoubtedly his. This is clear in the constancy of the choices and the cohesiveness of the collection he built. That MacDonald's eye was consistently unerring is borne out by a look back at some of his more prescient purchases.

Women's Committee funds first became available for the acquisition of artwork in 1954, and with the purchase that year of Charles Comfort's *Chuhaldin* (1931, fig. 19) a crucial acquisition lifeline was established. Nearly four hundred works have been added to the collection through the benefaction of the Women's Committee, among these many of the Gallery's most prized canvases: for example, George Reid's *Forbidden Fruit* (1889, cat. 7), Carl Schaefer's *Farm House by the Railway, Hanover* (1939, cat. 77), Horatio Walker's *Ave Maria* (1906, cat. 15) and, perhaps most notably, Maurice Cullen's *Logging in Winter, Beaupré* (1896, cat. 12).

Cullen's work initially found its way to Hamilton as a result of MacDonald's ongoing relationship with Robert Pilot, Cullen's stepson, as the two friends maintained close contact following MacDonald's relocation to Hamilton in 1947. The curator first proved his commitment to collecting Cullen's work by purchasing the important *Cape Diamond* (1909, cat. 21) in April of 1955, with bequest funds from Hamilton collector and former Board member H. L. Rinn. The following year Pilot and MacDonald became immersed in the planning of the 1956–1957 touring Cullen retrospective. The project was a collaboration between the Art Gallery of Hamilton, the National Gallery of Canada, the Art Gallery of Toronto and the Montreal Museum of Fine Arts, with MacDonald and Pilot responsible for making the selection of work, and Robert Hubbard, then chief curator of the National Gallery, acting as advisor. MacDonald and Pilot were in constant contact over the several months leading up to the exhibition's opening at the AGH in November 1956. As a consequence of MacDonald's role in bringing together the exhibition and certainly out of regard for Hamilton's burgeoning Cullen collection, Pilot gave him right of first refusal on *Logging in Winter, Beaupré* when it arrived in his studio from Freda Harris (the widow of artist

Robert Harris's nephew). Writing to MacDonald in March 1956, Pilot asked: "Do you want 1st choice on the 1896 Cullen? Cleaned it is a marvel ... I am in <u>NO</u> way involved in its sale, but I would like to have a proper home for it."[98] MacDonald's response was immediate, and in under three months the painting was in his office, accompanied by a price tag of nine hundred dollars. The fact that the Women's Committee could not at the time finance the purchase did not deter MacDonald: if he had his way, the painting would not leave Hamilton. *Logging* was offered to Janet and David Barber, important patrons who were building a private collection,[99] and at the beginning of July Pilot wrote MacDonald asking whether the Barbers had made a decision.[100] Meanwhile, the work remained in MacDonald's office for patrons and members to see, as he tried to find a way to keep it in Hamilton.[101] With the opening of the Cullen retrospective at the AGH, patrons were provided the rare opportunity of viewing the work in the context of the artist's *œuvre* and thereby assessing its relative merits. On 20 December 1956, days before the work was slated to go on tour (and surely be purchased), the Women's Committee once again rose to the occasion.[102] They had needed the intervening months to raise the money, and MacDonald's ability to "stall" had succeeded in securing for the Gallery what would prove to be one of its most important acquisitions.[103] Indeed, *Logging in Winter* has become a mark of distinction for the Gallery and its collection.

Pilot, a good friend to MacDonald, became in turn a good friend to the Gallery, donating over eighty works between 1950 and 1969, twenty-eight of which were Cullen drawings.[104] MacDonald's personal relationship with several key artists was arguably the single most important ingredient of his success, and it was an entirely natural one. As an artist, MacDonald sought out the company of other artists. Paul Duval has recently recalled how MacDonald "loved to talk about painting, to get at the guts of it."[105] It is important to remember that throughout his time as curator MacDonald maintained an active studio practice, exhibiting where and when possible – a rather remarkable feat given the demands of his day job.[106] His daughter, artist Katherine MacDonald, recalls her

father regularly spending several hours in the studio after his day's work at the Gallery.[107] It was a commitment that transcended the vicissitudes of his daily responsibilities and invariably returned him to what mattered most to him: painting. He studied it, understood it, lived it. And other artists knew and appreciated this fact. It was important to them that their work would enter a collection curated by an artist – and one whose work they respected. Looking back on the acquisition of *Horse and Train*, Alex Colville recently remarked: "It meant something to me that Tom had selected the painting, that he wanted it for the collection."[108] It is a refrain heard over and over in accounts of MacDonald's dealings with artists.

In fact, the majority of the works that entered the collection during MacDonald's tenure came from artists, as either gifts or purchases. Several important acquisitions came directly from the artist's studio, at MacDonald's instigation. A perfect case in point is Charles Comfort's *The Dreamer* (1929, cat. 60). First exhibited in the 1930 Ontario Society of Artists exhibition, the work was also shown the following year at the Montreal Museum of Fine Arts' Spring Exhibition, which is almost certainly where MacDonald – an exhibitor himself that year – saw it for the first time. At both shows the asking price was six hundred dollars, but the work failed to find a buyer and returned to Comfort's studio. Over the next couple of decades it was to all intents and purposes forgotten – except by MacDonald. He had an extraordinary ability to store away images in what must have been a vast visual memory bank, enabling him to recall paintings he had seen years earlier and set about checking their whereabouts and availability. Such was the case with *The Dreamer*. In 1957 Comfort served as a juror for the AGH's Annual Winter Exhibition, and it was at that time that MacDonald broached the idea of acquiring the painting. "Tom, being an artist himself, had a remarkable way of filing away in his mind all the paintings he considered important, hoping someday, somehow to acquire them for his gallery," Comfort later recollected. "I told him I did still own *The Dreamer* and, if I remembered correctly, it had been listed in the 1930 catalogue for $600. 'We only have $350,' said

Tom. I thought a moment and decided I could not think of a better home for *The Dreamer* than the Art Gallery of Hamilton."[109] MacDonald had asked after the work some twenty-six years after first seeing it, and when he realized that Comfort was willing to part with it he responded quickly. Upon receipt of prompt payment Comfort wrote: "The dispatch with which you have acted in this purchase precludes, of course, any reconsideration of your proposal on my part – a very smart move. Actually, I am delighted that it now forms part of a distinguished collection. I had always hoped that that might be its destiny."[110] The painting was a gutsy choice, for it is an atypical and edgy example of the artist's work. Thanks to MacDonald, its state of obscurity proved to have been a temporary condition. It was this innate ability of MacDonald's to recognize a painting's integrity, its fundamental staying power, that set him apart.

MacDonald's copious correspondence with artists is peppered with similar enquiries about specific images remembered and "filed away." Letters from Adrien Hébert, Edwin Holgate, Ernst Neumann, Goodridge Roberts and John Lyman regularly make mention of pictures MacDonald has asked after, as well as other work available for the collection. Not surprisingly, the direct approach yielded impressive results. Hébert's important *Elevator No. 1* (c.1929, cat. 57) was purchased directly from the artist in April 1962, John Lyman sold his *Femmes sur la Plage* (1948, fig. 36) in response to MacDonald's request for a figure painting, and Edwin Holgate dispatched his *Uncle George* (1947, cat. 83) immediately upon receiving a request from MacDonald. "In reply to your letter of the 16th I acted with promptitude and crated 'Uncle George' for shipping last Sunday morning," wrote Holgate. "I hope that your Directors see fit to acquire it – as I feel that it is fit for a public gallery and I would be honoured to be represented in Hamilton. After years of experience – I take nothing for granted but I can hope."[111]

MacDonald's memory also served him well with Carl Schaefer's work. Like Comfort's *Dreamer*, Schaefer's seminal canvas *Farm House by the Railway, Hanover* (cat. 77) had remained in the artist's studio following its initial

exhibition – in that case, with the Canadian Group of Painters (1939), the Montreal Spring Exhibition (1940) and the Canadian National Exhibition (1940). When MacDonald asked Schaefer to submit it to the AGH's 1964 Winter Exhibition, the artist found the proposition odd, given the work's date of 1939. "I am somewhat surprised as this is an early canvas dating back twenty-five years and I have only one other of approximate size and quality in my possession of these early years," he wrote.[112] Clearly, MacDonald had a particular goal in mind: getting the work to Hamilton in order to purchase it for the collection. As soon as he expressed interest in acquiring it, Schaefer offered the picture, at a discounted amount, saying: "I would be honoured if it was in your collection."[113] The work was promptly purchased in January 1964 with funds provided by the Women's Committee.

For MacDonald it was often simply a question of asking. Visiting Lawren Harris in the summer of 1956 with a view to organizing an exhibition of his recent work,[114] MacDonald was struck by *Waterfall, Algoma* (c.1920, cat. 42), then hanging in the artist's dining room. It was a work that obviously lingered with him; however, it took MacDonald nearly a year to make his move. With his characteristic gift for finding the appropriate tone, he wrote to Harris in May 1957: "Will you forgive me if I ask you an impertinent question? While in your home last summer I was much impressed by a large canvas of an Algoma Waterfall … It has taken me all this time to ask you if you would consider parting with it."[115] This patient and respectful approach, this gentlemanly manner – a hallmark of MacDonald's temperament – was in evidence in all of his interactions. Certainly, the tenor of this letter must have appealed to Harris, who responded in kind. "We have never considered selling the Algoma Waterfall canvas. It is one of a very few early canvases we still own and I must confess the more I see it the better I find it – I am so far removed from it in time that I see it quite objectively as though someone else had painted it and enjoy looking at it. However, my wife and I feel that if a leading gallery in the country wants it we should not keep it."[116] Elated by Harris's reaction, MacDonald wasted no time

Fig. 20
A. Y. JACKSON (1882–1974)
*The Old Gun, Halifax* 1919
oil on canvas
54.2 x 65.4 cm
Gift of the artist, 1954

in having the work shipped to Hamilton in order to hang it and begin the process of fundraising.[117] Once again the efforts of the Women's Committee – this time through their third Sale of Fine Arts – resulted in another major acquisition, and *Waterfall, Algoma* became the third Harris to enter the AGH collection.

MacDonald's ability to acquire important canvases from other members of the Group of Seven was greatly enhanced by his personal relationship with several of the founding members and/or their kin. Arthur Lismer, whom MacDonald knew from his Montreal days, gifted his *Bon Echo Rock* (1923, cat. 48) and *The Little Waterfall, St. Donat* (1941) to the AGH in 1951. A.J. Casson donated nine watercolours and drawings between 1961 and 1962, broadening representation of his work in these media. J.E.H. MacDonald's son Thoreau (also an artist) first made contact with T. R. MacDonald in May 1949 after hearing through Will Ogilvie[118] that the Gallery was interested in acquiring an example of his father's work.[119] The relationship between Thoreau MacDonald and the Gallery director proved a most fruitful one. The two jointly organized the J.E.H. MacDonald retrospective of 1957, and the younger MacDonald ensured entry into the collection of his father's important canvas *A Rapid in the North* (1913, cat. 33), which MacDonald had painted shortly after having seen the pivotal *Exhibition of Contemporary Scandinavian Painting* at the Albright Gallery, Buffalo, in January 1913.

Unquestionably, however, it was T. R. MacDonald's sustained friendship with A. Y. Jackson, more than with any other artist, that served – both overtly and more subtly – the building of Hamilton's collection. Jackson's role, an ongoing one, began with the acquisition of *La Cabane* (1949), his submission to the 1950 Winter Exhibition and winner of the purchase prize. In April of 1956 the painter pitched an idea to MacDonald that would see his sketches enter the collection on a regular basis:

As usual when I return from a sketching trip all the best sketches are acquired by collectors and I never seem to be able to keep any of them, though I have been trying for years to do so. Neither the Art Gallery of Toronto nor the National Gallery have [sic] a good selection of my sketches. They have not always purchased them from me and I would like to see a collection that I approve of myself. This is what I would like to do, if you approve – When I go on a sketching trip, if there is a sketch I like particularly I will give it to the Art Gallery of Hamilton until there is a collection of twelve or perhaps twenty sketches, after that if there are a few that fall below the general level they can be exchanged if better ones come along … It sounds egotistical but the idea is sound … I don't want to start a precedent, so make no announcement, and if you think this idea unwise don't hesitate to say so.[120]

MacDonald obviously thought the idea wise and that same year accepted six sketches into the collection. Importantly, Jackson didn't restrict his selections to current work but sought to deliver a representative and balanced group, both chronologically and thematically speaking. In the end, he gifted twenty-three sketches. Jackson was also interested in being represented by larger, more significant pieces, and therefore saw that *The Old Gun Halifax* (1919, fig. 20) was acquired by Hamilton in 1954. Apart from his own *œuvre*, moreover, the senior painter helped shape AGH holdings by donating the work of other artists and encouraging them to support the Gallery and its collection. Paintings by Cullen, Carmichael, Robinson and Schaefer entered the AGH as a result of Jackson's patronage. Supporting MacDonald's initiative to build a strong corpus by Montreal artists, Jackson both gifted work from his collection and provided MacDonald with funds to buy. In this manner, Jackson played a very direct role in ameliorating the collection of work by women painters associated with the Beaver Hall Group, including Mabel Lockerby, Anne Savage and Emily Coonan, whose important *Girl in Green* (1913, fig. 37) entered the Gallery through Jackson.

It was also Jackson's deft dealings with the Heward family that resulted in Prudence Heward's *Girl Under a Tree* (1931, cat. 63) joining the Hamilton collection. He became involved in the Heward acquisition at

the request of MacDonald, who was looking to acquire an important Heward canvas. Much as for Comfort's *Dreamer*, MacDonald remembered having seen the nude, likely in Montreal at the Heward exhibition held at W. Scott and Sons in 1932. Jackson served as intermediary between MacDonald and the Heward family, writing to MacDonald in December 1958: "I saw Jim Heward a while ago. I spoke about the 'nude.' I did not mention Hamilton as he asked me if five thousand dollars would be too much."[121] The issue lay dormant for some two years until the acquisition became a possibility following failed negotiations with the National Gallery. "There might be a chance of getting Prudence Heward's 'Nude.' The National Gallery have asked for it but they are cool towards that institution, there was not one of Prue's canvases hung so far as I know all the time Jarvis was director ..."[122] Jackson felt the time was right to approach the family. "The National Gallery are willing to accept it as a gift, but cannot purchase it. In other words they do not set much value on it. Naturally the family are not much interested. I have written them and suggested the painting would be much more appreciated in Hamilton."[123] The response was positive: "I had a letter from Jim Heward, he said he and his brother and sister had talked things over and they rather like the idea of Prudence's 'Nude' going to Hamilton."[124] No doubt the perception that the painting would have a central and valued place in the collection influenced the Heward family's decision to gift the work to Hamilton. And so another seminal canvas arrived in Hamilton through the well-placed energies of an artist and the patience and tenacity of the Gallery's curator/director.

## The Collection Comes of Age

A. Y. Jackson was a member of the generation of senior Canadian artists who felt a particular affinity and kinship to Hamilton and its collection, in large part because MacDonald was still, in the late 1960s and early 1970s, paying attention to them and their work. At a time when many senior artists were made to feel that their position in the art world was slowly evaporating, MacDonald

carved a purposeful place for them in Hamilton. In 1966 Anne Savage wrote MacDonald: "It is good of you to take in another stray lamb – Hamilton is becoming my spiritual home."[125] And although the composition of the Annual Winter Exhibitions naturally evolved under MacDonald's curatorship, he continued to invite those early contributors who were finding it increasingly difficult to place their practice within the institutional framework. Toronto painter Paraskeva Clark, a steadfast friend of the Gallery during the 1950s and 1960s, undoubtedly spoke for her generation when in 1971, following her inclusion in the 22nd Annual Exhibition,[126] she thanked MacDonald "for keeping a place for me in Canadian Art."[127] And while some would argue that MacDonald's strong associations to this generation of artists (*his* generation) somehow kept him and his curatorial vision anchored to the past, Clark's poignant comment eloquently reflects both the means and the end of MacDonald's activities in Hamilton. His vision for the collection and his laying of its foundation had relied heavily on such associations, and he remained true to them to the end, serving both artist and institution.

Upon his retirement in June 1973, T. R. MacDonald said: "This has been my real pleasure here, the collection. I'm a born collector and have been since I was a student. I'm a curator at heart, not a director."[128] The pleasure MacDonald took in his passion yielded remarkable results, and after a quarter-century of collection building he was able to assess and enjoy the fruits of his labours. But so, too, were others. In the final years of his directorship and immediately following his retirement, MacDonald saw his collection achieve considerable status outside the city. Several loan exhibitions dedicated solely to Hamilton's collection were presented across the province – unequivocal testimony to its importance and desirability.[129] And the momentum continued long after MacDonald's tenure. The collection, begun with so little and built up through the ingenuity and sheer will of a community of believers, now resonates at regional, national and international levels. With confidence and distinction, it has come of age. ~

## Notes

1. Duval made the remark in the article "'Hidden' Talent of Hamilton's Tom MacDonald," *The Hamilton Spectator,* 23 November 1968.

2. Ishbel Gordon, Countess of Aberdeen and Temair, *Through Canada with a Kodak* (Edinburgh: W. H. White, 1893), p. 54.

3. In recognition of the Art Gallery of Hamilton's seventy-fifth anniversary in 1989, AGH Curator Ross Fox and writer and former *Hamilton Spectator* art critic Grace Inglis wrote the gallery's history in *The Art Gallery of Hamilton: Seventy-Five Years (1914–1989)* (Hamilton: Art Gallery of Hamilton, 1989). Their discussion provides an excellent overview of the founding and subsequent development of the AGH and its collections. Readers may refer to this text for a more developed discussion of the early years (notably 1914 to 1947) and the post-T. R. MacDonald period. I acknowledge and thank both authors for the research set out in this volume; it was of considerable assistance to me in the early phases of this project and proved an invaluable guide throughout.

4. Canadian institutions that pre-date the AGH include the Art Association of Montreal (1860; now the Montreal Museum of Fine Arts), the Musée du Séminaire de Québec (1874; now the Musée national des beaux-arts du Québec), the National Gallery of Canada (1880), the Owens Museum of Fine Arts (1895; now the Owens Art Gallery), the Art Museum of Toronto (1900; now the Art Gallery of Ontario), the Nova Scotia Museum of Fine Arts (1908; now the Art Gallery of Nova Scotia) and the Winnipeg Art Gallery (1912).

5. For a fuller discussion of William Blair Bruce and his family's bequest to the City of Hamilton, as well as the inaugural exhibition, see Arlene Gehmacher, *Painting for Posterity: William Blair Bruce* (Hamilton: Art Gallery of Hamilton, 2000).

6. Key organizations in this movement were the Hamilton Art School (founded in 1885; classes began in February 1886), the Canadian Club (founded in 1893), the Hamilton branch of the Women's Art Association of Canada (founded in 1894) and the Hamilton Art Students' League (formed in 1895). Fox and Inglis, pp. 2-5.

7. "Art Gallery: Trustees Held Their First Meeting Yesterday," *Hamilton Daily Times,* 8 January 1914.

8. "Auspicious Opening of Local Art Gallery," *The Hamilton Spectator,* 2 July 1914.

9. The work of German sculptor Josef Jost was also included, likely through the efforts of his wife, Hamilton-born artist Ottilie Palm Jost.

10. "Review of Pictures at Art Gallery: An Exceptionally Fine Collection of Paintings, Etchings and Drawings Has Been Secured for the Opening Exhibition," *Hamilton Herald,* 4 July 1914.

11. Other exhibiting artists whose work would later be represented in the AGH collection are Mabel May, Marc-Aurèle de Foy Suzor-Coté, Clarence Gagnon, Randolph Hewton, William Clapp, Ottilie Palm Jost, Mary Hiester Reid, Elizabeth McGillivray Knowles, Dorothy Stevens, Frederick Bell-Smith and John Sloan Gordon.

12. "Auspicious Opening of Local Art Gallery," *The Hamilton Spectator,* 2 July 1914.

13. Gehmacher, *Painting for Posterity.*

14. The painting exhibited was a landscape, *The Border of the Forest, Morning.* Its present location is unknown.

15. Bruce and his sister Bell Bruce-Walkden had assisted William Long – first owner of the two Cullens – in building his collection.

16. William Blair Bruce in a letter to his father, July 1895, in Joan Murray, ed., *Letters Home: 1859–1906. The Letters of William Blair Bruce* (Moonbeam, Ontario: Penumbra Press, 1982), p. 195.

17. For further details on the Long and Bisby Memorial Collection see Fox and Inglis, pp. 7-8.

18. Sylvia Antoniou, *Maurice Cullen: 1866–1934* (Kingston: Agnes Etherington Art Centre, 1982), p. 86.

19. Ibid., p. 6. Carol Lowrey notes regular contact between the two artists between 1892 and 1894; see *Visions of Light and Air: Canadian Impressionism, 1885–1920* (New York: Americas Society Art Gallery, 1995), p. 18.

20. The Patriotic Fund exhibition, organized and circulated under the auspices of the Royal Canadian Academy, was entitled *Pictures and Sculptures Given by Canadian Artists in Aid of the Patriotic Fund.* Two works were purchased for the collection: A. Y. Jackson's *Near Canoe Lake,* exhibited as *In the North Country,* and J. W. Beatty's *Cloud Shadows* (c. 1914), presented by the Hamilton branch of the Women's Art Association of Canada. Other works exhibited but added to the collection later are Emily Coonan's *Girl in Green,* acquired through A. Y. Jackson in 1956, and Sir Edmund Wyly Grier's *The Blue Scarf* (c. 1910), acquired in 1960.

21. Jackson made his first trip to Canoe Lake in February 1914, returning north in October to sketch with Thomson and future Group of Seven members Arthur Lismer and Fred Varley. See A. Y. Jackson, *A Painter's Country: The Autobiography of A. Y. Jackson* (Toronto: Clarke, Irwin and Company Ltd., 1958), pp. 28, 30-31; and Dennis Reid, *The Group of Seven* (Ottawa: National Gallery of Canada, 1970), p. 76.

22. Jackson had studied and painted in Europe from 1907 to 1913.

23. Compositionally the work has strong affinities with Thomson's *In Algonquin Park* (1914), (McMichael Canadian Art Collection, Kleinburg, Ontario), painted the same year and also exhibited at the Patriotic Fund exhibition.

24. The most notable donation was the 1936 John Penman bequest, which included twenty-three oils and watercolours, primarily of European origin. Canadian works included two watercolours by Lucius O'Brien and two portraits of the Penmans by J.W.L. Forster.

25. Freda Waldon, "The Recurring Dream of a Cultural Centre for Hamilton," address given at the opening of the 15th annual exhibition of The Art Club of Hamilton, 30 May 1947; typescript, Special Collections, Hamilton Public Library.

26. Between 1914 and 1947 several part-time curators had overseen gallery activities, most notably artist Leonard Hutchinson (from 1945 to 1947) *Minutes of the Municipal Council of the City of Hamilton for the Year 1947,* Meeting of 19 February 1947 (Hamilton: Hamilton Typesetting Company, 1947), p. 152.

27. The Art Gallery of Hamilton would also prove to be MacDonald's home for a time. From his arrival in November 1947 until 1951, the young curator adapted a small part of the Gallery into a modest domestic living space.

28. Andrew Oko, *T. R. MacDonald 1908–1978* (Hamilton: Art Gallery of Hamilton, 1980), p. 50.

29. For a full discussion of this period in Montreal, see Charles C. Hill, *Canadian Painting in the Thirties* (Ottawa: National Gallery of Canada, 1975) and Esther Trépanier, *Peinture et modernité au Québec 1919–1939* (Quebec City: Éditions Nota bene, 1998).

30. In 1947 MacDonald was elected as an Associate of the RCA, becoming a full Academician in 1957.

31. "Proposal for Membership in The Arts Club," Application Form, File 1 "Adhésions," P2/H Recrutement. Arts Club fond, The Montreal Museum of Fine Arts Archives.

32. Minutes of the Council of the Arts Club, 5 November 1946, in *Procès-verbaux et documents afférents, 1946–1950,* P2/B2/2,5, Arts Club fond, The Montreal Museum of Fine Arts Archives.

33. Oko, *T. R. MacDonald,* p. 8.

34. While the AGH collection does not include any canvases by Hopper, it does hold one print. There is no question that this fact is due to financial factors rather than curatorial ones.

35. Oko, *T. R. MacDonald,* p. 50.

36. E. Howard Beynon, "Why Hasn't Hamilton a New Art Gallery?," *The Hamilton Spectator,* Letter to the Editor, 11 December 1946.

37. F. Maud Brown, "Eric Brown: His Contribution to the National Gallery," *Canadian Art,* vol. 4, no.1, November–December 1946, p. 8.

38. The 1951 Royal Commission on National Development in the Arts, Letters and Sciences (The Massey Report) refers to a professional staff of four that included the director and three "professional assistants," which would have included curatorial staff. The complete staff at the time numbered twenty-six, when all administrative and support staff were included. I thank Cyndie Campbell, Head, Archives, Documentation and Visual Resources at the NGC, for providing this information.

39. The Saskatoon Art Centre was established in 1944 as one of Canada's first artist-run centres; it was later absorbed into the Mendel Art Gallery when that institution was formed in 1964.

40. George Swinton in a letter to T. R. MacDonald, 3 March 1949, private collection, Hamilton.

41. *1924–1989: Six¹/₂ Decades: 65 Years of The Edmonton Art Gallery* (Edmonton: The Edmonton Art Gallery, 1989), p. 4.

42. Tom Smart, *The Collection, London, Canada* (London: London Regional Art and Historical Museums, 1990), p. 24.

43. "Hewton Paintings To Be Exhibited at Art Gallery, Policy Revealed by New Curator," *The Hamilton Spectator,* 20 December 1947.

44. The exhibition opened in Hamilton on 29 December 1947.

45. The Hewton exhibition had been held at the Arts Club in November 1947.

46. Typescript of T. R. MacDonald's talk to Art Gallery of Hamilton members, 20 March 1959, AGH Archives.

47. In 1955, in collaboration with the NGC, MacDonald organized a retrospective of Hamilton-born Robinson's work. The event triggered the acquisition of several Robinson canvases.

48. H. O. McCurry in a letter to T. R. MacDonald, 9 March 1948, 5.13 H Hamilton, Ontario, 1945-51 (Loans-Ontario), National Gallery of Canada fonds, National Gallery of Canada Archives, Ottawa.

49. "Art Exhibition Is Commended," *The Hamilton Spectator*, 5 February 1948. The exhibition was also well reviewed by Art Lover in "Art Show Will Suit All Tastes," *The Hamilton Spectator*, 7 February 1948.

50. T. R. MacDonald in a letter to William Withrow, 27 January 1965, AGH Archives.

51. "Show is a Landmark," *The Hamilton Spectator*, 25 November 1948.

52. Ibid.

53. Not surprisingly, most were artists MacDonald had known from his Montreal days.

54. The Contemporary Artists of Hamilton group was formed in March 1948 and included artists Madeline and Vincent Francis, Hortense Gordon, Rae Hendershot, Elizabeth Holbrook, Ray Mead, Charles Playfair, Henry W. and Marie Smith, as well as collector H. L. Rinn and Chief Librarian Freda Waldon. For a complete listing of group members between 1948 and 1971 see Stuart MacCuaig, *Climbing the Cold White Peaks: A Survey of Artists in and from Hamilton 1910–1950* (Hamilton: Hamilton Artists' Inc., 1986), pp. 209–210.

55. Although the Annual Winter Exhibitions also included abstract work, particularly during the 1960s, this kind of work was rarely purchased for the collection. An important exception was Jock MacDonald's *Iridescent Monarch*, acquired in 1960.

56. Artist-jurors who were abstractionists included Hortense Gordon (1948), Charles Playfair (1950), Ray Mead (1952), James W. G. MacDonald (1958), Walter Hickling (1960), Tom Hodgson (1963) and Harold Town (1966, the final year of jurying).

57. Mary Mason, "Fine Pictures at the Winter Show – But Prize-winner Isn't One of Them," *The Hamilton Spectator*, 1 February 1957.

58. It should be stressed that MacDonald did offer a balanced exhibition program that regularly presented abstract work. Two notable examples are an exhibition of abstracts by Lawren Harris in November 1957 and a Regina Five exhibition in December 1962.

59. Eric Williams, "Is it Art? Only Time Will Tell," *The Hamilton Spectator*, 21 October 1948.

60. Ibid.

61. Interview conducted by the author with Paul Duval, Toronto, 5 June 2003.

62. Quoted in Kay Kritzwiser, "How Tom MacDonald Gave Hamilton Art a Hand," *The Globe and Mail*, 12 May 1973.

63. Significant among these are the aforementioned Jock MacDonald; Paul-Émile Borduas's *Masks and Raised Finger* (1943, fig. 56, gift of H. S. Southam in 1953); Alfred Pellan's *Evasion* (1949, gift of the Women's Committee in 1959); Hortense Gordon's *Composition* (1948, gift of the Zonta Club of Hamilton in 1951); and Marian Scott's *Façade 2* (1954, gift of the Canadian National Exhibition Association in 1956).

64. Two important studies consider the rise and spread of abstraction in Canada during this period: Denise Leclerc, *The Crisis of Abstraction in Canada: The 1950s* (Ottawa: National Gallery of Canada, 1992) and Robert McKaskell et al., *Achieving the Modern: Canadian Abstract Painting and Design in the 1950s* (Winnipeg: Winnipeg Art Gallery, 1993).

65. Williams, "Is it Art?"

66. Typescript of T. R. MacDonald's talk to Gallery members (see note 46).

67. This is true in part because MacDonald's successor, Glen Cumming, who arrived at the Gallery in the summer of 1973, resolved to take the acquisition program in a different direction. While acknowledging the strengths of the existing collection, Cumming chose to redirect funds to the acquisition of contemporary painting with a view to ameliorating the collection of international art, as well as art from western Canada. In retrospect, these two successive visions were highly complementary, each building on the strength and knowledge of the director guiding them.

68. Minutes of the Board of Management, Art Gallery of Hamilton, 17 October 1949, AGH Archives.

69. Members of the Women's Committee regularly undertook the duties and responsibilities that are now handled by the education, development and public relations departments.

70. Quoted in Kathleen Steiner, "An Amateur's History of the Women's Committee of the Art Gallery of Hamilton, Ontario," in *Women's Committee, Art Gallery of Hamilton: A History of the Early Years to 1968 and Chapters on Our Special Projects to Date*, typescript, 1975, unpaginated, AGH Archives.

71. For a full discussion of the building and opening of the new AGH in 1953, see Fox and Inglis, *The Art Gallery of Hamilton*, pp. 14-17 (see note 3).

72. Kathleen Steiner, "An Amateur's History," n.p.

73. The exhibition route ran along both sides of James Street between Robinson's department store (at the western end of Gore Park) and Eaton's (located one block north of the King and James intersection), as well as along both sides of King Street between McNab and John Streets.

74. It is important to note that Thomas E. Nichols, a director on the Art Gallery of Hamilton's Board from 1949 to 1958, was associate editor of *The Hamilton Spectator* before serving as publisher from 1955 to 1970, thus ensuring ample coverage of Gallery activities in the paper.

75. Pearl McCarthy, "CNE Gallery To Have Provocative Exhibition," *The Globe and Mail*, 10 June 1950.

76. Fritz Brandtner's *Sun Breaking Through* (n.d.) is a good example, purchased by Freda Waldon from the first *Mile of Pictures* and bequeathed to the Gallery in 1974.

77. The Sale of Fine Arts was discontinued at the request of T. R. MacDonald, who was concerned that it might be in competition with the Annual Winter Exhibition, as the Winter Exhibition and the Sale of Fine Arts drew largely from the same pool of artists. The Women's Committee readily agreed to back the Winter Exhibition through publicity, openings, volunteers etc. See Kathleen Steiner, "An Amateur's History," n.p.

78. Mrs. T. F. Rahilly, "A Resumé of the Picture Rental Project of The Women's Committee of the Art Gallery of Hamilton 1955–1975," in *Women's Committee, Art Gallery of Hamilton: A History of the Early Years to 1968 and Chapters on Our Special Projects to Date*, typescript, 1975, unpaginated, AGH Archives.

79. Interview conducted by the author with Ruth McCuaig, Hamilton, 2 February 2000.

80. Goodridge Roberts in a letter to T. R. MacDonald, postmarked 22 November 1950, private collection, Hamilton.

81. Edwin Holgate in a letter to T. R. MacDonald, 26 October 1959, private collection, Hamilton.

82. Quoted in Kay Kritzwiser, "How Tom MacDonald Gave Hamilton Art a Hand" (see note 62).

83. Interview with Ruth McCuaig (see note 79). While many American works are credited to the McCuaigs as "Gift of," it is important to note that these works were never part of their private collection.

84. The exhibition *American Realists* was held at the Art Gallery of Hamilton from 11 March to 23 April 1961.

85. Paul Duval, "Hamilton's American Hoard," *The Hamilton Spectator*, 20 July 1968.

86. T. R. MacDonald quoted in Bill Brown, "Art From Over the Border," *The Hamilton Spectator*, Weekend Magazine, 26 September 1964.

87. Typescript of T. R. MacDonald's talk to Gallery members (see note 46).

88. *The Art Gallery News*, vol. 8, no. 1 (March 1960), AGH Archives.

89. Duval had written a review of IBM's British collection when it was presented at the Art Gallery of Toronto in 1947. Paul Duval, "Exhibition Proves That Art and Business Work Together to Enrich the National Spirit," *Saturday Night*, 25 October 1947.

90. Interview conducted by the author with Paul Duval, Toronto, 27 June 2002.

91. Ibid.

92. The four other works are Henry Lamb's *Felicia* (1940), Edward le Bas's *Off Duty* (n.d.) Cedric Morris's *Twyn y Waun* (n.d.) and Matthew Smith's *Lady with Roses* (n.d).

93. Duval became involved with *The Hamilton Spectator* when T. R. MacDonald approached him saying that the paper was looking for someone to write about art and asking if Duval would be interested. Interview conducted by the author with Paul Duval, Toronto, 5 June 2003.

94. Both works had been part of IBM's Canadian collection (see provenance notes in the *Catalogue*, pp. 218 and 219). Cole was also responsible for keeping Tom Thomson's *The Birch Grove, Autumn* (1915–1916, cat. 37) in Hamilton when he provided the Gallery with funds to purchase the work directly from The Hamilton Club in 1967. Minutes of the Board of Management, 30 November 1967, AGH Archives.

95. The first mention of an acquisitions committee appears in the minutes of the Board of Management meeting of 22 September 1949; it was to consist of five individuals including the director. Members were individuals with some experience and knowledge of art, most consistently artists and collectors, drawn exclusively from the Hamilton area. The first Committee members were T. R. MacDonald, Frank Garrow (Board president at the time), Frank Panabaker (artist), H. L. Rinn (collector) and Hugh Robertson (architect and artist). The number of members was changed to four in 1955. Minutes of the Board of Management, 14 April 1955, AGH Archives.

96. Lawren Harris and E. R. Hunter, "A Debate on Public Art Gallery Policy," *Canadian Art*, vol. 7, no. 4 (summer 1950), p. 148.

97. Ibid., p. 150.

98. Robert Pilot in a letter to T. R. MacDonald, 14 March 1956, Cullen Retrospective Exhibition File, AGH Archives.

99. Janet Barber had been the first president of the Women's Committee and remained an influential member until her move to Toronto in 1960. David Barber was a longstanding member of the Board, serving as chairman from November 1951 to March 1955.

100. Robert Pilot in a letter to T. R. MacDonald, 7 July 1956, Cullen Retrospective Exhibition File, AGH Archives.

101. T. R. MacDonald wrote to David Barber (who was vacationing in London) in June to ask whether he had made a decision regarding the purchase of *Logging in Winter, Beaupré*: "I am being harried both from Montreal and Mrs. Young who spotted it in my office and is rightly taken with it. I explained to her that you had the first refusal and she has asked me to let her know whether or not you had planned to buy it. Can you drop me a card? It's a fine canvas and improves greatly on acquaintance." T. R. MacDonald in a letter to David Barber, 21 June 1956, Accession File, Maurice Cullen, *Logging in Winter, Beaupré*, AGH.

102. The acquisition of Cullen's *Logging in Winter, Beaupré* was approved at the Board meeting of 20 December 1956. Minutes of the Board of Management, 20 December 1956, AGH Archives.

103. I am indebted to the late Mrs. Jean Keogh, president of the Women's Committee from 1956 to 1958, for relaying to me her vivid memories of this acquisition.

104. Pilot also gifted several of his own works, a sketchbook by William Brymner, a John Johnstone painting, and several Holgate and Neumann drawings.

105. Interview with Paul Duval (see note 90).

106. Notable exhibitions during his tenure at the Gallery were a solo exhibition at the McMaster University Art Gallery (20 November – 20 December 1968) and a two-man show with Clare Bice at the Montreal Museum of Fine Arts' Gallery XII (8–24 March 1957).

107. In 1953 T. R. MacDonald and his wife, artist Rae Hendershot, built a home in the Hamilton district of Westdale, complete with a large, north-facing studio. Today, their daughter Katherine and their granddaughter Rae, both artists, continue to use the studio. I warmly thank Katherine MacDonald for her gracious willingness to discuss her parents, their work and their lives during my regular visits to her home.

108. Telephone conversation between the author and Alex Colville, 16 January 2004.

109. Charles Comfort, "Haunting or Insulting? Views Differed. Now, The Dreamer Has Safe Haven," *The Globe and Mail*, 6 November 1976. In this article Comfort incorrectly recalls the year of acquisition as being 1954.

110. Charles Comfort in a letter to T. R. MacDonald, 23 January 1957, Accession File, Charles Comfort, *The Dreamer*, AGH.

111. Edwin Holgate in a letter to T. R. MacDonald, 23 January 1953, private collection, Hamilton.

112. Carl Schaefer in a letter to T. R. MacDonald, 12 December 1963, Accession File, Carl Schaefer, *Farm House by the Railway, Hanover*, AGH.

113. Ibid.

114. T. R. MacDonald curated an exhibition of Harris's abstracts, presented at the AGH in November 1957. The show had opened in Winnipeg in September and was also presented in Windsor in the following March, and in London in April and early May.

115. T. R. MacDonald in a letter to Lawren Harris, 9 May 1957, Exhibition File, Lawren Harris Exhibition 1957, AGH Archives. The typed letter uses the word "pertinent" rather than "impertinent," but given its general tone this is almost certainly an error.

116. Lawren Harris in a letter to T. R. MacDonald, 13 May 1957, Exhibition File, Lawren Harris Exhibition 1957, AGH Archives.

117. See a letter from T. R. MacDonald to Lawren Harris, 4 June 1957, Exhibition File, Lawren Harris Exhibition 1957, AGH Archives.

118. Will Ogilvie was one of T. R. MacDonald's closest friends, serving as best man at his marriage to painter Rae Hendershot in 1950, as well as speaking at his memorial service in 1978.

119. Thoreau MacDonald in a letter to T. R. MacDonald, 30 May 1949, private collection, Hamilton.

120. A. Y. Jackson in a letter to T. R. MacDonald, 11 April 1956, private collection, Hamilton.

121. A. Y. Jackson in a letter to T. R. MacDonald, 5 December 1958, private collection, Hamilton.

122. A. Y. Jackson in a letter to T. R. MacDonald, 21 February 1961, private collection, Hamilton.

123. A. Y. Jackson in a letter to T. R. MacDonald, 10 March 1961, private collection, Hamilton.

124. A. Y. Jackson in a letter to T. R. MacDonald, 24 May 1961, private collection, Hamilton.

125. Anne Savage in a letter to T. R. MacDonald, 9 May 1966, private collection, Hamilton.

126. The Annual Winter Exhibition was renamed the Annual Exhibition of Contemporary Canadian Art in 1972.

127. Paraskeva Clark in a letter to T. R. MacDonald, 13 October 1971, private collection, Hamilton.

128. Quoted in Kay Kritzwiser, "How Tom MacDonald Gave Hamilton Art a Hand" (see note 62).

129. Included among these were *Director's Choice from the Permanent Collection of the Art Gallery of Hamilton*, Art Gallery of Brant, 9 September–3 October 1971; *Director's Choice: Paintings from the Permanent Collection of The Art Gallery of Hamilton, by courtesy of Mr. T. R. MacDonald, Director*, Laurentian University, Sudbury, 8 September –1 October 1972; *19th and 20th Century Painting and Sculpture from the A.G.H.*, Robert McLaughlin Gallery, Oshawa, 5–30 September 1973; and *19th and 20th Century Canadian Paintings from the Art Gallery of Hamilton*, University of Guelph, 28 April–30 May 1974.

# L'émergence de l'art moderne au Québec : un parcours à travers la collection de l'Art Gallery of Hamilton

*Esther Trépanier*
*Professeure*
*Département d'histoire de l'art*
*Université du Québec à Montréal*

En 1948, le critique d'art Robert Ayre se penchait sur le développement de l'art canadien de la dernière décennie et comparait en ces termes Montréal et Toronto :

> [...] il semblait bien que Toronto était le centre de la peinture canadienne [...] Mais, avec l'influence de Brymner, Morrice et Lyman, Montréal a longtemps eu sa propre et puissante tradition moderne et, avec la montée d'hommes comme Alfred Pellan, Stanley Cosgrove, Paul-Émile Borduas, Jacques de Tonnancour et leurs partisans, il faut reconnaître que le centre de gravité s'est déplacé vers Montréal. Cela va de soi, si l'on considère le déplacement d'accent qui s'est fait de la peinture canadienne à la peinture en soi et pour soi. Car, en dépit du fait que le Québec est plus canadien que toute autre partie du Dominion, Montréal est beaucoup moins provinciale que Toronto et l'esprit qui a produit l'École de Paris, libéré de tout sentiment national, y est chez lui[1].

Cet article de Ayre paraît peu de temps avant la publication du manifeste *Prisme d'Yeux*, signé par des artistes regroupés autour de Pellan, et celle du *Refus global* de Borduas et des automatistes[2]. Avec eux s'achevait une certaine « tradition moderne », antérieure à l'avènement des avant-gardes et des courants abstraits qui allaient entraîner l'éclatement, en 1948 toujours, de la Société d'art contemporain de Montréal (SAC). Or, cette « tradition moderne » dont parle Ayre est précisément celle qui se trouve au cœur de la période historique privilégiée par la présente exposition, et les exemples abondent dans la collection de l'Art Gallery of Hamilton (AGH) qui permettent de bien la cerner.

La constitution d'une collection est un processus complexe, car elle est non seulement le produit d'enjeux esthétiques et idéologiques qui peuvent varier considérablement selon la conjoncture historique, mais elle dépend aussi de multiples conditions matérielles. L'importance des budgets d'acquisition, les réseaux amicaux et professionnels du directeur et des conservateurs, la capacité qu'ont ceux-ci d'attirer des donateurs sont autant d'éléments déterminants dans la nature d'une collection. Le texte de Tobi Bruce (voir p. 16–39) nous éclaire sur les fondements de la collection de l'AGH et met en évidence les liens privilégiés que le premier directeur du musée, T. R. MacDonald, entretenait avec le milieu artistique montréalais. Ces liens expliquent en partie pourquoi la « tradition moderne » est si bien représentée à l'AGH. La collection fut par la suite enrichie de nombreux dons et certains, comme ceux de H. S. Southam[3], furent majeurs en ce qui concerne la représentation de l'art moderne du Québec.

Après avoir eu le privilège d'étudier la collection dans les réserves mêmes de l'AGH et d'en apprécier l'intérêt et la richesse, il m'a semblé important de donner au lecteur l'aperçu le plus large possible de la « tradition moderne » montréalaise[4], telle qu'elle est représentée dans cette collection. Pour ce faire, j'ai choisi de suivre quelques-uns des méandres de cette modernité en m'appuyant, pour effectuer ce parcours, non seulement sur les œuvres sélectionnées pour l'exposition, mais aussi sur l'ensemble des œuvres québécoises qu'abrite le musée.

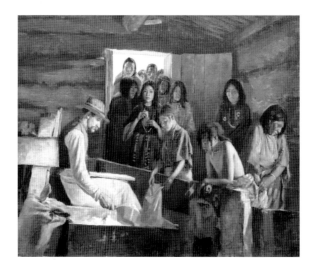

## Les années 1890–1914 : les esthétiques modernes européennes entre deux expressions du nationalisme en art

Quand, en 1886, William Brymner devient professeur à l'Art Association of Montreal, l'art canadien est à un tournant. Dans la foulée de la Confédération de 1867 s'était imposé un nationalisme artistique qui s'enracinait dans une idéologie victorienne de conquête du territoire. Ce nationalisme s'incarnait principalement dans les majestueux paysages de peintres comme Lucius O'Brien, John A. Fraser, Henry Sandham, Otto Jacobi et William Raphael, dont plusieurs gravitaient autour des studios montréalais et torontois du photographe William Notman. Nombre d'entre eux avaient bénéficié de l'appui du Chemin de fer Canadien Pacifique (le CP) pour aller immortaliser les sites emblématiques de l'unité canadienne. L'émergence de ce courant paysagiste se fait en parallèle avec la constitution des premières associations majeures d'artistes canadiens, comme la Society of Canadian Artists en 1867–1868, l'Ontario Society of Artists en 1872 et l'Académie royale des arts du Canada en 1880 ; elle coïncide également avec la fondation d'institutions muséales importantes, dont l'Art Association of Montreal (aujourd'hui le Musée des beaux-arts de Montréal) en 1860 et la Galerie nationale du Canada (aujourd'hui le Musée des beaux-arts du Canada) en 1880. L'amorce de création d'un champ artistique spécifiquement canadien et le soutien dont bénéficient ces paysagistes indiquent une volonté d'affirmer à la fois l'existence d'une nouvelle nation et le capital culturel de sa bourgeoisie. Cette affirmation que l'on trouve dans le *Mail* de Toronto le 27 mai 1879, lors de l'ouverture de la première galerie de l'Art Association, est révélatrice de cet état d'esprit :

> Montréal est bien situé et possède sa propre galerie ainsi qu'une bonne collection de base. La richesse de sa population, son goût raffiné et l'essor des jeunes talents contribueront à relever le niveau artistique du pays. En ce moment, un esprit nationaliste souffle sur nous tous, à l'exception de quelques Rouges et il est bon que notre art et notre littérature s'en imprègnent[5].

Toutefois, dans les années 1880, l'engouement pour ce courant paysagiste s'épuise au profit d'un art à saveur plus française. L'art académique et réaliste, enseigné à Paris, devient le modèle de l'accomplissement artistique. Nombreux sont les artistes canadiens qui iront acquérir une formation dans cette capitale de l'art.

Un tableau de l'AGH, *La distribution des rations aux Pieds-Noirs, T.N.-O.* (1886, fig. 21) de Brymner, reflète en quelque sorte la transition qui s'opère entre ces paysagistes, pour la plupart d'origine européenne, qui fondèrent une première école « nationale » et les artistes canadiens qui imposeront une peinture à saveur plus européenne (lire « française ») dans son style et ses sujets. En effet, cette scène de genre aurait pu tout aussi bien intéresser, par son exotisme, le public des Salons français qu'être versée au dossier des nombreuses scènes de genre canadiennes dans lesquelles ont excellé Robert Harris (*Une rencontre des commissaires d'école*, 1885, Ottawa, Musée des beaux-arts du Canada), George A. Reid (*Une hypothèque sur la ferme*, 1890, Musée des beaux-arts du Canada) ou encore William Blair Bruce, tout au moins dans *Le chasseur fantôme* (1888, cat. 6).

*La distribution des rations aux Pieds-Noirs*, peint par Brymner après son retour d'un séjour de neuf ans en Europe, est plus narratif que ne le sont les œuvres de Frederick A. Verner ou d'autres peintres de la génération précédente qui, à travers leurs explorations du paysage national, pouvaient mettre en scène des activités de la vie des Amérindiens. Il témoigne certes de l'idéologie colonialiste du temps, mais également du passage de Brymner à l'Académie Julian, où l'artiste a acquis une solide formation académique, tempérée par quelques effets empruntés au réalisme moderne. Le tableau, assez sombre, ouvre sur un ciel lumineux. La pénombre de la pièce contraste avec la blancheur de la chemise de l'homme blanc et des sacs de grain. Les quelques touches vives de rouge, de bleu et de jaune sur les visages et les vêtements des Amérindiens confèrent à l'œuvre une certaine vivacité.

Les seize œuvres de Brymner conservées à l'AGH permettent de mesurer l'évolution de son travail, une évolution qui sera aussi celle de plusieurs de ses contemporains et élèves. Alors qu'*Un matin d'été* (1888), par sa luminosité

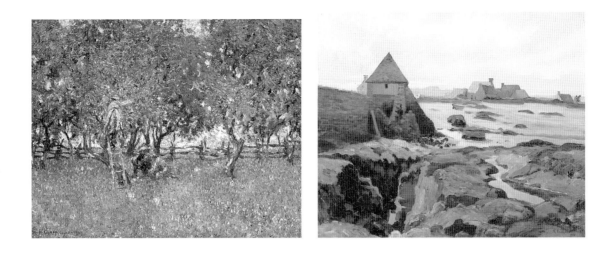

et sa fraîcheur, est déjà plus dans l'esprit des peintres de l'École de Barbizon que dans celui de Bouguereau (qui fut un de ses professeurs à Julian), *Paysage d'été, Martigues* (v. 1908–1914, cat. 19) atteste de l'influence grandissante de l'impressionnisme. Les formes humaines très synthétiques où les visages ne sont plus que des taches colorées, le pommelé des zones claires des troncs d'arbre qui traduit les percées de la lumière à travers un feuillage construit par petites touches, les ocres clairs et les orangés un peu roses des zones lumineuses bien découpées sont autant d'éléments qui renseignent sur la réceptivité de Brymner, comme de plusieurs autres de ses collègues ayant reçu une formation académique, à certains aspects de l'impressionnisme et, plus globalement, du pleinairisme.

Toutefois, ces emprunts à un art qui, comme le souligne Laurier Lacroix[6], était avant 1915 au Canada synonyme d'« art moderne » génèrent finalement un style que l'on pourrait qualifier de « juste milieu ». Car, si ces artistes s'ouvrent aux effets de lumière et de couleur particuliers au pleinairisme, s'ils adoptent souvent les ombres colorées des impressionnistes, ils n'iront jamais – sauf exceptions parmi lesquelles il faut compter William Clapp (*Dans le verger, Québec*, 1909, fig. 22) – jusqu'à remettre en question les règles de la perspective tridimensionnelle. Bien que leur coup de pinceau soit plus apparent et le travail de la matière picturale plus visible sur la surface du tableau, ils n'adoptent que rarement la fragmentation systématique d'une touche mise au service de l'analyse des composantes de la vision, indépendamment de l'intégrité de l'objet représenté. Ceci est encore plus manifeste dans leurs portraits de commande, où le traitement des visages, toujours conventionnel, contraste avec celui, plus audacieux, des vêtements et accessoires. *Les sœurs Vaughan* (1910, cat. 24) de Brymner le démontre bien.

En fait, les nombreux peintres canadiens qui ont séjourné en Europe ont découvert, en dehors de la formation traditionnelle qu'ils reçurent dans les diverses académies et écoles, un amalgame de courants artistiques modernes auxquels ils ont emprunté quelques éléments formels sans pour autant adhérer totalement à leurs principes esthétiques. Ainsi, à Paris dans les années 1890,

ils sont en contact non seulement avec les multiples adaptations de l'impressionnisme – devenu véritablement une tendance internationale par l'engouement que « la belle couleur vibrante » suscite chez tout un chacun –, mais aussi avec le divisionnisme des Seurat et Signac qui imposent le néo-impressionnisme à la fin des années 1880, avec le cloisonnisme et le synthétisme que Paul Gauguin, Émile Bernard et leurs disciples développent à partir de 1888 dans le petit village breton de Pont-Aven, avec le symbolisme qui s'affirme comme nouvelle orientation esthétique dès la fin des années 1880, avec le Mouvement esthétique de Whistler et avec les nombreuses variantes que les multiples emprunts à ces diverses tendances peuvent engendrer. On pense par exemple au tonalisme qui caractérise le travail de plusieurs peintres d'Amérique du Nord[7].

Une étude approfondie reste à faire des réseaux d'artistes canadiens en Europe, de l'influence qu'ils ont pu avoir les uns sur les autres, de leur insertion dans les différents milieux et institutions artistiques, si l'on veut mieux comprendre la genèse de la première modernité artistique dans le contexte canadien. Mais déjà, la richesse de la collection de l'AGH nous donne une bonne idée du travail d'exploration issu de ces contacts avec les esthétiques européennes. Plusieurs tableaux évoquent les séjours effectués sur des sites pour ainsi dire « consacrés » ou dans les « hauts lieux » de l'impressionnisme[8]. On pense notamment à Giverny où Claude Monet vit à partir des années 1880 et où s'établit une colonie d'artistes nord-américains au sein de laquelle on retrouve William Blair Bruce (*Giverny, France*, 1887, cat. 3; *Giverny*, v. 1887, cat. 2) – Giverny que visitent également Clarence Gagnon[9] et Brymner, de même que Maurice Cullen qui peindra également à Moret où habite Alfred Sisley.

Mentionnons aussi la Bretagne et la côte normande qui constituaient un passage obligé pour les artistes séjournant en France. Trois tableaux de la collection attestent de la diversité des styles dans lesquels on a représenté ces régions. *Le moulin à marée, Bretagne* (1900, fig. 23) de Cullen est traité par des procédés plus proches du réalisme que de l'impressionnisme. *Intérieur d'une église, Bretagne* (v. 1921–1922) de Robert Pilot est plus conforme à l'esthétique du

« juste milieu » dont je parlais précédemment, même s'il s'agit d'une œuvre du début des années 1920. Il rappelle ces scènes bretonnes de nature plus académique dont on trouve des exemples chez des Canadiens comme Paul Peel (*Dévotion*, 1881, Musée des beaux-arts du Canada) ou Marc-Aurèle de Foy Suzor-Coté (*Bretonne en prière*, 1905, Archevêché de Rimouski). Par contre, *Fête des filets bleus, Concarneau* (1921, fig. 24) d'Edwin Holgate, produit à la même période, offre une interprétation plus résolument moderne. Par le synthétisme extrême des personnages, par la présence de deux étonnants points, l'un rouge vif et l'autre jaune, qui animent les bleus profonds de cette scène de nuit, par la confusion des plans qu'induit l'uniformité de la texture du ciel et des bâtiments, et ce mur sur lequel sont juchés Bretons et Bretonnes, ce tableau s'inscrit dans une modernité post-impressionniste qui évoque celle de l'École de Pont-Aven. Bien qu'elle soit contemporaine d'*Intérieur d'une église, Bretagne* de Pilot, *Fête des filets bleus, Concarneau* est d'une modernité plus affirmée qui rejoint celle de James Wilson Morrice, lequel a, lui aussi, mais dans des décennies antérieures, abordé avec un synthétisme tout aussi radical ces régions de la France de même qu'il a aussi peint Concarneau, son marché et son cirque[10]. Le musée possède également une belle pochade d'Albert Robinson, *Saint-Malo* (1912, cat. 30), réalisée au moment où il visite la France avec son ami A. Y. Jackson. Cette pochade s'inscrit dans l'esprit du travail de

Morrice, qui est à la convergence des recherches de Whistler, des Nabis et d'artistes associés au mouvement fauve, dont Albert Marquet. Morrice, qui a inspiré plusieurs de ses collègues canadiens, aurait paraît-il, initié Clarence Gagnon et Maurice Prendergast à l'art de l'étude sur panneau de bois[11].

Il ne faudrait pas non plus oublier l'Italie qu'ont visitée plusieurs Canadiens. Mentionnons Jackson (*Clair de lune, Assise*, v. 1912, cat. 25), de même que Morrice dont les tableaux inspirés de Venise comptent sans doute parmi ses plus remarquables (*Un coin du palais des Doges*, v. 1901, cat. 13; *Le porche de l'église San Marco*, v. 1902–1904, cat. 14). Enfin, il y eut l'Afrique du Nord, dont les lumières et les couleurs ont retenu, entre autres, Cullen en 1893 et Morrice encore dans les années 1910 (*Vue d'une ville nord-africaine*, v. 1912–1914, cat. 31; *Près de la mer*, v. 1912, cat. 26).

Au bout du compte, les contacts avec l'art européen et la fréquentation des réseaux d'artistes qui ont élaboré une approche plus novatrice du tableau auront été déterminants dans l'avènement d'une nouvelle manière de représenter le paysage canadien et d'en traduire, par des procédés audacieux en regard de notre jeune tradition artistique, les couleurs, les lumières, les saisons et les atmosphères. C'est ce que démontrent, notamment, deux beaux Cullen de la collection : *Halage du bois, Beaupré* (1896, cat. 12) et *Cap Diamant* (1909, cat. 21).

La Première Guerre mondiale marque la fin des séjours d'études outre-mer et l'émergence d'un fort courant nationaliste en art. Elle ramène cependant quelques artistes sur le sol européen, mais dans de tout autres conditions : comme membre des forces armées. Avec la création, en 1916, du Fonds des souvenirs de guerre canadiens (FSGC), certains d'entre eux acquièrent le grade d'officier et se voient confier la mission d'illustrer la participation des troupes canadiennes au conflit. Le Musée de la guerre à Ottawa conserve une grande part de leurs œuvres de guerre, mais la collection de Hamilton en compte aussi quelques beaux exemples, dont nombre de dessins de Cullen, offerts par son beau-fils, le peintre Robert Pilot[12], qui a aussi fait don au musée d'un certain nombre de ses dessins à lui. *Le moulin rouge, Liévin* (v. 1918, fig. 25) et *Bâtiment pilonné* (1918) de Cullen, *Ruines, France* (1918, fig. 26) de

Fig. 24 EDWIN HOLGATE (1892–1977) *Fête des filets bleus, Concarneau* 1921 huile sur toile, 60.3 x 73.4 cm, don du Hamilton Spectator, 1972

Fig. 27
A. Y. JACKSON (1882–1974)
*Soir, Riaumont* 1918
huile sur toile
63.9 x 81.4 cm
Don de Samuel Bronfman, LL.D.,
1955

Pilot et *Soir, Riaumont* (1918, fig. 27) de Jackson donnent un aperçu de la façon dont ces artistes ont traité le paysage français dévasté par les bombardements.

## Les années 1920 : une modernité à saveur montréalaise

La participation du Canada à la Première Guerre mondiale aux côtés de la Grande-Bretagne renforcera son autonomie politique et un nationalisme qui, dans l'art du Canada anglais, se cristallise autour du Groupe des Sept. Chez les Canadiens français, le nationalisme en art et en littérature s'exprimait depuis longtemps, si bien que, dès la fin des années 1910, une active minorité regroupée autour de la revue *Le Nigog* avait commencé à en dénoncer les dangers pour le développement d'un véritable art moderne[13]. Toutefois, les assises politiques, sociales et culturelles de ce nationalisme que l'on qualifie aussi de régionalisme sont, au Québec francophone, fort différentes de ce qu'elles sont au Canada anglais, et ce régionalisme ne fait pas l'objet de la présente exposition.

Étant donné que les artistes associés au Groupe de Beaver Hall de Montréal (et particulièrement Holgate et Robinson) sont bien représentés dans la collection de l'AGH, je concentrerai ma réflexion sur ce qui distingue leur modernité à eux de celle des artistes ontariens du Groupe des Sept, au-delà des liens d'amitié qui pouvaient les unir et malgré le fait que Holgate deviendra, en 1929, le huitième membre des Sept.

Le Groupe de Beaver Hall est moins structuré que le Groupe des Sept et présente cette particularité d'être composé d'un nombre important de femmes qui s'imposeront comme artistes professionnelles. Il s'est constitué en 1920 autour d'un noyau d'artistes – dont plusieurs anciens élèves de Brymner – qui partageaient des ateliers sur la côte du Beaver Hall. S'ils n'exposèrent sous cette dénomination de Groupe de Beaver Hall qu'en 1921 et 1922, ces artistes conservèrent néanmoins des liens durant plusieurs années[14].

Leur approche présente à la fois des affinités et des différences avec celle de leurs confrères de Toronto. Au chapitre des affinités, notons, sur le plan formel, une ouverture à la modernité post-impressionniste, en particulier au synthétisme décoratif et, sur le plan thématique, chez quelques-uns, un intérêt marqué pour le paysage, les scènes du terroir ou la représentation de figures quasi archétypales de la nation (le paysan, le pêcheur, le pionnier, etc.). Au chapitre des différences, soulignons une attention peut-être plus aiguë de certains aux questions formelles, notamment celles que posait Cézanne quant à l'unité de la surface picturale et, chez plusieurs d'entre eux, et, devrais-je préciser, d'entre elles, un choix de sujets peints plus orienté vers l'univers contemporain, celui de la ville aussi bien que des lieux et des figures humaines qui constituent le quotidien des artistes.

## Art national et régional

Rappelons que, pour le Groupe des Sept, le véritable art national repose sur les liens entre la terre, le peuple et l'artiste. En butte à certains critiques qui leur reprochaient de réduire le Canada aux seules régions sauvages du nord de l'Ontario, les membres du Groupe des Sept vont inviter des artistes d'autres coins du pays à participer à leurs expositions[15] et promouvoir la manifestation d'un art ancré dans les diverses régions canadiennes.

Au Québec, les paysages de Holgate, de Savage et de Robinson contribuent à l'expression de ce régionalisme « moderne » que favorise le Groupe des Sept. La collection de l'AGH en compte plusieurs exemples, dont *Mare sombre, baie Georgienne* (1933) d'Anne Savage et *Racine d'un vieux pin, lac Tremblant* (1927) de Holgate, sans compter les très nombreuses scènes de villages québécois de Robinson. Dans *Village du Québec* (1923, cat. 49), le rendu des arbres de l'arrière-plan qui se découpent sur un fond dont les formes s'imbriquent un peu à la manière des pièces d'un casse-tête s'apparente à celui qu'adoptent certains membres du Groupe des Sept. D'ailleurs, *Village du Québec* est révélateur du changement de style qui s'opère chez Robinson au début des années 1920 lorsque, à l'instar de plusieurs de ses collègues du Beaver Hall (pensons à Mabel May et à Kathleen Morris), il favorise le synthétisme et le cloisonnisme comme mode de construction des formes. L'application de la couleur tend alors vers l'aplat légèrement

Fig. 28
ALBERT ROBINSON (1881–1956)
*Lever de brume, port de Montréal*
1908
huile sur toile
46.2 x 61.4 cm
Don de David M. Campbell, 1988

Fig. 29
ALBERT ROBINSON (1881–1956)
*Clair de lune, Basse-ville, Québec*
1924
huile sur carton
28.6 x 32.8 cm
Don du Comité féminin, 1958

texturé, alors que dans ses œuvres antérieures – *Lever de brume, port de Montréal* (1908, fig. 28), par exemple –, la surface était souvent parsemée de plus petites touches colorées. Citons encore, parmi d'autres œuvres de la collection, *Clair de lune, Basse-ville, Québec* (1924, fig. 29), une toile de Robinson proche, tant par le style que par le sujet, de *Basse-ville, Québec* (v. 1935, cat. 69) de sa collègue Kathleen Morris.

À propos de Robinson, il faut souligner une intéressante particularité. Tandis qu'auparavant la matière picturale recouvrait totalement la surface de la toile, les œuvres qu'il peint dans l'esprit de *Village du Québec* donnent à voir un cloisonnisme (c'est-à-dire l'utilisation d'un contour des formes large et apparent) qui n'en est pas un dans la mesure où l'effet d'une ligne de contour est, en réalité, produit par l'absence de pigment. Ici, le contour est un espace qui laisse paraître soit le grain de la toile, soit un large trait dessiné sur la toile, mais antérieurement à l'application de la matière picturale. Mieux encore, dans *Village du Québec*, les effets de texture que l'on peut observer, par exemple dans le traitement de la neige au premier plan, sont produits par un jeu où l'artiste combine pigment et toile brute. Voilà des éléments formels qui contribuent à l'affirmation de l'autonomie du tableau par rapport à la représentation du réel, un des postulats de l'art moderne.

## Les figures fondatrices de l'identité nationale

### Le pionnier

Une autre caractéristique de cet art national et de ses expressions régionales est d'être nourri par une certaine idéologie de la virilité. Les membres du Groupe des Sept et leurs partisans utilisent beaucoup la notion de virilité, sous-jacente à plusieurs discours esthétiques de l'entre-deux-guerres, pour qualifier leur entreprise[16]. En effet, par un glissement de sens, la virilité que l'on associe au climat et à la rude géographie du Canada devient une caractéristique de l'art de ces peintres qui vont affronter la nature, tels des explorateurs et des conquérants, afin de la maîtriser par la peinture[17]. Par conséquent, il est logique que, dans la construction d'un art national qui souhaite se fonder sur

la terre et le peuple, il y ait place pour la représentation des « héros » de la conquête du territoire, ainsi que pour les figures emblématiques des premières nations.

Au sein du groupe des artistes montréalais, il faut mentionner l'apport d'Edwin Holgate à cette tradition iconographique de représentation des figures viriles et résolues du bûcheron, du pêcheur, du paysan ou du prospecteur[18]. Même dans une petite estampe comme *Cabanes à poissons, Labrador* (1930, fig. 30) dont l'AGH possède une épreuve, Holgate réussit à magnifier, grâce à ses talents pour la gravure sur bois, la figure du pêcheur, entouré qu'il est d'un halo de lumière et se découpant sur la linéarité expressionniste d'un ciel qui pourrait tout aussi bien être lu comme une mer déchaînée.

Rappelons cependant que certaines femmes du Groupe de Beaver Hall, et plus particulièrement Prudence Heward, ont peint quelques représentations non moins déterminées de femmes du milieu rural qui pourraient être considérées comme des pendants féminins des « héros » masculins.

### L'Amérindien

Holgate excelle aussi dans les portraits de membres des tribus des premières nations de la côte Ouest, et l'AGH en possède quelques exemples, dont *Chef indien, rivière Skeena* (1926). Les œuvres qu'il consacre aux thèmes amérindiens nous éclairent également sur la communauté d'esprit qui existait entre Holgate et le Groupe des Sept, lequel partageait avec l'ethnologue Marius Barbeau cette conception que l'art populaire et l'art autochtone devaient être considérés comme parties prenantes de l'art national. Cette conception étant aussi celle de l'agent général de la publicité du CP, J. Murray Gibbon, diverses manifestations avaient été mises sur pied par les trois parties pour promouvoir ces formes de la culture « nationale ». La Compagnie des chemins de fer nationaux (le CN) contribuera lui aussi à ce mouvement en fournissant, tout comme le CP, des laissez-passer aux artistes. Ainsi, ceux que le CN donne aux peintres de l'Est du pays (dont Holgate et Savage) en 1926 leur permet d'aller étudier les villages, mâts totémiques, huttes et sépultures autochtones de la région de la rivière

Fig. 30
EDWIN HOLGATE (1892–1977)
*Cabanes à poissons, Labrador* 1930
gravure de bois sur papier
ed. 21/30
17.2 x 20.4 cm
Fonds d'acquisition du directeur, 1959

Fig. 31
EDWIN HOLGATE (1892–1977)
*Mâts totémiques, n° 5* v. 1930
gravure de bois colorée sur papier
ed. 18/30
15.0 x 12.3 cm
Fonds d'acquisition du directeur, 1953

Fig. 32
EDWIN HOLGATE (1892–1977)
*Mâts totémiques, n° 4* v. 1928
gravure de bois sur papier
ed. 19
15.1 x 12.3 cm
Fonds d'acquisition du directeur, 1953

Fig. 33
EDWIN HOLGATE (1892–1977)
*Baigneuses* v. 1930
gravure de bois sur papier
12.7 x 11.3 cm
Fonds d'acquisition du directeur, 1953

Fig. 34
EDWIN HOLGATE (1892–1977)
*Deux femmes – Jamaïque* v. 1933/37
gravure de bois sur papier
ed. 4/4
14.0 x 17.8 cm
Fonds d'acquisition du directeur, 1953

Skeena. Rappelons que Barbeau et le CN avaient uni leurs efforts pour y promouvoir la création d'un parc national (donc, un site touristique) évoquant ce « paradis perdu » dont la légende fera l'objet d'un livre de Barbeau, *The Downfall of Temlaham*, publié en 1928 et illustré d'œuvres d'artistes ayant séjourné dans la région[19].

Parmi les autres gravures de Holgate appartenant à l'AGH, mentionnons encore *Mâts totémiques, n° 5* (v. 1930, fig. 31), dont la composition et le traitement font ressortir l'interaction entre les figures totémiques, les motifs décoratifs des vêtements et les figures humaines, de même qu'entre la nature et les totems, un de ceux-ci se confondant avec le sommet de la montagne. Quant à *Mâts totémiques, n° 4* (v. 1928, fig. 32), anciennement intitulé *Le départ, rivière Skeena*, par sa lumière dramatique de fin de jour, par le vif contraste entre les noirs très denses des mâts et des ombres portées et les zones plus claires des éléments du paysage couverts de traits décoratifs, il évoque le déclin d'une civilisation et le déchirement d'un peuple abandonnant l'éden qui fut le sien.

Peut-être convient-il de rappeler aussi que, durant cette période, les artistes de Montréal semblent s'être davantage intéressés aux premières nations de la côte Ouest qu'à celles de leur propre région. Il y eut cependant quelques exceptions, dont témoignent deux œuvres de l'AGH : la fameuse sculpture de Suzor-Coté, *Femmes de Caughnawaga* (1924, cat. 53), et l'huile de Mabel May, *Femme indienne, Oka* (1927, cat. 55). Dans les deux, toutefois, seul le titre nous permet d'associer les sujets représentés aux réserves mohawks de la région montréalaise, en l'absence de « motif » identifiant leur appartenance.

## La figure humaine

### Le corps féminin

Durant cette décennie où triomphe un art qui, pour être reconnu comme canadien, se doit d'afficher une certaine « virilité », et dans ce pays où les mœurs sont telles qu'on admet difficilement le nu dans les expositions publiques, l'exploration du thème du corps féminin par certains artistes du Groupe de Beaver Hall est à souligner. Ici encore, la collection du musée recèle des exemples intéressants.

De prime abord, on pourrait considérer que plusieurs nus réalisés par Holgate, soit ceux qu'il choisit d'insérer dans un paysage, sont une contrepartie féminine à ses figures masculines « héroïques ». Dans des œuvres comme *Baigneuses* (v. 1930, fig. 33), les corps répondent formellement aux éléments d'un paysage dont les motifs (rochers, pins, rivières) et le traitement (arabesques décoratives, simplification des formes, etc.) rappellent singulièrement le travail du Groupe des Sept. Toutefois, c'est à la fin des années 1930 que Holgate réussit le mieux cette intégration du nu au paysage, dans des huiles telle *Début de l'automne* (1938, Musée des beaux-arts du Canada). La même chose vaut pour *Deux femmes – Jamaïque* (v. 1933/ 1937, fig. 34), une gravure dans laquelle, délaissant le paysage canadien, il réussit à établir un vrai corps à corps entre les personnages et la nature, en entremêlant les membres humains aux branches stylisées.

En fait, j'ignore si Holgate a voulu souligner la dimension féminine de la nature ou si ses nus n'indiquent pas plutôt une réceptivité à un traitement moderne du sujet, dans l'esprit d'un Cézanne qui souhaitait harmoniser « des courbes de femmes à des épaules de collines[20] ». Quoi qu'il en soit, cette façon d'aborder le nu en l'insérant dans le paysage est une approche du thème que l'on trouve à l'occasion chez d'autres artistes québécois de la génération précédente comme Suzor-Coté, mais aussi au sein du Groupe de Beaver Hall. *Jeune femme sous un arbre* (1931, cat. 63) de Prudence Heward, une pièce majeure de la collection de l'AGH, en est un exemple. À propos de ce tableau, le peintre et critique d'art John Lyman disait y voir un « nu à la Bouguereau sur un fond à la Cézanne[21] ». Bien que Lyman ait voulu souligner par là l'absence de relations formelles entre le corps et le fond résultat, selon lui, d'un trop grand « raidissement » de la volonté –, cette proposition surprend tout de même. En effet, le modelé du corps peint par Heward n'a rien de celui d'un Bouguereau et la sexualité qui s'en dégage diffère totalement de celle des Bouguereau. Les corps féminins de Bouguereau étalent une peau rose, des formes rondes où aucune aspérité, aucun muscle, aucune structure osseuse n'arrête le regard. Or, le nu de Heward gênait plutôt ce type d'objectivation

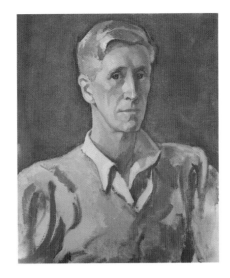

Fig. 35
LILIAS TORRANCE NEWTON (1896–1980)
*Keith MacIver* s.d.
huile sur toile
61. 1 x 51.1 cm
Don de la T. Eaton Co. Limited, 1955

et de consommation sensuelle auxquelles se prêtaient souvent les nus féminins de la peinture académique française.

Par ailleurs, il est intéressant de souligner que les corps féminins des œuvres de Holgate, de Heward mais aussi de Lilias Torrance Newton et de Henri Hébert, par exemple, sont représentatifs des changements qui s'opèrent dans l'entre-deux-guerres relativement aux critères de beauté féminine. Soulignons d'abord que plusieurs nus de Henri Hébert, entre autres *Mlle A.C., danseuse d'Oslo* (v. 1929, cat. 58) – dont l'AGH possède un bronze fondu en 1962 à partir du plâtre que le frère de l'artiste, Adrien Hébert, avait confié au musée en 1951, *Flapper* (1927, Musée des beaux-arts de Montréal) et *Charleston* (1927, collection particulière), de même que certains nus de Newton tel celui de la Thomson Collection (1933, fig. 67) sont, par leur posture et par la nature de leurs « attributs » (souliers, bas, coiffure[22], etc.) ancrés dans l'univers urbain de la « garçonne » ou de l'élégante Art déco. De plus, les corps féminins tels que traités par ces artistes répondent aux canons de la beauté et de la distinction sociale des années 1920 : être mince, musclée et bronzée. Cette image de la femme « moderne » était véhiculée par le cinéma et les magazines qui incitaient les femmes à acquérir certains attributs corporels. Ainsi, pour ne citer qu'un exemple, Jacques Langevin, professeur d'éducation physique et collaborateur à *La Revue moderne* publiée au Québec, écrivait en 1939 que « pour être beau, le corps féminin doit être athlétique [...]. Il faut la fermeté des chairs et la perfection des proportions, des muscles souples et longs sans excès de graisse[23] ». Cette campagne en faveur de l'exercice physique et de la minceur s'était amorcée à la revue dans la décennie précédente. Quant à la mode du bronzage, elle s'inscrit à la fois dans la foulée de la pratique du sport par les femmes et dans celle du mouvement hygiéniste, issu du XIXe siècle, qui attribuait au soleil des vertus curatives dans la lutte contre les « microbes et bactéries ». Or, le teint hâlé ne pouvait-il pas s'acquérir aussi bien au bord des grands lacs canadiens où les citadins établissaient leurs résidences secondaires que sur les plages européennes à la mode ? De ce point de vue, les baigneuses de Holgate sont des figures bien de leur temps.

## La figure contemporaine

C'est aussi par leur intérêt pour la figure humaine contemporaine que, dès les années 1920, les artistes montréalais se démarquent véritablement des tendances nationalistes. En 1940, John Lyman écrivait à propos de l'exposition *Art of Our Day in Canada*, organisée par la Société d'art contemporain :

> Fini les affiches, fini le « design » de la sauvagerie. Le paysage a perdu son quasi-monopole comme motif de l'expression libre; pas plus du quart des tableaux appartiennent à ce genre. Quarante pour cent des contributions sont celles d'artistes qui traitent, encore que non exclusivement, du sujet humain[24].

Au sein du Beaver Hall, les Hewton, Newton, Coonan et Heward (laquelle participait avec quelques autres femmes de ce groupe à l'exposition *Art of Our Day in Canada*) comptaient parmi ceux qui avaient adopté la figure humaine comme sujet important de leurs explorations modernes. Leurs portraits d'amis, de collègues artistes, de femmes élégantes, d'enfants, etc., dénotent une connaissance de Cézanne par leur solidité géométrique et la manière dont la touche colorée construit les volumes. Même si leur approche est tempérée par un réalisme qui a parfois une saveur Art déco, plusieurs présentent, à l'instar de Cézanne, cette volonté d'unifier la figure et le fond (qui est parfois un paysage) par un travail équilibré, d'un plan à l'autre, de la couleur et des formes.

Lilias Torrance Newton est passée maître dans l'art d'établir de riches correspondances fond / forme. Toutefois, le tableau de l'AGH, *Keith MacIver* (s.d., fig. 35), est dénué d'un arrière-plan défini. On peut néanmoins y admirer la belle angularisation des traits du visage et une répartition des couleurs de la même palette sur toute la surface de l'œuvre. Holgate aussi excelle dans la construction d'un dialogue formel entre figure et fond. Son *Oncle George* (1947, cat. 83) pourrait se classer parmi les nombreux « types canadiens » qu'il a réalisés, mais il retient surtout notre attention par le travail de géométrisation des plis, rides et autres traits du visage, ainsi que par l'utilisation des bruns, des verdâtres teintés de blanc dans la

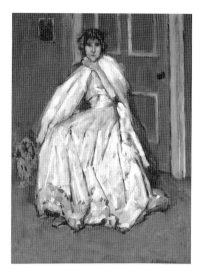

Fig. 37
EMILY COONAN (1885–1971)
*Jeune fille en vert* 1913
huile sur toile
66.4 x 49.0 cm
Don de A. Y. Jackson, C.M.G.,
R.C.A., 1956

casquette du personnage, des gris bleutés sur les tempes et autour du nez, qui permet de faire un rappel des couleurs utilisées pour les conifères, les rochers et la neige du fond. Quant à la composition du paysage de l'arrière-plan, plusieurs de ses lignes reprennent, comme c'est souvent le cas chez Holgate, les courbes du personnage.

Même s'il n'appartient pas au Groupe de Beaver Hall, il faudrait aussi mentionner John Lyman qui, construisant les volumes des visages et des corps par une vigoureuse touche colorée, s'inscrit dans la double filiation de Cézanne (pour la volumétrisation des formes) et de Matisse (pour la couleur et l'utilisation occasionnelle du cerne expressif). Bien que peint en 1948, *Femmes sur la plage* (fig. 36), dont on trouve une étude préparatoire au Musée national des beaux-arts du Québec, est une œuvre représentative de ce travail qui, chez Lyman, s'amorce dès les années 1910.

Cette solidité de construction caractérise aussi l'approche de la figure humaine chez Heward, May et Emily Coonan dont *Jeune fille en robe à pois* (v. 1923, cat. 45) signale une transformation stylistique assez impor-

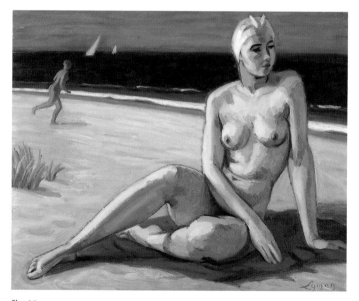

Fig. 36
JOHN LYMAN (1886–1967) *Femmes sur la Plage* 1948
huile sur carton, 60.8 x 76.0 cm, don du Comité féminin, 1961

tante en regard d'œuvres antérieures. En effet, si l'on compare ses tableaux des années 1910, comme *Jeune fille en vert* (1913, fig. 37) à l'AGH ou *La première communion* (v. 1912–1918, Musée des beaux-arts de Montréal) avec *Jeune fille en robe à pois*, on constate que Coonan est passée d'un effort de synthèse et d'une recherche d'effets de matière assez dans l'esprit de J. W. Morrice, à la structuration qui caractérise le travail de plusieurs artistes du Groupe de Beaver Hall dans les années 1920. Cependant, jamais (et c'est là une qualité que Coonan partage avec plusieurs de ses collègues modernes) elle ne cède à la tentation de la joliesse ou de la sentimentalité dans ses portraits d'enfants et d'adolescents; à ces jeunes qui grandissent dans une période troublée, elle donne plutôt un regard triste et méditatif. S'il m'est impossible de multiplier ici les exemples, qui seraient nombreux, j'aimerais citer un autre tableau de la collection, *Fenêtre de la maison de ferme* (1938, fig. 38) de Heward, représentatif, sur le plan stylistique, de la relative souplesse expressive que cette artiste développe au cours des années 1930.

À cette brève étude des portraits québécois de la collection pourraient encore s'ajouter *Femme indienne, Oka* (cat. 55) de Mabel May, qui signale ce même goût pour le façonnement des volumes par la touche colorée et, enfin, le *Portrait d'Albert H. Robinson, A.R.C.* (v. 1927–1929) de Randolph Hewton qui trahit cependant une certaine hésitation entre un traitement conventionnel et une recherche moderne.

## L'univers urbain

### La ville au quotidien

L'intérêt pour la scène urbaine est une autre particularité des artistes montréalais modernes. Rappelons qu'avec la Première Guerre mondiale, l'industrialisation et l'urbanisation s'accélèrent et que la proportion de la population du Québec vivant dans des villes atteint les 63,1 % en 1931[25]. La ville change d'aspect et son paysage architectural se modernise.

Plusieurs femmes du Beaver Hall, dont Sarah Robertson, Kathleen Morris, Mabel Lockerby, Mabel May et Ethel Seath, ont peint Montréal avec le synthétisme

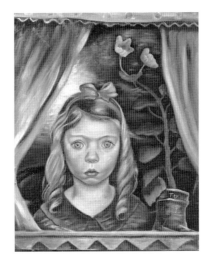

Fig. 38
PRUDENCE HEWARD (1896–1947)
*Fenêtre de la maison de ferme* 1938
huile sur toile
68.8 x 47.1 cm
Legs de H. S. Southam, Esq., 1966

propre à la plupart des artistes de ce groupe. En règle générale, leur rapport à la ville en est un d'intimité. Elles peignent les rues de leur voisinage et de leur quartier, et présentent souvent la ville depuis la fenêtre de leur appartement ou de leur atelier, dans un mouvement qui va de l'intérieur vers l'extérieur. Cette composition depuis l'intérieur permet parfois l'inclusion d'une nature morte qui ajoute au mélange des genres.

Anne Savage utilisera ce type de composition dans *Nature morte* (s.d., fig. 39), encore que, dans ce tableau, l'extérieur sur lequel donne la fenêtre est un paysage agricole. La nature morte – un bouquet – joue sur les oppositions expressives de vert et de rouge (ici violacé), comme dans *Fenêtre de la maison de ferme* (fig. 38) de Prudence Heward. Chez Heward, toutefois, les contrastes de rouge et de vert se concentrent non pas sur une nature morte, mais autour du visage terrifié de la fillette qui regarde à travers la fenêtre[26]. Dans ce tableau, au contraire du précédent, le mouvement va de l'extérieur vers l'intérieur.

La plupart des musées canadiens possèdent peu de représentations urbaines réalisées par les femmes du Beaver Hall. À l'AGH, on trouve *Vieilles tours* (1944) de Lockerby, *Basse-ville, Québec* (cat. 69) de Morris, mentionné précédemment, et *Couronnement* (1937, cat. 73) de Robertson, un tableau à la composition audacieuse, avec ses drapeaux tronqués et sa double perspective, cavalière dans le tiers inférieur de l'œuvre, puis frontale dans la partie supérieure où les motifs se superposent pour créer un espace qui remet en question la représentation traditionnelle de la profondeur.

Fig. 39
ANNE SAVAGE (1896–1971)
*Nature morte* s.d.
huile sur toile
61.1 x 51.3 cm
Don de H. S. Southam, Esq.,
C.M.G., LL.D., 1948

Enfin, sur le thème de la scène de rue vue depuis un appartement, soulignons la présence dans l'exposition d'une œuvre assez inusitée chez cet artiste qui deviendra, dans les années 1940, la figure de proue du mouvement automatiste : Paul-Émile Borduas. Il s'agit de *Matin de printemps* (1937, cat. 74), qui retient surtout l'attention par la délicatesse de la touche et la rythmique des diagonales et des rectangles – ceux, plus solides, des portes et ceux, plus évanescents, des jeux d'ombre et de lumière sur le trottoir.

## La ville en transformation

Rarement les femmes du Groupe de Beaver Hall s'attardent à l'architecture industrielle et à l'activité bourdonnante du centre-ville. Il en était allé de même de leurs prédécesseurs, les artistes généralement associés à l'impressionnisme qui, contrairement à leurs homologues parisiens des années 1870, ne se sont guère intéressés à la ville dans sa dimension moderne, sauf pour quelques « fumées du port de Montréal » qui ont occasionnellement retenu l'attention de peintres comme Cullen ou Suzor-Coté. L'AGH possède cependant quelques exemples intéressants d'œuvres qui font état du processus de transformation de Montréal en métropole moderne.

Mentionnons tout d'abord *Construction du tunnel du CN* (s.d., fig. 40) de Cullen. Bien que ce tableau ne soit pas à cataloguer parmi ses plus grandes œuvres, il est un des rares à témoigner de la déchirure du territoire urbain créée par la construction du tunnel qui, en passant sous le mont Royal, allait relier le centre-ville de la métropole au chemin de fer transcontinental. Mais c'est sans doute Marc-Aurèle Fortin qui a le plus systématiquement mis en scène cet envahissement de la ville traditionnelle, et plus encore de la campagne, par la ville moderne. L'AGH possède un beau paysage du village natal de Fortin, *Sainte-Rose en automne* (v. 1920–1935) ainsi qu'une aquarelle titrée *Hochelaga* (v. 1930, fig. 41) qui est, à mon avis, l'une des plus intéressantes que l'artiste ait réalisées sur le thème urbain. L'enchâssement de la ville dans la campagne et les éléments naturels, caractéristique de toutes les vues de Montréal peintes pas Fortin, se retrouve aussi dans *Hochelaga*, mais la complexité de la construction en multiples espaces-plans, servie par la verticalité du support, traduit encore

mieux visuellement le combat inégal entre la ville et la campagne. Comme d'habitude chez Fortin, le premier plan est celui d'un espace rural avec ses champs, sa charrette à foin, ses cultivateurs, mais déjà, l'architecture campagnarde y côtoie l'architecture semi-urbaine. Cet espace rural est brusquement interrompu par une zone de chemins de fer qui ne le traverse pas d'une simple diagonale, comme dans plusieurs autres vues d'Hochelaga de Fortin, mais se développe en un réseau tentaculaire de rails avec train et bâtiments. À l'intérieur de ces ramifications de rails subsiste un îlot de verdure où sont isolées les figures traditionnelles, toujours présentes dans les scènes urbaines de Fortin, de la mère et de l'enfant en jupes longues, qui appartiennent à un passé révolu. À ce premier étagement de plans se superpose ensuite celui des habitations proprement urbaines dont les roses, les jaunes et les rouges sont envahis de fumée. L'espace du fond, qui s'ouvre habituellement chez Fortin sur des motifs naturels comme le ciel, les montagnes et les nuages, est ici partiellement bloqué sur la gauche par les gris des massives constructions urbaines et portuaires.

Dans les années 1920, à Montréal, c'est très certainement Adrien Hébert qui rend de la manière la plus magistrale la ville moderne et son architecture portuaire. À l'AGH, les remarquables *Élévateur nº 1* (v. 1929, cat. 57) et *Chargement du grain, port de Montréal* (v. 1929–1930, fig. 42) en témoignent. Ces œuvres trouvent écho dans un autre beau tableau de la collection, *Construction d'un navire* (fig. 43), peint en 1919 par Robinson. Il faut cependant mentionner que *Construction d'un navire*, qui représente vraisemblablement un chantier de la Canadian Vickers Company à Montréal, est à verser au dossier des œuvres de guerre[27]. Il possède par ailleurs les caractéristiques propres aux Robinson d'avant les années 1920, soit une surface intégralement peinte qui, ici, est en grande partie scandée par le rythme de cette gigantesque grille que dessinent les échafaudages du chantier.

Univers urbain, univers industriel : ce sont là ceux des ouvriers intégrés à la structure mécanique ou à la rigoureuse dynamique de l'architecture, de nouveaux « héros » peu présents dans la peinture canadienne. Ils triompheront brièvement dans quelques œuvres des

années 1940, quand des peintres, souvent progressistes comme Fred Taylor, Fritz Brandtner, Louis Muhlstock et d'autres, illustreront l'effort de guerre sur le front industriel. *Polissage de la plaque d'un moteur pour un cargo de 10 000 tonnes : Dans la fonderie de la Dominion Engineering Works, Lachine, Québec, 14 mai 1943* (1943, fig. 44) de Fred Taylor en est un très bel exemple.

Fig. 41
MARC-AURÈLE FORTIN  (1888–1970)
*Hochelaga*  v. 1930
aquarelle sur papier
67.6 x 47.1 cm
Don de Mr. St. Clair Balfour, 1959

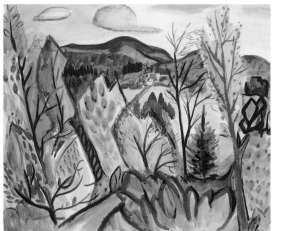

## Les années 1930 et le début des années 1940 : la complexité de la modernité figurative

L'espace urbain devient un véritable laboratoire d'expérimentation formelle pour plusieurs membres de la génération d'artistes qui entrent en scène dans les années 1930. Marian Dale Scott et Fritz Brandtner s'en inspireront pour réaliser des œuvres d'un modernisme qui dénote leur connaissance des courants internationaux contemporains[28]. Si cette dimension plus urbaine de leur production est absente de la collection, deux œuvres de l'AGH retiennent notre attention car elles permettent de cerner certains aspects de leurs recherches formelles.

Ainsi, *Bourgeon* (v. 1939, fig. 45) de Marian Scott, une acquisition récente, est un tableau exemplaire d'une série sur l'univers végétal que l'artiste produit parallèlement à celle qu'elle réalise sur l'univers urbain et industriel. Dans les années 1930, ces deux thèmes nourrissent sa quête d'un « art signifiant » (*significant art*) conjuguant une approche picturale novatrice qui tend vers une certaine abstraction avec une réflexion sur l'homme en lien avec son temps, sa société, mais aussi avec l'univers et le vivant au sens large. Son travail intègre alors les influences des courants modernistes européens aussi bien qu'américains. Dans le cas de *Bourgeon*, la filiation avec Georgia O'Keeffe est manifeste.

Quant à Fritz Brandtner, il fait partie comme Scott de la mouvance progressiste de Montréal. Artiste socialement engagé, il fonde en 1936 avec le médecin communiste Norman Bethune le Children's Creative Art Centre (auquel collabore aussi Scott) pour aider les enfants de milieux défavorisés à connaître la joie et la liberté qu'apporte l'expression artistique. S'il ne peut être qualifié de paysagiste, il produit tout de même un certain nombre de paysages, dont *Automne* (fig. 46), une aquarelle qui date sans doute du début des années 1940. Brandtner explore plusieurs avenues formelles, mais le style qu'il emploie dans *Automne* demeure cohérent avec ses interprétations antérieures du paysage. Il y donne priorité à la simplification et à la rigueur géométrique. Les massifs d'arbres sont réduits à des composantes géométriques (losange, triangle, etc.) souvent délimitées par de larges lignes de contour. À l'intérieur de ces formes, l'artiste, un peu à la manière de Raoul Dufy, superpose aux couleurs du fond des taches, des motifs décoratifs et des lignes qui représentent feuilles et branchages. Cette aquarelle de Brandtner peut être mise en rapport avec une autre œuvre de la collection, *Fantaisie automnale* (fig. 47) d'Anne Savage, sans doute un peu plus tardive. Son titre indique que l'artiste a pris ici plus de liberté qu'à son habitude. Si la composition de base – un cours d'eau au centre, encadré de montagnes et de forêts – est un classique chez Savage, le grand zigzag bleu et jaune qui la traverse et le fluide tourbillon des énormes feuilles jaunes du premier plan dénotent, en effet, une fantaisie assez inusitée. La présence de lignes bien marquées qui circonscrivent non seulement les feuilles, mais aussi les arbres ramenés à des formes géométriques traitées de manière décorative, apparente *Fantaisie automnale* à *Automne* de Brandtner.

Parmi les artistes qui, à Montréal, se singularisent par leur intérêt pour la scène urbaine et plus particulièrement pour les interactions entre l'homme et la ville contemporaine, il faut mentionner T. R. MacDonald qui s'établira à Hamilton en 1947 et Philip Surrey qui vivra à Montréal à partir de 1937. Les œuvres présentées dans l'exposition, *Les amants* (v. 1957, cat. 87) de Surrey et *Une heure du matin* (1956, cat. 86) de MacDonald datent des années 1950, mais elles sont, notamment par l'inquiétante étrangeté de leur atmosphère

Fig. 49
ERNST NEUMANN (1907–1956)
*Scène d'atelier : L'homme fort* 1931
lithographie sur papier
29.0 x 22.1 cm
Don de John Newman, Esq., 1958

Fig. 50
MILLER G. BRITTAIN (1912–1968)
*Nu féminin* 1936
crayon conté sur papier
45.3 x 26.6 cm
Don du Toronto Telegram Art
Fund, 1958

nocturne et par les intéressants contrastes de couleurs générés par l'éclairage électrique, dans la continuité de plusieurs de celles que tous deux réalisent dans les années 1930. D'ailleurs, *Une heure du matin* reprend un tableau que MacDonald avait peint sous le même titre en 1936 (voir fig. 6) et qui, par sa parenté avec l'approche d'Edward Hopper, rappelle l'intérêt que les artistes canadiens portent à l'art américain.

D'autres peintres montréalais – ceux de la communauté juive, dont plusieurs comptent parmi les membres fondateurs de la SAC – consacrent une part importante de leurs recherches formelles à la ville. On pense notamment à Louis Muhlstock, Alexander Bercovitch, Jack Beder, Sam Borenstein et Ernst Neumann[29]. Le musée possède des paysages de Muhlstock et de Bercovitch ainsi que plusieurs gravures de Neumann. De ce dernier, *Chômeur n° 6* (1933, fig. 48) atteste de l'attention que certains de ces artistes portent à la misère qui sévit dans les villes pendant la Dépression.

Neumann a aussi illustré, parfois dans un esprit proche de Daumier qu'il admirait, le milieu des avocats et celui de l'art, comme en témoignent *Artiste et critiques* (v. 1931), de même que *Scènes d'atelier n° 2 : La pause* (v. 1932) et *Scènes d'atelier : L'homme fort* (1931, fig. 49). Ces deux dernières œuvres donnent à voir un intéressant jeu d'inversion. Dans *La pause*, dont la composition est presque une citation de la partie centrale de *L'Atelier du peintre* (1854–1855, Paris, Musée d'Orsay) de Courbet, le modèle vivant est une femme alors que la sculpture au fond à droite est une figure masculine. Par contre, dans *L'homme fort*, une œuvre toute

empreinte de « virilité », le modèle nu – Arthur Dandurand, champion canadien du lever de poids – oppose sa musculature aux courbes amputées de la Vénus de plâtre placée au fond à gauche. Dans les deux cas, le travail dénote une filiation avec la tradition réaliste française et, plus encore, américaine. La sculpture de Neumann, *Boxeur* (cat. 78) est un autre exemple de cet héritage réaliste.

La tendance au réalisme social est également représentée dans la collection par Jack Humphrey et Miller Brittain, tous deux du Nouveau-Brunswick et membres de la SAC. À l'époque, la ville de Saint-Jean comptait un dynamique cercle culturel composé de poètes, de gens de théâtre (de la Theatre Guild of Saint John) et d'artistes comme Humphrey, Brittain et Avery Shaw. L'atelier de Ted Campbell, qui fut aussi professeur de Fred Ross, servait de lieu de réunion à ces créateurs dont plusieurs partageaient cette conviction que l'art devait être socialement engagé[30]. Comme leurs collègues montréalais préoccupés, dans le contexte de la Crise et de la montée du fascisme, par la question de la fonction sociale de l'art, ils s'intéressaient aux muralistes mexicains et américains. Plusieurs tableaux que Brittain peint dans les années 1930, de même que les cartons qu'il réalise pour un projet (qui ne se concrétisera jamais) de murales pour le Saint John Tuberculosis Hospital, sont conçus dans l'esprit de ce réalisme social qui anime certains muralistes américains. Même le simple dessin d'un nu de Brittain que possède l'AGH (*Nu féminin*, 1936, fig. 50) autorise une lecture « sociale » du sujet aussi

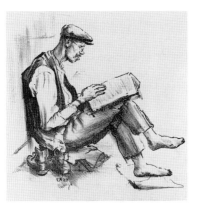

Fig. 48
ERNST NEUMANN (1907–1956)
*Chômeur n° 6* 1933
lithographie sur papier
17.9 x 17.9 cm
Collection des archives de la
Société des Peintres-eaufortistes
et graveurs, 1976

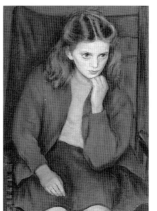

Fig. 51
JACK HUMPHREY (1901–1967)
*L'enfant songeuse (Winnie)* 1941
huile sur carton
87.5 x 61.0 cm
Don de Wintario, 1980

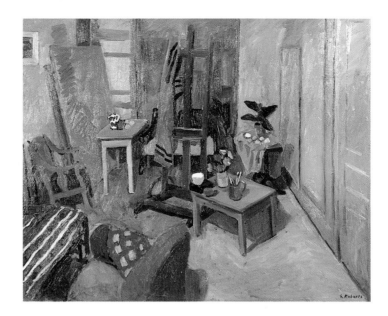

Fig. 52
GOODRIDGE ROBERTS (1904–1974)
*Intérieur d'atelier* v. 1947–1948
huile sur toile
125.0 x 153.2 cm
Fonds d'acquisition du directeur, 1957

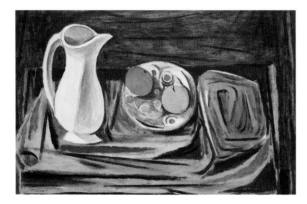

Fig. 53
STANLEY COSGROVE (1911-2002)
*Nature morte au pichet blanc* 1949
huile sur carton
59.3 x 91.1 cm
Don de H. S. Southam, C.M.G.,
LL.D., 1953

Fig. 54
JACQUES DE TONNANCOUR (1917–2005)
*Nature morte au caoutchouc* 1948
huile sur toile
121.8 x 163.0 cm
Don de H. S. Southam, C.M.G.,
LL.D., 1951

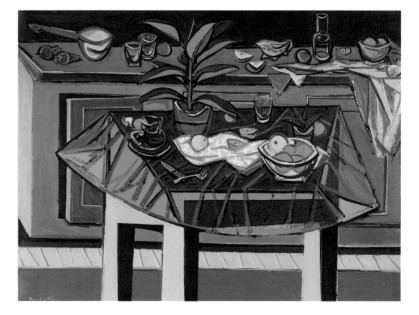

Fig. 55
ALFRED PELLAN (1906–1988)
*Vertige de la Toupie* 1947
lithographie sur papier
16.5 x 25.5. cm
Don de Mrs. Starr, 1967

bien par l'étroitesse du torse et la maigreur du modèle que par le travail des lignes qui induit une déformation presque rachitique du corps.

À l'instar de plusieurs artistes, Brittain et Humphrey réalisent aussi, durant cette période troublée, des portraits d'enfants et d'adolescents qui suscitent la compassion par leur tristesse et, parfois, leur allure misérable. Bien que *L'enfant songeuse (Winnie)* (1941, fig. 51) de Humphrey ne présente aucun signe de pauvreté, l'esprit général qui se dégage de cette œuvre permet de l'ajouter aux nombreux portraits d'enfants « de la dépression » qui parsèment l'art canadien de l'époque. Enfin, une récente donation, l'aquarelle *Champs et collines, Taxco* (1938) de Humphrey rappelle que le Mexique constituait aussi un pôle de référence pour plusieurs de ces artistes qui, dès les années 1930, y séjourneront.

## Aux limites de la modernité figurative

Sur la scène montréalaise des années 1930 et de manière accélérée à partir de 1937 se consolide, à travers les regroupements d'artistes, les expositions et le soutien de la critique, la reconnaissance d'un courant moderne affranchi du nationalisme en art et de plus en plus ouvert aux tendances internationales, notamment au cubisme. Même le surréalisme et l'abstraction commencent à être discutés dans le milieu moderne. La situation est mûre, en 1939, pour la création d'un organisme comme la SAC, fondée sous l'impulsion de John Lyman.

Si plusieurs des artistes qui composent ce milieu s'intéressent au monde contemporain et à ses enjeux sociaux, leur recherche d'un « art signifiant » s'ancre de plus en plus dans une conception du tableau comme lieu où s'expriment prioritairement, comme le soulignait John Lyman, des relations entre des formes et des couleurs[31]. Pour paraphraser Robert Ayre dans son commentaire sur l'exposition *Art of Our Day in Canada*, les artistes modernes de Montréal ont délaissé les étendues sauvages du territoire canadien pour s'ouvrir à l'humanité et, peut-être plus encore, chercher dans l'intimité de leur atelier les secrets de la peinture[32].

La nature du sujet peint importe de moins en moins. La figure humaine et le paysage se sont graduelle-

ment dépouillés de leurs investissements idéologiques pour devenir objets d'un travail d'exploration formelle. L'importance, croissante dans les années 1940, de la nature morte et de la scène d'atelier illustre aussi cette évolution. Dans la collection de l'AGH, des œuvres comme *Intérieur d'atelier* (v. 1947–1948, fig. 52) de Goodridge Roberts, *Nature morte au pichet blanc* (1949, fig. 53) de Stanley Cosgrove et *Nature morte au caoutchouc* (1948, fig. 54) de Jacques de Tonnancour en sont de beaux exemples. Les modalités de composition de ces œuvres – rabattement des plans, juxtaposition d'espaces multiples, variété des textures et couleurs vives – sont autant d'éléments qui dénotent l'influence grandissante de l'École de Paris.

Le retour d'Europe d'Alfred Pellan en 1940 et la rapide évolution de Paul-Émile Borduas vers l'automatisme (il expose ses premières abstractions en 1942[33]) allaient conduire à des débats d'une teneur nouvelle à Montréal. Le surréalisme (que pratique à l'occasion Pellan : *Vertige de la toupie*, 1947, fig. 55) et l'abstraction produite par la spontanéité du geste qui prend sa source dans l'inconscient et le monde surréel (Borduas, *Masques et doigt levé*, 1943, fig. 56) vont devenir des pôles majeurs d'un art qui se définira désormais comme « avant-garde ».

Ce modernisme plus radical, défendu alors par des artistes francophones, laissera dans l'ombre la modernité figurative majoritairement, encore que non exclusivement, associée aux anglophones des générations antérieures. C'est de cette modernité que ce texte a voulu témoigner à travers les œuvres québécoises de la collection de l'AGH. ~

Fig. 56
PAUL-ÉMILE BORDUAS
(1905–1960)
*Masques et doigt levé* 1943
huile sur toile, 47.1 x 56.1 cm,
Don de H. S. Southam, C.M.G.,
LL.D., 1953

## Notes

1. Robert Ayre, « Observations on a Decade, 1938–1948. Recent Developments in Canadian Painting », *Journal, Royal Architectural Institute of Canada*, vol. 25, n° 1, janvier 1948, p. 13.

2. Le manifeste *Prisme d'Yeux*, écrit par Jacques de Tonnancour, paraît en février 1948. Ses signataires sont Louis Archambault, Léon Bellefleur, Jacques de Tonnancour, Albert Dumouchel, Gabriel Filion, Pierre Garneau, Arthur Gladu, Je Anonyme (Jean Benoît), Lucien Morin, Mimi Parent, Alfred Pellan, Jeanne Rhéaume, Goodridge Roberts, Roland Truchon et Gordon Webber. *Refus global*, pour sa part, paraît en août 1948. Il est rédigé par Paul-Émile Borduas, qui en est signataire avec Madeleine Arbour, Marcel Barbeau, Bruno Cormier, Claude Gauvreau, Pierre Gauvreau, Muriel Guilbault, Marcelle Ferron, Fernand Leduc, Thérèse Leduc, Jean-Paul Mousseau, Maurice Perron, Louise Renaud, Françoise Riopelle, Jean-Paul Riopelle et Françoise Sullivan.

3. H. S. Southam et sa famille, par leurs diverses donations, ont fourni à l'AGH un bel échantillonnage d'œuvres témoignant du développement de l'art moderne au Québec. Ainsi, de son vivant, H. S. Southam a fait don au musée des œuvres suivantes : *Masques et doigt levé* (1943) de Borduas, *Couronnement* (1937) de Sarah Robertson, *Nature morte* (s.d.) d'Anne Savage, *Tête de femme* (1948) et *Nature morte au caoutchouc* (1948) de Jacques de Tonnancour et *Nature morte au pichet blanc* (1949) de Stanley Cosgrove. À son décès, il a légué *Fantaisie automnale* (s.d.) de Savage, *Fenêtre de la maison de ferme* (1938) de Prudence Heward, ainsi que *Paysage d'automne avec sapins* (s.d.), *Paysage d'automne* (s.d.) et *Champ, lac et collines* (1945) de Goodridge Roberts. Enfin, Janet Southam MacTavish a donné, en mémoire de son époux le sénateur Duncan R. MacTavish, *Composition sans titre* (s.d.) de Riopelle.

4. Je préfère parler de tradition moderne « montréalaise » plutôt que « québécoise » dans le contexte présent, d'une part, parce que Robert Ayre se référait précisément à celle-ci, et non à la tradition « régionaliste » qui, à certains égards, a elle aussi contribué à l'affirmation des tendances modernes (pensons, par exemple, à l'apport des Clarence Gagnon, Suzor-Coté, Ozias Leduc, André Biéler, etc.), et d'autre part, parce que la collection de l'AGH, par son histoire propre, n'est pas axée sur ce régionalisme plus francophone qui, au demeurant, ne fait pas l'objet de la présente exposition.

5. Cité dans Dennis Reid, *Notre patrie le Canada. Mémoires sur les aspirations nationales des principaux paysagistes de Montréal et de Toronto, 1860–1890*, Ottawa, Galerie nationale du Canada, 1979, p. 273. Cet ouvrage constitue la référence pour le courant paysagiste dont il est question ici.

6. Laurier Lacroix, « The Surprise of Today Is the Commonplace of Tomorrow : How Impressionism Was Received in Canada », dans Carol Lowrey (dir.), *Visions of Light and Air : Canadian Impressionism, 1885–1920*, New York, Americas Society Art Gallery, 1995, p. 42.

7. « Le tonalisme – tendance artistique qui s'est manifestée aux États-Unis du début des années 1880 jusqu'à 1915 – emprunte à l'impressionnisme la transcription des effets fugitifs de lumière et d'atmosphère. Lumière diaphane, ambiance palpable et contours flous sont autant d'éléments utilisés par les adeptes du tonalisme pour donner à leurs compositions une dimension onirique. [...] Le crépuscule et le soir comptent parmi les thèmes de prédilection des tenants du tonalisme à qui ils offrent non seulement la possibilité d'imposer une uniformité de ton et de brouiller les frontières entre les formes, mais de transcrire leur vision poétique. » Brian Foss, « Une expression empathique : l'esthétique de Mary Hiester Reid », dans Brian Foss et Janice Anderson, *L'univers harmonieux de Mary Hiester Reid*, Toronto, Musée des beaux-arts de l'Ontario, 2000, p. 63–64.

8. Plusieurs renseignements de cette section sont tirés de Carol Lowrey, « Into Line with the Progress of Art : The Impressionist Tradition in Canadian Painting, 1885–1920 », dans Lowrey (dir.), *Visions of Light and Air*, p. 16–39.

9. Outre Clarence Gagnon, dont l'AGH possède un certain nombre d'œuvres sur papier, de nombreux artistes québécois francophones font partie de ces réseaux de Canadiens en Europe.

10. Voir Nicole Cloutier (dir.), *James Wilson Morrice 1865–1924*, Montréal, Musée des beaux-arts de Montréal, 1985.

11. Lowrey, « Into Line with the Progress of Art », dans Lowrey (dir.), *Visions of Light and Air*, p. 18.

12. Cullen a joint le Fonds des souvenirs de guerre canadiens en mars 1918. Ses quatre beaux-fils, dont Robert Pilot, étaient déjà dans l'armée. Pilot, bien qu'il ait peint des scènes relatives à la guerre, ne semble pas avoir été un artiste de guerre officiel. Jackson, pour sa part, a joint le FSGC après avoir fait partie d'un bataillon de réserve. Voir Maria Tippett, *Art at the Service of War : Canada, Art and the Great War*, Toronto, University of Toronto Press, 1984, p. 14–15.

13. À propos du développement de l'art et de la critique moderne dans l'entre-deux-guerres, voir Esther Trépanier, *Peinture et modernité au Québec 1919–1939*, Québec, Éditions Nota bene, 1998.

14. La composition du Groupe de Beaver Hall est difficile à définir, comme le démontre Susan Avon dans son mémoire de maîtrise, *The Beaver Hall Group and its place in the Montreal art milieu and the nationalist network*, Montréal, Université Concordia, 1994. Le Groupe s'est constitué autour d'un noyau formé par Henrietta Mabel May, Randolph Hewton, Edwin Holgate et Lilias Torrance Newton. D'autres « membres » se sont ajoutés, dont Prudence Heward, Sarah Robertson, Mabel Lockerby, Nora Collyer, Emily Coonan, Anne Savage, A. Y. Jackson, Kathleen Moir Morris et Ethel Seath. Sont aussi en relation plus ou moins étroite, selon le cas, notamment parce qu'ils exposent avec eux, les Albert Robinson, Henri et Adrien Hébert, Robert Pilot, André Biéler, Regina Seiden, Adam Sheriff Scott, Hal Ross Perrigard, Thurstan G. Topham, etc.

15. Voir Charles C. Hill, *Le Groupe des Sept. L'émergence d'un art national*, Ottawa, Musée des beaux-arts du Canada, 1995, p. 178–181.

16. Les critiques d'art francophones de Montréal utilisent aussi nombre de termes connotant la virilité pour qualifier la rigueur formelle des œuvres modernes, indépendamment du sexe de leur concepteur. Voir Trépanier, *Peinture et modernité*, p. 73, 97, 100, 251–253, 256 et 299.

17. L'historien du Groupe des Sept, Frederick Housser, déclarait que l'artiste devait « quitter l'habit de velours pour revêtir la tenue du bûcheron et du prospecteur ». F.B. Housser, *A Canadian Art Movement* (1926), cité dans Doris Shadbolt, *Emily Carr*, Ottawa, Musée des beaux-arts du Canada, 1990, p. 67.

18. Voir la notice de Tobi Bruce (cat. 68), qui met en comparaison *Prospecteur (Peter Swanson)* (1934) de Yulia Biriukova avec le travail de Holgate.

19. Sur ces questions, voir Hill, *Le Groupe des Sept*, chapitre 10, p. 173–193.

20. « Je voudrais, comme dans le *Triomphe de Flore*, marier des courbes de femmes à des épaules de collines. » Tiré de Joachim Gasquet, *Conversations avec Cézanne (1921–1926)*, cité dans Raymond Jean, *Cézanne, la vie, l'espace*, Paris, Éditions du Seuil, 1986, p. 309–310.

21. Lyman, dans son journal. Cité dans Charles C. Hill, *Peinture canadienne des années trente*, Ottawa, Galerie nationale du Canada, 1975, p. 40–41.

22. Outre ses sculptures de danseuses, typiques de la « garçonne » des années 1920, Henri Hébert a dessiné nombre de nus féminins portant cheveux courts, souliers à talons hauts, bas noirs, etc., dont beaucoup sont aujourd'hui conservés au Musée national des beaux-arts du Québec. Voir Janet M. Brooke, *Henri Hébert, 1884–1950. Un sculpteur moderne*, Québec, Musée du Québec, 2000.

23. Cité dans Suzanne Marchand, *Rouge à lèvres et pantalon. Des pratiques esthétiques féminines controversées au Québec, 1920–1939*, Montréal, Hurtubise HMH, Cahiers du Québec, 1997, p. 52. Sur cette question de la modification des attributs corporels, voir particulièrement le chapitre 2, « Le culte du corps : le discours de *La Revue moderne* ».

24. John Lyman, « Art », *The Montrealer*, 1er décembre 1940, p. 20. Lyman avait écrit, au début de la même année que si, jusqu'alors, on avait associé les artistes académiques à la représentation de la figure humaine et les peintres indépendants à la peinture de paysage, ce rapprochement n'était plus valable car, à son avis, plus d'une demi-douzaine d'artistes s'exprimaient désormais de manière plus libre en traitant de la figure humaine « et ne demanderaient pas mieux que s'y consacrer entièrement s'ils avaient quelque chance de gagner ainsi leur vie ». John Lyman, « Art, CAS Exhibition; Man in Art », *The Montrealer*, 1er janvier 1940, p. 19.

25. Paul-André Linteau, René Durocher et Jean-Claude Robert, *Histoire du Québec contemporain*, Montréal, Boréal Express, 1979, tome 1, *De la Confédération à la crise*, p. 45.

26. Cet air effrayé semble avoir été voulu par l'artiste puisqu'elle avait demandé à son jeune modèle d'imaginer que quelque chose de terrible était arrivé à ses parents. C'est le modèle, Winnifred Tooey, qui a transmis cette information à l'AGH en 1997.

27. Après trois ans de travail dans une usine de munitions, Robinson eut, en joignant le FSGC, la possibilité de peindre l'effort industriel sur le front intérieur, notamment les chantiers de construction navale de l'usine Vickers à Montréal. Voir Maria Tippett, *Art at the Service of War*, p. 14–15, 56, 72, 91, et Jennifer Watson, *Albert H. Robinson : The Mature Years / L'épanouissement*, Kitchener (Ontario), Kitchener-Waterloo Art Gallery, 1982. La figure 8 du catalogue de Watson, *Construction du cargo* (1919, Ottawa, Musée canadien de la guerre) s'apparente à *Construction d'un navire* de l'AGH. Un grand merci à Alicia Boutilier pour son aide sur cette question des œuvres de guerre de Robinson et des artistes du FSGC.

28. Sur Fritz Brandtner, voir, entre autres, Helen Duffy et Frances K. Smith, *The Brave New World of Fritz Brandtner / Le meilleur des mondes de Fritz Brandtner*, Kingston, Agnes Etherington Art Centre, 1982. Sur Marian Scott, voir Esther Trépanier, *Marian Dale Scott : pionnière de l'art moderne*, Québec, Musée du Québec, 2000.

29. Sur ces artistes, voir Esther Trépanier, *Peintres juifs et modernité / Jewish Painters and Modernity, Montréal 1930–1945*, Montréal, Centre Saidye-Bronfman, 1987.

30. Sur ce milieu, voir Tom Smart, *The Art of Fred Ross : A Timeless Humanism*, Fredericton, Goose Lane Editions, 1993.

31. Cette position est celle des artistes qui, dès 1931, gravitent autour de Lyman. En effet, dans le prospectus de l'école du groupe dit de l'Atelier, auquel appartient Lyman, on lit cette affirmation dans le texte signé par Hazen Sise (affirmation qui pourrait être de Lyman, car il la reprendra ultérieurement) : « Dans son attitude envers l'art, l'Atelier adopte une position simple et sans équivoque : les qualités essentielles d'une œuvre d'art résident dans les rapports de forme à forme et de couleur à couleur. » (Cité dans Frances K. Smith, *André Biéler, An Artist Life and Time*, Toronto et Vancouver, Merritt Publishing Company Limited, 1980, p. 76).

32. « Nous devons alors comparer "l'art d'aujourd'hui au Canada" avec "l'art d'hier au Canada". [...] Mais qu'était cet "hier" ? [...] C'était une époque grandiose, une époque extraordinaire, héroïque, extravagante si l'on veut, optimiste. En voyant l'exposition, qui comprend surtout des œuvres montréalaises, avec quelques importations européennes, nous devons nous rappeler que le Groupe [des Sept] était de l'Ontario. Montréal n'a jamais été aussi exubérante, elle était plus proche de l'atelier que de la pleine nature. [L'art d'aujourd'hui...] se tourne vers l'intérieur, il est plus attentif à la sensibilité et s'applique peut-être plus à chercher les secrets de la peinture. En un sens, il a ouvert ses horizons, il explore l'humanité plutôt que la forêt. » Robert Ayre, « Art News and Reviews – Exhibition of "Art of Our Day" by Contemporary Arts Society Found Haunting and Significant », *The Standard* (Montréal), 7 décembre 1940, p. 7.

33. Voir François-Marc Gagnon, *Paul-Émile Borduas*, Montréal, Musée des beaux-arts de Montréal, 1988, p. 93–94.

# Entries / Notices

Works in the Exhibition

Œuvres de l'exposition

EUGÈNE BOUDIN (Français; 1824–1898)
*Trouville. Le port* 1884
huile sur bois
23,7 x 32,8 cm
Legs de Mlle Muriel Isabel Bostwick, 1966

En 1884, Eugène Boudin atteint sa soixantième année. Il est presque un vieil homme déjà, mais c'est seulement alors que sa carrière prend véritablement son essor.

L'année 1883 avait été marquée par plusieurs événements heureux dans la vie du peintre. Le 1er février, le célèbre marchand Durand-Ruel inaugurait ses nouveaux locaux, au 9 du boulevard de la Madeleine, avec une exposition de cent cinquante œuvres de Boudin comprenant des peintures, des pastels et des aquarelles. En avril, la galerie Dowdeswell and Dowdeswell, relais de Durand-Ruel à Londres, exposait dix œuvres de lui, lesquelles se trouvaient en la flatteuse compagnie de celles de Manet, de Degas et des impressionnistes. Non content de l'exposer, Durand-Ruel lui achetait soixante-treize tableaux. Parallèlement, en mai, l'artiste présentait deux tableaux au Salon et obtenait une médaille de deuxième classe. De plus, il assurait ses participations annuelles aux expositions des villes de province en France. Cette année-là, Caen, Bordeaux et Le Havre auront le privilège de présenter quelques œuvres de sa production.

Le peintre aborde donc l'année 1884 avec optimisme et, grâce à l'argent récemment gagné, décide de réaliser un vieux rêve : se faire bâtir une villa à Deauville. Il présente au Salon deux peintures, dont une, *Marée basse*, sera achetée par l'État. Conséquence de ces récents succès, les commandes affluent : amis, amateurs, marchands, organisateurs d'expositions lui réclament des tableaux. Son premier souci étant de payer sa maison, il n'a d'autre choix que de travailler sans répit. Comme d'habitude, il se rend à Dordrecht et à Rotterdam, en Hollande, où il passe un mois (du 11 juin au 11 juillet), et, en France, séjourne à Berck, au Havre, à Boulogne, à Trouville et à Deauville.

*Trouville. Le port* a donc été peint dans ce climat d'effervescence créé par la consécration officielle de l'artiste. Mais, en raison des circonstances évoquées plus haut, Boudin doit accélérer le rythme de sa production; à cause de cela, une certaine répétition s'installe dans le choix de ses sujets et l'exécution, parfois, en souffre.

Il existe cinq autres vues de Trouville, toutes de plus grandes dimensions et plus tardives, en tous points comparables à celle-ci[2]. Elles présentent sensiblement le même point de vue, le peintre observant le port de Trouville à partir de Deauville, et les éléments qui rythment la composition – barques, plan d'eau et alignement de maisons – sont presque superposables. Il est intéressant de faire remarquer qu'en plus de la version que possède l'Art Gallery of Hamilton, deux autres versions[2] ont appartenu à des collectionneurs canadiens après avoir transité par les Continental Galleries, établies à Montréal.

Boudin, auprès de qui Monet apprit à peindre en plein air dès 1858 et qui participa à la première exposition des impressionnistes en 1874, mena cependant une carrière parallèle à ceux-ci. Sa peinture claire, caractérisée par une palette sobre et raffinée, et une touche fondue plutôt que fragmentée, s'apparente en effet davantage à celle d'un Corot ou d'un Jongkind, qui n'eurent d'autre maîtresse que la nature et d'autre principe que son observation patiente et méthodique.

*Louise d'Argencourt*
*Historienne d'art*
*Paris*

Notes

1. Voir Robert Schmit, *Eugène Boudin 1824–1898*, Paris, Robert Schmit, vol. II (1973), n° 2394 (p. 410), vol. III (1973), n° 2687 (p. 50), n° 3579 (p. 367), et n° 3648 (p. 392), et deuxième supplément (1993), n° 3990 (p. 56).

2. Les deux ont pour titre *Trouville. Le port. Marée basse* et sont datées respectivement de 1896 et de 1897. L'une se trouve aujourd'hui au Musée national des beaux-arts du Québec, l'autre, dans une collection particulière. Voir Schmit, *Eugène Boudin*, vol. III, n° 3579 et n° 3648.

     English translation on page 275

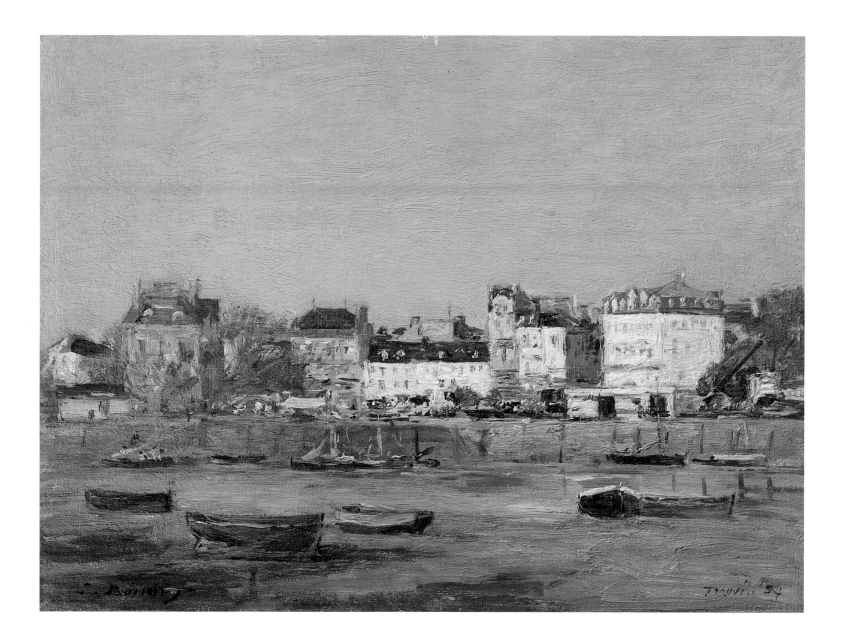

WILLIAM BLAIR BRUCE (1859–1906)
*Giverny* c. 1887
oil on canvas
26.4 x 35.0 cm
Bruce Memorial, 1914

WILLIAM BLAIR BRUCE (1859–1906)
*Giverny, France* 1887
oil on canvas
26.5 x 34.6 cm
Bruce Memorial, 1914

Cat. 4
GEORGE A. REID (1860–1947)
*Studio Study* 1880s
oil on laminated card
6.3 x 5.2 cm
Gift of Mr. and Mrs. J. A. McCuaig, 1966

Cat. 8
GEORGE A. REID (1860–1947)
*Study in the Park* 1889
oil on laminated card
6.9 x 9.8 cm
Gift of Mr. and Mrs. J. A. McCuaig, 1966

Cat. 5
GEORGE A. REID (1860–1947)
*At the Window (Study)* 1880s
oil on laminated card
10.2 x 9.5 cm
Gift of Mr. and Mrs. J. A. McCuaig, 1966

Cat. 10
GEORGE A. REID (1860–1947)
*Early Autumn* 1892
oil on wood
10.0 x 9.8 cm
Gift of Mr. and Mrs. J. A. McCuaig, 1966

GEORGE A. REID (1860–1947)
*Forbidden Fruit* 1889
oil on canvas
77.8 x 122.9 cm
Gift of the Women's Committee, 1960

WILLIAM BLAIR BRUCE (1859–1906)
*The Phantom Hunter* 1888
oil on canvas
151.1 x 192.1 cm
Bruce Memorial, 1914

The hunter in this picture is clearly in distress. Traversing the vast, barren snowscape alone (so the single set of footprints tells us), he has encountered a force that has compelled him to twist around and stumble to the icy ground. This force – the apparition – strides resolutely on, oblivious to the hunter's plight. The ghostly figure's outfit echoes the fallen man's, as though it were claiming the hunter's life for its own. It would seem that the phantom is taking possession of the hunter, body and soul, and that the moment depicted is that of impending death.

*The Phantom Hunter* was inspired by "The Walker of the Snow," a poem by C. D. Shanly about a hunter who, as William Blair Bruce understood it, meets his death by freezing.[1] Executed in France, where the artist was living (he borrowed a copy of Shanly's poem from an American friend and had the costume and snowshoes for the figure sent over by his parents),[2] this narrative painting was intended from the start as a piece of "Canadiana." It was Bruce's first proffering of such a "national" work to the Salon-going public of Paris, and he used it to test the marketability of such North American exotica.[3] Aside from being accepted for inclusion in the 1888 Salon of the Société des artistes français, however, *The Phantom* garnered little if any European notice.[4] Yet in Canada the work soon attracted the attention of the art editors of *The Dominion Illustrated*: in 1890 it was featured as a full-page reproduction, with an abbreviated version of Shanly's poem included in the same issue.[5] Ironically, cultural arbiters of the very country Bruce had sought to exoticize for a European audience themselves embraced Bruce's *Phantom*, and the painting eventually became an icon of Canadian self-identity – an embodiment of the idea of "Canada-as-North."[6]

Beyond this iconic status, though, *The Phantom Hunter* seems to communicate something of the existential ambivalence attendant on the human condition. The painting's expressive power resides in the tension created by the accumulation of pictorial paradoxes it encompasses. How are we to understand its many contrasts – between the highly detailed costume of the fallen hunter and its strange echo in the ghostly, impressionistic rendering of the agent of death; between the cool blue tones of the midwinter night and the subtle coral tinge suggesting the sun; between the discreet brushstrokes of the landscape and the assertive pigments that define the stars? Most poignant, perhaps, is the tension generated by the anticipation of an emotional connection with the fallen hunter and the non-fulfillment of that connection. The eyes, those "mirrors of the soul" that are so often integral to the telling of a narrative, offer no revelation here. For we soon realize that the hunter's gaze, shaded by his hood, is indiscernible. The artist gives, but he also takes away. He promises the viewer access to the painting, but simultaneously frustrates the quest for full comprehension and resolution. Evoking a panoply of conflicting emotion – hope, despair, fear, deliverance, betrayal, alienation, companionship, isolation – *The Phantom Hunter* haunts as it confronts. And herein lies its compelling fascination.

*Arlene Gehmacher*
*Curator*
*Department of World Cultures*
*Royal Ontario Museum, Toronto*

Notes _____

1. Bruce articulated his interpretation of the poem in a letter to his father, dated 13 November 1888. See Joan Murray, ed., *Letters Home: 1859–1906. The Letters of William Blair Bruce* (Moonbeam, Ontario: Penumbra Press, 1982), p. 167. *The Phantom of the Snow (Canadian Legend)* was Bruce's original title; see a letter from Bruce to his mother, 24 March 1888 (ibid., p. 162). The painting was listed in the catalogue of the 1888 Paris Salon simply as *Phantom of the Snow*.

2. See a letter from Bruce to his father, 26 January 1893, and another to his mother, 22 January 1888 (ibid., pp. 185 and 161).

3. See a letter from Bruce to his mother, 24 March 1888 (ibid., p. 162).

4. The reporting of Bruce's career in the Hamilton press provides an excellent gauge of the overseas reception of his work. *The Phantom* was mentioned in this context simply as having been "well spoken of by the art jury" ("A Canadian Artist Abroad," *Evening Times* [Hamilton], 14 April 1888, p. 3). See Arlene Gehmacher, *William Blair Bruce: Painting for Posterity* (Hamilton: Art Gallery of Hamilton, 2000), p. 19.

5. In *The Dominion Illustrated*, vol. 4, no. 93 (12 April 1890), the picture is reproduced on p. 237 under the title *The Walker of the Snow*. The poem appears on p. 231, and a brief career biography of Bruce on p. 230.

6. See Sherrill E. Grace, *Canada and the Idea of North* (Montreal: McGill-Queen's University Press, 2001), pp. 3–4, 104–120. Grace studies the ambiguities within both the painting and the poem by Shanly that served as its inspiration.

AUGUSTE RODIN  (French; 1840–1917)
*Frère et Soeur*  c. 1890
bronze
38.4 x 18.7 x 19.0 cm
Gift of H. S. Southam, C.M.G., LL.D., 1962

LOUIS-PHILIPPE HÉBERT (1850–1917)
*Self-Portrait* c. 1895
bronze
50.0 x 23.0 x 21.0 cm
Gift of Canadian Westinghouse Company, 1966

MAURICE CULLEN (1866–1934)
*Halage du bois, Beaupré* 1896
huile sur toile
64,1 x 79,9 cm
Don du Comité féminin, 1956,
à la mémoire de Ruth McCuaig,
présidente du Comité féminin de 1953 à 1955

*D*ans son ouvrage capital sur la peinture au Canada, paru en 1966, John Russell Harper publie une illustration en couleur de ce petit tableau de Maurice Cullen, qu'il présente comme une sorte de manifeste, ou plutôt un « talisman » capable d'influencer toute une génération d'artistes[1]. La popularité du tableau est cependant tardive et elle est due en grande partie au renouveau d'intérêt que connaît la peinture post-impressionniste depuis les années 1970[2].

À l'été 1895, Cullen revient de France, où il s'est familiarisé avec la peinture de plein air. C'est cette approche qui l'intéresse le plus, et il a été encouragé dans cette direction par son compatriote William Blair Bruce. Au cours de l'année 1896, William Brymner et Edmond Dyonnet entraînent Cullen avec eux pour peindre sur la côte de Beaupré, au nord de Québec, où ils logent chez Anna Blouin, épouse du marchand général Eugène Raymond. « Cullen et moi, raconte Dyonnet, partagions les frais des modèles. Nous avions des habitants qui venaient avec leurs bœufs poser pour nous[3]. »

De retour à Montréal, Cullen expose ses œuvres récentes, à propos desquelles on lit dans la *Gazette* du 2 décembre 1896 qu'elles « résultent de son séjour de huit mois dans la pittoresque région de Sainte-Anne-de-Beaupré ». Le commentateur ajoute : « M. Cullen est, à n'en pas douter, un impressionniste. [...] Manifestement, il se passionne pour cette région du pays où il est resté si longtemps, car, comme il le dit lui-même, il n'avait jamais à marcher plus de quinze minutes en dehors du village pour trouver un sujet. Dans ses nombreuses peintures, on trouve en effet une variété de sujets. Ses scènes de neige sont remarquablement belles et très agréables à l'œil[4]. »

*Halage du bois, Beaupré* a donc été peint dans un décor familier, au tout début de l'hiver 1896, et fort probablement montré aussitôt au public montréalais. Il s'agit d'abord et avant tout d'une étude de lumière éblouissante. En effet, la scène de halage qui lui donne son titre est secondaire, pour ne pas dire mal adaptée au format du tableau. On la dirait ajoutée après-coup pour animer le paysage et lui conférer un caractère narratif. Le sujet est véritablement la palette de couleurs inusitée et le traitement de la matière picturale qui laisse voir les mouvements du pinceau sur toute la surface.

Le point de vue en contre-plongée a pour effet de rabattre le premier plan. Ce procédé ramène la topographie accidentée de la côte de Beaupré à ses lignes essentielles et accentue la taille des arbres qui se prolongent au-delà du tableau. Le blanc pur de la neige et le bleu clair des ombres se mêlent pour donner la teinte bleutée du ciel. Aux diagonales formées par l'escarpement répondent le mouvement de la route et les motifs irréguliers des percées lumineuses sur la neige. Sur cette structure sont posées les verticales des troncs massifs des arbres, assemblages de tons de gris, de vert et de brun qui contrastent avec le ciel. L'ombre portée de la forêt enveloppe le peintre et le spectateur dans cet espace. Les trouées de lumière sur les troncs forment des taches claires qui s'opposent au vert sombre des conifères. Une reprise de toute la palette des verts, du jaune au noir, ferme la composition à gauche.

*Laurier Lacroix*
*Professeur*
*Département d'histoire de l'art*
*Université du Québec à Montréal*

Notes _____

1. John Russell Harper, *La peinture au Canada des origines à nos jours*, Québec, Les Presses de l'Université Laval, 1966, p. 253, 256, fig. 234 p. 258, sous le titre *Logging in Winter, Beaupré*.

2. Sylvia Antoniou, *Maurice Cullen: 1866–1934*, Kingston, Agnes Etherington Art Centre, 1982, p. 60 et 62.

3. Edmond Dyonnet, *Mémoires d'un artiste canadien*, Ottawa, Éditions de l'Université d'Ottawa, 1968, p. 67.

4. « Mr. M. Cullen's pictures », *The Gazette* (Montréal), 2 décembre 1896, p. 3.

JAMES WILSON MORRICE (1865–1924)
*Corner of the Doge's Palace, Venice* c.1901
oil on wood
17.3 x 25.2 cm
Bequest of Miss Margaret Rousseaux, 1958

James Wilson Morrice's *Corner of the Doge's Palace, Venice* is one of his most compelling images of the city. Seated at an outdoor table at the Gran Caffè Chioggia, by the steps of the Marciana Library, Morrice encapsulated the sensations of a Venetian afternoon through his empathy with the subject and his own pleasure in painting. The complexity and completeness of this image explain why the artist's small panels were so esteemed by his colleagues and seen as all the more remarkable for being painted out-of-doors, rather than in the studio. Exemplifying Baudelaire's "passionate observer," Morrice makes intimate the panorama that extends from the Piazzetta (the east end of Piazza San Marco) to the Molo, bordering the Lagoon's Bacino, and then across the Ponte della Paglia and along the Riva degli Schiavoni towards the easternmost tip of the city. The immediacy of the image and its heightened specificity of place derive from his intuitive and bold imposing of a design on one of the world's most celebrated vistas.

In Morrice's images of Venice, architecture functions as both fact and idea – as an armature for his enjoyment and realization of the sensory aspects of painting. The imposing southwest end of the Ducal Palace – known as the "Fig Tree Corner," after the late fourteenth-century sculpture of Adam and Eve in the Garden that tops the outermost column – becomes a patterned play of soft solids and voids. Its loosely square shape is echoed in the parallelogram formed by the paving stones of the Piazzetta and the

Molo, and again in the hovering, limpid sky. The compressed sweep of buildings and lamplights along the Riva is the key to the panel's structure, for it locks the entire image into place. The insistent frontality of the parallel modules of the Palace arcade's deep archways, and of the feathery lamppost on the Molo and the large commercial liner in the Bacino, is typical of Morrice's elegant modernism. His sensitivity to the harmonies of position and proportion is equally evident in the size and spacing of the shawled Venetian women. These figures punctuate the lower half of the painting like the notes on a musical score for his beloved flute. The rhythms between each contoured form and the measured intervals from shape to shape are gracefully sequenced and extraordinarily palpable. Morrice's deliberate balancing of every element of the panel is felt most acutely in the precision of the colour and its play of delicate

nuance. His carefully modulated tonalities and subtle repetitions of colour-shapes glow with that particular watery light that is the very essence of Venice.

Morrice made several trips to Venice, and *Corner of the Doge's Palace* can be linked to his other paintings depicting the city that belong to the Art Gallery of Hamilton. The site of this panel is framed by the ones shown in *The Porch of San Marco* (cat. 14), at the other end of the Piazzetta, and *Study, Venice* (fig. 57), painted at the Hotel Danieli on the Riva degli Schiavoni, near the Ponte della Paglia. The visual pleasure afforded by each of these paintings, all probably made around the turn of the twentieth century, clearly demonstrates that Morrice shared Whistler's belief that Venice was an "amazing city of palaces – created one would think especially for the painter."[1]

*Sandra Paikowsky*
*Professor*
*Department of Art History*
*Concordia University, Montreal*

Fig. 57
J. W. MORRICE
*Study, Venice*
oil on canvas
35.6 x 27.6 cm
Bequest of H. L. Rinn, 1956

Notes _____

1. James McNeill Whistler in an undated letter to his mother, Anna Matilda Whistler, (March–May 1880, Venice), Whistler Collection, Glasgow University Library, Scotland.

JAMES WILSON MORRICE (1865–1924)
*Le porche de l'église San Marco, Venise* c. 1902–1904
oil on wood
33.6 x 24.0 cm
Bequest of H. L. Rinn, 1956

HORATIO WALKER (1858–1938)
*Ave Maria* 1906
oil on canvas
116.8 x 86.2 cm
Gift of the Women's Committee, 1963

JOHN SLOAN (American; 1871–1951)
*Stein and Press* 1906
oil on canvas
81.3 x 66.3 cm
Gift of Mr. and Mrs. J. A. McCuaig in memory
of her father, H. B. Hall, 1964

The painting *Stein and Press* belongs to a transitional period in John Sloan's life and work, which began in 1904 with his relocation from Philadelphia to New York City and culminated in the few years that followed in the emergence of the unique, modern form of urban iconography on which his reputation now largely rests. The person who appears in this painting, Eugenie Stein (also known as Zenka or Efzenka), a professional model from Bohemia, is featured in several of Sloan's works from this period. One of these, entitled *Stein, Profile* and executed in 1904–1905 (present location unknown), is believed to be the first painting completed by Sloan in New York City. A slightly later work for which Stein modeled, *The Cot* of 1907 (Brunswick, Maine, Bowdoin College Museum of Art), was included in the landmark exhibition of the group of painters known as "The Eight," which took place in New York in 1908 and pushed the earthy, realist style of Sloan, Robert Henri and their colleagues to prominence in contemporary American art.

By late 1905, Sloan and his wife Dolly were living on the top floor of a five-storey walk-up on West Twenty-third Street in Manhattan, not far from the mid-town Tenderloin district where Sloan would discover some of his most memorable subjects. One room of their two-room apartment was used as a studio. This studio, which appears as the backdrop of *Stein and Press*, saw the creation of some of Sloan's most celebrated paintings; it was also the setting in which he began his famous series of etchings called New York City Life. Sloan completed the first ten of these etchings – the greater part of the series – in late 1905 and 1906. The prominent inclusion of the etching press in the background of *Stein and Press* may therefore be seen as a direct allusion to Sloan's current artistic endeavours.

John Sloan painted portraits and figure studies throughout his career. From 1904 to 1907, however, when he depicted Stein, he was just beginning to find his way as a painter, having spent most of the first dozen or so years of his career drawing illustrations for newspapers, books and magazines. During this period he tried various approaches to figure painting and portraiture, drawing inspiration from other artists. Robert Henri was a particularly important influence, as well as a close friend and supporter, and it was probably he who introduced Sloan to Stein. In *Stein and Press*, Sloan represents the figure full-length, as Henri often did, but with ample margins and space around it. As a contemporary reviewer said of the work, "it has a feeling of space and atmosphere, which makes [it] a notable achievement."[1] Henri was also pleased with Sloan's effort: on 19 October 1906 Sloan noted in his diary that his fellow artist very much approved of the picture.[2] Distinctive in its conception, *Stein and Press* represents a unique moment in Sloan's early development as a painter.

*Laural Weintraub*
*Art historian*
*New York City*

Notes _____

1. *New York Times*, 11 November 1907.

2. Bruce St. John, ed., *John Sloan's New York Scene* (New York: Harper & Row, 1965), p. 70.

ALBERT MARQUET (Français; 1875–1947)
*Le pont Marie vu du quai Bourbon* 1906–1907
huile sur toile
65,0 x 81,0 cm
Acheté grâce au legs Marion E. Mattice, 1958

*P*eintre voyageur, Albert Marquet n'a jamais traversé l'Atlantique, bien qu'il ait été connu aux États-Unis de son vivant grâce à plusieurs expositions internationales[1]. Au Canada, il faut attendre les années 1950 pour que son art entre dans les collections publiques, où l'on compte aujourd'hui une douzaine de ses œuvres, dont seulement six peintures : rareté qui rend leur présence d'autant plus précieuse.

Marquet doit la célébrité à ses vues de la Seine, ainsi que des ports d'Europe et d'Afrique. Ici, l'admirable vue du pont Marie à Paris figure parmi les premiers tableaux achetés par nos musées. L'œuvre porte au verso le numéro d'inventaire de la galerie d'Eugène Druet, marchand d'art et fervent défenseur de Marquet, à qui celui-ci doit d'ailleurs son rayonnement à l'extérieur de la France. Druet avait découvert le jeune peintre parmi les artistes réunis à la galerie de Berthe Weill et qui allaient bientôt être connus comme les « fauves ». Les œuvres de Marquet ne présentent cependant pas la facture heurtée, souvent sauvage, des tableaux d'Henri Matisse, d'André Derain ou de Maurice de Vlaminck, les principaux représentants du fauvisme. Elles ne comportent pas non plus les couleurs tout droit sorties du tube, vives, rutilantes et totalement infidèles à la nature, qui sont la marque de ce nouveau mouvement révolutionnaire. Jamais Marquet ne se

laissera vraiment emporter par ces humeurs auxquelles les artistes fauves et expressionnistes seront si sensibles et qui les inciteront à rompre radicalement avec les conventions figuratives.

Pendant les premières années de sa carrière, avant que la vente de ses tableaux ne lui permette de voyager aisément, Marquet peint Paris, les quais et les ponts, et il continuera jusqu'à son décès, constituant ainsi une remarquable série de vues de la Seine. À partir de 1903, il prend l'habitude d'installer son chevalet devant sa fenêtre et de saisir en plongée les lignes essentielles du paysage, avec un sens aigu de la simplification et une sûreté incomparable. Artiste d'une personnalité à la fois délicate et vigoureuse, il baigne ses compositions de la lumière particulière du lieu, préférant les atmosphères humides et voilées, les ciels brumeux et enneigés. À la finesse des tonalités s'ajoute le mouvement de l'activité humaine, qu'il rend sobrement : quelques signes calligraphiques, témoignant de l'influence du japonisme, suffisent pour suggérer une petite population grouillante, affairée aux tâches quotidiennes.

*Le pont Marie vu du quai Bourbon* est un bel exemple de l'art subtil et vivant de Marquet. Sa composition est architecturée par des diagonales et des obliques qui entraînent le regard au loin. La lumière est celle d'une journée d'automne, froide et nuageuse, que le peintre a « réchauffée » par quelques accents colorés : le vert de la Seine, l'orangé de la charrette, le rouge d'un arbre. De sa fenêtre, dans l'immeuble situé en bordure du quai, il peint au

premier plan les lavoirs. Ces formes sombres sont suivies du pont, dans toute sa clarté, trois de ses cinq arches se proposant comme les seules courbes de la composition. Malgré le traitement esquissé, on en reconnaît les contreforts en forme de becs et surmontés de niches. La vitalité de la scène doit beaucoup aux petites taches noires représentant les passants qui franchissent le pont et tournent le dos à l'île Saint-Louis pour se diriger vers la rive droite, vers le quai des Célestins[2].

*Michèle Grandbois*
*Conservatrice de l'art moderne*
*Musée national des beaux-arts du Québec*

Notes _____

1. Ses œuvres ont été montrées à New York, Cleveland et Pittsburgh. Le magnifique *Pont-Neuf la nuit* (1935–1939, Paris, Centre Georges Pompidou, Musée national d'art moderne / Centre de création industrielle) lui valut la première mention honorable à l'Exposition internationale de Pittsburgh en 1938.

2. Marquet a peint d'innombrables vues de Paris, s'attardant plus spécifiquement à son quartier de prédilection d'où il voit les quais

longeant l'île de la Cité. La vue qu'il nous offre ici du pont Marie est inusitée et, selon l'inventaire exhaustif effectué par le Wildenstein Institute, il n'existerait qu'un seul autre tableau peint depuis cette fenêtre. Ce second tableau représente plutôt le côté opposé, sans le pont, avec vue sur Notre-Dame et l'église Saint-Gervais. Nous devons à Michèle Paret du Wildenstein Institute, à Paris, les précisions concernant le point de vue adopté pour ces deux tableaux.

 English translation on page 278

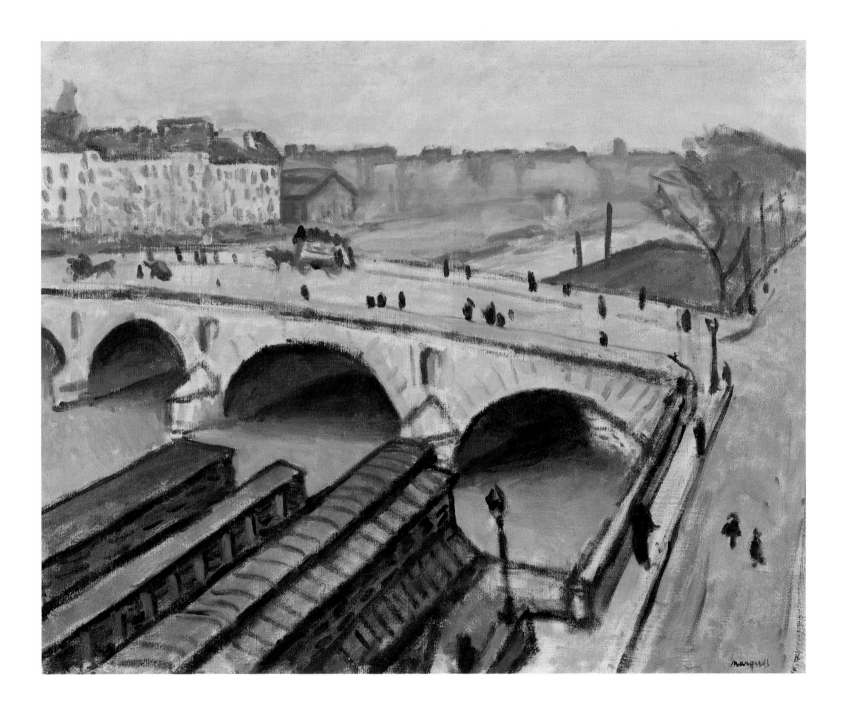

SPENCER GORE (British; 1878–1914)
*The Bedroom* 1908
oil on canvas
51.0 x 41.0 cm
Gift of the Women's Committee, 1960,
dedicated to the memory of Mary (Molly) Proctor,
President of the Women's Committee, 1960–1962

*D*uring a 1904 painting trip to Normandy with Slade School colleagues, Spencer Gore was introduced to Walter Richard Sickert, founder of the controversial Camden Town Group. Sickert later lent Gore his house in Neuville, outside Dieppe, for six months – from May to October of 1906 – and Gore took advantage of this sojourn in France to enhance his appreciation of the science of painting by studying the methods of the French Impressionists and Neo-Impressionists. It was also then that he formed a lasting friendship with Lucien Pissarro, who helped expand his knowledge of French Impressionism and its refashioning by Cézanne and Seurat.

Gore's fascination with the romanticism and the exoticism of the theatre, inspired by Goya's carnival scenes, resulted in works quite different from Sickert's sombre, slice-of-life depictions of the same world, which focus more upon audience than stage. Sickert did influence Gore's career, however, by taking him into the dingy bed-sitting rooms of London's Camden Town district that he used as studios and introducing him to the themes that established the identity of Camden Town painting.[1] From 1906 on, the two artists collaborated frequently, often portraying the same model against the same grim backdrop of one or other of the studios they rented in the area.[2]

Although it was Sickert who legitimized "the nude in the bedroom" subject matter they favoured, Gore was indebted to Lucien Pissarro, a fellow-member of the Fitzroy Street Group (a forerunner of the Camden Town Group), for the handling and palette of such paintings as *The Bedroom*. It was from his father, Camille Pissarro, that Lucien had acquired the technique of applying pigment in small touches of distinctly coloured light tones, sometimes referred to as Divisionism. Gore employed this pointillist technique fairly consistently in both his interior scenes and his landscapes from 1907 onward. As can be seen in *The Bedroom*, this painstaking application of bright, pure colour throughout the composition imparts a homogeneity to the scene that serves to compress the pictorial space. This precludes the tension evident in Sickert's canvases, which arises from a more elaborate treatment of the subject coupled with a merely cursory rendering of the background detail.

In *The Bedroom*, painted in Gore's studio at 31 Mornington Crescent, he has used the iron bedstead to create a grid-like construct, which organizes the interior space and is reiterated in the vertical lines defining the alcove that frames the petite model. This employment of the grid as a framing device is repeated in *Nude on a Bed* (c. 1910, Bristol, City Art Gallery) and *The Nursery Window, Rowlandson House* (1911, private collection).[3]

The woman shown standing here in her undergarments is the same model that Gore portrayed in *North London Girl* (c. 1911), now in the Tate Gallery.[4] She was the housekeeper who served tea on Saturday afternoons at the jointly rented Fitzroy Street studio, and she worked for Gore and his wife when they lived on Houghton Place in 1912–1913. She also appears in Gore's *Woman Standing in a Window* (c. 1908, fig. 58), now in the collection of The Beaverbrook Art Gallery in Fredericton.

*Ian Lumsden*
*Art historian*
*Fredericton*

Fig. 58
SPENCER GORE
*Woman Standing in a Window* c. 1908
oil on canvas
50.8 x 35.56 cm
Gift of The Second Beaverbrook Foundation
Beaverbrook Art Gallery, Fredericton, New Brunswick

Notes _____

1. Wendy Baron, *The Camden Town Group* (London: Scolar Press, 1979), p. 10.

2. Ibid., pls. 8 and 9.

3. Ibid., pls. 20 and 125.

4. Ibid., pl. 42.

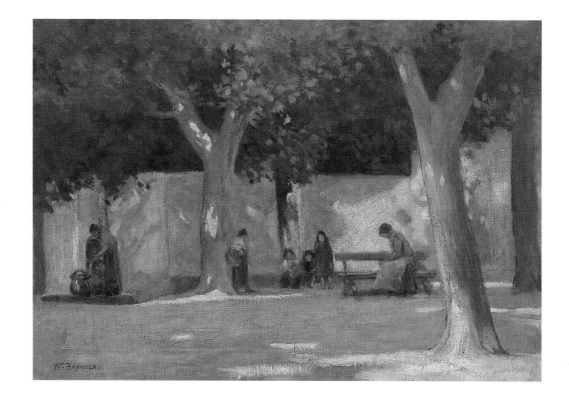

Cat. 19

WILLIAM BRYMNER (1855–1925)

*Le Cours Martigues* c.1908–1914

oil on canvas

48.0 x 68.3 cm

Gift of Mrs. Harold H. Leather, 1957

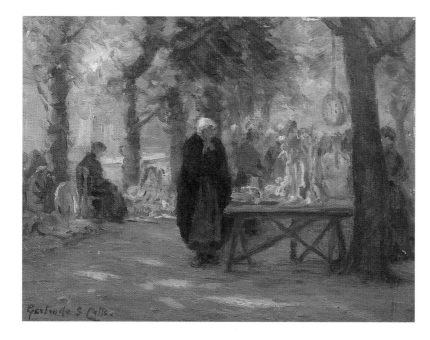

Cat. 20

GERTRUDE SPURR CUTTS (1858–1941)

*Flower Market, Bruges* c.1909

oil on wood

13.6 x 18.1 cm

Gift of Dr. J. S. Lawson, 1961

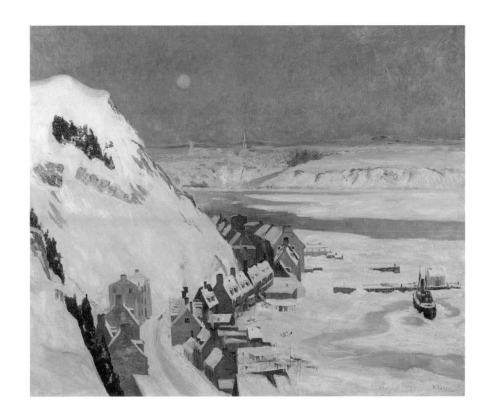

Cat. 21

MAURICE CULLEN (1866–1934)

*Cape Diamond* 1909

oil on canvas

144.9 x 174.5 cm

Bequest of H. L. Rinn, 1955

Cat. 23

JOHN W. RUSSELL (1879–1959)

*Beach* 1909

oil on canvas

50.2 x 61.0 cm

Gift of the Women's Committee and Wintario, 1978

JOHN SLOAN GORDON (1868–1940)
*First Snow* 1909
oil on canvas adhered to compressed fibreboard
35.7 x 31.0 cm
Gift of the heirs of John and Hortense Gordon, 1963

The setting for *First Snow* was likely in the vicinity of Cootes Paradise, a marsh near Hamilton where John Sloan Gordon and his friends often sketched. In this sparkling study of houses by the water, prism-like snowflakes catch the light – a light that suggests the golden tone of autumn rather than the cool blue of winter. Gordon has used dabs of paint to create a lively pictorial surface, which has the effect of softening edges and uniting the composition. The image concentrates the viewer's attention on the transforming effect of early snow, making a commonplace scene seem magical.

Fig. 59
JOHN SLOAN GORDON
*Niagara Falls* 1907
oil on canvas
51.0 x 38.0 cm
Collection of Kenneth W. Scott, Cobourg

Born in Brantford, Ontario, Gordon spent a season in Paris in 1895–1896, studying at the Académie Julian and the École des beaux-arts. After his return to Canada, he experimented with pointillism for over a decade. His noteworthy 1907 painting of Niagara Falls (fig. 59) uses this divisionist technique to brilliant effect,[1] and his nocturnal depiction of the *Old Kirby Mill, Brantford* (1908, Ottawa, National Gallery of Canada) offers another example of the same approach. *First Snow* demonstrates how Gordon was able to achieve *plein-air* effects by employing a broken-colour technique that did not adhere strictly to the model of Georges Seurat or Paul Signac.

Gordon was noted in his hometown of Hamilton as a teacher, raconteur and bon vivant who took an active part in a variety of literary and artistic events. He encouraged his students at the Hamilton Art School and later at the new Hamilton Technical Institute – where he served as the first head of the art department – to explore Impressionism and Post-Impressionism, and to draw from life. One of his pupils, who actually worked in his studio for a time, was Albert H. Robinson, later a well-known Canadian Impressionist.

Gordon favoured the narrative and the picturesque, working in small format and exercising a sensitive control over his medium. His landscapes in watercolour and oil include both scenes of southern Ontario and views executed during the yearly trips to Europe he made with his wife, artist Hortense M. Gordon, from 1920 until the mid-1930s. Many of his paintings were given away to friends, although occasionally he and Hortense would have a small sale of their work. His line and wash drawings were used to illustrate stories in *Saturday Night*, *The Christmas Globe* and *The Canadian Magazine of Politics, Science, Art and Literature*, as well as being featured in Canadian romances and adventure stories published by the Musson Book Company and William Briggs of Toronto between 1898 and 1908.

After he started teaching at the Hamilton Technical Institute, Gordon experimented less frequently with painting technique, and it is fair to say that most of his best works were executed before 1910, around the time he took this position. The clarity of his palette and his eye for unusual atmospheric effects and the engaging aspects of a scene combine with his pointillism to place him among such Canadian practitioners of Impressionism as Ernest Lawson, Maurice Cullen and Robert Pilot.

*Grace Inglis*
*Art historian*
*Uxbridge, Ontario*

Notes _____

1. Paul Duval, *Canadian Impressionism* (Toronto: McClelland & Stewart, 1990), pp. 90–91.

WILLIAM BRYMNER (1855–1925)
*The Vaughan Sisters* 1910
oil on canvas
102.4 x 129.0 cm
Gift of Mrs. Harold H. Leather, 1962

When William Brymner painted *The Vaughan Sisters* in 1909–1910 he was at the height of his fame and influence. He had been teaching at the Art Association of Montreal since 1886, and had expanded its course offerings and student numbers dramatically. He had recently been elected to his first term as President of the Royal Canadian Academy (RCA), and collectors of his work constituted the cream of Montreal society. The painter was therefore a central figure in the city's art world when lawyer and McGill University professor Victor Mitchell commissioned a portrait of his sister's two daughters. Brymner's subjects, twelve-year-old Irene Vaughan and her older sister Dorothy, were living with Mitchell and his wife prior to returning home to England. Twice a week they posed in Brymner's Bleury Street studio, where the artist's short temper ran up against their fidgeting and Irene's boredom, which she later blamed for her sulky expression in the finished painting.[1]

*The Vaughan Sisters* reveals Brymner's occasional use of visual effects associated with Impressionism, which in an 1897

Fig. 60
ROBERT HARRIS
(1849–1919)
*The Countess of Minto*
1903
oil on canvas
132.0 x 96.5 cm
The Montreal Museum of Fine Arts, Purchase, John W. Tempest Fund

public lecture he described with some sympathy as promoting vibrancy in art.[2] In 1902 he and Maurice Cullen visited Giverny, Claude Monet's home, and the stimulus of Cullen's Impressionist paintings is identifiable in Brymner's *plein-air* landscapes. However, this interest was complemented by the importance he attached in both his teaching and his art to the academic values in which he had been trained at the Académie Julian. In *The Vaughan Sisters* these values – sound draftsmanship, attentive observation of nature and carefully structured composition – manifest themselves in the intricate formal, physical and psychological relationships between the sitters, the prominent floral still life and the open book.

The painting's harmonization of visual freshness with what the critic and historian William Colgate later termed Brymner's "steady sober earnestness"[3] was highlighted in the large 1910 exhibition of Canadian art held at Liverpool's Walker Art Gallery, where *The Vaughan Sisters* shared wall space with Robert Harris's *The Countess of Minto* (1903, The Montreal Museum of Fine Arts, fig. 60). Harris was Canada's pre-eminent portraitist, and had been Brymner's predecessor both at the Art Association school and as President of the RCA. *The Countess of Minto*, a flamboyant and supremely self-confident statement in the established language of formal English portraiture, accentuated by contrast *The Vaughan Sisters'* marriage of academic order and delicate tonal harmonies, subtle lighting and often diaphanous paint application. This was a

combination that gave the painting a wider appeal than Harris's more consistently traditional canvas. Brymner's "daring conflict of lights" and "loose treatment approaching impressionism" were praised when the Canadian Art Club, from which critics expected art that looked "modern," included *The Vaughan Sisters* in a 1910 exhibition.[4] But later that year another journalist focused not on Brymner's experiments in colour and light but on those qualities that rooted his portraits in tradition and that the artist himself believed were the most enduringly important: "If you are lucky enough to get him to paint your portrait you will be sure of having a masterly drawing and good painting, an intelligent study of the subject, a getting at the character, a sounding of the keynote ... and last but by no means least, a picture."[5]

*Brian Foss*
*Professor*
*Department of Art History*
*Concordia University, Montreal*

Notes ———————

1. Irene Vaughan Menzies in a letter to T.R. MacDonald, director of the Art Gallery of Hamilton, March 1964, Accession File, Art Gallery of Hamilton.

2. Janet Braide, *William Brymner 1855–1925: A Retrospective* (Kingston: Agnes Etherington Art Centre, 1979), p. 12.

3. William Colgate, *Canadian Art: Its Origin and Development* (Toronto: The Ryerson Press, 1943), pp. 131–132.

4. "Notable Pictures at Art Club's Exhibition," *Globe* (Toronto), 15 January 1910, p. 6.

5. M. J. Mount, "Work," *Canadian Century*, vol. 1, no. 23 (11 June 1910), p. 7.

A. Y. JACKSON (1882–1974)
*Moonlight, Assisi* c. 1912
oil on canvas
54.4 x 65.0 cm
Presented by David S. I. Ker in memory of his
father, Frederick I. Ker, C.B.E., 2002

JAMES WILSON MORRICE (1865–1924)
*By the Sea* c. 1912
oil on wood
12.4 x 15.7 cm
Bequest of Miss Margaret Rousseaux, 1958

EMILY CARR (1871–1945)
*Yan, Q.C.I.* 1912
oil on canvas
98.8 x 152.5 cm
Gift of Roy G. Cole, 1992

Emily Carr painted the large canvas *Yan, Q.C.I.* in Vancouver after visiting the islands of Haida Gwaii in the summer of 1912. Named the Queen Charlotte Islands by British explorers and settlers, these islands, which lie eighty kilometres off the northwest coast of British Columbia, are the homeland of the Haida people. Yan is situated at their northern end, in the mouth of Masset Sound. Only twenty years before this painting was made, the toll taken by repeated smallpox epidemics had forced the last Native families to leave the outlying villages and to consolidate in their two largest centres, Masset and Skidegate. But the people of Yan still crossed the inlet regularly to tend to their potato patches and to harvest the village's fishing grounds. Carr's painting shows the great stand of thirty totem poles and the fishing huts that still remained there.

What was Emily Carr doing travelling by herself in Haida Gwaii in 1912? Born in Victoria into an English settler family, she had been fascinated since childhood by the Aboriginal population that still outnumbered incomers at the time. After attending art schools in San Francisco and England, Carr felt inspired by a sense of local patriotism to begin painting the Northwest Coast landscape and its Native peoples. This vocation strengthened and evolved in 1910–1911 during further studies in France, where she absorbed the brilliant palette of Fauvism and encountered the vogue for "Primitivism" among followers of Gauguin and Matisse. She recorded that one of her teachers of the time told her: "Your silent Indian will teach you more than all the art jargon."[1]

Back in Canada, Carr's interest in Native peoples and their carving traditions took on a new intensity. This was the moment of British Columbia's great railway and resource industry boom. Settlers were streaming north into the territories of the Kwakwaka'wakw, the Git'xan and the Haida. Carr herself had a niece who worked as a schoolteacher in the settler community of New Masset, close by Haida Masset, and her older sisters were great supporters of mission work among the Northwest Coast's First Nations. The missionaries performed a useful role for Native communities, serving as mediators and providers of the Euro-Canadian education that Native people needed to deal with this invasion of their territories; but they also helped to shape negative attitudes in the settler community towards Native traditions, which they regarded as harmful superstitions. Carr, by contrast, became a champion of Native cultures. When asked in 1927 why she had made her paintings of Native villages she replied: "It was for them – for the honour of the Indian – that I undertook this work. I love them! They are my friends!"[2]

Carr's large, luminous canvas *Yan* was made as part of the project she had conceived in 1907 to record Native totem poles in their original village settings. In the following years she visited Kwakwaka'wakw villages at Alert Bay, Campbell River and Cape Mudge. After her studies in Paris, she made a long

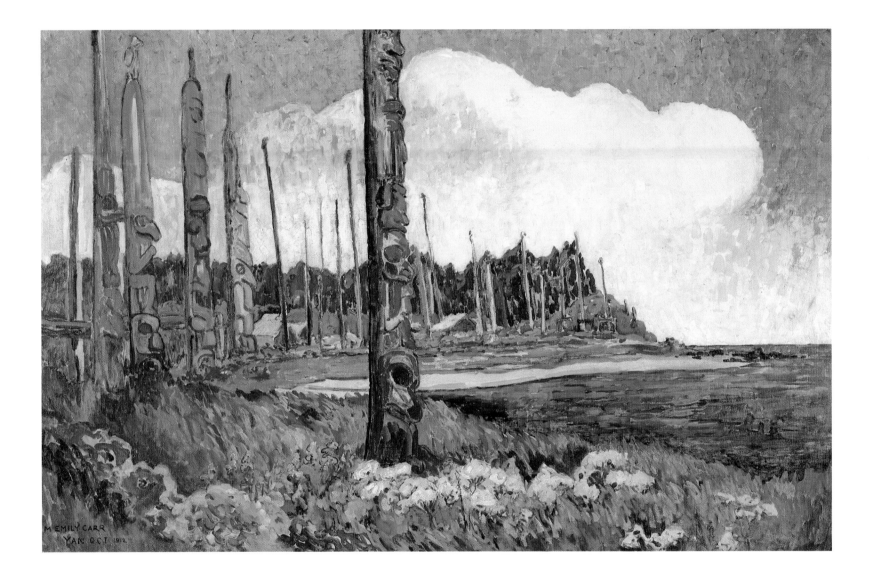

detail, EMILY CARR, *Yan, Q.C.I.* 1912

sketching trip in 1912 to the Skeena River and to Haida Gwaii. She learned much about Native history and traditions from her Haida guides, Clara and William Russ, who were members of high-ranking Skidegate families. They took her to many abandoned village sites, where great stands of poles and the frames of ancient community houses still reigned undisturbed.

During these travels Carr made as many sketches as possible at each site – views of whole villages wherever she could, and studies of individual poles. She knew that the animal figures carved on the poles – bears, killer whales, wolves, eagles and ravens – represented family crests and legends, and therefore had to be accurately recorded. Before she set out on her 1912 sketching tour she had prepared herself by reading some of the anthropological literature on the Native cultures of the Northwest Coast, and her hope was to make a contribution of her own to the field. On her return she asked the B.C. government to purchase her paintings for the provincial museum that was being constructed as part of the new legislative buildings. Due to a slump in the province's economy, this plan did not

materialize, but Carr nonetheless made contact with such anthropologists as Charles F. Newcombe and Lieutenant George T. Emmons, and also later on with Dr. Erna Gunther of the University of Washington. It is fascinating to realize that Carr was visiting the same Native villages and seeking help from the same sources as the eminent Franz Boas, although the two never met. Another contemporary of Carr's was the American photographer Edward S. Curtis, whose great project to photograph all the Native tribes of North America was financed by the railway tycoon J. Pierpont Morgan and endorsed by President Theodore Roosevelt. Carr and Curtis actually created their imagery of the Kwakwaka'wakw and Haida villages in the same years, 1910–1913, and this parallel gives us an idea of the ambition of Carr's undertaking.

Carr's own approach to the imaging of First Nations cultures was unusually empathetic and personally engaged. She was fascinated by the atmosphere of the traditional villages, by the monumentality of their poles and community houses, and by their dramatic settings on bays facing the ocean. Once back in Vancouver, she

would give greater finish to her many rapid watercolour field sketches, using some of them as the basis for large oil paintings that captured the ambience of each place and portrayed the imaginative world and sculptural achievement embodied in the poles. *Yan, Q.C.I.* is one of the largest of these canvases.

The artist described her visit to Yan vividly in a 1913 lecture: "I went there twice spending long days among the poles. Yan stands nearly opposite to Masset on the Northern Island of the Charlotte group, with a wide stretch of Masset Inlet between; this body of water can be extremely rough and unpleasant at times, full of treacherous currents and eddies. I went in a small dug out Indian boat, and my companions were an Indian woman and her two children. She sat in the stern with the baby in her lap and steered. A small girl of twelve deftly manipulated the sail, a home made affair of flour sacks. How well they do handle their boats; it seems born in them. It was a wild day and rained heavily, and I could only sketch between showers."[3] She exhibited this painting in a large exhibition of nearly two hundred pictures of Northwest Coast Native villages and totem poles that she mounted in Vancouver that same year. Her goal was to prove the greatness of the threatened Native cultural heritage, and to create a record that the children of First Nations and of settlers might share. At the time she was considered eccentric and her intentions were dismissed. Today, we can see that her vision, though tinged with a naive colonial romanticism, was prophetic. Contemporary Haida artists such as Robert Davidson and the late Bill Reid are celebrated for their skills in traditional design and carving, which they have renewed and adapted to a changing world.

*Gerta Moray*
*Professor*
*School of Fine Art and Music*
*University of Guelph*

Notes _____

1. Emily Carr, *Growing Pains: The Autobiography of Emily Carr*, 2nd ed. (Toronto: Clarke, Irwin & Company Ltd., 1966), p. 220.

2. Quoted in Muriel Brewster, "Some Ladies Prefer Indians," *Toronto Star Weekly*, 21 January 1928.

3. "Lecture on Totems," Emily Carr Papers, British Columbia Archives, Victoria.

ARTHUR WATKINS CRISP (1881–1974)
*Portrait of Miss X* 1912
oil on canvas
214.8 x 122.8 cm
Gift of the artist, 1961

Arthur Crisp arrived in New York from Hamilton in 1900 to study at the Art Students League, where he remained until 1903. For many Canadian artists wishing to complete their training, New York offered an alternative to Paris, and Crisp quickly immersed himself in the city's art milieu and the circle surrounding the painter Robert Henri.[1] As a consequence Crisp's work is not typical of Canadian art of the time, and although it displays strong affinities with the emerging New York school there are singular aspects. He drew from a wide range of cultural sources. For example, there is a definite strain of Orientalism in the textile and batik work on which he collaborated with his wife, Mary Ellen in the 1920s and 1930s. Crisp maintained a studio practice but is best known for his mural work, which began with the commissions he received around 1907 from the New York theatre impresario David Belasco for the state-of-the-art Stuyvesant Theatre, renamed the Belasco Theatre in 1910.

*Portrait of Miss X* is a society portrait that has many of the hallmarks of modernism. Its title is perhaps a nod towards John Singer Sargent's controversial 1884 depiction of Madame Gautreau, *Madame X*;[2] there are noteworthy similarities of composition, but Crisp's picture shows a "modern" girl, in a stance more typical of male portraits that contrasts sharply with the provocative pose used by Sargent. Miss X gazes out at the viewer, hand on hip and feet firmly apart. Her outfit is practical and subdued, but with an

"artistic" twist – a shirt-blouse (a "dashing Byron-esque" touch) and beads hanging askew. Typical of the period's fashion are the feathered bonnet held in her hand – on the small side and possibly simply a prop – and the high, buttoned shoes. These latter were impractical for everyday wear, suggesting middle-class status.[3] Modern in many ways, the painting includes references to art history. The pose can be compared to those of certain late fifteenth-century Renaissance compositions, and the "hunting" tapestry in the background likewise resonates of the past. Late in life, however, Crisp remarked, "art is like everything else, it has to be based on good common sense"[4] – a practical and essentially modern vision devoid of romanticism or nostalgia.[5]

The portrait was first exhibited as *Miss Burnett*, but at some undetermined time the title was changed to *Portrait of Miss X*, and the painting remained in Crisp's possession until it was donated to the Art Gallery of Hamilton in 1961. No documents have come to light explaining why the work stayed with him (if, as seems likely, it was a portrait commission) or the change of title. The identity of the sitter has not been confirmed, but evidence points to Mary Burnett (1895–1976) – here, a mature-looking seventeen-year-old – who would marry William Grosvenor (1886–1972) (Harvard Class of 1909) in September 1914.[6] The Grosvenors were a prominent Rhode Island family connected through marriage to the Peabodys and the Gardners, both known for their cultural philanthropy. Mary's father was the architect and farm designer

Edward Burnett, who worked in Rhode Island and New York for moneyed clients connected to the circle of artists also patronized by David Belasco.

*Ihor Holubizky*
*Art historian*
*Brisbane, Australia*

Notes _____

1. Crisp did not study directly with Henri, but made note of his presence and influence at the Art Students League as "one of the best portrait painters of our day"; Arthur Crisp, *Art Students League 1900–1903* (Elmsford, N.Y.: The Creative Team, Inc., 1975), p. 15 (copy in the Arthur Crisp Artist File, Art Gallery of Hamilton).

2. Crisp describes his copying of a Sargent subject for the Society of American Fakers, a recurring but short-lived event mounted by the Art Students League. Admission was charged for the week-long exhibition and an auction held at the conclusion (ibid., p. 7).

3. I am grateful for this reading of Miss X's apparel to Mary Ellen Kelly of New York (private correspondence with the author, 1996 and 2000), who also uncovered details of Crisp's early com-

mission work for the Stuyvesant Theatre.

4. Crisp in a letter to John Sheppard, Dominion Foundries and Steel Limited, Hamilton, 28 March 1973, Arthur Crisp Artist File, Art Gallery of Hamilton.

5. It is interesting to compare this portrait with William Brymner's *The Vaughan Sisters* (cat. 24). Brymner has also neutralized the background to highlight his subjects, but there is an overall lyricism in the colours, attire and two anecdotal props that is absent from the corresponding elements in this work.

6. The Burnett family, who have been contacted, do not agree with this proposition, but documented evidence to the contrary has not been put forward. Key documents would either be that from Crisp himself, or a period photograph of Mary Burnett, for comparison.

ROBERT HENRI (American; 1865–1929)
*Girl from Segovia* 1912
oil on canvas
81.2 x 66.5 cm
Gift of Mrs. C. H. Stearn, 1963

Cat. 30
ALBERT ROBINSON (1881–1956)
*St. Malo* 1912
oil on laminated card
20.5 x 27.0 cm
Gift of the heirs of John and Hortense Gordon, 1963

Cat. 31
JAMES WILSON MORRICE (1865–1924)
*View of a North African Town* c. 1912–14
oil on wood
12.2 x 15.0 cm
Bequest of David R. Morrice, 1978

J.E.H. MACDONALD (1873–1932)
*A Rapid in the North* 1913
oil on canvas
51.4 x 72.1 cm
Gift of the MacDonald Family, 1974

A. Y. JACKSON (1882–1974)
*Near Canoe Lake* 1914
oil on canvas
64.5 x 81.7 cm
Gift of A. M. Cunningham, 1915

HELEN McNICOLL (1879–1915)
*The Victorian Dress* c. 1914
oil on canvas
107.1 x 92.0 cm
Gift of A. Sidney Dawes, M.C., 1958

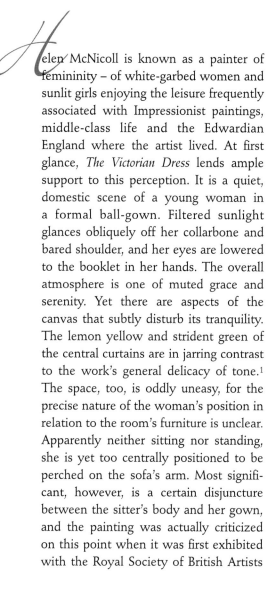

*H*elen McNicoll is known as a painter of femininity – of white-garbed women and sunlit girls enjoying the leisure frequently associated with Impressionist paintings, middle-class life and the Edwardian England where the artist lived. At first glance, *The Victorian Dress* lends ample support to this perception. It is a quiet, domestic scene of a young woman in a formal ball-gown. Filtered sunlight glances obliquely off her collarbone and bared shoulder, and her eyes are lowered to the booklet in her hands. The overall atmosphere is one of muted grace and serenity. Yet there are aspects of the canvas that subtly disturb its tranquility. The lemon yellow and strident green of the central curtains are in jarring contrast to the work's general delicacy of tone.[1] The space, too, is oddly uneasy, for the precise nature of the woman's position in relation to the room's furniture is unclear. Apparently neither sitting nor standing, she is yet too centrally positioned to be perched on the sofa's arm. Most significant, however, is a certain disjuncture between the sitter's body and her gown, and the painting was actually criticized on this point when it was first exhibited with the Royal Society of British Artists

in 1914. While praising McNicoll's handling of the "pretty girl who wears the garment," a reviewer for the *Connoisseur* drew attention to a certain discontinuity between the well-developed modeling of the figure and the undifferentiated handling of her white dress: "The frilled crinoline skirt … has apparently not interested the artist, and so forms an unattractive patch in an otherwise attractive picture."[2] Lack of interest was surely not the issue, however, for McNicoll was a painter of white fabric, and its connotations are central to her art. If these comprise the freshness and purity appropriate to a "pretty girl," they also suggest a degree of emptiness, a blankness that translates here as an element of structural vacancy. In short, the pretty girl and her garment do not mesh.

There is an historical dimension to this formal incongruity, for to a young woman of 1914 the full crinolines of her grandmother's generation would indeed have been alien. Nor was the anachronism merely sartorial. Victorian formal dress carried a heavy freight of cultural connotation, signifying a view of womanhood constricted as much by social conventions as by the corsets and hoops of feminine clothing. By 1914, substantial challenges to these restrictions were being mounted by women's vocal demands for female suffrage and equality of education.

Helen McNicoll was one of many women who carved out professional careers for themselves in the face of institutionalized discrimination. Yet whether despite or because of these changes, the ideal symbolized by the Victorian dress maintained its pull on the cultural imagination. It was a studio prop that still enthralled, even though (as the reviewer for the *Connoisseur* seems to have sensed) it is not a garment that McNicoll's female model occupies convincingly. Like McNicoll herself, the subject of this painting exists in a strongly gendered environment that she does not fully inhabit. Conventional femininity is, here, very like the Victorian dress the artist has depicted: more than just a costume, but less than natural attire.

*Kristina Huneault*
*Associate Professor*
*Department of Art History*
*Concordia University, Montreal*

Notes _____

1. The surprising stridency of the colour is lost in reproduction.

2. *Connoisseur*, vol. 40 (1914), p. 229.

MARION LONG (1882–1970)
*The Fan* 1914
oil on canvas
41.6 x 32.1 cm
Gift of Dr. J. S. Lawson, 1961

Although she wears a kimono, the figure in Marion Long's painting *The Fan* is not Japanese, but a Westerner in Japanese costume. *Japonisme*, as the taste for things Japanese was called, taken up with enthusiasm at the turn of the century in North America, is the source of the costume detail in Long's image. By no means limited to use as a prop by artists, the kimono was a common item of leisure wear for women in the late nineteenth and early twentieth centuries, in both North America and Europe. The black fan the figure holds at her side – the object that is the central focus of the work and provides its title – completes the outfit. The widespread interest in Japanese material culture had kept alive a centuries-old interest in the fan, an accessory evoking femininity in the West but also hinting at a secret language, a communication to be read only by those "in the know."

In marked contrast to the portraits of strong-featured military personnel that constitute the majority of Long's best-remembered works, the indistinct face of the model in *The Fan* makes it obvious that this is not a portrait, but rather the representation of an idea. The turn-of-the-century viewer of Long's image, familiar with the kimono, would most likely have interpreted it as that of a woman in her personal space. Her solitude and inactivity would have suggested a well-known trope: women in poses evoking reverie, self-absorption and contemplation were popular at the time of the work's execution.[1] Such self-reflexive figures were depicted by the artist in other paintings of the same type, such as *The Goldfish Bowl* (1916, Toronto, Art Gallery of Ontario), and were also a subject chosen by many of her female contemporaries. Long's canvas, then, combines a number of elements that make it very much the work of a Canadian woman painter, a work that typifies late nineteenth- and early twentieth-century aesthetics. The ubiquity of the theme has been interpreted by literary critics and art historians alike as suggesting the personal search of many women for the new meaning of their lives in a rapidly changing society. There is, however, a second possible interpretation. While the woman represented in *The Fan* may indeed be searching for inner meaning, the depersonalization of her features could also symbolize a moment of apprehension induced by loss of identity and the spectre of ensuing loneliness. Captured during a period that would transcend the constraints of the Victorian and Edwardian eras and propel her and those like her – quite possibly too rapidly – into an unknown future, the woman pictured may be unsure of her status. And her dilemma is perhaps reflected in her costume: no longer certain of her identity, she dons the garb of another culture. Would she still be admired primarily for her outward appearance, or would the inner reaches of her mind become the focus of her future worth? In the secret language of the fan at her side, the image poses the question but does not reveal the answer.

*Janice Anderson*
*Visual Resources Curator*
*Faculty of Fine Arts*
*Concordia University, Montreal*

Notes _____

1. For information on women in various states of reverie see Julia Gualtieri, "The Woman as Artist and Subject in Canadian Painting (1890–1930): Florence Carlyle, Laura Muntz Lyall, Helen McNicoll," M. A. thesis, Queen's University, Kingston, 1989, pp. 81–133.

# LAWREN HARRIS

## IN THE COLLECTION

*L*awren Stewart Harris played a leading role in the evolution of Canadian painting during the first half of the twentieth century. Scion of a wealthy family, Harris was in a position to devote himself to painting and even to support the activity of a number of other artists. Following his training in Germany, Harris returned to Canada and began a series of important views of the city of Toronto. These images, of which *Hurdy Gurdy* (1913, cat. 32) is a superb example, are characterized by their emphasis on light and an often exaggerated use of colour, which sometimes possesses expressive qualities. *Hurdy Gurdy* was influenced by the work of Scandinavian artists – among them Gustav Fjaestad – that Harris had seen in Buffalo in January of 1913. Perhaps the most Impressionist of Harris's works, the painting is remarkable for its lightness of touch and strong sense of movement. We can almost hear the wind rustling the leaves on the trees.

*In the Ward* (c. 1919, cat. 39) is an altogether quieter work. The use of colour is even more expressive, however, perhaps reflecting a change in Harris following the First World War. The message conveyed by each of his works had become a more central concern, and there can be little doubt that this vivid depiction of the slums of Toronto reflects the artist's growing awareness of the distinctions between social strata. That being said, there is little for us to relate to in the figures of this image, for they seem to be merely markers within the space rather than the object of any emotional focus. The drama of the image lies in the play of colour – the intense red of the house on the right, the clear white of the one adjacent to it, the brilliance of the autumnal leaves. The whole composition is bathed in an even, neutral light that allows the colours full voice.

Harris, as has been noted, had a decisive impact on Canadian painting. The construction in 1913–1914 of the Studio Building, instigated by him and Dr. James MacCallum, provided a centre for modernist painting in Toronto. This brand of modernism, though based on the example of Scandinavian artists and influenced by Post-Impressionism in France, took landscape as its principal subject matter. Harris was instrumental in this realm, too, organizing in 1918 the first of the so-called "boxcar" trips to the Algoma region of Ontario. These excursions resulted in a body of work that Harris and his colleagues exhibited for the first time at the Art Gallery of Toronto in May 1920. This inaugural exhibition by the artists known by then as the Group of Seven was a major turning point in the history of painting in Canada.

A work executed at or around the time of the first Group exhibition was the canvas *Waterfall, Algoma* (c. 1920, cat. 42). Painted in Toronto from a sketch done on the boxcar trip of fall 1919, the canvas is a striking example of the artist's growing interest in simplifying the landscape and employing light to reveal truths about nature. The composition as a whole is decidedly "unpretty": the use of colour is almost jarring, and the linear pattern that defines the waterfall is highly stylized. It is, in fact, a bold statement about how to depict a Canadian landscape. Harris's vision of the landscape, which emphasizes the strength and simplicity of natural forms, had an explicitly nationalist goal. Here, he was creating an image of the land that he knew and loved.

The Algoma region was important to the Group of Seven as a whole, but more significant to Harris personally was the north shore of Lake Superior. This region, which he first visited in 1921, was to provide him with sketches for several of his most important canvases. *Ice House, Coldwell, Lake Superior* (c. 1923, cat. 46) is one of the most interesting of Harris's Lake Superior canvases. Formally rigorous, the work is also informed by the artist's Theosophical beliefs. From his study of the ideas of the founder of Theosophy, Madame Blavatsky, Harris came to believe that painting could be a source of metaphysical inspiration. Using a highly controlled palette, simplified forms, strongly linear patterns and a supernatural light, he created images that resonate in a deeply spiritual way. This artificially

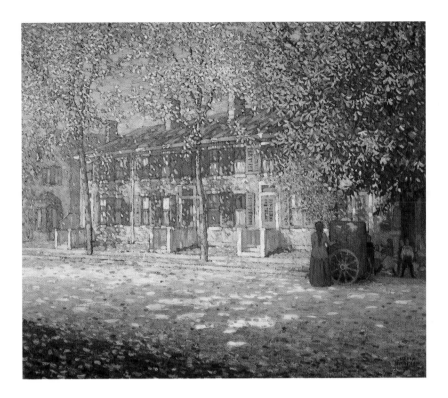

Cat. 32
LAWREN HARRIS (1885–1970)
*Hurdy Gurdy* 1913
oil on canvas
75.8 x 86.6 cm
Gift of Roy G. Cole, 1992

Cat. 39
LAWREN HARRIS (1885–1970)
*In the Ward, Toronto* c.1919
oil on beaverboard
26.7 x 35.4 cm
Gift from The Lillian and Leroy Page
Charitable Trust, 1964

LAWREN HARRIS (1885–1970)
*Waterfall, Algoma* c. 1920
oil on canvas
120.2 x 139.6 cm
Gift of the Women's Committee, 1957

LAWREN HARRIS (1885–1970)
*Ice House, Coldwell, Lake Superior* c.1923
oil on canvas
94.1 x 114.1 cm
Bequest of H. S. Southam, C.M.G., LL.D., 1966

Fig. 61
LAWREN HARRIS
*Goodsir Peaks, Rocky Mountains* c.1924–1929
oil on board, 30.5 x 37.9
Gift of Mr. Charles P. Fell, 1978

Fig. 62
LAWREN HARRIS
*Bylot Island* c.1930
oil on canvas, 81.3 x 97.0
Bequest of H. S. Southam, C.M.G., LL.D., 1966

illuminated image is theatrical, but moving. The details of architecture and landscape were clearly of secondary importance to the painter: if we feel some sense of transcendence when viewing this work, his goal has been achieved.

Although Harris remained a crucial member of the Group of Seven throughout its existence, the goals of his painting became increasingly spiritual and less nationalistic. This new spiritualism is apparent in a later image of Toronto houses, *Grey Day in Town* (cat. 50). Executed in 1923 but reworked later, probably in the early 1930s, the canvas provides a stark contrast to *Hurdy Gurdy* and even to *In the Ward*. There is little to invite one into the image: all the windows and doors of the dwellings depicted are blocked, and the harsh light exposes their poverty. It is an image generated by social conscience rather than the portrait of a city neighbourhood.

For Harris, the idea of the North as a place of purity and idealism, remote from everyday life, became increasingly important. Manifested initially in his Lake Superior paintings, and later in such images of the Rockies as *Goodsir Peaks, Rocky Mountains* (c.1924–1929, fig. 61) the artist's vision of the North as spiritual place is most successfully expressed in the series of paintings resulting from his only trip to the Arctic.

Encouraged by A. Y. Jackson, who had already visited the Far North, Harris travelled to Baffin Island and Greenland on a government supply ship called the *Beothic* in the summer of 1930. The sketches from this trip were the source of some of his most dramatic and spiritual canvases. Works such as *Bylot Island* (c.1930, fig. 62) and *Icebergs and Mountains, Greenland* (c.1930, cat. 62), depict a world far removed from the bustle of city life, where the mind is free to contemplate higher things. Formal control of the composition was still of great importance to Harris, as witness the stately progression into space in *Icebergs and Mountains, Greenland*. The careful balance of iceberg forms in the fore- and mid-grounds, the darker shapes of these bergs against the white purity of the distant mountains and the overarching shape in the sky have all been judiciously employed to shape our reading of the image. The skilful use of light, whether in the unearthly inner glow of the icebergs or the floodlit mountains in the background, also plays a crucial role. The viewer makes an imaginative journey to this whitely distant part of the world, but it was the evocation of a spiritual voyage to a far-off place of purity that was important for Harris, and central to his painting of the period.

The degree of stylization evident in works such as *Icebergs and Mountains, Greenland* and *Bylot Island* suggests that the landscape itself was of increasingly less interest to the artist. By the early 1930s, in contrast to his Group of Seven colleagues, Harris's aesthetic and spiritual journey had led him to abstraction. It is almost as if the ultimate landscape, the Arctic, had rendered any subject based on nature irrelevant. His abstractions, two fine examples of which are in the Art Gallery of Hamilton collection – *Abstract (Vertical)* (c.1939, fig. 63) and *Painting (Horizontal Abstract)* (c.1948, fig. 64) – while less popular than his landscapes, may be seen as the logical culmination of his work as a painter. Intellectually rigorous, rooted in his Theosophical beliefs and his explorations of abstraction with the Transcendental Painting Group in New Mexico, these works represented for Harris a new type of painting, a painting of pure idea and spirit unfettered by any relation to the earthly.

The collection of Harris works at the Art Gallery of Hamilton is a particularly rich one, containing several major canvases. It is also significant in that it allows viewers to trace the main developments of Harris's aesthetic evolution.

*Ian Thom*
*Senior Curator*
*Vancouver Art Gallery*

Fig. 63
LAWREN HARRIS
*Abstract (Vertical)* c.1939
oil on canvas, 122.5 x 77.1 cm
Bequest of H. S. Southam, C.M.G., LL.D., 1966

Fig. 64
LAWREN HARRIS
*Painting (Horizontal Abstract)* c.1948
oil on canvas, 81.8 x 109.7 cm
Bequest of H. S. Southam, C.M.G., LL.D., 1966

LAWREN HARRIS (1885–1970)
*Grey Day in Town* 1923
reworked early 1930s
oil on canvas
82.3 x 97.7 cm
Bequest of H. S. Southam, C.M.G., LL.D., 1966

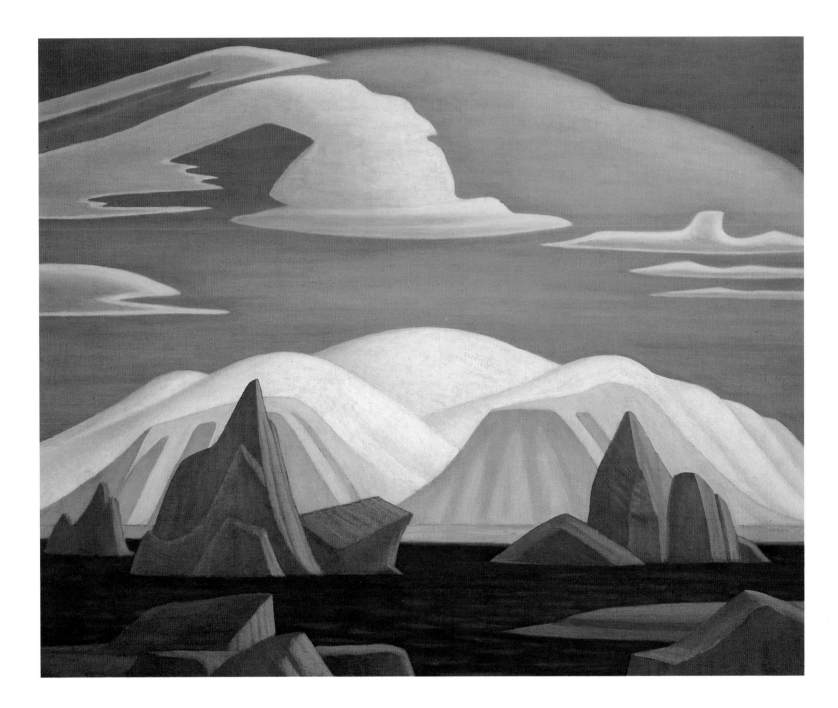

LAWREN HARRIS (1885–1970)
*Icebergs and Mountains, Greenland* c. 1930
oil on canvas
92.2 x 114.4 cm
Gift of H. S. Southam, C.M.G., LL.D., 1948

TOM THOMSON (1877–1917)
*The Birch Grove, Autumn* 1915–1916
oil on canvas
99.0 x 115.4 cm
Gift of Roy G. Cole, in memory of his parents,
Matthew and Annie Bell Gilmore Cole, 1967

*The Birch Grove, Autumn*, one of a number of large canvases painted by Tom Thomson over the winter of 1915–1916, can be considered among his most quintessentially modern works. In its flatness – a deliberate denial of pictorial depth – its arrangement of clean bold marks of pure colour and its emphasis on material and gesture over delineated form, this work represents a significant move away from a more dated pictorial approach that emphasized foreground, middle ground and background. This earlier type of staggered space can still be seen in other major canvases made by Thomson during the same winter – *Spring Ice*, for example (1915–1916, Ottawa, National Gallery of Canada) – as well as in the great Canadian icon painted a year or so later, *The Jack Pine*, (1916–1917, National Gallery of Canada). In that work, however, the most powerful resonance is with the gestural process employed in *The Birch Grove, Autumn*, rather than with the smoothly receding space seen in *Spring Ice*. *The Birch Grove, Autumn*, foreshadows the daring sketches that the artist would execute in 1916, small oils of wildflowers and autumn foliage that are remarkable for the primacy they seem to give to the act of painting. It is these works that testify conclusively to Thomson's rapid progression from late-Victorian picture-maker to modern painter.

As with most of Tom Thomson's works, the setting here is Algonquin Park. Following his first visit in 1912, Thomson spent an increasing amount of time there – away from Toronto and the commercial art studios where he worked (Grip Limited, and Rous and Mann), and isolated (through distance and the effects of the First World War) from the circle of artists who would later form the Group of Seven. It was a stark departure from what had hitherto been a largely urban existence. Despite the myth that has grown up around the artist, Thomson was not an untrained artist, a natural "man of the woods," and the "North" he moved through was no "virgin" wilderness. Algonquin was a site with a significant industrial history, focused initially on logging and later on tourism. The two industries were still flourishing in Thomson's day, and he was employed in the park as both a fishing guide and a fire ranger. Traces of these human activities are evident in many of Thomson's paintings. Birch trees and jack pines, which he depicted often, are considered fringe species that tend to grow in cleared areas, which in Algonquin Park were usually the result of the extensive culling of white pine and the frequent fires caused by unsafe logging practices.

Understanding the history of the park is critical when considering Thomson, for he has become very much part of ideas about the "North Country" and the dominant popular image of the idealized Canadian. Much of his life and his contribution as an artist is now shrouded in myth and storytelling, and it is crucial that we re-examine the artist and his work against a richer understanding of the landscape he inhabited and portrayed. Thomson struggled, with notable success, to define through painting a strong sense of place. Major works like *The Birch Grove, Autumn* inspire such a reconsideration, for they emphasize Tom Thomson's phenomenal accomplishments as a pure painter while providing evidence of his remarkable capacity to connect with his environment in all its complexity.

*Andrew Hunter*
*Artist, writer and independent curator*
*Dundas, Ontario*

FLORENCE H. MCGILLIVRAY (1864–1938)
*Winter at Rosebank, Lake Ontario* 1917
oil on laminated board
46.1 x 61.5 cm
Gift of Kathleen Hillary, 1957

*F*lorence H. McGillivray, a member of the Canadian Post-Impressionist group, is one of the Canadian artists most clearly influenced by Vincent van Gogh. After studying at the Central Ontario School of Art and Design under the Scottish-born William Cruikshank, and then at the studios of various painters, including portrait artist J.W.L. Forster, she travelled to Paris. There, in 1913, she attended the Académie de la Grande Chaumière and came into contact with Post-Impressionism: her boldly handled painting of a French nun, *Contentment* (Toronto, Art Gallery of Ontario), exhibited at the Salon des beaux-arts in 1913, revealed her interest in the new approach: using a palette knife, massing her colour, and tracing a strong black line around the forms, she created an enthusiastic and lyrically intense interpretation of the Post-Impressionist style. Owing to the strength of her work, McGillivray was soon accepted into the international community. In 1913, she was elected president of the International Art Union, a group that was dissolved at the outbreak of the First World War. In 1917, the year she painted *Winter at Rosebank*, two significant marks of favour came her way: she was elected to both the Ontario Society of Artists and the Society of Women Painters and Sculptors, in New York. In 1925, she was made an Associate of the Royal Canadian Academy. As one of the outstanding artists of her era, she gave generously of her time to talented younger contemporaries like Tom Thomson. He felt that she was a kindred spirit when she visited him in 1917, in the shack near the Studio Building in Toronto where he painted. Her interest in his work meant much to him, and he confided to an acquaintance, forest ranger Mark Robinson: "She was the only one who understood immediately what I was trying to do."[1]

*Winter at Rosebank*, painted at the famous summer resort and picnic area located at the mouth of the Rouge River in Pickering, between Whitby (where the artist's family lived) and Toronto (where she had numerous friends), shows McGillivray's special brand of descriptive painting. She made a number of other canvases and watercolours of the Rouge River, and Rosebank was evidently a favourite painting spot for the artist. The viewpoint here – echoed in a contemporary postcard (fig. 65) – indicates that she positioned herself on a bluff to capture the wintry view of the beach and Lake Ontario.

This canvas is an impressive one, painted in McGillivray's tumultuous style, which abbreviates the world into arrangements of thick paint vibrating with energy and rich colour. She conveys nature's turbulence in the heaving waters of Lake Ontario and the lavender and yellow sky of approaching evening, taking an impetuous delight in the physicality of paint and paying loving attention to surface. The boldly painted trunk of the birch tree in the left foreground displays the mastery of form and brushwork through which McGillivray, along with other Post-Impressionist artists, helped set the stage for the development of Modernism in Canada.

*Joan Murray*
*Interim Executive Director*
*McMichael Canadian Art Collection*
*Kleinburg, Ontario*

Fig. 65
Postcard of "The Beach, Rosebank, Ont." 1912, photographed by Herrington & Son, Trenton, Ontario.
Private collection

Notes _____

1. Mark Robinson in a letter to Blodwen Davies, 11 May 1930, Blodwen Davies fonds, MG30 D24, National Archives of Canada, Ottawa.

ROCKWELL KENT  (American; 1882–1971)
*Frozen Waterfall, Alaska*  1919
oil on canvas adhered to fibreboard
86.5 x 71.2 cm
Gift of the Women's Committee, 1971

I crave snow-topped mountains ... and the cruel Northern sea ... Here skies are clearer and deeper and, for the greater wonders they reveal, a thousand times more eloquent of the eternal mystery than those of softer lands.[1]

Rockwell Kent

"No! No! Thrice No!" he cried vigorously, and stroked his beard. "I know better! There still are blissful islands!"[2]

Friedrich Nietzsche

The American artist Rockwell Kent painted *Frozen Waterfall, Alaska* while living on Fox Island, off the coast of Seward, in the winter of 1918–1919. It is a composition of strong forms, cold crystal light and rich blues whose intensity at first glance hides the work's spiritual depth.[3] Kent was an individualist, an artist who sought life's meaning in the physical challenge of the wilderness and the harsh climates of the Far North. Tending to gravitate to the isolation offered by islands, he lived on Monhegan Island, Maine, and in Brigus, Newfoundland, before going to Alaska. Later, between 1929 and 1935, he had three extended sojourns in Greenland, settling during the last two on the tiny island of Igdlorssuit.

*Frozen Waterfall, Alaska* was painted while Kent and his nine-year-old son were wintering on the virtually uninhabited Fox Island. Their only companion was a lone trapper named Olson, who

introduced them to what Kent later described as paradise. Father and son lived like Robinson Crusoe. Such isolation, far from the urban bustle with which he was all too familiar, provided Kent with the solitude he needed to clarify his aesthetic vision.

The artist had long been drawn to the northern myths and tales of the Norse sagas. On Fox Island he read two notable books on exploration – George Anson's *A Voyage Round the World in the Years 1740–1744* and Fridtjof Nansen's *In Northern Mists* – but he also pored over Friedrich Nietzsche's long and obscurely prophetic book *Thus Spoke Zarathustra*. Kent was so profoundly moved by this work that it inspired him to create a set of illustrations entitled *The Mad Hermit*, to serve as an addition to his illustrated autobiographical book *Wilderness: A Journal of Quiet Adventure in Alaska*. This account allows the reader to follow Kent's daily life and to share his vision through texts and images describing the magnificent mountains, seascapes and waterfalls of his own "blissful island."

Zarathustra himself led the ugliest man by the hand, in order to show him ... the silvery waterfalls nigh unto his cave.[4]

*Frozen Waterfall* conjures an image of Kent as the actor-director of a great Wagnerian drama, standing on the shore of Fox Island and drawing back a curtain of iridescent aquamarine ice to reveal the breathtaking scene of Resurrection Bay, Bear Glacier and the Chugach mountain range. From offstage on the far left, the

golden sun of the winter solstice dawn illuminates the foot of the glacier and turns the mountain planes into sculptured pyramids – symbolic totems. Through his northern experience, Kent developed a highly personal iconography of spiritual meaning.

The striking similarity between this work and the northern paintings of Lawren Harris is too close to be coincidental. Kent and Harris were friends, and Harris owned all of Kent's illustrated books and many prints of his paintings.[5]

*Constance Martin*
*Art historian*
*Arctic Institute of North America*
*University of Calgary*

Notes _____

1. Introduction to his book *Wilderness: A Journal of Quiet Adventure in Alaska* (Hanover, N.H.: University Press of New England, [1920] 1996), p. xxvii.

2. *Thus Spoke Zarathustra*, quoted in David Traxel, *An American Saga: The Life and Times of Rockwell Kent* (New York: Harper & Row, 1980), p. 100.

3. There exists at least one other version, identical save for the lighting and the clouds, titled *Frozen Falls, Alaska* (1919, Plattsburgh State Art Museum). For other Alaskan paintings by

Kent featuring waterfalls see Fridolf Johnson, ed., *Rockwell Kent: An Anthology of His Work* (New York: Alfred Knopf, 1982), pp. 263–265.

4. Kent uses this Nietzschean quote as the caption for a drawing in *Wilderness*, p. 5. Additional illustrations of waterfalls appear on pp. 111, 114, 149, 151, 153, 169 and 190.

5. Constance Martin, *Distant Shores: The Odyssey of Rockwell Kent* (Berkeley: University of California Press, 2000), p. 27.

Cat. 41
ANNE SAVAGE (1896–1971)
*Portrait of William Brymner* 1919
oil on wood
22.8 x 17.8 cm
Gift of the artist, 1959

Cat. 43
J.E.H. MacDONALD (1873–1932)
*Lake Simcoe Garden* 1920
oil on laminated card
21.5 x 26.7 cm
Presented in memory of Suzanne Bowman 1939–1958,
by her Parents and Friends, 1962

CLARA S. HAGARTY (1871–1958)
*Lake Como* 1920s
oil on wood
34.9 x 26.3 cm
Gift of Gordon Conn, 1956

EMILY COONAN (1885–1971)
*Girl in Dotted Dress* c.1923
oil on canvas
76.0 x 66.4 cm
Gift of The Hamilton Spectator, 1968

*E*mily Coonan's *Girl in Dotted Dress* exemplifies the artist's ability to imbue the prosaic image with expressive force. The work possesses a visual eloquence that has less to do with content than with the poetics of formal articulation, and in this regard it reflects Coonan's affinity for the Post-Impressionist language being assimilated by a generation of Canadian artists in the early twentieth century. Among the first professional women painters to embrace a nascent modernism in this country, she produced work that stands apart for its bold and precocious interpretation of recent stylistic innovations.

From the first, Coonan was lauded as an original voice, "the kind of artist who is born not made."[1] While her professional career coincided with the rise of the Group of Seven, she did not subscribe to the nationalist idiom they proposed. Rather, she drew her inspiration from international modernism and the distilled, discreet aesthetic of James Wilson Morrice. Like other members of Montreal's Beaver Hall Group, with which she was briefly associated, Coonan worked from a broad iconographical repertoire that encompassed urban views, interior scenes and landscapes. But it was for her figure painting that she was acclaimed, and it is this work that most clearly displays the unique nature of her *œuvre*.

*Girl in Dotted Dress* is emblematic of the artist's particular approach to the figure. Painted shortly after her second trip to Europe and included in the 1924 British Empire Exhibition held in Wembley, England, it reflects the artist's interest in progressive formal techniques – in the compressed pictorial space, for instance, and its light, somewhat eccentric palette. Yet while the image displays a vigour that derives from its architectonic immediacy, forceful internal design and virtuoso execution, its tenor is tempered by a sense of pathos and introspection found often in Coonan's production. The artist's elegant touch, subtle tonal manipulations and lyrical use of decorative detail are compelling. The empty background betrays little more than the gestures of painting, and the sitter, devoid of social or personal referents, is treated almost as a motif or "found subject." That said, a powerful sense of individual presence still permeates the work: the unknown girl conveys a mood of charged quiescence, her elusive expression engaging our attention and curiosity.

It is perhaps this enigmatic quality, common to all Coonan's paintings but particularly evident in her portrayal of people, that distinguishes her figure painting from that of contemporaries such as Mabel May, Prudence Heward and Lilias Torrance Newton. While they shared an interest in consolidating a modernist syntax with figuration, Coonan's work remains distinct. For unlike May's *Indian Woman, Oka* (cat. 55) or Heward's *Girl on a Hill* (1928, Ottawa, National Gallery of Canada), her figures evade confrontation. Their gaze is rarely revealing and their settings remain anonymous – neither descriptive nor symbolic. Coonan's purpose is never, in fact, thematic (her concern is neither portraiture nor historicism), but rather the pursuit of the expressive potential of "significant form." *Girl in Dotted Dress* thus anticipates the fully-fledged modernism that would develop in Montreal in the 1930s. Yet regrettably, at what could have been a most propitious moment in her professional career, Emily Coonan mysteriously withdrew from Montreal's artistic scene, exhibiting her work for the last time in 1933.

*Karen Antaki*
*Art historian*
*Montreal*

Notes _____

1. "27th Annual Spring Exhibition," *The Standard* (Montreal), 25 March 1911.

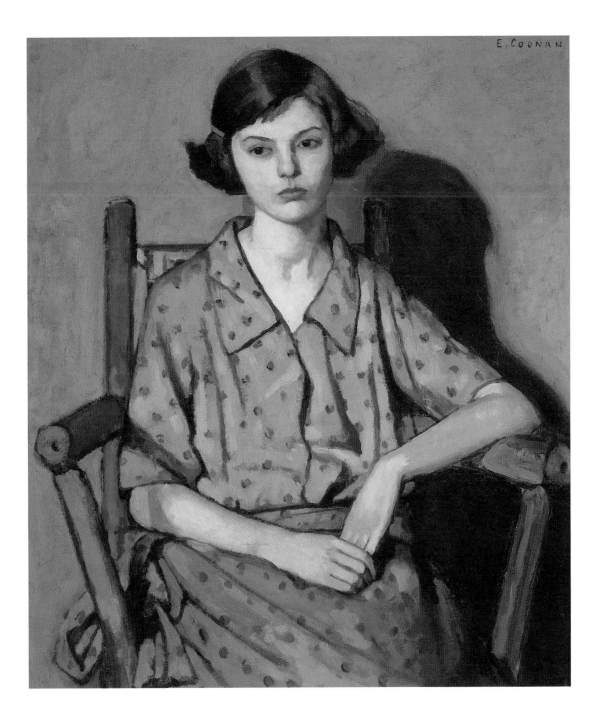

ARTHUR LISMER (1885–1969)
*Bon Echo Rock* 1923
oil on canvas
53.4 x 66.3 cm
Gift of the artist, 1951

ALBERT ROBINSON (1881–1956)
*Quebec Village* 1923
oil on canvas
69.3 x 84.7 cm
Gift of Mr. and Mrs. David C. Barber, 1980

J.E.H. MACDONALD (1873–1932)
*Rain in the Mountains* 1924
oil on canvas
123.5 x 153.4 cm
Bequest of H. L. Rinn, 1955

*I*n August of 1924, J.E.H. MacDonald travelled by train from Toronto to Lake O'Hara, in Yoho National Park, British Columbia. Disembarking at a mountain siding at Wapta Lake, he then rode a pack horse eleven kilometres up a trail to a tiny log cabin, built in 1911 in an idyllic meadow beneath the Wiwaxy Peaks and Mount Odaray, which are part of the Continental Ranges of the Canadian Rockies. In this place, a high altitude amphitheatre of unusually concentrated beauty, he found solace, peace of mind, and endless subject matter. MacDonald's lifelong struggles with his health were eased in this rustic, backcountry location, where that summer he was able to sketch for upwards of three weeks and where he returned the following six years for about the same period. He would produce over one hundred sketches during these trips.

*Rain in the Mountains* is the first canvas MacDonald produced using his sketches of Lake O'Hara as subject, and in fact there were to be relatively few. The majority of the artist's mountain works are in the sketch panel format – quickly executed oil studies of mountain scenery in its many moods: light effects, atmos-

pheric conditions, the endlessly changing colour patterns formed by rocks, trees and lakes. *Rain in the Mountains*, which was produced in his Toronto studio shortly after that first trip in 1924, is more than a landscape – it is an amalgam of his treasured mountain memories and experiences.

MacDonald was an accomplished designer as well as a distinguished painter. In this canvas, the designer and the painter have come together to create a work of subtle yet graphic elegance. The designer has painted a forest that is all pattern and a lake that is a vividly spare depiction of sunlight on water. The mosaic of the lichens on the shoreline rocks, the stylized form of Odaray Glacier and the patches of tree lichen on the bent-over trunk all contribute to the general harmony of the work. MacDonald the painter has captured the memory of the rain squalls characteristic of this area in all their driving unexpectedness. On sunlit days, often with little warning, the clouds can roll in from the south and west over Mount Biddle and send a sudden, sharp rain into the valley. The direction of MacDonald's brushwork, which moves from top left to bottom right of the canvas, enhances the impression, as the sun's gleam begins to return in the distance. MacDonald's aim was to capture the

essence of Lake O'Hara. In *Rain in the Mountains*, it is not raining *on* us, but *for* us: it is a picture of mountain memories.

The canvas is actually a combination of two perspectives on the same vista – the lakeshore view, from the far southwest shore of Lake O'Hara looking back towards Mount Odaray, and another view from the same direction but higher up, a hundred metres above on the Opabin Plateau. It is still possible to visit the location of the scene depicted by travelling to Yoho National Park, contacting the Park Information office and making arrangements to hike the Lake O'Hara region, just as MacDonald did in the 1920s.

*Lisa Christensen*
*Curator of Art*
*Whyte Museum of the*
*Canadian Rockies, Banff*

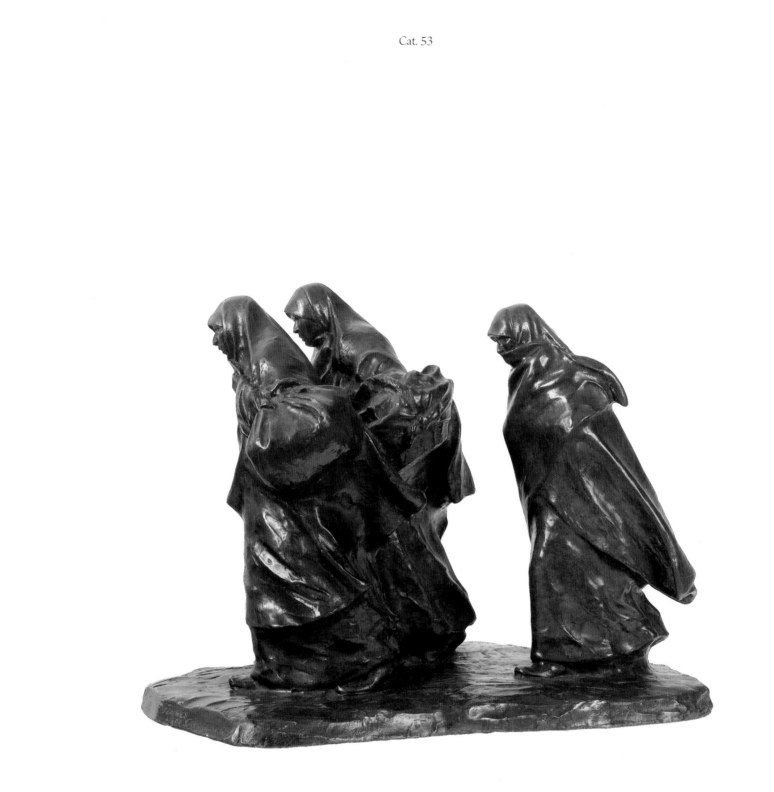

MARC-AURÈLE DE FOY SUZOR-COTÉ (1869–1937)
*Femmes de Caughnawaga* 1924
bronze
43.0 x 33.0 x 57.0 cm
Gift of the Women's Committee, 1956

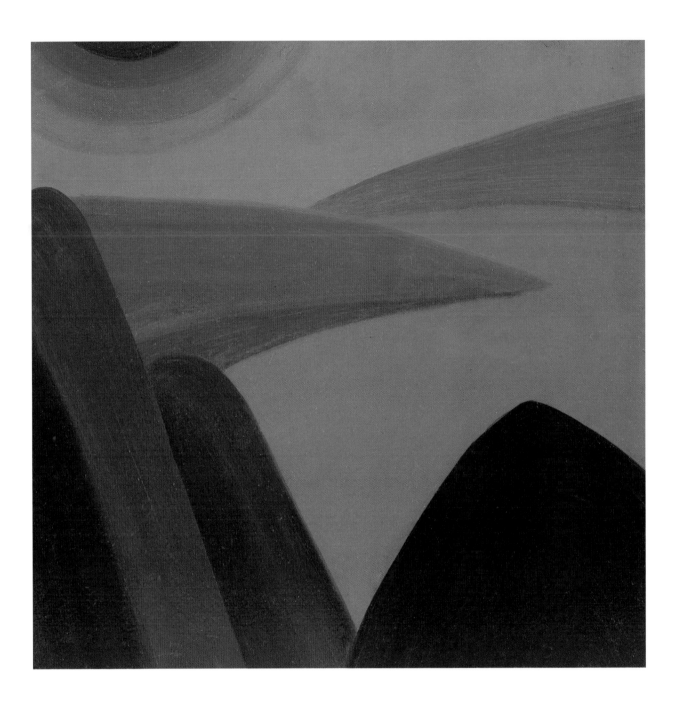

LOWRIE WARRENER (1900–1983)
*Pickerel River Abstraction* 1926
oil on laminated card
30.2 x 30.4 cm
Gift of the Volunteer Committee, 1984

H. MABEL MAY (1877–1971)
*Indian Woman, Oka* 1927
oil on canvas
67.0 x 54.0 cm
Bequest of Josephine M. Magee, 1958

*ndian Woman, Oka* by Henrietta Mabel May is one of many figure paintings the artist executed between 1910 and 1930. However, this particular work is distinct from the others in both manner and subject. The model's circumstances and character are reflected in May's stylistic approach. Undoubtedly influenced by the Fauves, she has used bold, saturated colours, simplified forms, and a flattened surface. Although the woman is the focus of the work, occupying the major part of the canvas, May's treatment of the background suggests that the shelter behind her is also important. The chromatic contrasts between the dark tones of the figure and the bright colours of the background have allowed the artist to treat each part with equal, if separate, emphasis. This approach differs from the one employed in earlier works, where the softer, muted colours convey a greater sense of passivity in the women depicted.[1]

Many of May's earlier portraits featured people she knew and often identified by name in the title, such as *Doris and Ruth* (c. 1916, present location unknown), which portrays two of her nieces. *Indian Woman, Oka* is perhaps thematically closer to works like *Immigrants, Bonaventure Station* (1914, present location unknown) and May's later Canadian War Memorials paintings of women making munitions –

*Women Making Shells* (1918, Ottawa, Canadian War Museum), for example – which concentrate on the social changes taking place in an expanding nation.[2]

This painting can also be seen against the broader backdrop of the historic iconography of Native people in Canadian art, which tended to present them as a "vanishing race," a homogeneous group characterized variously as noble, wild, savage, uncivilized, spiritual, and bloodthirsty.[3] May's painting, by contrast, is clearly a portrait of an individual with a personal identity. Her strong features and powerful gaze, directed straight at the viewer, create an eloquent impression of determination and pride.

At a time when there was a concerted move to document Native life in Canada before its anticipated demise, May chose to paint a particular, living Native woman and her home. Yet it is difficult to say if in so doing she was aiming to counter what she saw as an erroneous perception or whether she herself was attempting to "capture" the subject before it ceased to exist. The absence of a name in the title reinforces the otherness of the figure: with this omission, May eclipses the sitter's personal identity and replaces it with that of an entire ethnic group.[4]

As a viewer living after the Oka crisis of 1990, it is difficult to look at this portrait and read its title without recalling the Mohawk women warriors who stood firm during that confrontation. In Alanis Obomsawin's film *Kanehsatake: 270 Years of Resistance*, Ellen Gabriel explains the

women's instinctive reactions when the police began their attack: "[We] said the women must go to the front because that's our obligation: to protect the land – to protect our mother."[5] This assertion of self-determination and protection of the home seems to ring like an echo of the defiance in the eyes of this *Indian Woman*, painted by May so many decades earlier.

*Maura Broadhurst*
*Art historian*
*Toronto*

Notes _____

1. Karen Antaki, "H. Mabel May (1877–1971): The Montreal Years, 1909–1938," M.A. thesis, Concordia University, Montreal, 1992, p. 46. Antaki suggests that it is possible that even in these other portraits May is subversively challenging societal power structures. Nevertheless, *Indian Woman, Oka* is different in that the subject is more openly confrontational and her gaze unavoidable.

2. Through the Canadian War Memorials Fund, the Canadian government commissioned both Canadian and British artists to document Canada's wartime activity and the impact of the war at home, through paintings, sculpture and photography.

3. Daniel Francis, *The Imaginary Indian: The Image of the Indian in Canadian Culture* (Vancouver: Arsenal Pulp Press, 1992).

4. Charmaine Nelson, *Through An-Other's Eyes: White Canadian Artists – Black Female Subjects* (Oshawa: The Robert McLaughlin Gallery, 1998), p. 8.

5. Alanis Obomsawin, *Kanehsatake: 270 Years of Resistance*, National Film Board of Canada, 1993.

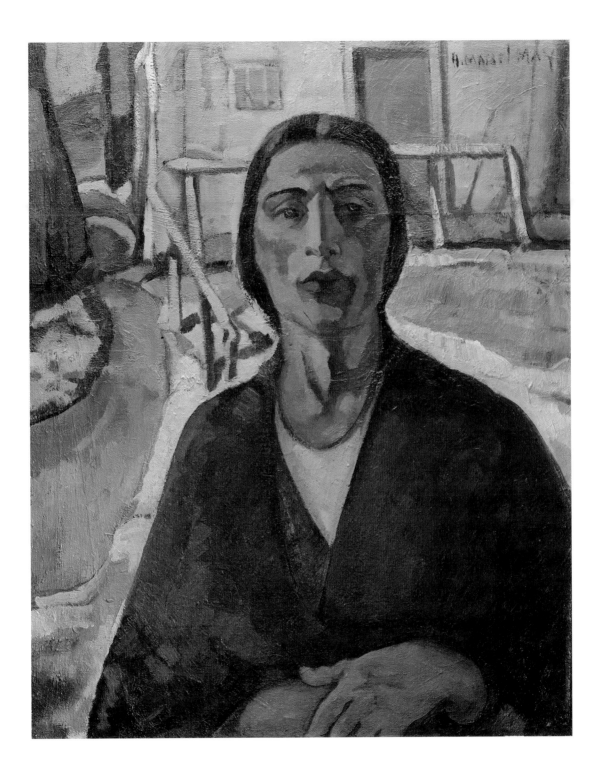

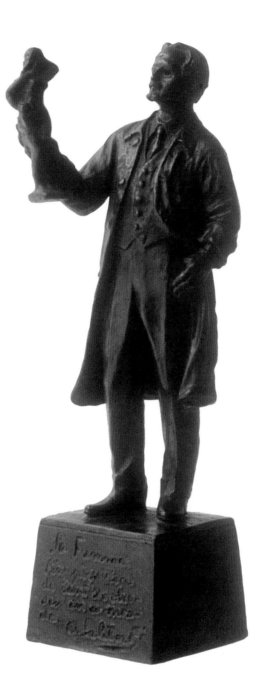

ALFRED LALIBERTÉ  (1878–1953)
*Self-Portrait*  c. 1928–1935
bronze
39.0 x 14.0 x 11.0 cm
Gift of Mr. Walter Klinkhoff, 1970

HENRI HÉBERT (1884–1950)
*Mlle A.C., danseuse d'Oslo* c.1929
posthumous cast 1962
bronze
84.0 x 33.4 x 19.4 cm
Gift of Adrien Hébert, R.C.A., 1951

ADRIEN HÉBERT (1890–1967)
*Élévateur n° 1* v. 1929
huile sur toile
104,7 x 63,8 cm
Don du Hamilton Spectator, 1962

Alors que le Groupe des Sept est en voie d'imposer une iconographie relative à la nature nordique comme emblème de la peinture «canadienne», Adrien Hébert fait figure d'exception en proposant une icône qui cristallise plutôt la quintessence d'une modernité urbaine et industrielle : celle des grands élévateurs portuaires.

Quand, en 1924, Hébert commence à peindre systématiquement le port de Montréal, celui-ci vient de remporter, pour la quatrième année consécutive, la palme du plus grand port exportateur de grain au monde. L'élévateur n° 1, construit entre 1901 et 1904 par la Steel Storage and Elevator Construction de Buffalo, était considéré comme l'un des plus modernes et des mieux équipés. Avec ses cinquante-neuf mètres de hauteur, il dépassait les gratte-ciel que l'on commençait à ériger à Montréal[1]. Au cours des deux décennies suivantes seront construits les autres élévateurs à grain que, bientôt, les architectes modernistes Walter Gropius et Le Corbusier citeront en exemple[2]. Ces bâtiments, les quais à haut niveau, les hangars permanents en acier et en béton, les entrepôts frigorifiques, ainsi que l'implantation d'un système de transbordeurs perfectionné, font du port de Montréal et de son réseau ferroviaire le principal centre de transport du Canada, en concurrence avec les grands ports américains de l'Atlantique. À l'aube des années 1920, le port, les

locomotives qui le sillonnent, les élévateurs et les transatlantiques à coque d'acier incarnent la nouvelle modernité économique, architecturale et industrielle du Québec.

L'organisation formelle d'un tableau comme *Élévateur n° 1* est assez particulière. Alors que, dans la grande majorité des paysages que l'on identifie alors à «l'art moderne canadien», les motifs naturels envahissent la surface par leurs couleurs vives et leurs empâtements affirmés, Hébert développe une tout autre approche. Les éléments naturels (ciel, eau, nuages) occupent peu d'espace, cadrés qu'ils sont par les éléments industriels. La couche picturale est mince et l'organisation linéaire, complexe, domine. La composition met l'accent sur la monumentalité de l'architecture portuaire. Ce sont les structures géométriques des élévateurs et des transbordeurs qui cadrent le tableau, et la figure humaine elle-même participe de cet univers rigoureusement construit. Dans *Élévateur n° 1*, l'homme est enchâssé dans la structure de la barrière métallique, tout comme le convoyeur l'est dans celle des hangars. D'ailleurs, la position de l'homme et l'angle de sa jambe gauche repliée reprennent, en l'inversant, l'organisation linéaire du convoyeur et de son ombre portée : la structure industrielle englobe la structure humaine qui la reproduit.

*Élévateur n° 1* est une œuvre qui a été beaucoup exposée, reproduite et commentée. Elle constitue en quelque sorte un archétype de la modernité telle qu'elle s'exprime dans la production d'Hébert à

la fin des années 1920. Elle rend hommage à cette esthétique fonctionnaliste des ingénieurs que saluaient, en 1918, certains amis du peintre dans la revue d'avant-garde *Le Nigog*, et qu'Hébert lui-même a défendue dans son art et dans ses écrits[3]. Elle réaffirme aussi la place d'Hébert en tant que précurseur de ces artistes qui, comme son ami T. R. MacDonald, consacreront dans les années 1930 une partie de leur œuvre à la représentation de Montréal. C'est d'ailleurs ce même MacDonald qui, devenu directeur et conservateur de l'Art Gallery of Hamilton, lui achètera, en 1962, *Élévateur n° 1* pour la collection du musée grâce à un don du *Spectator* de Hamilton.

*Esther Trépanier*
*Professeure*
*Département d'histoire de l'art*
*Université du Québec à Montréal*

Notes _____

1. Claude Bergeron, *Architectures du xxᵉ siècle au Québec*, Québec, Musée de la civilisation et Éditions du Méridien, 1989, p. 22.

2. Voir Melvin Charney, «The Grain Elevators Revisited», *Architectural Design*, vol. XXXVII (juillet 1967), p. 328–331.

3. Sur cette question, voir Esther Trépanier, «Sens et limites de la modernité chez Adrien Hébert et ses critiques», dans Pierre L'Allier (dir.), *Adrien Hébert,* Québec, Musée du Québec, 1993, p. 85–102.

 English translation on page 289

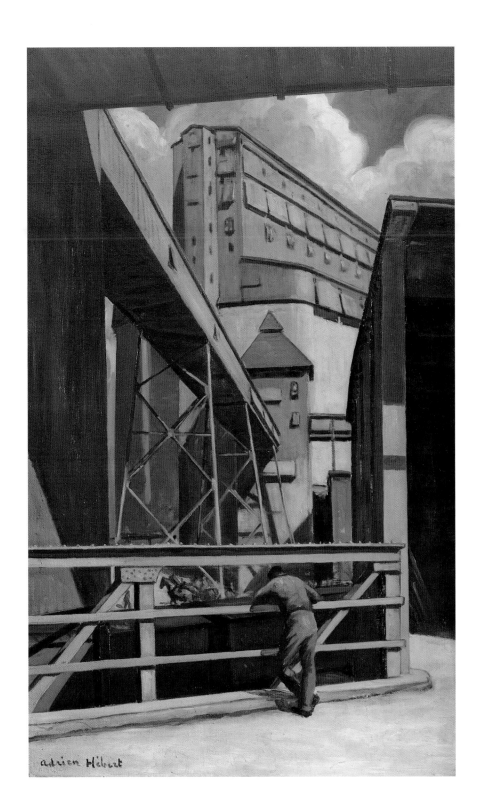

MARY E. WRINCH (1877–1969)
*Sparkling Water* c.1929
oil on laminated card
25.5 x 30.4 cm
Gift of the Gordon Conn–Mary E. Wrinch Trust, 1970

CHARLES COMFORT (1900–1994)
*The Dreamer* 1929
oil on canvas
101.7 x 122.1 cm
Gift of The Hamilton Spectator, 1957

RODY KENNY COURTICE (1895–1973)
*Northern Railway Town* c. 1929–1935
oil on canvas
86.6 x 102.2 cm
Gift from the Russell Nelson Eden Fund, 2000

When Rody Kenny Courtice and her friend Yvonne McKague sketched on the North Shore of Lake Superior in 1929, they were very aware of who had gone before (fig. 66). At the end of an uninspired sketching session, the friends decided to

> "… make a Lawren Harris!" So we went off and found a dead tree … and we propped it up on the rock with Lake Superior in the distance and one of those dramatic grey skies with clouds moving across … we worked with great vigour and finished our sketches in less than an hour. Then we packed up and went back to the Y.M.C.A. in Schreiber.[1]

Lawren Harris had been exhibiting Lake Superior landscapes since 1922. Dramatic clouds, bold lighting, barren hills and a calm lake – all of which Courtice incorporated into *Northern Railway Town* – had by the end of the decade been refined into symbols of the North Shore, Canada's frontier. As an artist working within a genre increasingly defined by the Group of Seven (several of whom had been her teachers at the Ontario College of Art and became her

Fig. 66
LAWREN HARRIS (Canadian 1885–1970)
*North Shore, Lake Superior* 1926
oil on canvas, 102.2 x 128.3 cm
National Gallery of Canada, Ottawa, purchase 1930

friends), Courtice knew that it was from them that she needed to distinguish herself. For *Northern Railway Town*, in contrast to her "bogus" Harris sketch,[2] Courtice combined iconic Lake Superior images with jaunty, almost playful, details. She also chose Schreiber as her subject – the CPR home terminal where she lodged – rather than one of the more artistically popular fishing villages of Rossport, Jackfish and Coldwell (see cat. 46).

In the pull between capturing and constructing landscape, Courtice has simplified the valley town. To heighten the impression of Schreiber's isolation she has selected a single church from several and reduced the number of streets and houses, organizing them into an enclosed circle. Owing to years of felling trees for fuel, the surrounding hills would have been quite stark by the late 1920s, but their barrenness has been exaggerated in the painting for the sake of perspective and aesthetic effect. Courtice has also added a distant view of Lake Superior, which would actually have been invisible from this standpoint.[3] The railroad appearing from under the ledge in the foreground and snaking away into the distance draws the viewer into the picture and beyond. Its central presence also underlines the primacy of rail as Schreiber's only land access route.[4]

The simplicity of the work does not, however, result in a sense of timelessness, as it would in "a Lawren Harris." The dramatic light heralds not a mystical phenomenon but rather an autumnal morning – windows still dark and streets empty, save for a few early risers engaged in everyday activities. Courtice revelled in small effects: the dollops of smoke and trees, the many tiny windows, the spindly water tower and the CPR station garden plots. She also painted these elements in a delib-

erately rudimentary, even naive, way. In contrast to the austere backdrop and boldly silhouetted houses, the train has a toy-like quality.[5] Thus did Courtice create and convey her own view of Lake Superior country. Through the interplay of intimate details and scale differences, a mundane moment unfolds in an awesome place.

*Alicia Boutilier*
*Independent curator*
*Bowmanville, Ontario*

Notes

1. Yvonne McKague Housser, quoted in a biographical manuscript by Margaret Gray and Margaret Rand (file 24, vol. 1, Yvonne McKague Housser fonds, MG30 D305, National Archives of Canada, Ottawa). The same incident is also recounted in Yvonne McKague Housser, "North Shore of Lake Superior," *Northward Journal: A Quarterly of Northern Arts*, no.16 (June 1980), p. 29. In *A Painter's Country* (Toronto: Clarke, Irwin & Company Ltd., 1958), A.Y. Jackson reveals that the dead stump in Harris's well-known *North Shore, Lake Superior* "was almost lost in the bush; from its position we could not see Lake Superior at all. Harris isolated the trunk and created a nobler background for it" (p. 48).

2. McKague Housser, "North Shore of Lake Superior," p. 29.

3. For finding this standpoint and sharing details from Schreiber's history, I am indebted to the Schreiber Archives and Historical Society.

4. The Trans-Canada highway, still under construction, had not yet reached Schreiber.

5. It is worth noting that Courtice often painted still-lifes of her son's and other children's toys. From the late 1930s on, she became known as a humorous and whimsical artist.



PRUDENCE HEWARD (1896–1947)
*Girl Under a Tree* 1931
oil on canvas
122.5 x 193.7 cm
Gift of the artist's family, 1961

The female nude was an unusual subject for a Canadian woman painter in 1931.[1] At that time, public galleries were reluctant to show nudes for fear of offending the puritanical sensibilities of some of their visitors. The Art Gallery of Toronto refused to let the Canadian Group of Painters hang Lilias Torrance Newton's *Nude* (also known as *Nude in a Studio*; 1933, fig. 67) in their 1933 exhibition, although two years earlier Prudence Heward's *Girl Under a Tree* had been included in the Group of Seven show at the same institution.[2] The objections to Newton's painting focused on the model's high-heeled shoes, which the Gallery felt disrupted the concept of an idealized female beauty. Most Canadian artists were at this period still conforming to the conventions established for painting the nude (intended to distinguish high art from pornography), whereas many European painters were engaging with the newer genre of the

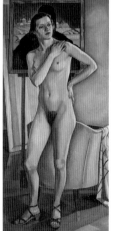

Fig. 67
LILIAS TORRANCE NEWTON
(1896–1980)
*Nude* 1933
oil on canvas
203.2 x 91.5 cm
The Thomson Collection

"naked."[3] Prudence Heward's *Girl Under a Tree* is on the borderline between these two categories.

In Heward's painting the model's limbs are arranged in a way that conceals the body hair, thus conforming to the conventions for painting the "nude." Nevertheless the image is not an idealization of female beauty, but a recognizable twentieth-century woman.[4] The model's head is turned so that she stares out at the viewer, conveying a strong sense of a unique personality. The hint of latent sexuality in the long, taut figure and the large, staring eyes make the work disturbing in a way that, for example, Randolph Hewton's nude *Sleeping Woman* (c. 1929, Ottawa, National Gallery of Canada) is not. Hewton, by representing his subject as unconscious of the viewer's gaze, objectifies her body and converts it into a potential site for male erotic fantasies.

Although the female nude in a landscape, particularly a mythological or historical landscape, was a traditional subject of Western European art, Heward has treated it in a highly individual way. The pastoral setting of *Girl Under a Tree* is interrupted by the flattened shapes in the mid-ground that suggest a city. In two earlier works, *At the Cafe* (c. 1928, The Montreal Museum of Fine Arts) – a portrait of the painter Mabel Lockerby – and *At the Theatre* (1928, The Montreal Museum of Fine Arts), Heward had associated women with the city and with culture. In *Girl Under a Tree* the triangular shapes of the woman's raised knee and arm are

echoed in the geometrical forms of the buildings – buildings that some critics have described as "Cézannesque."[5] The reclining woman is thus associated not only with untamed nature, but also with urban life, modernism, and culture. *Girl Under a Tree* can be read as an attempt by Heward to liberate the female body from stereotypical male fantasies and to reclaim it as a vehicle for the individual woman's desires and pursuits.

*Barbara Meadowcroft*
*Research Associate*
*Simone de Beauvoir Institute*
*Concordia University, Montreal*

Notes

1. Prudence Heward's *Girl Under a Tree* is the earliest nude by a woman cited by Jerrold Morris in *The Nude in Canadian Painting* (Toronto: New Press, 1972).

2. See Donald W. Buchanan, "Naked Ladies," *Canadian Forum*, vol. 15 (April 1935), pp. 273–274; and Natalie Luckyj, *Expressions of Will: The Art of Prudence Heward* (Kingston: Agnes Etherington Art Centre, 1986), p. 63

3. For the distinction between the "nude" and the "naked," see Kenneth Clark, *The Nude: A Study in Ideal Form* (New York: Pantheon Books, 1956), p. 3.

4. "The model I recognize as I painted her myself" (T.R. MacDonald in a letter to Ross W. Heward, 28 June 1961, Accession File, Art Gallery of Hamilton). MacDonald's comment indicates that the work is not a self-portrait, as Luckyj and others have suggested.

5. See *Inédits de John Lyman*, Hedwige Asselin, ed. (Montreal: Bibliothèque nationale du Québec, 1980), p. 107; and Luckyj, *Expressions of Will*, p. 61.

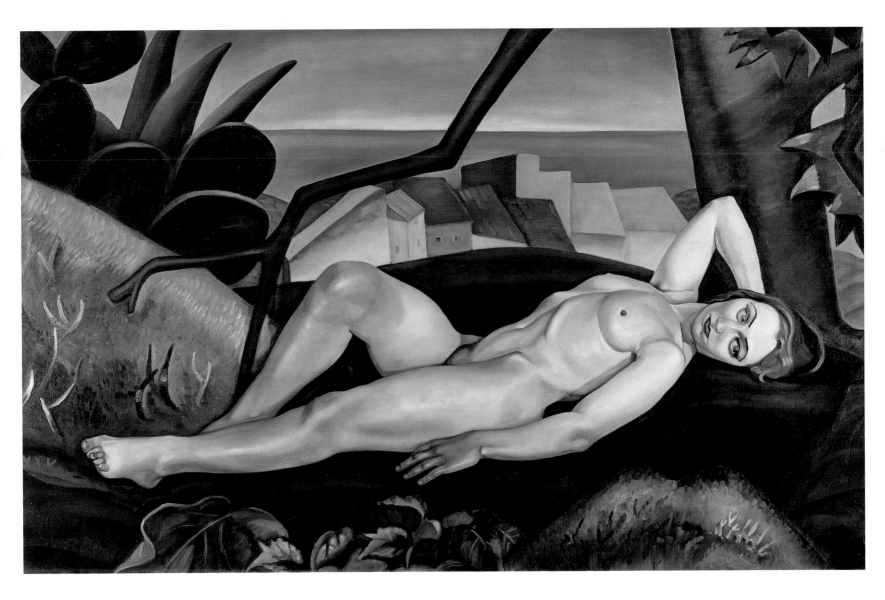

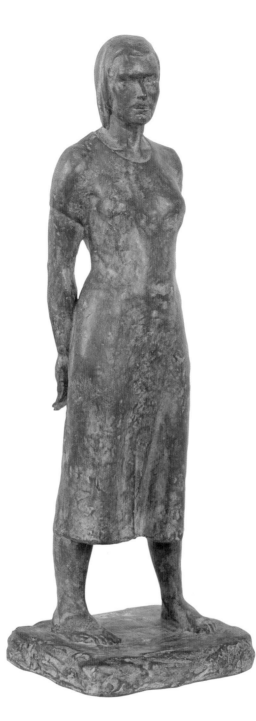

ELIZABETH WYN WOOD (1903–1966)
*Linda* 1931
posthumous cast 1970
bronze
56.5 x 20.0 x 17.0 cm
Gift of Elizabeth Bradford Holbrook, 1969

JOHN SLOAN (1890–1970)
*Forty Below* c. 1933
stone
72.2 x 28.5 x 27.0 cm
Gift of International Business Machines Corporation, 1960

E. GRACE COOMBS (1890–1986)
*Jack Ladder House* c. 1933
oil on laminated card
26.7 x 21.5 cm
Director's Purchase Fund, 1959

For a brief period in her career, before she became trapped in an endless and repressive cycle of flower painting, things seemed to come together for the Hamilton-born painter Grace Coombs.

Excited by her freedom to travel and create, and encouraged by J.E.H. MacDonald's personal interest in her progress – keep working and just "be yourself," he said – Coombs crossed the North American continent, painting whatever moved her with a sense of sweep and vigour.

On a trip to Haliburton, Ontario, in the early 1930s she witnessed (or possibly invented) a scene at a sawmill yard that satisfied her love of the outdoors but that also allowed her to express a familiar subject in Canadian art from a decidedly female perspective. The result was *Jack Ladder House*. In this quick study of backwoods life, Coombs divides our attention between the confident body language of the barrel-chested logger, seen legs straddled in the top of the picture, and the two children in the lower left-hand corner, playing quietly in the shadow of the pointers (flat-bottomed rowboats used by loggers in river drives).

So dominated was the national psyche by the landscape, images featuring people were both less popular and less common in Canadian art during the 1910s and 1920s. But the river driver and his brother the lumberjack were exceptions, because of their athletic embrace of the land and their close involvement with the true star of Canadian art and industry – the tree.

When Arthur Lismer, J.E.H. MacDonald and Clarence Gagnon painted river drivers they were always shown in the heat of the action, riding the rivers, alone or in packs. In *Jack Ladder House*, by adding the implied presence of women, Coombs offers a more human, less iconic picture of such men. She introduces the idea that these folkloric outdoorsmen had real lives, with social connections and responsibilities as both husbands and fathers that went beyond the landscape. Back at the camp, we find them having to keep one eye on their work and the other on their children.

Coombs never repeated the bold juxtapositions and quick, confident handling she achieved in *Jack Ladder House*. Not long after finishing the work, she chose to back out of the contemporary art world and to let go of friendships with such people as Yvonne McKague and Arthur Lismer. Sustaining these relationships would no doubt have challenged her powers of innovation and forced her to keep changing and growing. Instead, she gravitated towards the biblical community at the University of Toronto's Emmanuel College, where she pursued her relationship with Jim Lawson, a Ph.D. candidate in theology and an internationally recognized sculptor of wax fruit.[1] It was Lawson who encouraged Coombs to focus more on flowers and plant life, and they began painting side by side and exchanging their efforts as gifts.[2] After over fifteen years of dating, Coombs and Lawson finally married in 1942.

Although Coombs was not raised a Methodist, as an adult she chose to live by the words of Cardinal Newman's hymn "Lead Kindly Light." In order to be led by a higher power, she renounced her pride and willingly turned her back on the path that, in her younger days, had taken her through the Grand Canyon and up and over the windswept bluffs of Algoma.

*Alison Garwood-Jones*
*Independent writer*
*Toronto*

Notes _____

1. Today, many of Lawson's sculptures of apples, pea plant tendrils and poisonous mushrooms are housed in the New York State Agricultural Experiment Station at Cornell University, where he spent several summers working. Admired for his colouring and painstaking texturing, Lawson was said to have pulled hairs from his arms and cut them to the proper length when fashioning the bristles for his raspberries.

2. Hundreds of Coombs's works are now in the collection of the Art Gallery of Hamilton.

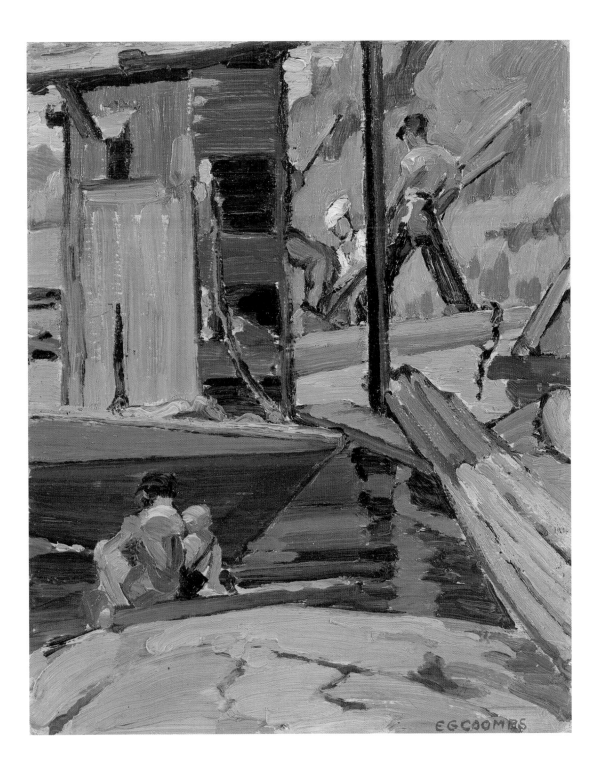

Cat. 47
**E. GRACE COOMBS** (1890–1986)
*Sand and Sage Brush,*
*Salt Lake Desert, Utah* 1923
oil on laminated card
21.5 x 26.5 cm
Gift of Dr. J. S. Lawson, 1961

Cat. 51
**E. GRACE COOMBS** (1890–1986)
*Desert near Salt Lake City* 1924
oil on laminated card
20.5 x 25.5 cm
Gift of Dr. J. S. Lawson, 1961

E. Grace Coombs (1890–1986)
*Sketch, Sawmill Yard, near Knoepfli* c.1933
oil on laminated card
21.5 x 26.5 cm
Gift of Dr. J. S. Lawson, 1961

YULIA BIRIUKOVA (1895–1972)

*Prospector (Peter Swanson)* 1934

oil on canvas

114.2 x 92.0 cm

Gift of Thoreau MacDonald, 1973

*P*eter Swanson is all man. It is evident in the massive forearms, the barrel chest, the piercing stare. In her striking portrait, the Russian-born Yulia Biriukova has depicted a character larger than life – which Swanson appears to have been. From the moment he landed among the group of artists and friends that revolved around Lawren Harris's Studio Building, in Toronto, he seems to have caused quite a stir.

Soon after Biriukova's November 1929 arrival in Toronto from Vladivostock, Russia, via Rome, the young artist secured a studio in the famed Studio Building. It was there that she came into contact with Swanson, who in partnership with Keith MacIver (fig. 35), was trying to make his fortune by prospecting northern Ontario and Quebec in search of mining opportunities. In November 1933 MacIver and Swanson were both living in "Tom Thomson's" shack behind the Studio Building, while using A. Y. Jackson's studio as temporary office headquarters.[1]

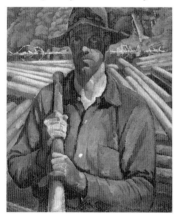

Fig. 68
EDWIN HOLGATE (1892–1977)
*The Lumberjack* 1924
oil on canvas, 64.8 x 54.6 cm
Gallery Lambton, Gift of the Sarnia Women's Conservation Art Association

Albeit brief and irregular, Swanson's presence in Toronto had an impact on many of those he met there, for whom he radiated an aura of romance and strength. For a brief period in the fall of 1933 – the period when Biriukova would have been working on her portrait – Swanson was "in great demand socially."[2] The combination of his reputation for second sight and the ability to read tea leaves with a certain masculine charm made him a prized guest at numerous artists' gatherings. Upon Swanson's departure with MacIver for the North in early January 1934, Jackson wrote: "All their lady friends went down to the station to see them off … Pete was never so much kissed in his life, but he says this women business is weakening and he has had enough of it."[3] Swanson's swagger had its dark side, however. Later the following year, Jackson recalled: "He was a pretty ugly customer down here last winter and it is a wonder he did not end up in jail."[4]

By most accounts, Swanson was the ultimate bad boy, at once charming and volatile, and Biriukova has successfully captured this particular combination of character traits. While her overall composition owes something to the pictorial tradition of the figure in the landscape – different human "types" framed within a contextual panorama, as perfected by Edwin Holgate in the 1920s and 1930s (fig. 68) – Biriukova has sought to personify her prospector, to capture something of the temperament behind the trade. Whereas so many of these portraits seem to fold the figure into the landscape, often sacrificing the subject's personal identity to such job-related

elements as logs, paddles and canoes, there is little question that here Biriukova was painting the man she had come to know.

Swanson's face, treated in an altogether more worked and concentrated manner than any other part of the canvas, is the focus of the composition. The paint is applied in planes of varying colours that serve to define the prospector's chiseled features while fully articulating flesh and form. The entire image comes together in his eyes, with all the formal elements leading to the dark, searing gaze. This is a man who knows his mind and will not hesitate to share it. Yulia Biriukova has succeeded in creating a portrait as memorable and arresting as the man himself.

*Tobi Bruce*
*Senior Curator*
*Art Gallery of Hamilton*

Notes _____

1. Letter from A. Y. Jackson to Anne Savage, 23 November 1933, file 14, vol. 1, Anne Savage fonds, MG30 D374, National Archives of Canada, Ottawa. Jackson himself was also actively involved in mining prospects, investing financially in many of MacIver's schemes.

2. A. Y. Jackson in a letter to Anne Savage, 8 December, 1933, ibid.

3. A. Y. Jackson in a letter to Mrs. H. P. DePencier, 9 January 1934, vol. 1, Norah Thomson DePencier fonds, MG 30 D322, National Archives of Canada, Ottawa.

4. A. Y. Jackson in a letter to Mrs. H. P. DePencier, 30 October 1935, ibid.

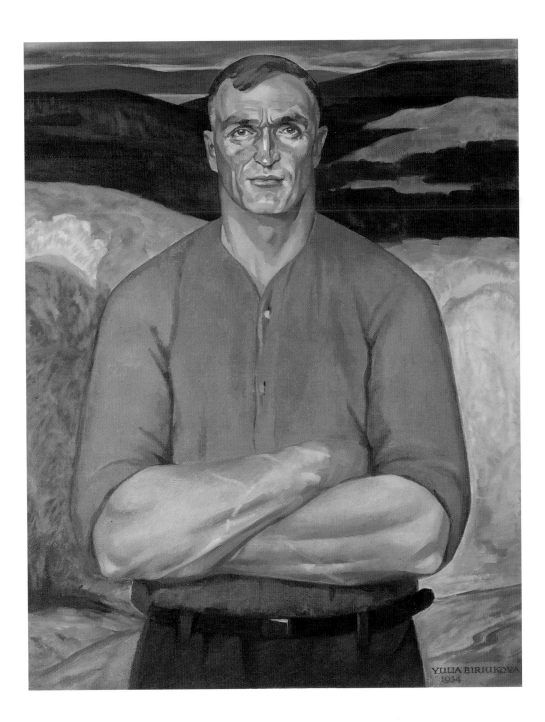

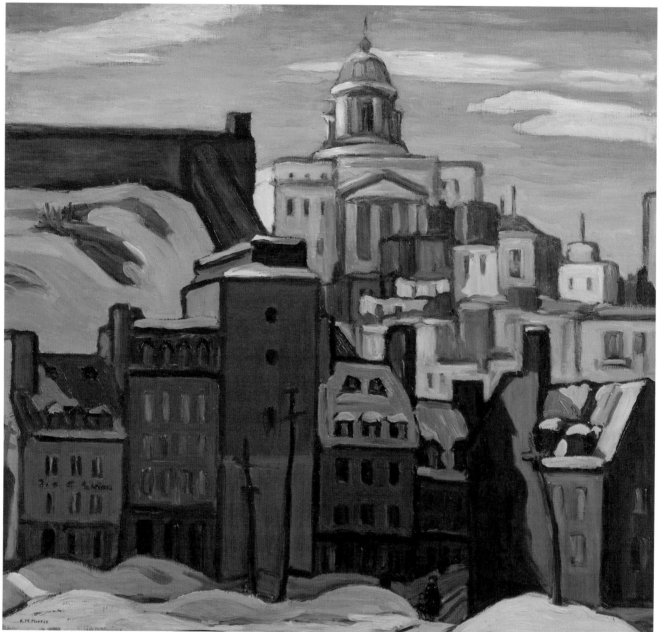

KATHLEEN MOIR MORRIS (1893–1986)
*Lower Town, Quebec* c. 1935
oil on canvas
71.3 x 76.5 cm
Gift of Mrs. A. V. Young, 1958

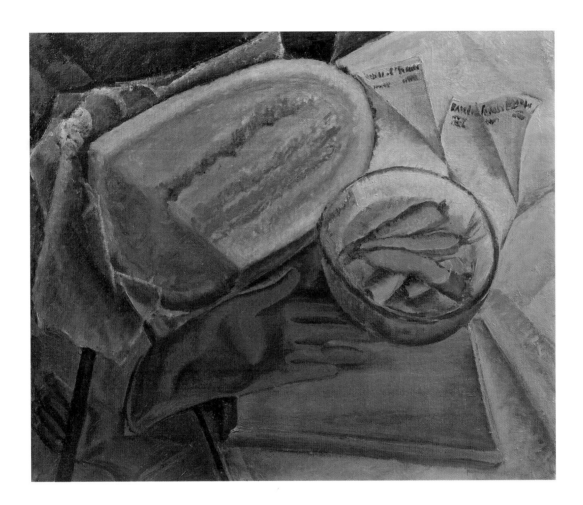

PARASKEVA CLARK (1898–1986)
*Rubber Gloves* 1935
oil on canvas
51.0 x 61.2 cm
Gift of Richard Alway, 2001

BERTRAM BROOKER (1888–1955)
*Seated Figure* 1935
oil on canvas
101.6 x 101.6 cm
Gift from the Marie Louise Stock Fund, 1996

Laura awakened just as the sun was rising. She stretched herself sleepily and watched the slow infusion of colour creeping over the pale sky. A broad ray suddenly climbed to the zenith from the hidden horizon. Another crept up beside it, and across the ceiling and walls of the room floated the first rosy hint of coming glory.[1]

*Seated Figure* is an intimate painting of a woman. She eases her weight on a heavily draped platform and lifts her head in thought. A clear light sharply models her body. The lipstick and rouge on her brightly lit face and the tan around her neck emphasize her nakedness. Her torso and legs are the tangibly fleshy focus of a sculptural life study, framed by a curtained backdrop. This ordinary woman, the artist's hired studio model, is raised up in extraordinary contemplation. She prefigures "Laura," the main character in Bertram Brooker's 1936 Governor General's Award-winning novel, *Think of the Earth*.

As the sunlight slowly warmed the room she slid her limbs into an easier posture, turned her body toward the window ... as she picked out of all that had happened the sweetest moments.[2]

After emigrating from England to Manitoba with his family at the age of seventeen, Brooker ran a movie theatre with his brother in Neepawa, a town northeast of Brandon. The imminence of revelation he described in 1936 as "the first rosy hint of coming glory" must have been conjured for him each day when the curtains opened and the film began to roll. As an artist, novelist and writer in Toronto, where he moved in 1921, Brooker sought the elusive experience of epiphany. In *Think of the Earth*, an exploration of aesthetic awakening to the "oneness" of humanity, the opening of the metaphoric curtains of consciousness emerges as the most forceful symbol of spiritual understanding. "When We Awake!" – his visionary essay on unity published in the 1929 *Yearbook of the Arts in Canada* – was followed by increasingly powerful accounts of "an awakening of the sense of harmony between man and the universe." Brooker was convinced of the artist's unique ability "to see things in new relationships, detached from his own puny affairs and desires, so that they take on the grandeur of symbols – symbols of movements, adjustments and laws that are universal, unattached to any particular time or place, and related only to the boundless and yet unified Being which is the central mystery of life."[3] Brooker's female nude here embodies the promise of an epiphany.

In 1931, Brooker described the aesthetic exploration of "the beauties of the nude figure" as a liberating expression of "the impulses of sex."[4] In both the character of "Laura" and the anonymous female nude in *Seated Figure*, we encounter a subject who holds "some deeper hint of that wholeness, guessed at and aspired to in the past as the ultimate secret, through knowledge of which we might all be one."[5]

*Anna Hudson*
*Assistant Professor*
*Department of Visual Arts*
*York University, Toronto*

Notes

1. Bertram Brooker, *Think of the Earth* (Toronto: Brown Bear Press, 2000), p. 197.

2. Ibid., p. 203.

3. Bertram Brooker, *Yearbook of the Arts in Canada, 1936* (Toronto: MacMillan, 1936), p. xxviii.

4. Bertram Brooker, "Nudes and Prudes," *Open House*, ed. William Arthur Deacon and Wilfred Reeves (Ottawa: Graphic Publishers, 1931), p. 105.

5. Ibid., p. 106.

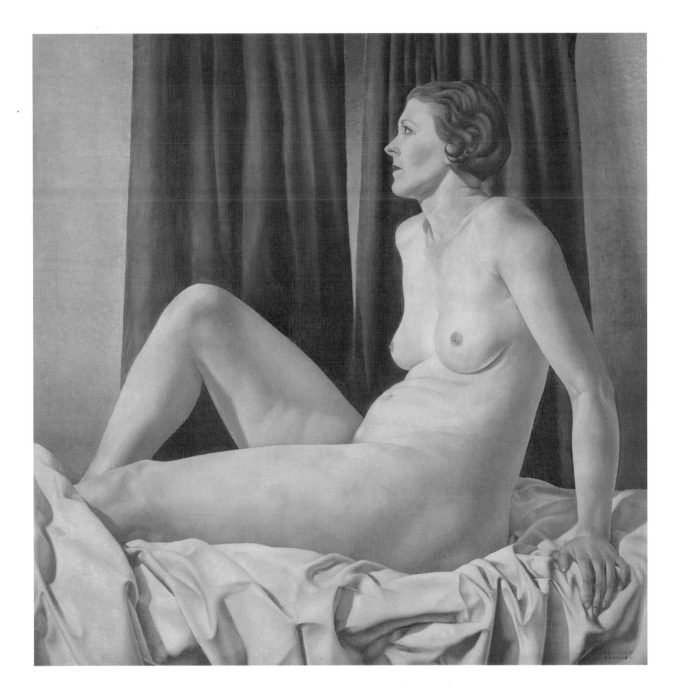

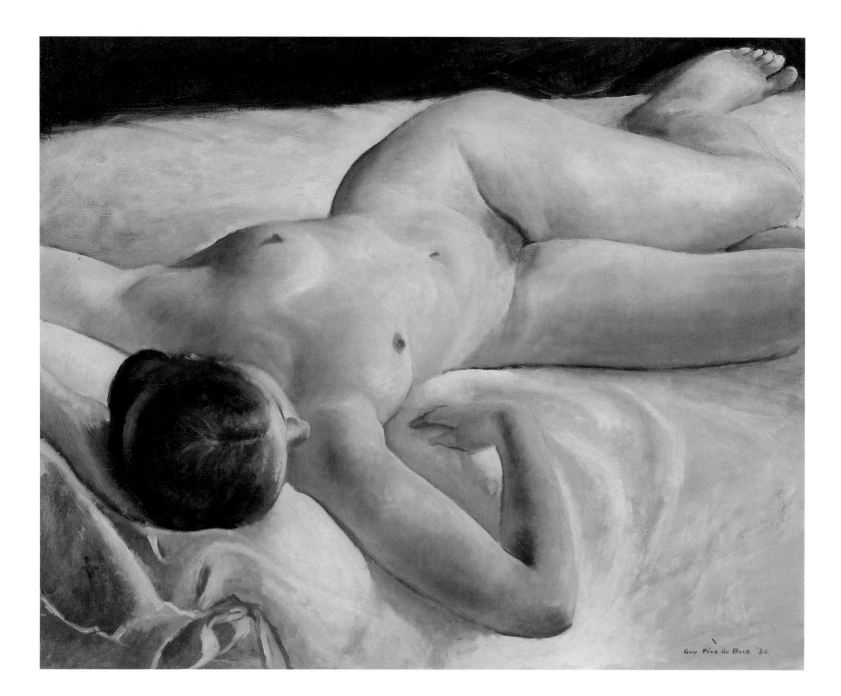

GUY PÈNE DU BOIS (American; 1884–1958)
*Reclining Nude* 1936
oil on canvas
74.2 x 92.0 cm
Gift of the Women's Committee, 1964

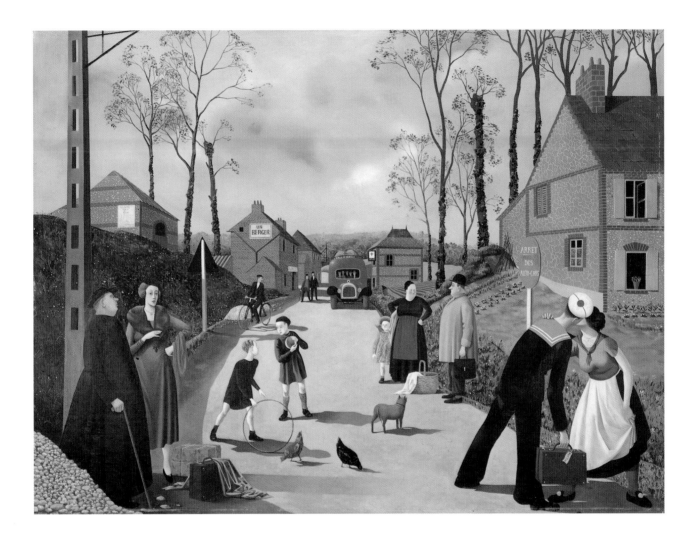

TRISTRAM HILLIER  (British; 1905–1983)
*L'Arrêt de Villainville*  1939
oil on canvas adhered to plywood
59.5 x 79.9 cm
Gift of the Women's Committee, 1967

SARAH ROBERTSON (1891–1948)
*Coronation* 1937
oil on canvas
84.4 x 60.9 cm
Gift of H. S. Southam, C.M.G., LL.D., 1951

*T*he dark door at the centre is not the first thing that one notices about Sarah Robertson's *Coronation*. Discussion of the painting has generally focused on the bold brushstrokes and brilliant colours, the branches that echo the fluttering flags, reflecting the joyous occasion of King George VI's coronation following the abdication of his brother, Edward VIII. A Beaver Hall Group member and active player in the Montreal art community, Robertson often painted the city where she lived all her life. The celebrations on 12 May 1937 were, newspapers proclaimed, the largest and best attended that Montreal had ever seen.[1] Buildings blazed with Union Jacks and the official royal colours of red, blue, white and gold. Thousands converged on Jeanne-Mance Park early in the morning to hear radio commentary from Westminster Abbey, broadcast over loudspeakers in both English and French, and in the evening to view a spectacular firework display, courtesy of *La Presse*.

Because so many people crowded the park and streets at the base of Mount Royal on that day, it is tempting to see the dark door and absence of figures in Robertson's painting as representing the city centre, which "avait ... l'aspect dominical: rues désertes dans la section commerciale."[2] But there is a metaphoric ominousness to the door. Though the left flagpole points directly to it, the exuberant decorations distract the viewer from this central element. Even the path swerves around it. While world war was not yet of broad public concern in 1937,

Montreal was barely emerging from the Depression, and the Spanish Civil War was in the news. Robertson appears to have interpreted the coronation pageantry as a welcome distraction, and the enthusiasm with which Montrealers embraced it as a wilful escape from difficult times.

At the same time, the painting is distanced from its title. The Union Jacks are so loosely interpreted as almost to deny their Imperial significance; and the royal colours, particularly in the background, are exploited more for visual effect than ideology. While in 1937 ties to Britain were still undeniably strong, Canada was increasingly desirous of autonomy as a nation. The blurred and dissipated emblems of empire that colour this Canadian cityscape reflect the growing isolationism that followed the Depression and characterized the Liberalism of Prime Minister Mackenzie King.

*Coronation* seems an appropriate choice for Harry Stevenson Southam, a man whose family's printing enterprise owned or controlled several major newspapers across Canada. H. S. Southam, publisher of the Ottawa *Citizen* and Chairman of the National Gallery of Canada's Board of Trustees, purchased Robertson's work soon after it was painted. An avid art collector, he lent particular support to contemporary Canadian artists, during the Depression and beyond. His choice of *Coronation* reflects his interest in art considered modern for Canada in the 1930s, for the painting marked a change from Robertson's earlier Group of Seven-influenced style.

In 1948, Southam began donating works to the Art Gallery of Hamilton, in the city where he grew up, later bequeathing the remainder of his collection to the institution in his will. He hoped his donations would "appeal to [Hamilton's] public and perhaps stimulate other collectors to do something similar."[3] Nevertheless, after having owned the work for over a decade, Southam was reluctant to part with *Coronation*, which had become one of his favourites.[4]

*Alicia Boutilier*
*Independent curator*
*Bowmanville, Ontario*

Notes

1. "As for the military parade," reported *Le Devoir*, "it is estimated to be the largest ever seen in Montreal" ("La journée d'hier à Montréal," 13 May 1937, p. 10). *The Gazette* declared: "Never in the history of Montreal has there been a day like this" ("Loyal Thousands Eagerly Awaiting Coronation Fetes," 12 May 1937, p. 15). And an enthusiastic *La Presse* announced that 300,000 people attended the evening festivities: "'Never has such a crowd invaded the mountain,' declared the superintendent of parks" ("Un grand jour fini en apothéose," 13 May 1937, p. 1).

2. "... had a Sunday feel to it: deserted streets in the business sector" ("La journée d'hier à Montréal," *Le Devoir*, 13 May 1937, p. 10).

3. H.S. Southam in a letter to T.R. MacDonald, 2 March 1948, H. S. Southam Source File, Art Gallery of Hamilton.

4. H.S. Southam in a letter to H.O. McCurry, 6 March 1951, 9.2S Southam, H.S., 1951–78, file 10, NGC fonds, National Gallery of Canada Archives, Ottawa.

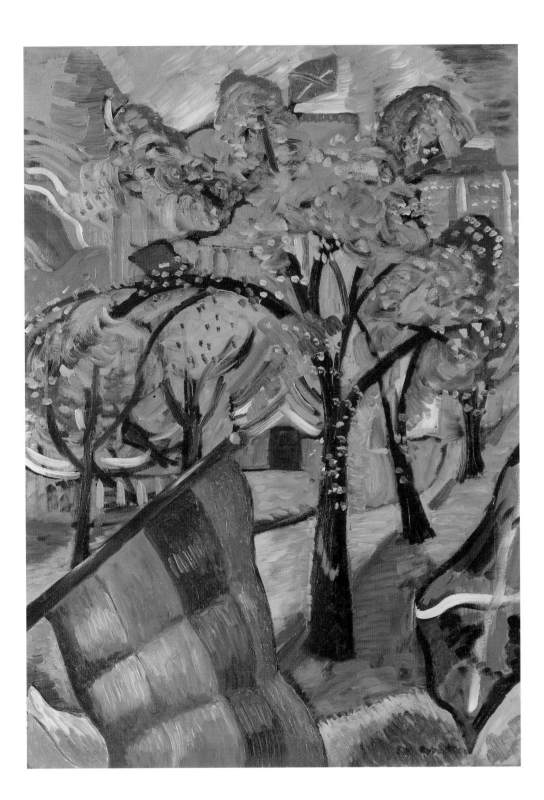

PAUL-ÉMILE BORDUAS (1905–1960)
*Matin de printemps* 1937
huile sur toile
30,5 x 39,3 cm
Don commémoratif Alfred Wavell Peene
et Susan Nottle Peene, 2001

Ce tableau figuratif de Paul-Émile Borduas, peint dans un style qui pourrait faire penser à Renoir ou à Pascin, deux artistes pour lesquels il exprima de l'admiration durant son premier séjour parisien en 1929–1930, nous révèle les premières influences subies par celui qui allait devenir l'un des peintres abstraits canadiens les plus importants de son temps. Mais son intérêt ne s'arrête pas là : au moment où il le peignit, Borduas vivait au 953 rue Napoléon, à Montréal, et avait son atelier tout près, au 3940 rue de Mentana. *Matin de printemps* représente la vue qu'il avait, de son appartement, sur l'entrée de son atelier, celle-ci correspondant à l'une des entrées plus sombres en bas à droite. C'est dans cet atelier que, quelques années plus tard, Borduas prit l'habitude de réunir quelques-uns de ses élèves de l'École du Meuble, auxquels

© Estate of Paul-Émile Borduas / SODRAC (Montréal) 2005

Fig. 69 PAUL-ÉMILE BORDUAS *Adolescente* 1937
huile sur toile, 27,9 x 21 cm, Collection privée

s'ajouteraient certains autres venus de l'École des beaux-arts, avec lesquels il formerait le groupe des automatistes. On peut donc dire qu'en peignant *Matin de printemps*, Borduas a, sans le savoir, peint le berceau du mouvement automatiste, mouvement dont on ne saurait exagérer l'importance dans le développement de la peinture au Canada.

L'endroit où le tableau fut exposé pour la première fois est cependant plus difficile à déterminer, ce qui constitue une intéressante étude de cas dans l'établissement de l'historique d'une œuvre. Étant donné que *Matin de printemps* porte au dos l'étiquette du 55e Salon du printemps de l'Art Association of Montreal, j'avais cru qu'il avait été exposé à ce salon, même si le Borduas annoncé au n° 12 du catalogue était *Adolescente* (1937, fig. 69)[1]. J'imaginais que l'artiste avait pu changer d'idée au dernier moment et substituer un tableau à l'autre après l'impression du catalogue. Or, cette hypothèse n'est pas sans soulever de sérieuses difficultés. Le Salon du printemps étant une exposition avec jury, il est plus probable que Borduas y présenta deux tableaux et que seul *Adolescente* fut retenu. Certes, on avait collé les étiquettes sur réception des deux tableaux; celle de *Matin de printemps* aurait dû être biffée, celle d'*Adolescente* est probablement tombée[2].

Cette histoire d'étiquette a plus d'importance qu'il n'y paraît. On sait, en effet, que c'est en voyant la peinture de Borduas à ce salon de 1938 que John Lyman voulut rencontrer son auteur[3]. Le tableau qui attira l'attention de Lyman n'était donc pas *Matin de printemps*, mais

*Adolescente*. Cela serait confirmé par le fait que Lyman y décela « l'influence de Maurice Denis », remarque qui s'applique beaucoup mieux à *Adolescente* qu'à *Matin de printemps*.

Est-ce à l'exposition de la Société d'art contemporain, tenue en décembre 1939 à la Frank Stevens Gallery de Montréal, que *Matin de printemps* fut présenté pour la première fois au public ? Le catalogue de cette exposition n'attribue à Borduas qu'un *Paysage*, dont Jacques de Tonnancour dit qu'il est « haut comme la main », description qui conviendrait mieux à l'un ou l'autre des petits paysages faits par Borduas en Gaspésie l'année précédente. Il semble donc qu'il ait fallu attendre la grande rétrospective Borduas du Musée des beaux-arts de Montréal en 1962 pour voir apparaître *Matin de printemps* dans une exposition publique; il y fut présenté sous un autre titre, qui contenait d'ailleurs une petite faute d'orthographe : *La Rue Montana* (au lieu de *Mentana*).

*François-Marc Gagnon*
*Directeur*
*Institut d'études en art canadien*
*Université Concordia, Montréal*

Notes _____

1. Voir F.-M. Gagnon, *Paul-Émile Borduas*, Montréal, Musée des beaux-arts de Montréal, 1988, p. 274, cat. 78.

2. Je remercie Alicia Boutilier, de l'Art Gallery of Hamilton, de me l'avoir signalé.

3. John Lyman, « Borduas and the Contemporary Arts Society », dans Evan H. Turner, *Paul-Émile Borduas 1905–1960*, Montréal, Musée des beaux-arts de Montréal, 1962, p. 40.

PAUL NASH  (British; 1889–1946)
*Monster Shore*  1939
oil on canvas
71.2 x 91.5 cm
Gift of the Women's Committee, 1966

*A*ll his life, the English landscape painter Paul Nash was preoccupied by death, a force that was for him both frightening and reassuring. In addition, he was entranced by the mysterious presences – intimations of immortality – that hover at the edge of daily existence. Earlier, in the nineteenth century, Blake, Palmer and Rossetti had manifested similar interests. Nash expressed the legacy of these three men in a distinctly twentieth-century idiom. He was an early and enthusiastic supporter of Surrealism, for it was an approach that allowed him to make the illogicality of dreams and the unconscious an integral part of his art.

Surrealism, for Nash, in addition to electrifying the intellectual atmosphere, had its roots in Britain. It began to live, according to him, in the world created by such poets as Wordsworth, Coleridge and, of course, Blake.[1] Most significantly, Surrealism represented a way for Nash to remain faithful to English Romanticism while simultaneously exploring an important trend in twentieth-century continental art.

In the mid-1930s, Nash became fascinated with yet another Surrealist commonplace – the "found object." In June 1938 he stayed at Madams, a house in Gloucestershire where his friends Clare and Charles Neilson had recently moved. He was entranced by the long prospects from the terrace, and he believed the small house's topiary garden to be haunted. During that visit, Nash came upon a field on Carswalls Farm near Newent, not far from Madams. This place, which seemed to have no beginning and no end, he called Monster Field, in honour of two stark objects he found there – the remains of two elm trees. To him, they looked like corpses: they were "two monster objects outside the plan of natural phenomena" that had "passed on" to another plane.[2]

Tree trunks often serve as symbols of death in Nash's work, and they perform this function in *Monster Shore*, which is a "view" of Monster Field. The image of stairs as a conduit from one sphere of existence to another was also a favourite device in his mature work. In *Monster Shore*, the stumps occupy the left and right sides of the composition, but the stairs, as if part of a stage set, lead the eye to the monster form, which has removed itself from the realm of finite existence and acceded to the infinite. In this canvas, Nash confronts the horror of mortality directly, suggesting the hope that through acceptance comes victory.

In 1939 Nash, who suffered from debilitating chronic asthma, was certain that he did not have long to live (he passed away in his sleep in July 1946, at the age of fifty-seven). Throughout his career, he attempted to understand and accept the transience of human existence. *Monster Shore* represents one more step in his ongoing effort to come to terms with death.

*James King*
*University Professor*
*McMaster University, Hamilton*

Notes _____

1. Paul Nash, "A New Poetry," *News Chronicle* (London), 7 June 1937.

2. Paul Nash, *Monster Field: A Discovery Recorded by Paul Nash* (Oxford: Counterpoint Publications, 1946), p. 4.

CARL SCHAEFER (1903–1995)
*Farm House by the Railway, Hanover* 1939
oil on canvas
87.0 x 117.8 cm
Gift of the Women's Committee, 1964

I try to analyse my subject matter for what it presents, initially for its meaning in mood and character and all emanations poured out immediately, with dispatch, retaining all emanations in a comparatively short period of time, only now or never, otherwise all is lost, the result of a bloodless production. It's to retain that first impact and get it out so it is vital and alive; often I turn my back on the subject and paint it for what it has given me.[1]

Carl Schaefer thus described both his method of working and his philosophy. Like his friend David Milne, Schaefer strove in his art to capture his immediate, personal emotional responses. These emotions were grounded in a firm sense of his historical roots, a deep appreciation of craftsmanship, a respect for tradition and a delight in the mystery of nature.

For Schaefer, then, transforming an experience into art was a process involving both understanding and feeling. First, this meant that he had to know his subject well before he could master its representations. Once complete, this protracted study gave him the freedom to turn his back on the subject – sometimes literally. "If you really know what is over there, you have an operation of space that is beyond the eye."[2] Such detailed knowledge also opened the "great space beyond the vision of the eye where there is no object, only mystery. Take the mystery out of a painting and it has no meaning, a mechanical production ..."[3] Knowledge is balanced by the unknowable.

*Farm House by the Railway* is a brilliant encapsulation of the artist's beliefs. Schaefer, who can be seen as a regionalist, recorded the precise location of this farm – "1¼ miles east of Hanover and about 1 mile north, looking south from the railway tracks of the Canadian Pacific Railway and near the north branch of the Saugeen River."[4] And, enjoying a joke, he "couldn't resist putting [in] the outhouse and playing it up in its nice sheltered place."[5] But a dark mood nevertheless pervades the work: Schaefer described this painting as "a reflection of my life during the Depression years of the thirties ..."[6] The farm and its outbuildings are guarded by a decrepit wire fence, the railway line, a twisted hydro pole, a gnarled dead tree and the railway crossing sign. The sense of death and destruction is only slightly relieved by the line of poplars and the vegetable garden. We immediately grasp Schaefer's emotional response to the scene he has portrayed and, vicariously, we are able to experience the same layered and conflicted emotions he clearly felt.

*Ann Davis*
*Director*
*The Nickle Arts Museum*
*University of Calgary*

Notes _____

1. Carl Schaefer in a letter to the author, 8 January 1982.

2. Carl Schaefer, "Personal Reminiscences," *Carl Schaefer Retrospective Exhibition – Paintings from 1926 to 1969* (Montreal: Sir George Williams University, 1969), p. 8.

3. Schaefer to author, 8 January 1982.

4. Carl Schaefer in a letter to Myra Davis, 8 June 1975 (copy in author's possession).

5. Schaefer to author, 8 January 1982.

6. Schaefer to Myra Davis, 8 June 1975.

Cat. 84

SING HOO (1909–2000)
*Portrait of a young girl* early 1950s
hollow cast plaster, painted
36.0 x 21.0 x 19.0 cm
Gift of Catherine Yuen, 2001

Cat. 78

ERNST NEUMANN (1907–1956)
*Boxer* n.d.
posthumous cast 1959
bronze
58.0 x 26.0 x 30.0 cm (including base)
Gift of John Newman, 1957

EDWARD ALEXANDER WADSWORTH (British; 1889–1949)
*Sussex Pastoral* 1941
egg tempera on canvas on wood
63.6 x 76.3 cm
Gift of The Hamilton Spectator, 1965

JOHN SLOAN (1890–1970)
*Rosie the Riveter* early 1940s
plaster
49.8 x 31.0 x 50.1 cm
Gift of the artist, 1965

During the Second World War, the theme of Rosie the Riveter, so popular in the American propaganda-based "We Can Do It" posters, was familiar to Canadian audiences through printed images and recruitment films. However, the flamboyant, defiant picture of Rosie they portrayed was remarkably different from John Sloan's plaster sculpture *Rosie the Riveter*. Sloan's *Rosie* pays far more restrained homage to the wartime contribution of the women who were cast in the non-traditional role of factory worker while the men were sent off to war.

Clothed in baggie trousers and shirt, with her hair tied back in a scarf, the female figure crouches intently, machine in hand, resolutely carrying out her assigned task – a symbol of strength on the home front. In this work, Sloan has encapsulated the efforts of all civilians, especially women working in the war industries, in much the same spirit as Frances Loring and Florence Wyle had in 1918–1919, in their fifteen bronze figures of munitions factory workers done for the Canadian War Memorials Fund.

Sloan's sculpture is an example of social realism, an approach that was explored by several Canadian sculptors in the 1930s and 1940s, including Elizabeth Wyn Wood. The static figure, although far from heroic in size and pose, possesses an iconic impact that makes it a symbol of the labourer. The classical features of the face establish its universal, timeless quality and its anonymity. Yet the tilt of the bowed head and the natural positioning of the bent legs tend to give a hint of the woman as an individual. There is a sense of nobility in the figure of *Rosie,* a dignity and honour that derives from the artist's treatment of a modern subject in a naturalistic, essentially classical style. This approach is echoed in many of Sloan's other works, including *Forty Below* (cat. 67) and *The Welder* (fig. 70). While there is an ominousness to the dark, masked form of *The Welder* that sets it apart from *Rosie,* the carved surface lines and simplified volumes evoke a similar impression of the humble yet stoic worker. In *Forty Below,* a man swathed in heavy clothing against the cold stands protectively over the curled form of a sleeping sled dog, undeterred by the inevitable hardship that awaits him. Like *Rosie,* both these figures are portraits of humanity, symbols of a nation at work and on guard.

The age of public monuments and memorials reached its apogee in the late nineteenth and early twentieth century, and by the time this work was executed sculpture no longer required a pedestal to reinforce its status. Its existence as an autonomous art form was firmly established. Expressed in a sculptural idiom that reflects this transition, *Rosie the Riveter* can be seen as a precursor of modernism in Canada.

*Joyce Millar*
*Director*
*Stewart Hall Art Gallery*
*Pointe-Claire, Quebec*

Fig. 70
JOHN SLOAN
*The Welder* n.d.
bronze, 72.3 x 47.0 x 46.3 cm
Art Gallery of Hamilton
Gift of the artist, 1948

RAE HENDERSHOT (1921–1988)
*The Three Graces* 1946
oil on canvas
45.8 x 61.1
Gift of H. L. Rinn, 1950

EDWIN HOLGATE (1892–1977)
*Uncle George* 1947
oil on Masonite
71.3 x 61.0 cm
Gallery purchase, 1953

A. J. CASSON (1898–1992)
*First Snow* 1947
oil on Masonite
76.2 x 91.3 cm
Gift of Mrs. Harold H. Leather, 1952

**T. R. MacDonald** (1908–1978)
*One A.M.* 1956
oil on canvas
41.6 x 51.0 cm
Gift of the Women's Committee, 1958,
dedicated to the memory of Jean Middleton Keogh,
President of the Women's Committee, 1956–1958

ALEX COLVILLE (b. 1920)
*Horse and Train* 1954
glazed oil on hardboard
41.5 x 54.3 cm
Gift of Dominion Foundries and Steel Limited (Dofasco), 1957

Alex Colville is Canada's best-known living artist. Even those who do not recognize his name will have had the coinage that he designed for the 1967 Centennial of Canadian Confederation in their pockets and purses, and many have certain of his images fixed in their minds. Folk music lovers will know *Horse and Train* from its use on a Bruce Cockburn record jacket. Colville's pictures – despite his own occasional doubt – have proven to possess broad popular appeal.

*Horse and Train* was purchased for the Art Gallery of Hamilton three years after Colville painted it. He wrote to fellow-artist and then gallery director T. R. MacDonald of his delight that the painting had found a home in Hamilton. Colville thought that "it was quite good" but realized that "few individuals would buy it for hanging in a home (most people seemed to consider it exceedingly morbid)…"[1] Many of Colville's images recall the Surrealist strategy of unusual association – the fusion of dream and reality – and possess an edgy, super-realist sense of impending disaster. They are unsettling, perhaps because the artist has been concerned since his service as a war artist (1944–1946) with death – a ubiquitous feature of armed conflict that reached particularly horrific proportions in the death camps of the Holocaust. At the end of the war, Colville, like many others, was concerned with the questions of conduct that had been raised by the Nazi phenomenon and the Holocaust.

*Horse and Train* is inspired by an inverted couplet from a long poem entitled "Dedication to Mary Campbell," published in 1949 by the South African poet Roy Campbell:

> Against a regiment I oppose a brain
> And a dark horse against an armoured train.

The human brain and the dark horse are equated in the poem, giving credence to an interpretation of the painting as a representation of the challenge that individual human creativity can present to systems of mass behaviour enforced by rules, regulations and ideologies. Campbell toured North America in 1953 and gave a reading in Sackville, New Brunswick, where Colville, a professor on the faculty of Mount Allison University, would have had an opportunity to meet him.[2]

The key to the reading of the image is given in Colville's letter to MacDonald. The artist is well read in philosophy, from the existentialists whose works were current after the war, to more recent writings on metaphysics and morals by the late Iris Murdoch. From his letter, we know that Colville had also explored the thought of the psychologist Carl Gustav Jung and was then "inclined to believe" in the existence of "the collective unconscious … Both horses and trains have, or call up in our minds (at least in mine), various symbolic and only vaguely comprehended echoes."[3]

Colville's horse is a symbol of "innocent power." That animals possess "innocence" is a view he continues to hold and to represent in his images. Animals, symbols of harmony, are essentially unknowable. We cannot *know* the horse, but the image stimulates us to construct narratives drawn from that fecund space between imagination and reality.

*Michael Bell*
*Adjunct Professor*
*Carleton University, Ottawa*

Notes_____

1. Alex Colville in a letter to T.R. MacDonald, 8 February 1957, Accession File, Art Gallery of Hamilton.

2. In his letter to T.R. MacDonald Colville quotes (incorrectly) from memory the two lines of Campbell's poem, describing the brain as a "human" brain. There is a full discussion of this painting in the publication accompanying the artist's 1983 retrospective: David Burnett, *Colville* (Toronto: Art Gallery of Ontario and McClelland & Stewart, 1983), pp. 96–105.

3. Colville to MacDonald, 8 February 1957.

PHILIP SURREY (1910–1990)
*The Lovers* c.1957
oil on canvas
61.3 x 45.8 cm
Bequest of Josephine M. Magee, 1958

*P*hilip Surrey acquired a taste for mood, atmosphere and the expressive use of colour through his early friendship with F. H. Varley, in Vancouver. During his subsequent travel and study in the United States he developed an interest in American regionalism that leaned towards illustration and narration, and drew upon local sites, events and myths for inspiration. William Gropper and Martin Lewis were both clear influences on his subsequent development. In Montreal, where he settled in 1937, he found a large urban stage and wealth of subjects.

Surrey was a loner by nature, given to irony and secrecy, and wary of emotional attachments. More often than not the figures in his paintings are also solitary, sharing little more than the city's streets and cafés. Where relationships are indicated, they tend to be troubled, even violent. Many of his paintings are nocturnes, filled with dark recesses, ambiguous shapes and menacing shadows.

*The Lovers* dates to around 1957, when Surrey, at the height of his power, was producing the most refined and ambitious paintings of his career. It is characterized by spatial complexity, distinct zones of colour, flickering brushwork, close observation and subtle nuances. This was not always the case, for many of Surrey's paintings verge on caricature.

The lovers stand in the left foreground against a shop window, dimly illuminated by sickly green light. The man leans forward, ardently pleading with the woman, whom he presses towards the window. She appraises him coolly, while holding him at bay. Their relationship appears to be in crisis. The shadowy setting, the stop sign and the turned backs of the other figures hint that it is also illicit. The egg- and oven-like forms visible through the shop window suggest that the woman might be pregnant. Most unsettling of all is the

Fig. 71
FREDERICK HORSMAN VARLEY (1881–1969)
*Night Ferry, Vancouver* 1937
oil on canvas, 81.9 x 102.2 cm
Purchase, 1983
McMichael Canadian Art Collection, 1983.10
© 2004 Estate Kathleen G. McKay

woman's face, which resembles that of Surrey's own wife, Margaret.

Is the man with his back to us part of a lovers' triangle? We can only speculate. But the inclusion of the third figure is a reminder of F. H. Varley's *Night Ferry, Vancouver* (1937, Kleinburg, McMichael Canadian Art Collection, fig. 71), which he painted after spending the Easter weekend of 1937 with Surrey in Montreal. In Varley's nocturne, two lovers stand at the railing of a ferry, bathed in moonlight. A solitary male can be seen nearby, his legs braced and back turned to the viewer. He is Varley's alter ego, the original lonely guy. The lovers exist only in his imagination, a representation of his romantic ideal of a trusting, heartfelt relationship. By comparison, Surrey's view of love – fraught with mistrust and anxiety – is altogether more credible and familiar.

*Christopher Varley*
*Art dealer and consultant*
*in historical Canadian art*

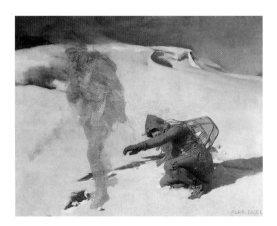

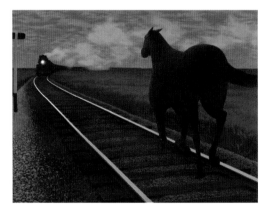

# Considering the Canon

*Joyce Zemans*
*University Professor*
*York University, Toronto*

It was in the village of Vienna, south of London, Ontario, during the Depression ... in [the] one-room schoolhouse that he encountered the travelling exhibition of Group of Seven reproductions that inspired him to dedicate his future to art. He always told me that seeing that show was the pivotal point in his passion for art.[1]

Noel Saltmarche describing his father, Kenneth Saltmarche, artist and founding director of the Art Gallery of Windsor

What attracts Canadians to a painting and why does it become a favourite? Why do some pictures become canonic – symbolic of a style, a moment in time, or a way of seeing the world? Is it a question of aesthetics? Is a "masterpiece" immediately recognizable? Or are there other reasons why certain works of art have become imprinted on the collective Canadian consciousness? My aim is to attempt to answer these questions by exploring the role that reproductions have played in locating a work of art in the public imagination. Looking at paintings in the collection of the Art Gallery of Hamilton (AGH), I will examine how some images have come to represent a moment in history, or at least in the history of Canadian art.

Designed to present the very best of the AGH's holdings of historical art, *Lasting Impressions* is bracketed by two such images, William Blair Bruce's *The Phantom Hunter* (1888, cat. 6) and Alex Colville's *Horse and Train* (1954, cat. 85). These works, along with three others in the Gallery's collection dating from the turn of the twentieth century – George Reid's *Forbidden Fruit* (1889, cat. 7),

Horatio Walker's *Ave Maria* (1906, cat. 15) and Maurice Cullen's *Logging in Winter, Beaupré* (1896, cat. 12) – will be the central focus of my discussion. In an effort to prove my case, I will conclude by considering a work of comparable quality that did not enter the canon, or at least not until very recently: Prudence Heward's *Girl Under a Tree* (1931, cat. 63).

Asked to name their most memorable image in the nation's art, most Canadians would cite Tom Thomson's *The West Wind* (1916–1917, Toronto, Art Gallery of Ontario, fig. 72) or *The Jack Pine* (1916–1917, Ottawa, National Gallery of Canada, fig. 73), or perhaps one of Lawren Harris's frozen Lake Superior scenes. Georgian Bay has been forever fixed in the Canadian consciousness by Fred Varley's *Stormy Weather, Georgian Bay* (1921, National Gallery of Canada) and Arthur Lismer's *A September Gale – Georgian Bay* (1921, National Gallery of Canada) – two other likely candidates. Almost everyone would recollect a landscape. Unpeopled wilderness scenes, many representing the geography of central Canada and most painted before 1930, have become synonymous with the notion of Canada for Canadians in every part of this country.

There are other images, however, that trigger a similar sense of familiarity and identification with the Canadian experience. In May 2003, reviewing the major Tom Thomson retrospective at the Art Gallery of Ontario, *Globe and Mail* critic James Adams described Thomson as "Canada's best-known painter, possibly even its *best*." But discussing *The West Wind*, known to every Canadian schoolchild, Adams went on to write that Thomson's

Fig. 72
TOM THOMSON (1877–1917)
*The West Wind* 1916–1917
oil on canvas
120.7 x 137.9 cm
Art Gallery of Ontario, Toronto
Gift of the Canadian Club of
Toronto, 1926

Fig. 73
TOM THOMSON (1877–1917)
*The Jack Pine* 1916–17
oil on canvas
127.9 x 139.8 cm
National Gallery of Canada,
Ottawa, purchase 1918

huge oil "is as indelibly etched into the Canadian conscious-ness as that damn dark horse that Alex Colville painted hurtling toward a train forty-nine years ago."[2]

Most Canadians would recognize *The West Wind* immediately and would probably even be able to identify Thomson, the archetypal Canadian artist – a figure of myth and romance – as its creator. Yet Adams suggests that we may be just as familiar with Alex Colville's *Horse and Train*. How have these images come to be so forcefully imprinted on our minds when few of us have seen the "real" paintings and we can only guess at the size or the technique of either?

In her 1966 exhibition *Images for a Canadian Heritage*, curator Doris Shadbolt included those works she believed had "caught" the Canadian imagination and become central to the Canadian narrative. Their staying power, she conjectured, lay not only in their artistic qual-ity, or their historical or sociological significance, but in "some unique blend of events, of vivid and condensed experience in a memorable form which only time, for its own peculiar combination of reasons, can verify."[3] *The Phantom Hunter*, *Forbidden Fruit*, and *Horse and Train* were all part of that exhibition.

Each of us has our favourites in every gallery or museum we visit, works that resonate and call us back. Even for first-time visitors there may be a moment when they stop, confronted with a work that particularly touches them – a work that strikes a chord of familiarity deep in their subconscious. In the AGH holdings, too, there are favourites – works that appeal to a broad audi-ence. Often, they have become part of the Canadian canon. More than just a collection of masterworks, these images have "that particular presence and impact which makes them capable of carrying over into the imagination as memorable and enduring images."[4] All represent some aspect of the Canadian experience. As Doris Shadbolt put it, "… they all speak for us."[5] I would argue that they also speak *to* us. In the case of the paintings we have selected for discussion from Hamilton's collection, they are not only representative of the artist's work but have become quintessential signifiers of a stylistic period and a moment

in time. These works are selected regularly for exhibition and reproduction, not only in Hamilton but across Canada and internationally.

There are multiple answers to the question of why certain works achieve this status, and some of them are intertwined. First, there is the work of art itself. How do we respond to it and why? The artist's place in the history of art is a critical issue, as is the importance of the indi-vidual work within the artist's own production. Yet for a work to become part of the Canadian imagination – a memorable and enduring part – it has to be accessible to a wide audience. Indeed, as the opening quote about Kenneth Saltmarche attests, the work need not even have been seen in the original for it to have a lifelong impact. Critic Walter Benjamin believed that reproductions of a work of art diminish the aura of the original. Yet it could be argued that Canadian art has been largely defined through surrogate images and through those generally unidentified cultural transactions that have made the "real" painting seem familiar to us even though we may never have actually encountered it face to face.

Through reproduction in prints and posters, in books on Canadian art and Canadian history, and in myr-iad other ways, these images have imprinted themselves on our consciousness. A little homework, and James Adams' familiarity with Alex Colville's *Horse and Train* comes as no surprise. Since the 1970s, the painting has not only been included in numerous books on Canadian art but has been widely distributed as a poster.[6] Less obviously, this evoca-tive image may have lodged in our subconscious when used as the cover image for works as diverse as Bruce Cockburn's 1973 record album *Night Vision* (the image appears today on Cockburn's website) and such books as Robert Kroetsch's *The Studhorse Man* (1982), Robert Wright's *Economics, Enlightenment and Canadian Nationalism* (1993)[7] and Jean Marcoux's *L'Homme qui souriait en dormant* (1995). The painting is also reproduced in Anthony Luengo's *Canadian Writer's Companion* (1995) to help readers recog-nize a sentence. The examples given include the following: "Alex Colville is a well-known painter. 'Horse and Train' [is] one of his most famous works."[8]

## The Right Place at the Right Time

It is fascinating to examine the way in which a number of works from the AGH's historical collection of Canadian art have been incorporated into and become central to the canon – that body of work selected for exhibition and reproduction as epitomizing the Canadian artistic experience. How this process occurred is particularly interesting if we consider that the Gallery only began collecting seriously in the 1950s, long after most of the paintings had been completed and the artists who created them had died.

By 1953, when the Gallery moved into its own building and T. R. MacDonald was actively building its collection, Bruce, Reid, Walker and Cullen were already well-established in Canadian art history and well-represented in existing survey texts.[9] Though Colville was at the beginning of his career, the distinctive quality in his work had been recognized. Nevertheless, except for Bruce's *Phantom Hunter*, a painting that had been regularly exhibited and reproduced since it entered the Gallery's collection in 1914, the works we are examining remained largely unknown. How did these works become, within a little over a decade, central to the narrative of Canadian art?

Synchronicity played a key role in the process. In the 1950s, with the development of new techniques for the printing of colour reproductions, art books not only became an important source of information for the general public but began shaping the knowledge of artists and art historians as well. From 1952 onwards, the Gallery itself regularly reproduced works from its collection in its newsletter.[10] While histories of Canadian art were not new, in the buildup to 1967 – the centenary of Canadian confederation – an increasing sense of nationhood and the desire to tell our own story coincided with the intense collecting activity that took place at the AGH in the late 1950s and the 1960s.[11]

In 1954, Malcolm Ross had written on the subject of Canadian identity: "As a people we are still 'becoming' in motion."[12] A decade later, that motion had propelled Canada into a mode simultaneously retrospective and forward-looking. This was the moment when, in anticipation of centennial year, the country began a serious stocktaking of its achievements. In the case of the nation's art, this spirit was manifested in a remarkable number of exhibitions and art books, all celebrating Canadian creation. Although the number of public galleries was still limited, there was a concerted attempt to represent the breadth of Canadian public collections in survey texts and exhibitions.[13] It was a propitious moment at which to introduce new works (albeit by well-established artists) into the public domain. *The Hamilton Spectator* would record the gallery's accomplishments: "Centennial year has strengthened the feeling of pride members of the Women's Committee of the Art Gallery of Hamilton [which had been responsible for a good number of the acquisitions] feel in the Gallery's permanent collection. Many of the books on Canadian art, published this year, contain illustrations attributed to the Hamilton Gallery." The journalist went on to quote Evelyn Rahilly, committee member and speaker at the 1967 Annual General Meeting, as saying: "Our collection is recognized now for its excellence."[14]

A brief look at some of the art survey books published during this period illustrates the Gallery's high profile. Not surprisingly, the National Gallery of Canada, whose mandate included the promotion of knowledge of Canadian art, was central to the publishing initiatives. In 1963 the National Gallery published *The Development of Canadian Art*. Its author, the Gallery's chief curator, Robert Hubbard (a McMaster University graduate who had spoken at the AGH's first annual general meeting in September 1949), discussed four of our five Hamilton artists (George Reid, oddly, was not included) in his relatively brief text designed to encompass all of Canadian art to date. The one Hamilton work he reproduced was Bruce's already well-known *Phantom Hunter*.

By 1966, when the University of Toronto Press published another survey text, this one written by the National Gallery's curator of Canadian art and dedicated exclusively to painting, the situation had changed. Russell Harper's *Painting in Canada: A History* became the first comprehensive, large format, well-researched and well-illustrated survey of Canadian painting. In his book Harper

not only discussed each of our five case-study artists but also reproduced all four of the historical works from the Hamilton collection. And though he did not reproduce *Horse and Train*, he described the work as verging on "surrealism: a black horse gallops along a railway track towards an onrushing train and creates a spirit of crisis."[15] When the second edition of this book was published in 1977, it included an image of *Horse and Train*. The principal popular survey text on Canadian painting, this book continued to shape public consciousness for several decades. (Dennis Reid's 1973 paperback, *A Concise History of Canadian Painting*, was designed principally as a text book and relied less on familiar iconic images, searching further afield for its subjects. It did, however, include discussions of all of the artists we are considering, as well as reproductions of George Reid's *Forbidden Fruit* and Maurice Cullen's *Logging in Winter, Beaupré*.)

Another celebratory centenary publication, the 1966 *Great Canadian Painting: A Century of Art*, edited by Elizabeth Kilbourn and Frank Newfeld, targeted a general audience.[16] Designed as a reasonably priced coffee-table book reproducing "masterpieces" of Canadian art, *Great Canadian Painting* was, as its title suggests, intended to be a summation of the best in Canadian painting. Each of the five pictures in the Hamilton collection that are the focus of this essay was reproduced, along with a history of the artist and of the work itself.

That same year, the Vancouver Art Gallery Association published *Images for a Canadian Heritage* to accompany an exhibition celebrating another historical moment, "the one-hundredth anniversary of the incorporation of the Colony of Vancouver Island into the Colony of British Columbia." Dedicated to the citizens of "the great Province of British Columbia," it reproduced Bruce's *Phantom Hunter* and Colville's *Horse and Train*. Curator Doris Shadbolt wrote: "To ourselves these [works] seem essentially national and to the world at large, in the best sense of the word, regional ... Yet all have emerged on some level of awareness and from some kind of experience which is peculiarly of this country."[17]

The catalogue of yet another National Gallery centennial project, Robert Hubbard and Jean-René Ostiguy's 1967 survey *Three Hundred Years of Canadian Art: An Exhibition Arranged in Celebration of the Centenary of Confederation*, included works by all five of our artists but reproduced only Reid's *Forbidden Fruit*. That same year, Clare Bice, curator at the London Public Library and Art Museum, who had been appointed visiting curator of the Canadian government pavilion at Expo '67, organized *Canadian Painting 1850–1950*. This circulating exhibition, which toured communities across Canada, was shown in Hamilton in the spring of 1967. An historical survey that borrowed widely from Canadian collections, it included *The Phantom Hunter* and *Logging in Winter, Beaupré*, both of which were illustrated in the catalogue.

The choices of these curators and authors varied somewhat, conditioned by such circumstances as the status of the artist, the importance of the individual work, and geographic and institutional representation. The accessibility of the image was, however, a common denominator. Though some works selected for exhibition or reproduction may have come from private collections, the majority of them had entered the public domain before their entry into the canon. Doris Shadbolt observed that many of the works she selected for exhibition and reproduction belonged to public collections or were widely known through having already been exhibited and reproduced. Like most of her colleagues, she sought works that had the potential to or had already "struck and lodged in the popular collective imagination."[18]

It becomes clear that the AGH began collecting in a significant way at a propitious moment – the very moment that the writing of Canadian art history became a serious enterprise. Although there have been numerous monographs and subject-specific texts published since that time, there has never been the same focus on – or resources dedicated to – creating an overview of Canadian art. Though each of the artists we are considering had already found his place in history, it can be argued that it was as a result of the synchronicity between T. R. MacDonald's interest in building (with the advantage of hindsight) a Canadian historical collection and the nation-wide effort

to create (taking advantage of developments in publishing technology) a new Canadian art history, that the five works from Hamilton's collection under discussion entered (and have remained in) the Canadian canon.

In subsequent years, their status was consolidated. *Through Canadian Eyes: Trends and Influences in Canadian Art 1815–1965,* the 1976 catalogue of an exhibition curated for the Glenbow-Alberta Institute by Moncrieff Williamson, director of the Confederation Centre Art Gallery in Charlottetown, included reproductions of *The Phantom Hunter, Forbidden Fruit* and *Logging in Winter, Beaupré.* Of the five artists that concern us, only Horatio Walker was not discussed. Patricia Godsell's popular 1976 coffee-table survey *Enjoying Canadian Painting* commented on all of the historical artists and included reproductions of Bruce's *Phantom Hunter* and Walker's *Ave Maria.* Twenty-five years later, Anne Newlands' selective *Canadian Art From Its Beginnings to 2000* reproduced three of the Hamilton works: *The Phantom Hunter, Forbidden Fruit* and *Horse and Train.*

Though paintings by Maurice Cullen had been reproduced regularly in art texts during the first half of the twentieth century (his importance as an artist having long been established), it was only after *Logging in Winter, Beaupré* entered the AGH collection in 1956 that it began to be included in texts on Canadian art. Since that time, it has become synonymous with Cullen's work and, for many Canadians, stands as the painting whose style and subject matter best illustrate his significance as a precursor to and inspiration for the Group of Seven.

Of course, contemporary standards or fashions (art historian Newton MacTavish astutely and somewhat impudently suggested that the two are often indistinguishable) certainly influenced the selection of artists and images for widely accessible books on Canadian art, as did the fact that the books and exhibitions were usually aimed at a general audience. Nevertheless, from author to author there is a remarkable consensus in the choice of artists selected for representation.

Personal taste also influenced the process. T. R. MacDonald's own practice and interests focused particularly on figure painting, a genre that had hitherto played a negligible role in the Canadian canon that, at this critical historical moment, was beginning to broaden its scope.[19] It is perhaps not surprising, then, despite the fact that Canadian art continues to be conflated with the image of the unpopulated landscape, that none of the Hamilton works selected for consideration is a pure landscape. Reflecting the Victorian era when they were created, the works by Bruce, Reid and Walker each has a strong narrative component, with a distinct story stated or implied. Each of the works represents a particular moment in Canada's social history and a particular stylistic period in Canadian art history. Though landscape is a significant element in all but the Reid work, the figure predominates, except in Cullen's *Logging in Winter* – and it is present, even there.

One more observation should be made at this point. All the works discussed here are paintings. Paintings are two-dimensional, generally colourful, and lend themselves easily to reproduction (and to exhibition, it might be added). When in the 1930s and 1940s gallery directors like Eric Brown and Harry McCurry of the National Gallery of Canada and artists such as A. Y. Jackson and Lawren Harris advocated programs of high-quality reproductions to promote Canadian art, they were concerned almost exclusively with paintings. In the late 1940s, the AGH had begun selling not only National Gallery reproductions but also reproductions of paintings from its own collection, particularly in postcard and Christmas card formats. As well as promoting the collection, reproductions proved to be a good source of income. By late 1950, sales of reproductions had generated sufficient funds for the Gallery to purchase A. Y. Jackson's *La Cabane* (1949). Almost immediately, the Gallery announced that a lithographic reproduction of the painting would shortly be on sale.[20] Sculpture, however, was a less likely subject. Even a sculpture like Hamilton's favourite, John Sloan's *Rosie the Riveter* (cat. 79), is little known outside the city. In the decades following their acquisition by the Gallery, however, the Reid, Cullen and Colville works were reproduced in poster-size images and marketed nationally and internationally through art galleries, framers and

department stores. Before long, they hung in homes, offices and public buildings across Canada.[21]

## Why These Works?

As we know, all five of the images that are the focus of our discussion were featured in 1966 in the book *Great Canadian Painting*. Each of them had, in Doris Shadbolt's terms, "caught" the Canadian imagination and become central to the Canadian narrative. Why? An analysis of the discussions of the works in the various survey texts answers our question, but there is no single reason. Neither their historical nor sociological significance alone, but a "unique blend of events, of vivid and condensed experience in a memorable form" has stamped these images on our consciousness. It is this "blend of events" that I propose to examine here. The importance of the artist (his role in Canadian art history) and the specific painting's aesthetic and historical significance will provide the framework for my discussion of each of the selected works.

William Blair Bruce provides an excellent case study. Born in Hamilton in 1859, he left Canada in 1881 to study in Paris. Bruce was an expatriate for most of his life, and his career and reputation were formed in Europe. An exhibitor at the Paris Salon, he painted for the European market, and contemporary European taste strongly influenced his choice of subject. Without the family bequest of his work to the AGH in 1914, he would, I submit, never have entered the Canadian canon.

Describing Bruce as an "Ontario lad," Newton MacTavish re-appropriated him for Canada in his 1925 book *The Fine Arts in Canada*, arguably the first important twentieth-century survey of the nation's art.[22] MacTavish singled Bruce out as *the* painter of the 1880s, suggesting that although both he and his Canadian contemporary Paul Peel had contributed to the "outstanding aesthetic progress of the 1890s," Bruce's work was "more interesting" and deserving of a "higher place in the Canadian canon."[23] This praise guaranteed Bruce, whose artistic career had been spent outside the country, a place in Canadian art history. And MacTavish's inclusion of *The Phantom Hunter*

in *The Fine Arts in Canada* was instrumental in establishing the painting's iconic position in Canadian art. Though the painting was not exhibited in Canada until after the artist's death, this "decidedly nationalistic" work would come to represent Bruce and his achievements to Canadian audiences.[24]

Subject matter certainly played a role in determining a work's popularity. In contrast to European painting of the period, which often represented nature in its bounty, *The Phantom Hunter* (executed in Giverny, France) represents the now familiar Canadian theme of confrontation with a hostile and threatening environment. Though its style, with its obvious Impressionist influences, was typical of the late nineteenth-century Paris Salon, its subject matter was not. Shadbolt describes "the trapper haunted by his fears as represented in the figure of the 'shadow hunter,'" adding that "this large work, painted entirely in variations of ghostly grey-blue, typifies the spell and terror of the lonely frozen north."[25] Bruce had hoped that the exotic drama of a Canadian story would appeal to the French Salon audience for whom it was created. In fact, it would be Canadians who were captivated by the visual drama of the winter scene. The image's later association with a First Nations legend, albeit interpreted by a late nineteenth-century American Romantic poet, would contribute to its enduring power.[26] Haunted and haunting, the painting and the legend it represents have remained a central image in the Canadian canon.

The place of Ontario-born George Agnew Reid in Canadian art history was guaranteed not only by his own art but also by the key role that he played in the history and development of Canadian art and its institutions. A prize-winning artist who exhibited internationally, he was a teacher and principal of the Central Ontario School of Art and Design and of its descendant, the Ontario College of Art. President of both the Ontario Society of Artists and the Royal Canadian Academy, he was influential in shaping the National Gallery of Canada and in the creation of the Art Gallery of Toronto (now the Art Gallery of Ontario). He also became a champion of mural art and public art generally, holding the philosophical view that

"morals and aesthetics in the highest sense cannot be separated."[27] Newton MacTavish dedicated a chapter of his survey to Reid.[28]

Educated in Canada, France and the United States, Reid was a firm believer in the academic tradition and was strongly influenced by the three years he spent at the Pennsylvania Academy of Fine Arts studying under the American realist Thomas Eakins.[29] Indeed, in his 1976 catalogue *Through Canadian Eyes*, Moncrieff Williamson credited Reid with introducing Eakins' method to Toronto.[30] A representative of late nineteenth-century North American realism, Reid has been variously described as a "genre painter" (by Russell Harper), as "one of the most significant of all Canadian realists" (by Paul Duval) and as an exponent of "sympathetic realism" (by Christine Boyanoski).[31]

Reid's painting *Forbidden Fruit* illustrates particularly clearly the influence of Eakins in the emergence of a Canadian realist tradition. Purchased from the artist in Philadelphia around 1890, after being exhibited at the Pennsylvania Academy, the painting did not enter the public domain until the AGH purchased it from a private dealer in Montreal in 1960. Within a few years it was being reproduced regularly – and little wonder, given the universal appeal of its depiction of rural childhood. Compositionally, it is easily accessible, and the psychological allure of the subject is undeniable: who cannot remember hiding away in order to finish a spellbinding book? In their description of the work, the authors of *Great Canadian Painting* add an element of drama, recounting that the artist's strict Scottish father would thrash him whenever he caught him "frittering away his time with crayons and paper," and observing that the book the boy has "hidden away to read is *The Arabian Nights*, one of the first books forbidden Reid by his father."[32] The attraction of reading, the hayloft setting, the romance of a moment of escape, nostalgia for one's own childhood – all these elements, combined with the work's capacity to represent narrative painting in Canadian art, account for its continued popularity once it had entered the Hamilton collection.[33]

Horatio Walker was also an Ontario lad, though his subject matter of preference was dramatized scenes of rural Quebec. These were painted less for local consumption than for the wealthy American collectors who made him one of the most popular painters in North America in the early decades of the twentieth century. When in 1906 the City Art Museum of St. Louis bought Walker's *Wood Cutters* (now in the Power Corporation Collection, Montreal) from him for $10,000, it was said to be the highest sum yet paid to a native artist on this continent.[34] Though he had established a New York studio in 1878 and was represented by a New York dealer, Walker played a major role in the shaping of a Canadian landscape image. Critic Hector Charlesworth described his art as "work of ... unmistakably native individuality,"[35] praising Walker's scenes for their "virility" and "cosmic power."[36] Walker settled on Quebec's Île d'Orléans in 1883 and continued to paint the life of its farmers until his death in 1938, at the age of eighty.

*Ave Maria*'s early attraction lay in its nostalgia for a way of life that was fast disappearing in a rapidly industrializing America. Like Walker's work in general, it owed in its ennoblement of peasant life a great debt to the French Barbizon artist Jean-François Millet. Indeed, Walker, said to have "out-Barbizoned the Barbizons,"[37] has been described as the only "American [sic] artist sufficiently endowed with the French artist's rare combination of raw simplicity and dramatic design to merit the title of 'The American Millet.'"[38] It is thus not surprising that *Ave Maria* was included in the 1975 exhibition *American Art in the Barbizon Mood*, shown at Washington's National Collection of Fine Arts. With its "gloriously tinted sunset glinting along the edge of a roadside Crucifixion," wrote curator Peter Bermingham, and "the finely chiseled figure of the dying Messiah hanging in mute contrast over a nondescript peasant boy and his indifferent oxen," the painting is "indebted to Millet's atypically sentimental *Angelus*."[39] The author went on to note that "for modern tastes, Walker is more effective in his attempts to re-create the timeless struggle of man and beast to forge a living or at least an existence, out of the unyielding pastures of the remote Île d'Orléans."[40]

This painting is at the heart of a fascinating tale about nationalism and the canon – and the importance of

accessibility. Painted in 1906, *Ave Maria* was sold in 1907 by the artist's New York dealer for $7,000 to the prestigious Corcoran Gallery of Art in Washington. However, once the work had gone out of fashion its Canadian authorship made it less desirable to a gallery focusing heavily on American art, and in the mid-1950s the painting was de-accessioned.[41] Purchased by the AGH in 1963 from Toronto's Laing Galleries for $5,500, it quickly assumed its position in Canadian art history as representative of a stylistic and historical moment in Canadian art and life.

Maurice Cullen, born in St. John's, Newfoundland, in 1866, has been described as the first Canadian painter to make art for art's sake and "in a quiet way the strongest native influence on later Canadian painters."[42] Recognized and honoured in Paris where he had studied, Cullen (unlike his friend and colleague James Wilson Morrice) chose – in what can hardly have been a career move – to return to live in Canada. He would struggle financially throughout his life. Cullen became a hero to many younger Canadian painters, and his work was quickly integrated into the art historical record. *Logging in Winter, Beaupré*, however, which had been acquired by the artist Robert Harris (possibly from Cullen's studio auction in 1897),[43] would not be reproduced until 1956, when it was purchased by the AGH on the occasion of the Cullen retrospective mounted by the Gallery in collaboration with the National Gallery, the Art Gallery of Toronto and the Montreal Museum of Fine Arts.

More than any other artist we have looked at, Cullen's position and the place of this particular painting in the canon have been guaranteed as a result of his importance to other artists. James Wilson Morrice said Cullen was *the* man in Canada who "gets at the guts of things."[44] A. Y. Jackson described him as teacher to the Group of Seven, a powerful stimulant who helped to create a climate receptive to radical change in response to the dull salon painting that prevailed.[45] Looking at *Logging in Winter*, Arthur Lismer recounted to a friend that it was Cullen who had taught him how to paint snow.[46] In paintings less atmospheric than the winter landscapes of such Impressionist-influenced colleagues as Marc-Aurèle de Foy Suzor-Coté, Cullen strove (wrote his stepson Robert Pilot), while mixing a tone on the palette, "to keep the colours as separate as possible so that liveliness and vibrancy would be achieved."[47] In his 1974 book *The History of Painting in Canada: Toward a People's Art*, a text dedicated to art that "reflects our people and places," Barry Lord described the subject as remarkable in the artist's attempt to "leap directly to the depiction of the working figure in the landscape. A lumberman applies the switch to an ox dragging a sleighload of logs up a hill and around a bend in the road in mid-winter."[48] Yet Lord, like other art historians and critics, concluded that the real strength of this work lies less in the image of the working man than in Cullen's concentration on the effects of bright sunlight and shadow on deep snow. Discussing the artist's application of Impressionist theories of light, Lord observed that the crisp, clear winter's day that Cullen depicted would have been unknown in France.[49] Since its acquisition by the AGH, *Logging in Winter, Beaupré* has assumed its rightful place in Canadian art history and has been regularly reproduced in histories of the Group of Seven, as well as in most survey texts on Canadian art.

The only contemporary artist of our Hamilton five, Alex Colville, has a special place in the history of Canadian art. Often described as a "regionalist" painter, he taught at Mount Allison University from 1946 to 1963, and his vision was influential in shaping the style often associated with East Coast Canadian artists in the second half of the twentieth century. Colville is one of Canada's most written-about artists, and his talent was acknowledged early in his career. In 1966, he was described as "one of the two or three best-known living Canadian painters – outside Canada."[50] Critic James Adams' remark about *Horse and Train*, quoted in the introduction, suggests, moreover, that Colville's paintings are amongst the most recognized in Canada. Though many of them have become familiar, *Horse and Train* has taken on a life of its own. As we have seen, its haunting image has been used to sell records, novels and textbooks, as well as being reproduced as a popular poster.

Like *The Phantom Hunter*, Alex Colville's *Horse and Train* was inspired by a poem. South African writer Roy

Fig. 74
CORNELIUS KRIEGHOFF
(1815–1872)
*The Habitant's Home*   1870
oil on canvas
69.5 x 92.8 cm
Gift of Reginald W. Watkins, 1962

Campbell's poem "Dedication to Mary Campbell" includes the lines: "Against a regiment I oppose a brain / And a dark horse against an armoured train." When the AGH purchased the work in 1957, Colville wrote to Gallery director T. R. MacDonald, saying how pleased he was that what many saw as a rather "morbid" work had found a home in a public gallery.[51] In his 2001 publication *A First Book of Canadian Art*, Richard Rhodes reproduced the painting alongside a text on Cold War Realism – another example of the staying power of this iconic image. Colville has described his paintings as the products of "'dreams, memories, recollections,' to borrow Jung's terms – a kind of synthesizing of total experience."[52] Like dreams, Colville's works demand interpretation: but the artist offers none. The outcome of this unforgettable scene remains unknown, but the image is indelibly fixed in our memories.

## Other Contenders

There are a number of other historical works in the AGH's collection that are well known and well loved, and that I might have chosen. William Brymner's *The Vaughan Sisters* (1910, cat. 24) is often reproduced and perhaps should have been included in this analysis, though it appears less frequently than the works selected for our case studies. Likewise, Cullen's *Cape Diamond* (1909, cat. 21) is a familiar work for many Canadians. Michael Tooby included it and *Logging in Winter, Beaupré* in his 1991 exhibition *The True North: Canadian Landscape Painting 1896 to 1939*, shown at London's Barbican Gallery. But only *Logging in Winter*, quintessentially representative of Cullen's work, earned a colour reproduction in the catalogue.

The AGH has a strong collection of work from the 1930s. I seriously considered including Charles Comfort's colourful and enigmatic *The Dreamer* (1929, cat. 60), but it is less familiar than his often reproduced and unforgettable portrait of the artist Carl Schaefer, *Young Canadian* (1932, acquired by Hart House, University of Toronto, in 1934), or his Precisionist-influenced landscape *Tadoussac* (1935, acquired by the National Gallery of Canada in 1968). Schaefer's own *Farm House by the Railway, Hanover* (1939,

cat. 77) also evokes a nostalgic sense of recognition for many viewers. However, a review of the literature reveals that this painting's familiarity may lie in the fact that similar images of the fields of Hanover County, acquired by other collections earlier in the century, have been regularly reproduced. As is the case with his contemporary in the United States, Charles Burchfield, Schaefer's images of farmhouses and wheat fields have come to symbolize the Depression-era farming community at that moment in North American history. The Gallery's well loved and often reproduced *The Habitant's Home* (1870, fig. 74) by Cornelius Krieghoff falls into the same category. Krieghoff's paintings are often variations on a theme, and similar images – such as the National Gallery's *The Habitant Farm* (1856) and the McCord Museum's *Log Hut on the St. Maurice* (1862, Montreal), which were also widely circulated in reproduction – are frequently selected to represent this aspect of his work.[53]

I also considered the Gallery's wonderful collection of works by Tom Thomson and members of the Group of Seven, such as Thomson's *The Birch Grove, Autumn* (1915–1916, cat. 37) or J.E.H. MacDonald's *A Rapid in the North*

Fig. 75  J.E.H. MACDONALD  (1873–1932)
*The Solemn Land*   1921, oil on canvas, 122.5 x 153.5 cm
National Gallery of Canada, Ottawa, purchase 1921

(1913, cat. 33), which was included in Roald Nasgaard's groundbreaking 1984 exhibition *The Mystic North: Symbolist Landscape Painting in Northern Europe and North America, 1890–1940*. MacDonald's exquisitely composed *Rain in the Mountains* (1924, cat. 52), and Lawren Harris's *Waterfall, Algoma* (c.1920, cat. 42) and *Icebergs and Mountains, Greenland* (c.1930 cat. 62) were all strong candidates. Harris's *Ice House, Coldwell, Lake Superior* (c.1923, cat. 46) is an equally dramatic image, with strong staying power. But in each case there are other works by these artists that have come to epitomize Canadian art: Thomson's *Spring Ice* (1915–1916, National Gallery of Canada), *The Jack Pine* or *The West Wind*, J.E.H. MacDonald's *Solemn Land* (1921, National Gallery of Canada, fig. 75) or Harris's *North Shore, Lake Superior* (1926, National Gallery of Canada, fig. 66) and *Isolation Peak, Rocky Mountains* (c.1930, Hart House, University of Toronto, fig. 76) – in the case of his northern scenes. Frequently exhibited (all entered a public collection relatively early in the twentieth century), these works are familiar to Canadians across the country, primarily through reproductions in textbooks on both Canada and Canadian art. Posters and silkscreen reproductions of nearly all of them have hung in classrooms, homes, banks and public institutions for most of the twentieth century.

Though the works by these artists in the AGH are deeply affecting, memorable, and often dramatic, there are other works by the same artists that have been deemed more central to the artist's œuvre, or more characteristic of a particular style or subject, or were simply accessible earlier. They have thus become more familiar, more deeply engraved on our consciousness and, not surprisingly, more regularly reproduced. Included in the early reproduction programs developed to familiarize Canadians with their own art and history, many of these images were reproduced in unlimited numbers for many decades. As a result, they became iconic images in the Canadian imagination, shaping the concepts of the north and the unpopulated wilderness of Canada that define our collective understanding of the Canadian experience.

## What About the Women? The Evolving Canon

Prudence Heward's *Girl Under a Tree* (1931, cat. 63), gifted to the AGH by the artist's family in 1961, presents a somewhat different case.[54] In his 1975 catalogue *Canadian Painting in the Thirties*, Charles Hill spoke of the painting's "compelling quality" and its "aura of high-strung sexuality,"[55] and in his 1995 catalogue text for *The Group of Seven: Art for a Nation* he described it as one of the large works that dominated the last Group of Seven exhibition.[56] Yet only one critic reviewed the work at that 1931 showing, commenting on its "curious elements of modernism and classicism," and noting that "while it is not sensational, it is assertive."[57] For obvious reasons, in the context of a canon constructed largely around the notion of the landscape, this work was not frequently reproduced. Stylistically modern and unconventional in its subject matter, it has seldom been discussed in general survey books, even after its acquisition by the AGH. Yet *Girl Under a Tree* represents a dramatic crossroads in Canadian art history.

Edwin Holgate, reviewing Heward's work retrospectively for *Canadian Art* magazine in 1947, would write: "Judgment of an artist rests chiefly on the relationship between his work and the critical standards of his time."[58] Brooke Claxton, in his remarks at Heward's 1948 memorial exhibition, observed that critics had "reflexes as natural as knee jerks. In Miss Heward they found a sea to which their traditional charts did not apply. But this did not deter pioneers like Prudence Heward."[59] Natalie Luckyj has summed up the situation: "Neither wholly modernist nor conventional, her synthesis of form and content was not easily placed within the critical framework."[60]

Gender has clearly played a role. Heward, along with a number of female artists, was a founding member of the Canadian Group of Painters and served as its vice-president. Yet until the mid-1970s and even later, relatively few works by women were acquired by public institutions. As our review of the literature has confirmed, inclusion in a public collection is almost a pre-condition for entry into the canon.

Fig. 77
PRUDENCE HEWARD (1896–1947)
*Dark Girl* 1935
oil on canvas
92.0 x 102.0 cm
Hart House Permanent Collection,
University of Toronto

Although *Girl Under a Tree* has not been repro-
duced in any of the popular survey books, it too may strike
a chord of familiarity in certain viewers. It is interesting
to trace how it has come, more recently, to take its place in
the Canadian canon. With *Dark Girl* (1935, fig. 77), also by
Heward, it was included in Hill's landmark 1975 exhibition
*Canadian Painting in the Thirties. Dark Girl,* purchased by
Hart House in 1936 – and thus in the public domain much
earlier – was actually included in such critical survey exhi-
bitions as the Tate Gallery's 1938 *A Century of Canadian
Art*, the Art Gallery of Toronto's 1945 *The Development of
Painting in Canada 1665–1945*, and Ottawa's 1948 memo-
rial exhibition *Prudence Heward 1896–1947*. It was also
borrowed for the AGH's 1953–1954 inaugural exhibition
(before the Gallery had acquired *Girl under a Tree*).

Having entered the public domain when Hamilton
acquired it, *Girl Under a Tree* has in recent years appeared
with some regularity in specialized exhibitions, particularly
those organized by women curators who have examined
the work through the lens of feminist theory.[61] It repre-
sents a number of key themes in the current examination
of Canadian painting – the investigation of modernism,
the female nude as subject, issues of sexuality and gendered
constructions of the figure.[62] Its dramatic composition and
the confrontational expression of its subject continue to
engage viewers and to stimulate discussion both about the
representation of the nude in Canadian art and about
women artists within the canon.

*       *       *

This has been a rich and rewarding journey of discovery,
which has complemented my research, not only on collec-
tion-building in public galleries and on the role that repro-
ductions have played in the creation of our understanding
of what is Canadian about Canadian art but also on the
position of women artists in Canadian art at the end of the
twentieth century.[63] Among other things, it has revealed
some of the problems associated with the way in which
the canon has been constructed, and its relative arbitrari-
ness. This is not to suggest that the works that we respond
so strongly to have not earned their position; they clearly
have. It seems obvious, though, that location, access and
the existing historical record are much more likely to
determine which works will be selected for exhibition and
reproduction in survey exhibitions than regular reassess-
ment of the full panorama of Canadian art history. Today,
the works of women and First Nations artists are regularly
included in cases where in the past they would have been
overlooked. It is vital that while we continue to cherish
those works that are part of the canon we remain receptive
to those that still deserve inclusion. We reserve for our-
selves the pleasure of going beyond familiarity and seeking
to discover or rediscover the "real" painting – the texture,
the scale and the nuances that are never fully captured in
reproduction. ~

*       *       *

## Notes

1. Noel Saltmarche's recollection is included in Bill Gladstone, "Kenneth Saltmarche 1920–2003: He Gave His City Artistic Merit," *The Globe and Mail* (Toronto), 19 July 2003.

2. James Adams, "The Great Canadian Enigma," *The Globe and Mail* (Toronto), 31 May 2003.

3. Doris Shadbolt, "Foreword," in *Images for a Canadian Heritage* (Vancouver: Vancouver Art Gallery, 1966), n.p.

4. Ibid.

5. Ibid.

6. *Canadart: Great Canadian Paintings in Reproduction*, Pandora Publishing Company, 1975, no. C5. See also *Canadart: Canadian Paintings in Reproduction*, Pandora Publishing Company, 1981, no. 305. Copies of these catalogues are in the National Gallery of Canada Library, Ottawa.

7. As well as appearing on the cover, *Horse and Train* is also reproduced in the body of Wright's text.

8. Anthony Luengo, *Canadian Writer's Companion* (Toronto: Prentice Hall Ginn Canada, 1995), p. 71.

9. All the artists had been discussed in Newton MacTavish's *The Fine Arts in Canada* (Toronto: MacMillan, 1925).

10. *The Art Gallery News* was first published in June 1949. From 1952, it regularly reproduced works from the permanent collection on its cover, many of them recent acquisitions. For example, Cullen's *Logging In Winter* was reproduced in March 1957; Bruce's *The Phantom Hunter* in October 1959; Reid's *Forbidden Fruit* in November 1960; and Walker's *Ave Maria* in October 1963. In December 1953, at the time of the opening of the new Gallery in Westdale, 8,450 copies of *The Art Gallery News* were printed (Minutes of the Annual General Meeting, 1954, AGH Archives).

11. Thanks to the Gallery's Women's Committee, *Forbidden Fruit*, *Ave Maria*, Cornelius Krieghoff's *The Habitant's Home*, William Brymner's *The Vaughan Sisters* and Ebenezer Birrell's *Good Friends* were all (among many other works) acquired in the 1960s.

12. Malcolm Mackenzie Ross, ed., *Our Sense of Identity: A Book of Canadian Essays* (Toronto: Ryerson Press, 1954), p. xi.

13. *The Canada Year Book* for 1963–1964 lists twelve principal art galleries (though it omits several, including those in Windsor, Charlottetown and Quebec City). In 1967, *The Canada Year Book* listed fourteen public galleries, twelve university galleries, and three arts council galleries (St. Catharines, Glenhyrst and Calgary).

14. "Art Gallery Wins Praise for Quality," *The Hamilton Spectator*, 26 September 1967.

15. J. Russell Harper, *Painting in Canada: A History*, 1st ed. (Toronto: University of Toronto Press, 1966), p. 402.

16. Elizabeth Kilbourn et al., *Great Canadian Painting* (Toronto: Canadian Centennial Publishing Co., 1966).

17. Shadbolt, *Images for a Canadian Heritage*, n.p.

18. Ibid.

19. See *The Artist in Canada*, Canadian Citizenship Series Pamphlet No. 6 (Ottawa: Canadian Citizen Branch, Department of Citizenship and Immigration, 1957). (The author of this document is not identified, although acknowledgement is made to Alan Jarvis, director of the National Gallery of Canada, R. H. Hubbard, chief curator of the NGC, and Gérard Morisset, director of the Museum of the Province of Quebec, for their suggestions and comments.) Discussing contemporary art since 1930, the author writes: "The 'national' style which evolved in the previous period continued for a time as a strong force but was soon modified by outside influences and by the personality of the artists. Many of them have moved away from an exclusive concentration on landscape and *are showing a lively interest in painting people*, as well as the various forms of abstraction introduced in the 1940s" (p. 92, italics, this author's).

20. T. R. MacDonald, "Curator's Report," Minutes of the Annual General Meeting, 24 September 1951, AGH Archives. The reproductions were ordered from the Hamilton-based Davis-Lisson Company and produced for them by Superior Engravers, also of Hamilton. The minutes of the 17 September 1959 Board of Management Committee meeting record the Gallery's entrepreneurial approach to reproductions as a source of revenue. MacDonald reported that the Royal Specialty Sales Co. of Toronto had agreed to produce 12,500 cards, of which 6,000 would go to the Gallery for $135, to be sold at 10 cents each. The Royal Specialty Sales Co. was to distribute the balance. To fund the project, MacDonald was to request $135 from the Women's Committee on the understanding that the funds would be returned when the sales were completed.

21. The AGH gave reproduction rights to Canadian Native Prints of Vancouver, which included these works (along with Krieghoff's *The Habitant's Home* and Harris's *Ice House*) in its catalogues during the 1960s and 1970s. See, for example, *Canadian Art Reproductions 1969* (Vancouver: Canadian Native Prints, 1969), pp. 7–8. Pandora Publishing Ltd. of Victoria took over the business in 1975. It specialized in larger images, including Colville's *Horse and Train*. Copies of Canadian Native Prints and Pandora Publishing's catalogues are in the National Gallery of Canada Library, Ottawa.

22. MacTavish, *The Fine Arts in Canada*, p. 28.

23. Ibid, p. 29.

24. As Arlene Gehmacher points out in her discussion of the work in this catalogue (cat. 6), the painting was reproduced in 1890 in *The Dominion Illustrated*. However, this publication would not have continued to circulate like the art books that kept an image in the public consciousness over an extended period of time. In their book *The Art Gallery of Hamilton: Seventy-Five Years (1914–1989)* (Hamilton: Art Gallery of Hamilton, 1989), Ross Fox and Grace Inglis called this work "the pinnacle of the artist's career in terms of public acclaim," but they were likely referring to its life after it was exhibited posthumously at the Art Gallery of Toronto in 1911.

25. Shadbolt, *Images for a Canadian Heritage*, n.p.

26. The poem, "The Walker of the Snow" by Charles Dawson Shanly, was seen by Bruce in the 1879 book *Locusts and Wild Honey* by John Burroughs. (The poem was first published in *The Atlantic Monthly* in 1859.) According to Sherrill Grace, in *Canada and the Idea of North* (Montreal: McGill-Queen's University Press, 2001), the story related in Shanly's poem is based on legends about the "shadow hunter," a "figure who bears some resemblance to the Windigo of Northern Ojibwa and Cree mythology" (pp. 3–4). Bruce, however, wrote that he thought the shadowy figure was Jack Frost (see a letter to his father dated 13 November 1888, in Joan Murray, ed., *Letters Home: 1859–1906. The Letters of William Blair Bruce* [Moonbeam, Ontario: Penumbra Press, 1982], p. 167). Kilbourn et al., *Great Canadian Painting*, were the first to suggest a Native link to the poem (p. 59).

27. George Reid, 1896, quoted in the National Gallery of Canada website, *CyberMuse*: Artist's Page. MacTavish wrote that Reid had "consistently opposed the 'taboo' placed on the subject picture, and in various ways … declared his belief in art for life's sake as opposed to 'art for art's sake'" (MacTavish, *The Fine Arts in Canada*, p. 97).

28. MacTavish, *The Fine Arts in Canada*, p. 96. "Everyone who knows must acknowledge that for at least thirty years in Canada George A. Reid has been the outstanding champion of art and of the importance that artistic application imparts to many of our common, day-by-day activities," MacTavish wrote.

29. Dennis Reid, *A Concise History of Canadian Painting*, 2nd ed. (Toronto: Oxford University Press, 1988), p. 100. He was also educated at the Ontario School of Art under Robert Harris and John Fraser, and in Paris at the Académies Julian and Colarossi.

30. Moncrieff Williamson, *Through Canadian Eyes: Trends and Influences in Canadian Art, 1815–1965* (Calgary: Glenbow-Alberta Institute, 1976), n.p.

31. See J. Russell Harper, *Painting in Canada: A History*, 1st ed. (Toronto: University of Toronto Press, 1966), p. 223; Paul Duval, *High Realism in Canada* (Toronto: Clarke, Irwin & Company Ltd., 1974), p. 29; Christine Boyanoski, *Sympathetic Realism: George A. Reid and the Academic Tradition* (Toronto: Art Gallery of Ontario, 1986), p. 9. Boyanoski borrowed the term from Hjalmar Hjorth Boyesen, "Boyhood and Girlhood," *The Monthly Illustrator*, vol. 4 (April 1895), pp. 6–7.

32. Kilbourn et al., *Great Canadian Painting*, pp. 16, 56.

33. Reproduced regularly in survey texts, it was also included in *Images of Man in Canadian Painting, 1878–1978* organized by the McIntosh Gallery, University of Western Ontario, London (1978).

34. Kilbourn et al., *Great Canadian Painting*, p. 16.

35. Quoted in ibid.

36. Quoted in ibid, p. 59.

37. Ibid., p. 14.

38. Peter Bermingham, *American Art in the Barbizon Mood* (Washington: Published for the National Collection of Fine Arts by the Smithsonian Institution Press, 1975), p. 85.

39. Ibid. As late as the mid-1930s, reproductions of Millet's *The Angelus* and *The Gleaners* were favourite subjects in North America, particularly in rural Canada. In 1934, Saskatchewan's *Prairie Farmer Free Press* ran an article describing its author's selection of National Gallery colour reproductions, remarking: "We certainly need some change from calendars and the two framed pictures of the Gleaners and the Angelus which we're tired to death of looking at." See "Colour Kate," *Prairie Farmer Free Press*, vol. 1, p. 8 (National Gallery of Canada, Library Archives, Ottawa).

40. Bermingham, *American Art in the Barbizon Mood*, p. 85.

41. In the intervening years it had been brought out of storage only for exhibition in Canada – at the National Gallery of Canada's Walker memorial exhibition in 1941 and, that same year, the *Thomson-Walker Exhibition* at the Art Gallery of Ontario. It does not appear to have been loaned for exhibition again until after it entered the AGH, when it was included in the 1965 exhibition *Treasures from the Commonwealth*, shown at London's Royal Academy.

42. Kilbourn et al., *Great Canadian Painting*, p. 17.

43. "Sale of Paintings," *The Montreal Star*, 21 December 1897. Cited by Sylvia Antoniou in *Maurice Cullen: 1866–1934* (Kingston: Agnes Etherington Art Centre, 1982), p. 61. The highest price paid for a work at the auction was just over $90 – a striking contrast to Horatio Walker's $10,000 sale a decade later.

44. Quoted in Reid, *A Concise History of Canadian Painting*, p. 125.

45. J. Russell Harper, *Painting in Canada: A History*, 2nd ed., p. 234.

46. Quoted in Kilbourn et al., *Great Canadian Painting*, p. 18.

47. Quoted in ibid.

48. Barry Lord, *The History of Painting in Canada: Toward a People's Art* (Toronto: NC Press, 1974), pp. 9, 109–110.

49. Ibid, p. 110.

50. Kilbourn et al., *Great Canadian Painting*, p. 96.

51. Colville in a letter to MacDonald, 8 February 1957, Accession File, Alex Colville, *Horse and Train*, AGH.

52. *Statements: 18 Canadian Artists 1967* (Regina: Norman Mackenzie Art Gallery, 1967). Quoted in William Withrow, *Contemporary Canadian Painting* (Toronto: McClelland and Stewart, 1972), p. 60.

53. A reproduction of *The Habitant's Home* was circulated from 1967 onwards by Canadian Native Prints (along with Cullen's *Logging in Winter*, among others). See, for example, the catalogue of reproductions published by Canadian Art Reproductions, Vancouver, *A Centennial Collection of Canadian Prints*, 1967. (In this catalogue the print size is given as 16 x 12 ins.; in later publications it is given as 13⅝ x 10 1/16 ins.). By 1974, *Canadart: Great Canadian Paintings*, Canadian Native Prints' current catalogue, also included a number of larger format reproductions of works by Krieghoff, among them the National Gallery's *The Habitant Farm* (13 x 20 ins.) and the McCord's *Log Hut*, under the title *Settler's Home* (14 1/4 x 20 ins.). When Pandora Publishing Ltd., of Victoria, took over the business in 1975, it continued to distribute only the larger format prints through its catalogue *Canadart: Great Canadian Paintings in Reproduction*. Copies of these catalogues are in the National Gallery of Canada Library, Ottawa.

54. The AGH is, today, strong in the representation of women artists, including in its collection works by Yulia Biriukova, Emily Carr, Paraskeva Clark, E. Grace Coombs, Emily Coonan, Rody Courtice, Clara Hagarty, Prudence Heward, Marion Long, Mabel May, Florence McGillivray, Helen McNicoll, Kathleen Morris, Sarah Robertson, Anne Savage, Gertrude Spurr Cutts, Elizabeth Wyn Wood and Mary Wrinch (among many others). However, the works of these artists – the majority of which had been acquired by the late 1960s (only Wrinch and Biriukova were not represented in the collection by 1969) – have been less frequently the object of reproduction or discussion in art historical texts than those of their male colleagues. These artists were not, with the exception of Carr and, more recently, McNicoll, Heward, Wyn Wood, Clark and Robertson, part of the canon, which in the early years of the twentieth century tended to representations of the land or the labour associated with nation-building. Except for Emily Carr, few of these artists' works were selected for the various programs of reproductions of Canadian art that circulated widely between 1928 and the 1960s (and even in Carr's case not until some years after the work had been completed).

55. Charles Hill, *Canadian Painting in the Thirties* (Ottawa: National Gallery of Canada, 1975), p. 42.

56. Charles Hill, *The Group of Seven: Art for a Nation* (Toronto: McClelland & Stewart, 1995), p. 268. Hill reproduced Heward's painting in this catalogue.

57. E. W. Harrold (1931), quoted in Hill, *The Group of Seven*, cat. 167, p. 335. See also Hill, *Canadian Painting in the Thirties*, where he cites Lyman's "astute criticism of the work in his journal," in which he wrote that "when an idea becomes explicit it dies …" Speaking of *Girl Under a Tree*, Hill continued: "The freely-brushed vegetation in the foreground isolates the highly finished, almost over-worked, figure in the centre, and the landscape background does have the air of a studio backdrop; yet the work has an extremely compelling quality. The staring eyes, the tension in the muscular body, the projections and sharp angles surrounding the figure create an aura of high-strung sexuality reminiscent of Gauguin's *La Perte du Pucelage*" (pp. 40–42).

58. Edwin Holgate, "Prudence Heward," *Canadian Art*, vol. 4, no.3 (1947), p. 161. Quoted in Natalie Luckyj, *Expressions of Will: The Art of Prudence Heward* (Kingston: Agnes Etherington Art Centre, 1986), p. 39.

59. Brooke Claxton, typescript, "Opening Remarks: Memorial Exhibition – Prudence Heward," 4 March 1948, Ottawa, National Gallery of Canada Archives. Quoted in Luckyj, *Expressions of Will*, p. 39.

60. Luckyj, *Expressions of Will*, p. 53.

61. Jerrold Morris reproduced the work in his book *The Nude in Canadian Painting* (Toronto: New Press, 1972), p. 55, fig. 34. Though not in Dorothy Farr and Natalie Luckyj's 1975–1976 exhibition *From Women's Eyes: Women Painters in Canada*, shown at the Agnes Etherington Art Centre, Kingston (which did include Heward's *Girl on a Hill* and *Portrait of Mrs. Zimmerman*), *Girl Under a Tree* was part of Luckyj's 1986 *Expressions of Will: The Art of Prudence Heward* (a travelling exhibition mounted by the Agnes Etherington Art Centre), Janet Braide's *Prudence Heward (1896–1947): An Introduction to Her Life and Work*, shown at Montreal's Walter Klinkhoff Gallery in September 1980 (and accompanied by a small catalogue), and Luckyj's seminal touring exhibition mounted in 1983 for the London Regional Art Gallery, *Visions and Victories: 10 Canadian Women Artists 1914–1945*. The painting was also discussed in Joyce Millar's article "The Beaver Hall Group: Painting in Montreal, 1920–1940" (*Woman's Art Journal*, spring-summer 1992, p. 5), where she argued that Heward "chose the human figure to embody the Canadian spirit." Millar also claimed that "the power and emotional tension in Heward's heroic females painted during the 1920s and 1930s offer … a revolutionary statement on womanhood" (ibid., p. 5).

62. Jerrold Morris sensed in the work a "feeling of psychological malaise, possibly a reflection of the troubled period of depression and social upheaval of the 1930s" (*The Nude in Canadian Painting*, p. 12). More than one writer has referred to the latent sexuality of the figure, and suggested that the work is an attempt to transcend gender stereotypes; see Luckyj, *Expressions of Will*, pp. 63–64, and Barbara Meadowcroft, *Painting Friends: The Beaver Hall Women Painters* (Montreal: Véhicule Press, 1999), p. 117, and her entry on this work in the present catalogue (cat. 63).

63. For articles on the role of reproductions in Canadian art, see Joyce Zemans, "Establishing the Canon: Nationhood, Identity and the National Gallery's First Reproduction Program of Canadian Art," *Journal of Canadian Art History*, vol. 16, no. 2 (1995), pp. 6–35; "Envisioning Nation: Nationhood, Identity and the Sampson-Matthews Silkscreen Project: The Wartime Prints," *Journal of Canadian Art History*, vol. 19, no. 1 (1998), pp. 6–47; "Sampson-Matthews and the NGC: The Post-War Years," *Journal of Canadian Art History*, vol. 21, nos. 1–2 (2000), pp. 96–136; and "The Canon Unbound," *Journal of Canadian Art History*, vol. 25 (2004), pp. 150–179. For a discussion of women artists and collection building in public galleries, see "A Tale of Three Women: The Visual Arts in Canada / A Current Account/ing," *Revue d'art canadienne / Canadian Art Review*, vol. 25, nos. 1–2 (1998), pp.103–122.

Fig. 78 Alex Colville discussing *Horse and Train* with Debra Daly Hartin of CCI. Photo: Jeremy Powell.

# Conserving a Canadian Icon:
# The Materials and Technique
# of Alex Colville's *Horse and Train*

*Debra Daly Hartin*
*Senior Conservator, Fine Arts*
*Canadian Conservation Institute, Ottawa*

Alex Colville's *Horse and Train* (cat. 85) makes a tremendous impact on the viewer. Its unsettling juxtaposition of a horse galloping towards an oncoming train, combined with the precision of the artist's technique, causes it to linger in the memory of those who have seen either the painting itself or reproductions of the image. A recent technical examination of the work and the opportunity to study and discuss it with the artist have resulted in a better understanding of its appearance, technique and condition (fig. 78).[1]

We might perhaps begin with a question: Does our recollection of this painting offer a true representation of its appearance as the artist created it? Both the lighting conditions under which we view the work and the accuracy of its numerous reproductions inevitably affect our memory of it. When faced for the first time with the actual painting, many viewers are struck by its size, commenting that it is physically smaller than they had imagined. Certainly, the impact of the painting is huge in relation to its relatively modest dimensions (painting: 41.5 cm x 54.3 cm; frame: 58.6 cm x 71.7 cm). Viewers also tend to say that it appears darker than they remember. In fact, reproductions rarely represent the painting accurately in this regard. They often fail to capture the calculated and distinct glow of the train's headlamp and its reflection on the metal rails, thereby eliminating the areas of stark, dramatic contrast that are part of the nocturnal scene. Reproductions can also misrepresent the painting in terms of hue; chromatic renditions vary, with the sky sometimes appearing as a bright blue and the grass as a bright green. One of the difficulties of photographing the painting centres on the fact that it appears

quite different under different lighting conditions – proof of the skill with which the artist has depicted colours seen through the veil of dusk, a time of changing light.

In discussing the work's general appearance, the artist has said: "Right from the beginning, I thought of this painting as dark; dark in the visual sense and in the metaphysical sense."[2] Nothing emerged from the technical examination to suggest that the painting has become darker; it is dark because the artist painted it that way. It is obvious from the artist's technique that he knew of the tendency for oil paint to become more translucent with age – a characteristic that could have resulted in a tonal change over time if dark underlayers had been used. Colville, however, used a white ground and applied a "first colouring" over it – an intermediate layer of tones that vary according to the image on top. He took the precaution of treating some areas *en reserve*; in other words, he left the ground white under the lightest areas of the design. For example, he made a conscious decision not to paint the train under the light, transparent smoke, where it might have become increasingly visible over time. In the final stages of his execution of *Horse and Train*, the artist used stand oil glazes,[3] and when the work was finished he applied a thin, natural resin varnish over the whole surface. The oil glazes and dammar varnish may have yellowed slightly with time, but on the dark paint layers this yellowing would not have a significant effect. It has likely resulted in a slight warming of tone, but this change would be only slightly visible on the white lamp and rails. The appearance of the painting has therefore not been significantly affected by aging or alterations in the materials

Fig. 79
ALEX COLVILLE (b. 1920)
Transfer Cartoon for panel
*Horse and Train* 1954
graphite on paper
39.1 x 27.0 cm
Art Gallery of Ontario, Toronto,
Gift of Dr. Helen J. Dow, Guelph,
1986

This cartoon, on tracing paper,
appears to have been traced
from the ink sketch of the horse
shown in fig. 80.

Fig. 80
ALEX COLVILLE (b. 1920)
Study for *Horse and Train* 1954
pen and black ink on paper
32.5 x 25.2 cm
Art Gallery of Ontario, Toronto,
Gift of Dr. Helen J. Dow, Guelph,
1986

over time. The tone was created by a careful choice of paint and pigmented glazes. In addition, the artist reinforced his intention by designing and constructing a frame that accentuates the sombre, dusky tone and contributes to the overall impression of darkness created by the work.

Even in the first few years after the painting was completed, its appearance may have been misunderstood. The artist recalls that when it was in New York, prior to being purchased by the Art Gallery of Hamilton (AGH) in 1957, someone attempted to clean it, possibly because they felt it was darker than it should be. This early cleaning effort, undertaken when the paint and oil glazes used by the artist were still fresh, may have contributed to the development of the drying cracquelure detectable today, which is a condition rarely seen in Colville's paintings.

## The Artist's Technique

Colville's technical process is thorough, meticulous and deliberate, and he makes every effort to impart a high degree of permanence to his works. "I really want the paintings to last. Right from the beginning, I've always felt this way. The idea that some painters have, that they actually like the paintings to age and transform ... there's nothing I'd like more to avoid."[4]

Colville begins a work with preparatory studies.[5] To achieve an accurate depiction of the lighting for this particular scene, he recalls going to look at the railway line one night at Aulac, just outside Sackville, where the elevated track crosses the Tantramar Marshes. The artist remembers with amusement that to avoid suspicion during this visit he "had to behave like a guilty person," hiding in a ditch beside the track while waiting for the train. As the train approached he stood up to observe the effect of the headlamp and its reflection on the metal rails.[6] *Study for Horse and Train* (1954, Toronto, Art Gallery of Ontario) a coloured sketch done in casein tempera, shows slight differences compared to the final painting in the placement and perspective of the horse and the railroad tracks. The painting technique is sketchy, with little detail, but the pigments used already reflect the sombre, dark appearance of the completed work. The artist apparently experienced

some difficulty with the figure of the horse, so he made a model of it, using chicken wire and plaster (or cement). After painting the model black, he made drawings from it. This model accompanied the painting to New York when it was exhibited there in 1955, but it is not known what became of it.[7]

The support of the painting is 1/8-inch hardboard. The artist prepared the support carefully with a smooth ground on the front and a thinner layer on the verso (textured side), applied to reduce the tendency of the panel to warp.[8] The surface was then carefully sanded to produce a smooth finish. The artist even chamfered the cut edges of the hardboard to provide protection against chipping and paint loss – another illustration of his constant effort to impart stability and permanence to his work.

The artist transferred the design of the horse and tracks to the prepared panel using a transfer cartoon (1954, fig. 79). To make this cartoon, Colville traced his final ink sketch of the horse (1954, fig. 80) onto tracing paper, adding the lines of the railroad tracks and a perspective box around the horse. All the lines of the cartoon were backed with graphite. Pencils of two different hardnesses (or possibly another pointed instrument) were used to trace the design through the cartoon onto the ground. When the final work is examined under a microscope, traces of the thin black lines of the transferred drawing can be seen where minute areas of ground are exposed. The transfer process also resulted in a fine groove in the surface along the contours of the horse and railroad, which is visible in raking light (a glancing light from one side).

Microscopic examination also reveals various lines of underdrawing and washes of "first colouring" applied over the white ground. Pencil and possibly brush sketch lines can be seen along the contours of the horse and tracks. A thin, particulate grey wash is visible under parts of the sky area, and under the gravel and tracks. This wash has accumulated in the fine sanding striations of the ground – an effect also observed in certain other paintings from the period, such as *Three Sheep* (1954, Ottawa, National Gallery of Canada). A red underlayer is visible immediately beneath the upper train rail and a light blue one under the metal part of the rail, while the clouds and

the billowing smoke of the train are among the areas where the white ground has been left *en reserve*.

Although the artist built up the image in his usual detailed, precise manner, the paint application is more varied than in many of his other paintings. Blended, wide strokes of colour have been used in the sky, and the clouds have been executed in broad, flat planes similar to colour washes. Circular areas of apparently flat colour, delineating shadow, mid-tone and highlight, are prominent in the gravel. Under close examination, however, a layering of small brushstrokes of various colours is evident: a deep red-black, a translucent red, a light blue-grey, a dark green-grey and highlights of a light ochre, applied in a thin, fluid brushstroke without texture. As the space recedes, the gravel is rendered in a more pointillist technique, using dots. A mixture of blended colour and thin brushstrokes have been used for the grass, although the strokes are not as fine as those used for this element in other paintings, including *Three Sheep*. The extremely fine brushstrokes so characteristic of Colville paintings are evident, however, in the glow of the headlamp and the hair of the horse, becoming finer and finer into the highlights (fig. 81).

The 1950s were a period of transition and experimentation in Colville's choice of paint mediums. If we compare *Horse and Train* to other paintings, the technical differences we observe reflect the evolution of the artist's materials. The artist was moving from oil paint, used in his student and wartime paintings, to a faster drying medium that permitted a layered technique and the application of fine, distinct, juxtaposed strokes of colour. He employed casein tempera in many sketches and paintings from this period, but he also used pigmented stand oil glazes over underpainting done in gum arabic emulsion. He believes this to be the technique employed in *Horse and Train*. The notes written by Colville in his 1945 edition of Ralph Mayer's *The Artist's Handbook of Materials and Techniques* describe the mixtures he was using at the time and the experiments he undertook with driers to obtain optimum drying time and surface appearance.[9] Pigmented glazes are readily apparent on the surface of *Horse and Train*. An analysis of minute samples taken from the painting[10] shows that the pigmented glaze is basically stand oil, with the possible presence of a small amount of dammar, which would be consistent with the recipes in the Mayer book. Speaking of his use of glazes at that time, Colville says: "In some cases I'm using a glaze to pull a certain area together, to cool it or warm it, or to neutralize a red with a yellow, or neutralize an over-intense colour with a grey, a kind of transparent veil …I haven't used that kind of thing for years."[11] The mediums of paintings from this period are described in different ways, including "glazed tempera" and "glazed oil emulsion," but only a few works bear the artist's inscriptions on the verso that confirm this information. On the reverse of *Horse and Train*, the artist has written "glazed oil."

In addition to what is visible when examining the surface of the painting, cross-sections reveal an isolating layer (probably resin or oil) over the underlayer (or "first colouring"), as well as a variety of pigments in the glaze (figs. 82a and 82b). In one area of the grass, the stand oil glaze was found to be pigmented with green earth, bone black, yellow ochre and viridian. A cross-section from the horse reveals that the boundary between the glaze and the paint layer below is indistinct, suggesting a wet-into-wet application (the laying down of paint or another medium onto a layer that is not yet dry). A drying oil was detected in the paint layers. To date, analysis has not confirmed that a gum-oil emulsion vehicle was used. However, the presence of gum in small amounts or its presence in areas that have not yet been examined, such as the gravel, which shows differences in technique and texture, cannot be ruled out. Investigations are ongoing.

The artist informed us that when the painting was finished he applied a thin coat of natural resin (dammar) varnish to the surface, with the idea that it would serve as a protective layer that could be removed and renewed as necessary, leaving the underlying glazing intact.[12] The presence of a thin dammar varnish on the painting has been confirmed by analysis.

The frame, designed and constructed by the artist, allows the work to be viewed as a whole, without interference from a highly contrasting border, since it continues the sombre tone of the painting. The artist has said that he likely used white, black and yellow ochre pigments, which were then quite standard in his palette.

Figs. 82a and 82b
The sample shown in these two images, in which the ground is missing, was taken from an area of grass in which the ultraviolet light examination shows a selective or thicker application of glaze. Full image width of the cross-section is 270 micrometers. Photomicrographs by Kate Helwig.

82a. In incident light, the following layers are visible from the bottom up: a light grey-green "first colouring," a dark grey-green layer and a thick pigmented glaze.

82b. Examination under autofluorescence causes the resinous layers to fluoresce brightly, indicating the presence of a thin resin layer between the bottom two layers and accentuating the resinous glaze and the thin varnish on top.

## The Condition and Treatment of *Horse and Train*

Considering that *Horse and Train* turned fifty years old in 2004, it is aging very well, and its general condition is good. However, a fine cracquelure can be observed over the surface that is unusual in Colville's work. In a few areas, where the stand oil glazes are most apparent, there is no cracking, but in other sections the upper layers of paint and varnish have "crawled" – or shrunk back – over the layers below. This type of cracking, which is often referred to as "drying cracquelure," can be caused by the materials used by an artist and the way the layers have been applied. Here, the possible use of gum arabic emulsion, oil paint, stand oil glazes and varnish could have exacerbated this problem of drying. However it is also likely that the ill-advised cleaning attempt made early in the painting's life contributed to the problem. Young, fresh paint films and glaze layers could have swollen in the presence of cleaning solvents and contracted upon drying to cause such cracquelure. The cracking is stable, there is no lifting of the paint, ground or glaze layers, and there is only minor abrasion and paint loss.

There was evidence of some earlier cleaning and disruption of the varnish layer. Examination under ultraviolet light showed some alteration in the varnish in the bottom left and top right corners (fig. 83). These areas are not visible under normal viewing conditions. The gloss over the surface of the painting was varied, and broad wipe marks were visible before surface cleaning.

The painting required only minimal treatment. A light surface cleaning resulted in a more even and heightened gloss to the surface. Varnish removal was not required, nor would it have been advisable due to the presence of oil/resin glazes under the varnish. Inpainting of minor abrasions and of the drying cracks around the headlamp, aimed at reducing the visibility of the light ground, was undertaken with the artist's permission.

Upon viewing the painting in the conservation laboratory, the artist was pleased with its condition and did not feel it had changed in any major way. Since the late 1950s, Colville has often written detailed notes on the reverse of his paintings, describing the materials used. "I thought the more information I gave for possible use by conservators and so on, the better."[13] It is his paintings from this transitional period, during the 1950s, that have developed minor defects, such as cracking and the slight discolouration of glazes. These changes are nonetheless relatively minor compared to the defects seen commonly in oil paintings in general. Fortunately, due to the deliberate choices made by the artist to ensure the permanence of his work, we are able to enjoy his paintings in a condition often as pristine as the one in which they left his studio.

## Acknowledgments

I would like to express my appreciation to the conservators of various collections who allowed me to examine Colville's paintings and related documentation: Stephen Gritt and Susan Walker Ashley of the National Gallery of Canada (NGC); Sandra Webster-Cooke and John O'Neill of the Art Gallery of Ontario; Catherine Stewart of the McMichael Canadian Art Collection; and Laurie Hamilton of the Art Gallery of Nova Scotia. I am also grateful to the Art Gallery of Hamilton for their support of Alex Colville's visit to Ottawa, and to Stephen Gritt, Chief Conservator at the NGC, for making arrangements to view and discuss the artist's paintings owned by the NGC in their conservation laboratory. I would like to acknowledge the work of Kate Helwig and Jennifer Poulin, Conservation Scientists at the Canadian Conservation Institute (CCI), who undertook the sampling and analysis of cross-sections, and Jeremy Powell and Carl Bigras, Scientific Documentation Technologists at the CCI, for their photographic documentation of the painting. Finally, I would like to express my gratitude to Alex Colville and his daughter Ann Kitz, who travelled to Ottawa to view *Horse and Train*, provided us with such valuable information, and treated us to such a memorable day. ~

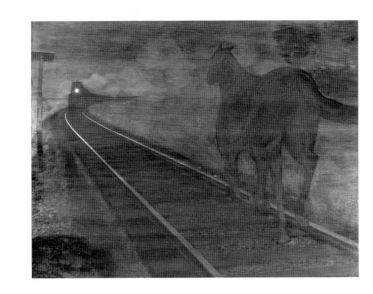

## Notes

1. Preparatory to this exhibition, the Art Gallery of Hamilton sent the painting to the Canadian Conservation Institute for assessment and treatment. Subsequently, in February 2004, the AGH invited the artist to travel from his home in Sackville, New Brunswick, to Ottawa for a day-long meeting to study the work and discuss with the author and other CCI staff the materials and techniques he was using at the time of its execution, in 1954.

2. Alex Colville, in conversation, Ottawa, 16 February 2004.

3. Stand oil is used by artists for glazes or as a painting medium. It consists of linseed oil that has been polymerized by heating, which results in an oil that possesses different properties from the raw oil: it is less prone to yellowing, and forms a tough, smooth film.

4. Alex Colville, in conversation, Ottawa, 16 February 2004.

5. In his catalogue of the Colville exhibition mounted by the Art Gallery of Ontario in 1983, David Burnett mentions that the idea for *Horse and Train* first appeared in a series of sketches dated 16 March 1954. See David Burnett, *Colville* (Toronto: Art Gallery of Ontario and McClelland and Stewart, 1983), p. 97.

6. Alex Colville, in conversation, Ottawa, 16 February 2004. Burnett describes this event as part of Colville's process of "authentification," designed to ensure that his scenes appear convincingly real. Burnett, *Colville*, pp. 97, 100, 105.

7. Alex Colville, in conversation, Ottawa, 16 February 2004.

8. In a phone conversation with the author (February 2004) the artist described how he normally applied three coats of ground to the front surface and two to the reverse. He usually used whiting and rabbit-skin glue, though he mentions using gelatin for a period of time when rabbit-skin glue was not available.

9. Below are several formulas written by Colville in his copy of Mayer's book, purchased in 1946. The artist's notations include dates from June 1954, when he could have been working on *Horse and Train*. (Nuodex is a drier used to accelerate the drying of the stand oil.)

"8 June 54

medium for use with Shiva oils over 'Shiva oil underpainting white' underpainting

    15 cc stand oil (Shiva)

    45 cc turp (Shiva)

    0.15 cc Nuodex 6%
    (1% vol. of stand oil)

11 June 54 – this dried too slowly – about 2–3 days

11 June 54

medium for use as above

    10 cc $\begin{cases} 6 \text{ cc stand oil (Shiva)} \\ 4 \text{ cc damar (Shiva)} \end{cases}$

    40 cc turp (Shiva)

    0.2 cc Nuodex 6% (2% of vol. of stand oil + dammar)

    this dried with almost matt surface

14 June 54 mixed

    20 cc $\begin{cases} 12 \text{ cc Stand oil} \\ 8 \text{ cc damar} \end{cases}$

    + 20 cc turp + 0.4 cc Nuodex 6% (2% vol. stand oil + damar)

    this dries overnight with glossy surface."

Additional notes written in 1952 and 1955 show variations on these mediums. A handwritten note describes a formula for a gum emulsion:

"Gum emulsion used:

    5 oz. gum solution

    1 oz. stand oil

    1 oz. damar varnish

    3/4 oz. glycerin"

This formula actually follows Mayer's recipe on pp. 192–193. "The gum solution is made by pouring 5 fluid ounces of hot water on 2 ounces of crushed or powdered gum arabic (2 ounces of finely pulverized gum arabic will equal approximately 2 1/2 ounces by volume – it will be slightly less). The damar varnish is the usual 5 pound cut mentioned under varnishes. The oily mixture is added to the gum solution in a slow stream with constant agitation which is continued until the mixture is a thick white liquid, homogeneous, and free from large globules or drops of oil. If no mixer is available, the emulsion may be made by shaking the ingredients together in a tall bottle no more than three-fourths full. The glycerin is to be mixed in thoroughly after emulsification of the gum solution with the oily ingredients." Ralph Mayer, *The Artist's Handbook of Materials and Techniques* (New York: The Viking Press, 1945).

10. A few samples, smaller than the size of a period on a printed page, were taken from the painting to elucidate the layered structure, investigate the composition of the layers and provide a clue as to the cause of the drying cracquelure condition. Conservation scientists prepared cross-sections, which were examined and analyzed using polarized light microscopy (PLM) and scanning electron microscopy/energy dispersive spectroscopy (SEM/EDS). Other microscopic samples were analyzed by Fourier transform infrared spectroscopy (FTIR), and gas chromatography-mass spectrometry (GC-MS).

11. Alex Colville, in conversation, Ottawa, 16 February 2004.

12. Alex Colville, in conversation, Ottawa, 16 February 2004. Also documented in National Gallery of Canada Restoration and Conservation files (written by S. W. Ashley) as having been used for *Woman, Man and Boat*.

13. Alex Colville, in conversation, Ottawa, 16 February 2004.

## Abbreviations List

Art societies:

| | |
|---|---|
| CAS | Contemporary Arts Society |
| CGP | Canadian Group of Painters |
| CSPWC | Canadian Society of Painters in Water Colour |
| OSA | Ontario Society of Artists |
| RCA | Royal Canadian Academy of Arts |
| SSC | Sculptors' Society of Canada |

Institutions:

| | |
|---|---|
| AAM | Art Association of Montreal (now MMFA) |
| AEAC | Agnes Etherington Art Centre, Kingston |
| AGGV | Art Gallery of Greater Victoria |
| AGH | Art Gallery of Hamilton |
| AGNS | Art Gallery of Nova Scotia, Halifax |
| AGO | Art Gallery of Ontario, Toronto |
| AGP | Art Gallery of Peterborough |
| AGT | Art Gallery of Toronto (now AGO) |
| AGW | Art Gallery of Windsor |
| BAG | Beaverbrook Art Gallery, Fredericton |
| CCAG | Confederation Centre Art Gallery, Charlottetown |
| CCAGM | Confederation Centre Art Gallery and Museum, Charlottetown (now CCAG) |
| CNE | Canadian National Exhibition, Toronto |
| DUAG | Dalhousie University Art Gallery, Halfax |
| EAG | Edmonton Art Gallery |
| GAI | Glenbow-Alberta Institute, Calgary (now GM) |
| GM | Glenbow Museum, Calgary |
| KWAG | Kitchener-Waterloo Art Gallery, Kitchener |
| LBEAG | The Leonard and Bina Ellen Art Gallery, Montreal |
| LPLAM | London Public Library and Art Museum (later LRAG, then LRAHM, now ML) |
| LRAG | London Regional Art Gallery (later LRAHM, now ML) |
| LRAHM | London Regional Art and Historical Museum (now ML) |
| MAG | Mendel Art Gallery, Saskatoon |
| MCAC | McMichael Canadian Art Collection, Kleinburg |
| ML | Museum London |
| MMFA | Montreal Museum of Fine Arts |
| MNBAQ | Musée nationale des beaux-arts du Québec |
| MQ | Musée du Québec (now the MNBAQ) |
| MSAC | Macdonald Stewart Art Centre, Guelph |
| MSVUAG | Mount Saint Vincent University Art Gallery, Halifax |
| NAM | The Nickle Arts Museum, Calgary |
| NGC | National Gallery of Canada, Ottawa |
| OAG | Owens Art Gallery, Mount Allison University, Sackville |
| OCA | Ontario College of Art, Toronto (now the Ontario College of Art and Design) |
| RHAC | Rodman Hall Arts Centre, St. Catharines |
| RMG | Robert McLaughlin Gallery, Oshawa |
| VAG | Vancouver Art Gallery |
| WAG | Winnipeg Art Gallery |

# Artist Biographies

*Compiled by Alicia Boutilier*

**BIRIUKOVA, Yulia (b. 1895, Vladivostok, Russia; d. 1972, Toronto, Ontario)**
See cat. 68

Biriukova studied at the Imperial Academy of Art in Petrograd (now St. Petersburg), then at the Royal Academy of Art in Rome, where her family settled after the Russian Revolution. In 1929, following the stockmarket crash, she arrived in Toronto with her sister Alexandra (an architect who designed Lawren Harris's house in 1930). Biriukova found space in the Studio Building and befriended many of the artists who worked and convened there, including J.E.H. MacDonald. After his death, she moved into his Thornhill home, which she shared with his son, artist Thoreau MacDonald. In 1932, she joined the staff at Central Technical School, where Carl Schaefer and Elizabeth Wyn Wood also taught. Around this time, she also painted life-size figures on the iconostasis (altar screen) of the Christ the Saviour Russian Orthodox Church in Toronto. She was mainly a portrait painter, receiving many commissions, and exhibited regularly in the 1930s, particularly with the OSA. In 1942 she began teaching at Upper Canada College, where she organized sketching trips in southern Ontario and helped students design sets for the annual stage show. An inspiring teacher, she retired in 1963; the College dedicated a gallery of contemporary works in her honour in 1968.

**BORDUAS, Paul-Émile (b. 1905, Saint-Hilaire, Quebec; d. 1960, Paris, France)**
See cat. 74

Borduas's studies began in 1922 with his apprenticeship under Ozias Leduc as a church decorator. After graduating from the École des beaux-arts in Montreal in 1927, he taught with the Catholic School Commission for a year before leaving for Paris to study at Maurice Denis's Ateliers d'art sacré. Returning to Canada in 1930, Borduas continued to work for Leduc and to teach, accepting a position at the École du Meuble in 1937. Inclusion in the 1938 AAM Spring Exhibition led to his meeting with John Lyman, with whom he founded the CAS in 1939. Soon after, Borduas produced his first non-representational, "automatic" paintings, influenced by Surrealism. By 1946, as the CAS became increasingly factional, Borduas was exhibiting with his followers in a group dubbed the "Automatistes." In 1948 he was dismissed from the École du Meuble for publishing *Refus Global*, a manifesto against Quebec conservativism. In 1953 he moved to New York City, then two years later to Paris, where he painted the black and white abstracts for which he is best known. The year of his death, Borduas received a Guggenheim Award for *Black Star*. The following year, his first retrospective was held at the Stedelijk Museum, Amsterdam; in 1962, his first Canadian retrospective was held at the MMFA, NGC and AGT.

**BOUDIN, Eugène (French; b. 1824, Honfleur, France; d. 1898, Deauville, France)**
See cat. 1

Boudin worked as a stationer in Le Havre (where his family moved in 1835), before travelling to Paris in 1847 to study on his own at the Louvre. In 1851, the city of Le Havre awarded him a study grant for three more years in Paris. Rather than enrolling in a studio, he chose instead to copy works by seventeenth-century Dutch landscape artists. Boudin loved the sea and throughout his life painted the coast of his native Normandy and of other regions of France, Belgium, Holland and Italy. He knew Corot, Millet and several Barbizon artists, who encouraged him to depict light with freer brushstrokes. Boudin exhibited regularly at the Salon des artistes français from 1859 and the Salon de la Société nationale des beaux-arts from 1890. The Paris dealer Paul Durand-Ruel organized his first solo show in 1883 and promoted his work in Britain and North America. Boudin produced large paintings – deemed necessary to vie for attention on crowded Salon walls – but preferred to work in smaller format. Though not an Impressionist himself, he exhibited with Manet and Monet and participated in the First Impressionist Exhibition in 1874.

**BROOKER, Bertram (b. 1888, Croydon, England; d. 1955, Toronto, Ontario)**
See cat. 70

Brooker immigrated to Manitoba in 1905 and moved to Toronto in 1921 to join an advertising trade journal, which he left to become a freelance journalist and pursue his interest in abstract art. Inspired by Kandinsky but with no formal training, Brooker held his first exhibition in 1927 at the Arts and Letters Club, a Toronto meeting place for male artists and intellectuals. The following year, he was invited to exhibit with the Group of Seven. Brooker also began writing about art and culture: in his syndicated column "The Seven Arts" from 1928 to 1930, and as editor of the *Yearbook of the Arts in Canada* (1928–1929 and 1936). After meeting Winnipeg realist Lionel LeMoine FitzGerald in 1929, he gave up abstract painting for almost a decade. In 1933 he became a founding member of the CGP – an expansion of the Group of Seven – though he was critical of its nationalism. A man of many talents, he returned to the advertising industry during the Depression, producing two books on the subject. His first novel, *Think of the Earth*, won the Governor General's Award for Fiction in 1936.

**BRUCE, William Blair (b. 1859, Hamilton, Ontario; d. 1906, Stockholm, Sweden)**
**See cats. 2, 3, 6**

In Hamilton, Bruce took private lessons from Henry Martin, whom he would later call his "old master," and may have taken drawing classes at the Mechanics Institute. In 1881 he travelled to London and then Paris, where he studied at the Académie Julian under the academic artists Tony Robert-Fleury and William Bouguereau. That year, control of the Paris Salon had switched from the State to the Société des artistes français, and in 1882 Bruce's first submission was accepted for exhibition. He returned to Canada only twice: in 1885, to recuperate from a collapse with his family, and again in 1895 with his wife, Caroline Benedicks, a Swedish sculptor whom he married in 1888. From 1899, the couple made their home on Gotland Island, in the Baltic Sea, where they founded an artists' colony. Bruce regularly sent works back to Canada for exhibition, however, and in 1885 he lost many paintings in the wreck of the steamship *Brooklyn*, which had sailed from Liverpool. Although adept at figure painting, Bruce preferred landscape. Towards the end of his life, he repeatedly painted the view of the sea from his home, using a light-filled, Barbizon-inspired naturalistic style that sometimes verged on Impressionism.

**BRYMNER, William (b. 1855, Greenock, Scotland; d. 1925, Wallasey, Cheshire, England)**
**See cats. 19, 24**

Brymner studied architecture in Ottawa before travelling to Paris in 1878, inaugurating what would become a trend for Canadian artists. He enrolled at the Académie Julian, under William Bouguereau and Tony Robert-Fleury, returning to Canada occasionally and finally settling in Montreal in 1886 to direct the art school of the AAM. Despite his academic training, Brymner encouraged exploration among his students and inspired many – including Helen McNicoll, A. Y. Jackson, Sarah Robertson, Prudence Heward, Anne Savage, and Mabel May – before retiring in 1921. In 1897 Brymner gave an influential lecture on Impressionism at the AAM. On vacation, he would sketch *en plein air* in the Quebec countryside with friends Maurice Cullen and J.W. Morrice. In 1905, he and Cullen built a studio at Saint-Eustache. Brymner was always interested in the human figure, but towards the end of his career he turned his attention increasingly to atmospheric landscapes. In 1909, he was elected president of the RCA (having been a member since 1886), and he joined the Canadian Art Club, which promoted Canadian works over Hague School imports. A frequent overseas traveller, he died while visiting his wife's family in England; a memorial exhibition was held the following year at the AAM.

**CARR, Emily (b. 1871, Victoria, British Columbia; d. 1945, Victoria, British Columbia)**
**See cat. 27**

Carr studied at the California School of Design in San Francisco from 1891 to 1893, then from 1899 at the Westminster School of Art in London. She also spent eight months in St. Ives, Cornwall, under Julius Olsson and Algernon Talmage. Returning to British Columbia in 1904, she sketched in First Nations settlements along the West Coast. In 1910, at age thirty-eight, Carr traveled to Paris and studied first at the Académie Colarossi and then at the private studio of John Duncan Fergusson, who introduced her to the Fauvist colour and technique that would appear in her First Nations paintings back home. After an unproductive period in the

1920s (when she ran a boarding house in Victoria), Carr was invited to exhibit in the NGC's *Canadian West Coast Art: Native and Modern* of 1927. While travelling east for the opening, she met the Group of Seven and was particularly inspired by Lawren Harris, with whom she subsequently corresponded. By the early 1930s, Carr was painting the dense forest interior with more subdued colour and sculptural form; towards the end of the decade her work became increasingly open and spiritual as she turned for her subjects to logging clearings and the seashore, using oil paint thinned with gasoline. She also wrote several autobiographical books in the 1940s.

**CASSON, A. J. (Alfred Joseph) (b. 1898, Toronto, Ontario; d. 1992, Toronto, Ontario)**
**See cat. 82**

Casson studied under John Sloan Gordon at the Hamilton Technical and Art School and worked at Laidlaw Lithography before returning to his native city of Toronto, where he attended life classes at Central Technical School from 1915 to 1917 under Alfred Howell, then at OCA under J. W. Beatty. From 1916, he also studied landscape with Harry Britton, who encouraged outdoor excursions. Casson was hired at Rous and Mann in 1919 as assistant to Franklin Carmichael, who introduced him to the Arts and Letters Club and with whom he often sketched in rural Ontario. In 1925 he founded the Canadian Society of Painters in Water Colour with Carmichael and Fred Brigden, and in 1926 became the seventh member of the Group of Seven (replacing Frank [Franz] Johnston who had left in 1921). That same year, Casson joined Sampson-Matthews, where he later helped produce Canadian art silkscreens for army barracks and schools. A founding member of the CGP in 1933, Casson was elected president of the OSA in 1941 and of the RCA in 1949. He retired from Sampson-Matthews in 1958 to paint full-time, and experimented briefly with a more modern approach. He was honoured with a retrospective at McMaster University's art gallery in 1971 and another mounted jointly by the Art Gallery of Windsor and the AGO in 1978.

**CLARK, Paraskeva (b. 1898, St. Petersburg, Russia; d. 1986, Toronto, Ontario)**
**See cat. 71**

From 1916, Clark (née Plistik) studied landscape under Savely Seidenberg at the Petrograd Academy. When it became the Svomas (Free State Art Studios) under the Soviets, she studied portraiture and still life with Kuzma Petrov-Vodkin, sharing his interest in Cézanne. After graduating in 1921, she painted stage scenery, then moved to Paris when her first husband drowned in 1923. While working in interior design she met her second husband, Canadian Philip Clark, whose membership in the Arts and Letters Club eased her entry into Toronto's arts community following her immigration in 1931. She exhibited with the RCA in 1932 and the new CGP in 1933, becoming a member of the latter in 1936. A friend of Norman Bethune, Clark advocated the social responsibility of the artist in both print and paint. *In Aid of Russia*, held in 1942, was her second solo exhibition at the Picture Loan Society. In 1944 she was elected vice-president of the Federation of Russian Canadians, and was appointed by the NGC to depict the RCAF Women's Division. Clark also painted landscapes during family vacations in northern Ontario and Quebec. Somewhat marginalized in the late 1950s and 1960s by developing art movements, Clark's work was the object of renewed public interest during the 1970s and 1980s.

## COLVILLE, Alex (b. 1920, Toronto, Ontario)
See cat. 85

Colville's family moved to Amherst, Nova Scotia, in 1929, and at fourteen he began taking art classes in nearby Sackville. In 1938 he enrolled at Mount Allison University, where he developed an appreciation for Italian Renaissance painting under Stanley Royle. Graduating in 1942 with a BFA (one of the first such degrees in Canada), he married fellow student Rhoda Wright and enlisted. He received an Official War Artist commission in 1944, travelling to Holland and Germany, and spending a few days in the liberated Bergen-Belsen concentration camp. The physical aspects of war were to have a profound effect on his art. Back in Canada, Colville taught at Mount Allison from 1946 until 1963, when he left to paint full-time. In 1965 he designed the Centennial coins and in 1966 represented Canada at the 23rd Venice Biennale, after which his international renown grew. In 1973 Colville moved to Wolfville, where he still lives today. A decade later, the AGO mounted his first retrospective, which toured nationally and internationally. He has held numerous exhibitions around the world, including a fifty-year retrospective at the NGC in 2000. Colville's approach, sometimes termed "magic realism," is characterized by a neo-pointillist brushstroke and a geometric structuring of space.

## COMFORT, Charles (b. 1900, Edinburgh, Scotland; d. 1994, Ottawa, Ontario)
See cat. 60

In 1912, Comfort immigrated to Winnipeg, where he worked for Fred Brigden's commercial art studio and attended the Winnipeg School of Art. After a year at the New York Art Students League under Robert Henri, Comfort settled in Toronto in 1925, opening a commercial studio with Will Ogilvie and Harold Ayres in 1931 and painting his first large mural in 1932 (for North American Life Assurance). Many others would follow, including those made for the Toronto Stock Exchange in 1937 and the National Library of Canada in 1966. Active in the arts community, Comfort was a founding member of the CGP in 1933 and President of the RCA from 1957 to 1960. He gave up graphic design for teaching at OCA in 1935, then joined the University of Toronto art department in 1938. By 1936, he was painting in the Studio Building next to A. Y. Jackson, with whom he sketched in Georgian Bay. He won first prize in the 1937 joint American and Canadian *Great Lakes Exhibition*, intended to highlight the area's distinct artistic regionalism. From 1943 to 1946, he served as Senior Official War Artist, later publishing *Artist at War* (1956), a book about his experiences. Back in Canada, he resumed teaching at the University of Toronto until 1960, when he became Director of the NGC until 1965.

## COOMBS, E. (Edith) Grace (b. 1890, Hamilton, Ontario; d. 1986, St. Catharines, Ontario)
See cats. 47, 51, 65, 66

While a student at OCA from 1913 to 1918, Coombs received particular encouragement from George Reid, J.E.H. MacDonald, Robert Holmes and Emanuel Hahn. In the summer of 1929, she also took classes at the New York School of Fine and Applied Art. Coombs was Head of Art at Edgehill College in Windsor, Nova Scotia, for a year, and then art mistress at Havergal College in Toronto, before becoming an instructor at OCA in 1920. Although she made some sculpture during her student years, Coombs worked primarily in oil, watercolour and pastels. Her early boldly coloured landscapes were inspired by the Group of Seven, many of whom were her teaching colleagues. She also painted delicate still lifes of wildflowers. In the late 1930s, she began experimenting with abstraction. A regular contributor to OSA, RCA and CNE exhibitions, Coombs was also a member of the Heliconian Club, a Toronto arts and letters club for women. She would paint and conduct summer classes at Camp Charmette, in the Parry Sound district, the summer home she shared with her husband James Sharp Lawson. Her 1956 retirement from OCA allowed her time for several sketching expeditions overseas, including a trip to Russia and Scandinavia in 1961.

## COONAN, Emily (b. 1885, Montreal, Quebec; d. 1971, Montreal, Quebec)
See cat. 45

Born in Pointe Saint-Charles, Montreal, Coonan lived in her family home until the late 1960s. Encouraged by her mother, she studied at the Conseil des arts et manufactures around 1898, and then in about 1905 enrolled at the AAM School under William Brymner, winning a scholarship in Life Class in 1907. In 1912, Coonan travelled in Europe (Northern France, Belgium, Holland) with Mabel May, returning in early 1913, while May continued to England and Scotland. The following year, she was awarded the NGC Trustees' first Travelling Scholarship, but the award was delayed (due to WWI) until 1920, when she again left for Europe. Coonan showed an early interest in Post-Impressionism, and she and Lilias Torrance Newton were the first women to exhibit with the Group of Seven, on their second American tour (1923). Although she briefly rented a studio on Beaver Hall Hill, Coonan was never heavily involved with the Beaver Hall Group. By the late 1920s, she had little contact with the Montreal arts community and no longer exhibited regularly with the CNE, RCA and OSA. Her last exhibition was at the AAM in 1933, but she painted until the end of her life, sketching outdoors with family members.

## COURTICE, Rody Kenny (b. 1895, Renfrew, Ontario; d. 1973, Toronto, Ontario)
See cat. 61

Courtice studied at OCA from about 1920 to 1925, under George Reid, J. W. Beatty, Arthur Lismer and J.E.H. MacDonald. She also attended the Art Institute of Chicago in 1927, where she studied the figure under Karl Buehr, and puppets and stagecraft at the Institute's Goodman Theatre under Tony Sarg. During the 1930s she was an instructor for the Saturday morning children's classes at the AGT; later she taught children in her home. Courtice divided her time between Toronto, where she was active in the Heliconian Club (founded in 1909 for women in arts and letters), and her country home near Markham. A founding member of the CGP in 1933, she sketched with fellow members Yvonne McKague Housser and Isabel McLaughlin on the north shore of Lake Superior and in northern Ontario mining towns in the late 1920s and early 1930s. Her subject matter was varied: aside from landscapes, she painted farm activities and animals around her country home, as well as her son's toys, sometimes employing a refracted space inspired by Cubism. In 1950, she attended Hans Hofmann's summer school in Provincetown, Massachusetts. Her work became increasingly (although never wholly) abstract during the 1950s and 1960s.

**CRISP, Arthur Watkins (b. 1881, Hamilton, Ontario; d. 1974, Biddeford, Maine)**
See cat. 28

Crisp studied at the Hamilton Art School under John Sloan Gordon, and from 1900 to 1903 at the Art Students League in New York, under Bryson Burroughs, Frank DuMond and John Twachtman. He taught at art schools in New York in the 1910s and 1920s, including his alma mater, but his main career was as a muralist. Crisp completed numerous commissions for private and public buildings in New York and New Jersey, as well as six murals for the reading room of the new House of Commons in Ottawa. He was a member of several New York based art societies, including the Architectural League, the National Society of Mural Painters and the American Watercolor Society. In 1956, Crisp moved to Biddeford, Maine, where his failing eyesight increasingly impeded his work. He was guided through his final mural in 1963 by his wife Mary Ellen, with whom he also collaborated in designing tapestries. Though an expatriate most of his life, Crisp never forgot his birthplace. In 1963 the AGH held a retrospective exhibition of work by the Crisps, to coincide with their donation of several of his paintings and mural studies.

**CULLEN, Maurice (b. 1866, St. John's, Newfoundland; d. 1934, Chambly, Quebec)**
See cats. 12, 21

In 1870 Maurice Cullen's family moved to Montreal, where he studied at Abbé Chabert's art school (from 1884 until its destruction by fire in 1887) and with the sculptor Louis-Philippe Hébert. He travelled in 1888 to Paris, where he attended the Académie Colarossi and Académie Julian (with George Reid and William Brymner), and was officially accepted at the École des beaux-arts in 1890 under Jules-Élie Delaunay and later Alfred Roll. That same year, several artists left the Société des artistes français (which controlled the annual Paris Salon) to form the Société nationale des beaux-arts, of which Cullen became the first Canadian Associate member in May 1895. Three months later, he returned to Canada a noted Impressionist and began painting around Quebec, especially at Beaupré. From 1911, Cullen taught at the AAM School, taking students on sketching trips each year – except during his service as Canadian War Records artist between 1918 and 1920 – until the school suspended operations in 1923. He also taught private classes in his Beaver Hall Square studio, which led to the founding of the Arts Club of Montreal in 1912. From 1923 to 1934, the art dealer William Watson held annual Cullen exhibitions (including works by his stepson Robert Pilot). A Cullen retrospective was mounted by the province of Quebec in 1930.

**GORDON, John Sloan (b. 1868, Brantford, Ontario; d. 1940, Hamilton, Ontario)**
See cat. 22

Gordon worked for the Howell Litho Company and as a freelance illustrator in Hamilton before travelling to Paris in 1895, where he studied at the Académie Julian under Jean-Paul Laurens and Benjamin Constant. He opened a studio in Paris, and co-founded the arts and literary magazine *Quartier Latin* (1896–1898), as well as contributing to publications in London, New York and Boston. When he returned to Hamilton in 1896, Gordon continued to receive illustration commissions for major Canadian magazines and books. In 1898 he helped organize the Art League of Hamilton (successor to the Art Students' League of Hamilton), where he taught painting and drawing. In 1904 the League joined with the Hamilton Art School, where Gordon continued to teach. He became principal of the Art Department in 1909 when the School amalgamated with the Board of Education's Technical School (renamed the Hamilton Technical Institute in 1923), holding the position until his retirement in 1932. Arthur Crisp, John Sloan and Albert Robinson were among his students, together with Hortense Mattice, who would become his wife in 1920. A wide traveller in the United States and Europe, Gordon began developing a personal form of pointillism in the early 1900s, and became known as the first Canadian artist to practice this technique.

**GORE, Spencer (British; b. 1878, Epsom, England; d. 1914, Richmond, England)**
See cat. 18

From 1896 to 1899, Gore studied at London's Slade School of Art, where he met Albert Rothenstein (later Rutherston), Harold Gilman and Wyndham Lewis. In 1904, he and Rothenstein visited Walter Sickert in Dieppe. The artists who gathered at Sickert's London studio became known in 1907 as the Fitzroy Street Group. Here Gore met Lucien Pissarro and became familiar with his father Camille's work, which influenced his own pointillist technique. Later, he incorporated the influences of Gauguin, Matisse and Cézanne, and participated in Roger Fry's Second Post-Impressionist Exhibition of 1912. Known as an organizer and mediator, Gore co-founded the Allied Artists' Association in 1908 and joined the New English Art Club in 1909. In 1911 Gore became a founding member and first president of the Camden Town Group, named after the working class district in northwest London where he lived. He would paint in the countryside almost every summer, but he also began portraying the London scenes and figure studies for which the Camden Town Group was known. After three exhibitions at the Carfax Gallery, the group merged with others to form the London Group in 1913, the same year that Gore moved to Richmond. There, he painted his last works before succumbing to pneumonia at age thirty-five.

**HAGARTY, Clara S. (Sophia) (b.1871, Toronto, Ontario; d. 1958, Toronto, Ontario)**
See cat. 44

Hagarty began her studies in Toronto with Wyly Grier and Sydney Strickland Tully. She also attended William Merritt Chase's Shinnecock School of Art on Long Island in the summers. Later, she travelled abroad to study in Holland and in Paris, under Luc-Olivier Merson, Henri Caro-Delvaille and Claudio Castelucho. When WWI broke out, Hagarty left Paris for England to work for the Red Cross. Upon returning to Toronto, soon after the opening of a new wing at the AGT, she began keeping the Gallery records and served as assistant curator until 1928. A member of the OSA since 1899 and Associate of the RCA since 1903, she shared a studio for some years with Mary Wrinch. Two trips to Europe (in 1921 and 1925) resulted in a 1927 exhibition of Italian and Scottish landscapes in the T. Eaton Co. Picture Department, where she exhibited frequently. In 1930, an exhibition of work by Hagarty, Wrinch and Marion Long inaugurated the Art Galleries of the new Eaton's-College Street in Toronto. Initially a painter of landscape, interiors and figures, Hagarty became increasingly known for her flower studies.

**HARRIS, Lawren (b. 1885, Brantford, Ontario; d. 1970, Vancouver, British Columbia)**
See cats. 32, 39, 42, 46, 50, 62

Upon his return from studies in Berlin (1904–1908), Harris became a founding member of the Arts and Letters Club in Toronto, where he met J.E.H. MacDonald and through him F.H. Varley, Frank (Franz) Johnston, Arthur Lismer and Franklin Carmichael. Along with A. Y. Jackson, these artists would in 1920 form the Group of Seven, to promote what they believed to be a national art movement. In the years leading up to the Group's formation Harris was active in fostering the artists' shared vision, financing (along with patron Dr. James MacCallum) the Studio Building on Severn Street, completed in 1914, and organizing sketching trips to Algoma, Ontario. When the Group was absorbed and expanded into the CGP in 1933, Harris became its first president. Soon after, however, he left for New Hampshire with his second wife Bess, an artist who shared his spiritual interests, including Theosophy. The increased formalism of his paintings from the 1920s and early 1930s, featuring Lake Superior's north shore, the Rockies and the Arctic, eventually led to the development of a pure abstract style. In 1938 Harris moved to New Mexico and joined the Transcendental Painting Group. He returned to Canada in 1940, to reside in Vancouver.

**HÉBERT, Adrien (b. 1890, Paris, France; d. 1967, Montreal, Quebec)**
See cat. 57

Hébert studied at the Conseil des arts et manufactures in Montreal from 1904 to 1906, under Edmond Dyonnet, Joseph Saint-Charles and Joseph Franchère, then under William Brymner at the AAM School until 1911. He was encouraged to become an artist by his father Louis-Philippe Hébert, who took him to Paris to study at the École des beaux-arts, one of many trips to France that Hébert made. When he returned to Montreal in 1914, he taught first at the Conseil, and then with the Catholic School Commission from 1917 to 1954. Hébert was a frequent exhibitor in and juror for the AAM Spring Exhibitions (he won the Jessie Dow prize twice). He also contributed illustrations to *Le Nigog*, an avant-garde review founded in 1918, and became a member of the Beaver Hall Group in 1920. During the 1920s, Hébert's work began focusing on Montreal's streets and harbour. Solo exhibitions of his Montreal scenes were held in 1931 at the Galerie Bareiro in Paris and the Arts Club in Montreal (where he also socialized with T. R. MacDonald, Edwin Holgate and Robert Pilot). Though renowned for his cityscapes, he also sketched around Chicoutimi and Percé Rock.

**HÉBERT, Henri (b. 1884, Montreal, Quebec; d. 1950, Montreal, Quebec)**
See cat. 58

Hébert studied in Montreal at the Conseil des arts et manufactures under Edmond Dyonnet and at the AAM School under William Brymner. He also studied in Paris, at the École du soir de la Ville de Paris and the École nationale des arts décoratifs between 1898 and 1902, and from 1904 at the École nationale et spéciale des beaux-arts under the sculptor Gabriel Thomas. Though he would return to Paris several times, he established himself in Montreal in 1909, sharing his father Louis-Philippe Hébert's Labelle Street studio. He taught modelling at McGill's new School of Architecture from 1910 to 1921 and at the Conseil des arts et manufactures from 1923. As a contributor to the avant-garde periodical *Le Nigog* in 1918, Hébert advocated form over subject matter and the integration of sculpture into architecture. Unlike his contemporaries Alfred Laliberté and Marc-Aurèle de Foy Suzor-Coté, Hébert avoided regionalist themes in his later works. He completed numerous public and funerary monuments and architectural collaborations during his forty-year career, as well as exhibiting in annual exhibitions of the AAM, RCA, OSA and NGC. In 1928 at his Labelle Street studio, Hébert co-founded the SSC with Frances Loring, Florence Wyle, Emanuel Hahn and Elizabeth Wyn Wood, to promote the public recogition of modernist sculpture.

**HÉBERT, Louis-Philippe (b. 1850, Sainte-Sophie-d'Halifax, Quebec; d. 1917, Westmount, Quebec)**
See cat. 11

After serving with the Papal Zouaves in Rome, Hébert joined the studio of Adolphe Rho in Bécancour, Quebec, in 1872, before becoming Napoléon Bourassa's apprentice in Montreal the following year. He is also listed as an instructor at the Conseil des arts et manufactures for 1875, where he taught sporadically until the end of the century. In 1879 Hébert began his collaboration with architect Georges Bouillon on Ottawa's Notre-Dame Cathedral, eventually completing about sixty sculptures in wood for the choir. Other commissions for church decorations would follow, including Notre-Dame de Montréal, as well as for monuments: by the time he made his last, *Edward VII* (Montreal, 1914), he had completed about fifty across Canada. In 1886 he received a commission to model historical figures for the new Hôtel du Parlement de Québec, which required study in Paris. He would spend several years there, refining his techniques and returning to Canada frequently. Hébert also completed busts, statuettes and medals of historical and contemporary figures, including himself and family members. He was particularly interested in episodes from Canadian history and Aboriginal subjects. For his achievements, he was honoured with the Confederation Medal, the Vatican's Bene Merenti, France's Order of the Legion of Honour, and Britain's Order of Saint Michael and Saint George.

**HENDERSHOT, Rae (b. 1921, Hamilton, Ontario; d. 1988, Hamilton, Ontario)**
See cat. 81

After graduating in 1939 from the technical program at Westdale Secondary School in Hamilton, where she studied under art director Ida G. Hamilton, Hendershot exhibited as a member of the Women's Art Association of Canada, Hamilton branch. At OCA, in Toronto, she studied in the Painting and Drawing Department under John M. Alfsen, Rowley Murphy, Manly MacDonald and Archibald Barnes, graduating in 1946. As a teacher of figure painting, Alfsen would have the greatest influence on Hendershot, who was also interested in American Realism. Back in Hamilton, she took life drawing at the AGH under John Sloan and rented a studio, where she painted portraits and urban genre scenes, mostly featuring women and children, using a soft brushstroke and rich colour. In 1948 she became one of thirteen founding members of the Contemporary Artists of Hamilton. After her marriage to artist and AGH Director T. R. MacDonald in 1950 and the birth of their daughter Katherine in 1953, Hendershot lessened her involvement in art societies, though she continued to submit to annual exhibitions of the AGH and the AGW. A mutual source of inspiration, Hendershot and MacDonald often painted together. Hendershot's first solo exhibition was held in 1961 at the Westdale Gallery, Hamilton.

**HENRI, Robert (American; b. 1865, Cincinnati, Ohio; d. 1929, New York, New York)**
See cat. 29

In 1886, Henri entered the Pennsylvania Academy of Fine Arts under Thomas Anshutz, an influential proponent of Social Realism. He left in 1888 for Paris, studying at the Académie Julian and the École des beaux-arts. Back home in 1891, Henri returned briefly to the Pennsylvania Academy and taught at the Philadelphia School of Design for Women. After extended trips to Paris, Belgium and Holland, he moved permanently to New York, where he taught at the New York School of Art (1902–1908), the Modern School of the Ferrer Society (1911–1916) and the Art Students League (1915–1928). He also ran his own School from 1909 to 1912, attended by Rockwell Kent, Guy Pène du Bois, Edward Hopper and George Bellows. A full member of the National Academy of Design by 1906, Henri became dissatisfied with its conservative juries. In 1908, he organized an exhibition of outsiders – "The Eight" – at Macbeth Galleries, New York. This circle around Henri (some of whom were students) became known as the Ashcan School. In 1910 he mounted the *Exhibition of Independent Artists*, with no jury or prizes, to coincide with the National Academy's Spring Exhibition. He travelled frequently throughout the United States and overseas, particularly Spain and Ireland, painting urban and working-class life.

**HEWARD, Prudence (b. 1896, Montreal, Quebec; d. 1947, Los Angeles, California)**
See cat. 63

Heward lived in Montreal virtually all her life. She began drawing lessons when she was twelve, and in 1912 won a scholarship in the Senior Elementary Class at the AAM School but interrupted her studies to work for the Red Cross in England from 1916 to 1918. She studied in Paris in 1925 at the Académie Colarossi under Charles Guérin and the École des beaux-arts under Bernard Naudin. She returned in 1929 and enrolled at the Scandinavian Academy with artist Isabel McLaughlin. In 1936 she made the first of several trips to the McLaughlin vacation home in Bermuda, where she was inspired by the landscape. Associated with the Beaver Hall Group, Heward would invite artists to her family's summer home at Fernbank (near Brockville, Ontario) for sketching. She exhibited three times with the Group of Seven, becoming a founding member of the CGP in 1933, a year after her first solo exhibition at William Scott and Sons, Montreal. In 1939, she also became a member of the CAS, initiated by John Lyman to promote modern art. By this time, Heward was becoming known for her monumental nudes and portraits, having received praise abroad in international exhibitions of Canadian art. The NGC mounted a memorial exhibition of her work in 1948.

**HILLIER, Tristram (British; b. 1905, Peking, China; d. 1983, Somerset, England)**
See cat. 75

After apprenticing briefly as an accountant, Hillier studied under Henry Tonks at the Slade School of Art in 1926, and in the evenings under Randolph Schwabe and Bernard Meninsky at the Westminster School of Art. Two years later, he travelled to Paris and studied with Cubist André Lhote. For years Hillier travelled and lived throughout Europe, sending his paintings back to London. His first solo exhibition, at the Lefevre Gallery in 1931, was favourably reviewed by Paul Nash for *The Listener*. He was subsequently invited to join Unit One (formed by Nash in 1933

with Henry Moore and others to promote modern British art) and contributed to its first exhibition at the Mayor Gallery in 1933. He often painted with Edward Wadsworth, another member. From 1935 to the 1970s, Hillier exhibited regularly with Arthur Tooth & Sons Gallery, London. He finally returned to London himself in 1936 and set up a studio in Chelsea. After serving in the Royal Naval Volunteer Reserve (1940–1944), Hillier settled with his second wife, Leda, in Somerset, England, and published his autobiography, *Leda and the Goose*, in 1954. Hillier's interest in Cubism and Surrealism eventually gave way to Realism, but he retained the hard-edged clarity of his signature style.

**HOLGATE, Edwin (b. 1892, Allandale, Ontario; d. 1977, Montreal, Quebec)**
See cat. 83

In 1910 Holgate enrolled full-time at the AAM School under William Brymner, joining Maurice Cullen's summer course at Beaupré. Two years later, he attended the Académie de la Grande Chaumière in Paris. After serving with the Field Artillery from 1916 to 1919, Holgate co-founded the Beaver Hall Group in Montreal, then returned to Paris where he studied under Adolf Milman. In his renowned portraits and nudes, Holgate would synthesize the Russian artist's strong line with a Cézannesque structure. Back in Montreal in 1922, Holgate rented space in Alfred Laliberté's studio building along with Cullen, Robert Pilot and Marc-Aurèle de Foy Suzor-Coté. In 1926 he travelled with A. Y. Jackson and anthropologist Marius Barbeau to the Skeena River to record First Nations culture. Subsequently, in 1929, he used Northwest Coast-inspired designs to decorate a new wing of the Château Laurier, Ottawa. From 1928 to 1934, Holgate taught printmaking at Montreal's École des beaux-arts, after which he and Lilias Torrance Newton revived the AAM School in 1934–1936, and again in 1938–1940. He became the eighth member of the Group of Seven in 1930 and a founding member of the CGP in 1933. Holgate served as Official War Artist for the Air Force in 1943–1944, after which he moved to the Laurentians and painted mostly landscape.

**HOO, Sing (b. 1909, Canton [now Guangzhou], China; d. 2000, Toronto, Ontario)**
See cat. 84

Hoo arrived in Canada in 1922, a year before the Exclusion Act barred Chinese immigrants from entering until 1947. He graduated from OCA in 1933, having studied under Emanuel Hahn, J. W. Beatty and Frederick Challener. He also attended the Slade School of Art in London, and travelled to Paris and Rome. From 1934 to 1942, Hoo worked in the Paleontology department at the Royal Ontario Museum, sculpting replicas and lecturing on Western and Eastern art. He began exhibiting sculpture in 1933, with the OSA and at the CNE. He also exhibited regularly with the SSC and RCA, of which he became an associate member in 1948 and a full member in 1966, depositing a bust of his wife, Norah Chambers, as his diploma piece. In 1984 and 1992 Hoo returned to China by invitation of the government, to lecture in schools on Canadian art. He assisted Emanuel Hahn on the monument to Sir Adam Beck (Toronto), and Elizabeth Wyn Wood on another to King George VI (Niagara Falls). He also designed the sundial for Mount Pleasant Cemetery, Toronto. In his personal work, he preferred to sculpt animals and human busts. The SSC held a retrospective of his sculpture in 1999.

## JACKSON, A. Y. (Alexander Young) (b. 1882, Montreal, Quebec; d. 1974, Kleinburg, Ontario)
See cats. 25, 35

Jackson worked in lithography while taking art classes under William Brymner at the AAM School. In 1906 he moved to a Chicago firm, studying at the Art Institute by night. The following year, he studied briefly at the Académie Julian in Paris. Inspired by French Impressionism, Jackson returned to Europe, painting in Brittany and Assisi from 1911 to 1913. Soon after this trip, he met J.E.H. MacDonald, Arthur Lismer, F. H. Varley and Lawren Harris, and decided to move to Toronto. An exhibition of Jackson's Georgian Bay sketches at the Arts and Letters Club in 1913 provoked the first attack on the new modernism. In 1915 Jackson enlisted and in 1916 was the first Canadian commissioned to paint for the Canadian War Memorials Fund. The Group of Seven was formed in 1920, with Jackson as a founding member. A driving force in the arts community, he was president of the Beaver Hall Group in 1920 and a founding member of the CGP in 1933. He taught for one year at OCA (1924), but gave up teaching because it interfered with his sketching trips. Although Jackson painted all over Canada – including in the Skeena River region in 1926, the Arctic in 1930 and Alberta in the late 1930s and 1940s – he favoured the Quebec countryside.

## KENT, Rockwell (American; b. 1882, Tarrytown Heights, New York; d. 1971, Plattsburgh, New York)
See cat. 40

While an architecture student at Columbia University, Kent studied for three summers (1900–1902) with William Merritt Chase, who awarded him a scholarship for the New York School of Art. Kent also assisted Abbot H. Thayer for one summer in his New Hampshire studio. Encouraged by his teacher Robert Henri, Kent first visited Monhegan Island, Maine, in 1905. He built a house there in 1907, the year of his first solo exhibition at Claussen Galleries, New York. He participated in the 1910 *Exhibition of Independent Artists*, but became increasingly disassociated with Henri's circle, preferring isolated landscapes and peoples to the urban scene. He lived in Newfoundland from 1913 to 1915 and in Alaska with his son in 1918–1919, after which he published *Wilderness*, the first of several illustrated journals. Around this time he took up wood engraving, influenced by the visionary realism of William Blake. Kent also travelled to Tierra del Fuego (1922) and Greenland (1929, 1931–1933, 1934–1935). His edition of *Moby Dick*, published by R.R. Donnelley & Sons in 1930, quickly sold out and was reissued by Random House in smaller format. A life-long socialist, Kent was summoned to testify before the McCarthy hearings in 1953. He donated a large collection of his works to the Soviet Union in 1960.

## LALIBERTÉ, Alfred (b. 1878, Sainte-Élisabeth de Warwick, Quebec; d. 1953, Montreal, Quebec)
See cat. 56

Laliberté was carving wood as early as 1894, though modelling would become his preferred method. In 1898, he began studying at the Conseil des arts et manufactures in Montreal, winning first prize in sculpture at the Conseil in 1900 and 1901. In 1902, he enrolled at the École des beaux-arts in Paris, where he studied under Gabriel-Jules Thomas and later Jean-Antoine Injalbert. In Paris, he also met fellow Quebec artist Marc-Aurèle de Foy Suzor-Coté. Upon his return to Montreal in 1907, Laliberté taught sculpture at the Conseil des arts et manufactures and began winning

commissions for public monuments (including several for the parliament building in Quebec City), medals and medallions. He returned to Paris in 1910, setting up a studio on the Impasse Ronsin, but was back in Quebec the following year. In 1923, he began teaching evening modelling classes at the École des beaux-arts in Montreal and finished Sir Wilfrid Laurier's funerary monument for Notre-Dame Cemetery in Ottawa. Laliberté was also becoming known as a sculptor of traditional Québécois life. By 1932 he had completed a series of over 200 sculptures, "Légendes, métiers et coutumes disparus du Canada," which was purchased by the provincial government.

## LISMER, Arthur (b. 1885, Sheffield, England; d. 1969, Montreal, Quebec)
See cat. 48

Lismer studied at the Sheffield School of Art from 1898–1905, then enrolled at the Académie royale des beaux-arts, Antwerp, in 1906. He immigrated to Canada in 1911, where he first worked at Grip Limited, Toronto (meeting J.E.H. MacDonald, Tom Thomson, Franklin Carmichael and Frank [Franz] Johnston). He switched to Rous and Mann in 1912, returning briefly to Sheffield to marry Esther Mawson and convince F. H. Varley to emigrate. His interest in Canadian landscape was initiated by trips to Georgian Bay in 1913 and Algonquin Park in 1914 with Thomson, A. Y. Jackson and Varley. Lismer had an extensive career in art education, particularly as a strong advocate of child art, about which he lectured internationally. From 1916 to 1919 he was principal of the Victoria School of Art and Design in Halifax (where he also painted harbour activity for Canadian War Records), and vice-principal of OCA in Toronto from 1919 to1927. He supervised art education and children's classes at the AGT (1927–1938), the NGC (1939–1940) and the AAM – later the MMFA (1941–1967). He also taught at McGill University from 1941 to 1955. A member of the Group of Seven and the CGP, Lismer often depicted the smaller details of landscape: undergrowth, a rock face, beach litter. The AGT held a retrospective of his work in 1950.

## LONG, Marion (b. 1882, Toronto, Ontario; d. 1970, Toronto, Ontario)
See cat. 36

After studying at OCA under George Reid and privately with Laura Muntz (Lyall), Long studied in New York under Robert Henri and William Merritt Chase for possibly two winters (1907–1908), then in Provincetown, Massachusetts, under Charles Hawthorne for the summer of 1913. She moved into the Studio Building on Severn Street, Toronto, around 1915, occupying Studio One after it was vacated by A. Y. Jackson and Tom Thomson. In 1933, after ten years as an associate, Long was the first woman to be elected a full member of the RCA since Charlotte Schreiber in 1880, the year of its founding. During WWII, she painted a portrait series of service personnel, including members of the Norwegian Air Force, for which the government of Norway awarded her the King Haakon VII Liberation Medal. In 1943, she was commissioned by Imperial Tobacco to paint eleven portraits of sailors for their Player's Navy Cut campaign, four of which were used in posters and ads. She had also illustrated several covers and stories for the *Canadian Home Journal* in the early 1920s. In her own personal work, Long preferred portraiture, often depicting reflective women in interiors, but she also painted flower still-lifes and Toronto scenes.

**MacDONALD, J.E.H. (James Edward Hervey) (b. 1873, Durham, England; d. 1932, Toronto, Ontario)**
See cats. 33, 43, 52

After moving to Hamilton, Ontario, in 1887, MacDonald attended night classes at the Hamilton Art School. Two years later, he continued his studies at Toronto's Central Ontario School of Art and Design (later OCA), under George Reid. He worked at Grip Limited from 1894 until 1903, when he travelled to England. That year he also joined the Toronto Arts Students' League (modelled on the one in New York), whose members would sketch in rural areas near the city. When MacDonald returned from England in 1907, he was rehired at Grip as head designer, and was joined successively by Tom Thomson, Arthur Lismer, Franklin Carmichael, Frank (Franz) Johnston and F. H. Varley. MacDonald held his first solo exhibition in 1911 at the Arts and Letters Club, and left Grip that year to pursue his late-blooming art career. Inspired by a 1913 exhibition of Scandinavian art at the Albright Art Gallery in Buffalo, MacDonald's interpretation of the Ontario north would become increasingly bold in colour and paint application. From 1924, he spent his summers sketching at Lake O'Hara in the Rockies. After the formation of the Group of Seven, MacDonald began teaching at OCA in 1921, replacing George Reid as principal in 1928.

**MacDONALD, T. R. (Thomas Reid) (b. 1908, Montreal, Quebec; d. 1978, Paris, France)**
See cat. 86

From 1928 to 1930, MacDonald studied privately under Adam Sherriff Scott (whom he later assisted) and, from 1930 to 1933, under Edmond Dyonnet in life classes run by the RCA at the AAM (whose own School had been suspended in 1924). A painter and photographer, his early urban scenes and figure studies were inspired by the American Realists. As a member of the Montreal Arts Club, he befriended several of the city's artists; he also participated in annual exhibitions of the AAM from 1929 and of the RCA from 1931. In 1941 he enlisted, and in 1944 received a commission as Official War Artist. In Italy, he painted some military portraits, but was otherwise left on his own to depict army activities and the devastated landscape, mostly in watercolour. After the war, MacDonald was director of the Owens Art Gallery and the Department of Fine Arts at Mount Allison University, in Sackville, New Brunswick, for a year before accepting the position of director at the AGH in 1947, which he held until his retirement in 1973. He married fellow artist Rae Hendershot in 1950. In 1968, the McMaster University Art Gallery mounted a retrospective of his work.

**MARQUET, Albert (French; b. 1875, Bordeaux, France; d. 1947, Paris, France)**
See cat. 17

From 1891 to 1893, Marquet attended Paris's École nationale des arts décoratifs, where he met Henri Matisse. From 1894, he and Matisse studied at the École des beaux-arts under Gustave Moreau until his death in 1898, then at a private academy under Eugène Carrière, working from live models and sketching in the streets and gardens of Paris. In 1899, Marquet exhibited for the first time in the Salon de la Société nationale des beaux-arts; when his work was rejected in 1901, he never submitted again, deeming the Salon too bourgeois. Instead Marquet exhibited with the Salon des indépendants from 1901 and the Salon

d'automne (of which he was a founding member) from 1903. Two years later, along with other Salon d'automne exhibitors, Marquet would be dubbed a "Fauve" by critic Louis Vauxcelles. In 1904 Marquet began his life-long association with the Galerie Druet, where he held his first solo exhibition in 1907. Known as a painter of Parisian quays and bridges, he also began painting nudes around 1909. From 1920, the worldwide traveller began spending his winters in North Africa, living there year-round during WWII with his wife Marcelle Martinet. His early Fauve style gave way to more naturalistic work in later years.

**MAY, H. (Henrietta) Mabel (b. 1877, Montreal, Quebec; d. 1971, Vancouver, British Columbia)**
See cat. 55

Encouraged by her father, May began drawing classes when she was twelve years old. Around 1902 she enrolled at the AAM School, under William Brymner, where her tuition was later covered by Life Class scholarships. In 1912–1913 she travelled in Europe with Emily Coonan, where she admired (and began to assimilate) the light effects of Impressionism, as well as the vibrant colour and patterning of Post-Impressionism. She won the Jessie Dow prize at the AAM Annual Spring Exhibition twice: in 1914 for watercolour and 1918 for oil. In 1918 she was also one of four women artists commissioned to paint the home front for the Canadian War Memorials Fund – in her case, women munitions workers at Montreal's Northern Electric plant. Soon after, May moved away from figure work towards urban and rural landscape, painting in New England and eastern Quebec as well as Montreal. She also became a founding member of the Beaver Hall Group in 1920 and the CGP in 1933. During the Depression, May moved to Ottawa and taught art at Elmwood School (1936– 1947), as well as supervising the children's Saturday art classes at the NGC. She returned to Montreal briefly and held a solo exhibition at Dominion Gallery in 1950, before moving to Vancouver.

**McGILLIVRAY, Florence H. (Helena) (b. 1864, Whitby Township, Ontario; d. 1938, Toronto, Ontario)**
See cat. 38

McGillivray studied at the Central Ontario School of Art (later OCA) under William Cruikshank, as well as privately under W. L. Forster, Lucius O'Brien and F. McGillivray Knowles. She taught art at the Ontario Ladies' College in Whitby (now Trafalgar Castle School) and gave criticisms at Pickering College, until the school burned down in 1905. In 1913 she studied in Paris under Lucien Simon and Émile-René Ménard, also travelling in England and Italy. That same year, she was elected president of the International Art Union, Paris, which dissolved when the war broke out. In 1917 McGillivray was elected a member of the OSA and of the Society of Women Painters and Sculptors in New York. She travelled extensively throughout her life, sketching in Quebec, Vancouver, Alaska, the New England states, Newfoundland and Labrador, and the West Indies (Trinidad, Jamaica and the Bahamas). In 1935 she retired to Toronto and became involved in the Guild of All Arts, an artist collective on the Scarborough bluffs. In her early work, McGillivray incorporated elements of Art Nouveau before it became popular in Canada. Later, she became interested in the bold colours and dark outlines of Fauvism.

**McNICOLL, Helen (Galloway) (b. 1879, Toronto, Ontario; d. 1915 Swanage, Dorset, England)**
See cat. 34

As a child living in Montreal, McNicoll lost her hearing as the result of scarlet fever. Encouraged by her wealthy family, she studied at the AAM School under William Brymner, and then took life drawing and painting at the Slade School of Art, London. In late 1905 or early 1906, after a three-month stay in Paris (during which she also travelled), she enrolled at Julius Olsson's School of Landscape and Sea Painting in St. Ives, Cornwall (not long after Emily Carr had attended). There she studied under Algernon Talmage, who like Brymner emphasized painting *en plein air*. Around this time, McNicoll's early Barbizon-influenced works gave way to light-filled, loosely-brushed Impressionist depictions, primarily of women and children, often outdoors. It was most likely at the popular St. Ives artists' colony that she met British artist Dorothea Sharp, with whom she travelled in Europe and lived in England. From 1906, McNicoll regularly sent work back to Canada for exhibition at the AAM, RCA, CNE and OSA. In 1908 she shared the AAM Spring Exhibition's first Jessie Dow Prize with W. H. Clapp. Her 1913 election to the Royal Society of British Artists was widely publicized in Montreal. A decade after her death from diabetic complications, McNicoll was honoured by a memorial exhibition at the AAM (1925).

**MORRICE, James Wilson (b. 1865, Montreal, Quebec; d. 1924, Tunis, Tunisia)**
See cats. 13, 14, 26, 31

Morrice's Montreal merchant family was supportive of his artistic pursuits. In 1889, though fully trained to become a lawyer, he left for Europe, where he eventually studied art at the Académie Julian in Paris. It appears he did not stay long, being more interested in landscape than academic painting. Early work displays subtle tonalities and formal concerns reminiscent of Whistler. Later he met Matisse – who called him "the artist with the delicate eye" – and sketched with him on two trips to Morocco (1911–1913). Morrice's palette and handling became progressively lighter under the influence of warmer climes and Fauvism. Though an expatriate most of his life – living primarily in Paris but travelling extensively in Europe, the West Indies and North Africa – Morrice regularly sent works for exhibit to Canada and returned on several occasions to paint the Quebec landscape with Brymner and Cullen. Plagued by ill health, due primarily to his heavy drinking, Morrice stopped painting after a trip to Algiers in 1922, where he had joined Marquet. He was listed prematurely as deceased in the 1923 catalogue of the Salon d'automne, at which Morrice had shown since 1907.

**MORRIS, Kathleen Moir (b. 1893, Montreal, Quebec; d. 1986, Rawdon, Quebec)**
See cat. 69

In her early artistic pursuits, Morris was encouraged by her mother's cousin, artist Robert Harris, who had sketched the young Kathleen in 1901. Around 1906 she entered the Elementary classes at the AAM, and would later fondly recall Maurice Cullen's spring sketching class in Carillon, Quebec. Morris completed her studies at the AAM in 1917. Though not a member of the short-lived Beaver Hall Group, she associated and exhibited with the same women artists. From 1923 to 1929 she lived in Ottawa with her mother (summering at Marshall's Bay near Arnprior, Ontario) and befriended NGC director Eric Brown and his wife Maud. In 1924 she participated in the British Empire Exhibition at Wembley. The Canadian section caused controversy, first because the NGC assumed control of its organization over the RCA, and later because British reviewers overlooked Canada's academicians in praise of its more modern painters, including Morris. She became an Associate of the RCA in 1929, and a member of the CGP in 1940. Morris loved to paint communal activity – street scenes, market places, gatherings for Church mass – mostly in the winter, when she would go on sketching trips to Quebec City and Berthierville.

**NASH, Paul (British; b. 1889, London, England; d. 1946, Boscombe, Hampshire, England)**
See cat. 76

Nash enrolled at the Slade School of Art in 1910, where he met Stanley Spencer, Mark Gertler and Christopher Nevinson. He left the Slade in 1912 and, upon Roger Fry's invitation, joined the Omega Workshops in 1914. In 1917, Nash exhibited war-torn landscapes at the Goupil Gallery, inspired by his service at Ypres (during which he was injured). He returned to Ypres again in the fall, this time as a war artist, and later painted at Vimy for the Canadian War Records (as several British artists did). Nash would be commissioned again as a war artist in 1940. Though he experimented with interior scenes and abstracts, he never abandoned his imaginative landscapes, influenced by the metaphysical painter Giorgio de Chirico. In 1933 he co-founded Unit One (with Henry Moore, Barbara Hepworth, Ben Nicholson, Edward Burra and Edward Wadsworth), which lasted until 1935, and sought to revitalize British art by looking to the European avant-garde. Nash also served on the Committee for the 1936 *International Surrealist Exhibition* held in London, and contributed to others in subsequent years. In 1938 he paid his first visit to "Madams," the home of friends in Gloucestershire, which would inspire many later works and to which he would return several times.

**NEUMANN, Ernst (b. 1907, Budapest, Hungary; d. 1956, Vence, France)**
See cat. 78

Neumann immigrated to Canada with his parents in 1912 at the age of five. Around 1924 he attended the new École des beaux-arts in Montreal, which opened in 1923. He also took life classes run by the RCA at the AAM (whose own School closed as a result of the free tuition offered by the École). Sometime before 1932 Neumann apprenticed in a commercial art firm, where he became interested in lithography, woodcut and etching. Between 1936 and 1938 he shared a studio and taught classes with Goodridge Roberts, a former École student. Inspired by Goya and Daumier, Neumann was drawn to the human condition and urban scenes. During the Depression, he portrayed the unemployed of Montreal. Though he took portrait commissions and sculpted, he made his living primarily through prints, which he apparently peddled door-to-door. He exhibited regularly in the RCA and the AAM Spring exhibitions, and held several solo and small group shows. In 1955 Neumann was awarded a Royal Society of Canada grant to study in Europe, where he settled in Paris but died of heart failure on a trip to southern France. A year after his death, the NGC sponsored an exhibition of his work that travelled nationally; the catalogue's foreword was written by AGH Director T. R. MacDonald, a close friend of Neumann's.

**PÈNE DU BOIS, Guy (American; b. 1884, Brooklyn, New York; d. 1958, Boston, Massachusetts)**
See cat. 72

In 1899 Pène du Bois enrolled at the New York School of Art (then the Chase School), where he became Robert Henri's class monitor. In 1905 he went to Paris, where he studied at the Académie Colarossi and privately with Théophile Steinlen. From 1906 to 1912 he worked as reporter then full-time art critic for the *New York American*. In 1912 he joined the Association of American Painters and Sculptors, which organized the 1913 Armory Show, intended to represent modern American and international styles and oppose the staid National Academy of Design. Immediately after, Pène du Bois, Robert Henri and John Sloan resigned from the Association, in a split between realists and modernists. Pène du Bois held his first solo exhibition at the Whitney Studio Club in 1918, the year it was founded. He worked for various publications and taught at the Arts Students League before moving to France with his family in 1924, where he had his most productive period, depicting the social gatherings of American expatriates. He returned to New York in 1930 and from 1932 to 1950 conducted the Guy Pène du Bois Summer School in Connecticut. In 1940 he published *Artists Say the Silliest Things*. Though his interest in fashionable society continued, from the 1930s onward he also painted models and nudes.

**REID, George A. (Agnew) (b. 1860, Wingham, Ontario; d. 1947, Toronto, Ontario)**
See cats. 4, 5, 7, 8, 10

After apprenticing in architecture, Reid studied at the Ontario School of Art under Robert Harris (1879–1880 and 1882), the Pennsylvania Academy of Fine Arts in Philadelphia under Thomas Eakins (1883–1884), and the Julian and Colarossi academies in Paris (1888–1889). After returning to Toronto, he continued to send genre paintings to the Paris Salon. In 1891 Reid began teaching at the Central Ontario School of Art and Design (previously the Ontario School of Art, renamed OCA in 1912), serving as its principal from 1909 to 1928. There he initiated an outdoor summer school (which moved to Port Hope in 1922), and was chief architect for OCA's McCaul Street building (1919). A founding member of several art societies, including the Society of Mural Decorators (1894), the Toronto Guild of Civic Art (1897) and the Canadian Society of Painters in Water Colour (1926), Reid was also president of the OSA from 1897 to 1901 and the RCA from 1906 to 1907. After an 1896 return to the Académie Julian, he attempted to apply a more Impressionist technique to his academic method of modelling forms with light and dark. He also began taking on mural projects in Toronto, including works for City Hall (1897–1899) and the Royal Ontario Museum (1934–1938). His first wife, artist Mary Hiester, died in 1921, and in 1923 Reid married Mary Wrinch.

**ROBERTSON, Sarah (b. 1891, Montreal, Quebec; d. 1948, Montreal, Quebec)**
See cat. 73

In 1910 Robertson won a scholarship in the Senior Elementary Class at the AAM School, where she studied for several years. She joined the Beaver Hall Group in 1921 and exhibited with them the following year. Robertson was considered the central organizer for the "gang" of women artists that formed through the short-lived Group and the AAM School. She painted primarily landscapes, both urban and rural, but specialized in Montreal scenes, including the Sulpician Seminary at the top of Fort Street,

where she lived from 1927. Although her sketching trips were limited to day picnics and the summer homes of artist friends (Prudence Heward's near Brockville and Nora Collyer's in the Eastern Townships) and family in Vermont, she did travel to Bermuda with Collyer around 1929. Her brushwork became more vigorous in the late 1930s. During the Depression, she also painted some murals in private homes. Like several of the former Beaver Hall women, she was a founding member of the CGP in 1933. She was closest to Heward, and helped organize her NGC memorial exhibition in 1948, shortly before her own death from bone cancer. The NGC held a memorial exhibition in her honour in 1951.

**ROBINSON, Albert (b. 1881, Hamilton, Ontario; d. 1956, Montreal, Quebec)**
See cat. 30, 49

Robinson studied under John Sloan Gordon at the Hamilton Art School from 1901 to 1903, while working as chief illustrator at *The Hamilton Times*. Between 1903 and 1906, he studied under William Bouguereau and Marcel-André Baschet at the Académie Julian in Paris, then Gabriel Ferrier at the École des beaux-arts, and privately under T. W. Marshall. By 1909 Robinson had settled in Montreal and, with the support of his patrons Mr. and Mrs. William Davis, begun painting the Quebec landscape. In 1911 he was elected to the Pen and Pencil Club, which included William Brymner and Maurice Cullen, and painted in France (St. Malo and Carhaix) with A. Y. Jackson. After depicting shipbuilding in Montreal for the Canadian War Records in 1919, Robinson was an invited contributor to the first Group of Seven exhibition and was elected a full member of the RCA. In 1921, Jackson, who would later claim to be influenced by his painting companion's light effects, encouraged Robinson to join him for the first of many winter trips together to the lower St. Lawrence. Robinson would become best known for his Quebec winter scenes in high-keyed colour. A founding member of the CGP, he exhibited in several international exhibitions of Canadian art. A retrospective of his work was organized by the AGH and shown there and at the NGC the year before he died.

**RODIN, Auguste (French; b. 1840, Paris, France; d. 1917, Meudon, France)**
See cat. 9

After attending a school for drawing and mathematics known as the "Petite École" from 1854 to 1857, Rodin made three unsuccessful attempts to enter Paris's École des beaux-arts. He assisted the sculptors Albert-Ernest Carrier-Belleuse (from 1864) and Antoine-Joseph Van Rasbourgh (from 1873), and visited Italy in 1875 to study the works of Michelangelo. Two years later, he exhibited *The Bronze Age* at the Salon des artistes français in Paris. Radical in its naturalism, it was purchased in 1880 by the State, which also commissioned a door for a proposed museum. Never really completed, this project – *The Gates of Hell* – nonetheless spawned the famous sculptures *The Thinker* and *The Kiss*. In 1890 Rodin became a founding member of the Société nationale des beaux-arts. Several major international exhibitions would follow, together with a number of commissioned monuments, including *The Burghers of Calais*, unveiled in Paris in 1895. His monument to Balzac, commissioned in 1891, was not installed until 1939 because of protests concerning its rough modelling. A pavilion of the 1903 Universal Exhibition in Paris was devoted to his work, and in 1912 New York's Metropolitan Museum installed a Rodin Room. Renowned for his expressive and energetic busts and figures (some erotic and many fragmentary), Rodin donated his collection to France to form the Musée Rodin in Paris, which opened in 1919.

**RUSSELL, John W. (Wentworth) (b. 1879, Binbrook, Ontario; d. 1959, Toronto, Ontario)**
See cat. 23

Russell studied at the Hamilton Art School, and between 1898 and 1904 at the Art Students League in New York, where he boarded with Arthur Crisp. He subsequently moved to Paris but maintained ties with Canada, exhibiting with the RCA and the Canadian Art Club, of which he became a member in 1909. His early paintings of the Brittany coast are characterized by pastel colours and subtle tones. He lived in New York during his brief marriage to illustrator Helen Dryden, who designed covers for *Vogue*. The two also stayed in Ottawa in 1912, while Russell painted the portrait of Wilfrid Laurier. In 1927 his nude *A Modern Fantasy* caused considerable controversy in Toronto at the CNE. He returned from Paris once again in 1931 to exhibit at Eaton's Fine Art Galleries, taking an opportunity to speak in Hamilton about the need for a public art gallery. The following year he opened the Russell School of Fine Arts in Toronto, which closed with the outbreak of war. After his 1933 submissions to the CNE were rejected, Russell decided to hold annual exhibitions of his own work, renting a floor in the Automotive Building at the CNE in subsequent years. Russell travelled abroad extensively, returning to Toronto just shortly before his death.

**SAVAGE, Anne (b. 1896, Montreal, Quebec; d. 1971, Montreal, Quebec)**
See cat. 41

From 1914 to 1918, Savage studied at the AAM School under William Brymner and Maurice Cullen, during which time her twin brother Donaldson was killed in action. After graduation, she shared a studio with Nora Collyer at Beaver Hall Hill, and became a founding member of the Beaver Hall Group in 1920. She would also become a founding member of the CGP in 1933 and of the CAS in 1939. Savage taught art at the Commercial and Technical High School for a year before transferring to Baron Byng High School as its first art teacher (1922–1948). After retiring, she supervised art education full time for the Montreal Protestant School Board until 1953, and taught art education at McGill University from 1954 to 1959. Savage also directed Saturday morning children's art classes at the AAM from 1937, until Arthur Lismer took over in 1941. Though teaching occupied much of her time, Savage managed to paint on sketching trips: in 1927 to the Skeena River with Florence Wyle (an expedition organized by anthropologist Marius Barbeau to record First Nations culture), and in 1933 to Georgian Bay with lifelong friend A. Y. Jackson. Mostly she painted at her family's summer property on Lake Wonish, north of Montreal, where she built a studio in the 1930s.

**SCHAEFER, Carl (b. 1903, Hanover, Ontario; d. 1995, Toronto, Ontario)**
See cat. 77

Schaefer enrolled at OCA in 1921, under Arthur Lismer and J.E.H. MacDonald, but left in 1924. Thereafter he did a variety of free-lance work, including assisting MacDonald in decorating the Claridge Apartments and Concourse Building in Toronto. While working for the commercial art studio Brigden's Limited, he met lifelong friend Charles Comfort, who painted Schaefer's portrait three times. In 1929 he was hired by René Cera as a display designer for the T. Eaton Co., but was made redundant the following year due to the Depression. During the 1930s Schaefer became a member of the CGP and taught part-time at Central

Technical School and Hart House in Toronto, and Trinity College School in Port Hope. In the summers from 1932 to 1940, he and his family lived in Hanover, Ontario, with the grandparents who raised him. There he painted the rural countryside in a regionalist manner. In the 1930s Schaefer also began experimenting with what would become his preferred medium: watercolour. In 1940 he became the first Canadian recipient of a Guggenheim Fellowship, and moved to Vermont to paint for a year. Three years later, he served as an Official War Artist, depicting RCAF activities in the U.K. and Iceland. Subsequently, he taught at OCA (1948–1970).

**SLOAN, John (American; b. 1871, Lock Haven, Pennsylvania; d. 1951, Hanover, New Hampshire)**
See cat. 16

A self-taught etcher, Sloan studied at the Pennsylvania Academy of Fine Arts from 1892 (under Thomas Anshutz) while working as illustrator for the Philadelphia *Inquirer*. In 1893 he formed the Charcoal Club with fellow student Robert Henri and others who would later become known as the Ashcan School. Sloan left the *Inquirer* for the Philadelphia *Press* in 1895 and soon began painting seriously in oils, influenced by the direct observation of newspaper reportage. By 1904 he had left the *Press* and moved to New York. In 1908 he was one of "The Eight" who showed at Macbeth Galleries, and in 1910 participated in the *Exhibition of Independent Artists*. From 1918 to 1944 he was president of the Society of Independent Artists. Sloan became increasingly involved in the Socialist Party, illustrating publications and twice running for office. In 1916 he held his first solo exhibition, at the Whitney Studio (Gloria Vanderbilt Whitney's first gallery), and began a life-long association with the Kraushaar Gallery. In 1949 he was elected president of the New Mexico Alliance for the Arts, in Santa Fe, where he summered almost every year from 1919. In 1952 the Whitney Museum of American Art held a retrospective of his work, selected just before his death.

**SLOAN, John (b. 1890, Aberdeen, Scotland; d. 1970, Hamilton, Ontario)**
See cats. 67, 79

Before immigrating to Hamilton in 1914, Sloan apprenticed in a sculptor's studio and attended Gray's School of Art in his home-town. Not long after enrolling at the Hamilton Technical and Art School, he became John Sloan Gordon's assistant. By 1915, he was a member of the staff, teaching until his retirement in 1956. In 1936, the year he was elected an associate member of the RCA, the Academy also gave him a grant to teach evening art classes at the AGH; these classes, which Sloan taught for fifteen years, were free for local students and artists who were granted admission. Highly active in the Hamilton arts community, Sloan served from 1934 to 1946 on the executive of the Hamilton Art Club, which held annual exhibitions and meetings at the AGH. Originally the Men's Art Club, it opened membership to women in 1938. Along with OSA, CNE and RCA exhibitions, Sloan also participated in the AGH's own Annual Exhibitions. Principally a sculptor whose realist work became formally simplified during the 1940s, Sloan also painted, having studied under John Beatty at OCA's Port Hope summer school. The AGH held a retrospective of his sculpture in 1959.

**SPURR CUTTS, Gertrude (b.1858, Scarborough, England; d. 1941, Port Perry, Ontario)**
See cat. 20

After studying at the Scarborough School of Art under Albert Strange, and the Lambeth School of Art, London, under John H. Smith, Spurr Cutts sketched in Belgium and Holland. She was already exhibiting with the Royal Society of British Artists and the Society of Women Artists when she immigrated to Canada in 1890, joining her parents in Toronto and establishing a studio. She quickly became involved in the arts community, gaining membership in the OSA the following year and serving as corresponding secretary for the Toronto Art Students' League in 1896. Founded ten years earlier, the League was modelled on its New York counterpart and encouraged outdoor sketching. Around 1900–1901, Spurr Cutts studied at the New York Art Students League summer school, in Woodstock, under George Bridgman and Birge Harrison. She also studied with John F. Carlson, who had his own school of landscape painting in Woodstock. In 1909, she married artist William Cutts. The two shared a studio in Toronto and painted outdoors together. They also travelled to England, residing at the artists' colony in St. Ives, Cornwall, for a time around 1912. Back in Canada, they moved to Port Perry, Ontario, in 1915.

**SURREY, Philip (b. 1910, Calgary, Alberta; d. 1990, Montreal, Quebec)**
See cat. 87

Surrey worked at Brigden's commercial art studio in Winnipeg while attending the Winnipeg School of Art under Lionel Lemoine FitzGerald (1926–1927). In 1929 he moved to Vancouver, where he took lessons from F. H. Varley. He also studied briefly in 1936 at the Art Students League in New York (under Frank Vincent Dumond and Alexander Abels), where he was influenced by American Social Realism. Surrey settled in Montreal the following year, beginning his long career as a journalist and photography editor for the *Montreal Standard* and *Weekend Magazine*. The city would become a frequent subject of his painting. In 1939, the year he married writer Margaret Day, Surrey replaced Jack Humphrey as the sixth member of the Eastern Group of Painters, organized by John Lyman in support of international art movements. That same year Surrey was also a founding member of the CAS. In 1943 and 1944, the CAS boycotted the AAM Spring Exhibition because of its academic jury; in 1945, as a concession, the jury was divided into two sections, one composed of CAS members. Surrey had many solo exhibitions, including one presented at the Musée d'art contemporain, Montreal, in 1971 and at the Canadian Cultural Centre, Paris, in 1972.

**SUZOR-COTÉ, Marc-Aurèle de Foy (b. 1869, Arthabaska, Quebec; d. 1937, Daytona Beach, Florida)**
See cat. 53

Suzor-Coté apprenticed under painter-decorator Joseph-Thomas Rousseau from 1886 until 1891, when he left for France. There, he studied with Léon Bonnat and landscape artist Henri Harpignies before entering the École des beaux-arts. He returned to Paris in 1897 to attend the Julian and Colarossi academies, exhibiting regularly in the Salon of the Société des artistes français. Back at his Arthabaska studio in 1907, Suzor-Coté concentrated on Canadian landscape – employing vivid colour and an often Impressionist stroke – as well as rural Québécois portraits. That same year he exhibited his first known sculpture, *The Trapper*,

with the Salon of the Société nationale des beaux-arts. He also received portrait commissions, including one for Sir Wilfrid Laurier in 1909. Becoming increasingly known as a gifted painter and sculptor, Suzor-Coté exhibited extensively with the AAM (winning the Jessie Dow Prize twice), RCA and OSA. In 1913 he was invited to join the Canadian Art Club. He exhibited his first nudes in 1915 and four years later moved into a Montreal studio built by Alfred Laliberté. In the mid-1920s, he hired models from the Caughnawaga (today Kahnawake) Mohawk reserve. A 1927 stroke resulted in his moving to Daytona Beach, Florida. The Quebec government held a major retrospective of his work at Montreal's École des beaux-arts in 1929.

**THOMSON, Tom (b. 1877, near Claremont, Ontario; d. 1917, Canoe Lake, Ontario)**
See cat. 37

After briefly attending the Canada Business College in Chatham, Ontario, and the Acme Business College in Seattle, Washington, Thomson obtained employment as an engraver. By 1909 he was working at Grip Limited, Toronto, for J.E.H. MacDonald. In 1912 he made the first of many trips to Algonquin Park, and left Grip for Rous and Mann Press Limited. Soon, however, he decided to paint full-time, working occasionally as a fire ranger or guide in Algonquin and returning to Toronto only in winter, to translate a few of his many sketches into canvases. In 1914 he shared a studio with A. Y. Jackson in the new Studio Building, then moved into a shack behind it the following year. From 1915 to 1916 he completed mural panels for Dr. James MacCallum's cottage in Go-Home Bay, Georgian Bay, a commission shared with MacDonald and Arthur Lismer. In July 1917 his body was found in Canoe Lake. With no formal training and only a very brief painting career (six years), Thomson learned from his associates. His work incorporated elements of decorative design from his commercial experience, and became more freely brushed and vibrant toward the end of his life.

**WADSWORTH, Edward Alexander (British; b. 1889, Cleckheaton, Yorkshire, England; d. 1949, London, England)**
See cat. 80

While studying engineering in Munich in 1906–1907, Wadsworth also took art classes at Heinrich Knirr's private school. Returning to Yorkshire, he enrolled at the Bradford School of Art, but then in 1908 won a scholarship for the Slade School of Art in London, where he remained until 1912. After having participated in the 1912 Second Post-Impressionist Exhibition at the Grafton Galleries, curated by Roger Fry, Wadsworth was invited to join Fry's Omega Workshops in 1913. He left with Wyndham Lewis soon after and joined Lewis's rival group, The Rebel Art Centre, founded in 1914 to promote a Cubo-Futurist style. Wadsworth signed the Vorticist manifesto in the first issue of *Blast* (June 1914) and contributed to the Vorticist Exhibition of 1915. During WWI, he served with the Royal Naval Volunteer Reserve in the Mediterranean until 1917, then spent a year painting dazzle camouflage for ships. After the war he retained an interest in industrial and marine subjects, becoming increasingly influenced by Surrealism and reviving the use of tempera paint. In 1933 Éditions Sélection of Antwerp published a monograph on him, and he also became a founding member of Unit One, along with Paul Nash. In 1940, Wadsworth's work was chosen to represent Britain at the Venice Biennale.

## WALKER, Horatio (b. 1858, Listowel, Ontario; d. 1938, Sainte-Pétronille, Île d'Orléans, Quebec)
See cat. 15

The OSA held its first exhibition at Notman and Fraser's photographic firm in Toronto in 1873, the same year that Walker was hired there to colour photographs. Largely self-taught, he received some instruction from co-workers, including Robert F. Gagen and John A. Fraser, the OSA's first president. In 1876 Walker left for the United States, where he lived first in Rochester and later in New York City. He regularly spent his summers in Quebec, depicting rural workers and farm animals in a Barbizon-influenced, moody-toned style. By the turn of the century, he was at the height of his success. A member of the American Water Color Society, the Society of American Artists, and the National Academy of Design in New York, Walker won numerous medals and awards. He exhibited more frequently in Canada after he became a founding member of the Canadian Art Club in 1908, for which he served as president in 1915. Walker contributed to the annual exhibitions of the CNE and the RCA, which amended its constitution in 1913 especially so that he (considered a non-resident) could become a full member. From 1928, he resided permanently on Quebec's Île d'Orléans. In 1929 the AGO and Montreal's École des beaux-arts held a retrospective of his work.

## WARRENER, Lowrie (b. 1900, Sarnia, Ontario; d. 1983, Toronto, Ontario)
See cat. 54

After three years of study at OCA under Emanuel Hahn and Arthur Lismer, Warrener dropped out in 1924 and travelled to Europe. He enrolled at the Académie royale des beaux-arts in Antwerp, but left for Paris in 1925, where he attended the Académie de la Grande Chaumière. Back in Toronto in 1926, he was invited to exhibit with the Group of Seven and moved into the Studio Building. That summer, he sketched in Pickerel River with Carl Schaefer. Around this time, Warrener began painting landscape in abstracted forms. He also developed an interest in theatre design and collaborated with playwright Herman Voaden, travelling west with him in 1930, on Canadian Pacific rail passes, to write a Canadian drama. Warrener was back West the following summer (this time on a pass arranged by Marius Barbeau), to paint at Kitwanga, British Columbia. When he returned to Toronto, he opened an unsuccessful paint business and worked as an inspector of anti-tank rifles. In 1944 he joined the Eagle Pencil Company, where he remained until his retirement in 1968. Warrener stopped exhibiting regularly in the 1940s, and his art production was reduced to sketching during summer vacations and printing linoblock cards at Christmas.

## WOOD, Elizabeth Wyn (b. 1903, Orillia, Ontario; d. 1966, Toronto, Ontario)
See cat. 64

Wood studied at OCA from 1921 to 1926 (including one post-graduate year) under Arthur Lismer, J.E.H. MacDonald and sculptor Emanuel Hahn. She married Hahn in 1926 and attended the Art Students League in New York, under Edward McCarton and Robert Laurent. Upon her return, she began interpreting landscape in sculpture, inspired by the Group of Seven, Art Deco and her own annual trips to northern Ontario. In 1928 Wood became a founding member of the SSC, succeeding her husband as president in 1935. From 1928 to 1961 she taught sculpture at Central Technical School. Much of her work of the 1930s and 1940s consisted of modernist figures and busts. She won many public sculpture competitions, including the Welland-Crowland War Memorial (1934–1939), the Simcoe Monument in Niagara-on-the-Lake (1951–1953) and the George VI monument in Niagara Falls (1955–1961). Wood helped organize the sculpture component of several international Canadian art exhibitions. She was also involved in the political representation of artists, as a member of the Federation of Canadian Artists, secretary of the Arts Reconstruction Committee, and chair of the Foreign Relations Committee of the Canadian Arts Council, which replaced the Arts Reconstruction Committee in 1945. After Hahn's death, she became increasingly interested in designing medals and coins, and founded the Canadian Society of Medallic Art in 1963.

## WRINCH, Mary E. (Evelyn) (b. 1877, Kirby-le-Soken, Essex, England; d. 1969, Toronto, Ontario)
See cat. 59

After the death of her father, Wrinch moved with her family to Ontario. From 1893, she studied at the Central Ontario School of Art and Design under George Reid and Robert Holmes, as well as in Reid's private studio class (where Laura Muntz [Lyall] also taught at the time). In 1897 she went to London where she studied life drawing under Walter Donne at Grosvenor Life School and miniature painting with Alyn Williams. She continued to explore miniatures (using a stippled watercolour on ivory technique) under Alice J. Beckington at the Art Students League in New York, eventually turning to landscape in oil after her first trip to Muskoka in 1906. Four years later, Wrinch built her own studio on Lake of Bays in Ontario, where she would summer. In 1923 she married George Reid, with whom she would go on sketching trips in Algoma, Temagami, the Ottawa Valley and Quebec. She was the first woman elected to the executive of the OSA, serving as vice-president and treasurer (1924–1925). Around 1928, Wrinch began making linoleum block prints. Working from small oil sketches and inspired by Gauguin, she would simplify a landscape or flower arrangement into a flat pattern, experimenting with colour contrast.

\*    \*    \*

Note to Reader:

All artists are Canadian unless otherwise stated. For painting dimensions, height precedes width; and for sculpture, the order is height, width, then depth. In the provenances, if the residences of the first owner and of the artist are known and the same, the city name appears only once. The exhibition histories are selective, including major exhibitions as well as those significant to the history of the Art Gallery of Hamilton. In these selected exhibition histories, titles of works are given only if they are known to differ from the current title; provinces are not included, states are (unless already in the institution's name); and "England" is used only after "London" to avoid confusion with London, Ontario. If a city is part of an institution's name, it is not repeated. Exhibitions that are probable, but not confirmed, appear in square brackets.

# Catalogue

*Compiled by Alicia Boutilier*

Cat. 1

**EUGÈNE BOUDIN**  (French; 1824–1898)
*Trouville. Le port*   1884
oil on wood
23.7 x 32.8 cm
Bequest of Miss Muriel Isabel Bostwick, 1966
66.43.24  (Schmit no.1985)
Inscriptions recto: l.l., *E. Boudin*–; l.r., *Trouville 84*
Provenance: Paul Detrimont (art dealer, son of Eugène
Detrimont), purchased from the artist, Paris, Feb 1885. [Watson
Art Galleries, Montreal?] Muriel Isabel Bostwick, Hamilton;
bequest, Dec 1966.
Exhibitions:
*Louis Eugène Boudin: Precursor of Impressionism*, Santa Barbara
    Museum of Art, California, 8 Oct–21 Nov 1976 / Art
    Museum of South Texas, Corpus Christi, 2 Dec 1976–
    9 Jan 1977 / Museum of Fine Arts, St. Petersburg, Florida,
    18 Jan–27 Feb 1977 / Columbus Gallery of Fine Arts,
    Ohio, 10 Mar–24 Apr 1977 / Fine Arts Gallery of San
    Diego, California, 5 May–12 Jun 1977, no. 15, repr.

Cat. 2

**WILLIAM BLAIR BRUCE**  (1859–1906)
*Giverny*  c. 1887
oil on canvas
26.4 x 35.0 cm
Bruce Memorial, 1914
14.5
Inscriptions: none
Provenance: Estate of the artist; artist's family, Hamilton and
Sweden; gift, May 1914.
Exhibitions:
*Minnesutställning W. Blair Bruce*, Stockholm, Kunstakadamien,
    Nov 1907, no. 144, *Från Giverny*
*William Blair Bruce, 1859–1906*, RMG, 26 Oct–28 Nov 1982 / AGW,
    1–30 Jan 1983 / RHAC, 4–27 Feb 1983 / Burlington
    Cultural Centre, 7 Apr–1 May 1983 / Sterling and
    Francine Clark Institute, Williamstown, Massachusetts,
    18 Jun–4 Sep 1983 / St. Mary's University Art Gallery,
    Halifax, 12 Oct–8 Nov 1983 / CCAGM, 16 Nov–18 Dec
    1983 / NAM, 24 Feb–25 Mar 1984 / MAG, 20 Apr–3 Jun
    1984 / LRAG, 6 Jul–2 Sep 1984 / KWAG, 6 Sep–21 Oct
    1984, no. 11, *Trees by Stream*, repr.
*William Blair Bruce: Painting For Posterity*, AGH, 16 May 1998–
    3 Oct 1999, no. 5, repr.

Cat. 3

**WILLIAM BLAIR BRUCE**  (1859–1906)
*Giverny, France*   1887
oil on canvas
26.5 x 34.6 cm
Bruce Memorial, 1914
14.8
Inscriptions recto: l.l., *BLAIR BRUCE / 87*
Provenance: Estate of the artist; artist's family, Hamilton and
Sweden; gift, May 1914.
Exhibitions:
*Minnesutställning W. Blair Bruce*, Stockholm, Kunstakadamien,
    Nov 1907, no. 173, *Från Frankrike*
*Inaugural Exhibition*, AGT, 29 Jan–28 Feb 1926, no. 246, *Giverney*
    [sic], *France*
*William Blair Bruce*, RMG, 26 Mar–11 May 1975 / AGH, 5–29 Jun
    1975 / AEAC, 8 Jul–12 Aug 1975 / Memorial University
    Art Gallery, St John's, 29 Aug–5 Oct 1975 / Concordia
    University Art Gallery, Montreal, 16 Oct–23 Nov 1975
    / WAG, 15 Jan–22 Feb 1976 / Woodstock Public Library
    and Art Gallery, 24 Mar–2 May 1976, no. 5, repr.
*William Blair Bruce, 1859–1906*, RMG, 26 Oct–28 Nov 1982 / AGW,
    1–30 Jan 1983 / RHAC, 4–27 Feb 1983 / Burlington
    Cultural Centre, 7 Apr–1 May 1983 / Sterling and
    Francine Clark Institute, Williamstown, Massachusetts,
    18 Jun–4 Sep 1983 / St. Mary's University Art Gallery,
    Halifax, 12 Oct–8 Nov 1983 / CCAGM, 16 Nov–18 Dec
    1983 / NAM, 24 Feb–25 Mar 1984 / MAG, 20 Apr–3 Jun
    1984 / LRAG, 6 Jul–2 Sep 1984 / KWAG, 6 Sep–21 Oct
    1984, no. 7, repr.
*Visions of Light and Air: Canadian Impressionism 1885–1920*, MQ,
    14 Jun–4 Sep 1995 / Americas Society Art Gallery, New
    York (organizer), 27 Sep–17 Dec 1995 / The Dixon
    Gallery and Gardens, Memphis, Tennessee,18 Feb–14
    Apr 1996 / The Frick Art Museum, Pittsburgh,
    Pennsylvania, 12 Jun–11 Aug 1996 / AGH, 12 Sep–8 Dec
    1996, no. 2, repr.
*William Blair Bruce: Painting For Posterity*, AGH, 16 May 1998–3
    Oct 1999, no. 6, repr.

Cat. 4

**GEORGE A. REID** (1860–1947)
*Studio Study* 1880s
oil on laminated card
6.3 x 5.2 cm
Gift of Mr. and Mrs. J. A. McCuaig, 1966
66.105.24
Inscriptions verso: on label, *Studio Study / at Philadelphia / by G.A. Reid / M.W. Reid.*
Provenance: Estate of the artist; Mary Wrinch (artist's wife), Toronto; Paul Duval, Toronto, 1961; purchased with funds from Mr. and Mrs. J. A. McCuaig, Nov 1966.
Exhibitions:
*la belle époque: Standards in Taste, Ontario 1880–1910*, KWAG, 5 Jun– 5 Sep 1976, no cat. no.

Cat. 5

**GEORGE A. REID** (1860–1947)
*At the Window (Study)* 1880s
oil on laminated card
10.2 x 9.5 cm
Gift of Mr. and Mrs. J. A. McCuaig, 1966
66.105.25
Inscriptions recto: l.r., *GA Reid*; verso: c., *Study for / "At the Window" / 1888 / Catskills*; on loose label, *At the Window. / Study 19/0. [?] / by. G.A. Reid / canvas ——— 4′4 x 4′4*
Provenance: Estate of the artist; Mary Wrinch (artist's wife), Toronto; Paul Duval, Toronto, 1961; purchased with funds from Mr. and Mrs. J. A. McCuaig, Nov 1966.
Exhibitions:
*la belle époque: Standards in Taste, Ontario 1880–1910*, KWAG, 5 Jun–5 Sept 1976, no cat. no., *At the Window*

Cat. 6

**WILLIAM BLAIR BRUCE** (1859–1906)
*The Phantom Hunter* 1888
oil on canvas
151.1 x 192.1 cm
Bruce Memorial, 1914
14.26
Inscriptions recto: l.r. *BLAIR BRUCE*; verso: stretcher, u.c., on label [torn], *M [___] Blair / chez M [___] net 5 h rue [?] / Notre Dame des champs. / "Le Phantôme de la Neige"*; stretcher, c.l., *Le Chasseur Fantome*
Provenance: Estate of the artist; artist's family, Hamilton and Sweden; gift, May 1914.
Exhibitions:
*Salon de la Société des Artistes Français*, Paris, May–Jun 1888, no. 405, *Le fantôme de la neige/Snow-Ghost*, repr.
[*Exposition de la Société des Artistes*, Crystal Palace, Munich, 1 Jun–end Oct 1888?]
*Exposition Universelle* (Canadian Pavilion), Paris, 1900, no. 10, *Le chasseur fantôme/The Phantom Hunter*
*Exposition Rétrospective de l'Œuvre de W. Blair Bruce*, Galeries Georges Petit, Paris, 11–26 May 1907, no. 36, *Le fantôme chasseur*
*Loan Collection of Paintings by Deceased Canadian Artists*, Art Museum of Toronto, 24 Jan–22 Feb 1911, no. 7, *Le Fantôme Chasseur*
*Inaugural Exhibition*, AGT, 29 Jan–28 Feb 1926, no. 242, *The Walker of the Snow*, repr.

*Images for a Canadian Heritage*, VAG, 20 Sep–30 Oct 1966, no. 53, repr.
*Canadian Painting, 1850–1950*, NGC (organizer), Willistead Art Gallery, Windsor, 8 Jan–12 Feb 1967 / LPLAM, 17 Feb–26 Mar 1967 / AGH, 1 Apr–7 May 1967 / AEAC, 12 May–10 Jun 1967 / Rothmans Art Gallery of Stratford, 16 Jun–30 Jul 1967 / MAG, 9 Aug–9 Sep 1967 / EAG, 15 Sep–10 Oct 1967 / AGGV, 20 Oct–28 Nov 1967 / CCAGM, 30 Nov–30 Dec 1967 / New Brunswick Museum, St. John, 15 Jan–15 Feb 1968 / BAG, Feb 1968 / MQ, 15 Mar–14 Apr 1968, no. 10, repr.
*19th and 20th Century Painting and Sculpture from the A.G.H.*, RMG, 5–30 Sep 1973, no cat. no. (exhibition list)
*19th and 20th Century Canadian Paintings from the Art Gallery of Hamilton*, University of Guelph, 28 Apr–30 May 1974, no. 5
*William Blair Bruce*, RMG, 26 Mar–11 May 1975 / AGH, 5–29 Jun 1975 / AEAC, 8 Jul–12 Aug 1975 / Memorial University Art Gallery, St John's, 29 Aug–5 Oct 1975 / Concordia University Art Gallery, Montreal, 16 Oct–23 Nov 1975 / WAG, 15 Jan–22 Feb 1976 / Woodstock Public Library and Art Gallery, 24 Mar–2 May 1976, no. 7, repr.
*Through Canadian Eyes: Trends and Influences in Canadian Art 1815–1965*, GAI, 22 Sep–24 Oct 1976, no. 45, repr.
*Fact and Fiction: Canadian Painting and Photography 1860–1900*, McCord Museum, Montreal, 20 Jun–12 Aug 1979, no cat. no.
*William Blair Bruce, 1859–1906*, RMG, 26 Oct–28 Nov 1982 / AGW, 1–30 Jan 1983 / RHAC, 4–27 Feb 1983 / Burlington Cultural Centre, 7 Apr–1 May 1983 / Sterling and Francine Clark Institute, Williamstown, Massachusetts, 18 Jun–4 Sep 1983 / St. Mary's University Art Gallery, Halifax, 12 Oct–8 Nov 1983 / CCAGM, 16 Nov–18 Dec 1983 / NAM, 24 Feb–25 Mar 1984 / MAG, 20 Apr–3 Jun 1984 / LRAG, 6 Jul–2 Sep 1984 / KWAG, 6 Sep–21 Oct 1984, no. 14, repr.
*The Art Gallery of Hamilton: Seventy-Five Years (1914–1989)*, AGH, 28 Sep–19 Nov 1989, no. 9, repr.
*I Believe in Magic*, AGH, 29 Oct 1994–22 Jan 1995, no cat. no., repr.
*William Blair Bruce: Painting For Posterity*, AGH, 16 May 1998–3 Oct 1999, no. 17, repr.

Cat. 7

**GEORGE A. REID** (1860–1947)
*Forbidden Fruit* 1889
oil on canvas
77.8 x 122.9 cm
Gift of the Women's Committee, 1960
60.105.Y
Inscriptions recto: l.r., *G.A. Reid. / 1889*
Provenance: L.A. Scott, Pennsylvania, purchased from the artist through the *60th Annual Exhibition*, Pennsylvania Academy of Fine Arts, Mar 1890. Continental Galleries, Montreal, 1959; purchased, Oct 1960.
Exhibitions:
*60th Annual Exhibition*, Pennsylvania Academy of Fine Arts, 30 Jan–6 Mar 1890, no. 172
*Hamilton Collects*, Willistead Art Gallery, Windsor, 21 Mar–18 Apr 1962, no. 3
*Images for a Canadian Heritage*, VAG, 20 Sep–30 Oct 1966, no. 55
*Three Hundred Years of Canadian Art*, NGC, 12 May–17 Sep 1967 / AGO, 20 Oct–26 Nov 1967, no. 157, repr.

*Director's Choice from the Permanent Collection of the Art Gallery of*
    *Hamilton*, Art Gallery of Brant, Brantford, 9 Sep–3 Oct
    1971, no. 6
*19th and 20th Century Canadian Paintings from the Art Gallery of*
    *Hamilton*, University of Guelph, 28 Apr–30 May 1974,
    no. 27, repr.
*The Ontario Community Collects: A Survey of Canadian Painting*
    *from 1766 to the Present*, AGO, 12 Dec 1975–1 Feb 1976
    (did not travel to the subsequent venues), no. 78, repr.
*Through Canadian Eyes: Trends and Influences in Canadian Art*
    *1815–1965*, GAI, 22 Sep–24 Oct 1976, no. 57, repr.
*100 Years: Evolution of the Ontario College of Art*, AGO, 5 Nov
    1976–2 Jan 1977 / AGH, 3–27 Feb 1977 / St. Catharines
    and District Arts Council, Rodman Hall, 4–27 Mar
    1977 / KWAG, 31 Mar–23 Apr 1977 (did not travel to
    the subsequent venues), no cat. no.
*The Image of Man in Canadian Painting: 1878–1978*, McIntosh
    Gallery, London, 1 Mar–2 Apr 1978 / GAI, 1 May–15 Jun
    1978 / VAG, 1 Jul–1 Aug 1978 / AGO, 19 Aug–17 Sep 1978
    / BAG, 1 Oct–1 Nov 1978, no. 5, repr.
*Fact and Fiction: Canadian Painting and Photography, 1860–1900*,
    McCord Museum, Montreal, 20 Jun–12 Aug 1979, no
    cat. no.
*Heritage and the New Wave: Canadian Roots, 1850–1940*. RHAC,
    19 Nov–3 Jan 1982
*Rural Route Ontario*, AGP, 2 Nov–16 Dec 1984, no. 22
*Sympathetic Realism: George A. Reid and the Academic Tradition*,
    AGO, 22 Aug–19 Oct 1986 / Thunder Bay National
    Exhibition Centre, 19 Nov–29 Dec 1986 / KWAG,
    15 Jan–22 Feb 1987 / Burlington Cultural Centre, 5–29
    Mar 1987 / RHAC, 10 Apr–17 May 1987, no. 34, repr.
*The Art Gallery of Hamilton: Seventy-Five Years (1914–1989)*, AGH,
    28 Sep–19 Nov 1989, no. 57, repr.
*Ozias Leduc: An Art of Love and Reverie*, MMFA, 22 Feb–19 May
    1996 / MQ, 12 Jun–15 Sep 1996 / AGO, 18 Oct 1996–19
    Jan 1997 (not in catalogue; accompanied exhibition)

Cat. 8
**GEORGE A. REID** (1860–1947)
*Study in the Park*   1889
oil on laminated card
6.9 x 9.8 cm
Gift of Mr. and Mrs. J. A. McCuaig, 1966
66.105.26
Inscriptions recto: l.l., *G.A. REID. 1889.*; verso: c., on label
[torn], *Study [___] painted in Paris / by G.A. Reid*
Provenance: Estate of the artist; Mary Wrinch (artist's wife),
Toronto; Paul Duval, Toronto, 1961; purchased with funds from
Mr. and Mrs. J. A. McCuaig, Nov 1966.
Exhibitions:
*la belle époque: Standards in Taste, Ontario 1880–1910*, KWAG,
    5 Jun– 5 Sept 1976, no cat. no., *In the Park*
*Sympathetic Realism: George A. Reid and the Academic Tradition*,
    AGO, 22 Aug–19 Oct 1986 / Thunder Bay National
    Exhibition Centre, 19 Nov–29 Dec 1986 / KWAG,
    15 Jan–22 Feb 1987 / Burlington Cultural Centre, 5–29
    Mar 1987 / RHAC, 10 Apr–17 May 1987, no. 33, repr.

Cat. 9
**AUGUSTE RODIN**  (French; 1840–1917)
*Frère et soeur*   c.1890
bronze
38.4 x 18.7 x 19.0 cm
Gift of H. S. Southam, C.M.G., LL.D., 1962
62.105.10
Inscriptions: back of base, *A. Rodin*; back of base, *Alexis Rudier. /*
*Fondeur. Paris.*
Provenance: Musée Rodin, Paris; Dominion Gallery, Montreal,
Jun 1962; purchased, Oct 1962.
Note: This work was purchased with insurance funds from the
1960 theft of three works donated in 1948 by H. S. Southam, all
recovered in 1965.
Exhibitions:
*The Art Gallery of Hamilton: Seventy-Five Years (1914–1989)*, AGH,
    28 Sep–19 Nov 1989, no. 58, *Le frère et la soeur*, repr.
*The Modernists: Rodin to Caro: Sculpture from the Collection of the*
    *Art Gallery of Hamilton*, The Koffler Gallery, North York,
    20 Oct–1 Dec 1993 / AGH, 19 Feb–15 May 1994, no cat.
    no., repr.
*Shape Shifters: Sculptures and the Modern Age*, AGH, 23 Mar–18 Jun
    1995, no cat. no., repr.

Cat. 10
**GEORGE A. REID**  (1860–1947)
*Early Autumn*   1892
oil on wood
10.0 x 9.8 cm
Gift of Mr. and Mrs. J. A. McCuaig, 1966
66.105.22
Inscriptions verso: c., *Early Autumn / 10 minute sketch / G.A. Reid*
*/ 1892  4x4*
Provenance: Estate of the artist; Mary Wrinch (artist's wife),
Toronto; Paul Duval, Toronto, 1961; purchased with funds from
Mr. and Mrs. J. A. McCuaig, Nov 1966.
Exhibitions:
*la belle époque: Standards in Taste, Ontario 1880–1910*, KWAG,
    5 Jun–5 Sept 1976, no cat. no.

Cat. 11
**LOUIS-PHILIPPE HÉBERT**  (1850–1917)
*Self-Portrait*   c.1895
bronze
50.0 x 23.0 x 21.0 cm
Gift of Canadian Westinghouse Company, 1966
66.72.27
Inscriptions: back of base, *P. HEBERT*; top of base, at back, *PH*;
top of base, at back, foundry stamp, THIEBAUT FRERES /
FONDEURS / PARIS
Provenance: Estate of the artist. Purchased from a dealer, with
funds from Canadian Westinghouse Co., Aug 1966.
Exhibitions:
*The Hand Holding the Brush*, LRAG, 4 Nov 1983–8 Jan 1984 /
    MSAC, 20 Jan–4 Mar 1984 / AGH, 19 Mar–29 Apr 1984 /
    McCord Museum, Montreal, 14 May–24 Jun 1984 /
    BAG, 9 Jul–19 Aug 1984 / MSVUAG, 3 Sep–14 Oct 1984 /
    AEAC, 29 Oct–16 Dec 1984, no. 7, repr.
*Curatorial Laboratory Project #6: Glut: Culture as Accumulation*,
    28 Jun–28 Aug 1991, no cat. no., repr.
*Louis-Philippe Hébert, 1850–1917*, MQ (co-organizer with MMFA),
    7 Jun–3 Sep 2001 / NGC, 12 Oct 2001–6 Jan 2002,
    no. 55, repr.

Cat. 12

**MAURICE CULLEN** (1866–1934)
*Logging in Winter, Beaupré* 1896
oil on canvas
64.1 x 79.9 cm
Gift of the Women's Committee, 1956, dedicated to the memory of Ruth McCuaig, President of the Women's Committee, 1953–1955
56.56.V
Inscriptions recto: l.r., *MAURICE CULLEN. 96*
Provenance: possibly Robert Harris, purchased from the artist through auction, Fraser Institute Hall, 2–18 Dec 1897; James E. Harris (nephew of Robert Harris); purchased from Mrs. Freda E. Harris (widow of James E. Harris), Charlottetown, Dec 1956.
Exhibitions:
*Maurice Cullen 1866–1934*, MMFA, 5–28 Oct 1956 / AGH, 9
        Nov–16 Dec 1956 / MQ, 10–23 Jan 1957 / AGT, 8 Feb–3
        Mar 1957/ NGC, 8–31 Mar 1957 / EAG, 10 Apr–1 May
        1957 / VAG, 7 May–2 Jun 1957 / WAG, 20 Jun–14 Jul
        1957, no. 10, repr.
*Hamilton Collects*, Willistead Art Gallery, Windsor, 21 Mar–
        18 Apr 1962, no. 4
*Canadian Painting, 1850–1950*, NGC (organizer), Willistead Art
        Gallery, Windsor, 8 Jan–12 Feb 1967 / LPLAM, 17 Feb–26
        Mar 1967 / AGH, 1 Apr–7 May 1967 / AEAC, 12 May–10
        Jun 1967 / Rothmans Art Gallery of Stratford, 16 Jun–
        30 Jul 1967 / MAG, 9 Aug–9 Sep 1967 / EAG,
        15 Sep–10 Oct 1967 / AGGV, 20 Oct–28 Nov 1967 /
        CCAGM, 30 Nov–30 Dec 1967 / New Brunswick
        Museum, St. John, 15 Jan– 15 Feb 1968 / BAG, Feb 1968
        / MQ, 15 Mar–14 Apr 1968, no. 17, repr.
*Director's Choice from the Permanent Collection of the Art Gallery of
        Hamilton*, Art Gallery of Brant, Brantford, 9 Sep–3 Oct
        1971, no. 4
*Canadian Landscape Painting, 1670–1930: The Artist and the Land*,
        Elvehjem Art Center, University of Wisconsin,
        Madison, 11 Apr–23 May 1973 / Hopkins Center Art
        Galleries, Dartmouth College, Hanover, New
        Hampshire, 15 Jun–1 Aug 1973 / University Art
        Museum, University of Texas, Austin, 20 Aug–7 Oct
        1973, no. 35, repr.
*Impressionism in Canada 1895–1935*, VAG, 16 Jan–24 Feb 1974 /
        EAG, 8 Mar–21 Apr 1974 / Saskatoon Gallery and
        Conservatory Corp., 4 May–10 Jun 1974 / CCAGM,
        22 Jun–1 Sep 1974 / RMG, 19 Sep–3 Nov 1974 / AGO
        (organizer), 17 Nov 1974–5 Jan 1975, no. 5, repr.
*Through Canadian Eyes: Trends and Influences in Canadian Art
        1815–1965*, GAI, 22 Sep–24 Oct 1976, no. 52, repr.
*To Found a National Gallery: The Royal Canadian Academy of Arts
        1880–1913*, NGC, 6 Mar–27 Apr 1980 / AGO, 23 May–29
        Jun 1980 / VAG, 26 Jul–24 Aug 1980 / GAI, Calgary,
        15 Sep–15 Oct 1980 / MMFA 15 Nov 1980–4 Jan 1981,
        no. 52
*Maurice Cullen: 1866–1934*, AEAC, 26 Sep–31 Oct 1982 / AGO,
        13 Feb–27 Mar 1983 / AGH, 17 Apr–29 May 1983 / NGC,
        12 Jun–31 Jul 1983 / EAG, 21 Aug–2 Oct 1983, no 11, repr.
*When Winter Was King: The Image of Winter in 19th Century
        Canada*, Whyte Museum of the Canadian Rockies,
        26 Jan–6 Mar 1988 / LRAG, 9 Apr–24 May 1988 / AGW
        4 Jun–10 Jul 1988 / McCord Museum, Montreal,
        16 Sep–31 Oct 1988, no. 70, repr.
*The Art Gallery of Hamilton: Seventy-Five Years (1914–1989)*, AGH,
        28 Sep–19 Nov 1989, no. 19, repr.

*The True North: Canadian Landscape Painting 1896–1939*, Barbican
        Art Gallery, London, England, 19 Apr–16 June 1991,
        no. 25, repr.
*Visions of Light and Air: Canadian Impressionism 1885–1920*, MQ,
        14 Jun–4 Sep 1995 / Americas Society Art Gallery, New
        York (organizer), 27 Sep–17 Dec 1995 / The Dixon
        Gallery and Gardens, Memphis, Tennessee, 18 Feb–14
        Apr 1996 / The Frick Art Museum, Pittsburgh,
        Pennsylvania, 12 Jun–11 Aug 1996 / AGH, 12 Sep–8 Dec
        1996, no. 24, repr.
*Vision Made Real: An Exhibition Celebrating the 50th Anniversary of
        the Volunteer Committee*, AGH, 23 Apr–29 Aug 1999

Cat. 13

**JAMES WILSON MORRICE** (1865–1924)
*Corner of the Doge's Palace, Venice* c.1901
oil on wood
17.3 x 25.2 cm
Bequest of Miss Margaret Rousseaux, 1958
58.86.Q
Inscriptions recto: l.r., *Morrice*; verso: c., studio stamp, STUDIO / J.W. MORRICE
Provenance: Miss Margaret Rousseaux (related to the artist's family), Hamilton; bequest, May 1958.
Exhibitions:
*Canadian Artists in Venice: 1830–1930*, AEAC, 18 Feb–1 Apr 1984,
        no. 24

Cat. 14

**JAMES WILSON MORRICE** (1865–1924)
*Le porche de l'église San Marco, Venise* c.1902–1904
oil on wood
33.0 x 24.0 cm
Bequest of H.L. Rinn, 1956
56.86.L
Inscriptions recto: l.l., *Morrice*
Provenance: M. Georges Manoury, Paris, purchased from the artist; Laing Galleries, Toronto; purchased with funds from the bequest of H.L. Rinn, Mar 1956.
Exhibitions:
*James Wilson Morrice, R.C.A., 1865–1924: Memorial Exhibition*,
        NGC, 25 Nov–27 Dec 1937 / AGT, from 8 Jan 1938 /
        AAM, Feb 1938, no. 75
*J.W. Morrice 1865–1924*, MMFA, 30 Sep–31 Oct 1965 / NGC,
        12 Nov–5 Dec 1965, no. 52, *The Portal of Saint Mark/Le
        Porche de l'eglise Saint-Marc*, repr.
*Ten Canadians – Ten Decades*, AGGV, 25 Apr–14 May 1967, no. 5,
        *The Portal of Saint Mark*
*James Wilson Morrice: 1865–1924*, VAG, 3 Jun–3 Jul 1977, no cat.
        no.
*Canadian Painting: Selected Works from the Collections of the Art
        Gallery of Hamilton and the Kitchener-Waterloo Art Gallery*,
        KWAG, 19 Feb–29 Mar 1981, no cat. no. (exhibition list)
*Canadian Artists in Venice: 1830–1930*, AEAC, 18 Feb–1 Apr 1984,
        no. 25

Cat. 15

**HORATIO WALKER** (1858–1938)
*Ave Maria* 1906
oil on canvas
116.8 x 86.2 cm
Gift of the Women's Committee, 1963
63.117.R
Inscriptions recto: l.r., *Copyright 1906 by Horatio Walker* (as origi-
nally signed by the artist; "*Copyright*" has since been removed)
Provenance: Newmann E. Montross (art dealer), purchased from
the artist, New York; Corcoran Gallery of Art, Washington,
D.C., purchased through the *First Annual Exhibition*, Feb 1907;
deaccessioned, Mar 1955; sold through Victor H. Spark, New
York, 1955. Laing Galleries, Toronto, 1962; purchased, Jun 1963.
Exhibitions:
*First Annual Exhibition: Oil Paintings by Contemporary American
    Artists*, Corcoran Gallery of Art, 7 Feb–9 Mar 1907,
    no. 119
*Thomson–Walker Exhibition*, AGT, Jan 1941, no cat. no. (exhibition
    list)
*Horatio Walker, R.C.A., N.A. (1858–1938): Memorial Exhibition*,
    NGC (assembled by the AGT), 1 Mar–8 Apr 1941, no. 4
*Commonwealth Arts Festival: Treasures from the Commonwealth*,
    Royal Academy of Arts, London, England, 17 Sep–13
    Nov 1965, no. 327
*Director's Choice from the Permanent Collection of the Art Gallery of
    Hamilton*, Art Gallery of Brant, Brantford, 9 Sep–3 Oct
    1971, no. 9
*19th and 20th Century Painting and Sculpture from the A.G.H.*, RMG,
    5–30 Sep 1973, no cat. no. (exhibition list)
*19th and 20th Century Canadian Paintings from the Art Gallery of
    Hamilton*, University of Guelph, 28 Apr–30 May 1974,
    no. 37
*American Art in the Barbizon Mood*, National Collection of Fine
    Arts, Smithsonian Institution, Washington, 23 Jan–19
    Apr 1975, no. 84, repr.
*la belle époque: Standards in Taste, Ontario 1880–1910*, KWAG,
    5 Jun–5 Sep 1976, no cat. no., *Ava Maria*
*Horatio Walker 1858–1938*, AEAC, 17 Dec 1977–28 Jan 1978,
    no. 25, repr.
*The Image of Man in Canadian Painting: 1878–1978*, McIntosh
    Gallery, London, 1 Mar–2 Apr 1978 / GAI, 1 May–15 Jun
    1978 / VAG, 1 Jul–1 Aug 1978 / AGO, 19 Aug–17 Sep 1978
    / BAG, 1 Oct–1 Nov 1978, no. 14, repr.
*Canadian Painting: Selected Works from the Collections of the Art
    Gallery of Hamilton and the Kitchener-Waterloo Art Gallery*,
    KWAG, 19 Feb–29 Mar 1981, no cat. no. (exhibition list)
*Le Grand Héritage*, MQ, 10 Sep 1984–13 Jan 1985, no. 252, repr.
*Horatio Walker, 1858–1938*, MQ, 25 Sep–23 Nov 1986 / MCAC,
    1 Feb–4 Apr 1987 / New Brunswick Museum, St. John,
    1 May–28 Jun 1987, no. 15, repr.
*The Art Gallery of Hamilton: Seventy-Five Years (1914–1989)*, AGH,
    28 Sep–19 Nov 1989, no. 71, repr.

Cat. 16

**JOHN SLOAN** (American; 1871–1951)
*Stein and Press* 1906
oil on canvas
81.3 x 66.3 cm
Gift of Mr. and Mrs. J. A. McCuaig in memory of her father,
H. B. Hall, 1964
64.111.5 (Elzea no. 72)
Inscriptions recto: l.r., –*John Sloan*
Provenance: Estate of the artist; purchased through Kraushaar
Galleries, New York, with funds from Mr. and Mrs. J. A. McCuaig,
May 1964.
Exhibitions:
*Eighth Annual Fellowship Exhibition*, Pennsylvania Academy of
    Fine Arts, Philadelphia, 28 Oct–17 Nov 1907, *Girl and
    the Etching Press*
*Special Exhibition of Contemporary Art*, National Arts Club, New
    York, 4–25 Jan 1908, no. 63
*Exhibition of Paintings and Drawings by John Sloan*, C.W. Kraushaar
    Art Galleries, New York, 3–22 Mar 1919, no. 8
*John Sloan Exhibition of Paintings*, Hudson Guild Neighborhood
    House, New York, 8–28 Feb 1940, no. 1
*Original American Paintings, Watercolors, Prints, Drawings*, New
    York Storm King Art Center, Mountainville, New York,
    3 Sep–5 Oct 1961, no. 27 (brochure)
*Director's Choice from the Permanent Collection of the Art Gallery of
    Hamilton*, Art Gallery of Brant, Brantford, 9 Sep–3 Oct
    1971, no. 30, repr.
*Selections from the American Collection of the Art Gallery of Hamilton*,
    Oakville Centennial Gallery, 4 Jun–3 Jul 1977
*Selected Works Representing the American Regionalist-Ashcan Schools
    of Painting from the Permanent Collection of the A.G.H.*,
    RHAC, 14 Mar–13 Apr 1986
*20th Century American Painting*, McMaster University Art Gallery,
    15 Mar–12 Apr 1987
*The Art Gallery of Hamilton: Seventy-Five Years (1914–1989)*, AGH,
    28 Sep–19 Nov 1989, no. 64, repr.

Cat. 17

**ALBERT MARQUET** (French; 1875–1947)
*Le pont Marie vu du quai Bourbon* 1906–1907
oil on canvas
65.0 x 81.0 cm
Bequest of Marion E. Mattice, 1958
58.86.T
Inscriptions recto: l.r., *marquet*; verso: stretcher, u.l., *Pont Marie*
Provenance: Galerie Druet, purchased from the artist, Paris,
around 1907 or 1908. Anna and Eugène Boch, Paris; Anna Boch,
Brussels; Galerie Le Roy, Brussels, 15 Dec 1936, no. 431. Paul
Brame (art dealer), Paris; Laing Galleries, Toronto, c.1955;
purchased with funds from the bequest of Marion E. Mattice,
Jun 1958.
Exhibitions:
*Exhibition of Paintings and Sculpture Arranged by the Fine Arts
    Committee of the Canadian National Exhibition Association
    (Gallery V)*, CNE, 24 Aug–8 Sep 1956, no. 131, *Le Pont
    Marie*
*French Painting from the Impressionists to the Present*, LPLAM,
    6 Feb–31 Mar 1959, no. 29, *Le pont Marie*
*Masterpieces from Canadian Museums*, Detroit Institute of Arts,
    Michigan, 3–28 Mar 1963, no. 10, *Le Pont Marie*
    (exhibition list)

*Through Canadian Eyes: Trends and Influences in Canadian Art 1815–1965*, GAI, 22 Sep–24 Oct 1976, no. 44, repr.
*Scottish Painting Canada*, AGNS, 6 Jul–mid Aug 1979, no. 2
*To Found a National Gallery: The Royal Canadian Academy of Arts 1880–1913*, NGC, 6 Mar–27 Apr 1980 / AGO, 23 May–29 Jun 1980 / VAG, 26 Jul–24 Aug 1980 / GAI, 15 Sep–15 Oct 1980 / MMFA 15 Nov 1980–4 Jan 1981, no. 70
*The Canadian Art Club 1907–1915*, EAG, 1 Apr–5 Jun 1988 / MCAC, 1 Jul–15 Aug 1988 / BAG, 15 Sep–31 Oct 1988 / MQ, 1 Dec 1988–15 Jan 1989 / MacKenzie Art Gallery, Regina, 15 Feb–31 Mar 1989 / AGGV, 1 May–15 Jun 1989, no. 26, repr.
*The Art Gallery of Hamilton: Seventy-Five Years (1914–1989)*, AGH, 28 Sep–19 Nov 1989, no. 10, repr.

## Cat. 25

**A. Y. JACKSON** (1882–1974)
*Moonlight, Assisi* c. 1912
oil on canvas
54.4 x 65.0 cm
Presented by David S.I. Ker in memory of his father, Frederick I. Ker, C.B.E., 2002
2002.27
Inscriptions recto: l.r., *A. Y. JACKSON*; verso: vertical crossbar, c., on label [illegible], *LE CHATEAU [___]Y.* / *ALEX. Y. JACKSON* / *$600.*; vertical crossbar, u., *MOONLIGHT ASSISI.*; stretcher, l.r. [obscured], *[___]HT IN ASSISI*; stretcher, l.l. [obscured], *[___] PARIS*; stretcher, l.r., *G-26*
Provenance: Watson Art Galleries, stock no. 12637A; Canadian Press, Apr 1949; Frederick Innes Ker, Hamilton, presented by Officers and Members of the Canadian Press in appreciation of his services as President (1946–1948), 1949; David S.I. Ker, Hamilton; gift, Dec 2002.
Exhibition History:
[*Inaugural Exhibition*, AGH, from 30 Jun 1914?]
*A. Y. Jackson, A Retrospective Exhibition*. LPLAM, 29 Jan–20 Feb 1960 / AGH (organizer), Mar–Apr 1960, no. 32

## Cat. 26

**JAMES WILSON MORRICE** (1865–1924)
*By the Sea* c.1912
oil on wood
12.4 x 15.7 cm
Bequest of Miss Margaret Rousseaux, 1958
58.86.R
Inscriptions verso: c.l., *RB Morrice*; c., studio stamp, STUDIO / J.W. MORRICE
Provenance: Miss Margaret Rousseaux (related to the artist's family), Hamilton; bequest, May 1958.

## Cat. 27

**EMILY CARR** (1871–1945)
*Yan, Q.C.I.* 1912
oil on canvas
98.8 x 152.5 cm
Gift of Roy G. Cole, 1992
1992.22.5
Inscriptions recto: l.l., *M EMILY CARR / YAN Q.C.I 1912*; verso: frame, u.r., on label, *58 / Village of Yan / by Emily Carr / (British Columbia – Canada)*
Provenance: International Business Machines Corporation

(I.B.M.), New York, purchased from the artist, Victoria, through Fred Haines, by 1940; Paul Duval, Toronto, Dec 1961; Roy G. Cole, Hamilton; gift, Jan 1992.
Exhibitions:
*Exhibition of Canadian West Coast Art Native and Modern*, NGC, 20 Nov–31 Dec 1927 / AGT, 7–29 Jan 1928 / AAM, 17 Feb–25 Mar 1928, no. 14, *Yan, Queen Charlotte Islands*
*Contemporary Art of Canada and Newfoundland, Collection of the International Business Machines Corporation Shown by IBM*, CNE, 23 Aug–7 Sep 1940, no. 6, *Village of Yan*, repr.
*Visions of Light and Air: Canadian Impressionism 1885–1920*, MQ, 14 Jun–4 Sep 1995 / Americas Society Art Gallery, New York (organizer), 27 Sep–17 Dec 1995 / The Dixon Gallery and Gardens, Memphis, Tennessee, 18 Feb–14 Apr 1996 / The Frick Art Museum, Pittsburgh, Pennsylvania, 12 Jun–11 Aug 1996 / AGH, 12 Sep–8 Dec 1996, no. 20, repr.
*Birth of the Modern: Post-Impressionism in Canadian Art: c.1900–1920*, RMG, 1 Nov 2001–6 Jan 2002 / LBEAG, 19 Feb–30 Mar 2002 / ML, 3 Aug–13 Oct 2002 / BAG, 24 Nov 2002–26 Jan 2003 / WAG, 10 Apr–29 Jun 2003, no. 6, repr.

## Cat. 28

**ARTHUR WATKINS CRISP** (1881–1974)
*Portrait of Miss X* 1912
oil on canvas
214.8 x 122.8 cm
Gift of the artist, 1961
62.56.181
Inscriptions recto: l.l. *CRISP / 12*
Provenance: Gift of the artist, Biddeford, Maine, 1961.
Exhibitions:
*Annual Exhibition*, The National Academy of Design, New York, 1913, no. 316, *Miss Burnett*
*Ninth Annual Exhibition of Selected Paintings by American Artists*, City Art Museum, St. Louis, Missouri, from 6 Sep 1914, no. 27, *Miss Burnett*, repr.
*The Honorable Arthur Crisp, N.A. and Mary Ellen Crisp: A Retrospective Exhibition*, AGH, May 1963, no. 1
*20th Century American Painting*, McMaster University Art Gallery, 15 Mar–12 Apr 1987

## Cat. 29

**ROBERT HENRI** (American; 1865–1929)
*Girl from Segovia* 1912
oil on canvas
81.2 x 66.5 cm
Gift of Mrs. C. H. Stearn, 1963
63.72.11
Inscriptions: none
Provenance: Estate of the artist; Hirschl and Adler Galleries, New York (*Selections from the Collection*, vol. 6, no. 35, repr.), 1962–63; purchased, Jun 1963.
Note: This work was purchased with insurance funds from the 1960 theft of Kreighoff's *The Trader*, donated in 1957 by Mrs. C. H. Stearn, recovered in 1965.
Exhibitions:
*Selections from the American Collection of the Art Gallery of Hamilton*, Oakville Centennial Gallery, 4 Jun–3 Jul 1977
*Selected Works Representing the American Regionalist-Ashcan Schools*

of *Painting from the Permanent Collection of the A.G.H.*, RHAC, 14 Mar–13 Apr 1986

*20th Century American Painting*, McMaster University Art Gallery, 15 Mar–12 Apr 1987

*The Art Gallery of Hamilton: Seventy-Five Years (1914–1989)*, AGH, 28 Sep–19 Nov 1989, no. 32, repr.

## Cat. 30

**ALBERT ROBINSON**  (1881–1956)
*St. Malo*   1912
oil on laminated card
20.5 x 27.0 cm
Gift of the heirs of John and Hortense Gordon, 1963
63.105.13
Inscriptions recto: l.l., *Albert Robinson. 1912*; verso: u.l., *St. Malo / 25.00*
Provenance: Estate of John and Hortense Gordon; gift, Jun 1963.

## Cat. 31

**JAMES WILSON MORRICE**  (1865–1924)
*View of a North African Town*   c. 1912–1914
oil on wood
12.2 x 15.0 cm
78.48
Bequest of David R. Morrice, 1978
Inscriptions verso: c., studio stamp, STUDIO / J.W. MORRICE
Provenance: David Rousseaux Morrice (artist's nephew), Montreal; bequest, Dec 1978.
Exhibitions:
*Masterpieces of Twentieth-Century Canadian Painting*, Norton Gallery and School of Art, West Palm Beach, Florida, 18 Mar–29 Apr 1984, no cat. no.
*James Wilson Morrice 1865–1924*, MMFA, 6 Dec 1985–2 Feb 1986 / MQ, 27 Feb–20 Apr 1986 / BAG, 15 May–29 Jun 1986 / AGO, 25 Jul–14 Sep 1986 / VAG, 9 Oct–23 Nov 1986, no. 88, repr.
*Birth of the Modern: Post-Impressionism in Canadian Art: c.1900–1920*, RMG, 1 Nov 2001–6 Jan 2002 / LBEAG, 19 Feb–30 Mar 2002 / ML, 3 Aug–13 Oct 2002 / BAG, 24 Nov 2002–26 Jan 2003 / WAG, 10 Apr–29 Jun 2003, no. 36, repr.

## Cat. 32

**LAWREN HARRIS**  (1885–1970)
*Hurdy Gurdy*   1913
oil on canvas
75.8 x 86.6 cm
Gift of Roy G. Cole, 1992
1992.22.4
Inscriptions recto: l.r., *LAWREN / HARRIS / 13*; verso: stretcher, u.l., *Hurdy Gurdy*
Provenance: Paul Duval, Toronto, purchased from the artist, Vancouver, 1957; Roy G. Cole, Hamilton, 1965; gift, 1992.
Exhibitions:
*Visions of Light and Air: Canadian Impressionism 1885–1920*, MQ, 14 Jun–4 Sep 1995 / Americas Society Art Gallery, New York (organizer), 27 Sep–17 Dec 1995 / The Dixon Gallery and Gardens, Memphis, Tennese, 18 Feb–14 Apr 1996 / The Frick Art Museum, Pittsburgh, Pennsylvania, 12 Jun–11 Aug 1996 / AGH, 12 Sep–8 Dec 1996, no. 34, repr.

*Lawren Stewart Harris: A Painter's Progress*, Americas Society Art Gallery, New York, 5 Sep–5 Nov 2000 / MCAC, 14 Apr–17 Jun 2001 / AGH, 1 Sep–21 Oct 2001 / AGW, 16 Feb–21 Apr 2002, no. 4, repr.

## Cat. 33

**J.E.H. MacDONALD**  (1873–1932)
*A Rapid in the North*   1913
oil on canvas
51.4 x 72.1 cm
Gift of the MacDonald Family, 1974
74.87.2
Inscriptions recto: l.r., *J.E.H. MacDonald: 13*
Provenance: Estate of the artist; Thoreau MacDonald (artist's son), Thornhill; gift, Apr 1974.
Exhibitions:
OSA, Art Museum of Toronto, 5–26 Apr 1913, no. 62
*Retrospective Exhibition of Painting by Members of the Group of Seven 1919–1933*, NGC, 20 Feb–15 Apr 1936 / AAM, 17 Apr–3 May 1936 / AGT, 15 May–15 Jun 1936, no. 164
*J.E.H. MacDonald R.C.A. 1873–1932*, AGT, 13 Nov–12 Dec 1965 (did not travel to the other venue), no. 11, repr.
*Canadian Painting: Selected Works from the Collections of the Art Gallery of Hamilton and the Kitchener-Waterloo Art Gallery*, KWAG, 19 Feb–29 Mar 1981, no cat. no. (exhibition list)
*The Mystic North: Symbolist Landscape Painting in Northern Europe and North America 1890–1940*, AGO, 13 Jan–11 Mar 1984, no. 107, repr.
*Climbing the Cold White Peaks: A Survey of Artists In and From Hamilton 1910–1950*, AGH and Hamilton Artists Inc., 11 Jul–10 Aug 1986, no cat. no., repr.
*Directors Collect*, AGH (co-organizer),  Jun–13 Aug 1995 / AGW (co-organizer), 9 Sep 1995–20 Jan 1996 / Gallery/Stratford, 27 May–8 Sep 1996 / LRAHM (co-organizer), 14 Dec 1996–2 Feb 1997, no cat. no. (brochure)
*Terre Sauvage: Canadian Landscape Painting and the Group of Seven*, NGC (organizer), Museo de Arte Moderno, Mexico City, 26 Aug–31 Oct 1999 / Prins Eugens Waldemarsudde, Stockholm, 10 Feb–2 Apr 2000 / Kunstforeningen, Copenhagen, 15 Apr–12 Jun 2000 / Lillehammer Art Museum, 29 Jul–23 Sep 2000 / Gothenburg Art Gallery, 14 Oct–3 Dec 2000, no. 48, repr.

## Cat. 34

**HELEN McNICOLL**  (1879–1915)
*The Victorian Dress*   c.1914
oil on canvas
107.1 x 92.0 cm
Gift of A. Sidney Dawes, M.C., 1958
58.87.Q
Inscriptions recto: l.r., *Helen McNicoll–*
Provenance: AAM, gift of Mrs. D. McNicoll (artist's mother), 1922; Mr. A. Sidney Dawes, purchased from the MMFA (previously the AAM), 1958; gift, Jul 1958.
Exhibitions:
*Autumn Exhibition*, Royal Society of British Artists, 1914, no. 51
*Thirty-ninth Spring Exhibition*, AAM, 21 Mar–15 Apr 1922, no.195
*Memorial Exhibition of Paintings by the late Helen G. McNicoll, R.B.A., A.R.C.A.*, AAM, 7 Nov–6 Dec 1925, no. 129, repr.
CNE, 22 Aug–6 Sep 1930, no. 133
*Helen McNicoll, A Canadian Impressionist*, AGO, 10 Sep–12 Dec 1999 / The Appleton Museum of Art, Florida,

6 May–25 Jun 2000 / LBEAG, 27 Sep–5 Nov 2000 / Carleton University Art Gallery, Ottawa, 13 Nov–14 Jan 2001 / AGNS, 3 Feb–1 Apr 2001 / AEAC, 27 May–12 Aug 2001, no. 49, repr.

Cat. 35
**A. Y. JACKSON** (1882–1974)
*Near Canoe Lake* 1914
oil on canvas
64.5 x 81.7 cm
Gift of A.M. Cunningham, 1915
48.73
Inscriptions recto: l.r. *A.Y JACKSON*
Provenance: Donated by the artist, Toronto, to the RCA *Patriotic Fund* exhibition, 1914; A.M. Cunningham, Hamilton, purchased from this exhibition for the AGH, 1915; gift, Apr 1915.
Exhibitions:
*Pictures and Sculpture Given by Canadian Artists in Aid of the Patriotic Fund*, RCA, Art Museum of Toronto, from 13 Dec 1914 (subsequently circulated to venues in Winnipeg, Halifax, St. John, Quebec City, Montreal, London [cancelled], and Hamilton; closed in Toronto 1915), no. 9, *In the North Country*, repr.
*A. Y. Jackson, A Retrospective Exhibition*, LPLAM, 29 Jan–20 Feb 1960 / AGH (organizer), Mar–Apr 1960, no. 13, *Canoe Lake*
*The Group of Seven*, NGC, 19 Jun–8 Sep 1970 / MMFA, 22 Sep–31 Oct 1970, no. 39, repr.
*Impressionism in Canada 1895–1935*, VAG, 16 Jan–24 Feb 1974 / EAG, 8 Mar–21 Apr 1974 / Saskatoon Gallery and Conservatory Corp., 4 May–10 Jun 1974 / CCAGM, 22 Jun–1 Sep 1974 / RMG, 19 Sep–3 Nov 1974 / AGO (organizer), 17 Nov 1974–5 Jan 1975, no. 72, repr.

Cat. 36
**MARION LONG** (1882–1970)
*The Fan* 1914
oil on canvas
41.6 x 32.1 cm
Gift of Dr. J.S. Lawson, 1961
61.77.Q
Inscriptions recto: l.r., *Marion Long 1914*; verso: stretcher, u.r., on label [torn], *[___] Building / [___] ST:*
Provenance: James Sharp Lawson, Guelph; gift, May 1961.
Exhibitions:
[RCA, Art Museum of Toronto, 20 Nov–19 Dec 1914, no. 130, *The Japanese kimono?*]

Cat. 37
**TOM THOMSON** (1877–1917)
*The Birch Grove, Autumn* 1915–1916
oil on canvas
99.0 x 115.4 cm
Gift of Roy G. Cole, in memory of his parents, Matthew and Annie Bell Gilmore Cole, 1967
67.112.Z
Provenance: Estate of the artist; George Thomson (artist's brother), Owen Sound; Mellors-Laing Galleries, Toronto, 1941; Hamilton Club, 1943; purchased with funds donated for the purpose by Roy G. Cole, Hamilton, Nov 1967.
Inscriptions: none

Exhibitions:
*Memorial Exhibition of Paintings by Tom Thomson*, AGT, 13–29 Feb 1920, no. 22, *Birch and Rocks, Autumn* (unfinished)
*Inaugural Exhibition*, AGH, 12 Dec 1953–Jan 1954, no. 55, repr.
*Exhibition of Paintings and Sculpture Arranged by the Fine Arts Committee of the Canadian National Exhibition Association* (Gallery V), CNE, 24 Aug–8 Sep 1956, no. 163.
*Tom Thomson Exhibition, 1877–1917*, KWAG, 21 Sep–8 Oct 1956, no. 7
*Tom Thomson and the Group of Seven*, Tom Thomson Memorial Gallery and Museum of Art, Owen Sound, 27 May–11 Jun 1967, no. 4
*The Art of Tom Thomson*, AGO, 30 Oct–12 Dec 1971 / Norman MacKenzie Art Gallery, Regina, 15 Jan–13 Feb 1972 / WAG, 25 Feb–31 Mar 1972 / MMFA, 14 Apr–28 May 1972 / CCAGM, 2 Jul–5 Sep 1972, no. 111, repr.
*19th and 20th Century Canadian Paintings from the Art Gallery of Hamilton*, University of Guelph, 28 Apr–30 May 1974, no. 33
*The Art Gallery of Hamilton: Seventy-Five Years (1914–1989)*, AGH, 28 Sep–19 Nov 1989, no. 66, repr.
*Stand By Your Man or Annie Crawford Hurn: My Life with Tom Thomson*, AGH, 17 Mar–27 May 2001 / CCAGM, 24 Jun–27 Aug 2001 / EAG, 21 Sep 2001–2 Feb 2002, no cat. no., repr.
*Tom Thomson*, NGC, 7 Jun–8 Sep 2002 / VAG, 5 Oct 2002–5 Jan 2003 / MQ, 6 Feb–3 Apr 2003 / AGO, 30 May–7 Sep 2003 / WAG, 29 Sep–7 Dec 2003, no. 78, repr.

Cat. 38
**FLORENCE H. McGILLIVRAY** (1864–1938)
*Winter at Rosebank, Lake Ontario* 1917
oil on laminated board
46.1 x 61.5 cm
Gift of Miss Kathleen Hillary, 1956
57.75.D
Inscriptions recto: l.l., *F H McGilliVRAY 1917.*; verso: c.l., *F. H. McGillivray / Whitby–*; frame, u.c., *For Washington*; u.r. [obscured], *Rosebank in Winter near Toronto / [___]vray / 292 Frank St–Ottawa*
Provenance: Kathleen Hillary (artist's niece); gift, through Gordon Conn, Oct 1956.
Exhibitions:
*Annual Exhibition of Canadian Art*, NGC, 11 Jan–28 Feb 1927, no. 155, *Rosebank In Winter Near Toronto*
*Exhibition of Paintings by Contemporary Canadian Artists under the Auspices of the American Federation of Arts*, Corcoran Gallery, Washington, 9–30 Mar 1930 / Rhode Island School of Design, Providence, Apr 1930 / Baltimore Museum of Art, 4–28 May 1930 / Grand Central Galleries, New York City, Apr 1930 / Minneapolis Institute of Arts, Jul 1930 / City Art Museum, St. Louis, Missouri, Aug 1930, no. 41 [in the Corcoran Gallery, Baltimore Museum of Art, and City Art Museum catalogues; did not travel to the subsequent venues]

Cat. 39
**LAWREN HARRIS** (1885–1970)
*In the Ward, Toronto* c.1919
oil on beaverboard
26.7 x 35.4 cm
Gift from The Lillian & Leroy Page Charitable Trust, 1964
64.72.15.A
Inscriptions recto: l.r., *LAWREN / HARRIS*; verso: c., *IN THE WARD–TORONTO / lawren / Harris* ⊕ / *$* [price scratched out]
Provenance: Laing Galleries, Toronto; purchased, Dec 1964.
Exhibitions:
*Masterpieces of Twentieth-Century Canadian Painting*, Norton
   Gallery and School of Art, West Palm Beach, Florida, 18
   Mar–29 Apr 1984, no cat. no., repr.

Cat. 40
**ROCKWELL KENT** (American; 1882–1971)
*Frozen Waterfall, Alaska* 1919
oil on canvas adhered to fibreboard
86.5 x 71.2 cm
Gift of the Women's Committee, 1971
71.75.1
Inscriptions recto: l.r., *Rockwell Kent*; verso: inner frame, u.c., *R. Kent*
Provenance: Larcada Gallery, New York, acquired from the
artist; Paul Duval, Toronto, 1966; purchased, Jan 1971.
Exhibitions:
*Director's Choice from the Permanent Collection of the Art Gallery of*
   *Hamilton*, Art Gallery of Brant, Brantford, 9 Sep–3 Oct
   1971, no. 28
*Selections from the American Collection of the Art Gallery of Hamilton*,
   Oakville Centennial Gallery, 4 Jun–3 Jul 1977
*A Distant Harmony: Comparisons in the Painting of Canada and the*
   *United States of America*, WAG, 8 Oct–28 Nov 1982 / AGH,
   17 Feb–27 Mar 1983, no. 81, repr.
*Selected Works Representing the American Regionalist-Ashcan Schools*
   *of Painting from the Permanent Collection of the A.G.H.*,
   RHAC, 14 Mar–13 Apr 1986
*20th Century American Painting*, McMaster University Art Gallery,
   15 Mar–12 Apr 1987
*Vision Made Real: An Exhibition Celebrating the 50th Anniversary of*
   *the Volunteer Committee*, AGH, 23 Apr–29 Aug 1999

Cat. 41
**ANNE SAVAGE** (1896–1971)
*Portrait of William Brymner* 1919
oil on wood
22.8 x 17.8 cm
Gift of the artist, 1959
59.111.O
Inscriptions verso: u.r., *Anne Savage / 1919*
Provenance: Gift of the artist, Montreal, May 1959.
Exhibitions:
*Anne Savage: A Retrospective*, Sir George Williams University,
   Montreal, 4–30 Apr 1969, no. 47, repr. (brochure)
*Birth of the Modern: Post-Impressionism in Canadian Art:*
   *c.1900–1920*, RMG, 1 Nov 2001–6 Jan 2002 / LBEAG, 19
   Feb–30 Mar 2002 / ML, 3 Aug–13 Oct 2002 / BAG, 24
   Nov 2002–26 Jan 2003 / WAG, 10 Apr–29 Jun 2003, no.
   42, repr.

Cat. 42
**LAWREN HARRIS** (1885–1970)
*Waterfall, Algoma* c.1920
oil on canvas
120.2 x 139.6 cm
Gift of the Women's Committee, 1957
57.72.N
Inscriptions verso: stretcher, u.l., *WATER FALLS, AGAWA CANYON, ALGOMA*; stretcher, u.r., *LAWREN HARRIS*
Provenance: Purchased from the artist, Vancouver, Sep 1957.
Exhibitions:
*Lawren Harris Retrospective Exhibition, 1963*, NGC, 7 Jun–8 Sep
   1963 / VAG, 4–27 Oct 1963, no. 23
*19th and 20th Century Canadian Paintings from the Art Gallery of*
   *Hamilton*, University of Guelph, 28 Apr–30 May 1974,
   no. 13
*Lawren S. Harris, Urban Scenes and Wilderness Landscapes*
   *1906–1930*, AGO, 14 Jan–26 Feb 1978, no. 64, repr.
*Lawren Harris: Ontario Landscapes*, AGO (organizer), National
   Exhibition Centre, Thunder Bay, 15 May–14 Jun 1981 /
   AGP, 19 Jun–26 Jul 1981 / Lynwood Arts Centre, Simcoe,
   31 Jul–23 Aug 1981 / Art Gallery of Algoma, Sault Ste.
   Marie, 4–27 Sep 1981 / Laurentian University Museum
   and Arts Centre, Sudbury, 6–25 Oct 1981, no. 8
*The Mystic North: Symbolist Landscape Painting in Northern Europe*
   *and North America 1890–1940*, AGO, 13 Jan–11 Mar
   1984, no. 38, repr.
*The Art Gallery of Hamilton: Seventy-Five Years (1914–1989)*, AGH,
   28 Sep–19 Nov 1989, no. 31, repr.
*I Believe in Magic*, AGH, 29 Oct 1994–22 Jan 1995, no cat. no.,
   repr.
*Directors Collect*, AGH (co-organizer), Jun–13 Aug 1995 / AGW (co-
   organizer), 9 Sep 1995–20 Jan 1996 / Gallery/Stratford,
   27 May–8 Sep 1996 / LRAHM (co-organizer), 14 Dec
   1996–2 Feb 1997, no cat. no. (brochure)

Cat. 43
**J.E.H. MacDONALD** (1873–1932)
*Lake Simcoe Garden* 1920
oil on laminated card
21.5 x 26.7 cm
Presented in memory of Suzanne Bowman 1939–1958, by her
Parents and Friends, 1962
62.87.W
Inscriptions verso: u.r., *J. MacD./ Roche's Point/ '20*; u.c., *Certified / Thoreau MacDonald / Nov. '62*; c., *Lake Simcoe Garden / J.E.H. MacDonald, '20*; l.l., *A.C. Kenny / Collection*; l.r., on label, *FIGURE IS ELEANOR HAMILTON / GARDEN OF R.A. LAIDLAW*
Provenance: A. Crawford Kenny, Toronto. Roberts Gallery,
Toronto, stock no. 7225; purchased with funds from The
Bowman Fund, Dec 1962.
Exhibitions:
*Director's Choice: Paintings from the Permanent Collection of The Art*
   *Gallery of Hamilton*, Laurentian University, Sudbury,
   8 Sep–1 Oct 1972, no cat no. (exhibition list)

Cat. 44

**CLARA S. HAGARTY** (1871–1958)
*Lake Como* 1920s
oil on wood
34.9 x 26.3 cm
Gift of Gordon Conn, 1956
57.72.O
Inscriptions recto: l.r., *C.S. Hagarty*; verso: u.c., *LAKE COMO*
Provenance: Gordon Conn, Toronto; purchased, Oct 1956.

Cat. 45

**EMILY COONAN** (1885–1971)
*Girl in Dotted Dress* c.1923
oil on canvas
76.0 x 66.4 cm
Gift of The Hamilton Spectator, 1968
68.56.199
Inscriptions recto: u.r., *E. COONAN*; verso: l.c., tacking edge
flap, *E. COONAN*
Provenance: Purchased from Gemst Art Dealers & Picture Frame
Mfg. Ltd., Montreal, Sep 1968.
Exhibitions:
*Fortieth Spring Exhibition*, AAM, 16 Mar–14 Apr, 1923, no. 53, *Girl
in a Dotted Dress*
CNE, 25 Aug–8 Sep 1923, no. 148
*British Empire Exhibition, Canadian Section of Fine Arts*, Wembley
Park, London, England, 23 Apr–31 Oct 1924 / Leicester
Museum and Art Gallery, 12 Nov–12 Dec 1924 /
Kelvingrove Art Galleries, Glasgow, Scotland, late Dec
1924–17 Jan 1925 / City of Birmingham Municipal Art
Gallery, 30 Jan–31 Mar 1925, no. 37, repr. (in *A Portfolio
of Pictures from the Canadian Section of Fine Arts*, British
Empire Exhibition, Wembley Park)
*Emily Coonan 1885–1971*, Concordia Art Gallery, Montreal, 16
Sep–24 Oct 1987, no. 21, repr.

Cat. 46

**LAWREN HARRIS** (1885–1970)
*Ice House, Coldwell, Lake Superior* c.1923
oil on canvas
94.1 x 114.1 cm
Bequest of H. S. Southam, C.M.G., LL.D., 1966
66.72.22
Inscriptions verso: stretcher, u.r., *FISH HOUSE, COLDWELL*;
stretcher, u.l., *LAWREN / HARRIS*; stretcher, u.l., *SEVERN ST. /
TORONTO*
Provenance: F. B. Housser, acquired from the artist, Toronto,
1928; the artist, by 1935; H. S. Southam, Ottawa, purchased
from the artist, New Mexico, 1939; bequest, Jan 1966.
Exhibitions:
*An Exhibition of Canadian Paintings by The Group of Seven*, AGT,
Feb 1928, no. 23, *Ice house, Coldwell*
*Exhibition of Paintings by Canadian Artists*, Albright Art Gallery,
Buffalo, 14 Sep–14 Oct 1928 / *Paintings by Canadian
Artists*, Memorial Art Gallery, Rochester, New York, 14
Nov 1928–6 Jan 1929, no. 20, *Fish House, Caldwell* [sic]
*Retrospective Exhibition of Painting by Members of the Group of Seven
1919–1933*, NGC, 20 Feb–15 Apr 1936 / AAM, 17 Apr–3
May 1936 / AGT, 15 May–15 Jun 1936, no. 88.
*Exhibition of Contemporary Canadian Painting; arranged on behalf of
the Carnegie corporation of New York for circulation in the*

*southern dominions of the British Empire*, NGC (organizer),
*Empire Exhibition* (Canadian section), Palace of Fine Arts,
Johannesburg, South Africa, 15 Sep 1936–15 Jan 1937
(subsequently circulated to venues in South Africa,
Australia, New Zealand and Hawaii, to Apr 1939), no.
831, *Fish House, Coldwell, Lake Superior* (in
Johannesburg catalogue), no. 32, *Fish House, Coldwell,
Lake Superior*, repr. (in NGC catalogue)
*Paintings lent by H. S. Southam Esq., C.M.G., Ottawa*, NGC, 27
May–2 Jul 1944 /AAM, Aug 1944, no. 38, *Fishhouse,
Coldwell, Lake Superior*
*Lawren Harris Paintings 1910–1948*, AGT, Oct–Nov 1948 / NGC, 9
Dec–3 Jan 1949 / LPLAM, 7–31 Jan 1949 / *Lawren Harris:
Retrospective Exhibition of His Painting, 1910–1948*, VAG,
1–20 Mar 1949, no. 43, *Fishouse[sic], Coldwell* (in AGT
catalogue), no. 40, *Ice House, Coldwell Bay, Lake Superior*
(in VAG catalogue)
*The Art Gallery of Hamilton Presents The H. S. Southam Collection*,
AGH, 17 May–12 Jun 1966, no. 11
*The Group of Seven*, NGC, 19 Jun–8 Sep 1970, MMFA, 22 Sept–31
Oct 1970, no.144, repr.
*19th and 20th Century Painting and Sculpture from the A.G.H.*, RMG,
5–30 Sep 1973, no cat. no. (exhibition list)
*19th and 20th Century Canadian Paintings from the Art Gallery of
Hamilton*, University of Guelph, 28 Apr–30 May 1974,
no. 14
*Lawren S. Harris, Urban Scenes and Wilderness Landscapes
1906–1938*, AGO, 14 Jan–26 Feb 1978, no. 109, repr.
*Canadian Painting: Selected Works from the Collections of the Art
Gallery of Hamilton and the Kitchener-Waterloo Art Gallery*,
KWAG, 19 Feb–29 Mar 1981, no cat. no. (exhibition list)
*Lawren Harris: Ontario Landscapes*, AGO Extension Exhibition,
National Exhibition Centre, Thunder Bay, 15 May–14
Jun 1981 / AGP, 19 Jun–26 Jul 1981 / Lynwood Arts
Centre, Simcoe, 31 Jul–23 Aug 1981 / Art Gallery of
Algoma, Sault Ste. Marie, 4–27 Sep 1981 / Laurentian
University Museum and Arts Centre, Sudbury, 6–25
Oct 1981, no. 28
*Treasures: A Selection from our Regional Heritage*, LRAG, 3 Dec
1988–22 Jan 1989 / Sarnia Public Library and Art
Gallery, 24 Mar–24 Apr 1989 / KWAG, 18 May–25 Jun
1989 / AGH, 14 Sep–29 Oct 1989 / RHAC, 3 Nov–3 Dec
1989, no cat. no. (brochure)
*The Art Gallery of Hamilton: Seventy-Five Years (1914–1989)*, AGH,
28 Sep–19 Nov 1989, no. 30, repr. (in conjunction with
*Treasures*)
*North by West: the Arctic and Rocky Mountain Paintings of Lawren
Harris 1924–1931*, GM, 27 Apr–23 Jun 1991 / MCAC, 14
Jul–15 Sep 1991 / AGH, 14 Nov 1991–12 Jan 1992 /
OAG, 6 Feb–29 Mar 1992 / VAG, 22 Apr–21 Jun 1992,
no. 87
*Lawren Stewart Harris: A Painter's Progress*, Americas Society Art
Gallery, New York, 5 Sep–5 Nov 2000 / MCAC, 14
Apr–17 Jun 2001 / AGH, 1 Sep–21 Oct 2001 / AGW, 16
Feb–21 Apr 2002, no. 13, repr.

Cat. 47

**E. GRACE COOMBS** (1890–1986)
*Sand and Sage Brush, Salt Lake Desert, Utah* 1923
oil on laminated card
21.5 x 26.5 cm
Gift of Dr. J.S. Lawson, 1961
61.X.108
Inscriptions recto: l.r., *E.G Coombs 1923*; verso: u.l. [encircled], *118*; c., *Coombs / I Sand & sage brush / Salt Lake Desert / Utah / June–*
Provenance: James Sharp Lawson (artist's husband), Guelph; gift, Apr 1961.
Exhibitions:
*From the Studio: Selections from the Edith Grace Coombs Archive*, AGH, 30 Jan–21 Sep 1997

Cat. 48

**ARTHUR LISMER** (1885–1969)
*Bon Echo Rock* 1923
oil on canvas
53.4 x 66.3 cm
Gift of the artist, 1951
51.77.A
Inscriptions verso: stretcher, u.c., *Arthur Lismer 1922–23–Bon Echo Rock–*
Provenance: Gift of the artist, Montreal, Jun 1951.
Exhibitions:
OSA, AGT, 10 Mar–8 Apr 1923, no. 115, *Dawn, The Big Rock, Bon Echo*
*19th and 20th Century Canadian Paintings from the Art Gallery of Hamilton*, University of Guelph, 28 Apr–30 May 1974, no. 18
*Heritage and the New Wave: Canadian Roots, 1850–1940*. RHAC, 19 Nov–3 Jan 1982
*The Art Gallery of Hamilton: Seventy-Five Years (1914–1989)*, AGH, 28 Sep–19 Nov 1989, no. 44, repr.
*Bon Echo "Dreams and Visions"*, AEAC, 1 Dec 1991–9 Feb 1992 / Peterborough Centennial Museum, 1–29 Jul 1993 / Hastings County Museum, 17 Aug–16 Oct 1993, no. 5
*Directors Collect*, AGH (co-organizer), Jun–13 Aug 1995 / AGW (co-organizer), 9 Sep 1995–20 Jan 1996 / Gallery/Stratford, 27 May–8 Sep 1996 / LRAHM (co-organizer), 14 Dec 1996–2 Feb 1997, no cat. no. (brochure)

Cat. 49

**ALBERT ROBINSON** (1881–1956)
*Quebec Village* 1923
oil on canvas
69.3 x 84.7 cm
Gift of Mr. and Mrs. David C. Barber, 1980
80.28
Inscriptions recto: l.r., *Albert Robinson 1923*.
Provenance: Estate of the artist; Mr. and Mrs David C. Barber, by 1957; gift, Apr 1980 (remained with the Barbers until Sep 2000).

Cat. 50

**LAWREN HARRIS** (1885–1970)
*Grey Day in Town* 1923; reworked early 1930s
oil on canvas
82.3 x 97.7 cm
Bequest of H. S. Southam, C.M.G., LL.D., 1966
66.72.23
Inscriptions verso: frame, l.l., on label [illegible], *For [___] / Lawren Harris*
Provenance: H. S. Southam, Ottawa, purchased from the artist, Hanover, New Hampshire, 1936; bequest, Jan 1966.
Exhibitions:
*British Empire Exhibition, Canadian Section of Fine Arts*, Wembley Park, London, 23 Apr–31 Oct 1924, no. 88
*Exhibition of the Group of 7*, AGT, 7–31 May 1926, no. 22
*Paintings, Sculpture and Prints in the Department of Fine Arts, Sesquicentennial International Exposition*, Philadelphia, Pennsylvania, from 24 Jul 1926, no. 1546
*Canadian Paintings*, Memorial Art Gallery, Rochester, New York, 30 Jan–Feb 1927 / *Paintings by Contemporary Canadian Artists*, Toledo Museum of Art, Ohio, 6–27 Mar 1927 / Syracuse Museum of Fine Arts, New York, 10 Apr–8 May 1927, no. 12 (in Rochester catalogue)
*Paintings by Contemporary Canadian Artists*, AGT, 30 Jun–2 Oct 1927, no cat. no.
*Paintings by Canadian Artists*, Leonardo Society, Montreal, Apr 1928
*Exhibition of Paintings by Canadian Artists*, Albright Art Gallery, Buffalo, 14 Sep–14 Oct 1928 / *Paintings by Canadian Artists*, Memorial Art Gallery, Rochester, New York, 14 Nov 1928–6 Jan 1929, no. 21
*Lawren Harris Exhibition*, Dartmouth College, Hanover, New Hampshire, Jun–Oct 1931, no cat. no.
CGP, AGT, from 3 Nov 1933, no. 20
CGP, AAM, 1–21 Jan 1934, no. 17
CGP, McMaster University, Hamilton, Feb 1934, no. 11
*Retrospective Exhibition of Painting by Members of the Group of Seven 1919–1933*, NGC, 20 Feb–15 Apr 1936 / AAM, 17 Apr–3 May 1936 / AGT, 15 May–15 Jun 1936, no. 73, repr.
*A Century of Canadian Art*, Tate Gallery, London, England, 15 Oct–15 Dec 1938, no. 81, repr.
*Paintings lent by H. S. Southam Esq., C.M.G.*, Ottawa, NGC, 27 May–2 Jul 1944 /AAM, Aug 1944, no. 34
*Lawren Harris Paintings 1910–1948*, AGT, Oct–Nov 1948 / NGC, 9 Dec–3 Jan 1949 / LPLAM, 7–31 Jan 1949 / *Lawren Harris: Retrospective Exhibition of His Painting, 1910–1948*, VAG, 1–20 Mar 1949, no. 25 (in AGT catalogue), no. 23 (in VAG catalogue)
*Inaugural Exhibition*, AGH, 12 Dec 1953–21 Jan 1954, no. 18
*The Art Gallery of Hamilton Presents The H. S. Southam Collection*, AGH, 17 May–12 Jun 1966, no. 12, repr.
*Masterpieces of Twentieth-Century Canadian Painting*, The Norton Gallery and School of Art, West Palm Beach, Florida, 18 Mar–29 Apr 1984, no cat. no., repr.
*The Group of Seven: Art for a Nation*, NGC, 13 Oct–31 Dec 1995 / AGO, 17 Feb–5 May 1996 / VAG, 19 Jun–2 Sep 1996 / MMFA, 3 Oct–1 Dec 1996, no. 94, repr.
*Lawren Stewart Harris: A Painter's Progress*, Americas Society Art Gallery, New York, 5 Sep–5 Nov 2000 / MCAC, 14 Apr–17 Jun 2001 / AGH, 1 Sep–21 Oct 2001 / AGW, 16 Feb–21 Apr 2002, no. 19, repr.

Cat. 51

**E. GRACE COOMBS** (1890–1986)
*Desert near Salt Lake City* 1924
oil on laminated card
20.5 x 25.5 cm
Gift of Dr. J.S. Lawson, 1961
61.X.107
Inscriptions recto: l.l., *EG Coombs / 1924*; verso: c., *8 1/2 x 10 1/2 / Desert near Salt Lake City / 1924*; l.r., *Coombs*
Provenance: James Sharp Lawson (artist's husband), Guelph; gift, Apr 1961.
Exhibitions:
*From the Studio: Selections from the Edith Grace Coombs Archive*, AGH, 30 Jan–21 Sep 1997

Cat. 52

**J.E.H. MacDONALD** (1873–1932)
*Rain in the Mountains* 1924
oil on canvas
123.5 x 153.4 cm
Bequest of H.L. Rinn, 1955
55.87.J
Inscriptions verso: stretcher, u.l., *NO / RAIN IN THE MOUNTAINS*
Provenance: Estate of the artist; Mellors-Laing Galleries, Toronto. Purchased from Dominion Gallery, Montreal, with funds from the bequest of H.L. Rinn, 1955.
Exhibitions:
*Group of Seven Exhibition of Paintings*, AGT, 9 Jan–2 Feb 1925, no. 47
*British Empire Exhibition, Canadian Section of Fine Arts*, Wembly Park, London, England, 9 May–Oct 1925 / *Exhibition of Canadian Art*, Whitechapel Art Gallery, London, 26 Nov–23 Dec 1925 / York City Art Gallery, 16 Jan–13 Feb 1926 / *Exhibition of Canadian Art*, Corporation Art Gallery, Bury, 20 Feb–20 Mar 1926 / Blackpool, 27 Mar–24 Apr 1926 / *Exhibition of Canadian Art*, Corporation Art Gallery, Rochdale, 1–29 May 1926 / *Exhibition of Canadian Art*, Corporation Art Gallery, Oldham, 12 Jun–10 Jul 1926 / Cartwright Memorial Hall, Bradford, 17 Jul–14 Aug 1926 / *Exhibition of Canadian Pictures*, Queen's Park Branch Art Gallery, Manchester, 28 Aug–9 Oct 1926 / Sheffield, 15 Oct–11 Dec 1926 / Municipal Museum and Art Gallery, Plymouth, 12 Jan–12 Feb 1927, no cat. no.
Vancouver Exhibition, from 12 Aug 1928 / New Westminster Provincial Exhibition, B.C., Sep 1928 / *Edmonton Museum of Arts Loan Exhibition*, 29 Oct–3 Nov 1928 / Calgary Public Museum, Dec 1928 / Drumheller Public Library, Feb 1929, no. 16 (in Edmonton catalogue)
RCA, AAM, 21 Nov–22 Dec 1929, no. 137
*Memorial Exhibition of the Work of J.E.H. MacDonald, R.C.A.*, AGT, from 6 Jan 1933, no. 145
*Memorial Exhibition of the Work of James E.H. MacDonald, R.C.A., 1873–1932*, NGC, 7 Feb–6 Mar 1933, reduced version: WAG, Apr–8 May 1933 / VAG, from c.20 May 1933 / Calgary Exhibition and Stampede, 10–15 Jul 1933, no. 38
*Retrospective Exhibition of Painting by Members of the Group of Seven 1919–1933*, NGC, 20 Feb–15 Apr 1936 / AAM, 17 Apr–3 May 1936 / AGT, 15 May–15 Jun 1936, no. 175
*J.E.H. MacDonald, Memorial Exhibition*, Dominion Gallery, Montreal, 20 Nov–3 Dec 1947, no. 32

*Hamilton Collects*, Willistead Art Gallery, Windsor, 21 Mar–18 Apr 1962, no. 7
*19th and 20th Century Painting and Sculpture from the A.G.H.*, RMG, 5–30 Sep 1973, no cat. no. (exhibition list)
*Heritage and the New Wave: Canadian Roots, 1850–1940*. RHAC, 19 Nov–3 Jan 1982
*Climbing the Cold White Peaks: A Survey of Artists In and From Hamilton 1910–1950*, AGH and Hamilton Artists Inc., 11 Jul–10 Aug 1986, no cat. no., repr.
*The Art Gallery of Hamilton: Seventy-Five Years (1914–1989)*, AGH, 28 Sep–19 Nov 1989, no. 45, repr.
*The True North: Canadian Landscape Painting 1896–1939*. Barbican Art Gallery, London, England, 19 Apr–16 Jun 1991, no. 70
*The Group of Seven: Art for a Nation*, NGC, 13 Oct–31 Dec 1995 / AGO, 17 Feb–5 May 1996 / VAG, 19 Jun–2 Sep 1996 / MMFA, 3 Oct–1 Dec 1996, no. 83, repr.
*Stand By Your Man or Annie Crawford Hurn: My Life with Tom Thomson*, AGH, 17 Mar–27 May 2001 / CCAG, 24 Jun–27 Aug 2001 / EAG, 21 Sep 2001–2 Feb 2002, no cat. no.
*The Group of Seven in Western Canada*, GM, 13 Jul–14 Oct 2002 / AGNS, 2 Nov 2002–2 Feb 2003 / WAG, 22 Feb–18 May 2003 / NGC, 10 Oct 2003–2 Jan 2004, no. 45, repr.

Cat. 53

**MARC-AURÈLE DE FOY SUZOR-COTÉ** (1869–1937)
*Femmes de Caughnawaga* 1924
bronze
43.0 x 33.0 x 57.0 cm
Gift of the Women's Committee, 1956
56.111.I
Inscriptions: front of base, *FEMMES / DE CAUGHNAWAGA*; back of base, *Copyright / Canada + U.S. 1925*; back of base, foundry stamp, ROMAN BRONZE WORKS INC., N.Y.
Provenance: Continental Galleries, Toronto; purchased, Jan 1956.
Exhibitions:
*Director's Choice from the Permanent Collection of the Art Gallery of Hamilton*, Art Gallery of Brant, Brantford, 9 Sep–3 Oct 1971, no. 54
*19th and 20th Century Painting and Sculpture from the A.G.H.*, RMG, 5–30 Sep 1973, no cat. no. (exhibition list)

Cat. 54

**LOWRIE WARRENER** (1900–1983)
*Pickerel River Abstraction* 1926
oil on laminated card
30.2 x 30.4 cm
Gift of the Volunteer Committee, 1984
84.1
Inscriptions verso: u.r., *1926*
Provenance: Estate of the artist; purchased through Christopher Varley, Inc., Toronto, Apr 1984.
Exhibitions:
*Lowrie Lyle Warrener 1900–1983*, Sarnia Public Library and Art Gallery, 24 Nov 1989–8 Jan 1990 / RMG, 22 Feb 1990–11 Mar 1990 / GM, 28 Apr 1990–10 Jun 1990 / AGW, 29 Jun 1990–6 Aug 1990, no. 13 (incorrectly attributed to Masters Gallery)

Cat. 55
**H. MABEL MAY** (1877–1971)
*Indian Woman, Oka* 1927
oil on canvas
67.0 x 54.0 cm
Bequest of Josephine M. Magee, 1958
58.86.V
Inscriptions recto u.r., *H MABEl MAY*
Provenance: Dominion Gallery, purchased from the artist,
Montreal, stock no. D1036, 1950; purchased with funds from
the bequest of Josephine M. Magee, Jun 1958.
Exhibitions:
*Special Sale of Paintings by H. Mabel May A.R.C.A.*, Dominion
Gallery, 8–25 Feb 1950, no. 45 *Indian Woman*
(exhibition list)
*Canadian Cancer Society Art Exhibition: A Tribute to Women*, CNE, 24
Aug–10 Sep 1960, no cat. no.
*Faces Of Canada: Portraits Paintings and Sculptures from 1900 to the
Present Day*, Stratford Festival (Festival Arena), 15
Jul–12 Sep 1964, no cat. no., repr.
*Birth of the Modern: Post-Impressionism in Canadian Art:
c.1900–1920*, RMG, 1 Nov 2001–6 Jan 2002 / LBEAG, 19
Feb–30 Mar 2002 / ML, 3 Aug–13 Oct 2002 / BAG, 24
Nov 2002–26 Jan 2003 / WAG, 10 Apr–29 Jun 2003, no.
30, repr.

Cat. 56
**ALFRED LALIBERTÉ** (1878–1953)
*Self-Portrait* c.1928–1935
bronze
39.0 x 14.0 x 11.0 cm
Gift of Mr. Walter Klinkhoff, 1970
70.77.9
Inscriptions: front of base, *La Femme / l'inspiratrice / de tant de
cho– / ses en ce mon– / de. / A. Laliberté*; back of base, foundry
stamp, ROMAN BRONZE WORKS INC. N.Y.
Provenance: Gift of Mr. Walter Klinkhoff, Mar 1970.

Cat. 57
**ADRIEN HÉBERT** (1890–1967)
*Élévateur n° 1* c.1929
oil on canvas
104.7 x 63.8 cm
Gift of The Hamilton Spectator, 1962
62.72.7
Inscriptions recto: l.l., *Adrien Hébert*; verso: canvas, u.l., ~~1929~~;
u.r., *ÉLEVATEUR / No 1 / $300.00*
Provenance: Purchased from the artist, Montreal, Apr 1962.
Exhibitions:
*Exposition Adrien Hébert: le port de Montréal*, Galerie A. Barreiro,
Paris, 17–31 March 1931, no. 28, *Vue de la passerelle,
Élévateur no 3*
*Adrien Hébert et Robert W. Pilot*, Galerie XII, MMFA, 5–24 Nov
1949, no. 14
*Adrien Hébert*, Arts Club, Montreal, Jun 1950
*Adrien Hébert*, Cercle Universitaire, Montreal, 17–31 Dec 1951
*Exposition Adrien Hébert*, restaurant Hélène-de-Champlain,
Montreal, 9–31 May 1956, no. 4
*Adrien Hébert*, La Grange aux moines, Saint-Jean-des-Piles, Jul
1959, no. 2

*Adrien Hébert: Thirty Years of his Art 1923–1953*, NGC, 20 Aug–19
Sep 1971 / Sir George Williams University, Montreal,
1–30 Nov 1971 / AGH, 15 Dec 1971–15 Jan 1972 /
Centennial Art Gallery, Halifax, 1–29 Feb 1972 / WAG,
15 Mar–15 Apr 1972 / AGGV, 1–31 May 1972, no.17,
repr.
*Hommage à Adrien Hébert*, Galerie Walter Klinkhoff, Montreal,
10–22 Sep 1984, no. 8
*Industrial Images*, AGH, 28 May–27 Jul 1987 / VAG, 18 Sep–8 Nov
1987 / EAG, 28 Nov 1987–14 Feb 1988 / WAG, 5 Mar–1
May 1988 / GM, 1 Jul–28 Aug 1988 / MSVUAG, 20
Sep–23 Oct 1988, no. 35, repr.
*Adrien Hébert*, MQ, 16 Jun–3 Oct 1993, no. 41, repr.
*Adrien Hébert: An Artist's View of Montreal Harbour*, Maison de la
culture Frontenac, Montreal, 21 Jun–5 Sep 1996 /
Maison de la culture Mercier, Montreal, 14 Sep–20 Oct
1996 / Galerie Les Trois C, La Salle, 7–24 Nov 1996 /
Maison de la Ville de Lachine, 29 Nov 1996–5 Jan 1997
/ Centre culturel de Dorval, 11 Jan–6 Feb 1997 / Centre
d'histoire de Montréal, 13 Feb–23 Mar 1997 / MMFA
(organizer), 11 Apr–27 Jul 1997, no. 1, repr. cover
(brochure)

Cat. 58
**HENRI HÉBERT** (1884–1950)
*Mlle A.C., danseuse d'Oslo* c.1929; posthumous cast 1962
bronze
84.0 x 33.4 x 19.4 cm
Gift of Adrien Hébert, R.C.A., 1951
51.72.B
Inscriptions: back of base, foundry stamp, ROMAN BRONZE
WORKS INC.
Provenance: Adrien Hébert (artist's brother), Montreal, as a plas-
ter; gift (probably for the purpose of casting), Jul 1951; cast in
bronze at Roman Bronze Works, Inc., New York, as ordered by
the AGH, Aug 1962
Exhibitions:
*Curatorial Laboratory Project #6: Glut: Culture as Accumulation*, 28
Jun–28 Aug 1991, no cat. no., repr.

Cat. 59
**MARY E. WRINCH** (1877–1969)
*Sparkling Water* c.1929
oil on laminated card
25.5 x 30.4 cm
Gift of the Gordon Conn–Mary E. Wrinch Trust, 1970
70.117.7
Inscriptions recto: l.r., *M E WRINCH*; verso: u.c., on label, ~~The~~
*Sparkling* ~~Lake~~ / *Water*; c., *Temagami Forest Reserve*; frame, u.c.,
on label, *Sparkling Water*
Provenance: Gift of the Gordon Conn-Mary E. Wrinch Trust,
May 1970.
Exhibitions:
[RCA, Calgary Exhibition and Stampede, 8–13 Jul 1929 / EAG, Jul
1929 / Canadian Pacific Exhibition, Vancouver, 7–17 Aug
1929, no. 160, *Temagami forest reserve ?*]

Cat. 60

**CHARLES COMFORT** (1900–1994)
*The Dreamer* 1929
oil on canvas
101.7 x 122.1 cm
Gift of The Hamilton Spectator, 1957
57.56.T
Inscriptions recto: l.r., *COMFORT*; verso: frame, c.l., *"THE DREAMER"*
Provenance: Purchased from the artist, Jan 1957.
Exhibitions:
OSA, AGT, Mar 1930, no. 30, repr.
CNE, 22 Aug–6 Sep 1930, no. 28
*Forty-eighth Spring Exhibition*, AAM, 20 Mar–19 Apr 1931, no. 54
*Charles Fraser Comfort: Fifty Years*, WAG, 19 Oct–20 Nov 1972 / AGW, 2–29 Jan 1973 / AGH, 15 Feb–14 Mar 1973 / CCAGM, 1–30 Apr 1973, no. 8
*Charles Fraser Comfort 1925–1950*, Sarnia Public Library and Art Gallery, 9 Jan–4 Feb 1976 / Woodstock Public Library and Art Gallery, 9–28 Feb 1976 / Tom Thomson Memorial Art Gallery, 5–28 Mar 1976
*The Image of Man in Canadian Painting: 1878–1978*, McIntosh Gallery, London, 1 Mar–2 Apr 1978 / GAI, 1 May–15 Jun 1978 / VAG, 1 Jul–1 Aug 1978 / AGO, 19 Aug–17 Sep 1978 / BAG, 1 Oct–1 Nov 1978, no. 21, repr.
*Canadian Portraiture: A Continuing Tradition*, 11 Sep–26 Oct 1980, Glendon Gallery, Toronto, no. 5
*Something Borrowed*, AEAC, 18 Dec 1982–20 Jan 1983, no. 2, repr.
*Curatorial Laboratory Project #4: The Erotic/Neurotic*, 17 Jan–14 Apr 1991, no cat. no., repr.
*Making Faces*, Carleton University Art Gallery, 4 Feb–14 Apr 1996, no. 1, repr.

Cat. 61

**RODY KENNY COURTICE** (1895–1973)
*Northern Railway Town* c.1929–1935
oil on canvas
86.6 x 102.2 cm
Gift from the Russell Nelson Eden Fund, 2000
2000.3
Inscriptions recto: l.r., *RODY / KENNY / COURTICE*
Provenance: Estate of the artist; Paul Courtice (artist's son), Vancouver; purchased through Christopher Varley Inc., Toronto, Nov 2000.
Exhibitions:
*The Artists' Annual Non-Jury Exhibition*, CNE, 1–15 May 1935, no. 55, *Railway Town, Lake Superior*
*A Century of Canadian Art*, Tate Gallery, London, England, 15 Oct–15 Dec 1938, no. 42

Cat. 62

**LAWREN HARRIS** (1885–1970)
*Icebergs and Mountains, Greenland* c.1930
oil on canvas
92.2 x 114.4 cm
Gift of H. S. Southam, C.M.G., LL.D., 1948
50.66
Provenance: H. S. Southam, Ottawa, purchased from the artist, New Mexico, 1939; gift, Feb 1948.
Exhibitions:

*Retrospective Exhibition of Painting by Members of the Group of Seven 1919–1933*, NGC, 20 Feb–15 Apr 1936 / AAM, 17 Apr–3 May 1936 / AGT, 15 May–15 Jun 1936, no. 85
*Exhibition of Contemporary Canadian Painting; arranged on behalf of the Carnegie corporation of New York for circulation in the southern dominions of the British Empire*, NGC (organizer), *Empire Exhibition* (Canadian section), Palace of Fine Arts, Johannesburg, South Africa, 15 Sep 1936–15 Jan 1937 (subsequently circulated to venues in South Africa, Australia, New Zealand and Hawaii, to Apr 1939), no. 830, repr. (in Johannesburg catalogue), no. 31 (in NGC catalogue)
*Paintings lent by H. S. Southam Esq., C.M.G., Ottawa*, NGC, 27 May–2 Jul 1944 / AAM, Aug 1944, no. 37, *Icebergs*
*Lawren Harris Paintings 1910–1948*, AGT, Oct–Nov 1948 / NGC, 9 Dec–3 Jan 1949 / LPLAM, 7–31 Jan 1949 / *Lawren Harris: Retrospective Exhibition of His Painting, 1910–1948*, VAG, 1–20 Mar 1949, no. 57, repr. (in AGT catalogue), no. 59 (in VAG catalogue)
*Hamilton Collects*, Willistead Art Gallery, Windsor, 21 Mar–18 Apr 1962, no. 12
*Lawren Harris Retrospective Exhibition, 1963*, NGC, 7 Jun–8 Sep 1963 / VAG, 4–27 Oct 1963, no. 43, *Icebergs and Mountains*
*The Art Gallery of Hamilton Presents The H. S. Southam Collection*, AGH, 17 May–12 Jun 1966, no. 8
*Canadian Painting in the Thirties*, NGC, 31 Jan–2 Mar 1975 / VAG, 1 Apr–1 May 1975 / AGO, 24 May–20 Jun 1975, reduced version: GAI, 6 Jul–17 Aug 1975 / EAG, 5 Sep–1 Oct 1975 / MAG, 15 Oct–15 Nov 1975 / Musée d'art contemporain, Montréal, 27 Nov 1975–4 Jan 1976, no. 12, repr.
*Lawren S. Harris, Urban Scenes and Wilderness Landscapes 1906–1930*, AGO, 14 Jan–26 Feb 1978, no.172, repr.
*A Distant Harmony: Comparisons in the Painting of Canada and the United States of America*, WAG, 8 Oct–28 Nov 1982 / AGH, 17 Feb–27 Mar 1983, no. 92, repr.
*The Expressionist Landscape*, Birmingham Museum of Art, Alabama, 11 Sep–4 Nov 1987 / IBM Gallery of Science and Art, New York, 24 Nov 1987–30 Jan 1988 / Everson Museum of Art, Syracuse, New York, 14 Feb–27 Mar 1988 / Akron Art Museum, Ohio, 9 Apr–5 Jun 1988 / VAG, 30 Jun–21 Aug 1988, no. 55, repr.
*North by West: the Arctic and Rocky Mountain Paintings of Lawren Harris 1924–1931*, GM, 27 Apr–23 Jun 1991 / MCAC, 14 Jul–15 Sep 1991 / AGH, 14 Nov 1991–12 Jan 1992 / OAG, 6 Feb–29 Mar 1992 / VAG, 22 Apr–21 Jun 1992, no.62, repr.

Cat. 63

**PRUDENCE HEWARD** (1896–1947)
*Girl Under a Tree* 1931
oil on canvas
122.5 x 193.7 cm
Gift of the artist's family, 1961
61.72.4
Inscriptions recto: l.r., *P. HEWARD*; verso: frame, u.c., on label, *Title – Girl Under a Tree.*
Provenance: Estate of the artist; artist's family, Montreal; gift, Jun 1961.
Exhibitions:
*Exhibition of the Group of Seven*, AGT, 4–24 Dec 1931, no. 73
*Seventh Annual Exhibition of Canadian Art*, NGC, 22 Jan–23 Feb 1932, no. 119

*Heward Exhibition*, W. Scott and Sons, Montreal, from 19 Apr
  1932
*19th and 20th Century Painting and Sculpture from the A.G.H.*, RMG,
  5–30 Sep 1973, no cat. no. (exhibition list)
*Canadian Painting in the Thirties*, NGC, 31 Jan–2 Mar 1975 / VAG, 1
  Apr–1 May 1975 / AGO, 24 May–20 Jun 1975 / reduced
  version: GAI, 6 Jul–17 Aug 1975 / EAG, 5 Sep–1 Oct
  1975 / MAG, 15 Oct–15 Nov 1975 / Musée d'art
  contemporain, Montréal, 27 Nov 1975–4 Jan 1976, no.
  25, repr.
*Prudence Heward Exhibition*, Walter Klinkhoff Gallery, Montreal,
  13–27 Sep 1980, no cat. no.
*Visions and Victories: 10 Canadian Women Artists 1914–1945*, LRAG,
  13 May–27 Jun 1983 / Laurentian University, Sudbury,
  15 Aug–25 Sep 1983 / KWAG, 3–27 Nov 1983 / MSVUAG,
  19 Dec 1983–29 Jan 1984 / AGO, 23 Apr–10 Jun 1984,
  no. 7, repr.
*Expressions of Will: The Art of Prudence Heward*, AEAC, 1 Mar–27
  Apr 1986 / Concordia University Art Gallery, Montreal,
  4 Jun–5 Jul 1986 / MCAC, 31 Aug–16 Nov 1986 / MAG, 9
  Jan–15 Feb 1987, no.16, repr.
*Canadian Art in the Thirties*, The Art Gallery of Peel, 18 Jan–4
  Mar 1990, no cat. no., repr. (brochure)
*The Group of Seven: Art for a Nation*, NGC, 13 Oct–31 Dec 1995 /
  AGO, 17 Feb–5 May 1996 / VAG, 19 Jun–2 Sep 1996 /
  MMFA, 3 Oct–1 Dec 1996, no. 167, repr.

Cat. 64

**ELIZABETH WYN WOOD** (1903–1966)
*Linda*   1931; posthumous cast 1970
bronze
56.5 x 20.0 x 17.0 cm
Gift of Elizabeth Bradford Holbrook, 1969
69.117.3
Inscriptions: top of base at back, *Elizabeth Wood / 1931*
Provenance: Elizabeth Bradford Holbrook (former Hahn studio
assistant), as a plaster; gift to the AGH, Nov 1969; cast in bronze
at Roman Bronze Works, New York, as ordered by Holbrook
and the AGH, May 1970.

Cat. 65

**E. GRACE COOMBS** (1890–1986)
*Jack Ladder House*   c.1933
oil on laminated card
26.7 x 21.5 cm
Director's Purchase Fund, 1959
59.56.4
Inscriptions recto: l.r., *EG COOMBS*; verso: c., *Jack Ladder House*
*/ [encircled] 267 / [encircled] 427 Jack Ladder House / 8 1/2 x 10 1/2*
*/ E Grace Coombs OSA. AOCA. / 64 Grenville St. Studio 3 Toronto*
Provenance: James Sharp Lawson (artist's husband), Guelph;
purchased, Dec 1959.
Exhibitions:
*From the Studio: Selections from the Edith Grace Coombs Archive*,
  AGH, 30 Jan–21 Sep 1997

Cat. 66

**E. GRACE COOMBS** (1890–1986)
*Sketch, Sawmill Yard, near Knoepfli*   c.1933
oil on laminated card
21.5 x 26.5 cm
Gift of Dr. J.S. Lawson, 1961
61.X.59
Inscriptions recto: l.l., *EG COOMBS*; verso: u.c., *O.SA. SMALL*
*PICTURE SHOW 1933.*; u.c. [obscured], *[__] Township / [__]*
*tario*; u.r. [encircled], *124*
Provenance: James Sharp Lawson (artist's husband), Guelph,
Ontario; gift, Apr 1961.
Exhibitions:
*Little Pictures by Members of the Ontario Society of Artists*, AGT, Dec
  1933, no. 147, *Sketch, Saw Mill Yard near Knoepfli*
*From the Studio: Selections from the Edith Grace Coombs Archive*,
  AGH, 30 Jan–21 Sep 1997

Cat. 67

**JOHN SLOAN** (1890–1970)
*Forty Below*   c.1933
stone
72.2 x 28.5 x 27.0 cm
Gift of International Business Machines Corporation, 1960
60.111.R
Inscriptions: none
Provenance: International Business Machines Corporation
(IBM), New York, by 1959; gift, Nov 1960.
Exhibitions:
*Retrospective Exhibition of Sculpture by John Sloan, A.R.C.A., S.S.C.*,
  AGH, 2–25 Jan 1959
*Centennial Exhibition: Some Artists Who Have Lived and Worked in*
  *Hamilton*, 27 Sep–26 Nov 1967, no. 72, repr.
*Canadian Figurative Sculpture*, Burlington Cultural Centre,
  Burlington, 8 Sep–2 Oct 1983
*Climbing the Cold White Peaks: A Survey of Artists In and From*
  *Hamilton 1910–1950*, AGH and Hamilton Artists Inc.,
  11 Jul–10 Aug 1986, no cat. no., repr.
*Curatorial Laboratory Project #6: Glut: Culture as Accumulation*,
  28 Jun–28 Aug 1991, no cat. no., repr.

Cat. 68

**YULIA BIRIUKOVA** (1895–1972)
*Prospector (Peter Swanson)*   1934
oil on canvas
114.2 x 92.0 cm
Gift of Thoreau MacDonald, 1973
74.43.1
Inscriptions recto: l.r., *YULIA BIRIUKOVA / 1934*
Provenance: Estate of the artist; Thoreau MacDonald
(companion of the artist), Thornhill; gift, Dec 1973.
Exhibitions:
OSA, AGT, Mar 1934, no. 8, *Prospector*
CNE, 24 Aug–8 Sep 1934, no. 284, *Prospector*

Cat. 69

**KATHLEEN MOIR MORRIS** (1893–1986)
*Lower Town, Quebec* c.1935
oil on canvas
71.3 x 76.5 cm
Gift of Mrs. A.V. Young, 1958
58.86.S
Inscriptions recto: l.l., *K. M. Morris*
Provenance: Mrs. A.V. Young, likely purchased from the artist
through the *First Annual Winter Exhibition*, Dec 1948; gift, May
1958.
Exhibitions:
*Fifty-third Spring Exhibition*, AAM, 19 Mar–12 Apr 1936, no. 309
*First Annual Winter Exhibition*, AGH, 2–31 Dec 1948, no. 59
*Through Canadian Eyes: Trends and Influences in Canadian Art
        1815–1965*, GAI, 22 Sep–24 Oct 1976, no. 85, repr.
*Canadian Art in the Thirties*, The Art Gallery of Peel, 18 Jan–4
        Mar 1990, no cat. no. (brochure)

Cat. 70

**BERTRAM BROOKER** (1888–1955)
*Seated Figure* 1935
oil on canvas
101.6 x 101.6 cm
Gift from the Marie Louise Stock Fund, 1996
1996.15
Inscriptions recto: l.r., *BERTRAM BROOKER*
Provenance: Estate of the artist; Phyllis Brooker Smith (artist's
daughter), Midhurst; purchased through Christopher Varley Inc.,
Toronto, Aug 1996.
Exhibitions:
OSA, AGT, Mar 1935, no. 21
CNE, 23 Aug–7 Sep 1935, no. 208, repr.

Cat. 71

**PARASKEVA CLARK** (1898–1986)
*Rubber Gloves* 1935
oil on canvas
51.0 x 61.2 cm
Gift of Richard Alway, 2001
2001.24
Inscriptions recto: l.r., *paraskeva clark 35*; verso: frame, c.r.,
*Paraskeva Clark*
Provenance: Gordon McNamara, Toronto; Georges Loranger,
Toronto; Christopher Varley, Toronto, 1989; Masters Gallery,
Calgary, 1995; Richard Alway, Toronto, 1997; gift, Dec 2001.
Exhibitions:
Galleries of J. Merritt Malloney, Toronto, 4–18 Jan 1936, no. 48,
        *Rubber Gloves – Still Life*
*Paraskeva Clark: Paintings and Drawings*, DUAG, 9 Sep–17 Oct
        1982 / NGC, 19 Nov 1982–2 Jan 1983 / AGO, 25 Jan–4
        Mar 1983 / AGGV, 20 Mar–19 May 1983, no. 11, repr.
*Home Truths: A Celebration of Home Life by Canada's Best-loved
        Painters*, RMG, 4 Sep–26 Oct 1997 / The Living Arts
        Centre, Mississauga, 13 Nov–28 Dec 1997 / RHAC, 11
        Jan–22 Feb 1998, no. 126, repr.

Cat. 72

**GUY PÈNE DU BOIS** (American; 1884–1958)
*Reclining Nude* 1936
oil on canvas
74.2 x 92.0 cm
Gift of the Women's Committee, 1964
64.56.2
Inscriptions recto: l.r., *GUY Pène du Bois '36*
Provenance: Toledo Museum of Art, purchased from the artist,
through C.W. Kraushaar Art Galleries, New York, Jun 1937;
deaccessioned, Jan 1962; Kraushaar Galleries, New York, on
consignment, Oct 1962; purchased, Jun 1964.
Exhibitions:
*Six American Artists*, Brooklyn Museum, New York, 20 Oct–29
        Nov 1936, no. 18
*Fifteenth Exhibition of Contemporary American Oil Paintings*, Corcoran
        Museum, Washington, 28 Mar–9 May 1937, no. 47
*Twenty-Fourth Annual Exhibition of Selected Paintings by
        Contemporary American Artists*, Toledo Museum of Art,
        Ohio, 6 Jun–29 Aug 1937, no. 17, repr.
*Fiftieth Anniversary: An Exhibition of The Contemporary American Oil
        Paintings Acquired by the Toledo Museum of Art
        1901–1951*, Toledo Museum of Art, Ohio, Aug–Sep
        1951, no cat. no.
*The Nude in American Painting*, The Brooklyn Museum, 6 Oct–10
        Dec 1961, no. 40, repr.
*Three Centuries of the American Nude*, New York Cultural Center
        8 May–29 Jun 1975 / Milwaukee Art Center, 20 Jul–30
        Jul 1974 / Minneapolis Institute of Art, 1 Oct–15 Nov
        1975 / Worcester Art Museum, 15 Nov–31 Dec 1975,
        no. 77, repr.
*Selections from the American Collection of the Art Gallery of Hamilton*,
        Oakville Centennial Gallery, 4 Jun–3 Jul 1977
*Guy Pène du Bois: Artist About Town*, Corcoran Gallery of Art,
        Washington, 10 Oct–30 Nov 1980 / Joslyn Art
        Museum, Omaha, 10 Jan–1 Mar 1981 / Mary and Leigh
        Block Gallery, Northwestern University, Evanston, 20
        Mar–10 May 1981, no. 72, repr.
*20th Century American Painting*, McMaster University Art Gallery,
        15 Mar–12 Apr 1987
*Permeable Border: Art of Canada and the United States*, AGO, 28 Oct
        1969–7 Jan 1970, no. 37, repr.
*Vision Made Real: An Exhibition Celebrating the 50th Anniversary of
        the Volunteer Committee*, AGH, 23 Apr–29 Aug 1999

Cat. 73

**SARAH ROBERTSON** (1891–1948)
*Coronation* 1937
oil on canvas
84.4 x 60.9 cm
Gift of H. S. Southam, C.M.G., LL.D., 1951
51.105.A
Inscriptions recto: l.r. *S.M. Robertson*
Provenance: H. S. Southam, Ottawa, purchased from the artist,
Montreal, through the Canadian Group of Painters, 1937; gift,
Mar 1951.
Exhibitions:
CGP, AGT, 19 Nov–19 Dec 1937 / AAM, Jan 1938, no.68, repr.
CGP, NGC, 12–27 Feb 1938, no. 65
*A Century of Canadian Art*, Tate Gallery, London, England,
        15 Oct–15 Dec 1938, no. 189
CGP, World's Fair, New York, 1 Aug–15 Sep 1939, no. 52

*Canadian Art 1760–1943*, Yale University Art Gallery, New Haven, Connecticut, Mar–Apr 1944, no cat. no.

*Paintings Lent By H. S. Southam, Esq., C.M.G., Ottawa*, NGC, 27 May–2 Jul 1944 / AAM, Aug 1944, no cat. no. (later addition to original numbered exhibition list)

*The Development of Painting in Canada 1665–1945*, AGT, 10–28 Jan 1945 / AAM, Feb–21 Mar 1945 / NGC, 8 Jun–14 Jul 1945 / Musée de la province de Québec, Apr 1945, no. 174

*Canadian Women Artists*, Riverside Museum, New York, 27 Apr–18 May 1947, no. 62

*Exhibition of Paintings by Canadian Women Artists*, NGC, 30 Sep–14 Nov 1947, no. 50

*Memorial Exhibition: Sarah Robertson 1891–1948*, NGC, 3–29 Nov 1951 / MMFA, 16 Feb–5 Mar 1952 / AGH, May, 1952 / LPLAM, 20 Jun–14 Jul, 1952 / VAG, 2–21 Sep 1952 / Moose Jaw Normal School, Oct 1952 / Regina College, from 1 Dec 1952 / WAG, 14 Mar–2 Apr 1953, no. 48, repr.

*The Art Gallery of Hamilton Presents The H. S. Southam Collection*, AGH, 17 May–12 Jun 1966, no. 32

*19th and 20th Century Canadian Paintings from the Art Gallery of Hamilton*, University of Guelph, 28 Apr–30 May 1974, no. 31

*Canadian Painting in the Thirties*, NGC, 31 Jan–2 Mar 1975 / VAG, 1 Apr–1 May 1975 / AGO, 24 May–20 Jun 1975, reduced version: GAI, 6 Jul–17 Aug 1975 / EAG, 5 Sep–1 Oct 1975 / MAG, 15 Oct–15 Nov 1975 / Musée d'art contemporain, Montreal, 27 Nov 1975–4 Jan 1976, no. 15, repr.

*Visions and Victories: 10 Canadian Women Artists 1914–1945*, LRAG, 13 May–27 Jun 1983 / Laurentian University, Sudbury, 15 Aug–25 Sep 1983 / KWAG, 3–27 Nov 1983 / MSVUAG, 19 Dec 1983–29 Jan 1984 / AGO, 23 Apr–10 Jun 1984, no. 36, repr.

*Canadian Art in the Thirties*, The Art Gallery of Peel, 18 Jan–4 Mar 1990, no cat. no. (brochure)

*Sarah Robertson (1891–1948)*, La Galerie Walter Klinkhoff, Montreal, 7–21 Sep 1991, no. 10, repr.

Cat. 74

**PAUL-ÉMILE BORDUAS** (1905–1960)
*Matin de printemps*  1937
oil on canvas
30.5 x 39.3 cm
Gift from the Alfred Wavell Peene and Susan Nottle Peene Memorial, 2001
2001.2
Inscriptions recto: l.r., *Borduas / 1937*
Provenance: Gilles Beaugrand, gift from the artist, Montreal, 1941; IEGOR – Hôtel des Encans, Montreal, lot 8, 18 Sep 2000; Christopher Varley, Toronto, Sep 2000; purchased, May 2001.
Exhibitions:
*Paul-Émile Borduas: 1905–1960*, MMFA, 11 Jan–11 Feb 1962 / NGC, 8 Mar–8 Apr 1962 / AGT, 4 May–3 Jun 1962, no.11, *La Rue Montana* [sic], repr.

*Paul-Émile Borduas, peinture*, La Maison des arts La Sauvegarde, 30 Jun–30 Aug 1967, no.2, *La Rue Montana* [sic]

*The Contemporary Arts Society: Montreal: 1939–1948*, EAG, 5 Sep–26 Oct 1980 / GM, 8 Nov 1980–18 Jan 1981 / AGW, 5 Apr–3 May 1981 / Musée d'art contemporain, Montreal, 21 May–21 Jun 1981 / AEAC, 29 Jun–2 Aug 1981 / DUAG, 13 Aug–13 Sep 1981, no. 6, *Matin de printemps (la rue Mentana)*, repr.

*Paul-Émile Borduas*, MMFA, 6 May–7 August 1988, no.78, repr.

Cat. 75

**TRISTRAM HILLIER** (British; 1905–1983)
*L'Arrêt de Villainville*  1939
oil on canvas adhered to plywood
59.5 x 79.9 cm
Gift of the Women's Committee, 1967
67.72.28
Inscriptions verso: frame, u.c., on label [torn]: "L' [__] / VILLAINVILLE." / 1939.
Provenance: Arthur Tooth & Sons Ltd., London, no. 1072. International Business Machines Corporation (I.B.M.), New York, by 1947; Paul Duval, Toronto, Nov 1966; purchased, Oct 1967.
Exhibitions:
*Paintings and Sculpture from Great Britain: Permanent Collection: International Business Machines Corporation*, AGT, 18 Oct–16 Nov 1947, no. 14

*IBM British paintings and etchings*, AGH, Oct 1955

*Director's Choice from the Permanent Collection of the Art Gallery of Hamilton*, Art Gallery of Brant, Brantford, 9 Sep–3 Oct 1971, no. 22, repr. cover

*Director's Choice: Paintings from the Permanent Collection of The Art Gallery of Hamilton*, Laurentian University, Sudbury, 8 Sep–1 Oct 1972, no cat no. (exhibition list)

*Vision Made Real: An Exhibition Celebrating the 50th Anniversary of the Volunteer Committee*, AGH, 23 Apr–29 Aug 1999

Cat. 76

**PAUL NASH** (British; 1889–1946)
*Monster Shore*  1939
oil on canvas
71.2 x 91.5 cm
Gift of the Women's Committee, 1966
66.89.2
Inscriptions recto: l.l. *Paul Nash*
Provenance: Arthur Tooth & Sons Ltd., London, no. 1068, by 1940. International Business Machines Corporation (IBM), New York, by 1947; Paul Duval, Toronto, Apr 1965; purchased, Apr 1966.
Exhibitions:
*Art of Today: Some Trends in British Painting*, Alex. Reid & Lefevre Ltd., Jan–Feb 1940, no. 37

*Paintings and Sculpture from Great Britain: Permanent Collection: International Business Machines Corporation*, AGT, 18 Oct–16 Nov 1947, no. 23

*Paul Nash: Paintings and Watercolours*, Tate Gallery, London, 12 Nov–28 Dec 1975, reduced version, Arts Council of Great Britain (organizer): *Paul Nash*, City Museum and Art Gallery, Plymouth, 17 Jan–8 Feb 1976 / The Minories, Clochester, 15 Feb–7 Mar 1976 / City Art Gallery and Museum, Bradford, 13 Mar–4 Apr 1976 / City Art Gallery, Manchester, 10 Apr–2 May 1976, no. 178

*Paul Nash*, The Arts Council of Great Britain (touring exhibition selected from the above), 1976, no. 178

*A Sense of Place: The Paintings of Edward Burra and Paul Nash*, Grey Art Gallery and Study Center, New York University, New York, 24 Feb–3 Apr 1982, no cat. no.

*The Art Gallery of Hamilton: Seventy-Five Years (1914–1989)*, AGH, 28 Sep–19 Nov 1989, no. 51, repr.

*The British Imagination: Twentieth-Century Paintings, Sculpture, and Drawings*, Hirschl and Adler Galleries, New York, 10 Nov 1990–12 Jan 1991, no. 9, repr.

*Aerial Creatures: Paul Nash*, Imperial War Museum, London,
England, 3 Oct 1996–27 Jan 1997 / Oriel Mostyn,
Llandudno, North Wales, 15 Feb–3 Apr 1997, no. 12,
repr.

Cat. 77

**CARL SCHAEFER**  (1903–1995)
*Farm House by the Railway, Hanover*   1939
oil on canvas
87.0 x 117.8 cm
Gift of the Women's Committee, 1964
64.111.4
Inscriptions recto: l.r. of c., *C. Schaefer / 39*; verso: stretcher, u.l.,
*HANOVER 1938–39 FARM HOUSE BY THE RAILWAY*
Provenance: Purchased from artist, Toronto, Jan 1964.
Exhibitions:
CGP, AGT, 20 Oct–13 Nov 1939 / AAM, Jan 1940, no cat. no.
(exhibition list)
CNE, 23 Aug–7 Sep 1940, no cat. no.
*Carl Schaefer Retrospective Exhibition: Paintings from 1926–1969,*
Sir George Williams University, Montreal, 1969 / AEAC /
AGH / LPLAM / AGW, no 28, repr.
*The Ontario Community Collects: A Survey of Canadian Painting
from 1766 to the Present*, AGO, 12 Dec 1975–1 Feb 1976 /
Sarnia Public Library and Art Gallery, 27 Feb–24 Mar
1976 / AGW, 31 Mar–28 Apr 1976 / St. Catharines and
District Arts Council, Rodman Hall, 7–30 May 1976 /
LPLAM, 4–27 Jun 1976 / Tom Thomson Memorial
Gallery and Museum of Fine Art, Owen Sound, 8–28
Jul 1976 / AGH, 6–27 Aug 1976 / RMG, 3 Sep–5 Oct
1976 / Laurentian University Museum and Arts Centre,
Sudbury, 12–31 Oct 1976 / Gallery/Stratford, 5–28 Nov
1976 / University of Guelph Art Gallery, 3–28 Dec
1976 / KWAG, 6–30 Jan 1977 / AEAC, 18 Feb–28 Mar
1977, no. 84, repr.
*A Distant Harmony: Comparisons in the Painting of Canada and the
United States of America*, WAG, 8 Oct–28 Nov 1982 / AGH,
17 Feb–27 Mar 1983, no. 99, repr.
*Rural Route Ontario*, AGP, 2 Nov–16 Dec 1984, no. 24
*The Art Gallery of Hamilton: Seventy-Five Years (1914–1989)*, AGH,
28 Sep–19 Nov 1989, no. 60, repr.
*Canadian Art in the Thirties*, The Art Gallery of Peel, 18 Jan–4
Mar 1990, no cat. no., repr. (brochure)

Cat. 78

**ERNST NEUMANN**  (1907–1956)
*Boxer*  nd; posthumous cast 1959
bronze
58.0 x 26.0 x 30.0 cm
Gift of John Newman, 1957
57.89.E
Inscriptions: none
Provenance: John Newman (artist's brother), Montreal, as a
plaster; gift, 1957; cast in bronze, as ordered by the AGH, with
funds from the Women's Committee, Apr 1959.

Cat. 79

**JOHN SLOAN**  (1890–1970)
*Rosie the Riveter*   early 1940s
plaster
49.8 x 31.0 x 50.1
Gift of the artist, 1965
65.111.9
Inscriptions: none
Provenance: Gift of the artist, Oct 1965.
Exhibitions:
*Retrospective Exhibition of Sculpture by John Sloan, A.R.C.A., S.S.C.,*
AGH, 2–25 Jan 1959
*Climbing the Cold White Peaks: A Survey of Artists In and From
Hamilton 1910–1950*, AGH and Hamilton Artists Inc.,
11 Jul–10 Aug 1986, no cat. no., repr.

Cat. 80

**EDWARD ALEXANDER WADSWORTH**
(British; 1889–1949)
*Sussex Pastoral*   1941
egg tempera on canvas on wood
63.6 x 76.3 cm
Gift of The Hamilton Spectator, 1965
65.117.T
Inscriptions recto: l.r., *WADSWORTH 1941*
Provenance: Arthur Tooth & Sons Ltd., London, no. 1071.
International Business Machines Corporation (IBM), New York,
by 1947; Paul Duval, Toronto, Apr 1965; purchased Aug 1965.
Exhibitions:
*Paintings and Sculpture from Great Britain: Permanent Collection:
International Business Machines Corporation*, AGT, 18
Oct–16 Nov 1947, no. 32

Cat. 81

**RAE HENDERSHOT**  (1921–1988)
*The Three Graces*   1946
oil on canvas
45.8 x 61.1
Gift of H. L. Rinn, 1950
50.64
Inscriptions recto: l.l., *Hendershot*
Provenance: H.L. Rinn, purchased from the artist, Hamilton; gift,
1950.
Exhibitions:
*1st Exhibition of the Contemporary Artists of Hamilton 1949–1950,*
AGH, 1–15 Jan 1950, no. 20
*Mile of Pictures*, downtown Hamilton, 23 Sep–4 Oct 1950
*Paintings Loaned by the Art Gallery of Hamilton*, KWAG, 15–31 Jan
1960, no. 49 (exhibition list)
*Climbing the Cold White Peaks: A Survey of Artists In and From
Hamilton 1910–1950*, AGH and Hamilton Artists Inc.,
11 Jul–10 Aug 1986, no cat. no., repr.
*Rae Hendershot 1921–1988*, AGH, 13 Sep–2 Dec 1990, no. 4, repr.

Cat. 82

**A. J. CASSON** (1898–1992)
*First Snow* 1947
oil on Masonite
76.2 x 91.3 cm
Gift of Mrs. Harold H. Leather, 1952
52.56.C
Inscriptions recto: l.r., *A. J. CASSON*
Provenance: Purchased from the artist, Toronto, through the
*Fifth Annual Winter Exhibition*, with the Purchase Prize donated
by Mrs. H. H. Leather, Dec 1952.
Exhibitions:
CGP, AGT, 22 Nov–21 Dec 1947 / AAM, 1948, no. 17, *October
      Snow*
*Fifth Annual Winter Exhibition*, AGH, Dec 1952, no. 9
*A. J. Casson*, AGW 14 May–9 Jul 1978 / AGO, 22 Jul–27 Aug 1978,
      no. 45, repr.
*Climbing the Cold White Peaks: A Survey of Artists In and From
      Hamilton 1910–1950*, AGH and Hamilton Artists Inc.,
      11 Jul–10 Aug 1986, no cat. no., repr.
*A. J. Casson: An Artist's Life*, MCAC, 14 Nov 1998–14 Feb 1999 /
      MSAC, 1 Apr–16 May 1999 / Art Gallery of Algoma,
      Sault Ste. Marie, 27 May–4 Jul 1999 / West Parry
      Sound District Museum, Parry Sound, 19 Jul–7 Sep
      1999 / Thunder Bay Art Gallery, 17 Sep–7 Nov 1999,
      no. 44, repr.

Cat. 83

**EDWIN HOLGATE** (1892–1977)
*Uncle George* 1947
oil on Masonite
71.3 x 61.0 cm
Gallery purchase, 1953
53.72.C
Inscriptions recto: l.l., *E. HolgAtE. 47*
Provenance: Purchased from the artist, Morin Heights, Quebec,
Mar 1953.
Exhibitions:
CGP, AGT, 22 Nov–21 Dec 1947 / AAM, 1948, no. 40
*Hamilton Collects*, Willistead Art Gallery, Windsor, 21 Mar–18
      Apr 1962, no. 16
*Faces Of Canada: Portraits Paintings and Sculptures from 1900 to the
      Present Day*, Stratford Festival (Festival Arena), 15
      Jul–12 Sep 1964, no cat. no., repr.
*Edwin Holgate: Paintings*, NGC, 25 Jul–7 Sep 1975 / EAG, 1–31 Oct
      1975 / AGGV, 15 Nov–15 Dec 1975 / McMaster Art
      Gallery, Hamilton, 1–31 Jan 1976 / Concordia
      University, Montreal, 17 Feb–15 Mar 1976 / Memorial
      University Art Gallery, St. John's, 1–30 Apr 1976 /
      DUAG, 15 May–15 Jun 1976, no. 33
*Figures and Portraits in the Thirties and Forties: A Selection of
      Canadian Paintings and Works on Paper*, AGO (organizer),
      Lynnwood Arts Centre, Simcoe, 3 Aug–3 Sep 1979 /
      Saulte Ste. Marie Public Library, 21 Sep–14 Oct 1979 /
      KWAG, 1–30 Dec 1979 / Tom Thomson Memorial
      Gallery and Museum of Fine Art, 8 Jan–3 Feb 1980 /
      Laurentian University Museum and Art Centre, 12–30
      Mar 1980 / AGP, 1 May–8 Jun 1980, no. 9
*The Art Gallery of Hamilton: Seventy-Five Years (1914–1989)*, AGH,
      28 Sep–19 Nov 1989, no. 35, repr.

Cat. 84

**SING HOO** (1909–2000)
*Portrait of a Young Girl* early 1950s
hollow cast plaster
36.0 x 21.0 x 19.0 cm
Gift of Catherine Yuen, 2001
2001.21.2
Inscriptions: none
Provenance: Estate of the artist; Catherine Yuen (artist's daugh-
ter), Toronto, 2000; gift, Aug 2001.

Cat. 85

**ALEX COLVILLE** (b. 1920)
*Horse and Train* 1954
glazed oil on hardboard
41.5 x 54.3 cm
Gift of Dominion Foundries and Steel Limited (Dofasco), 1957
57.56.U
Inscriptions recto: l.r., *Alex Colville 1954*; verso: u.l., *HORSE
AND TRAIN / ALEX COLVILLE 1954 / (GLAZED OIL)*
Provenance: Purchased from the artist, Sackville, through the
*Eighth Annual Winter Exhibition*, with the Purchase Prize donated
by Dominion Foundries and Steel Ltd., Feb 1957.
Exhibitions:
*Alex Colville*, Hewitt Gallery, New York, 1955
*Five New Brunswick Artists*, Art Gallery of Toronto, 9 Nov–4 Dec
      1955, no. 2
CNE, 24 Aug–8 Sep 1956, no. 34
*Eighth Annual Winter Exhibition*, AGH, Feb 1957, no. 26
*Sketch and Finished Painting*, LPLAM, 22 Oct–30 Nov 1957 / AGH,
      Dec 1957 / École des beaux arts, Montreal, Jan 1958,
      no cat. no. (brochure)
*Paintings by Alex Colville*, Laing Galleries / Hart House, Toronto,
      1958
*Six East Coast Painters: Miller C. Brittain, D. Alexander Colville,
      Lawren P. Harris, Jack W. Humphrey, Frederick J. Ross,
      Ruth Wainwright*, NGC (organizer), LPLAM, 8–29 Sep 1961
      / EAG, 9–30 Oct 1961 / New Brunswick Museum, St.
      John, 8–29 Nov 1961 / Calgary Allied Arts Centre,
      6–27 Dec 1961 / Brandon Allied Arts Centre, 5–26 Jan
      1962; Saskatoon Art Centre, 5–26 Feb 1962 / Mount
      Allison University, Sackville, 8–29 Mar 1962 / KWAG,
      9–30 Apr 1962 / WAG, 11 May–1 Jun 1962, no. 8
*Surrealism in Canadian Painting*, LPLAM, Mar 1964 / KWAG, Apr
      1964 / AGH, May 1964 / Queen's University, Kingston,
      Jun 1964, no. 20
*Images for a Canadian Heritage*, VAG, 20 Sep–30 Oct 1966, no.
      111, repr.
*Canadian Art of Our Time*, WAG, 5 Jun–8 Aug 1967, no cat. no.
*The Acute Image in Canadian Art*, OAG, 1 Apr–15 May 1974, no
      cat. no.
*Alex Colville*, Norman MacKenzie Art Gallery, Regina, 30 Jan–29
      Feb 1976, no. 3 (brochure)
*Aspects of Realism*, Rothmans of Pall Mall Canada Ltd.
      (organizer), Gallery/Stratford, 8 Jun–5 Sep, 1976 /
      Vancouver Centennial Museum, 16 Sep–17 Oct 1976 /
      GAI, 29 Oct–28 Nov 1976 / MAG, 10 Dec 1976–9 Jan
      1977 / WAG, 20 Jan–20 Feb 1977 / EAG, 1 Mar–1 Apr
      1977 / Memorial University Art Gallery, St. John's,
      14 Apr–14 May 1977 / CCAG, 26 May–26 Jun 1977 /
      Musée d'Art Contemporain, Montreal, 7 Jul–7 Aug
      1977 / DUAG, 18 Aug–18 Sep 1977 / AGW, 29 Sep–23

Oct 1977 / LPLAM and McIntosh Memorial Art Gallery, London, 3–27 Nov 1977 / AGH, 8 Dec 1977–8 Jan 1978, no. 3, repr.

*Colville*, AGO, 22 Jul–18 Sep 1983 / Staatliche Künsthalle, Berlin, 14 Oct–16 Nov 1983 / Museum Ludwig, Cologne, 9 Dec 1983–15 Jan 1984 / MMFA, 8 Feb–1 Apr 1984 / DUAG, 19 Apr–27 May 1984 / VAG, 15 Jun–5 Aug 1984 / Beijing Exhibition Centre, 15 Nov–15 Dec 1984 / Fung Ping Shan Museum, University of Hong Kong, 16 Jan–10 Feb 1985 / Metropolitan Teien Museum, Tokyo, 20 Feb–21 Mar 1985 / Canada House, London, England, 11 Apr–7 May 1985, no. 43, repr.

*Treasures: A Selection from our Regional Heritage*, LRAG, 3 Dec 1988–22 Jan 1989 / Sarnia Public Library and Art Gallery, 24 Mar–24 Apr 1989 / KWAG, 18 May–25 Jun 1989 / AGH, 14 Sep–29 Oct 1989 / RHAC, 3 Nov–3 Dec 1989, no cat. no. (brochure)

*The Art Gallery of Hamilton: Seventy-Five Years (1914–1989)*, AGH, 28 Sep–19 Nov 1989, no. 16, repr. (in conjunction with *Treasures*)

*Curatorial Laboratory Project #4: The Erotic/Neurotic*, AGH, 17 Jan–14 Apr 1991, no cat. no., repr.

*I Believe in Magic*, AGH, 29 Oct 1994–22 Jan 1995, no cat. no.

*Alex Colville: Milestones*, NGC, 23 Jun–17 Sep 2000, no. 3

Cat. 86

**T. R. MacDONALD**  (1908–1978)
*One A.M.*  1956
oil on canvas
41.6 x 51.0 cm
Gift of the Women's Committee, 1958, dedicated to the memory of Jean Middleton Keogh, President of the Women's Committee, 1956–1958
58.87.P
Inscriptions recto: l.r., *T R MAcDONALD 1956*
Provenance: Purchased from the artist, Hamilton, Mar 1958.
Exhibitions:
Gallery XII (with Clare Bice), MMFA, 8–24 Mar 1957, no. 2 (exhibition list)

*T. R. MacDonald: 1908–1978*, AGH, 24 Oct–30 Nov 1980 / AGW, 25 Jan 1980–28 Feb 1981 / RHAC, 6 Mar–5 Apr 1981, no. 42, repr.

*Climbing the Cold White Peaks: A Survey of Artists In and From Hamilton 1910–1950*, AGH and Hamilton Artists Inc., 11 Jul–10 Aug 1986, no cat. no., repr.

*Directors Collect*, AGH (co-organizer), Jun–13 Aug 1995 / AGW (co-organizer), 9 Sep 1995–20 Jan 1996 / Gallery/Stratford, 27 May–8 Sep 1996 / LRAHM (co-organizer), 14 Dec 1996–2 Feb 1997, no cat. no. (brochure)

Cat. 87

**PHILIP SURREY**  (1910–1990)
*The Lovers*  c.1957
oil on canvas
61.3 x 45.8 cm
Bequest of Josephine M. Magee, 1958
58.111.M
Inscriptions recto: u.l. of c., *Surrey*
Provenance: Purchased from the artist with funds from the bequest of Josephine M. Magee, Apr 1958.
Exhibitions:
*Ninth Annual Winter Exhibition*, AGH, Feb 1958, no. 93

*Philip Surrey: Le peintre dans la ville*, Musée d'art contemporain, 28 Oct–28 Nov 1971 / Centre culturel canadien, Paris, 20 Jan–20 Mar 1972, no. 15

*Director's Choice: Paintings from the Permanent Collection of The Art Gallery of Hamilton*, Laurentian University, Sudbury, 8 Sep–1 Oct 1972, no cat no. (exhibition list)

*19th and 20th Century Canadian Paintings from the Art Gallery of Hamilton*, University of Guelph, 28 Apr–30 May 1974, no. 32

*The Contemporary Arts Society: Montreal: 1939–1948*, EAG, 5 Sep–26 Oct 1980 / GM, 8 Nov 1980–18 Jan 1981 / AGW, 5 Apr–3 May 1981 / Musée d'art contemporain, Montreal, 21 May–21 Jun 1981 / AEAC, 29 Jun–2 Aug 1981 / DUAG, 13 Aug–13 Sep 1981, no. 59, repr.

*Directors Collect*, AGH (co-organizer), Jun–13 Aug 1995 / AGW (co-organizer), 9 Sep 1995–20 Jan 1996 / Gallery/Stratford, 27 May–8 Sep 1996 / LRAHM (co-organizer), 14 Dec 1996–2 Feb 1997, no cat. no. (brochure)

# TRANSLATIONS / TRADUCTIONS

# Ambition moderne
# L'affirmation d'une collection canadienne

*Tobi Bruce*
*Conservatrice principale*
*Art Gallery of Hamilton*

Avec un rare mélange de goût, d'économie, de savoir et de cette volonté si écossaise, il a bâti de toutes pièces une remarquable collection d'œuvres d'art[1].

Paul Duval, à propos du premier directeur de l'Art Gallery of Hamilton, T. R. MacDonald.

L'histoire pourrait commencer ainsi : « Il était une fois des gens qui rêvaient de bâtir pour la ville de Hamilton quelque chose de durable – un musée et une collection d'œuvres d'art de qualité et d'envergure. Et ensemble, ils ont travaillé à donner corps à cette ambition. » À mon avis, c'est une histoire assez remarquable, faite de détermination tranquille, d'ingéniosité et de dévouement, de stratégies habiles, de visions inspirées. Les acteurs – artistes, conservateurs, bénévoles, collectionneurs, marchands, mécènes – y ont tous joué un rôle important. Cette histoire qui couvre plusieurs décennies et plusieurs provinces, et qui a traversé la vie de tant de gens, n'est sans doute pas vraiment originale car, depuis cent cinquante ans, elle s'est répétée dans bien des villes du pays. Chaque situation porte la marque de ceux qui l'ont vécue, chaque institution est le fruit de son époque. Ainsi la collection de l'Art Gallery of Hamilton (AGH) a-t-elle sa personnalité propre. Je me propose ici de voir de quoi elle est faite et comment elle s'est développée.

L'histoire de la collection d'art canadien moderne de l'AGH est celle d'une réussite et, bien sûr, elle a ses héros. En novembre 1947, Thomas Reid (T. R.) MacDonald (1908–1978), un artiste de Montréal, devenait le premier directeur et conservateur à temps plein de ce musée. Cette nomination marque un tournant dans l'évolution de l'AGH, car cet homme effacé, astucieux et déterminé apportait avec lui une vision créatrice et la volonté de transformer une institution et une collection de manière telle qu'encore aujourd'hui elles se distinguent au Canada.

## Les débuts : La Ville ambitieuse et l'ambitieux artiste qui en était issu

En 1858, un auteur populaire parlait de Hamilton comme de « l'ambitieuse et dynamique petite ville ». Le nom lui allait à merveille. Mais « petite », Hamilton n'est plus, puisqu'avec une population dépassant les 50 000 habitants, elle est aujourd'hui la troisième cité du Dominion. Et ceux qui l'envient préfèrent ne pas rappeler qu'elle est dynamique. De sorte que, si vous cherchez des nouvelles de Hamilton dans le journal, vous devez regarder sous la rubrique « La Ville ambitieuse »[2].

Ishbel Gordon, comtesse d'Aberdeen, épouse du gouverneur général du Canada, 1893

Le qualificatif d'ambitieux, appliqué très tôt à la ville de Hamilton, est un leitmotiv qui colle bien cette histoire, puisque c'est à l'ambition – au désir de réaliser un rêve – que l'Art Gallery of Hamilton doit son développement. Fondé et constitué en société en 1914[3], l'AGH est l'un des plus anciens musées d'art du Canada[4]. En 1906, à la mort prématurée du peintre William Blair Bruce – considéré à l'époque comme le plus ambitieux et le plus brillant artiste de Hamilton, bien qu'il ait passé presque toute sa carrière à l'étranger –, sa veuve la sculpteure Caroline Benedicks-Bruce, son père William et sa soeur Bell Bruce-Walkden ont légué vingt-neuf de ses peintures à la ville, à la condition qu'on y aménage un musée pour abriter et présenter cette collection[5]. Ce legs galvanise tous ceux qui depuis la fin du XIXe siècle tentaient en vain de doter Hamilton d'un centre culturel[6]. Il remet le projet à l'ordre du jour. La ville est mûre pour une telle entreprise et ses leaders sont résolus, cette fois, à ne pas laisser passer l'occasion. Il faudra encore huit longues années pour choisir et préparer un espace susceptible d'être transformé en musée (surtout parce que la ville ne possède

pas d'édifice convenable pour abriter la collection), et l'Art Gallery of Hamilton ouvre officiellement ses portes le 30 juin 1914. Au dire de tous, on se souviendra longtemps de cet événement : la collection Bruce revient dans la ville natale de l'artiste accompagnée d'une impressionnante exposition d'huiles, d'aquarelles, d'estampes et de dessins canadiens. Cette dernière a été rassemblée en grande partie par le photographe Alexander M. Cunningham, récemment nommé président du conseil d'administration du musée, et par l'artiste hamiltonien John Sloan Gordon (voir cat. 22), depuis peu secrétaire du même conseil[7], en collaboration avec l'Académie royale des arts du Canada, l'Ontario Society of Artists et le Canadian Art Club; s'ajoutent des œuvres prêtées par des artistes et des collectionneurs locaux[8]. Que l'exposition inaugurale de l'AGH soit composée presque exclusivement d'œuvres canadiennes[9] ne passe pas inaperçu; admiratif, un critique de Hamilton y voit la preuve des progrès réalisés en art canadien :

> Les idées pessimistes sur l'avenir de l'art canadien s'évanouiront après une visite à l'Art Gallery of Hamilton, inaugurée cette semaine par le lieutenant-gouverneur. La collection de tableaux [...] fait honneur à la ville, et une surprise attend le visiteur dans ce foyer de l'art qui s'est développé grâce à la persévérance tenace de plusieurs citoyens dévoués. L'exposition est tout à fait représentative et cosmopolite. On trouve, dans les nombreuses toiles présentées, un rappel de chaque école de peinture, mais dans toutes, il y a une incontestable originalité qui confirme l'ascension d'une nouvelle venue dans le monde de l'art – une école canadienne[10].

En privilégiant les talents locaux, régionaux et nationaux dans son exposition inaugurale, l'AGH annonce sans le savoir ses futures stratégies et priorités. Parmi les nombreux artistes qui formeront plus tard le noyau de sa collection d'art canadien moderne, on trouve William Brymner, George Agnew Reid, Maurice Cullen, A. Y. Jackson, Arthur Lismer, Lawren Harris et Albert Robinson[11]. Au judicieux mélange d'œuvres locales et nationales, anciennes et contemporaines, s'ajoutent des créations de plusieurs artistes plus modernes de l'époque.

Le musée, situé au deuxième étage du premier immeuble occupé par la bibliothèque municipale de Hamilton (fig. 1), devient vite trop petit. L'exiguïté des locaux et la décision d'accueillir des expositions prêtées ou mises en tournée par d'autres musées canadiens et diverses sociétés d'art décourage aussitôt la constitution d'une collection permanente. Dès l'inauguration, A. M. Cunningham établit clairement ce à quoi on peut s'attendre : « Nous avons discuté du meilleur moyen d'obtenir des tableaux pour les salles qui restent et conclu que, tant que l'espace demeurera aussi restreint et que le tiers de cet espace sera réservé à la collection Bruce, il n'est pas souhaitable de réunir une collection permanente, dont on se désintéresserait rapidement[12]. » La plupart des gens sont d'avis que la collection Bruce suffit pour assurer la renommée de la ville et de son jeune musée. Elle constitue un bel échantillonnage de la production de l'artiste, rend compte de ses travaux à Hamilton, en France et en Suède, comprend des paysages, des marines, des portraits et des peintures de figures, et ces œuvres sont de divers formats, depuis les petites esquisses intimes jusqu'aux grandes toiles. Le legs Bruce, une acquisition de bon augure pour toute collection municipale, témoigne du talent d'un enfant de Hamilton qui a réussi à l'étranger. En relatant régulièrement les succès européens de l'artiste, notamment sa participation aux très prestigieux Salons de Paris, les journaux de Hamilton ont bâti sa réputation et son prestige à l'échelle locale. Comme le démontrera Arlene Gehmacher, Bruce incarne l'ambi-

tion de Hamilton, les aspirations de cette ville au début du XXe siècle[13]. Ses peintures, preuves tangibles que la réussite est possible, deviendront pour une trentaine d'années la signature de Hamilton, synonymes de l'AGH et de sa collection.

La production de Bruce nous donne un bon point de départ pour étudier la collection d'art moderne de Hamilton, puisqu'elle reflète le parcours et la sensibilité d'un peintre ambitieux à la fin du XIXe siècle. Quittant Hamilton pour Paris en juillet 1881, Bruce est l'un des premiers artistes du Canada à faire le pèlerinage vers la capitale culturelle de l'Occident, en quête d'occasions d'apprendre et d'exposer. Il s'inscrit à l'Académie Julian et son premier envoi au Salon est accepté en 1882[14]. Encouragé par une approbation aussi immédiate et poussé par le désir d'assimiler et d'adapter les nouvelles manières de peindre le paysage, il se rend à Barbizon, à Grez-sur-Loing et à Giverny, villages de France autour desquels gravitent des communautés d'artistes. Son immersion dans ces communautés – en particulier à Giverny où, durant l'été de 1887, il fait partie d'un groupe de peintres nord-américains fondateurs d'une colonie artistique – forme à la fois son œil et sa sensibilité.

Deux esquisses de cette période, aujourd'hui à l'AGH, *Giverny, France* (1887, cat. 3) et *Giverny* (v. 1887, cat. 2), montrent que Bruce a adopté plusieurs techniques impressionnistes, notamment le travail en plein air pour saisir les effets de lumière, une palette brillante et une touche fractionnée. Elles montrent aussi Bruce dans ce qu'il a de plus moderne. C'est dans ces essais intimes que nous voyons l'artiste libérer son coup de pinceau, jouer avec la couleur et avec la composition – essentiellement, se départir des règles inculquées pour la grande peinture destinée au Salon et se laisser aller, ne serait-ce qu'un peu. Cette dualité d'intention – l'expérimentation, d'une part, et la maîtrise du sujet, d'autre part – explique en partie les polarités de sa pratique; ces deux aspects sont admirablement présents dans le don de la famille Bruce à Hamilton. Dès 1888, Bruce atteint les sommets artistiques auxquels il aspire dans *Le chasseur fantôme* (cat. 6), un tableau accepté la même année au Salon de Paris et qui est incontestablement son chef-d'œuvre. Son inclusion dans le legs Bruce en 1914 donne à ce corpus, dès le début, une marque de distinction. Voilà un tableau sur un thème canadien, peint et exposé à l'étranger, un tableau au sujet mystérieux et fascinant, et, fait très important, un tableau de grand format. Mais surtout, voilà une œuvre *héroïque*. *Le chasseur fantôme*, qui traduit l'esprit du jeune artiste allant chercher fortune et gloire dans des contrées lointaines, est la pièce maîtresse d'une collection déjà impressionnante. S'il est possible à un seul artiste de porter sur ses épaules les aspirations de toute une communauté, d'un nouveau musée et d'une collection permanente, William Blair Bruce s'est montré à la hauteur de la tâche. Par sa forme et ses visées, l'œuvre de Bruce est une assise particulièrement bien choisie pour la collection naissante de Hamilton; elle fixe les critères en fonction desquels seront jugées les autres acquisitions dans les années à venir.

Toutefois, conformément à la décision annoncée par Cunningham en juin 1914, on s'intéresse fort peu au développement de la collection après l'exposition inaugurale. Cela, ajouté à la déclaration de la guerre au mois d'août suivant, relègue les acquisitions au second plan. Quelques œuvres significatives font néanmoins leur entrée à l'AGH, notamment deux Maurice Cullen : *Lavoirs sur la Seine* (v. 1894, fig. 2) et *Le barrage à Passy* (1894, fig. 3), acquises en 1923. Ces peintures ont auparavant trouvé place dans une importante collection particulière de Hamilton en partie grâce à William Blair Bruce, ami de Cullen[15].

Je vous écris assez tard au sujet des tableaux de Cullen, mais il n'est pas facile d'écrire quand on se trouve dans un train ou un bateau. Je pense qu'il aurait été préférable de publier dans l'article du journal quelque chose comme suit : « Les deux tableaux exposés depuis quelques jours dans la vitrine de M. Blanchfords (sic) sont, avons-nous appris, les excellents exemples du travail de l'un des meilleurs paysagistes d'ici, Monsieur Maurice Cullen de Montréal, qui a eu cette année le grand honneur d'être élu membre associé de la Société Nationale des Beaux-Arts, Salon des Champs de Mars, Paris, France, où ont été exposés l'an dernier les excellents exemples de paysages modernes ci-haut mentionnés, ajoutés depuis à la nombreuse collection de Monsieur W.D. Long, de cette ville. »[16]

Ces deux Cullen, qui font partie du legs de Jane Long Bisby, sœur de feu William Dubart Long[17], sont un précieux ajout à la collection Bruce, car elles se greffent au noyau d'œuvres de la première génération d'artistes canadiens ayant peint à l'étranger. Cullen et Bruce se sont rencontrés à Paris en 1892[18] et revus plusieurs fois chez les Bruce à Grez-sur-Loing entre 1892 et 1895[19]. *Lavoirs sur la Seine* de Cullen présente des affinités avec la production de Bruce, en particulier des passages de son tableau *Agréable rencontre* (fig. 4), exposé au Salon de 1893. Les deux peintures se caractérisent par une palette de mauves et de roses, et un tonalisme qui crée des effets lumineux. Elles se ressemblent aussi par le traitement des arbres dans le lointain – des arbres hauts et dégarnis, délicatement posés et disposés pour un maximum d'efficacité. Cependant, Cullen suggère plus qu'il ne détaille et prend ici une indéniable liberté dans l'application de la peinture, alors que Bruce adopte un traitement plus naturaliste et académique. Les deux tableaux de Cullen fournissent une base solide à ce qui deviendra un ensemble sélect mais appréciable de ses œuvres à Hamilton.

Parmi les premières acquisitions de l'AGH, il convient également de souligner *Près du lac Canoe* (1914, cat. 35) d'A. Y. Jackson, acheté par A. M. Cunningham à l'exposition du Fonds patriotique tenue à Hamilton du 23 avril au 1er mai 1915[20]. Cette toile, peinte l'année du premier voyage de Jackson dans le parc Algonquin avec Tom Thomson et de futurs membres du Groupe des Sept, représente un moment important dans l'évolution de l'artiste[21] : le choc entre sa formation européenne[22] et sa première expérience du Nord canadien. C'est un tableau peint avec assurance dans des tons de bleu, de rose et de mauve, où Jackson rend les variations de couleur sur la neige en adaptant au paysage canadien les leçons apprises à l'étranger[23]. Il est heureux que, si tôt dans son histoire, l'AGH ait acquis l'une des premières œuvres dans lesquelles Jackson traite du Nord canadien, étant donné le rôle déterminant que cet artiste jouerait dans l'enrichissement de la collection sous l'administration de T. R. MacDonald.

Néanmoins, les propos décourageants de Cunningham sur la constitution d'une collection permanente à l'AGH se révéleront exacts pour des années encore, du moins dans le domaine de la peinture moderne. Quoique l'AGH reçoive d'importants legs d'œuvres historiques dans l'entre-deux-guerres[24], ce n'est qu'après la fin de la Seconde Guerre mondiale que Hamilton connaît un certain essor culturel. Depuis longtemps – en fait, depuis l'ouverture de l'AGH ou presque –, les citoyens font campagne pour l'obtention d'un nouveau musée à l'épreuve du feu et disposant d'un budget convenable, mais en 1947, ils le revendiquent haut et fort, dans le cadre d'un mouvement général visant l'épanouissement culturel et intellectuel de la ville. Freda Waldon, bibliothécaire en chef de la bibliothèque municipale, est l'une des chefs de file et porte-parole de ce mouvement. En mai 1947, inaugurant la 15e

exposition annuelle de l'Art Club of Hamilton, elle prononce une allocution sur ce rêve récurrent qu'est la fondation d'un centre culturel. Waldon y résume le développement culturel de la ville, situe les revendications dans leur contexte historique et conclut par une sorte d'appel aux armes : « Croyez, je vous en conjure, que vous faites partie d'un mouvement plus vaste que certains appellent Loisirs et d'autres Éducation permanente, et que d'autres encore voudraient appeler la naissance d'une culture canadienne distincte, et qui vise essentiellement à apporter à tous les bonnes choses de la vie, la jouissance des choses de l'esprit et l'énergie créatrice. [...] Croyez qu'une ère nouvelle approche[25]. »

Les paroles de Waldon sont prophétiques : une ère nouvelle s'amorce, en effet, six mois plus tard, avec l'arrivée de T. R. MacDonald. Après l'octroi d'une subvention sans précédent de 8 500 dollars de la Ville de Hamilton, sous réserve expresse que l'AGH embauche son premier conservateur à temps plein[26], MacDonald s'installe à Hamilton. Le 12 novembre 1947, il se met au travail[27]. Il arrive au bon endroit, au bon moment, et il est, sans conteste, l'homme de la situation. La suite le prouvera.

## T. R. MacDonald : artiste avant tout

Commençons par le commencement. Pour comprendre T. R. MacDonald le conservateur, il faut d'abord comprendre T. R. MacDonald le peintre, parce qu'au fond, MacDonald fut et demeura toujours un artiste; c'était l'essence même de son identité. En fait, c'est cet aspect de sa biographie qui nous éclaire le mieux sur la vision et la sensibilité, tant esthétiques que philosophiques, qui sont à la base de la collection permanente de Hamilton. Dès le début, l'art fut le point de repère de MacDonald, le centre de sa vie. Le fait que son identité de peintre ait été éclipsée par son travail de conservateur et de directeur ne fait qu'accentuer le rôle crucial que sa pratique picturale a joué dans sa façon de concevoir la collection de l'AGH. C'est avec l'œil d'un peintre, l'instinct d'un artiste que MacDonald a enrichi la collection de Hamilton durant plus d'un quart de siècle.

Thomas Reid MacDonald naît à Montréal le 28 juin 1908, de parents écossais – Thomas Fraser MacDonald et Katherine MacLean. À l'âge de cinq ans, il perd sa mère, et la sœur de celle-ci, Grace MacLean, vient d'Écosse pour s'occuper de lui[28]. Très jeune, MacDonald s'intéresse aux arts. Il fréquente l'école privée d'Adam Sherriff Scott entre 1928 et 1930 et suit les cours de dessin d'après modèle d'Edmond Dyonnet à l'Art Association of Montreal entre 1930 et 1933. Ces deux professeurs sont des peintres figuratifs et académiques, et de très bons dessinateurs dont les œuvres demeurent traditionnelles par la facture et la sensibilité. Sur cette solide formation académique, MacDonald élabore sa vision artistique particulière, qui se tonifiera au contact des artistes passionnés de peinture moderne dans le Montréal des années 1930.

La décennie au cours de laquelle se confirme la vocation artistique de MacDonald est sans contredit une période dynamique dans la métropole canadienne d'alors. Parmi les artistes chevronnés qui exposent régulièrement, il y a les chefs de file de la peinture moderne montréalaise – les Edwin Holgate, Adrien Hébert, John Lyman, Lilias Torrance Newton, Marian Scott, Goodridge Roberts, Prudence Heward et Philip Surrey. Tous sont d'éminents peintres figuratifs et, par son immersion dans la puissante tradition figurative montréalaise, MacDonald acquiert des principes dont il ne s'écartera jamais. En matière de sujet et de traitement, le fait d'avoir grandi à Montréal aura pour lui des conséquences d'une portée considérable, tant pour son évolution en tant que peintre que sur le plan de l'art qu'il

privilégiera – en fait, cherchera à acquérir – pour la collection de Hamilton. En effet, beaucoup d'artistes montréalais des années 1930, peu intéressés par les paysages sauvages célébrés par le Groupe des Sept de Toronto (1920–1932), préfèrent peindre leur environnement immédiat et les gens qui l'habitent. Le milieu urbain, la figure humaine et le portrait deviennent des thèmes centraux et récurrents[29]. MacDonald, en homme de son temps, commence très tôt à utiliser ce vocabulaire. Toute sa vie, il aura une prédilection pour les portraits et les études de personnages, qui sont pour lui une source de défis constants et d'inépuisables possibilités.

Tout au long des années 1930, MacDonald expose régulièrement à Montréal, ce qui dénote une certaine ambition et certainement une pratique quotidienne de l'art. Le jeune peintre de vingt ans fait ses débuts au Salon du printemps de l'Art Association of Montreal en 1929 et y expose chaque année jusqu'en 1938. Il expose aussi avec l'Académie royale des arts du Canada[30] lorsque celle-ci tient ses expositions à Montréal (1931, 1933, 1935, 1937) et participe avec les membres de l'Académie à *Canadian Art*, organisée sous la direction de la Galerie nationale du Canada (aujourd'hui le Musée des beaux-arts du Canada) et présentée à l'Exposition universelle de New York en 1939. MacDonald ne se contente pas de ces expositions collectives et cherche des occasions de montrer au public une plus grande partie de sa production; il y parvient grâce à l'Arts Club de Montréal, où il expose avec Leslie Smith en 1932 et seul en 1935.

À l'Arts Club, cerclé privé pour hommes fondé en 1912 et ouvert l'année suivante par l'élite culturelle de la ville, MacDonald trouve une « confrérie » artistique dont font partie plusieurs de ses amis et collègues de peinture. Sa candidature est proposée le 11 octobre 1937 par Leslie Smith et James Crockart, et appuyée par Robert Pilot et Adrien Hébert[31]. Pilot, avec qui il partage un atelier dans les années 1930, est l'un de ses amis les plus intimes et il jouera un rôle important dans l'enrichissement de la collection de l'AGH après l'arrivée de MacDonald à Hamilton. David Morrice (neveu du peintre James Wilson Morrice), dont la demande d'adhésion parvient à l'Arts Club dix jours seulement après celle de MacDonald, est un autre ami avec qui il restera lié après son départ de Montréal et qui, avec sa tante Margaret Rousseaux, sera en grande partie responsable de l'apport d'œuvres de J. W. Morrice à l'AGH (y compris les nos de cat. 13, 26 et 31). Mais, outre la camaraderie et le réseau social qu'il apporte, le Club permet à MacDonald de participer à un grand nombre d'expositions que, pendant un certain temps, il contribue à organiser. En novembre 1946, par exemple, MacDonald fait partie du comité des expositions du Club, avec Pilot (président), Smith, Hébert et Morrice[32].

Deux membres de l'Arts Club en particulier, Adrien Hébert et Edwin Holgate, semblent avoir donné à MacDonald des moyens de s'affranchir des contraintes tout en conservant la forme et la structure essentielles à sa pratique picturale. Un nu de 1937 (fig. 5) dénote l'influence de Holgate, dans la construction de la forme par plans de couleur et l'importance accordée à l'unité structurelle de l'ensemble. Dans le domaine de la forme et de la composition cependant, ce sont les toiles de Hébert qui sont pour MacDonald le modèle le plus intéressant. Le traitement spatial des intérieurs s'appuie sur des stratégies visuelles qui deviendront, pour lui, capitales. Et, bien que MacDonald s'essaie durant les années 1930 à une manière plus libre où prédominent les effets de matière, c'est une petite toile très réussie intitulée *Une heure du matin* (1936, fig. 6) – dont il retravaillera le sujet en 1956 (cat. 86) – qui le montre dans ce qu'il a de plus typique. Dans ce tableau direct, à la composition serrée, le traitement tout en nuances et les

couleurs sourdes créent une ambiance feutrée. Ici, la maîtrise formelle et chromatique accentue l'effet atmosphérique. L'intérêt primordial que MacDonald accorde à la structure des choses, à la construction méthodique des formes et des masses, est évident. Cette œuvre évocatrice traduit bien son souci premier qui est d'établir un cadre visuel efficace pour raconter ses histoires. L'impression de détachement et d'anonymat, la relation de l'individu avec son environnement, témoignent de cette volonté de comprendre la condition humaine qui ne le quittera jamais. Que ce soit dans ses portraits et ses nus, fruits d'une observation attentive, ou dans ses scènes urbaines, en apparence plus froides, MacDonald produit, par l'objectivité soutenue doublée d'une tranquille introspection, des toiles à la fois intimes et universelles.

On a rattaché cet aspect de la peinture de MacDonald aux œuvres des réalistes américains[33], plus particulièrement celles des membres de l'Ashcan School et d'Edward Hopper. Les fascinants et mélancoliques nocturnes de Hopper s'accordaient particulièrement bien à la sensibilité de MacDonald. Point n'est besoin de chercher plus loin que son *Drugstore* de 1965 (fig. 7) et de le comparer à l'œuvre du même titre peinte par Hopper en 1927 (fig. 8) – que MacDonald inclurait en 1961 dans l'exposition *American Realists* à Hamilton – pour reconnaître tout ce que l'artiste doit à son collègue étatsunien[34]. Cette tradition essentiellement américaine a également trouvé des échos à Montréal, surtout dans les scènes urbaines de Philip Surrey (voir cat. 87).

MacDonald quitte Montréal pour servir dans l'armée durant la Deuxième Guerre mondiale. Enrôlé en mars 1941, il est envoyé en Angleterre en août, avec le grade de sergent. Il est nommé artiste de guerre en mai 1944 et passe la plus grande partie des mois d'hostilités qui restent en Italie[35]. Outre-mer se consolident plusieurs des relations qu'il maintiendra à son retour au Canada, notamment avec les artistes Charles Comfort and Will Ogilvie.

On comprend, en considérant la jeunesse de T. R. MacDonald et son évolution comme artiste, à quel point sa vision esthétique, tant comme peintre que comme collectionneur, a été déterminante pour l'AGH durant son mandat à la direction de cette institution. Mais un autre aspect tout aussi important de ces années de formation aura une incidence sur la collection : le riche réseau d'artistes-collègues qu'il a développé et qu'il continuera d'entretenir à Hamilton. Comme nous le verrons, c'est en grande partie grâce aux relations de MacDonald à Montréal et aux artistes qu'il appelait ses amis que l'AGH a acquis bon nombre de ses plus précieuses toiles.

## Cinquante-deux marches

> Il est tout à fait inutile d'insister sur le fait que l'actuel immeuble [du musée] est vétuste et menace ruine, sinon pour dire que c'est une honte dans une ville où la culture parmi les gens de toutes conditions ne cesse de progresser[36].
>
> E. Howard Beynon, vice-président,
> The Art Club of Hamilton, décembre 1946

Quand T. R. MacDonald se présente au travail le 12 novembre 1947 et gravit les infâmes cinquante-deux marches menant au deuxième étage du Public Health Building (l'ancienne bibliothèque municipale) où loge le musée, les lieux n'ont absolument rien d'inspirant. Les salles sont dans un état de délabrement avancé et elles ont grandement besoin de réparations et d'un sérieux remodelage. Bien sûr, la situation à Hamilton n'est pas unique : d'autres directeurs de musée au Canada ont connu des débuts passablement consternants. L'arrivée d'Eric Brown à la Galerie nationale, par exemple, a été tout aussi mémorable.

« Quand Eric Brown arriva à Ottawa en 1910 comme conservateur de la Galerie nationale du Canada, cette institution, bien qu'elle existât depuis trente ans, occupait encore un petit espace miteux au-dessus de la salle d'exposition du ministère des Pêches, sur la rue O'Connor. Eric adorait raconter que, le premier jour, un petit garçon avait passé la tête par l'embrasure de la porte et lui avait lancé, "Hé, m'sieur, elle est où, la baleine ? "[37] » Beaucoup d'institutions culturelles canadiennes ont continué de croupir jusqu'à la fin de la Seconde Guerre mondiale. En 1950, la situation de la Galerie nationale ne se sera guère améliorée : ce musée occupera toujours des locaux temporaires et son personnel professionnel ne comptera que quatre employés[38]. L'arrivée de T. R. MacDonald à Hamilton ressemble à celle, à peu près contemporaine, de George Swinton comme conservateur du Saskatoon Art Centre[39]. Dans une lettre à son vieil ami « Mac », Swinton raconte sur un ton engageant sa première journée de travail : « Je suis arrivé en haut et me suis trouvé dans une situation indescriptible. [...] J'étais au seuil d'une nouvelle carrière – et j'ai dû tout de suite me mettre ... à nettoyer. [...] Je pouvais commencer à bâtir, de toutes pièces. Malheureusement, j'ai découvert que, tant sur le plan financier que sur le plan artistique, les ressources étaient – c'est le moins qu'on puisse dire – rares et extrêmement précaires[40]. »

Naturellement, les circonstances varient d'une ville à une autre et d'un établissement à un autre, mais seules quelques villes canadiennes – Montréal, Québec, Toronto et Vancouver – peuvent se vanter de conserver et de présenter leurs œuvres d'art dans des salles expressément conçues à cette fin. La plupart des institutions doivent s'accommoder de locaux de fortune, mal équipés, qui ne sont évidemment ni à l'épreuve du feu ni climatisés. La Winnipeg Art Gallery, fondée en 1912 (soit deux ans seulement avant l'AGH) – et donc l'un des plus anciens musées du pays – loge dans l'immeuble de l'Auditorium municipal depuis 1932 et y restera jusqu'en 1971. L'Edmonton Museum of Art occupe des locaux dans l'Edmonton Motors Building depuis 1945; il s'installera à Secord House en 1955 et changera officiellement de nom pour devenir l'Edmonton Art Gallery l'année suivante[41].

Après la guerre, toutefois, les programmes de reconstruction facilitent la réalisation de projets culturels et il ne fait aucun doute que cette période est propice à un enrichissement plus rapide des collections en Ontario. Le nouveau London Public Library and Art Museum (aujourd'hui Museum London) a ouvert ses portes dans l'édifice Elsie Perrin Williams en octobre 1940[42], et la Willistead Art Gallery (aujourd'hui l'Art Gallery of Windsor) a été constituée en société en 1944; les deux musées commencent leur ascension à la fin des années 1940. Sous la direction de Clare Bice et de Kenneth Saltmarche respectivement, ils se mettent sérieusement à planifier des acquisitions et à rassembler des œuvres dans des galeries bien aménagées. Comme MacDonald, ces deux hommes qui sont aussi des artistes consacreront leur carrière à leurs musées respectifs et les développeront par une programmation dynamique et un enrichissement soutenu des collections. C'est à cause de leur dévouement à un lieu et à une entreprise que l'on en viendra à les identifier à leur musée. En coulant leur institution et ses collections dans le moule de leur choix, ces hommes – Bice à London de 1940 à 1972, Saltmarche à Windsor de 1946 à 1985, et MacDonald à Hamilton de 1947 à 1973 – deviendront synonymes de leur musée.

Si déçu qu'il soit par son nouvel environnement, MacDonald ne renonce pas à remplir sa mission. En fait, avec trois employés dont une secrétaire et un technicien qui était aussi homme à tout faire, il s'attaque avec ferveur à ce qu'il doit considérer alors comme quelque chose de remarquablement prometteur.

Il commence à toute allure, redéfinit le programme d'expositions et d'activités, et fait part de son ambition d'enrichir la collection. Dans sa première entrevue avec *The Hamilton Spectator*, il explique : « Nous faisons de notre mieux avec les piètres installations dont nous disposons actuellement et nous espérons bientôt avoir un endroit plus moderne et une collection substantielle[43]. » L'auteur de l'article ajoute que MacDonald projette de tenir des expositions mensuelles, en commençant par une exposition de dix-sept peintures de Randolph Hewton[44] qu'il a rapportées de l'Arts Club de Montréal (fig. 9)[45]. Dès le début de son mandat, MacDonald sait ce qu'il veut et comment y parvenir : mettre au point un programme d'expositions bien rempli (en tablant sur ses relations montréalaises) afin de bâtir une collection de valeur. Pour MacDonald, c'est l'objectif qui importe, et les expositions sont dans une large mesure un moyen d'atteindre cet objectif. Dans une allocution présentée aux membres du musée en mars 1959, il expliquera : « À mon avis, dans une communauté, rien ne peut remplacer une collection vivante, qui prend de l'ampleur, surtout si on y adjoint de bonnes expositions et, quand c'est possible, des expositions qui ont un lien avec elle. Je pense que le plaisir et les bienfaits des expositions disparaissent quand il n'y a pas de point de référence, et une collection permanente est un point de référence[46]. » MacDonald ne perd pas de temps; en moins de deux mois, il achète son premier tableau pour Hamilton – *Chute de neige, Les Éboulements*, peint par Albert Robinson en 1926 – après avoir convaincu le conseil d'administration d'affecter à cet achat le peu d'argent qu'il a en banque[47]. Très vite, MacDonald a compris qu'il doit montrer des œuvres, et le plus d'œuvres possible, pour que les gens les *voient*, s'il veut à la fois recruter un public pour le musée et développer un goût pour les collections d'œuvres d'art dans la ville. Il réussit promptement les deux.

MacDonald ne met pas beaucoup de temps non plus à forger de bonnes relations avec l'un des plus importants mécènes du Canada de l'époque. En février 1948, il se rend à Ottawa dans le but précis de rencontrer Harry Stevenson Southam, éditeur du *Citizen* et président du conseil d'administration de la Galerie nationale du Canada, qui a grandi à Hamilton. Le jeune conservateur obtient quatre peintures pour l'AGH, dont le spectaculaire *Icebergs et montagnes, Groenland* (v. 1930, cat. 62) de Lawren Harris, qui arrive à Hamilton la semaine suivante. Peu après cette visite, le directeur de la Galerie nationale, H. O. McCurry, lui écrit : « J'espère que vos gens à Hamilton ont été bien impressionnés par le succès de votre expédition et vous laisseront revenir encore[48]. » Cette association bénéfique et amicale se maintiendra durant toute la vie de Southam. Celui-ci donnera encore treize œuvres canadiennes et européennes au musée de sa ville natale et en léguera vingt-deux autres à sa mort en 1954.

MacDonald fixe tout de suite le rythme de son programme d'expositions et en donne le ton. Moins de trois mois après son arrivée à Hamilton, il a déjà organisé une grande exposition regroupant des peintures d'artistes de Toronto et de Montréal, qui permet de comparer ces deux importantes écoles. Celle-ci est accueillie avec enthousiasme, et l'on estime qu'elle augure bien de la suite. Un critique commente : « C'est en grande partie à T. R. MacDonald, conservateur de la galerie d'art de Hamilton [...] où l'exposition a lieu, que nous devons d'avoir réuni les œuvres qui composent le plus bel assemblage du genre présenté à Hamilton depuis des années[49]. » La formule est gagnante – pour le musée, ses mécènes et les artistes – et elle servira de modèle à ce qui deviendra un événement annuel à l'Art Gallery of Hamilton : le Salon d'hiver.

## Donner le ton : le Salon d'hiver, 1948–1973

La première initiative à long terme de MacDonald est de mettre sur pied un Salon d'hiver, exposition d'œuvres prêtées qui se tiendra chaque année en décembre de 1948 à 1955, puis en février jusqu'en 1973, cette période coïncidant presque exactement avec celle où il exercera sa charge à Hamilton. MacDonald fonde beaucoup d'espoirs sur cette exposition avec jury; il veut fournir aux artistes un autre endroit où exposer et, surtout, assembler des œuvres de qualité, susceptibles d'être acquises par l'AGH. En 1965, il résumera ainsi son projet initial dans une lettre à William Withrow, directeur de l'Art Gallery of Toronto : « J'avais à l'esprit, je suppose, l'ancien Salon du printemps de Montréal qui, avant la guerre, offrait à quiconque ayant quelque aptitude, ou presque, la possibilité d'exposer ses œuvres avec des artistes établis. Je pense que ce salon remplissait une fonction très utile et j'espère que le nôtre, à sa manière, remplit cette fonction[50]. » Le Salon d'hiver remplit en effet cette fonction, rassemblant en un même endroit des artistes amateurs et professionnels.

Mais le Salon d'hiver a une portée plus considérable encore. Il est à vrai dire le premier signe de la maturation artistique de la ville et de son musée, une maturation provoquée par la vision qu'apporte avec lui T. R. MacDonald. L'initiative, qui suscite la fierté des citoyens de Hamilton, est applaudie dans la presse locale. *The Hamilton Spectator* annonce le premier Salon d'hiver avec la manchette « Une exposition qui fera date[51] ». Et elle fait date. Même si l'auteur (anonyme) de l'article exagère un peu, le Salon marque certainement un tournant dans la vie du musée : « Du marasme dans lequel elle se trouvait il y a seulement un an, la galerie d'art municipale s'est sortie et elle a fait des progrès tels qu'elle peut maintenant tenir sa propre exposition indépendante. Le Premier Salon d'hiver de l'Art Gallery of Hamilton ouvre ses portes dans quelques jours[52]. »

Le premier Salon d'hiver est assez représentatif des salons suivants. Tous les ans, les citoyens de Hamilton pourront voir des œuvres qui, sans être d'avant-garde, constituent un bon échantillonnage de la peinture (à l'huile et à l'aquarelle), de la gravure et de la sculpture canadiennes. Le Salon d'hiver, qui présente en moyenne une centaine d'œuvres, privilégiera systématiquement la production des artistes de Hamilton, de Montréal et de Toronto. Parmi les participants réguliers de Montréal dans les premières années, on trouve Adrien Hébert, Philip Surrey, Ghitta Caiserman, Robert Pilot, Kathleen Morris, Goodridge Roberts, Frederick Taylor, Louis Muhlstock et Anne Savage[53]. Les habitués torontois et ontariens sont Charles Comfort, A. Y. Jackson, Jack Bush, Paraskeva Clark, Carl Schaefer, Peter Haworth, Bobs Cogill Haworth, A.J. Casson, George Pepper, Kathleen Daly Pepper, Rowley Murphy et John Alfsen. Hamilton est souvent représentée par la sculpteure Elizabeth Bradford Holbrook, Hortense Mattice Gordon, Ray Mead et d'autres membres des Contemporary Artists of Hamilton[54]. Il y a sans contredit une cohérence et une continuité dans ces expositions annuelles, tant sur le plan des artistes et des jurés que de l'esthétique, surtout dans les années 1950. La majorité des habitués sont des artistes figuratifs[55], et pour ceux d'entre eux qui en sont les piliers et y exposent durant plus de dix ans, ces salons servent à légitimer leur production auprès du public de Hamilton.

Pour former les jurys, on fait dès le début appel à des artistes réputés qui sont, à quelques exceptions près, des peintres figuratifs (fig. 10)[56] et on mêle habituellement les célébrités locales, régionales et nationales. Le jury du premier Salon, par exemple, est composé de A. Y. Jackson, Charles Comfort et Hortense Gordon. Feront plus tard partie des jurys Carl Schaefer

(1949), Will Ogilvie (1950, 1954, 1965), Kenneth Saltmarche (1951, 1959), Clare Bice (1949, 1957, 1962), Jack Nichols (1952, 1954), George Pepper (1951, 1958), Yvonne McKague Housser (1955), Jock MacDonald (1958), Philip Surrey (1960), Goodridge Roberts (1963) et Robert Pilot (1964). Grâce à la production de catalogues et aux fonds amassés à Hamilton pour offrir des œuvres au musée, le Salon d'hiver devient vite un *événement*. La fréquentation augmente sans cesse, les gens de Hamilton revenant chaque année en plus grand nombre pour admirer ce vaste ensemble de peintures contemporaines – souvent pour le simple plaisir, souvent pour acheter. Le Salon d'hiver est une précieuse source d'acquisitions pour l'AGH. Tous les ans, on sollicite de l'argent d'un mécène ou d'une entreprise locale pour acheter l'œuvre primée, choisie par le comité d'acquisitions. Plusieurs tableaux importants entrent dans la collection de cette manière : *Première neige* (1947, cat. 82) d'A.J. Casson en 1952; le seul Lilias Torrance Newton que l'AGH possède, *Keith MacIver* (s.d., fig. 35) en 1955; *Monarque iridescent* (1957) de Jock MacDonald en 1960; *Femmes sur la plage* (1948, fig. 36) de John Lyman en 1961; *Variation sur un thème de Poussin* (1962, fig. 11) de Philip Surrey en 1963; ainsi que *Pluie sur la fenêtre* (s.d.) de Paraskeva Clark et *Nu allongé no 2* (1961) de Goodridge Roberts, tous deux en 1964.

La plus célèbre œuvre primée demeure sans nul doute *Cheval et train* (1954, cat. 85) d'Alex Colville, achetée au Salon de 1957 (dont le jury est composé de Charles Comfort, Clare Bice et Henry Walter Smith). Ce choix n'est pas populaire à l'époque, du moins auprès d'une commentatrice (fig. 12), Mary Mason, qui entame sa critique de l'exposition en s'interrogeant sur la pertinence de cet achat : « Il y a certes de très belles peintures au Salon d'hiver de l'Art Gallery of Hamilton, mais l'œuvre primée n'en fait hélas pas partie[57]. » Comme le démontre Joyce Zemans ailleurs dans le présent catalogue, *Cheval et train* accédera bientôt au statut d'icône, mais à l'époque il constitue, assez curieusement, un choix plutôt provocant. Que cette peinture ait pu déconcerter, ne serait-ce qu'un peu, la critique témoigne du degré d'acceptation du public, en 1957, à l'égard des formes plus contemporaines d'expression artistique.

## T. R. MacDonald : « Je ne suis pas un joueur. Nous dépensons l'argent des contribuables. »

Le Salon d'hiver nous donne un bon moyen de jauger l'art pendant la période à l'étude. Les œuvres de beaucoup d'artistes qui y exposent dans les années 1950 en sont venues à former la collection d'art contemporain de Hamilton. La majorité de ces artistes travaillent alors dans un style figuratif sans doute déphasé par rapport à l'avant-garde artistique de leur époque. Dans les décennies où le discours artistique porte principalement sur l'abstraction, le programme d'acquisitions de Hamilton demeure résolument figuratif, et le nouveau conservateur est, dès le début, très explicite sur ce point. S'il est prêt à élaborer et même à garantir un programme d'expositions équilibré, où l'art figuratif côtoie un art plus avant-gardiste[58], MacDonald ne cache pas ce qu'il pense de ce dernier. Un an après son arrivée, il met à l'affiche l'exposition la plus « contemporaine » que Hamilton ait jamais vue[59]. Organisée par la Hart House de l'université de Toronto, elle comprend des œuvres de six peintres contemporains de Montréal : Gordon Webber, Jacques de Tonnancour, Albert Dumouchel, Alfred Pellan, Pierre Gauvreau et Goodridge Roberts. À l'exception de Roberts, qui est un bon ami de MacDonald, tous travaillent dans un style abstrait. « Qu'on le veuille ou non, dit MacDonald, cela

existe et c'est très répandu – ce n'est pas limité à quelques excentriques. Remarquez, je ne suis pas prêt à dire que c'est de l'art. Le temps décidera. Si ce n'est pas de l'art, ça ne durera pas[60]. » Cette distance par rapport à l'art non figuratif se manifeste évidemment dans le domaine des acquisitions. Dès le départ, MacDonald estime qu'il doit exercer son rôle de collectionneur pour un établissement public avec prudence. Cela ne veut pas dire qu'il est anti-moderne; il discute souvent de peinture abstraite avec son associé et ami Paul Duval, et s'intéresse particulièrement au travail de Borduas[61]. Cependant, MacDonald est convaincu qu'une collection publique doit se bâtir autour d'un noyau d'œuvres historiques réalisées par des artistes réputés, qui ont fait leurs preuves. C'est ainsi qu'il voit son mandat et jamais il n'en démordra. Évaluant rétrospectivement ses méthodes au moment de sa retraite en 1973, MacDonald dira : « J'ai eu beaucoup de plaisir ici compte tenu de la mentalité conservatrice. Mais je ne suis pas un joueur. Nous dépensons l'argent des contribuables. Un musée comme le nôtre n'a pas à parier sur des artistes. À mon avis, c'est aux collectionneurs de le faire[62]. » MacDonald demeurera fidèle à cette conception de son rôle et, au fil de ses vingt-six années à Hamilton, seulement une poignée d'œuvres abstraites seront acquises pour la collection[63]. Étant donné que cette période est également celle de l'essor et du règne de l'art abstrait au Canada, ce fait constitue la preuve irréfutable d'un parti pris.

On s'en souviendra, les années 1950 sont celles d'un débat musclé entre les défenseurs de l'art figuratif et les tenants de l'abstrait. Partout au pays, le « nouvel » art et sa légitimité, de même que sa pertinence aux yeux du public, font couler beaucoup d'encre[64]. Hamilton ne fait pas exception. Dès le début, l'art abstrait est diversement accueilli, et cet accueil va de l'acceptation mitigée à la condamnation pure et simple, en passant par l'inquiétude perplexe. Les quotidiens de la ville expriment ce malaise en même temps qu'ils le provoquent. Très tôt, ils donnent le ton. Dans sa critique de l'exposition des peintres montréalais tenue en 1948, Eric Williams du *Hamilton Spectator* pose d'entrée de jeu la question suivante : « "Mais à quoi diable veut-on en venir ?" Voilà ce que se demandera, inquiet, plus d'un Hamiltonien qui visitera le musée au cours des prochaines semaines. Car la grande exposition en cours comprend surtout des études abstraites. » Et bien que, dans l'ensemble, il essaie de jeter un regard impartial sur les œuvres, et traiter surtout de leurs qualités formelles et décoratives, Williams clôt son argument de la même manière qu'il l'a commencé : « Ce groupe de peintures est le fruit d'une hypersensibilité à un seul aspect de l'art, qui va jusqu'à effacer tous les autres. Nous doutons qu'il atteigne à une véritable grandeur[65]. »

Les arguments sur l'essor et la valeur de l'art abstrait demeurent, malgré tout, assez primaires, certains auteurs se livrant à des attaques en règle tandis que d'autres, indécis, hésitent à condamner. Dans un pays où l'éducation artistique en est encore à ses balbutiements, il est normal que le public soit déconcerté. Par ailleurs, en exprimant ouvertement ses doutes, MacDonald ne contribue ni à susciter l'intérêt du public pour l'abstraction, ni à lui en démontrer le bien-fondé. De plus, quoiqu'il tienne à présenter des expositions d'art abstrait, MacDonald ne change pas d'avis en ce qui a trait aux acquisitions. Il le réaffirmera devant les membres de l'AGH en 1959, après une décennie passée à enrichir la collection :

On me demande de temps à autre : A) pourquoi le musée ne se concentre-t-il pas exclusivement sur les artistes contemporains dont il peut acheter les œuvres à bon prix, et B) pourquoi, au moins, n'achète-il pas plus d'œuvres contemporaines ? Pour répondre au nom du comité d'acquisitions, je dirai que nous avons essayé de faire deux choses. D'abord, veiller à ce que le musée possède une collection aussi belle et représentative que possible d'art canadien de toutes les périodes. [...] Nous essayons d'acquérir ces œuvres anciennes pendant qu'il en est encore temps. La concurrence est féroce depuis que le nombre de musées et de collectionneurs privés augmente. Il y a beaucoup d'artistes dont les œuvres, si nous ne les achetons pas maintenant ou dans un proche avenir, seront bientôt impossibles à trouver, même à des prix beaucoup plus élevés que ceux qui prévalent aujourd'hui. Je pense qu'il faut garder à l'esprit que nous dépensons l'argent des contribuables et je pense qu'il est de notre devoir de l'investir le plus sûrement et le plus sagement possible. Je ne suis pas prêt à dire que la première obligation d'un musée est de soutenir les jeunes artistes. Je me demande si cette tâche n'incombe pas plutôt au collectionneur privé qui, en achetant leurs œuvres pour sa collection personnelle ou pour les offrir à des musées, permettrait ainsi aux jeunes artistes d'être reconnus et de recevoir l'encouragement dont ils ont tant besoin[66].

Essentiellement, ce que MacDonald a entrepris de faire, c'est d'instaurer des stratégies en vue de sensibiliser le public à l'art, de faire naître l'enthousiasme et de développer un réseau de collectionneurs. Le Salon d'hiver, en tant que forme d'éducation visuelle sur la peinture contemporaine figurative du Canada, remplit en partie cette fonction. Il met périodiquement au menu des citoyens de Hamilton un assortiment d'œuvres de qualité, provenant au début de l'Ontario et du Québec et, par la suite, de partout au pays. Il donne au public le goût des artistes qui y exposent. Dès ce stade se dessine ce qui deviendra une approche remarquablement cohérente et graduelle, qui bâtit sur elle-même en rappelant et en confirmant l'importance de certains artistes et d'une certaine esthétique. Ainsi se tissent, assez tôt pendant le mandat de MacDonald, les divers fils – expositions, acquisitions, conférences, campagnes de financement – d'une stratégie bien définie qui deviendra, avec le temps, de plus en plus claire. Quoiqu'on puisse aujourd'hui soutenir que cette façon de faire, partiale, ne favorisait ni l'artiste d'avant-garde ni le discours de l'art contemporain, elle bâtissait néanmoins sur le savoir et les relations de MacDonald. Et si elle était discutable à l'époque, il ne fait aucun doute maintenant que cette stratégie a remarquablement bien servi la collection de Hamilton[67].

## Une communauté se mobilise

Si MacDonald demeure l'âme dirigeante du musée, les infatigables travailleuses du Comité féminin (renommé Comité des bénévoles en 1977) se chargent, pour leur part, de la conception, de l'élaboration et de l'exécution de nombreux projets. Le Salon d'hiver est la première d'une série de stratégies mises en branle par MacDonald, mais quand vient le temps d'organiser des activités connexes pour attirer un plus vaste public au musée, c'est sur ce comité que l'on compte. Le Comité féminin (qui porte d'abord et pour une très courte période le nom de Women's Auxiliary) est formé en mars 1950 à la demande du conseil d'administration pour s'occuper de la musique des concerts du dimanche après-midi au musée[68]. C'est la seule fonction qu'on lui imagine alors, et personne ne soupçonne quel rôle crucial il jouera, à tant d'égards, dans la réussite du musée. Des comités semblables existent déjà dans plusieurs autres institutions canadiennes – l'Art Gallery of Toronto, le London Public Library and

Art Museum, la Winnipeg Art Gallery –, reflet de la nouvelle dynamique sociale et culturelle de l'après-guerre, où de nombreuses femmes instruites ayant du temps à elles et le désir de participer à l'épanouissement de leur communauté consacrent leurs énergies à diverses causes. À une époque où les musées emploient un personnel professionnel minime, la contribution de ces femmes se révèle indispensable[69].

Le premier mandat du Comité féminin est clair : « Les Auxiliaires auront deux grands objectifs : susciter un nouvel intérêt pour le musée en recrutant des membres, et lancer des projets en vue d'amasser des fonds. Les Auxiliaires se chargeront également de la réception et des rafraîchissements lors des vernissages, de même qu'en toute autre occasion où le conseil d'administration leur demandera de le faire[70]. » Les initiatives se succèdent et, très vite, on reconnaît l'importance de ce groupe dans l'organisation. Particulièrement doué pour mobiliser et motiver les gens, le Comité féminin compte déjà, trois mois après sa formation, soixante-dix membres. Et les projets commencent, nombreux. Le Comité féminin réussira le tour de force de générer des revenus pour le musée tout en élargissant et en instruisant le public intéressé aux arts à Hamilton. Au début, il se concentre sur la collecte de fonds pour la construction d'un nouvel édifice – édifice où l'Art Gallery of Hamilton s'installera en décembre 1953 (fig. 13)[71].

Le Comité féminin se met tout de suite au travail et, en six mois seulement, organise une exposition fort originale, le *Mile of Pictures* (fig. 14). À la suggestion de M^me C. W. Murphy (belle-sœur de l'artiste Rowley Murphy), qui a assisté à un événement semblable dans la capitale française[72], et sous la direction de sa première présidente, Janet Barber, le Comité se lance dans cet ambitieux projet qui consiste à demander à tous les propriétaires des magasins situés le long des deux grandes artères commerciales de la ville[73] d'exposer des œuvres d'art dans leurs vitrines. Il parvient à obtenir toutes les vitrines, sauf trois. L'exposition se déroule pendant une semaine à la fin de septembre 1950. On y vend les œuvres à prix abordable – jamais plus que cent dollars – et cinquante pour cent des profits sont versés au fonds pour la construction du nouveau musée. Le Comité s'est adressé à plus de quatre-vingt-dix artistes du Canada et il a reçu plus d'une centaine de peintures et sculptures. Des artistes de réputation locale et nationale ont accepté de participer, si bien que les nouveaux collectionneurs de Hamilton peuvent se procurer, pour une somme raisonnable, des créations de gens comme Arthur Lismer, A. Y. Jackson, Charles Comfort, Goodridge Roberts, Fritz Brandtner, Carl Schaefer ou Paraskeva Clark. L'événement, que le Comité féminin a annoncé de manière experte à la radio et dans la presse locale[74], de même que dans le *Globe and Mail* de Toronto, suscite énormément d'enthousiasme. C'est le genre de manifestation que les citoyens de Hamilton ne peuvent pas refuser d'appuyer. Depuis des décennies, en effet, on leur rappelle sans cesse la nécessité de construire un nouveau musée; depuis des décennies, on parle de ramasser de l'argent pour ce faire, et enfin, il se passe quelque chose de concret, qui servira en outre l'ensemble de la communauté. Quelque mois auparavant, Pearl McCarthy du *Globe and Mail* a astucieusement annoncé dans sa chronique :

> Hamilton nous réserve une surprise pour l'automne, quelque chose de vraiment nouveau en Ontario. Un comité qui transcende tous les groupes d'intérêts [...] organise une gigantesque vente de tableaux peints par des artistes canadiens. La rumeur [...] veut que ces tableaux soient exposés dans plusieurs magasins. [...] Voilà qui est très astucieux et aussi très utile. Hamilton a besoin d'un musée et d'une politique

artistique, mais les politiques publiques découlent d'enthousiasmes privés, et rien ne nous incite davantage à nous intéresser à l'art que d'acheter, avec nos propres économies, un tableau ou une petite sculpture. Théorie devient passion[75].

Et donc, le Comité féminin commence à mettre la théorie en pratique, à participer à ce patient processus par lequel se bâtit un réseau d'amateurs d'art et de collectionneurs. Ce premier événement apporte l'art dans les rues et dans la vie des gens, expose ceux-ci au travail des artistes canadiens contemporains et leur permet de contribuer, personnellement et de manière positive, au financement du futur édifice. Plus de mille neuf cents dollars sont recueillis, et la moitié des œuvres, vendues. Certaines d'entre elles reviendront plus tard au musée et entreront dans la collection permanente, preuve que l'institution a vu juste en cherchant à développer un réseau de collectionneurs qui lui feront éventuellement don de leurs œuvres[76].

Le Comité féminin prend une autre initiative qui se révélera tout aussi heureuse, la Vente d'œuvres d'art, dont la première a lieu en 1954 et qui se répétera en 1957, 1959 et 1961[77]. Cette exposition à laquelle on est admis sur invitation propose, comme le Salon d'hiver, des œuvres de qualité à des collectionneurs potentiels; elle s'inscrit en même temps dans la stratégie visant à sensibiliser le public à la production des artistes contemporains établis. Mais c'est en 1955 que le Comité féminin lance l'un de ses projets à caractère civique les plus impressionnants : la location d'œuvres d'art (fig. 15). Les musées de Vancouver et de London ont déjà des programmes de ce genre et l'on estime à Hamilton qu'une telle formule servira les objectifs de l'AGH. Grâce au programme de location plus qu'à tout autre, des œuvres d'art originales entreront dans les foyers. En vivant avec elles, les citoyens apprendront à apprécier l'art et seront peut-être tentés de devenir collectionneurs. Même si l'un des principaux objectifs demeure d'amasser des fonds, les premières organisatrices du programme de location entretiennent des aspirations beaucoup plus nobles. On reconnaîtra plus tard : « Le projet doit son véritable succès à l'importance accordée à l'esthétique et à l'éducation du public. [...] Les femmes qui en furent responsables à ses débuts étaient déterminées à ne montrer que le meilleur de la production des artistes canadiens établis et elles étaient certaines qu'une telle façon de procéder ne pouvait qu'être bénéfique tant pour les locataires des œuvres que pour les artistes eux-mêmes[78]. »

Pour s'assurer de la qualité, le Comité féminin consulte MacDonald dans la préparation de la liste des artistes invités à participer. MacDonald ne cesse en effet de jouer un rôle consultatif et il aura toujours énormément d'influence sur toutes les questions d'intérêt artistique. Ruth McCuaig, qui est à la fois l'une des plus grandes bienfaitrices du musée et l'une des premières animatrices du Comité féminin, le confirmera plus tard : « Nous ne voulions rien [mettre en location] que Tom ne jugerait pas digne d'être mis en location. [...] Après un Salon d'hiver ou une Vente d'œuvres d'art, nous lui demandions de faire le tour avec nous et lui posions la question : "Pensez-vous que cette œuvre conviendrait pour le programme de location ?"[79] » Bâtir un réseau de collectionneurs demeure de la plus haute importance pour MacDonald et pour le musée. L'idée est simple et pleine de bon sens : montrer aux citoyens de Hamilton le plus grand nombre possible d'œuvres de qualité et mettre à leur disposition divers moyens de les acquérir.

En dehors de ces programmes et mécanismes mis en place pour la vente, MacDonald agit, discrètement, comme intermédiaire entre divers artistes et les collectionneurs de Hamilton. Étant sans cesse à la recherche d'œuvres pour le musée, il est en contact avec

les artistes, et comme il connaît bien les collections locales, il peut aussi diriger les œuvres vers des foyers susceptibles de les accueillir. Souvent, si on lui propose un tableau que le musée n'a pas les moyens d'acheter, il crée les conditions optimales pour qu'un collectionneur potentiel le voie. Il l'expose dans une des galeries, l'éclaire avantageusement, puis appelle un acheteur potentiel et le lui montre. Beaucoup de peintures sont entrées dans des collections particulières de Hamilton de cette manière, et la communauté en a profité tout autant que les artistes. En 1950, son ami Goodrige Roberts, qui l'approvisionne régulièrement de Montréal, lui écrit : « L'habileté avec laquelle tu transformes mes œuvres en argent m'émerveille et me transporte de joie – et elle arrive à point nommé maintenant que j'ai emménagé dans un appartement non meublé et que je dois me procurer des choses aussi indispensables que des stores, des chaises et un poêle[80]. » Adrien Hébert et Edwin Holgate, deux autres de ses vieux amis de Montréal, trouvent aussi des protecteurs à Hamilton grâce aux bons offices de MacDonald. Après avoir reçu paiement d'un certain nombre de dessins envoyés à Hamilton, Holgate écrit : « Je suis impressionné par la réception des dessins. [...] Merci pour le chèque et l'occasion[81]. » La stratégie de MacDonald est efficace car beaucoup d'œuvres qu'il aide à placer dans des collections particulières reviendront plus tard à la collection permanente de l'AGH. *Village du Québec* (1923, cat. 49) d'Albert Robinson, acquis par M. et M^me David Barber, vraisemblablement pendant le mandat de MacDonald, en est un parfait exemple; donné au musée en 1980, ce tableau est resté chez les Barber jusqu'à son arrivée à l'AGH en 2000.

## T. R. MacDonald : « Obtenir l'argent nécessaire à l'achat de tableaux pour une collection est toujours un problème. Mais quand les gens savent que vous voulez des choses, ils vous aident[82]. »

De la bouche de MacDonald, cela paraît si simple. Mais les apparences sont trompeuses. Modeste, le directeur ne dit rien de toute la détermination et de la persévérance qu'il faut pour enrichir la collection dans les années 1950 et 1960, à une époque où il n'y a ni budget d'acquisitions fixe, ni fonds garantis. Dans de très rares cas, le réseau de collectionneurs qu'il bâtit à Hamilton sert directement les objectifs d'acquisition du musée. Ruth et John McCuaig, par exemple, qui ont une confiance absolue en son jugement et en sa compétence, lui permettent de constituer une belle collection d'art américain avant que les œuvres des membres de l'Aschan School et des réalistes sociales ne deviennent inabordables. Américaine de naissance, Ruth McCuaig considère cette association tout indiquée et, avec son mari, elle finance un grand nombre d'excursions que MacDonald fait régulièrement à New York pour sélectionner des œuvres[83]. L'AGH doit à la fidélité de ces philanthropes plusieurs toiles majeures, dont *Stein devant une presse* (1906, cat. 16) de John Sloan, *Grand Windsor Hotel* (1939, fig. 16) de Reginald Marsh et *Portrait de Meredith Hare* (1921, fig. 17) de George Bellows. Bien sûr, d'autres personnes défendent elles aussi la cause américaine, notamment Herman Levy, M^me Murray Proctor, M^me F. F. Dalley, M^me C. H. Stearn et M^me C. W. Robinson, qui font toutes partie de la « famille » de l'AGH et (sauf Levy, évidemment) du Comité féminin. Après la grande exposition des réalistes américains organisée par MacDonald en 1961[84], la stratégie visant à se servir des expositions pour faire connaître au public une école particulière de peinture et

constituer ainsi un cercle d'amateurs de cette école a certainement persuadé une poignée de mécènes loyaux à l'AGH d'aider MacDonald à diversifier les avoirs du musée. Et cela se fait rapidement. Dès l'été 1968, MacDonald a acquis suffisamment de bons tableaux américains pour que le critique Paul Duval le souligne dans le *Hamilton Spectator* : « Que Hamilton possède un aussi magnifique échantillon de tableaux américains est plus qu'un geste culturel de bonne volonté internationale. Ce fait témoigne aussi de la bonne volonté d'un groupe de citoyens de Hamilton déterminés à ce que le musée ne soit pas de reste dans certains domaines fondamentaux de l'art. Pratiquement toutes les peintures américaines ont été données, sur les conseils du directeur T. R. MacDonald, par des particuliers qui appuient l'AGH[85]. » MacDonald voit chez les réalistes américains non seulement des affinités avec sa propre pratique picturale, mais aussi un contexte intéressant pour l'étude de la peinture canadienne : « Je pense qu'en entourant les Canadiens d'Américains, de Britanniques et d'Européens, nous pouvons comprendre où notre art se situe et le mettre en perspective. D'après moi, les Américains sont particulièrement précieux. Nous sommes tous des Nord-Américains et nous partageons, en gros, la même expérience. Pourtant, à la même période, les artistes des États-Unis ont eu une plus grande conscience sociale que les nôtres. De sorte que les deux groupes se complètent harmonieusement[86]. »

Certes, la collection est d'abord et avant tout canadienne. MacDonald a été très clair sur cette question dès le début. Il le rappelle devant les membres de l'AGH en 1959 : « Il semblait tout naturel et souhaitable que notre premier objectif soit de former la meilleure collection possible de peintures, d'estampes, de sculptures et de dessins canadiens[87]. » La même année, toutefois, en discutant de la formulation d'une politique d'acquisition officielle, MacDonald et les membres du conseil d'administration décident de se concentrer sur l'art moderne britannique, en particulier sur les peintres associés au groupe de Camden Town. Cette décision est certainement dictée en partie par des considérations financières, puisque les œuvres de ces peintres sont encore, à l'époque, abordables, mais elle sera aussi une bonne décision muséologique. En mars 1960, le Comité féminin verse l'argent nécessaire pour que le conservateur séjourne deux mois en Europe. MacDonald se rend entre autres à Paris, à Amsterdam, à Rotterdam et à Édimbourg[88], mais il passe aussi beaucoup de temps à Londres et, à son retour, propose à l'AGH d'acquérir quatre œuvres, dont *La chambre* (1908, cat. 18) de Spencer Gore et *Hubby et Marie* (1914, fig. 18) de Walter Sickert. Les fonds provenant du Comité féminin se révéleront par la suite indispensables pour enrichir la collection britannique et permettront, sous l'administration de MacDonald, l'acquisition de plusieurs toiles et sculptures importantes.

L'autre acteur principal dans la constitution des collections tant américaine que britannique est cependant un proche de MacDonald, l'auteur Paul Duval, directeur des pages artistiques au magazine *Saturday Night* de 1944 à 1963. Apprenant que l'International Business Machines Company (IBM) de New York, qui a bâti d'assez grosses collections nationales d'œuvres d'art dans les années 1930, ralentit ses activités d'acquisition, Duval, qui connaît bien ces collections[89], demande à la compagnie ce qu'elle a l'intention d'en faire et se dit intéressé à acheter. En quelques années, il réussit à acquérir de larges portions des collections canadienne et britannique d'IBM[90]. Du fait de son étroite association avec le directeur de l'AGH et de son respect pour la ténacité avec laquelle celui-ci bâtit la collection, Duval donne la priorité à MacDonald dans le choix des œuvres et les lui offre au prix coûtant[91]. Pas moins de sept peintures britanniques

passent ainsi d'IBM à l'AGH, entre autres *L'Arrêt de Villainville* (1939, cat. 75) de Tristram Hillier, *Le rivage Fantôme* (1939, cat. 76) de Paul Nash et *Pastorale, Sussex* (1941, cat. 80) d'Edward Wadsworth[92].

Duval se rend fréquemment à Hamilton où, pendant un certain temps dans les années 1960, il est critique d'art au *Hamilton Spectator*[93]. Il entretient des relations avec plusieurs des collectionneurs les plus en vue de la ville et leur propose souvent des œuvres intéressantes. C'est par son intermédiaire que l'homme d'affaires Roy Cole, par exemple, qui est membre du conseil d'administration et du conseil des gouverneurs du musée pendant des années, ainsi que membre du comité d'acquisitions entre 1968 et 1970, acquiert deux toiles canadiennes majeures, *Village de Yan, Î. R.-C.* (1912, cat. 27) d'Emily Carr et *L'orgue de Barbarie* (1913, cat. 32) de Lawren Harris[94]. Duval a acheté le Carr à IBM en décembre 1961 pour la somme de cent cinquante dollars. Une trentaine d'années après, Cole fera don des deux toiles à l'AGH, consolidant ainsi de manière significative et durable la collection d'art moderne canadien.

Avec le recul, la décision de collectionner l'art moderne britannique et l'art américain du début du XXᵉ siècle paraît fort judicieuse, puisqu'elle a permis à l'AGH de se distinguer de manière tout à fait unique au Canada. Le rapport entre ces écoles et la peinture canadienne était encore inexploré à l'époque, et aucune autre institution régionale de taille moyenne au pays – à l'exception de la Galerie d'art Beaverbrook de Fredericton, issue de la collection d'art moderne britannique de lord Beaverbrook – ne collectionnait activement des œuvres dans ces domaines. En choisissant de compléter son fonds canadien par des œuvres d'écoles étrangères, de diversifier ainsi sa collection et de lui donner plus d'envergure, l'AGH faisait la preuve de sa confiance en soi. Encore petite, mais beaucoup plus ambitieuse, la collection commençait indéniablement à s'affirmer.

## « Il est des nôtres » : le réseau des artistes

C'est surtout dans les perspicaces et astucieux achats d'œuvres d'art que se révèlent le goût et le jugement d'un conservateur. MacDonald a bâti la collection habilement et comme il l'entendait, avec tact et détermination. Le Comité féminin est la seule source sûre de fonds d'acquisitions, et MacDonald a besoin de cet argent pour donner à la collection la forme qu'il souhaite. Mais la participation du Comité féminin s'arrête là : dès le début, il est clair que les décisions sur le choix des œuvres relèvent exclusivement du conservateur/directeur et du comité d'acquisitions[95]. A posteriori, nous pouvons dire que cette façon de faire était essentielle au succès du programme d'achats du musée – et à la qualité de la collection qui en résulte –, parce qu'elle a permis à MacDonald de concrétiser sa vision sans entraves. Cependant, même s'il est tout à fait normal et légitime qu'un conservateur imprime sa vision à une collection permanente, la question des décisions unilatérales a longtemps fait l'objet de débats.

Dans un article du *Canadian Art* paru à l'été de 1950, l'artiste Lawren Harris et le directeur du High Museum of Art d'Atlanta, E. R. Hunter (un Canadien qui a travaillé dans des galeries d'art d'Ottawa, de Toronto et de Montréal), débattent précisément de cette question de savoir si les décisions touchant l'orientation d'une collection doivent relever d'une seule personne ou d'un comité. Harris défend un modèle démocratique, estimant que les musées canadiens doivent être «placés sous la stricte autorité de conseils et de comités composés à la fois de profanes et d'artistes, élus par les membres du musée, et que les bureaux du directeur et du conservateur doivent, en matière

artistique, se plier aux décisions de ces conseils et comités[96].» Hunter réplique : «La sélection par comité résulte presque toujours en compromis, et si le compromis est parfois prudent en politique, en art il est invariablement ennuyeux [...] les collections formées par un seul homme, bien qu'elles soient souvent moins variées, ont habituellement plus d'éclat et contiennent plus de très bonnes peintures que celles qui sont choisies par un comité[97]. » Tous deux s'entendent néanmoins sur un point : si le conservateur/directeur est lui-même peintre, il comprend mieux le processus de création et il est davantage porté à agir de concert avec l'artiste. Bien que MacDonald l'artiste ait travaillé avec un comité d'acquisitions, il est indubitable que sa vision a prévalu. Cela est clair dans la constance des choix et dans la cohésion de l'ensemble. Certains de ses achats les plus prémonitoires confirment la sûreté de son jugement.

Les fonds amassés par le Comité féminin de l'AGH peuvent pour la première fois servir à l'acquisition d'œuvres d'art en 1954 et, avec l'achat cette année-là de *Chuhaldin* (1931, fig. 19) de Charles Comfort, un lien vital est établi. Grâce à la générosité du Comité féminin, le musée s'enrichira de près de quatre cents œuvres, parmi lesquelles on compte plusieurs de ses toiles les plus prisées, par exemple, *Le fruit défendu* (1889, cat. 7) de George Reid, *Une ferme au bord de la voie ferrée, Hanover* (1939, cat. 77) de Carl Schaefer, *Ave Maria* (1906, cat. 15) d'Horatio Walker et, plus particulièrement peut-être, *Halage du bois, Beaupré* (1896, cat. 12) de Maurice Cullen.

La production de Cullen fait d'abord son chemin jusqu'à Hamilton en raison de l'amitié qui unit MacDonald et Robert Pilot, le beau-fils de Cullen, car les deux homme restent en contact étroit après le départ de MacDonald pour cette ville en 1947. Le conservateur démontre qu'il tient à collectionner des œuvres de Cullen en achetant un tableau important, *Cap Diamant* (1909, cat. 21) en avril 1955, avec des fonds légués par le collectionneur de Hamilton et ancien membre du conseil d'administration H. L. Rinn. L'année suivante, Pilot et MacDonald se lancent dans la planification de la rétrospective Cullen – une collaboration de l'AGH, de la Galerie nationale du Canada, de l'Art Gallery of Toronto et du Musée des beaux-arts de Montréal –, rétrospective qui sera mise en tournée en 1956–1957. Ils sont responsables de la sélection des œuvres et Robert Hubbard, alors conservateur en chef à la Galerie nationale, agit comme conseiller. MacDonald et Pilot correspondent régulièrement pendant les mois qui précèdent l'ouverture de l'exposition à l'AGH en novembre 1956. Quand Pilot reçoit dans son atelier *Halage du bois, Beaupré*, remis par Freda Harris (veuve du neveu de l'artiste Robert Harris), il l'offre en premier à MacDonald, vu le rôle que celui-ci a joué dans l'organisation de l'exposition, et certainement par égard aussi pour la collection Cullen que l'AGH commence à monter. En mars 1956, il lui écrit : «Veux-tu le premier choix sur le Cullen de 1896 ? Nettoyé, ce tableau est une merveille. [...] Je ne m'occupe absolument PAS de le vendre, mais j'aimerais bien lui trouver un foyer convenable[98]. » MacDonald lui répond sur-le-champ et, moins de trois mois plus tard, la peinture est dans son bureau, avec une étiquette de prix de neuf cents dollars. Le Comité féminin ne peut pas, à ce moment-là, en financer l'achat, mais MacDonald ne se laisse pas décourager : si tout se passe comme il le veut, la peinture ne quittera pas Hamilton. MacDonald la propose à Janet et David Barber, éminents bienfaiteurs qui sont en train de constituer leur propre collection particulière[99]; au début de juillet, Pilot lui écrit pour savoir si les Barber ont pris une décision[100]. Entretemps, *Halage* reste dans le bureau de MacDonald, qui essaie de trouver un moyen de garder cette toile à Hamilton en la montrant aux mécènes et membres de l'AGH[101]. À l'ouverture de

la rétrospective Cullen, ceux-ci ont la très rare chance de voir les œuvres dans le contexte de la production de l'artiste et d'en évaluer ainsi les mérites. Le 20 décembre 1956, soit quelques jours avant que le tableau ne parte en tournée (et soit sûrement vendu), le Comité féminin se porte une fois de plus au secours du musée[102]. Les dames du Comité ont eu besoin de ces quelques mois pour amasser l'argent, et MacDonald, habile, a réussi à faire patienter tout le monde. C'est ainsi que le musée acheta une de ses œuvres les plus importantes[103] – un des fleurons de sa collection.

Pilot, en bon ami de MacDonald, devient aussi un bon ami du musée et, entre 1950 et 1969, il fait don de plus de quatre-vingts œuvres, dont vingt-huit dessins de Cullen[104]. Les relations personnelles que MacDonald entretient avec plusieurs artistes réputés sont sans doute l'ingrédient le plus important de son succès. Étant artiste lui-même, MacDonald recherche tout naturellement la compagnie des artistes. Paul Duval racontera plus tard combien il « adorait parler de peinture, et aller au cœur du sujet[105] ». N'oublions pas que, durant toute la période où il est conservateur de l'AGH, MacDonald continue de peindre – et d'exposer[106] –, ce qui n'est pas un mince exploit compte tenu des exigences de son poste. Sa fille, l'artiste Katherine MacDonald, se souviendra des longues heures qu'il passait dans son atelier le soir, après sa journée de travail au musée[107]. Cet engagement lui permet de transcender les vicissitudes quotidiennes et le ramène invariablement à ce qui compte le plus pour lui : la peinture. MacDonald a étudié la peinture, la comprend, la vit. Et les autres artistes le savent et y sont sensibles. Ils apprécient que leur œuvre entre dans une collection montée par un artiste – et un artiste qu'ils respectent. Se rappelant l'acquisition de *Cheval et train*, Alex Colville dira : « Cela signifiait quelque chose pour moi que Tom ait choisi cette peinture, qu'il la veuille pour la collection[108]. » Ce refrain, on l'entendra maintes et maintes fois à propos des rapports entre MacDonald et les artistes.

En fait, la majorité des œuvres données ou achetées pour la collection pendant le mandat de MacDonald proviennent directement d'artistes. Plusieurs œuvres importantes sont achetées, à l'instigation de MacDonald, à leur atelier même. *Le rêveur* (1929, cat. 60) de Charles Comfort en est un bon exemple. D'abord exposé en 1930 à l'Ontario Society of Artists, ce tableau est présenté l'année suivante au Salon du printemps du Musée des beaux-arts de Montréal où MacDonald – qui y expose lui aussi la même année – le voit probablement pour la première fois. Aux deux endroits, le prix demandé est de six cents dollars mais, faute de trouver preneur, le tableau retourne à l'atelier de Comfort. Pratiquement tout le monde l'oubliera durant un quart de siècle, sauf MacDonald. Car MacDonald a une extraordinaire faculté d'emmagasiner des images dans son immense mémoire visuelle; des années plus tard, il peut s'en souvenir et aller aux nouvelles. C'est ce qui se produit avec *Le rêveur*. En 1956, Comfort est membre du jury du Salon d'hiver de l'AGH, et MacDonald lui parle de cette peinture. « Étant lui-même un artiste, écrira Comfort, Tom avait une manière bien particulière de classer dans son esprit toutes les peintures qu'il jugeait importantes, espérant pouvoir un jour trouver le moyen de les acquérir pour son musée. [...] Je lui ai dit que *Le rêveur* était encore en ma possession et que, s'il avait bonne souvenance, cette toile était inscrite à 600 $ dans le catalogue de 1930. "Nous n'avons que 350 $", m'a-t-il répondu. J'ai réfléchi un moment et conclu que je ne pouvais trouver meilleur endroit que l'Art Gallery of Hamilton pour *Le rêveur*[109]. » Voyant que Comfort est prêt à s'en départir, MacDonald passe à l'action. Promptement, il fait parvenir le paiement à Comfort, qui lui répond : « La célérité avec laquelle tu as agi dans cet achat m'empêche, bien sûr, de revenir sur ma décision – c'est très

brillant de ta part ! À vrai dire, je suis enchanté que [*Le rêveur*] fasse maintenant partie d'une collection prestigieuse. J'avais toujours espéré que tel soit son destin[110]. » Le choix était courageux, car *Le rêveur* – un tableau qui dérange – n'est pas typique de la production de Comfort. Heureusement, grâce à MacDonald, il n'est resté que temporairement dans l'ombre. C'est ce talent inné pour reconnaître l'intégrité d'une peinture, sa capacité de durer, qui faisait de MacDonald un être à part.

MacDonald parsème sa copieuse correspondance avec des artistes de questions de ce genre sur des images qu'il a classées dans son esprit. Dans leurs lettres, Adrien Hébert, Edwin Holgate, Ernst Neumann, Goodridge Roberts et John Lyman mentionnent régulièrement des tableaux dont le conservateur s'est enquis, ainsi que d'autres œuvres susceptibles de l'intéresser pour la collection. Cette manière de procéder donne, bien sûr, d'impressionnants résultats. *Élévateur n° 1* (v. 1929, cat. 57) de Hébert est acheté directement de l'artiste en avril 1962; John Lyman vend *Femmes sur la plage* (1948, fig. 36) en réponse à une demande de MacDonald, qui voudrait obtenir une peinture de figures; et Edwin Holgate expédie son *Oncle George* (1947, cat. 83) dès que MacDonald la lui réclame. « En réponse à ta lettre du 16, je me suis empressé de mettre "Oncle George" en caisse et l'ai expédié dimanche matin, écrit Holgate. J'espère que le conseil jugera bon de l'acquérir – car je le juge bon pour un musée et serais honoré d'être représenté à Hamilton. Après tant d'années, je ne prends rien pour acquis, mais j'ai de l'espoir[111]. »

La mémoire de MacDonald le sert bien aussi avec Carl Schaefer. *Une ferme au bord de la voie ferrée, Hanover* (1939, cat. 77) est resté (comme *Le rêveur* de Comfort) dans l'atelier de l'artiste depuis ses premières expositions – dans ce cas-ci, au Groupe des peintres canadiens (1939), au Salon du printemps de Montréal (1940) et à la Canadian National Exhibition (1940). Quand MacDonald lui demande de présenter cette toile au Salon d'hiver de l'AGH en 1964, Schaefer trouve la proposition étrange, vu que l'œuvre date de 1939 : « Je suis quelque peu surpris étant donné que cette toile a déjà vingt-cinq ans et que je n'en ai en ma possession qu'une seule autre de cette période qui soit de format et de qualité semblables[112]. » De toute évidence, MacDonald a un objectif en tête : amener la toile à Hamilton afin de l'acheter pour la collection. Dès qu'il se dit intéressé à l'acquérir, Schaefer la lui offre, à prix réduit : « Je serais honoré qu'elle soit dans votre collection[113] », lui écrit-il. Le tableau est acheté en janvier 1964 avec de l'argent fourni par le Comité féminin.

Souvent, MacDonald n'a qu'à demander. En visite chez Lawren Harris à l'été de 1956 pour organiser une exposition de ses œuvres récentes[114], MacDonald est frappé par *Chute, Algoma* (v. 1920, cat. 42), accroché dans la salle à manger de l'artiste. Il ne l'oublie évidemment pas, mais il mettra un an à se décider à agir. Avec ce don qu'il a de trouver le ton juste, il écrit à Harris en mai 1957 : « Me pardonnerez-vous si je vous pose une question impertinente ? Quand j'étais chez vous l'an dernier, j'ai été très impressionné par une grande toile représentant une chute de l'Algoma. [...] Il m'a fallu tout ce temps pour vous demander si vous envisageriez de vous en dessaisir[115]. » Cette attitude patiente et respectueuse, ces manières de gentilhomme – caractéristiques de son tempérament –, colorent tous ses rapports avec autrui. Le ton de sa lettre a certainement plu à Harris, car celui-ci lui répond de la même manière : « Nous n'avons jamais envisagé de vendre la Chute de l'Algoma. C'est l'une des très rares anciennes toiles que nous avons encore et je dois avouer que plus je la regarde, plus je la trouve réussie – j'ai tellement de recul maintenant que je peux la voir objectivement, comme si quelqu'un d'autre l'avait peinte, et la regarder avec plaisir. Cependant, ma femme et moi

estimons que si un grand musée du pays la veut, nous ne devrions pas la garder[116]. » Ravi, MacDonald se hâte de faire expédier la toile à Hamilton pour l'accrocher et commencer à recueillir des fonds[117]. Une fois encore, le travail du Comité féminin – cette fois lors de la troisième Vente d'œuvres d'art – permet une acquisition majeure, et *Chute, Algoma* devient le troisième Harris à entrer dans la collection de l'AGH.

Les relations personnelles que MacDonald entretient avec plusieurs membres fondateurs du Groupe des Sept ou leur famille facilitent beaucoup l'acquisition de toiles importantes. Arthur Lismer, qu'il a connu à Montréal, fait don du *Rocher Bon Echo* (1923, cat . 48) et de *La petite chute, Saint-Donat* (1941) en 1951. En 1961 et 1962, A. J. Casson ajoute neuf de ses aquarelles et dessins à ceux que l'AGH possède déjà. Thoreau MacDonald, le fils de J.E.H. MacDonald, communique pour la première fois avec T. R. MacDonald en mai 1949 après avoir appris par Will Ogilvie[118] que l'AGH est intéressé à acheter une œuvre de son père[119]. La relation entre Thoreau MacDonald (qui est lui aussi un artiste) et le conservateur du musée sera des plus fécondes. Les deux hommes organisent ensemble la rétrospective J.E.H. MacDonald de 1957, et Thoreau veille à ce que le musée acquière une toile majeure, *Rapides du Nord* (1913, cat. 33), que son père a peinte peu après avoir vu la grande exposition de peintures scandinaves contemporaines à l'Albright Gallery de Buffalo en janvier 1913. Incontestablement, toutefois, c'est à sa longue amitié avec A. Y. Jackson, plus qu'avec tout autre artiste, que MacDonald doit d'avoir pu, à la fois ouvertement et discrètement, enrichir la collection de Hamilton. Le premier des nombreux Jackson acquis par le musée est *La cabane* (1949), œuvre primée au Salon d'hiver de 1950. En avril 1956, Jackson lance une idée pour approvisionner régulièrement l'AGH en esquisses. Il écrit à MacDonald :

> Comme d'habitude, quand je reviens de voyage, mes meilleures esquisses sont achetées par des collectionneurs et je ne suis jamais capable d'en conserver une, même si j'essaie depuis des années de le faire. Ni l'Art Gallery of Toronto ni la Galerie nationale n'en possède une bonne sélection. Ils ne les ont pas toujours achetées de moi et j'aimerais bien qu'il existe une collection qui me plaise. Voici ce que je voudrais faire, si tu es d'accord. – Quand je vais faire des esquisses, s'il y en a une que j'aime particulièrement, je la donnerai à l'Art Gallery of Hamilton, jusqu'à ce que vous en ayez une collection d'une douzaine ou peut-être d'une vingtaine, après quoi, s'il y a quelques-unes qui sont moins bonnes que la moyenne, nous pourrons les changer contre de meilleures si j'en fais de meilleures. [...] Cela paraît égocentrique, mais l'idée est bonne. [...] Je ne veux pas créer de précédent, donc, n'en dis rien pour le moment, et si tu penses que l'idée est mauvaise, n'hésite pas à me le faire savoir[120].

De toute évidence, MacDonald trouve que l'idée est bonne et, la même année, il accepte six esquisses. Fait à souligner, Jackson ne choisit pas seulement parmi ses œuvres les plus récentes, mais essaie d'offrir un échantillon représentatif et équilibré de sa production, du point de vue tant chronologique que thématique. Au bout du compte, il aura donné vingt-trois esquisses. Également intéressé à ce que l'AGH possède de grands tableaux de lui, il veille à ce que le musée acquière *Le vieux canon, Halifax* (1919, fig. 20) en 1954. En outre, il contribue à diversifier la collection en donnant des œuvres d'autres artistes et en encourageant ceux-ci à soutenir le musée. Par son entremise, l'AGH obtient des peintures de Cullen, de Carmichael, de Robinson et de Schaefer. Pour aider

MacDonald à constituer comme il le souhaite un solide corpus montréalais, Jackson donne des pièces de sa collection personnelle ou verse au directeur des fonds pour en acquérir. Ainsi contribue-t-il directement à améliorer la représentativité des femmes peintres associées au Groupe de Beaver Hall, entre autres Mabel Lockerby, Anne Savage, et Emily Coonan dont l'importante *Jeune fille en vert* (1913, fig. 37) entre à l'AGH grâce à lui.

Les habiles négociations de Jackson avec la famille Heward permettent également l'acquisition de *Femme sous un arbre* (1931, cat. 63) de Prudence Heward. Jackson commence à s'occuper de cette affaire à la demande de MacDonald, qui voudrait bien obtenir une toile majeure de Heward. Comme cela avait été le cas pour *Le rêveur* de Comfort, MacDonald se souvenait de ce nu de Heward, qu'il avait probablement vu à l'exposition tenue chez W. Scott and Sons, à Montréal, en 1932. Jackson, qui sert d'intermédiaire entre le conservateur et la famille Heward, écrit à MacDonald en décembre 1958 : « J'ai vu Jim Heward il y a quelque temps. Je lui ai parlé du "nu." Je n'ai pas mentionné Hamilton car il m'a demandé si cinq mille dollars, ce serait trop[121]. » L'affaire reste en veilleuse environ deux ans, puis, après l'échec des négocations entre la famille Heward et la Galerie nationale du Canada, MacDonald entrevoit de nouveau la possibilité d'acquérir la toile. « Il y a peut-être une chance d'obtenir le "Nu" de Prudence Heward, lui écrit Jackson. La Galerie nationale l'a demandé, mais [les Heward] restent froids devant cette institution; pas une seule toile de Prue n'y a été accrochée, à ce que je sache, pendant toute la période où Jarvis en a été directeur [...][122]. » Jackson considère que le moment est propice pour s'adresser à la famille. « La Galerie nationale est prête à l'accepter comme don, mais ne peut pas l'acheter. Autrement dit, elle n'y accorde pas beaucoup de valeur. Naturellement, la famille n'est pas très intéressée. Je leur ai écrit et laissé entendre que la peinture serait beaucoup plus appréciée à Hamilton[123]. » La réponse est positive : « J'ai reçu une lettre de Jim Heward, il dit que lui et son frère et sa sœur ont discuté de la chose et qu'ils aiment bien l'idée que le "Nu" de Prudence aille à Hamilton[124]. » La famille Heward a compris que la peinture occuperait une place de choix dans la collection, et il ne fait aucun doute que cela a joué dans sa décision de la donner à l'AGH. Ainsi, une autre toile majeure arrivait à Hamilton grâce à la judicieuse intervention d'un artiste ainsi qu'à la patience et à la ténacité du directeur/conservateur.

## La collection s'affirme

A. Y. Jackson fait partie de cette génération d'artistes canadiens plus âgés qui, à la fin des années 1960 et au début des années 1970, se sentent une affinité particulière – une parenté – avec Hamilton et son musée, en grande partie parce que MacDonald s'intéresse encore à eux et à leurs travaux. Beaucoup de ces artistes ont alors l'impression d'être balayés lentement de la scène, et le directeur de l'AGH taille pour eux une place utile à Hamilton. En 1966, Anne Savage écrit à MacDonald : « Vous êtes bien bon d'accueillir une autre brebis égarée – Hamilton est en train de devenir mon foyer spirituel[125]. » Et quoique, naturellement, le genre d'œuvres exposées au Salon d'hiver change au cours du mandat de MacDonald, celui-ci continue d'inviter les participants des débuts qui sont de plus en plus difficilement acceptés dans les autres institutions. D'aucuns pourront soutenir que MacDonald, à cause de ses liens étroits avec cette génération d'artistes (qui sont les artistes de *sa* génération), est dans une certaine mesure resté accroché au passé. Mais la peintre torontoise Paraskeva Clark, amie dévouée du musée durant les années 1950 et 1960, parle sans doute au nom de sa génération en 1971 quand,

après avoir été admise au 22ᵉ Salon[126], elle remercie MacDonald de lui « garder une place dans l'art canadien[127]. » Ce touchant témoignage met précisément en lumière la mission que le conservateur s'est donné à Hamilton et les moyens qu'il a pris pour l'accomplir. MacDonald a imaginé la collection et en a jeté les bases en s'appuyant pour beaucoup sur ces artistes. Jusqu'à la fin, il leur est resté fidèle, servant ainsi la cause de l'artiste et celle de l'AGH.

Au moment de partir à la retraite en juin 1973, T. R. MacDonald déclare : « Bâtir la collection a été, ici, mon plus grand plaisir. Je suis un collectionneur né et je le suis toujours resté depuis mes années d'études. Je suis un conservateur dans l'âme, pas un directeur[128]. » Ce plaisir, cette passion, a donné des résultats remarquables et, au bout d'un quart de siècle, le conservateur peut évaluer et admirer les fruits de son travail. Il n'est pas le seul, toutefois, à les admirer. Dans les dernières années de son mandat et tout de suite après son départ, MacDonald voit sa collection acquérir énormément de prestige à l'extérieur de Hamilton. Plusieurs expositions contenant exclusivement des œuvres de l'AGH sont présentées à travers la province, témoignage sans équivoque de son importance et de son attrait[129]. Et l'intérêt se maintiendra bien longtemps encore. La collection, commencée avec si peu et bâtie grâce à l'ingéniosité et à la pure volonté d'un groupe de convaincus, est maintenant reconnue à l'échelle régionale, nationale et internationale. Avec confiance et distinction, elle s'est affirmée. ~

## Notes

1. Paul Duval, « 'Hidden' Talent of Hamilton's Tom MacDonald », *The Hamilton Spectator*, 23 novembre 1968.

2. Ishbel Gordon, marquise d'Aberdeen et de Temair, *Through Canada with a Kodak*, Édimbourg, W.H. White, 1893, p. 54.

3. Pour souligner le soixante-quinzième anniversaire de l'AGH en 1989, le conservateur du musée, Ross Fox, ainsi que l'auteure et ancienne critique d'art au *Hamilton Spectator*, Grace Inglis, ont publié une histoire du musée sous le titre *The Art Gallery of Hamilton : Seventy-Five Years (1914–1989)* (Hamilton, Art Gallery of Hamilton, 1989). Ils y présentent un excellent aperçu de la fondation et de l'évolution de l'AGH et de ses collections. Les lecteurs trouveront dans leur livre une discussion plus fouillée des premières années (notamment de 1914 à 1947) ainsi que de la période qui a suivi l'administration de T. R. MacDonald. Je remercie les deux auteurs de la recherche qu'ils ont faite pour cet ouvrage; elle m'a été d'une grande utilité aux premières étapes de mon projet et s'est révélée tout au long un précieux guide.

4. Quelques institutions sont antérieures à l'AGH, dont l'Art Association of Montreal (1860; aujourd'hui le Musée des beaux-arts de Montréal), le Musée du Séminaire de Québec (1874; aujourd'hui le Musée national des beaux-arts du Québec), la Galerie nationale du Canada (1880; aujourd'hui le Musée des beaux-arts du Canada), l'Owens Museum of Fine Arts (1895; aujourd'hui l'Owens Art Gallery), l'Art Museum of Toronto (1900; aujourd'hui le Musée des beaux-arts de l'Ontario), le Nova Scotia Museum of Fine Arts (1908; aujourd'hui l'Art Gallery of Nova Scotia) et la Winnipeg Art Gallery (1912).

5. Pour une discussion plus complète sur William Blair Bruce et le legs de sa famille à la ville de Hamilton, de même que sur l'exposition inaugurale, voir Arlene Gehmacher, *Painting for Posterity : William Blair Bruce*, Hamilton, Art Gallery of Hamilton, 2000.

6. Les principaux initiateurs de ce mouvement étaient la Hamilton Art School (fondée en 1885; début des cours en février 1886), le Canadian Club (fondé en 1893), la section de Hamilton de la Women's Art Association of Canada (fondée en 1894) et la Hamilton Art Students' League (formée en 1895). Fox et Inglis, p. 2–5.

7. « Art Gallery : Trustees Held Their First Meeting Yesterday », *Hamilton Daily Times*, 8 janvier 1914.

8. « Auspicious Opening of Local Art Gallery », *The Hamilton Spectator*, 2 juillet 1914.

9. Le sculpteur allemand Josef Jost fut également représenté dans cette exposition, vraisemblablement grâce à l'initiative de sa femme, l'artiste Ottilie Palm Jost, native de Hamilton.

10. « Review of Pictures at Art Gallery : An Exceptionally Fine Collection of Paintings, Etchings and Drawings Has Been Secured for the Opening Exhibition », *Hamilton Herald*, 4 juillet 1914.

11. Parmi les autres exposants dont l'AGH posséderait plus tard des œuvres, mentionnons Mabel May, Marc-Aurèle de Foy Suzor-Coté, Clarence Gagnon, Randolph Hewton, William Clapp, Ottilie Palm Jost, Mary Hiester Reid, Elizabeth McGillivray Knowles, Dorothy Stevens, Frederick Bell-Smith et John Sloan Gordon.

12. « Auspicious Opening of Local Art Gallery », *The Hamilton Spectator*, 2 juillet 1914.

13. Gehmacher, *Painting for Posterity*.

14. La peinture exposée est un paysage, *La lisière de la forêt, matin*. Sa localisation actuelle est inconnue.

15. Bruce et sa sœur Bell Bruce-Walkden avaient aidé William Long, premier propriétaire des deux Cullen, à bâtir sa collection.

16. William Blair Bruce dans une lettre à son père, juillet 1895, dans Joan Murray (dir.), *Letters Home : 1859–1906. The Letters of William Blair Bruce*, Moonbeam (Ontario), Penumbra Press, 1982, p. 195.

17. Pour plus de détails sur la Collection commémorative Long et Bisby, voir Fox et Inglis, p. 7–8.

18. Sylvia Antoniou, *Maurice Cullen : 1866–1934*, Kingston, Agnes Etherington Art Centre, 1982, p. 86.

19. *Ibid.*, p. 6. Carol Lowrey note qu'entre 1892 et 1894, les deux artistes ont été régulièrement en contact; voir *Visions of Light and Air : Canadian Impressionism, 1885–1920*, New York, Americas Society Art Gallery, 1995, p. 18.

20. Cette exposition avait été organisée et mise en tournée sous les auspices de l'Académie royale des arts du Canada; les recettes de la vente des œuvres – des peintures et sculptures données par des artistes canadiens – étaient versées au Fonds patriotique canadien. Deux tableaux furent achetés pour la collection de l'AGH : *Près du lac Canoe* d'A. Y. Jackson, exposé sous le titre *In the North Country*, et *Ombres de nuages* (v. 1914) de J.W. Beatty, offert par la section de Hamilton de la Women's Art Association of Canada. Deux autres œuvres de l'exposition seront ajoutées à la collection plus tard : *Jeune fille en vert* d'Emily Coonan, acquis par l'entremise d'A. Y. Jackson en 1956, et *L'écharpe bleue* (v. 1910) de sir Edmund Wyly Grier, acquis en 1960.

21. Le premier voyage de Jackson au lac Canoe date de février 1914; l'artiste retourna dans le Nord en octobre pour faire des esquisses avec Thomson et les membres du futur Groupe des Sept, Arthur Lismer et Fred Varley. Voir A. Y. Jackson, *A Painter's Country : The Autobiography of A. Y. Jackson*, Toronto, Clarke, Irwin & Company Ltd., 1958, p. 28 et 30–31; ainsi que Dennis Reid, *Le Groupe des Sept*, Ottawa, Galerie nationale du Canada, 1970, p. 76.

22. Jackson avait étudié et peint en Europe de 1907 à 1913.

23. Sur le plan de la composition, ce tableau a beaucoup d'affinités avec *Dans le parc Algonquin* (1914, Kleinburg [Ontario], Collection McMichael d'art canadien) de Tom Thomson, peint la même année et aussi présenté à l'exposition du Fonds patriotique.

24. Le plus important fut le legs John Penman en 1936, qui comprenait vingt-trois huiles et aquarelles, surtout européennes. Parmi les œuvres canadiennes, on trouvait deux aquarelles de Lucius O'Brien et deux portraits des Penman par J.W.L. Forster.

25. Freda Waldon, « The Recurring Dream of a Cultural Centre for Hamilton », allocution présentée au vernissage de la 15ᵉ exposition annuelle de l'Art Club of Hamilton, 30 mai 1947; tapuscrit, Special Collections, Hamilton Public Library.

26. Entre 1914 et 1947, il y eut plusieurs conservateurs à temps partiel, notamment l'artiste Leonard Hutchinson (de 1945 à 1947). *Minutes of the Municipal Council of the City of Hamilton for the Year 1947*, réunion du 19 février 1947, Hamilton, Hamilton Typesetting Company, 1947, p. 152.

27. En plus, une partie de l'Art Gallery of Hamilton servait de maison pour MacDonald, dès son arrivée en novembre 1947 jusqu'à 1951.

28. Andrew Oko, *T. R. MacDonald 1908–1978*, Hamilton, Art Gallery of Hamilton, 1980, p. 50.

29. Pour en savoir davantage sur cette période à Montréal, voir Charles C. Hill, *Peinture canadienne des années trente*, Ottawa, Galerie nationale du Canada, 1975, et Esther Trépanier, *Peinture et modernité au Québec 1919–1939*, Québec, Éditions Nota bene, 1998.

30. MacDonald sera élu membre associé de l'Académie royale des arts du Canada en 1947 et académicien en 1957.

31. « Proposal for Membership in The Arts Club », demande d'adhésion, dossier 1 « Adhésions », P2/H Recrutement, Fonds Arts Club, Archives du Musée des beaux-arts de Montréal.

32. Minutes of the Council of the Arts Club, 5 novembre 1946, dans *Procès-verbaux et documents afférents, 1946–1950*, P2/B2/2,5, Fonds Arts Club, Archives du Musée des beaux-arts de Montréal.

33. Oko, *T. R. MacDonald*, p. 8.

34. L'AGH ne possède aucune toile de Hopper, mais elle possède une estampe, ce qui s'explique de toute évidence par des considérations financières, et non par un parti pris esthétique.

35. Oko, *T. R. MacDonald*, p. 50.

36. E. Howard Beynon, « Why Hasn't Hamilton a New Art Gallery ? », *The Hamilton Spectator*, Letter to the Editor, 11 décembre 1946.

37. F. Maud Brown, « Eric Brown: His Contribution to the National Gallery », *Canadian Art*, vol. 4, n° 1 (novembre–décembre 1946), p. 8.

38. Dans son rapport de 1951, la Commission royale d'enquête sur l'avancement des arts, des lettres et des sciences au Canada (commission Massey) fait état d'un personnel professionnel composé du directeur et de trois « adjoints spécialisés ». Si l'on ajoutait le personnel administratif et de soutien, le nombre total d'employés était de vingt-six. Je remercie Cyndie Campbell, chef des Archives, Documentation et Ressources visuelles, Musée des beaux-arts du Canada, qui m'a fourni ce renseignement.

39. Le Saskatoon Art Centre, créé en 1944, fut l'un des premiers centres d'artistes autogérés du Canada; il fut absorbé par la Mendel Art Gallery au moment de la formation de cette institution en 1964.

40. George Swinton dans une lettre à T. R. MacDonald, 3 mars 1949, collection particulière, Hamilton.

41. *1924–1989 : Six¹/₂ Decades: 65 Years of The Edmonton Art Gallery*, Edmonton, The Edmonton Art Gallery, 1989, p. 4.

42. Tom Smart, *The Collection, London, Canada*, London, London Regional Art and Historical Museums, 1990, p. 24.

43. « Hewton Paintings To Be Exhibited in Art Gallery, Policy Revealed by New Curator », *The Hamilton Spectator*, 20 décembre 1947.

44. L'exposition fut inaugurée à Hamilton le 29 décembre 1947.

45. L'exposition Hewton avait été présentée à l'Arts Club en novembre 1947.

46. Tapuscrit de l'allocution présentée par T. R. MacDonald aux membres de l'Art Gallery of Hamilton, 20 mars 1959, Archives de l'AGH.

47. D'autres toiles de l'artiste Albert Robinson (né à Hamilton) entreront à l'AGH après la tenue, en 1955, de la rétrospective Robinson, organisée par MacDonald en collaboration avec la Galerie nationale du Canada.

48. H.O. McCurry dans une lettre à T. R. MacDonald, 9 mars 1948, 5.13H Hamilton, Ontario, 1945–51 (Loans–Ontario), fonds Musée des beaux-arts du Canada, Archives du Musée des beaux-arts du Canada, Ottawa.

49. « Art Exhibition Is Commended », *The Hamilton Spectator*, 5 février 1948. L'exposition obtint également une bonne critique, signée « Art Lover », « Art Show Will Suit All Tastes », *The Hamilton Spectator*, 7 février 1948.

50. T. R. MacDonald dans une lettre à William Withrow, 27 janvier 1965, Archives de l'AGH.

51. « Show is a Landmark », *The Hamilton Spectator*, 25 novembre 1948.

52. *Ibid.*

53. On ne s'étonne pas que la plupart soient des artistes que MacDonald a personnellement connus à Montréal.

54. Faisaient partie des Contemporary Artists of Hamilton, groupe formé en mars 1948, les artistes Madeline et Vincent Francis, Hortense Gordon, Rae Hendershot, Elizabeth Holbrook, Ray Mead, Charles Playfair, Henry W. et Marie Smith, de même que le collectionneur H. L. Rinn et la bibliothécaire en chef Freda Waldon. Pour une liste complète des membres de ce groupe entre 1948 et 1971, voir Stuart MacCuaig, *Climbing the Cold White Peaks : A Survey of Artists in and from Hamilton 1910–1950*, Hamilton, Hamilton Artists' Inc., 1986, p. 209–210.

55. L'AGH présente aussi des œuvres abstraites à ses Salons d'hiver, surtout durant les années 1960, mais elle en achète rarement. *Monarque iridescent* de Jock MacDonald, acquis en 1960, est une importante exception.

56. Parmi les artistes et membres du jury qui sont des abstractionnistes, mentionnons Hortense Gordon (1948), Charles Playfair (1950), Ray Mead (1952), James W.G. MacDonald (1958), Walter Hickling (1960), Tom Hodgson (1963) et Harold Town (1966, dernière année où il y a jury).

57. Mary Mason, « Fine Pictures at the Winter Show – But Prize-winner Isn't One of Them », *The Hamilton Spectator*, 1er février 1957.

58. Il est vrai que MacDonald a régulièrement mis à son programme des expositions d'art abstrait. Donnons-en comme exemples une exposition d'œuvres abstraites de Lawren Harris en novembre 1957 et une du groupe des Cinq de Regina en décembre 1962.

59. Eric Williams, « Is it Art? Only Time Will Tell », *The Hamilton Spectator*, 21 octobre 1948.

60. *Ibid.*

61. Entrevue de l'auteure avec Paul Duval, Toronto, 5 juin 2003.

62. Cité dans Kay Kritzwiser, « How Tom MacDonald Gave Hamilton Art a Hand », *The Globe and Mail*, 12 mai 1973.

63. Les plus importantes sont le Jock MacDonald mentionné précédemment; *Masques et doigt levé* de Paul-Émile Borduas (1943, fig. 56, donné par H. S. Southam en 1953); *Évasion* d'Alfred Pellan (1949, donné par le Comité féminin en 1959); *Composition* d'Hortense Gordon (1948, donné par le Zonta Club de Hamilton en 1951); et *Façade 2* de Marian Scott (1954, donné par la Canadian National Exhibition Association en 1956).

64. Il existe deux grandes études sur l'essor et la diffusion de l'art abstrait au Canada pendant cette période : Denise Leclerc, *La crise de l'abstraction au Canada. Les années 1950*, Ottawa, Musée des beaux-arts du Canada, 1992, ainsi que Robert McKaskell *et al.*, *L'arrivée de la modernité : la peinture abstraite et le design des années 50 au Canada*, Winnipeg, Winnipeg Art Gallery, 1993.

65. Williams, « Is it Art ? ».

66. Tapuscrit de l'allocution de T. R. MacDonald aux membres de l'AGH (voir note 46).

67. Cela est vrai en partie parce que le successeur de MacDonald, Glen Cumming, arrivé au musée en été de 1973, décida de réorienter le programme d'acquisitions. Tout en reconnaissant les points forts de la collection de l'époque, il décida d'affecter de l'argent à l'acquisition de peintures contemporaines en vue d'améliorer la collection d'art international et d'art de l'Ouest canadien. Avec le recul, ces deux conceptions successives de la collection nous paraissent très complémentaires; chacune a bâti sur les forces et le savoir d'un des directeurs.

68. Minutes of the Board of Management, Art Gallery of Hamilton, 17 octobre 1949, Archives de l'AGH.

69. Les membres du Comité féminin se sont régulièrement chargées des fonctions et responsabilités aujourd'hui assumées par les services de l'éducation, du développement et des relations publiques.

70. Cité dans Kathleen Steiner, « An Amateur's History of the Women's Committee of the Art Gallery of Hamilton, Ontario », dans *Women's Committee, Art Gallery of Hamilton : A History of the Early Years to 1968 and Chapters on Our Special Projects to Date*, tapuscrit, 1975, s.p., Archives de l'AGH.

71. Pour une discussion sur la construction et l'inauguration du nouvel édifice de l'AGH en 1953, voir Fox et Inglis, *The Art Gallery of Hamilton*, p. 14–17 (voir note 3).

72. Kathleen Steiner, « An Amateur's History », s.p.

73. Le parcours longeait les deux côtés de la rue James, entre les magasins Robinson (à l'extrémité ouest de Gore Park) et Eaton (une rue au nord de la rue King), de même que les deux côtés de la rue King, entre les rues McNab et John.

74. Il est important de souligner que Thomas E. Nichols, qui fit partie du conseil d'administration de l'AGH de 1949 à 1958, fut rédacteur associé du *Hamilton Spectator* avant d'en être l'éditeur (de 1955 à 1970), ce qui assurait une bonne couverture des activités du musée dans ce journal.

75. Pearl McCarthy, « CNE Gallery To Have Provocative Exhibition », *The Globe and Mail*, 10 juin 1950.

76. *Percée de soleil* (s.d.) de Fritz Brandtner en est un bon exemple; il fut acheté par Freda Waldon au *Mile of Pictures* et légué au musée en 1974.

77. La Vente d'œuvres d'art fut arrêtée à la demande de T. R. MacDonald, qui s'inquiétait de la concurrence qu'elle pouvait livrer au Salon d'hiver, puisque les œuvres provenaient habituellement des mêmes artistes. Le Comité féminin accepta de bon gré d'appuyer le Salon d'hiver en s'occupant de la publicité, du vernissage, etc. Voir Kathleen Steiner, « An Amateur's History », s.p.

78. Mrs. T. F. Rahilly, « A Resumé of the Picture Rental Project of The Women's Committee of the Art Gallery of Hamilton 1955-1975 », dans *Women's Committee, Art Gallery of Hamilton : A History of the Early Years to 1968 and Chapters on Our Special Projects to Date*, tapuscrit, 1975, s.p.. Archives de l'AGH.

79. Entrevue de l'auteure avec Ruth McCuaig, Hamilton, 2 février 2000.

80. Goodridge Roberts dans une lettre à T. R. MacDonald, oblitérée le 22 novembre 1950, collection particulière, Hamilton.

81. Edwin Holgate dans une lettre à T. R. MacDonald, 26 octobre 1959, collection particulière, Hamilton.

82. Cité dans Kay Kritzwiser, « How Tom MacDonald Gave Hamilton Art a Hand » (voir note 62).

83. Entrevue avec Ruth McCuaig (voir note 79). Beaucoup d'œuvres américaines sont identifiées comme « dons » des McCuaig, mais elles n'ont jamais fait partie de leur collection particulière.

84. L'exposition *American Realists* a eu lieu à l'Art Gallery of Hamilton du 11 mars au 23 avril 1961.

85. Paul Duval, « Hamilton's American Hoard », *The Hamilton Spectator*, 20 juillet 1968.

86. Bill Brown, « Art From Over the Border », *The Hamilton Spectator*, cahier Weekend , 26 septembre 1964.

87. Tapuscrit de l'allocution de T. R. MacDonald aux membres de l'AGH (voir note 46).

88. *The Art Gallery News*, vol. 8, n° 1 (mars 1960), Archives de l'AGH.

89. Duval a publié une critique de la collection britannique d'IBM lorsque celle-ci fut exposée à l'Art Gallery of Toronto en 1947. Paul Duval, « Exhibition Proves That Art and Business Work Together to Enrich the National Spirit », *Saturday Night*, 25 octobre 1947.

90. Entrevue de l'auteure avec Paul Duval, Toronto, 27 juin 2002.

91. *Ibid.*

92. Les quatre autres peintures étaient *Felicia* (1940) de Henry Lamb, *Permission* (s.d.) d'Edward le Bas, *Twyn y Waun* (s.d.) de Cedric Morris et *La dame aux roses* (s.d.) de Matthew Smith.

93. Duval a commencé à écrire dans *The Hamilton Spectator* après que T. R. MacDonald lui eut dit que le journal cherchait un critique d'art et lui eut demandé s'il était intéressé. Entrevue de l'auteure avec Paul Duval, Toronto, 5 juin 2003.

94. Les deux œuvres avaient fait partie de la collection canadienne d'IBM (voir leur historique dans la Catalogue p. 218 et 219). Cole était chargé de garder *Bosquet de bouleaux, automne* (1915–1916, cat. 37) de Tom Thomson à Hamilton quand il fournit au musée l'argent pour acheter cette toile directement au Hamilton Club en 1967. Minutes of the Board of Management, 30 novembre 1967, Archives de l'AGH.

95. La première mention d'un comité d'acquisitions figure au procès-verbal de la réunion du conseil d'administration du 22 septembre 1949; ce comité devait comprendre cinq membres, dont le directeur. Les membres étaient des personnes ayant une certaine expérience et connaissance de l'art – surtout des artistes et des collectionnneurs – et provenant toutes de la région de Hamilton. Le premier comité fut composé de T. R. MacDonald, Frank Garrow (président du conseil d'administration), Frank Panabaker (artiste), H.L. Rinn (collectionneur) et Hugh Robertson (architecte et artiste.) Le nombre de membres fut ramené à quatre en 1955. Minutes of the Board of Management, 14 avril 1955, Archives de l'AGH.

96. Lawren Harris et E.R. Hunter, « A Debate on Public Art Gallery Policy », *Canadian Art*, vol. 7, n° 4 (été 1950), p. 148.

97. *Ibid.*, p. 150.

98. Robert Pilot dans une lettre à T. R. MacDonald, 14 mars 1956, dossier de la rétrospective Cullen, Archives de l'AGH.

99. Première présidente du Comité féminin, Janet Barber a continué à jouer un rôle influent dans ce comité jusqu'à son départ pour Toronto en 1960. David Barber a longtemps fait partie du conseil d'administration et il en fut président de novembre 1951 à mars 1955.

100. Robert Pilot dans une lettre à T. R. MacDonald, 7 juillet 1956, dossier de la rétrospective Cullen, Archives de l'AGH.

101. En juin, T. R. MacDonald écrivit à David Barber (alors en vacances à Londres) pour lui demander s'il avait pris une décision au sujet de l'achat de *Halage du bois, Beaupré*: « Je suis harcelé par Montréal et par M^me Young qui a remarqué [cette toile] dans mon bureau et s'y intéresse vivement, avec raison. Je lui ai expliqué que vous aviez priorité et elle m'a demandé de lui faire savoir si oui ou non vous aviez l'intention de l'acheter. Pouvez-vous m'envoyer un mot ? C'est une belle toile et elle gagne beaucoup à être connue. » T. R. MacDonald dans une lettre à David Barber, 21 juin 1956, dossier d'acquisition, Maurice Cullen, *Halage du bois, Beaupré*, AGH.

102. L'acquisition de *Halage du bois, Beaupré* est approuvée par le conseil d'administration le 20 décembre 1956. Minutes of the Board of Management, 20 décembre 1956, Archives de l'AGH.

103. Je suis reconnaissante envers feu M^me Jean Keogh, présidente du Comité féminin de 1956 à 1958, de m'avoir raconté ses souvenirs de cette acquisition.

104. Pilot donna également plusieurs de ses œuvres à lui, un carnet de croquis de William Brymner, une peinture de John Johnstone ainsi que plusieurs dessins de Holgate et Neumann.

105. Entrevue avec Paul Duval (voir note 90).

106. Entre autres expositions de ses œuvres pendant son mandat à l'AGH, mentionnons une exposition solo à la McMaster University Art Gallery (20 novembre – 20 décembre 1968) ainsi qu'une exposition conjointe avec Clare Bice à la Galerie XII du Musée des beaux-arts de Montréal (8 – 24 mars 1957).

107. En 1953, T. R. MacDonald et sa femme, l'artiste Rae Hendershot, avaient fait construire à Hamilton, dans le quartier de Westdale, une maison avec un grand atelier faisant face au nord. Leur fille Katherine et leur petite-fille Rae, toutes deux artistes, utilisent encore aujourd'hui cet atelier. Mes remerciements chaleureux à Katherine MacDonald qui a si aimablement accepté de me parler de ses parents, de leur travail et de leur vie durant mes nombreuses visites chez elle.

108. Conversation téléphonique entre l'auteure et Alex Colville, 16 janvier 2004.

109. Charles Comfort, « Haunting or Insulting? Views Differed. Now, The Dreamer Has Safe Haven », *The Globe and Mail*, 6 novembre 1976. Dans cet article, Comfort donne, par erreur, 1954 comme année de l'acquisition.

110. Charles Comfort dans une lettre à T. R. MacDonald, 23 janvier 1957, dossier d'acquisition, Charles Comfort, *Le rêveur*, AGH.

111. Edwin Holgate dans une lettre à T. R. MacDonald, 23 janvier 1953, collection particulière, Hamilton.

112. Carl Schaefer dans une lettre à T. R. MacDonald, 12 décembre 1963, dossier d'acquisition, Carl Schaefer, *Une ferme au bord de la voie ferrée, Hanover*, AGH.

113. *Ibid.*

114. L'exposition d'œuvres abstraites de Harris, inaugurée à Winnipeg en septembre 1957, fut présentée à l'AGH en novembre, puis à Windsor en mars, de même qu'à London en avril et au début de mai.

115. T. R. MacDonald dans une lettre à Lawren Harris, 9 mai 1957, dossier de l'exposition Lawren Harris 1957, Archives de l'AGH. La lettre dactylographiée contient le mot « pertinent[e] » plutôt que « impertinent[e] », mais compte tenu du ton général, c'est presque certainement une erreur.

116. Lawren Harris dans une lettre à T. R. MacDonald, 13 mai 1957, dossier de l'exposition Lawren Harris 1957, Archives de l'AGH.

117. Voir une lettre de T. R. MacDonald à Lawren Harris, 4 juin 1957, dossier de l'exposition Lawren Harris 1957, Archives de l'AGH.

118. Will Ogilvie était un grand ami de T. R. MacDonald. Il lui servit de témoin à son mariage avec la peintre Rae Hendershot en 1950, et prit la parole à ses funérailles en 1978.

119. Thoreau MacDonald dans une lettre à T. R. MacDonald, 30 mai 1949, collection particulière, Hamilton.

120. A. Y. Jackson dans une lettre à T. R. MacDonald, 11 avril 1956, collection particulière, Hamilton.

121. A. Y. Jackson dans une lettre à T. R. MacDonald, 5 décembre 1958, collection particulière, Hamilton.

122. A. Y. Jackson dans une lettre à T. R. MacDonald, 21 février 1961, collection particulière, Hamilton.

123. A. Y. Jackson dans une lettre à T. R. MacDonald, 10 mars 1961, collection particulière, Hamilton.

124. A. Y. Jackson dans une lettre à T. R. MacDonald, 24 mai 1961, collection particulière, Hamilton.

125. Anne Savage dans une lettre à T. R. MacDonald, 9 mai 1966, collection particulière, Hamilton.

126. Le Salon d'hiver (*Annual Winter Exhibition*) prendrait en 1972 le nom d'Exposition annuelle d'art canadien contemporain (*Annual Exhibition of Contemporary Canadian Art*).

127. Paraskeva Clark dans une lettre à T. R. MacDonald, 13 octobre 1971, collection particulière, Hamilton.

128. Cité dans Kay Kritzwiser, « How Tom MacDonald Gave Hamilton Art a Hand » (voir note 62).

129. Entre autres, *Director's Choice from the Permanent Collection of the Art Gallery of Hamilton*, Art Gallery of Brant, 9 septembre – 3 octobre 1971; *Director's Choice : Paintings from the Permanent Collection of The Art Gallery of Hamilton, by courtesy of Mr. T. R. MacDonald, Director*, Université Laurentienne, Sudbury, 8 septembre – 1 octobre 1972; *19th and 20th Century Painting and Sculpture from the A.G.H.*, Robert McLaughlin Gallery, Oshawa, 5 – 30 septembre 1973; et *19th and 20th Century Canadian Paintings from the Art Gallery of Hamilton*, University of Guelph, 28 avril – 30 mai 1974.

# The Emergence of Modern Art in Quebec: A Journey through the Art Gallery of Hamilton Collection

*Esther Trépanier*
*Professor*
*Department of Art History*
*Université du Québec à Montréal*

In 1948, reflecting on the development of Canadian art over the previous decade, the art critic Robert Ayre compared Montreal and Toronto in the following terms:

> It looked as if Toronto were the hub of Canadian painting ... But with Brymner, Morrice and Lyman for influences, Montreal has long had a powerful modern tradition of its own, and with the rise of men like Alfred Pellan, Stanley Cosgrove, Paul-Émile Borduas and Jacques de Tonnancour, and their followers, it might be said that the center of gravity has moved to Montreal. This is natural enough when you consider the shift in emphasis from Canadian painting to painting for its own sake; for in spite of the fact that Quebec is more intensely Canadian than any other part of the Dominion, Montreal is much less provincial than Toronto and the spirit that made the school of Paris, unrestricted by any national sentiment, is at home there.[1]

Ayre's article was published only a short time before the *Prisme d'Yeux* manifesto, signed by Pellan and the artists of his group, and the *Refus global* of Borduas and the Automatistes.[2] These proclamations marked the end of the "modern tradition" referred to by Ayre, which had preceded emergence of the avant-garde movements and abstract trends that led, in that same year of 1948, to the break-up of Montreal's Contemporary Arts Society. Flourishing during the historical period covered by the exhibition, this "modern tradition" can be comprehensively defined by numerous examples belonging to the Art Gallery of Hamilton (AGH).

The building of a collection is a complex process, influenced not only by aesthetic and ideological factors, which can vary considerably according to historical circumstance, but also by a number of practical considerations. The size of acquisition budgets, the personal and professional networks of directors and curators, and the skill of these latter in attracting donors can all have a decisive impact on the character of a collection. Tobi Bruce's essay (see pp. 17–39) explores the origins of the AGH collection and highlights the special links that existed between the Gallery's first director, T. R. MacDonald, and the Montreal art world. These links go some way to explaining why the "modern tradition" is so well represented at the AGH. The collection was subsequently the object of many donations, however, some of which – notably those of H. S. Southam[3] – significantly enhanced the institution's holdings of modern Quebec art.

After having had the privilege of studying the contents of the AGH vaults, and of appreciating their interest and richness, I felt it was important to offer the reader as broad a view as possible of Montreal's "modern tradition" as represented in this collection.[4] I have therefore chosen to explore some of the byways of this particular modernity by including on my itinerary all the Quebec works belonging to the Gallery, and not only those selected for the exhibition.

## 1890 to 1914: Two Forms of Artistic Nationalism Flanking the Influence of Modern Europe

When William Brymner began teaching at the Art Association of Montreal in 1886, Canadian art was at a turning point. In the wake of the 1867 Confederation, a form of artistic nationalism had emerged that was rooted in a Victorian ideology of territorial conquest. This nationalist vision was expressed mainly in the majestic landscapes of such painters as Lucius O'Brien, John A. Fraser, Henry Sandham, Otto Jacobi and William Raphael, several of whom gravitated around the Montreal and Toronto studios of the photographer William Notman. A number of them had also received backing from the Canadian Pacific Railway (CPR) to portray sites symbolic of Canadian unity. The development of this

landscape movement coincided with the establishment of the country's first major artists' associations (notably the Society of Canadian Artists in 1867–1868, the Ontario Society of Artists in 1872 and the Royal Canadian Academy of Arts in 1880) and the foundation of important museums (including the Art Association of Montreal – now the Montreal Museum of Fine Arts – in 1860, and the National Gallery of Canada in 1880). The genesis of a specifically Canadian art scene and the support offered these landscapists testify to a desire both to proclaim the existence of the new nation and to promote the cultural capital of its middle class. The following statement, published in the Toronto *Mail* on 27 May 1879 in a report on the opening of the Art Association's first gallery, reflects the prevailing mood:

> Montreal too is central, has its own gallery, a fine collection to begin with; and the wealth of its citizens, with the improvement of taste and the gradual manifestation of talent, will prove a lever toward general aesthetic improvement and development. We are all in the national mood just now, barring a few Grits, and it might be worthwhile to infuse the spirit into our art and literature.[5]

During the 1880s, however, the popularity of this type of landscape painting waned, to be replaced by a taste for art with a more French flavour. The academic realism taught in Paris became the model of artistic excellence, and many Canadian artists travelled to the French capital for training.

A painting in the AGH collection, Brymner's *Giving Out Rations to the Blackfoot Indians, N.W.T.* (1886, fig. 21), could be seen as illustrating the transition between the landscapists, mostly European-born, who founded the first "national" school, and the Canadian artists who practiced a form of painting that in both style and subject matter was more "European" (read "French"). This genre scene might well have appealed to the public of the French Salons, attracted by its exoticism, but it can also be classed alongside the many Canadian genre scenes produced by such artists as Robert Harris (*A Meeting of the School Trustees*, 1885, Ottawa, National Gallery of Canada), George A. Reid, (*Mortgaging the Homestead*, 1890, National Gallery of Canada) and even William Blair Bruce – at least in *The Phantom Hunter* (1888, cat. 6).

*Giving Out Rations to the Blackfoot Indians, N.W.T.*, painted by Brymner shortly after his return from a nine-year stay in Europe, is more narrative than the works of Frederick A. Verner and other artists of the preceding generation, who, in their explorations of Canada's landscapes, sometimes portrayed different aspects of the Aboriginal way of life. This painting is clearly imbued with the colonialist ideology of the time, but it also shows evidence of the solid academic training Brymner had acquired at the Académie Julian, tempered by certain effects derived from modern realism. The rather dark picture opens onto a brilliant sky, and the gloom of the interior strikes a contrast with the paleness of the white man's shirt and the sacks of grain. The image is enlivened by the few touches of bright red, blue and yellow that here and there highlight the faces and clothes of the Aboriginal people.

The evolution of Brymner's art, well illustrated in the sixteen pieces by him that belong to the AGH, was echoed in the work of a number of his contemporaries and pupils. While the luminosity and freshness of *A Summer Morning* (1888) is already closer in spirit to the Barbizon School than to Bouguereau (under whom Brymner studied at the Académie Julian), *Summer Landscape, Martigues* (c. 1908–1914, cat. 19) shows the growing influence of Impressionism. The highly simplified human figures (the faces mere patches of colour), the dappled pale areas on the tree trunks (capturing the sun gleaming through foliage rendered by a mass of small brushstrokes), the light ochre and pinkish orange tones of the clearly defined lit areas – all are evidence of Brymner's receptivity (shared with several other academically-trained colleagues) to certain aspects of Impressionism and, more generally, of *plein-air* painting.

These borrowings from an aesthetic that in pre-1915 Canada was, as Laurier Lacroix has pointed out,[6] synonymous with "modern painting," nevertheless resulted in a style that can be qualified as "middle-of-the-road." For although these artists were open to the effects of light and colour characteristic of *plein-air* painting, and while they often adopted the coloured shadows of the Impressionists, they did not – with a few exceptions, notably William Clapp (*In the Orchard, Quebec*, 1909, fig. 22) – go so far as to question the rules of three-dimensional perspective. And although they employed a more obvious brushstroke and a more palpable paint layer, they rarely made use of a consistently fragmented stroke in order to translate optical effects independently of the object being represented. This is especially evident in their commissioned portraits, where the conventional handling of the faces contrasts with the rather more daring treatment of the clothes and accessories. Brymner's *The Vaughan Sisters* (1910, cat. 24) is a particularly good example.

In fact, aside from their formal training, the many Canadian painters who attended the various academies and schools of Europe were exposed to a mix of modern art movements, from which they absorbed certain formal techniques without fully embracing the movements' aesthetic principles. In the Paris of the 1890s, for example, they came into contact not only with the numerous adaptations of Impressionism – which, due to the universal appeal of "beautiful, vibrant colour," had become an international movement – but also with the Divisionism of Seurat and Signac, which defined Neo-Impressionism from the late 1880s, with the Cloisonnism and Synthetism that Paul Gauguin, Émile Bernard and their disciples began developing in the small Breton village of Pont-Aven in 1888, with the Symbolism that emerged as a new trend towards the end of the same decade, with Whistler's Aesthetic Movement, and with the many permutations to which the influence of these different currents gave rise. One interesting offshoot was the Tonalism adopted by a number of North American painters.[7]

A full understanding of the sources of modern art in Canada would require an in-depth study (yet to be undertaken) of the network of Canadian artists who spent time in Europe, the influence they may have had upon one another, and their affiliations with different artistic groups and institutions. But even now, the rich collection of the AGH gives us a quite clear idea of the kind of explorations that resulted from this contact with the aesthetic movements of Europe. Many paintings were executed at "hallowed" sites, such meccas of Impressionism as Giverny,[8] where Claude Monet settled in the 1880s and which became the centre of a colony of North American artists that included William Blair Bruce (*Giverny, France*, 1887, cat. 3; *Giverny*, c. 1887, cat. 2). Clarence Gagnon[9] and Brymner were among the artists to visit Giverny, as was Maurice Cullen, who also painted at Moret, home to Alfred Sisley.

Brittany and the Normandy coast also became essential stops on the circuit of Canadian artists travelling in France. Three paintings from the collection illustrate the variety of styles employed in portraying these regions. The handling of Cullen's *The Tidal Mill, Brittany* (1900, fig. 23) takes it closer to realism than

Impressionism. Despite having been painted in the early 1920s, *Church Interior, Brittany* (c. 1921–1922) by Robert Pilot is an example of the "middle-of-the-road" style referred to earlier. It is a work reminiscent of those more academic images of Brittany painted by such fellow Canadians as Paul Peel (*Devotion*, 1881, National Gallery of Canada) and Marc-Aurèle de Foy Suzor-Coté (*Breton Woman at Prayer*, 1905, Archbishopric of Rimouski). By contrast, Edwin Holgate's *Blue Nets Festival, Concarneau* (1921, fig. 24), executed around the same time, is more decisively modern. With the extreme simplification of its figures, the two amazing spots – one bright red, the other yellow – that illuminate the deep blues of this night scene, the intermingling of planes created by a textural uniformity between sky and buildings, and the wall on which a row of Breton men and women are perched, this work is informed by a Post-Impressionism close to that of the Pont-Aven group. Although contemporary with Pilot's *Church Interior*, Holgate's painting displays a modernity that recalls that of James Wilson Morrice, who, in the preceding decades, had used an equally radical Synthetism to create images of regional France – including the market and circus at Concarneau.[10] The Gallery also owns a very fine *pochade* (oil sketch) by Albert Robinson, *St. Malo* (1912, cat. 30), executed during a trip to France with his friend A. Y. Jackson. This *pochade* echoes Morrice's approach, which fuses the discoveries of Whistler, the Nabis and artists associated with the Fauve movement, such as Albert Marquet. Morrice, who was a source of inspiration to a number of his fellow-Canadians, apparently introduced Clarence Gagnon and Maurice Prendergast to the practice of sketching in oil on small wood panels.[11]

Italy, too, was visited by a number of Canadian artists, including Jackson (*Moonlight, Assisi*, c. 1912, cat. 25) and Morrice, whose paintings of Venice are undoubtedly among his finest (*Corner of the Doge's Palace, Venice*, c. 1901, cat. 13; *The Porch of San Marco, Venice*, c. 1902–1904, cat. 14). And we should not, of course, forget North Africa, whose light and colours lured several artists – Cullen in 1893, and Morrice again some twenty years later (*View of a North African Town*, c. 1912–1914, cat. 31; *By the Sea*, c. 1912, cat. 26).

Ultimately, exposure to European art and membership in the network of artists who had adopted a more innovative approach to painting had a decisive influence on the development of a new way of representing the Canadian landscape and of conveying – using techniques that were boldly original in the context of a national art tradition that was still very young – its colours, light effects, seasons and atmospheres. This new approach is particularly well illustrated by two fine Cullens in the collection: *Logging in Winter, Beaupré* (1896, cat. 12) and *Cape Diamond* (1909, cat. 21).

The First World War put an end to overseas study and saw the emergence of a powerful new current of artistic nationalism. A few artists did find themselves back on European soil, but under very different circumstances, as members of the armed forces. With the creation in 1916 of the Canadian War Memorials Fund (CWMF), several of them were given officer rank and charged with illustrating the role played in the conflict by Canada's troops. Many of the resulting works are held at the Canadian War Museum, in Ottawa, but Hamilton boasts several remarkable examples, including a large group of drawings by Cullen donated by his stepson, the painter Robert Pilot,[12] who also gave the Gallery a selection of his own sketches. Cullen's *Red Mill, Liévin* (c. 1918, fig. 25) and *Shelled Building* (1918), Pilot's *Ruins, France* (1918, fig. 26) and Jackson's *Evening, Riaumont* (1918, fig. 27) offer a glimpse of the way these artists saw the bomb-shattered countryside of France.

## The 1920s: Modernity, Montreal-Style

Canada's participation alongside Great Britain in the First World War reinforced both its political autonomy and a nationalism that crystallized in the art of English Canada around the Group of Seven. Nationalism had already been a component of the art and literature of French Canada for some time – to the degree, in fact, that around 1918 a small but active group associated with the review *Le Nigog* had begun denouncing it as a threat to the development of genuinely modern art.[13] However, the political, social and cultural foundations of the nationalism of French-speaking Quebec, also labelled regionalism, were very different from those operating in English Canada, and this regionalism is not the focus of the AGH's exhibition.

Since the artists of Montreal's Beaver Hall Group (and especially Holgate and Robinson) are well represented in the AGH collection, I shall concentrate on the question of what distinguishes their particular modernity from that of the Ontario artists of the Group of Seven – in spite of the friendships that united them and the fact that in 1929 Holgate actually became the eighth member of the Seven.

Less structured than the Group of Seven, the Beaver Hall Group was remarkable for including a large number of women who went on to become successful professional artists. It was founded in 1920 by a group – including several former students of Brymner – who shared studio space on Beaver Hall Hill. Although they only exhibited together as the Beaver Hall Group in 1921 and 1922, these artists remained close for a number of years.[14]

There are both similarities and differences between their approach and that of their Ontario colleagues. The similarities include, on the formal front, an openness to Post-Impressionist modernity, particularly decorative Synthetism; thematically speaking, several of them displayed a marked interest in portraying landscapes, rural scenes and such quasi-archetypical national figures as the peasant, the fisherman and the pioneer. As regards differences, we note a rather more acute sensitivity among several of the Montreal artists to formal questions, especially those raised by Cézanne concerning the unity of the picture plane; and many of the painters (notably the women) displayed an interest in the contemporary world as a thematic source – the city, but also the places and people that filled their everyday lives.

### National and Regional Art

For the Group of Seven, truly national art was rooted in links between the land, its people and the artist. Reacting to critics who claimed that they reduced Canada to the wild reaches of northern Ontario, the Group's members began inviting artists from across the country to take part in their exhibitions[15] and encouraging the development of art originating in regional areas.

In Quebec, the landscapes of Holgate, Savage and Robinson were a manifestation of the "modern" regionalism advocated by the Group of Seven. Among the many examples in the AGH collection are *Dark Pool, Georgian Bay* (1933) by Anne Savage and *Old Pine Root, Lac Tremblant* (1927) by Holgate, as well as numerous images by Robinson of villages across Quebec. In his 1923 *Quebec Village* (cat. 49), the handling of the trees, which stand out against a background whose forms fit into one another like the pieces of a jigsaw, recalls the technique of several members of the Group of Seven. This painting actually illustrates the change that occurred in Robinson's style in the early 1920s, when, like some of his Beaver Hall colleagues (Mabel May and Kathleen Morris, for instance), he adopted a synthetist and cloisonnist approach to formal construction. He also began laying the paint down in areas

of slightly textured flat colour, while in his earlier works – *Rising Mist, Montreal Harbour* (1908, fig. 28) comes to mind – small coloured brushstrokes were often scattered across the pictorial surface. Also worth singling out is *Moonlight, Lower Town, Quebec* (1924, fig. 29), a canvas by Robinson that can be related both stylistically and thematically to *Lower Town, Quebec* (c. 1935, cat. 69), by fellow-Montrealer Kathleen Morris.

There is an especially interesting feature of Robinson's production: although in earlier works he had applied paint over the whole canvas, in *Quebec Village* and paintings like it he employed a modified version of Cloisonnism (which normally involves the outlining of forms with a powerful contour) by rendering the outlines with an *absence* of paint. In these pictures, the outline consists of a broad "reserve" band, sketched in prior to the painting stage and devoid of pigment, that reveals the weave of the canvas. And in *Quebec Village* the artist has gone even further: the various textural effects – the handling of the snow in the foreground, for example – have been created using a combination of pigment and raw canvas. Such formal techniques reinforce the autonomy of the painting with regard to the representation of reality – one of the axioms of modern art.

## The Founding Figures of a National Identity

### The Pioneer

Another characteristic of this nationalist art and its regional forms was their grounding in an ideology of virility. In describing their approach, members of the Group of Seven and their supporters did not hesitate to invoke the notion of virility that underlay a number of aesthetic discourses in the years between the wars.[16] In a kind of semantic shift, the virility associated with Canada's climate and rugged geography became a characteristic of the work of painters who would, like explorers and conquerors, confront nature and attempt to tame it through art.[17] It was therefore logical that the construction of a national art founded on the land and its people should allow room for the representation of the "heroes" of territorial conquest, and of figures symbolizing the First Nations.

Among the Montreal group, the tradition of portraying the resolutely masculine figures of the lumberjack, the fisherman, the peasant and the prospector was particularly effectively pursued by Edwin Holgate.[18] Even in a small print like *Fish Houses, Labrador* (1930, fig. 30), of which the AGH possesses an impression, Holgate was able to successfully use his talent in the woodcut medium to ennoble the figure of the fisherman: surrounded by a halo of light, he stands out against the expressionist lines of a sky that could as easily be read as a raging sea.

It should not be forgotten, though, that several women members of the Beaver Hall Group, most notably Prudence Heward, painted a number of equally potent images of rural women, who can be seen as the female counterparts of such masculine "heroes."

### The Aboriginal

Holgate also excelled in portraits of members of First Nations tribes of the West Coast, of which the AGH possesses a few examples, including *Indian Chief, Skeena River* (1926). His works on Aboriginal themes reveal his intellectual kinship with the Group of Seven, whose members shared with the ethnologist Marius Barbeau the view that folk and Aboriginal art should both be considered an integral part of national art. It was an opinion also held by J. Murray Gibbon, general publicity agent of Canadian Pacific, and these two men and the Group organized a number of events designed to promote these forms of "national"

culture. Like Canadian Pacific, Canadian National Railways also contributed towards the movement by providing artists with free rail passes. The CN passes issued to eastern artists (including Holgate and Savage) in 1926 enabled them to travel west to study Aboriginal villages, totem poles, huts and burial grounds in the Skeena River region. Marius Barbeau and CN had joined forces in promoting the creation of a national park in the area (thus making it a tourist destination) conjuring the "lost paradise" whose legend Barbeau recounted in his book *The Downfall of Temlaham*, which was published in 1928 and illustrated with works by artists who had visited the region.[19]

The composition and handling of another Holgate woodcut in the AGH collection, *Totem Poles, No. 5* (c. 1930, fig. 31), focus on the interaction not only between the totemic figures, the decorative patterns of the clothing and the human figures, but also between the natural setting and the totems, one of which converges with a distant mountain peak. In *Totem Poles, No. 4* (c. 1928, fig. 32), previously known as *Departing People, Skeena River*, the theatrical evening light, which creates powerful contrasts between the dense, matte blacks of the cast shadows and the lighter areas in the decoratively treated landscape, evokes the decline of a civilization and the drama of a people forced to abandon the paradise that once was theirs.

Generally speaking, Montreal artists of the period seem to have been more interested in the First Nations of the West Coast than in those of their own region. But there were a few exceptions, as witness two works in the AGH collection: Suzor-Coté's famous sculpture, *Caughnawaga Women* (1924, cat. 53), and an oil by Mabel May entitled *Indian Woman, Oka* (1927, cat. 55). In neither case, however, is there any visual hint of the subjects' origin: only the titles point us to two Mohawk reserves not far from Montreal.

## The Human Figure

### The Female Body

In a decade that saw the triumph of an art that, to be truly Canadian, felt obliged to project an image of "virility," and in a country where moral standards were such that public exhibition of the nude figure was still frowned upon, the focus on the theme of the female body by several artists of the Beaver Hall group was quite remarkable. And here again the Gallery's holdings include some interesting examples.

At first view, it is possible to interpret several of Holgate's nudes – those that he chose to place within a landscape – as the female equivalents of his "heroic" masculine figures. In works like *The Bathers* (c. 1930, fig. 33), the bodies interact formally with elements of a landscape whose components (rocks, pine trees, river) and handling (use of decorative arabesques, simplification of forms) are strikingly reminiscent of the Group of Seven. It was towards the end of the 1930s, however, that Holgate was most successful in this integration of nude and landscape, in oils like *Early Autumn* (1938, National Gallery of Canada). Also impressive is the woodcut *Two Figures – Jamaica* (c. 1933/1937, fig. 34), where, in a setting far from Canadian, the artist has pictured a veritable wrestling match between figures and nature, interweaving human limbs and stylized branches to great effect.

It is not actually clear whether Holgate was trying to underline the female dimension of nature or whether his nudes simply denote a desire to take a modern approach to his subject, like Cézanne trying to strike a harmony between "the curves of women and the shoulders of hills."[20] This insertion of the nude into a landscape was an approach to the theme adopted occasionally by Quebec artists of the preceding generation, such as Suzor-Coté, but also by other members of the Beaver Hall Group.

An example is Prudence Heward's *Girl Under a Tree* (1931, cat. 63), one of the major pieces of the AGH collection. The painter and critic John Lyman described this painting as a "Bouguereau nude against a Cézanne background."[21] Although Lyman was referring to the lack of formal relations between the body and the ground – the result, according to him, of an excessive "stiffening" of the artist's will – the statement is nonetheless surprising. The modelling of the body painted by Heward in no way resembles that of a Bouguereau, and the sexuality the figure emanates is entirely non-Bougueresque. Bouguereau's female bodies are endowed with pink skin and curved forms whose surfaces remain undisturbed by any irregularity, any muscle, any bony structure that might check the viewer's gaze. Heward's *Girl* seems rather to preclude the sensual commodification of which the female nudes of French academic painting were often victim.

It is interesting to note, too, how the female bodies portrayed by Holgate and Heward, but also by such artists as Lilias Torrance Newton and Henri Hébert, reflect the changes in standards of feminine beauty that occurred between the wars. A number of Henri Hébert's nudes, including *Miss A.C., Dancer from Oslo* (c. 1929, cat. 58) – of which the AGH owns a bronze, cast in 1962 from the plaster that the artist's brother, Adrien Hébert, had presented to the Gallery in 1951 – *Flapper* (1927, The Montreal Museum of Fine Arts) and *Charleston* (1927, private collection), together with several nudes by Newton, such as the one in the Thomson Collection (1933, fig. 67), are, by their poses and "attributes" (shoes, stockings, hairstyles),[22] rooted firmly in the urban world of the *garçonne* and the elegant Art deco beauty. And as represented by these artists, their bodies – slim, muscular and tanned – reflect the fashions and social distinctions of the 1920s. This image of the "modern" woman, transmitted via movies and magazines, encouraged women to cultivate particular bodily traits. In 1939, for example, Jacques Langevin, physical education instructor and contributor to the Quebec publication *La Revue moderne*, wrote: "To be beautiful, a woman's body must be athletic … Flesh must be firm and proportions perfect, muscles supple and long, with no excess fat."[23] The magazine had begun its campaign in favour of physical exercise and slimness the previous decade. The fashion for the suntan had a dual source: the growing number of woman practicing sports and the nineteenth-century hygienist movement, which credited sunlight with curative effects in the battle against "microbes and bacteria." A tanned complexion could be acquired as easily on the shores of one of Canada's great lakes, where city dwellers were purchasing holiday homes, as on the fashionable beaches of Europe. Holgate's bathers, then, were very much women of their time.

## The Contemporary Figure

It was through their interest in the human figure, in fact, that from the 1920s on Montreal artists really began to distinguish themselves from the prevailing nationalist trend. In a 1940 review of the exhibition *Art of Our Day in Canada*, organized by the Contemporary Arts Society, John Lyman wrote:

> Gone are the posters, gone the "designs" of the wilderness. Landscape has lost its quasi-monopoly as a motive of free expression; not more than a quarter of the pictures belong to this class. Forty percent of the contributors are artists who deal, though not all exclusively, with the human subject.[24]

Of the Beaver Hall artists, Hewton, Newton, Coonan and Heward (one of a few women of the group who participated in the exhibition *Art of Our Day in Canada*) were among those who had adopted the human figure as a major focus of their modern explorations. In a certain geometric solidity and the way the coloured brushstroke is used to construct the volumes, their portraits of friends, fellow artists, fashionable women and children reveal a familiarity with Cézanne. Although their approach is tempered by a realism that occasionally carries a whiff of Art Deco, a number of these artists show a Cézannesque desire to unify figure and ground (sometimes a landscape) by creating a chromatic and formal equilibrium between the various planes.

Lilias Torrance Newton was past master at establishing rich figure/ground relationships. Although in her AGH painting *Keith MacIver* (n.d., fig. 35) there is no clearly defined background, we may admire the beautiful faceting of the features and the skilful disposition of colours from a relatively limited palette across the whole pictorial surface. Holgate, too, excelled in constructing a formal dialogue between figure and ground. *Uncle George* (1947, cat. 83) could qualify as one of the many "Canadian types" portrayed by this artist, but the picture is most remarkable for the exquisitely geometrical treatment of the folds and wrinkles of the aging face, and for its manipulation of the browns, the white-tinted greens of the cap, and the bluish greys on the temples and around the nose, which echo the tones employed for the fir trees, rocks and snow in the background. From a compositional point of view, several of the background forms reiterate the curves of the figure – a device seen frequently in Holgate's work.

Although he was not a member of the Beaver Hall Group, we should not forget the work of John Lyman, who, using a powerful coloured brushstroke to construct the volumes of faces and bodies, proved himself heir to both Cézanne (in the geometric modelling of the forms) and Matisse (in the palette and the occasional use of an expressive outline). Not painted until 1948, *Girls on the Beach* (fig. 36) (a preparatory study for which is in the Musée national des beaux-arts du Québec) is nonetheless typical of the style Lyman first began developing in the second decade of the twentieth century.

A similar solidity of construction is evident in the approach to the human figure adopted by Heward, May and Emily Coonan, whose *Girl in Dotted Dress* (c. 1923, cat. 45) signals a major stylistic change in this artist's work. If we compare it to paintings from the previous decade, such as the AGH's *Girl in Green* (1913, fig. 37) or *First Communicants* (c. 1912–1918, The Montreal Museum of Fine Arts), we see that Coonan had moved away from a synthetic style that aimed at certain painterly effects, rather in the spirit of James Wilson Morrice, to the more powerfully structured approach characteristic of several Beaver Hall artists during the 1920s. Never, though (and this was a quality shared with a number of her modern colleagues), did she allow her portraits of children and adolescents to descend into "prettiness" or sentimentality; many of her young subjects were growing up in troubled times, and she often gave them a sad or meditative look. Examples abound in this genre, and it would be impossible to mention them all, but I cannot omit Prudence Heward's *Farm House Window* (1938, fig. 38), also in the Gallery's collection, since it illustrates so clearly the more expressive manner she developed during the 1930s.

Before concluding this brief survey of Quebec portraiture in the AGH collection, I should call attention again to Mabel May's *Indian Woman, Oka* (cat. 55), which also employs the coloured brushstroke to create architecturally constructed volumes, and finally *Portrait of Albert H. Robinson, R.C.A.* (c. 1927–1929), by Randolph Hewton, a work that seems to hesitate in its approach between the conventional and the modern.

## The Urban World

### City Life

Another characteristic of Montreal's modern painters was their interest in city life. In the wake of the First World War, industrialization and urbanization were increasing fast, and by 1931 the proportion of Quebec's urban-dwelling population had reached 63.1 percent.[25] The look of the city was changing, with the architectural landscape becoming distinctly more modern.

A number of the female Beaver Hall artists, including Sarah Robertson, Kathleen Morris, Mabel Lockerby, Mabel May and Ethel Seath, painted images of Montreal using the synthetist approach typical of most of the group. As a rule, their relationship to the city was a personal one: they pictured the streets where they lived, their neighbourhood, often showing the city from a window of their apartment or studio in views that carry the gaze from interior to exterior. This indoor perspective sometimes allows the inclusion of a still life, with a resulting mix of genres.

Anne Savage made use of this type of composition in *Still Life* (n.d., fig. 39), although in this work the outside view is a farm landscape. The still life – a vase of flowers – exploits an expressive opposition of green and red (here of a purplish hue), which also comes into play in Prudence Heward's *Farmhouse Window* (fig. 38). In Heward's picture, however, the contrasts of red and green are not concentrated on the still life, but around the terrified face of the little girl looking out of the window,[26] and the movement is reversed, going from exterior to interior.

The majority of Canada's museums possess few examples of cityscapes by the women of the Beaver Hall Group. The AGH owns *Old Towers* (1944) by Lockerby, *Lower Town, Quebec* (cat. 69) by Morris, mentioned earlier, and *Coronation* (1937, cat. 73) by Robertson. This latter work is a highly original composition, with its bisected flags and double perspective – from a slightly raised position in the lower part of the picture and frontal in the upper part, where the overlapping elements create a space that undermines the traditional representation of depth.

Finally, the exhibition includes one more street scene observed from an apartment, a rather atypical work by the artist who during the 1940s would become the leader of the Automatiste movement: Paul-Émile Borduas. *Spring Morning* (1937, cat. 74) is principally notable for its delicate touch, and for the rhythm created by the interplay of diagonals and rectangles – the solid oblongs of the doorways and the more evanescent forms created by patches of shadow and light on the sidewalk.

### The Changing City

The women painters of the Beaver Hall Group were rarely concerned with industrial architecture or the bustling downtown sector. The same had been true of their predecessors, the artists generally associated with Impressionism; unlike their Parisian counterparts of the 1870s, they showed little interest in the city's modern face, although a smoky view of Montreal's harbour had occasionally caught the attention of Cullen or Suzor-Coté. The Gallery's collection does, however, include some fascinating examples of works that illustrate Montreal's gradual metamorphosis into a modern metropolis.

First, let us look at Cullen's painting *C.N.R. Tunnel under Construction* (n.d., fig. 40). Although not considered among the artist's greatest works, it is one of the few that pictures the disruption of the urban fabric caused by the building of the tunnel that would pass under Mount Royal and provide a link between the city's downtown area and the transcontinental railway. But it was undoubtedly Marc-Aurèle Fortin who most systematically recorded the invasion of the traditional town – and even more frequently of the countryside – by the modern city. As well as a beautiful landscape of Fortin's native village, *Sainte-Rose in Autumn* (c. 1920–1935), the AGH owns a watercolour entitled *Hochelaga* (c. 1930, fig. 41) that in my view is one of this artist's most interesting works on an urban theme. As in all Fortin's views of Montreal, *Hochelaga* shows the city against its natural landscape setting; but the complexity of the many-planed composition, made possible by the vertical format, conveys in visual terms even more effective than usual the unequal struggle between town and country. Typically with Fortin, the foreground is a rural space of fields, hay wagon and farm workers – although already the country architecture is being shouldered out by more urban-looking buildings. And this rural space is soon sharply interrupted by a series of railway tracks that do not span it with a single diagonal, as in many of the artist's other views of Hochelaga, but multiply into a tentacular network, complete with train and buildings. In the middle of this complex of rail tracks survives a small pastoral island where we can just discern two anachronistic figures – the long-skirted mother and child invariably present in Fortin's urban scenes. Above these staggered planes comes another showing the dwellings of the city proper, whose pink, yellow and red tones are enveloped in smoke. The background, which generally in Fortin's pictures opens onto natural features like the sky, mountains and clouds, is here partially blocked on the left by the huge grey structures of the city's industrial area and its port.

In the Montreal of the 1920s, it was unquestionably Adrien Hébert who created the most masterly images of the modern city and its harbour buildings, as witness two fine works in the AGH collection – *Elevator No. 1* (c. 1929, cat. 57) and *Loading Grain, Montreal Harbour* (c. 1929–1930, fig. 42). These paintings are echoed in another remarkable piece belonging to the Gallery, *Ship Building* (fig. 43), executed in 1919 by Robinson, although this painting, apparently illustrating a shipyard belonging to the Canadian Vickers Company, in Montreal, should more properly be classified as war art.[27] The work displays a feature characteristic of Robinson's work prior to the 1920s – an entirely painted pictorial surface, which in this case is almost completely dominated by the lines of the gigantic grid formed by the scaffolding of a ship under construction.

The urban and industrial worlds sometimes overlap in images where workers are combined with mechanical forms or a rigorously architectural dynamic. Such modern-day "heroes" have played only a small role in Canadian painting, but they triumphed briefly in a handful of works from the 1940s, illustrations of the industrial war effort by progressive artists like Fred Taylor, Fritz Brandtner and Louis Muhlstock. Taylor's *Chipping the Bedplate of an Engine for a 10,000 ton Cargo Ship: In the Iron Foundry, Dominion Engineering Works, Lachine, Quebec, 14–5–43* (1943, fig. 44) is a splendid example.

## The 1930s and Early 1940s: The Complexity of Figurative Modernity

For many members of the generation of artists who began their careers in the 1930s, the urban space became a veritable laboratory for formal experimentation. Marian Dale Scott and Fritz Brandtner drew inspiration from the city in works whose modernism clearly reveals their authors' familiarity with contemporary international movements.[28] Although there are no examples of this urban facet of their work in the collection, two paintings

belonging to the AGH are of interest for the light they throw on certain features of these artists' formal explorations.

The first, Scott's *Bud* (c. 1939, fig. 45) – a recent acquisition – is an excellent example of a series on the plant world that the artist produced concurrently with her works on urban and industrial subjects. During the 1930s, these two themes nourished Marian Scott's pursuit of a "significant art" that combined an innovative and abstractionist pictorial approach with a meditation on the relationship of human beings to their own era and society, but also to the cosmos and the living world in general. In this quest, her work was influenced by modernist trends originating in both Europe and the United States. In the case of *Bud*, the links to Georgia O'Keeffe are evident.

Like Scott, Fritz Brandtner was part of Montreal's progressive movement. In 1936, this socially *engagé* artist joined forces with the Communist doctor Norman Bethune to found the Children's Creative Art Centre (in which Marian Scott was also involved), whose goal was to offer children from disadvantaged backgrounds the opportunity to discover the joy and freedom of artistic expression. Although he cannot be described as a landscapist, Brandtner did produce a few works in the genre, including *Fall* (fig. 46), a watercolour dating probably from the early 1940s. Brandtner explored a number of different artistic approaches, but the style he employed for *Fall* is consistent with that of his earlier landscapes. His main formal tools here are simplification and geometricization. The masses of the trees have been reduced to geometric shapes (rhombus, triangle, etc.), often surrounded by a heavy outline. Within these forms, the artist has overlaid the background colours with patches of paint, decorative motifs and lines to represent foliage and branches – rather in the style of Raoul Dufy. This Brandtner watercolour can be compared to another work in the collection, Anne Savage's *Autumn Fantasy* (fig. 47), almost certainly executed somewhat later. The title of Savage's work is a hint that the artist was allowing herself a little more liberty than was her wont. Although the basic composition – a river in the centre, framed by mountains and forest – is a Savage classic, the large blue and yellow zigzag at its heart and the fluid whirlwind of huge yellow leaves in the foreground are indeed signs of an unusual "spontaneity." The kinship between this work and Brandtner's *Fall* is obvious in the distinct contours that outline both the leaves and the geometric shapes of the decoratively handled trees.

Among the Montreal artists who showed a definite interest in the urban world, and more especially in the interaction between man and the modern city, we should note Thomas R. MacDonald, who moved to Hamilton in 1947, and Philip Surrey, who settled in Montreal in 1937. Although two works by them presented in the exhibition – Surrey's *The Lovers* (c. 1957, cat. 87) and MacDonald's *One A.M.* (1956, cat. 86) – were painted in the 1950s, the rather disquieting oddness of their electrically-lit nocturnal atmospheres echoes paintings executed by these artists a couple of decades earlier. *One A.M.* is in fact another version of a MacDonald picture with the same title dating from 1936 (fig. 6), whose resemblance to the work of Edward Hopper speaks of Canadian artists' awareness of the American art scene.

Other Montreal painters, members of the city's Jewish community – several of whom were founding members of the CAS – made the theme of the city an important part of their artistic approach. This group included Louis Muhlstock, Alexander Bercovitch, Jack Beder, Sam Borenstein and Ernst Neumann.[29] As well as landscapes by Muhlstock and Bercovitch, the Gallery's collection includes several of Neumann's prints. One of these, *Unemployed #6* (1933, fig. 48), exemplifies the concern among these artists for the poverty that plagued cities during the Depression.

In a spirit sometimes reminiscent of Daumier, whom he admired, Neumann also illustrated the worlds of law and of art, as witness *Artist and Critics* (c. 1931), *Studio Scenes No. 2: The Rest Period* (c. 1932) and *Studio Scene: The Strong Man* (1931 fig. 49). These two last works embody an interesting inversion: in *The Rest Period*, whose composition is remarkably similar to the central part of Courbet's painting *The Artist's Studio* (1854–1855, Paris, Musée d'Orsay), the live model is a woman, while the sculpture in the right background is a male figure; in *The Strong Man*, however, a work steeped in "virility," the almost-nude model – Canadian weightlifting champion Arthur Dandurand – displays his muscles in front of the amputated curves of a plaster Venus, seen towards the rear on the left. In both cases, there are clear links to the realist tradition of France and, even more markedly, of the United States. Neumann's sculpture entitled *Boxer* (n.d., cat. 78) offers another example of this realist current.

Social realism is also represented in the collection by the work of Jack Humphrey and Miller Brittain, both from New Brunswick and members of the CAS. At the time they were active, the city of Saint John was home to a dynamic group composed of poets, theatre people (members of the Theatre Guild of Saint John) and artists, including Humphrey, Brittain and Avery Shaw. The studio of Ted Campbell, who also taught Fred Ross, became a meeting place for these creators, many of whom shared the conviction that art should involve social commitment.[30] Concerned like their Montreal colleagues with the question of art's social function – this against the backdrop of the Depression and the rise of Fascism – the group was drawn to the work of the Mexican and American muralists. Several of Brittain's paintings from the 1930s, as well as the sketches he made for a series of murals for the Saint John Tuberculosis Hospital (never executed), were conceived in the same spirit of social realism that inspired a number of muralists working in the U.S. Even the simple drawing of a *Female Nude* (1936, fig. 50) belonging to the AGH can be read as a "social" comment, given the model's extreme thinness and the almost pathological deformation of her body.

Like many artists during this troubled period, Brittain and Humphrey also made portraits of children and adolescents whose sad gaze and sometimes miserable circumstances inspire compassion. Although there are no signs of poverty in Humphrey's painting *The Pensive Child* (*Winnie*) (1941, fig. 51), the general mood of the work allows us to place it alongside the many other pictures of "children of the Depression" produced by Canadian artists of the time. Finally, the recent donation of another work by Humphrey, *Fields and Hills, Taxco* (1938), serves as a reminder that Mexico was one more reference point for several of these artists, who travelled there regularly from the 1930s on.

## Pushing the Boundaries of Figurative Modernity

In the Montreal of the 1930s, and very swiftly after 1937, the impact of artists' associations, exhibitions and critical support combined to give credibility to a new, non-nationalistic form of modernity that was increasingly open to international movements, especially Cubism. Even Surrealism and abstraction were now a subject of discussion in modern circles. The situation was clearly ripe for the creation of an organization like the CAS, founded in 1939 by John Lyman.

Although a number of the artists involved in these developments were preoccupied by contemporary social issues, their quest for a "significant art" focused increasingly on a conception

of the painting as essentially a place in which to express – as John Lyman pointed out – the relations between forms and colours.[31] As Robert Ayre put it in his review of the exhibition *Art of Our Day in Canada*, Montreal's modern artists had turned away from Canada's untamed landscapes and towards humanity, seeking in the privacy of their studios the very secrets of painting.[32]

The subject of a painting mattered less and less. The human figure and the landscape had gradually shed their ideological baggage to become simply objects of formal exploration. This development was reflected during the 1940s in the increasing importance of the still life and the studio scene. The AGH possesses some particularly fine examples in these two genres, among them *Studio Interior* (c. 1947–1948, fig. 52) by Goodridge Roberts, *Still Life with White Pitcher* (1949, fig. 53) by Stanley Cosgrove and *Still Life with Rubber Plant* (1948, fig. 54) by Jacques de Tonnancour. The compositional techniques employed in these works – the flattening of planes, juxtaposition of multiple spaces, and use of a variety of textures and bright colours – all denote the growing influence of the School of Paris.

Alfred Pellan's return from Europe in 1940 and Paul-Émile Borduas's rapid move towards Automatisme (he exhibited his first abstract works in 1942)[33] would trigger entirely new debates in Montreal. Surrealism (to which Pellan was occasionally drawn: *Spinning Top Vertigo*, 1947, fig. 55) and the abstraction that resulted from a spontaneous gesturality nourished by the subconscious and the surrealist realm (Borduas, *Masks and Raised Finger*, 1943, fig. 56) would become the principal poles of the art that henceforth defined itself as "avant-garde."

This more radical modernism, practiced by francophone artists, would soon overshadow the figurative modernity associated largely (although not exclusively) with anglophone artists of the preceding generations. It is this modernity – and its manifestation in numerous Quebec works belonging to the AGH – that has been the focus of this essay. ~

Notes————————

1. Robert Ayre, "Observations on a Decade, 1938–1948: Recent Developments in Canadian Painting," *Journal, Royal Architectural Institute of Canada*, vol. 25, no. 1 (January 1948), p. 13.

2. The *Prisme d'Yeux* manifesto, written by Jacques de Tonnancour and published in February 1948, was signed by Louis Archambault, Léon Bellefleur, Jacques de Tonnancour, Albert Dumouchel, Gabriel Filion, Pierre Garneau, Arthur Gladu, Je Anonyme (Jean Benoît), Lucien Morin, Mimi Parent, Alfred Pellan, Jeanne Rhéaume, Goodridge Roberts, Roland Truchon and Gordon Webber. *Refus global* appeared in August 1948. Authored by Paul-Émile Borduas, it was signed by him and Madeleine Arbour, Marcel Barbeau, Bruno Cormier, Claude Gauvreau, Pierre Gauvreau, Muriel Guilbault, Marcelle Ferron, Fernand Leduc, Thérèse Leduc, Jean-Paul Mousseau, Maurice Perron, Louise Renaud, Françoise Riopelle, Jean-Paul Riopelle and Françoise Sullivan.

3. Through their various gifts, H. S. Southam and his family provided the AGH with a fine selection of works reflecting the development of modern art in Quebec. During his lifetime, H. S. Southam donated *Masks and Raised Finger* (1943) by Borduas, *Coronation* (1937) by Sarah Robertson, *Still Life* (n.d.) by Anne Savage, *Head of a Woman* (1948) and *Still Life with Rubber Plant* (1948) by Jacques de Tonnancour and *Still Life with White Pitcher* (1949) by Stanley Cosgrove. On his death, he bequeathed *Autumn Fantasy* (n.d.) by Savage, *Farmhouse Window* (1938) by Prudence Heward, and *Autumn Landscape with Fir Trees* (n.d.), *Autumn Landscape* (n.d.) and *Field, Lake and Hills* (1945) by Goodridge Roberts. Finally, in memory of her husband, Senator Duncan R. MacTavish, Janet Southam MacTavish donated *Untitled Composition* (n.d.) by Riopelle.

4. I have opted to talk here of the modern tradition of Montreal rather than of Quebec at large – on the one hand because this is what Robert Ayre was referring to, rather than the "regionalist" tradition that also played a certain role in the development of modern movements (one thinks, for instance, of the work of such artists as Clarence Gagnon, Suzor-Coté, Ozias Leduc and André Biéler), and on the other because owing to its particular history the collection of the AGH does not encompass this more francophone regionalism, nor is it the focus of this exhibition.

5. Quoted in Dennis Reid, *"Our Own Country Canada": Being an Account of the National Aspirations of the Principal Landscape Artists in Montreal and Toronto, 1860–1890* (Ottawa: National Gallery of Canada, 1979), p. 273. This book is the definitive reference on the subject of this landscape movement.

6. Laurier Lacroix, "The Surprise of Today Is the Commonplace of Tomorrow: How Impressionism Was Received in Canada," in Carol Lowrey (ed.), *Visions of Light and Air: Canadian Impressionism, 1885–1920* (New York: Americas Society Art Gallery, 1995), p. 42.

7. "Tonalism [which] enjoyed its greatest popularity between the early 1880s and c. 1915 … emulated Impressionism's concern with ephemeral effects of light and atmosphere, but emphasized a dreamy moodiness through the harmonious diffusion of light, a palpable atmosphere, the softening of outlines, and the resulting effect of unity … Dusk and evening, as well as vaporous atmospheric effects, were favourite themes for tonalist-inspired artists, to whom they offered the opportunity both to impose a general uniformity and to minimize the clarity of boundaries between forms, all in the name of an enhanced poetic effect." Brian Foss "Sympathetic Self Expression: Mary Hiester Reid and Aesthetic Ideals," in Brian Foss and Janice Anderson, *Quiet Harmony: The Art of Mary Hiester Reid* (Toronto: Art Gallery of Ontario, 2000), pp. 63–65.

8. Much of the information in this section is taken from Carol Lowrey, "Into Line with the Progress of Art: The Impressionist Tradition in Canadian Painting, 1885–1920," in Lowrey (ed.), *Visions of Light and Air*, pp. 16–39.

9. Aside from Clarence Gagnon (by whom the AGH possesses a number of works on paper), many other French-speaking Quebec artists were part of this network of Canadians in Europe.

10. See Nicole Cloutier (ed.), *James Wilson Morrice 1865–1924* (Montreal: The Montreal Museum of Fine Arts, 1985).

11. Lowrey, "Into Line with the Progress of Art," in Lowrey (ed.), *Visions of Light and Air*, p. 18.

12. Cullen joined the Canadian War Memorials Fund in March 1918. His four stepsons, including Robert Pilot, were already in the army. Although Pilot himself depicted several war scenes, he does not seem to have been an official war artist. Jackson joined the CWMF after having seen active service in a reserve battalion. See Maria Tippett, *Art at the Service of War: Canada, Art and the Great War* (Toronto: University of Toronto Press, 1984), pp. 14–15.

13. I refer those readers interested in the question of the development of modern art and criticism between the wars to Esther Trépanier, *Peinture et modernité au Québec 1919–1939* (Quebec City: Éditions Nota bene, 1998).

14. As Susan Avon has shown in her master's thesis *The Beaver Hall Group and Its Place in the Montreal Art Milieu and the Nationalist Network* (Montreal, Concordia University, 1994), the precise composition of the Group is difficult to determine. It grew up around the kernel formed by Henrietta Mabel May, Randolph Hewton, Edwin Holgate and Lilias Torrance Newton. Additional "members" joined later, among them Prudence Heward, Sarah Robertson, Mabel Lockerby, Nora Collyer, Emily Coonan, Anne Savage, A. Y. Jackson, Kathleen Moir Morris and Ethel Seath. Other artists who were associated with those named in varying degrees (notably through having exhibited with them) include Albert Robinson, Henri and Adrien Hébert, Robert Pilot, André Biéler, Regina Seiden, Adam Sheriff Scott, Hal Ross Perrigard and Thurstan G. Topham.

15. See Charles C. Hill, *The Group of Seven: Art for a Nation* (Ottawa: National Gallery of Canada, 1995), pp. 178–181.

16. Montreal's francophone critics also used many terms connotative of virility to characterize the formal rigour of certain modern works, regardless of the sex of their creators. See Trépanier, *Peinture et modernité*, pp. 73, 97, 100, 251–253, 256, 299.

17. Group of Seven historian Frederick Housser declared that the artist had to "divest himself of the velvet coat" and "put on the outfit of the bushwhacker and prospector." F. B. Housser, *A Canadian Art Movement* (1926), quoted in Doris Shadbolt, *Emily Carr* (Ottawa: National Gallery of Canada, 1990), p. 67.

18. See the entry by Tobi Bruce (cat. 68), which compares Yulia Biriukova's painting *Prospector (Peter Swanson)* (1934) with Holgate's work.

19. For more on this subject, see Hill, *The Group of Seven*, chapter 10, pp. 173–193.

20. "My aim, as in the *Triumph of Flora*, is to marry the curves of women and the shoulders of hills." From Joachim Gasquet, *Conversations avec Cézanne (1921–1926)*, quoted in Raymond Jean, *Cézanne, la vie, l'espace* (Paris: Éditions du Seuil, 1986), pp. 309–310.

21. Lyman, writing in his journal. Quoted in Charles C. Hill, *Canadian Painting in the Thirties* (Ottawa: The National Gallery of Canada, 1975), pp. 40–42.

22. Aside from his sculptures of dancers, which epitomize the 1920s *garçonne*, Henri Hébert made many sketches of female nudes sporting short hair, high-heeled shoes and black stockings, a number of which are now at the Musée national des beaux-arts du Québec. See Janet M. Brooke, *Henri Hébert, 1884–1950. Un sculpteur moderne* (Quebec City: Musée du Québec, 2000).

23. Quoted in Suzanne Marchand, *Rouge à lèvres et pantalon. Des pratiques esthétiques féminines controversées au Québec, 1920–1939* (Montreal: Hurtubise HMH, Cahiers du Québec, 1997), p. 52. On the question of the modification of bodily traits, see especially chapter 2, "Le culte du corps : le discours de *La Revue moderne*."

24. John Lyman, "Art," *The Montrealer*, 1 December 1940, p. 20. Earlier that year, Lyman had written that although academic artists had hitherto been associated with representation of the human figure and independent painters with landscape, the parallel no longer held; in his view, there were over half a dozen artists who were currently expressing themselves more freely in their portrayals of the human figure "and who would like nothing better than to devote themselves entirely to it if they had any chance of making a living thereby." John Lyman, "Art, CAS Exhibition; Man in Art," *The Montrealer*, 1 January 1940, p. 19.

25. Paul-André Linteau, René Durocher and Jean-Claude Robert, *Histoire du Québec contemporain* (Montreal: Boréal Express, 1979), vol. 1, *De la Confédération à la crise*, p. 45.

26. The frightened look seems to have been intended, since the artist had actually asked the child to imagine that something dreadful had happened to her parents. This information was communicated to the AGH in 1997 by the model herself, Winnifred Tooey.

27. After three years working in a munitions factory, Robinson joined the CWMF, and was thus in a position to illustrate the industrial effort on the home front, notably in the naval shipyards of the Vickers factory, in Montreal. See Maria Tippett, *Art at the Service of War*, pp. 14–15, 56, 72, 91, and Jennifer Watson, *Albert H. Robinson: The Mature Years* (Kitchener, Ont.: Kitchener-Waterloo Art Gallery, 1982). Figure 8 in Watson's catalogue, *Starting the Freighter* (1919, Ottawa, Canadian War Museum) can be compared to the AGH's *Ship Building*. Special thanks to Alicia Boutilier for her help in clarifying this question of the war works by Robinson and other artists of the CWMF.

28. For more on Fritz Brandtner, see, among others, Helen Duffy and Frances K. Smith, *The Brave New World of Fritz Brandtner / Le meilleur des mondes de Fritz Brandtner* (Kingston: Agnes Etherington Art Centre, 1982). On Marian Scott, see Esther Trépanier, *Marian Dale Scott: Pioneer of Modern Art* (Quebec City: Musée du Québec, 2000).

29. For more on these artists, see Esther Trépanier, *Peintres juifs et modernité / Jewish Painters and Modernity, Montréal 1930–1945* (Montreal: Saidye Bronfman Centre, 1987).

30. For more on this group, see Tom Smart, *The Art of Fred Ross: A Timeless Humanism* (Fredericton: Goose Lane Editions, 1993).

31. This was the view of all the artists who, from 1931, were part of Lyman's circle. In the prospectus of the school known as The Atelier, which Lyman organized, the following statement appears in a text signed by Hazen Sise (although it may well have originated with Lyman, who later repeated it): "In its attitude towards art, The Atelier takes a simple, definite stand: the essential qualities of a work of art lie in relationships of form to form and colour to colour." Quoted in Frances K. Smith, *André Biéler, An Artist Life and Time* (Toronto and Vancouver: Merritt Publishing Company Limited, 1980), p. 76.

32. "We must then compare the 'Art of Our Day in Canada' with the 'Art of Our Yesterday in Canada' … What was Yesterday? … It was a grand time, a big, dramatic, heroic, if you like extravagant, optimistic time. Looking at the current show which is largely Montreal with European importations, we must remember that the Group [of Seven] was centred in Ontario. Montreal was never so exuberant; it has been closer to the studio than to the great outdoors. [Art of our Day …] turns inwards, it applies itself to more heart-searching and to more searching perhaps, after the secrets of painting. In another sense, it has broadened and deepened, going into humanity instead of into the woods." Robert Ayre, "Art News and Reviews – Exhibition of 'Art of Our Day' by Contemporary Arts Society Found Haunting and Significant," *The Standard* (Montreal), 7 December 1940, p. 7.

33. See François-Marc Gagnon, *Paul-Émile Borduas* (Montreal: The Montreal Museum of Fine Arts, 1988), pp. 94–95.

# À propos du canon

*Joyce Zemans*
*Professeur*
*York University, Toronto*

C'est dans la toute petite école du village de Vienna, au sud de London, en Ontario, pendant la Crise, qu'il a vu l'exposition itinérante de reproductions du Groupe des Sept qui l'a amené à consacrer sa vie à l'art. Il m'a toujours dit que sa passion pour l'art était née à ce moment-là[1].

— Noel Saltmarche parlant de son père, Kenneth Saltmarche, artiste et directeur-fondateur de l'Art Gallery of Windsor

Qu'est-ce qui attire les Canadiens vers une peinture et pourquoi la préfèrent-ils à d'autres ? Pourquoi certains tableaux deviennent-ils « canoniques », c'est-à-dire représentatifs d'un style, d'une époque ou d'une façon de voir le monde ? Est-ce une question d'esthétique ? Le public reconnaît-il immédiatement un « chef-d'œuvre » ? Ou y a-t-il d'autres raisons pour lesquelles certaines images restent gravées dans la conscience nationale ? Je tenterai ici de répondre à ces questions en étudiant le rôle que les reproductions ont joué pour faire entrer une œuvre dans l'imagination populaire. En prenant pour corpus les peintures de la collection de l'Art Gallery of Hamilton (AGH), j'examinerai comment certaines images en sont venues à symboliser un moment dans l'histoire ou, du moins, dans l'histoire de l'art canadien.

Conçue pour présenter les joyaux de la collection d'art historique de l'AGH, l'exposition *Souvenirs impérissables* s'ouvre et se clôt sur de telles images : *Le chasseur fantôme* (1888, cat. 6) de William Blair Bruce et *Cheval et train* (1954, cat. 85) d'Alex Colville. Ces œuvres, de même que trois autres datant de la fin du XIXe ou du début du XXe siècle – *Le fruit défendu* (1889, cat. 7) de George Reid, *Ave Maria* (1906, cat. 15) d'Horatio Walker et *Halage du bois, Beaupré* (1896, cat. 12) de Maurice Cullen – seront au cœur de ma discussion. Pour démontrer ce que j'avance, je conclurai par quelques réflexions sur une œuvre de qualité comparable, mais qui, jusqu'à tout récemment du moins, ne faisait pas partie du canon : *Femme sous un arbre* (1931, cat. 63) de Prudence Heward.

Si on leur demande quelle est, pour eux, l'image la plus mémorable dans l'art de leur pays, la plupart des Canadiens répondront *Vent d'ouest* (1916–1917, Toronto, Musée des beaux-arts de l'Ontario, fig. 72) ou *Le pin* (1916–1917, Ottawa, Musée des beaux-arts du Canada, fig. 73) de Tom Thomson, ou peut-être l'une des scènes d'hiver sur le lac Supérieur de Lawren Harris. La baie Georgienne est à jamais inscrite dans la conscience nationale depuis *Tempête, baie Georgienne* (1921, Musée des beaux-arts du Canada) de Fred Varley et *Une bourrasque en septembre, baie Georgienne* (1921, Musée des beaux-arts du Canada) d'Arthur Lismer, deux autres candidates possibles. Presque tout le monde se souviendrait d'un paysage. Les vues des grandes étendues sauvages – qui, dans bien des cas, sont celles de la région géographique du centre et ont pour la plupart été peintes avant 1930 – sont devenues synonymes du Canada pour les Canadiens de tous les coins du pays.

Il existe cependant d'autres images qui éveillent un semblable sentiment de familiarité et d'appartenance. En mai 2003, James Adams du *Globe and Mail* écrivait, dans sa critique de la grande rétrospective Tom Thomson tenue aux Musée des beaux-arts de l'Ontario, que Thomson était « le peintre canadien le plus célèbre, peut-être même le *meilleur* ». Mais, dans son passage sur *Vent d'ouest* (que tous les écoliers du Canada connaissent), Adams ajoutait que cette immense huile de Thomson était « tout aussi profondément gravée dans la conscience canadienne que ce damné cheval noir fonçant vers un train qu'Alex Colville a peint il y a quarante-neuf ans[2] ».

La plupart des Canadiens reconnaîtraient tout de suite *Vent d'ouest* et seraient probablement en mesure d'en nommer l'auteur, Thomson, l'archétype du peintre canadien, héros romantique, figure légendaire. Pourtant, Adams laisse entendre que nous reconnaîtrions tout aussi aisément *Cheval et train* d'Alex Colville. Comment ces images ont-elles pu à ce point marquer nos esprits alors que si peu d'entre nous avons vu les « vrais » tableaux et ne peuvent qu'en imaginer les dimensions et la facture ?

Dans son exposition de 1966, *Images for a Canadian Heritage*, la conservatrice Doris Shadbolt réunissait les œuvres qui, selon elle, avaient « captivé » l'imagination des Canadiens et servi d'assises à la construction des récits fondateurs du pays. Leur pérennité, supposait-elle, ne tenait pas seulement à leur qualité artistique, ou à leur importance historique ou sociologique, mais à « un mélange unique d'événements, un condensé d'expériences inoubliables que seul le temps, pour des raisons qui lui sont propres, peut établir[3] ». *Le chasseur fantôme*, *Le fruit défendu* ainsi que *Cheval et train* faisaient tous trois partie de cette exposition.

Chacun d'entre nous a ses tableaux favoris dans les musées qu'il fréquente, des œuvres qui ont une résonance et qu'il prend plaisir à revoir. Même ceux qui en sont à leur première visite au musée se laissent parfois arrêter par une image – une image qui les touche particulièrement et va chercher quelque chose de familier au fond de leur subconscient. À l'AGH aussi, il y a des favorites, des œuvres qui plaisent à un vaste public. Beaucoup d'entre elles font maintenant partie du canon national. Plus qu'une simple collection de chefs-d'œuvre, ces images possèdent « cette présence et cette puissance particulières qui leur permettent de se transposer dans l'imagination et d'y laisser une marque indélébile[4] ». Toutes illustrent un aspect ou un autre de l'expérience canadienne. Comme le disait Doris Shadbolt, « elles parlent toutes de nous[5] ». J'ajouterais qu'elles nous parlent aussi *à nous*. Les peintures de Hamilton choisies ici pour discussion ne sont pas seulement représentatives du travail de l'artiste, elles sont devenues les signifiants par excellence d'une période stylistique ou historique. Régulièrement, elles sont exposées et reproduites, non seulement à Hamilton, mais au Canada et à l'étranger.

Bien des raisons expliquent que certaines œuvres accèdent à ce statut d'icône et plusieurs sont interreliées. D'abord, il y a l'œuvre elle-même : comment réagissons-nous devant elle, et pourquoi ? La place de l'artiste dans l'histoire de l'art est un critère essentiel, tout comme l'importance de l'œuvre dans l'ensemble de sa production. Néanmoins, pour entrer dans l'imaginaire, l'œuvre doit être accessible à un vaste public. Or, comme en témoigne la citation sur Kenneth Saltmarche placée en exergue, il n'est pas nécessaire qu'elle ait été vue dans sa version originale pour laisser une marque indélébile. Le critique d'art Walter Benjamin était d'avis que la reproduction enlève à l'original une part de son aura. Pourtant, on pourrait soutenir que l'art canadien a été, dans une large mesure, défini au moyen d'images de substitution et d'obscures transactions culturelles qui nous font paraître la « vraie » peinture familière même si nous ne l'avons jamais vue de nos yeux.

Grâce à leur reproduction sous forme d'estampes ou d'affiches, ou dans des livres sur l'art ou l'histoire du Canada, ou d'une foule d'autres manières, ces images se sont imprimées dans notre conscience. Un peu de recherche, et la remarque de James Adams à propos de *Cheval et train* d'Alex Colville ne surprend plus. Depuis les années 1970, non seulement cette peinture a figuré dans de nombreux livres sur l'art canadien, elle a aussi été largement diffusée sur des affiches[6]. Peut-être s'est-elle logée à notre insu dans notre subconscient quand nous l'avons aperçue sur la pochette du disque *Night Vision* (1973) de Bruce Cockburn (ou, plus récemment, sur le site web de Cockburn) ou encore sur la couverture de livres aussi divers que *The Studhorse Man* (1982) de Robert Kroetsch, *Economics, Enlightenment and Canadian Nationalism* (1993) de Robert Wright[7] ou *L'Homme qui souriait en dormant* (1995) de Jean Marcoux. Elle est aussi reproduite dans le *Canadian Writer's Companion* (1995) d'Anthony Luengo pour aider les lecteurs à reconnaître une phrase. Parmi les exemples donnés, on trouve : « Alex Colville est un peintre réputé. "Cheval et train" [est] une de ses œuvres les plus célèbres[8]. »

# Au bon endroit, au bon moment

Il est fascinant de voir comment certains tableaux de la collection historique de l'AGH en sont venus à faire partie du corpus d'œuvres considérées comme emblématiques de l'art canadien et à occuper une place centrale dans ce canon. Ce processus est particulièrement intéressant quand on sait que le Musée n'a commencé à constituer sérieusement sa collection que dans les années 1950, soit bien longtemps après l'achèvement de la plupart de ces tableaux et le décès des artistes qui les avaient peints.

En 1953, au moment où le Musée s'installait dans son nouvel édifice et que T. R. MacDonald bâtissait la collection, Bruce, Reid, Walker et Cullen étaient déjà des peintres réputés dont la contribution était reconnue dans les ouvrages sur l'art[9]. Colville n'en était encore qu'au début de sa carrière, mais l'originalité de son travail ne passait pas inaperçue. Néanmoins – sauf pour *Le chasseur fantôme* de Bruce, une peinture maintes fois exposée et reproduite depuis son acquisition par l'AGH en 1914 –, les œuvres que nous étudions ici restaient assez peu connues. Comment sont-elles parvenues, en à peine plus d'une décennie, à occuper une place centrale dans l'histoire de l'art canadien ?

Cela tient en grande partie à un concours de circonstances. Dans les années 1950, grâce aux nouvelles techniques d'impression en couleur, les livres d'art sont devenus non seulement d'importantes sources d'information pour le public, mais de précieux instruments de travail pour les artistes et les historiens. À partir de 1952, l'AGH a publié régulièrement des reproductions de ses œuvres dans son bulletin[10]. Les histoires de l'art au Canada n'étaient pas nouvelles, mais au moment où l'AGH s'activait à enrichir sa collection à la fin des années 1950 et dans les années 1960[11], les préparatifs des célébrations du centenaire de la Confédération intensifiaient le sentiment national et notre désir de raconter nous-mêmes notre passé.

En 1954, Malcolm Ross avait écrit que les Canadiens étaient « encore un peuple en devenir, en mouvement[12] ». Une décennie plus tard, ils en étaient déjà aux bilans et aux projets. C'était l'époque où, en prévision de son centenaire en 1967, le pays commençait un sérieux inventaire de ses réalisations. En art, cet esprit se manifesta dans une profusion d'expositions et de livres célébrant tous la création canadienne. Malgré le nombre encore restreint de musées[13], il y eut un effort concerté pour représenter la diversité des collections publiques canadiennes dans les publications et les expositions. Le moment était propice pour l'introduction d'œuvres nouvelles (quoiqu'attribuables à des artistes connus) dans le domaine public. *The Hamilton Spectator* soulignait ainsi les réalisations de l'AGH : « L'année du centenaire a accentué le sentiment de fierté que les membres du Comité féminin de l'Art Gallery of Hamilton [à qui ce musée doit bon nombre de ses acquisitions] éprouvent devant la collection permanente. Beaucoup de livres sur l'art canadien parus cette année contiennent des illustrations provenant du musée de Hamilton. » On lisait dans le même article ces paroles d'Evelyn Rahilly, membre du comité, qui avait déclaré à l'assemblée générale annuelle de 1967 : « Notre collection est maintenant reconnue pour son excellence[14]. »

Un coup d'œil sur les livres d'histoire de l'art publiés pendant cette période permet de mesurer l'importance de l'AGH. Le Musée des beaux-arts du Canada (appelé à l'époque Galerie nationale du Canada), qui a pour mandat de faire connaître l'art canadien, prit bien sûr l'initiative de plusieurs publications. En 1963, il publiait *L'évolution de l'art au Canada*. Dans un texte relativement court sur l'ensemble de l'art canadien jusqu'à cette date, le conservateur en chef de ce musée, Robert Hubbard (diplômé de l'université McMaster, qui avait prononcé une allocution à

la première assemblée générale annuelle de l'AGH en septembre 1949), discutait de quatre de nos cinq artistes de Hamilton (curieusement, sans mentionner George Reid). Il reproduisait également une œuvre de la collection de Hamilton, le déjà célèbre *Chasseur fantôme* de Bruce.

En 1966, quand Les Presses de l'Université Laval publièrent un autre ouvrage de nature historique, écrit celui-là par le conservateur de l'art canadien au Musée des beaux-arts du Canada et consacré exclusivement à la peinture, la situation avait changé. *La peinture au Canada des origines à nos jours*, de Russell Harper, devint la première étude exhaustive sur la peinture canadienne et le premier livre de grand format, bien illustré et bien documenté, sur ce sujet. Non seulement Harper y discutait de chacun de nos cinq artistes, mais il reproduisait les quatre œuvres historiques se trouvant à Hamilton. À propos de *Cheval et train* (qui ne fut reproduit que dans la deuxième édition de ce livre, parue en anglais seulement, en 1977), Harper disait néanmoins que ce tableau frisait le « surréalisme : un cheval noir galopant le long d'une voie ferrée vers un train qui fonce sur lui crée une atmosphère de crise[15] ». Le livre de Harper, qui fut l'un des grands ouvrages de vulgarisation sur la peinture canadienne, continua à façonner la conscience populaire durant des décennies. (*A Concise History of Canadian Painting* de Dennis Reid, publié en 1973 en format de poche, était surtout conçu comme un manuel; sortant des sentiers battus, l'auteur y présentait moins d'images emblématiques et familières. On y trouvait néanmoins des discussions sur tous les artistes étudiés ici, de même que des reproductions du *Fruit défendu* de George Reid et de *Halage du bois, Beaupré* de Maurice Cullen.)

Une autre publication du centenaire, *Great Canadian Painting : A Century of Art*, écrite sous la direction d'Elizabeth Kilbourn et Frank Newfeld, et parue en 1966, s'adressait au grand public[16]. Ce beau livre d'un prix abordable dans lequel on trouvait des reproductions des « chefs-d'œuvre » de l'art canadien était, comme son titre l'indique, destiné à présenter le meilleur de la peinture canadienne. Les cinq tableaux de la collection de Hamilton discutés ici y figuraient, avec un résumé de leur histoire et de celle de l'artiste.

La même année, la Vancouver Art Gallery Association publiait *Images for a Canadian Heritage* pour accompagner une exposition soulignant un autre événement historique, le centième anniversaire de la fusion de la colonie de l'île de Vancouver avec la colonie de la Colombie-Britannique. Dédié aux citoyens de la « magnifique Province de la Colombie-Britannique », ce livre contenait des reproductions du *Chasseur fantôme* de Bruce ainsi que de *Cheval et train* de Colville. La conservatrice Doris Shadbolt y écrivait : « Ces [œuvres] nous paraissent, à nous, essentiellement nationales, alors qu'au reste du monde, elles paraissent, dans le meilleur sens du terme, régionales. [...] Pourtant, toutes sont nées d'une certaine forme de conscience et d'expérience particulière à notre pays[17]. »

Le catalogue d'une autre exposition du centenaire tenue au Musée des beaux-arts du Canada en 1967, *Trois cents ans d'art canadien*, par Robert Hubbard et Jean-René Ostiguy, contenait des œuvres de nos cinq artistes, mais seulement une reproduction du *Fruit défendu* de Reid. La même année, Clare Bice, conservateur au London Public Library and Art Museum et conservateur invité au pavillon du gouvernement canadien à l'Expo '67, organisait *La peinture canadienne 1850–1950*. Cette exposition itinérante fit le tour du pays et fut présentée à Hamilton au printemps de 1967. Elle proposait un survol historique à l'aide d'œuvres empruntées à diverses collections, dont *Le chasseur fantôme* et *Halage du bois, Beaupré*, toutes deux illustrées dans le catalogue.

Le choix de ces conservateurs et auteurs variait légèrement selon, par exemple, l'importance de l'artiste ou de l'œuvre et la nécessité d'une représentation géographique ou institutionnelle. La facilité d'accès à l'image restait toutefois un dénominateur commun. Si quelques-unes des œuvres exposées ou reproduites provenaient de collections particulières, la majorité d'entre elles étaient, avant d'accéder au canon, entrées dans le domaine public. Doris Shadbolt faisait remarquer que beaucoup d'œuvres qu'elle avait sélectionnées pour l'exposition ou le catalogue appartenaient à des collections publiques ou étaient déjà fort connues du public grâce aux expositions ou aux reproductions. Comme la plupart de ses collègues, Shadbolt avait cherché des œuvres qui avaient « frappé l'imagination populaire[18] » ou étaient susceptibles de le faire.

Il devient évident que l'AGH a commencé à travailler intensément à l'enrichissement de sa collection à un moment propice – au moment même où écrire l'histoire de l'art canadien devenait une entreprise sérieuse. Beaucoup de monographies ont été publiées depuis cette époque, mais jamais on n'a retrouvé pareille volonté de composer un panorama de l'art canadien, ni disposé de telles ressources pour le faire. Même si chaque artiste étudié ici avait déjà fait son chemin jusque dans l'histoire, on peut dire que c'est parce que T. R. MacDonald s'est attaché à bâtir (avec l'avantage du recul) une collection témoignant de l'histoire de l'art canadien au moment même où, partout au pays, on entreprenait (en tirant profit des nouvelles techniques d'édition) de créer une nouvelle histoire de l'art du Canada, que les cinq œuvres de Hamilton sont entrées (et restées) dans le canon canadien.

Au cours des années suivantes, le statut de ces œuvres s'est consolidé. *Through Canadian Eyes: Trends and Influences in Canadian Art 1815–1965*, catalogue d'une exposition organisée en 1976 pour le Glenbow-Alberta Institute par Moncrieff Williamson, directeur du Confederation Centre Art Gallery de Charlottetown, contenait des reproductions du *Chasseur fantôme*, du *Fruit défendu* et de *Halage du bois, Beaupré*. De nos cinq artistes, seul Horatio Walker était passé sous silence. En 1976, dans un livre abondamment illustré qui connut beaucoup de succès, *Enjoying Canadian Painting*, Patricia Godsell commentait nos cinq artistes et publiait des reproductions du *Chasseur fantôme* de Bruce et de l'*Ave Maria* de Walker. Vingt-cinq ans plus tard, le plus sélectif *Canadian Art From its Beginnings to 2000* d'Anne Newlands reproduisait trois des œuvres de Hamilton : *Le chasseur fantôme*, *Le fruit défendu* ainsi que *Cheval et train*.

Bien que des peintures de Maurice Cullen en régulièrement figuré dans des textes sur l'art pendant la première moitié du XXe siècle (l'importance de cet artiste étant depuis longtemps établie), ce n'est qu'après son entrée dans la collection de l'AGH en 1956 que *Halage du bois, Beaupré* commença à être reproduit dans des ouvrages sur l'art canadien. Depuis cette époque, ce tableau est devenu synonyme de la production de Cullen et, pour beaucoup de Canadiens, il demeure celui dont le style et le sujet illustrent le mieux l'influence de Cullen comme précurseur et inspirateur du Groupe des Sept.

Certes, les critères et les modes de chaque époque (dont l'historien d'art Newton MacTavish disait pertinemment et avec un peu d'insolence qu'ils étaient souvent confondus) ont influé sur le choix d'artistes et d'images figurant dans les livres populaires sur l'art, tout comme le fait que les livres et expositions s'adressaient habituellement au grand public. Néanmoins, d'un auteur à un autre, le consensus dans le choix des artistes demeure remarquable.

Les goûts personnels ont également eu une influence. T. R. MacDonald faisait lui-même de la peinture de figures et il avait un faible pour ce genre qui, après avoir joué un rôle négligeable dans

le canon canadien, commençait à y prendre de l'importance[19]. On ne s'étonnera pas donc que, même si l'art canadien continue d'être rempli de paysages inhabités, aucune des œuvres de Hamilton dont il est question ici ne soit un paysage pur. Reflets de l'époque victorienne dont elles sont issues, les œuvres de Bruce, Reid et Walker ont toutes une forte composante narrative, et chacune raconte ou évoque une histoire différente. Chacune correspond à un moment particulier de l'histoire sociale du Canada et à une période stylistique particulière de l'histoire de l'art canadien. Bien que le paysage soit un élément important dans toutes ces œuvres hormis celle de Reid, la figure humaine prédomine, sauf dans *Halage du bois, Beaupré*, mais même dans ce tableau de Cullen, elle est présente.

Il convient à ce stade de faire une autre remarque. Toutes les œuvres discutées ici sont des peintures. Les peintures sont bidimensionnelles, habituellement intéressantes par la couleur, faciles à reproduire (et, ajouterais-je, à exposer). Quand, dans les années 1930 et 1940, les directeurs de musées tels Eric Brown et Harry McCurry du Musée des beaux-arts du Canada, et les artistes tels A. Y. Jackson et Lawren Harris préconisaient des programmes de reproductions de qualité pour diffuser l'art canadien, ils avaient presque exclusivement des peintures à l'esprit. À la fin des années 1940, l'AGH a commencé à vendre tant des reproductions d'œuvres du Musée des beaux-arts que des reproductions de peintures de sa propre collection, surtout sous forme de cartes postales et de cartes de Noël. Ces reproductions faisaient connaître la collection, mais elles étaient aussi une bonne source de revenu. À la fin de 1950, la vente de ces reproductions généra suffisamment de profits pour que l'AGH achète *La cabane* (1949) d'A.Y. Jackson. Presque tout de suite, le musée annonça qu'il publierait bientôt une reproduction lithographique de cette peinture[20]. La sculpture, toutefois, retenait moins l'attention. Même une sculpture comme *Rosie la riveteuse* (cat. 79) de John Sloan, qui est pourtant une favorite de Hamilton, reste peu connue à l'extérieur de cette ville. Dans les décennies qui suivirent leur acquisition par l'AGH cependant, on tira, des tableaux de Reid, Cullen et Colville, des affiches qui furent vendues au Canada et à l'étranger dans des musées, galeries d'art, grands magasins et boutiques d'encadrement. Il ne fallut pas longtemps pour que l'on voie ces affiches accrochées aux murs des maisons, des bureaux et des édifices publics partout au Canada[21].

## Pourquoi ces œuvres-là ?

Nous l'avons dit, les cinq images sur lesquelles porte notre discussion figuraient toutes en 1966 dans le livre *Great Canadian Painting*. Chacune, pour reprendre les termes de Doris Shadbolt, avait captivé l'imagination des Canadiens et servi d'assise à la construction des récits fondateurs du pays. Pourquoi ? L'analyse de ce que l'on dit de ces œuvres dans les divers ouvrages répond à cette question, mais aucune raison ne peut à elle seule expliquer ce phénomène. Si ces œuvres se sont imprimées dans la conscience collective, ce n'est pas simplement à cause de leur importance historique ou sociologique, c'est grâce à « un mélange unique d'événements, un condensé d'expériences inoubliables ». C'est ce mélange que je me propose d'étudier ici. Le rôle de l'artiste dans l'histoire de l'art canadien ainsi que la valeur esthétique et historique de chaque peinture me serviront de paramètres pour la discussion des œuvres sélectionnées.

William Blair Bruce est un cas fort intéressant. Né à Hamilton en 1859, il partit étudier à Paris en 1881 et passa presque toute sa vie à l'étranger. Il fit carrière en Europe, et c'est là qu'il fit aussi sa renommée. Il exposa au Salon de Paris, peignit pour le marché européen, et le goût européen de son époque eut

une énorme influence sur son choix de sujets. Si sa famille n'avait légué son œuvre à l'AGH en 1914, Bruce n'aurait jamais, selon moi, accédé au canon canadien.

En décrivant Bruce comme un « gars de l'Ontario » dans *The Fine Arts in Canada* en 1925 – sans doute le premier véritable panorama de l'art canadien publié au XXe siècle –, Newton MacTavish faisait en sorte que le Canada se réapproprie cet artiste[22]. MacTavish voyait en Bruce *le* peintre des années 1880, laissant entendre que même si lui et son contemporain Paul Peel avaient tous deux contribué au « remarquable progrès esthétique des années 1890 », la production de Bruce était « plus intéressante » et méritait une « position plus élevée dans le canon[23] ». Cet éloge garantissait à Bruce, dont la carrière s'était déroulée à l'extérieur du pays, une place dans l'histoire de l'art du Canada. En reproduisant *Le chasseur fantôme* dans son livre, MacTavish contribuait aussi à lui donner le statut d'icône. Même si elle ne fut exposée au Canada qu'après la mort de l'artiste, cette peinture « résolument nationaliste » en viendrait à représenter Bruce pour le public canadien[24].

Le choix du sujet joue certainement un rôle dans la popularité d'une œuvre. Contrairement aux peintures européennes de la même époque, qui montraient souvent la nature généreuse, *Le chasseur fantôme* (exécuté à Giverny, en France) illustre le thème canadien, maintenant familier, de l'affrontement avec une nature hostile et menaçante. Si son style, où les influences impressionnistes sont manifestes, est typique des salons parisiens de la fin du XIXe siècle, son sujet ne l'est pas. Shadbolt décrit « le trappeur angoissé, dont les appréhensions s'incarnent dans le "chasseur fantôme" », ajoutant que « ce grand tableau, entièrement peint dans des tons spectraux de bleu-gris, rend bien l'envoûtement et la terreur du Nord lointain et glacé[25] ». Bruce avait espéré que ce drame exotique canadien plaise au public du Salon français pour lequel il l'avait créé. Mais en fait, ce sont les Canadiens qui furent captivés par le caractère dramatique de cette scène d'hiver. Plus tard, l'image fut associée à une légende amérindienne, quoiqu'interprétée par un poète romantique américain de la fin du XXe siècle, ce qui contribua à l'immortaliser[26]. Tourmentée et obsédante, la peinture est restée, avec la légende qu'elle évoque, une image centrale du canon canadien.

La place de l'artiste ontarien George Agnew Reid dans l'histoire lui fut assurée non seulement par sa propre production – qui lui valut des prix et des expositions à l'étranger –, mais par le rôle clé qu'il joua dans le développement de l'art canadien et de ses institutions. Reid enseigna à la Central Ontario School of Art and Design et à son successeur, l'Ontario College of Art, et il en fut également directeur. Président de l'Ontario Society of Artists et de l'Académie royale des arts du Canada, il eut énormément d'influence sur la formation du Musée des beaux-arts du Canada et la création de l'Art Gallery of Toronto (aujourd'hui le Musée des beaux-arts de l'Ontario). Sa position philosophique selon laquelle « morale et esthétique, à leur sens le plus élevé, ne peuvent être séparés[27] » l'amena également à défendre l'art mural et l'art public en général. Newton MacTavish lui a consacré un chapitre de son livre[28].

Reid, qui avait étudié au Canada, en France et aux États-Unis, croyait fermement à la tradition académique et ses trois années passées à la Pennsylvania Academy of Fine Arts sous la direction du réaliste américain Thomas Eakins l'avaient profondément marqué[29]. De fait, dans le catalogue de l'exposition *Through Canadian Eyes* en 1976, Moncrieff Williamson attribue à Reid le mérite d'avoir introduit la méthode d'Eakins à Toronto[30]. Représentant du réalisme nord-américain de la fin du XIXe siècle, Reid a été diversement décrit comme un « peintre de genre »

(par Russell Harper), comme « l'un des plus importants réalistes canadiens » (par Paul Duval) et comme un interprète du « réalisme compatissant » (par Christine Boyanoski)[31].

*Le fruit défendu* illustre particulièrement bien l'influence d'Eakins dans l'émergence d'une tradition réaliste canadienne. Achetée à Reid lui-même à Philadelphie vers 1890 après son exposition à la Pennsylvania Academy, cette peinture n'est pas entrée dans le domaine public avant que l'AGH ne l'acquière d'un marchand à Montréal en 1960. Quelques années plus tard, elle était régulièrement reproduite, ce qui ne surprend guère étant donné l'intérêt universel que présente son évocation de l'enfance en milieu rural. La composition est facile à comprendre et l'attrait psychologique du sujet, indéniable : en effet, qui d'entre nous n'a jamais poursuivi en cachette la lecture d'un livre passionnant ? Dans leur description, les auteurs de *Great Canadian Painting* ajoutent un élément dramatique : ils racontent que le père de l'artiste, un Écossais sévère, lui donnait la fessée chaque fois qu'il le prenait à « gaspiller son temps avec des crayons et du papier », et font remarquer que le jeune garçon « se cache pour lire *Les Mille et Une Nuits* », un des premiers livres interdits à Reid par son père[32]. Le plaisir de la lecture, le décor du grenier à foin, le charme d'un moment d'évasion, la nostalgie de l'enfance – tous ces éléments, ajoutés à la valeur narrative de l'œuvre, expliquent sa popularité après son entrée dans la collection de Hamilton[33].

Horatio Walker était aussi un « gars de l'Ontario », mais sa préférence alla, dans son choix de sujets, aux scènes dramatisées du Québec rural. Ces scènes, il les destinait moins aux acheteurs locaux qu'aux riches collectionneurs américains qui firent de lui un des peintres les plus populaires d'Amérique du Nord dans les premières décennies du XXe siècle. Quand, en 1906, le City Art Museum de St. Louis lui acheta *Scieurs de bois* (aujourd'hui dans la collectin de la Power Corporation, à Montréal) pour 10 000 dollars, on dit que c'était la plus grosse somme jamais payée à un artiste né sur ce continent[34]. Bien qu'il ait ouvert un atelier à New York en 1878 et pris un agent new-yorkais, Walker joua un rôle capital dans le façonnement de la représentation du paysage canadien. Le critique Hector Charlesworth décrivit son art comme celui « d'une personnalité qui est bien d'ici[35] » et vanta la « puissance cosmique » et la « virilité » de ses scènes[36]. Walker s'établit à l'île d'Orléans, près de Québec, en 1883 et continua à peindre la vie des habitants de cet endroit jusqu'à sa mort en 1938 à l'âge de quatre-vingts ans.

L'intérêt suscité très tôt par *Ave Maria* tenait à la nostalgie d'un mode de vie sur le point de disparaître dans une Amérique en voie d'industrialisation rapide. Comme l'art de Walker en général, ce tableau doit beaucoup, dans son ennoblissement de la vie des paysans, au maître français de Barbizon, Jean-François Millet. De fait, on a dit de Walker qu'il avait « surpassé dans leur style les peintres de Barbizon eux-mêmes[37] » et qu'il était le seul « artiste américain (*sic*) suffisamment doté comme l'artiste français de ce rare mélange de simplicité naturelle et de sens dramatique pour mériter le titre de « Millet d'Amérique"[38] ». Il n'est donc pas surprenant qu'*Ave Maria* ait figuré dans l'exposition *American Art in the Barbizon Mood* présentée à la National Collection of Fine Arts de Washington en 1975. Le conservateur Peter Bermingham y voyait, dans la « magnifique lumière du couchant qui scintille autour de la croix du chemin » et « le corps finement sculpté du Christ agonisant qui domine un petit paysan aux traits indéfinis et un bœuf indifférent », un lien avec ce « tableau particulièrement sentimental chez Millet qu'est l'*Angelus* ». Bermingham ajoutait que « pour le goût moderne, Walker est plus efficace quand il cherche à recréer la lutte éternelle de l'homme et de la bête pour tirer de quoi vivre ou, du moins, subsister des pâturages ingrats de la lointaine île d'Orléans[40] ».

Ce tableau est au cœur d'une fascinante histoire à propos du nationalisme et du canon – et de l'importance de l'accessibilité. Peint en 1906, il fut vendu en 1907 pour 7 000 dollars par le marchand new-yorkais de l'artiste à la prestigieuse Corcoran Gallery of Art de Washington. Cependant, une fois passé de mode, il devenait moins intéressant, du fait de sa paternité canadienne, pour un établissement davantage axé sur l'art des États-Unis, si bien qu'au milieu des années 1950, la Corcoran Gallery la retira de son inventaire[41]. Acheté par l'AGH en 1963 des Laing Galleries de Toronto pour la somme de 5 500 dollars, *Ave Maria* prit rapidement la place qui lui revenait dans l'histoire de l'art canadien en tant qu'œuvre représentative du style artistique et du mode de vie d'une époque.

De Maurice Cullen, né à St. John's, Terre-Neuve, en 1866, on a dit qu'il fut le premier peintre canadien à faire de l'art pour l'art et le « peintre d'ici qui, discrètement, eut la plus forte influence sur les peintres canadiens de la génération suivante[42] ». Reconnu et honoré à Paris où il avait étudié, Cullen (contrairement à son ami et collègue James Wilson Morrice) choisit – pour des raisons qu'on ne pourrait sûrement pas qualifier de carriéristes – de revenir vivre au Canada, où il ne cesserait pourtant jamais d'éprouver des difficultés financières. Cullen devint un héros pour beaucoup de ses jeunes compatriotes et son œuvre entra rapidement dans les annales de l'histoire de l'art. Cependant, *Halage du bois, Beaupré*, acquis par l'artiste Robert Harris (peut-être lors d'une vente-encan en 1897[43]), ne serait pas reproduit avant que l'AGH l'achète en 1956 à l'occasion de sa rétrospective Cullen, organisée en collaboration avec le Musée des beaux-arts du Canada, l'Art Gallery of Toronto et le Musée des beaux-arts de Montréal.

Plus que tout autre artiste étudié ici, Cullen doit sa position et celle de cette peinture – dans le canon à l'importance qu'il a eue aux yeux des autres artistes. Pour James Wilson Morrice, il était *celui* qui, au Canada, « allait au cœur des choses[44] ». Pour A. Y. Jackson, il fut le professeur du Groupe des Sept, un puissant inspirateur[45] ayant contribué à créer un climat propice à l'acceptation d'un changement radical par rapport à l'ennuyeuse peinture de salon qui prévalait. Devant *Halage du bois*, Arthur Lismer confia à un ami que c'est Cullen qui lui avait appris comment peindre la neige[46]. Dans des peintures moins atmosphériques que les paysages d'hiver de ses collègues impressionnistes, tel Marc-Aurèle de Foy Suzor-Coté, Cullen cherchait (écrit son beau-fils Robert Pilot) à ne pas trop mêler les couleurs sur sa palette « afin d'en conserver la vivacité et l'éclat[47] ». Dans *The History of Painting in Canada: Toward a People's Art*, un livre consacré à l'art qui est le « reflet du peuple et du pays même », Barry Lord écrit que le sujet est remarquable par la manière dont l'artiste « passe directement à la description du travailleur dans le paysage. Un bûcheron donne un coup de cravache au bœuf qui tire un traîneau chargé de rondins vers le haut d'une colline et dans une courbe du sentier en plein hiver[48] ». Pourtant Lord, comme les autres critiques et historiens d'art, conclut que la puissance réelle de cette peinture tient moins dans la représentation de l'homme au travail que dans le soin apporté par l'artiste aux effets de lumière et d'ombre sur la neige. À propos de l'application, par Cullen, des théories impressionnistes sur la lumière, Lord fait remarquer que les Français ne connaissaient pas de telles journées claires et glaciales d'hiver[49]. Depuis son acquisition par l'AGH, *Halage du bois, Beaupré* a trouvé sa juste place dans l'histoire, et il est régulièrement reproduit dans les livres sur le Groupe des Sept de même que dans la plupart des ouvrages généraux sur l'art canadien.

Seul artiste contemporain parmi les cinq retenus ici, Alex Colville est un cas particulier dans l'histoire de l'art canadien. Souvent considéré comme un peintre « régionaliste », il a enseigné

à l'université Mount Allison de 1946 jusqu'à 1963, et sa vision a contribué à façonner le style associé aux artistes de la côte Est dans la seconde moitié du XX<sup>e</sup> siècle. Colville est l'un des artistes canadiens sur lesquels on a le plus écrit et son talent a été reconnu dès le début de sa carrière. En 1966, on le désignait comme « l'un des deux ou trois peintres canadiens vivants les plus célèbres – à l'extérieur du Canada[50] ». La remarque du critique James Adams à propos de *Cheval et train*, citée précédemment, porte à croire que les tableaux de Colville sont aussi parmi les plus célèbres au Canada. Si beaucoup d'entre eux sont devenus familiers, *Cheval et train* a mené, pourrait-on dire, une vie particulièrement bien remplie : popularisé sous forme d'affiche, il a également servi à vendre des disques, des romans et des manuels scolaires.

Comme *Le chasseur fantôme*, *Cheval et train* est inspiré d'un poème – dans ce cas-ci un poème de l'écrivain sud-africain Roy Campbell, « Dedication to Mary Campbell », où on lit : « Contre un régiment j'oppose un cerveau / Et un sombre cheval contre un train blindé ». À l'achat du tableau par l'AGH en 1957, Colville écrivit au directeur T. R. MacDonald pour lui dire combien il était ravi que cette œuvre, jugée plutôt « morbide » par bien des gens, ait été accueillie dans un musée public[51]. En 2001, dans *A First Book of Canadian Art*, Richard Rhodes a reproduit la peinture avec un texte sur le réalisme de la Guerre froide – autre exemple de la puissance iconique de cette image. Colville explique que ses peintures sont « le produit de "rêves, de souvenirs, de rappels provoqués par la mémoire" pour m'exprimer à la manière de Jung – une sorte de synthèse d'une perception globale[52] ». Comme les rêves, ses peintures appellent une interprétation. Mais l'artiste n'en offre aucune. L'issue de cette inoubliable scène demeure inconnue, mais l'image reste à jamais fixée dans nos mémoires.

## D'autres œuvres que j'aurais pu retenir

Il y a dans la collection historique de l'AGH d'autres tableaux bien connus et bien aimés que j'aurais pu choisir. *Les sœurs Vaughan* (1910, cat. 24) de William Brymner, souvent reproduit, aurait peut-être dû être englobé dans cette étude de cas, quoiqu'il soit moins diffusé que les cinq œuvres retenues. Il en va de même de *Cap Diamant* (1909, cat. 21) de Cullen, familier à bien des Canadiens. Michael Tooby l'avait sélectionné, avec *Halage du bois, Beaupré*, pour l'exposition *The True North : Canadian Landscape Painting 1896 to 1939* à la Barbican Gallery de Londres en 1991; mais seul *Halage du bois*, si typique de la production de Cullen, avait eu droit à une illustration en couleur dans le catalogue.

L'AGH possède une belle collection d'œuvres des années 1930. J'ai sérieusement envisagé d'ajouter l'énigmatique *Rêveur* (1929, cat. 60) de Charles Comfort, mais il est moins connu que son inoubliable portrait de l'artiste Carl Schaefer, *Jeune Canadien* (1932, acquis par la Hart House, University of Toronto, en 1934), ou que son paysage d'influence précisionniste *Tadoussac* (1935, acquis par le Musée des beaux-arts du Canada en 1968). L'huile de Schaefer *Une ferme au bord de la voie ferrée, Hanover* (1939, cat. 77) éveille elle aussi, chez beaucoup d'entre nous, le nostalgique sentiment de reconnaître quelque chose. Cependant, si cette peinture nous paraît familière, c'est peut-être à cause des reproductions d'images semblables des champs du comté de Hanover, entrées dans d'autres collections plus tôt au XX<sup>e</sup> siècle et régulièrement reproduites par la suite. Comme son contemporain Charles Burchfield aux États-Unis, Schaefer nous a donné des images de fermes et de champs de blé qui en sont venues à symboliser la vie dans les campagnes en Amérique du Nord pendant la Crise. *La maison de l'habitant* (1856, fig. 74) de Cornelius Krieghoff, un autre tableau chéri de l'AGH, se classe dans la même catégorie. Krieghoff a souvent peint des variations sur un même thème, et des tableaux similaires – comme *La ferme* (1856, Musée des beaux-arts du Canada) et *Cabane en bois rond sur la Saint-Maurice* (1862, Montréal, Musée McCord), largement diffusés en reproductions – sont fréquemment choisis pour représenter cet aspect de son œuvre[53].

J'ai également considéré la magnifique collection d'œuvres de Tom Thomson et du Groupe des Sept que possède l'AGH, notamment *Bosquet de bouleaux, automne* (1915–1916, cat. 37) de Thomson, ou encore *Rapides du Nord* (1913, cat. 33) de J.E.H. MacDonald, qui faisait partie de l'audacieuse exposition *The Mystic North : Symbolist Landscape Painting in Northern Europe and North America, 1890–1940*, organisée par Roald Nasgaard. De MacDonald, j'aurais également pu retenir *Pluie dans les montagnes* (1924, cat. 52), d'une exquise composition. Ou encore, de Lawren Harris, *Chute, Algoma* (v. 1920, cat. 42), *Icebergs et montagnes, Groenland* (v. 1930, cat. 62), ou *Glacière, Coldwell, Lac Supérieur* (v.1923, cat. 46), tout aussi spectaculaire et impressionnant. Il reste que d'autres œuvres de chacun de ces artistes en sont venues à incarner elles aussi l'art canadien : *Débâcle* (1915–1916, Musée des beaux-arts du Canada), *Le pin* et *Vent d'ouest* de Thomson, *Terre solennelle* (1921, Musée des beaux-arts du Canada, fig. 75) de J.E.H. MacDonald, ou *Rive nord du lac Supérieur* (1926, Musée des beaux-arts du Canada, fig. 66) et *Pic Isolation, montagnes Rocheuses* (v. 1930, Hart House, University of Toronto, fig. 76) de Harris – pour ce qui est de ses paysages nordiques. Fréquemment exposées (toutes sont entrées dans des collections publiques assez tôt au XX<sup>e</sup> siècle), ces œuvres sont bien connues des Canadiens de tous les coins du pays, surtout par des reproductions dans des livres sur le Canada ou l'art canadien. Presque toutes ont fait l'objet d'affiches ou de sérigraphies qui ont été accrochées dans les salles de classe, les foyers, les banques et les établissements publics pendant la plus grande partie du XX<sup>e</sup> siècle.

Bien que leurs tableaux à l'AGH soient extrêmement émouvants, mémorables et souvent spectaculaires, ces artistes ont peint d'autres œuvres que l'on juge plus importantes dans l'ensemble de leur production ou plus caractéristiques d'un style ou d'un sujet – ou qui ont tout simplement été accessibles avant. Devenues plus familières, plus profondément gravées dans notre conscience, elles ont donc été plus largement diffusées. Choisies pour les premiers programmes visant à faire connaître aux Canadiens leur art et leur histoire, beaucoup de ces images ont été reproduites à l'infini des décennies durant. Elles ont pris valeur d'icône dans l'imagination populaire, façonnant l'idée du Nord et des vastes étendues sauvages par laquelle nous définissons le Canada.

## Qu'en est-il des femmes ? L'évolution du canon

*Femme sous un arbre* (1931, cat. 63) de Prudence Heward, donné à l'AGH par la famille de l'artiste en 1961, est un cas passablement différent[54]. Dans *Peinture canadienne des années trente*, paru en 1975, Charles Hill parle de la « qualité irrésistible » de cette peinture et de son « aura de sexualité exaltée[55] ». Dans *Le Groupe des Sept. L'émergence d'un art national* en 1995, Hill la mentionne parmi les grandes œuvres qui « dominent » la dernière exposition de ce groupe en 1931[56]. Pourtant, un seul critique de l'exposition de 1931 parle de *Femme sous un arbre*, signalant ses « curieux éléments de modernisme et de classicisme »; « même en l'absence de sensationnel, ajoute-t-il, l'œuvre ne manque pas d'assurance[57] ». Pour des raisons évidentes, dans un contexte où le canon était largement construit autour de la notion de paysage, cette peinture ne fut pas souvent reproduite. Moderne par le style, non conven-

tionnelle par le sujet, elle a rarement été commentée dans les panoramas de l'art canadien, même après son acquisition par l'AGH. Elle marque pourtant un moment décisif dans l'histoire de l'art au Canada.

Revenant sur l'œuvre de Heward en 1947 dans le magazine *Canadian Art*, Edwin Holgate écrivait : « Le jugement que l'on porte sur un artiste repose principalement sur la relation qui existe entre son œuvre et les normes critiques de son époque[58]. » Brooke Claxton, inaugurant une exposition à la mémoire de Heward en 1948, faisait observer que les critiques « avaient des réactions aussi instinctives que le réflexe rotulien. Ils trouvèrent en Mademoiselle Heward un océan sur lequel leur grille d'analyse traditionnelle ne leur permettrait pas de naviguer. Mais cela ne découragea pas des pionniers comme Prudence Heward[59] ». Natalie Luckyj a bien résumé la situation : « Sa synthèse de la forme et du contenu, ni totalement moderniste ni entièrement traditionnelle, ne trouvait pas facilement place dans leur grille critique[60]. »

Le fait que Heward ait été une femme est certainement entré en ligne de compte. Avec un certain nombre d'autres femmes artistes, Heward a participé à la fondation du Groupe des peintres canadiens; elle en a également été vice-présidente. Pourtant, jusqu'au milieu des années 1970 et même après, assez peu d'œuvres réalisées par des femmes ont été acquises par des établissements publics. Or, comme nous venons de le voir, l'entrée dans une collection publique est généralement une condition préalable à l'accession au canon.

Même si *Femme sous un arbre* n'a été reproduit dans aucun des livres populaires sur l'art canadien, ce tableau éveille parfois un sentiment de familiarité chez certains spectateurs. Il est intéressant de voir comment il a, plus récemment, pris place dans le canon canadien. Avec *Femme brune*, également de Heward, il faisait partie de *Peinture canadienne des années trente*, incontournable exposition organisée par Hill en 1975. *Femme brune,* (fig. 77) acheté par la Hart House en 1936 – et donc dans le domaine public depuis beaucoup plus longtemps – avait en fait été présenté dans des expositions aussi prestigieuses que *A Century of Canadian Art* à la Tate Gallery en 1938 et *The Development of Painting in Canada 1665–1945* à l'Art Gallery of Toronto en 1945, de même que dans l'exposition commémorative *Prudence Heward 1896–1947* à Ottawa en 1948. L'AGH l'avait également emprunté pour son exposition inaugurale en 1953–1954 (avant d'acquérir *Femme sous un arbre*).

Étant entré dans le domaine public grâce à son acquisition par Hamilton, *Femme sous un arbre* a ces dernières années figuré assez régulièrement dans des expositions spécialisées, particulièrement des expositions organisées par des historiennes d'art l'ayant examiné sous l'angle de la théorie féministe[61]. Il illustre quelques-uns des thèmes majeurs des études actuelles sur la peinture canadienne : le modernisme, la représentation de la femme comme sujet pensant dans le nu féminin, la sexualité et la construction « genrée » du corps humain[62]. L'audace de la composition et l'expression provocatrice du personnage continuent de retenir l'attention des spectateurs et de stimuler la discussion sur le nu dans l'art canadien tout autant que sur la place des femmes artistes dans le canon.

\* \* \*

\* \* \*

Voilà qui termine un voyage riche en découvertes, un voyage passionnant au cours duquel j'ai poursuivi ma recherche non seulement sur l'enrichissement des collections dans les musées publics et sur le rôle des reproductions dans l'idée que nous nous faisons de ce qu'il y a de proprement canadien dans l'art canadien, mais aussi sur la place des femmes artistes dans l'art du Canada à la fin du XXe siècle[63]. Il a mis en évidence, entre autres choses, certains problèmes liés à la constitution même du canon, et à son relatif arbitraire. Cela ne veut pas dire que les œuvres qui nous touchent si profondément n'ont pas mérité d'accéder au canon; bien au contraire. Il semble toutefois évident que le choix des œuvres exposées ou illustrées dans des catalogues d'exposition dépend davantage de leur localisation, de leur accessibilité et de l'histoire déjà écrite sur elles que d'un réexamen périodique de l'ensemble de la production artistique canadienne. Les œuvres des femmes et des artistes des premières nations sont aujourd'hui régulièrement retenues dans des cas où, autrefois, on les aurait passées sous silence. Il est essentiel pour nous de continuer à chérir les œuvres qui font partie du canon tout en nous montrant réceptifs à celles qui mériteraient d'y figurer. Réservons-nous le plaisir d'aller au-delà du connu, du familier, et de chercher à découvrir ou à redécouvrir la « vraie » peinture – sa texture, ses dimensions et les nuances qu'une reproduction ne peut jamais tout à fait saisir. ~

\* \* \*

## Notes

1. Cité dans Bill Gladstone, « Kenneth Saltmarche 1920-2003 : He Gave His City Artistic Merit », *The Globe and Mail* (Toronto), 19 juillet 2003.

2. James Adams, « The Great Canadian Enigma », *The Globe and Mail* (Toronto), 31 mai 2003.

3. Doris Shadbolt, « Foreword », dans *Images for a Canadian Heritage*, Vancouver, Vancouver Art Gallery, 1966, s.p.

4. *Ibid.*

5. *Ibid.*

6. *Canadart : Great Canadian Paintings in Reproduction,* Pandora Publishing Company, 1975, n° C5. Voir aussi *Canadart : Canadian Paintings in Reproduction*, Pandora Publishing Company, 1981, n° 305. On peut consulter ces catalogues à la Bibliothèque du Musée des beaux-arts du Canada à Ottawa.

7. *Cheval et train* figure également à l'intérieur du livre de Wright.

8. Anthony Luengo, *Canadian Writer's Companion*, Toronto, Prentice Hall Ginn Canada, 1995, p. 71.

9. Dès 1925, Newton MacTavish avait traité de tous ces artistes dans *The Fine Arts in Canada* (Toronto, MacMillan).

10. *The Art Gallery News* parut pour la première fois en juin 1949. À compter de 1952, on reproduisit régulièrement sur sa couverture des œuvres de la collection permanente, dont beaucoup étaient des acquisitions récentes. Par exemple, *Halage du bois* de Cullen fut reproduit en mars 1957, *Le chasseur fantôme* de Bruce en octobre 1959, *Le fruit défendu* de Reid en novembre 1960, et *Ave Maria* de Walker en octobre 1963. En décembre 1953, à l'occasion de l'inauguration du nouveau musée à Westdale, *The Art Gallery News* fut tiré à 8 450 exemplaires. (Minutes of the Annual General Meeting, 1954, Archives de l'AGH).

11. Grâce au Comité féminin, l'AGH a acquis de nombreuses œuvres dans les années 1960, dont *Le fruit défendu*, *Ave Maria, La maison de l'habitant* de Cornelius Krieghoff, *Les sœurs Vaughan* de William Brymner et *Les bons amis* d'Ebenezer Birrell.

12. Malcolm Mackenzie Ross (dir.), *Our Sense of Identity : A Book of Canadian Essays*, Toronto, Ryerson Press, 1954, p. xi.

13. L'*Annuaire du Canada* de 1963–1964 donne la liste de douze importants musées d'art (bien qu'il en omette plusieurs, dont ceux de Windsor, de Charlottetown et de Québec). L'*Annuaire du Canada* de 1967 énumère quatorze musées publics, douze musées universitaires et trois galeries relevant de conseils des arts (St. Catharines, Glenhyrst et Calgary).

14. « Art Gallery Wins Praise for Quality », *The Hamilton Spectator*, 26 septembre 1967.

15. J. Russell Harper, *La peinture au Canada des origines à nos jours*, Québec, Les Presses de l'Université Laval, 1966, p. 403. Publié en anglais sous le titre *Painting in Canada : A History*, Toronto, University of Toronto Press, 1966, 2e édition 1977.

16. Elizabeth Kilbourn *et al.*, *Great Canadian Painting*, Toronto, Canadian Centennial Publishing Co., 1966.

17. Shadbolt, *Images for a Canadian Heritage*, s.p.

18. *Ibid.*

19. Voir *Les arts au Canada*, Cahiers de la citoyenneté canadienne n° 6, Ottawa, Direction de la citoyenneté canadienne, Ministère de la citoyenneté et de l'immigration, 1958. (L'auteur de ce document n'est pas identifié, mais l'on remercie Alan Jarvis, directeur de la Galerie nationale du Canada, R.H. Hubbard, conservateur en chef du même musée, ainsi que Gérard Morisset, directeur du Musée de la province de Québec, de leurs précieux conseils et commentaires. À propos de l'art contemporain depuis 1930, l'auteur écrit (p. 92) : « Le style "national" qui s'était manifesté dans la période précédente reste encore un élément puissant mais les influences extérieures et la personnalité des artistes vont bientôt le modifier. Plusieurs artistes canadiens cessent de s'appliquer exclusivement à la peinture paysagiste et s'intéressent vivement à l'art du portrait. Diverses formes d'art abstrait émanant de l'École de Paris et d'autres mouvements européens sont introduits au Canada au cours des années 1940 et 1950 et y trouvent plusieurs partisans. »

20. T. R. MacDonald, « Curator's Report », Minutes of the Annual General Meeting, 24 septembre 1951, Archives de l'AGH. Les reproductions avaient été commandées à une entreprise de Hamilton, la Davis-Lisson Company, et produites pour elle par Superior Engravers, de Hamilton également. Le procès-verbal d'une réunion tenue en septembre 1959 témoigne du sens des affaires du Musée, qui voyait les reproductions comme une source de revenu. MacDonald expliqua que la Royal Specialty Sales Co. de Toronto avait accepté de produire 12 500 cartes, dont 6 000, achetées par l'AGH pour 135 dollars, seraient vendues 10 cents chacune. La Royal Specialty Sales Co. distribuerait le reste. Pour financer le projet, MacDonald devait emprunter 135 dollars au Comité féminin et lui

rembourser cette somme une fois les cartes vendues. Voir Minutes of the Board of Management Committee, 17 septembre 1959, Archives de l'AGH.

21. L'AGH accorda des droits de reproduction à la Canadian Native Prints de Vancouver, qui publia ces œuvres (avec *La maison de l'habitant* de Krieghoff et *Glacière* de Harris) dans ses catalogues des années 1960 et 1970. Voir, par exemple, *Canadian Art Reproductions 1969*, Vancouver, Canadian Native Prints, 1969, p. 7–8. La Pandora Publishing Ltd. de Victoria racheta l'affaire en 1975 et se spécialisa dans les grandes images, dont *Cheval et train* de Colville. La Bibliothèque du Musée des beaux-arts du Canada, à Ottawa, possède des exemplaires des catalogues de la Canadian Native Prints et de la Pandora Publishing.

22. MacTavish, *The Fine Arts in Canada*, p. 28.

23. *Ibid.*, p. 29.

24. Comme le rappelle Arlene Gehmacher dans sa notice sur cette œuvre (voir cat. 6), la peinture fut reproduite en 1890 dans *The Dominion Illustrated*. Cette publication fut cependant plus éphémère que les livres d'art qui préservaient longtemps les images dans la conscience collective. Dans *The Art Gallery of Hamilton: Seventy-Five Years (1914–1989)* (Hamilton, Art Gallery of Hamilton, 1989), Ross Fox et Grace Inglis disaient du *Chasseur fantôme* que cette œuvre marquait « l'apogée de la carrière de l'artiste sur le plan de la reconnaissance publique », mais ils pensaient vraisemblablement à la renommée qu'elle connut après avoir été exposée (après la mort de l'artiste) à l'Art Gallery of Toronto en 1911.

25. Shadbolt, *Images for a Canadian Heritage*, s.p.

26. Bruce avait lu le poème de Charles Dawson Shanly, « The Walker of the Snow » (Le marcheur des neiges) dans *Locusts and Wild Honey*, publié par John Burroughs en 1879. (Le poème avait paru pour la première fois dans *The Atlantic Monthly* en 1859.) Sherrill Grace soutient dans *Canada and the Idea of North* (Montréal, McGill-Queen's University Press, 2001, p. 3–4) que l'histoire racontée dans le poème de Shanly s'inspire de légendes à propos du « chasseur fantôme », un « personnage qui présente quelque ressemblance avec le Windigo de la mythologie des Cris et des Ojibwas du Nord ». Dans une lettre à son père datée du 13 novembre 1888 (voir Joan Murray [dir.], *Letters Home : 1859–1906. The Letters of William Blair Bruce*,

Moonbeam [Ontario], Penumbra Press, 1982, p. 167), Bruce disait toutefois que, d'après lui, ce fantôme était l'incarnation du Froid. La première mention d'un lien entre le poème et une légende amérindienne se trouve dans Kilbourn *et al.*, *Great Canadian Painting*, p. 59.

27. George Reid, 1896, cité sur le site web du Musée des beaux-arts du Canada, *CyberMuse*, page de l'artiste. MacTavish a écrit que Reid s'est « constamment opposé au "tabou" qui frappe le tableau de genre et, de diverses manières [...] a affirmé sa foi en "l'art pour la vie", par opposition à l'art pour l'art » (MacTavish, *The Fine Arts in Canada*, p. 97).

28. MacTavish écrit (*The Fine Arts in Canada*, p. 96) : « Tous ceux qui sont au courant ont le devoir de reconnaître que, depuis au moins trente ans au Canada, George A. Reid s'est fait le champion de l'art et de l'importance que l'application artistique confère à beaucoup de nos activités quotidiennes. »

29. Dennis Reid, *A Concise History of Canadian Painting*, Toronto, Oxford University Press, 1988, p. 100. George Reid étudia également à l'Ontario School of Art auprès de Robert Harris et de John Fraser, ainsi qu'à Paris aux académies Julian et Colarossi.

30. Moncrieff Williamson, *Through Canadian Eyes : Trends and Influences in Canadian Art, 1815–1965*, Calgary, Glenbow-Alberta Institute, 1976, s.p.

31. Voir J. Russell Harper, *La peinture au Canada des origines à nos jours*, p. 223; Paul Duval, *High Realism in Canada*, Toronto, Clarke, Irwin & Company Ltd., 1974, p. 29; Christine Boyanoski, *Sympathetic Realism: George A. Reid and the Academic Tradition*, Toronto, Art Gallery of Ontario, 1986, p. 9. Boyanoski emprunte le terme « sympathetic realism » (« réalisme compatissant ») à Hjalmar Hjorth Boyesen, « Boyhood and Girlhood », *The Monthly Illustrator*, vol. 4 (avril 1895), p. 6–7.

32. Kilbourn *et al.*, *Great Canadian Painting*, p. 16 et 56.

33. Reproduit régulièrement dans des histoires générales de l'art, *Le fruit défendu* faisait aussi partie de l'exposition *Images of Man in Canadian Painting, 1878–1978* organisée par la McIntosh Gallery, University of Western Ontario, à London, en 1978.

34. Kilbourn *et al.*, *Great Canadian Painting*, p. 16.

35. Cité dans *ibid.*

36. Cité dans *ibid.*, p. 59.

37. *Ibid.*, p. 14.

38. Peter Bermingham, *American Art in the Barbizon Mood*, Washington, Published for the National Collection of Fine Arts by the Smithsonian Institution Press, 1975, p. 85.

39. *Ibid.* Les reproductions de l'*Angelus* et des *Glaneuses* de Millet connurent beaucoup de succès en Amérique du Nord, en particulier dans les campagnes canadiennes, jusqu'au milieu des années 1930. En 1934, le *Prairie Farmer Free Press* de Saskatchewan publia un article dans lequel l'auteur, décrivant son choix de reproductions en couleur d'œuvres de la Galerie nationale, faisait remarquer : « Les calendriers et les deux images encadrées des Glaneuses et de l'Angelus, nous les avons assez vues; il nous faut du changement ! » Voir « Colour Kate », *Prairie Farmer Free Press*, vol. 1, p. 8 (Archives de la Bibliothèque du Musée des beaux-arts du Canada, Ottawa).

40. Bermingham, *American Art in the Barbizon Mood*, p. 85.

41. Entretemps, il n'était sorti des réserves que pour deux expositions au Canada en 1941, soit l'exposition commémorative Horatio Walker à la Galerie nationale du Canada et la *Thomson-Walker Exhibition* à l'Art Gallery of Toronto. Il ne semble pas avoir été exposé ailleurs avant son acquisition par l'AGH, qui le prêta en 1965 pour *Treasures from the Commonwealth* à la Royal Academy de Londres.

42. Kilbourn *et al.*, *Great Canadian Painting*, p. 17.

43. « Sale of Paintings », *The Montreal Star*, 21 décembre 1897. Mentionné dans Sylvia Antoniou, *Maurice Cullen: 1866–1934*, Kingston, Agnes Etherington Art Centre, 1982, p. 60–62, sous le n° 10, *Charroi de billots en hiver, Beaupré*. La plus grosse somme payée pour une œuvre à cet encan dépassait à peine 90 dollars, alors qu'une décennie plus tard, un Horatio Walker se vendrait 10 000 dollars.

44. Cité dans Reid, *A Concise History of Canadian Painting*, p. 125.

45. J. Russell Harper, *La peinture au Canada des origines à nos jours*, p. 257.

46. Cité dans Kilbourn *et al.*, *Great Canadian Painting*, p. 18.

47. Cité dans *ibid.*

48. Barry Lord, *The History of Painting in Canada : Toward a People's Art*, Toronto, NC Press, 1974, p. 9 et 109--110.

49. *Ibid.*, p. 110.

50. Kilbourn *et al.*, *Great Canadian Painting*, p. 96.

51. Lettre de Colville à MacDonald, 8 février 1957, dossier d'acquisition, Alex Colville, *Horse and Train / Cheval et train*, AGH.

52. *Statements : 18 Canadian Artists 1967*, Regina, Norman Mackenzie Art Gallery, 1967. Cité dans William Withrow, *La peinture canadienne contemporaine*, traduit de l'anglais par René Chicoine, Montréal, Éditions du Jour, 1973, p. 60.

53. La Canadian Native Prints diffusa une reproduction de *La maison de l'habitant* à compter de 1967 (avec, entre autres, *Halage du bois* de Cullen). Voir, par exemple, le catalogue de reproductions publié par la Canadian Art Reproductions de Vancouver, *A Centennial Collection of Canadian Prints*, en 1967. (Les dimensions de la reproduction indiquées dans ce catalogue sont de 16 x 12 po., alors que dans des publications plus tardives, elles sont de 13 5/8 x 10 1/16 po. Dès 1974, *Canadart: Great Canadian Paintings*, l'actuel catalogue de la Canadian Native Prints, comprenait également un certain nombre de plus grandes reproductions d'œuvres de Krieghoff, dont *La ferme* du Musée des beaux-arts du Canada (13 x 20 po.) et *Cabane en bois rond* du Musée McCord, sous le titre « Cabane de l'habitant sur la rivière Saint-Maurice » (14 1/4 x 20 po.). Quand la Pandora Publishing Ltd. de Victoria racheta l'affaire en 1975, elle ne continua à distribuer que les reproductions de plus grand format, annoncées dans son catalogue *Canadart : Great Canadian Paintings in Reproduction*. On peut consulter ces catalogues à la Bibliothèque du Musée des beaux-arts du Canada à Ottawa.

54. L'AGH possède aujourd'hui une bonne collection d'œuvres de femmes artistes, entre autres Yulia Biriukova, Emily Carr, Paraskeva Clark, E. Grace Coombs, Emily Coonan, Rody Courtice, Clara Hagarty, Prudence Heward, Marion Long, Mabel May, Florence McGillivray, Helen McNicoll, Kathleen Morris, Sarah Robertson, Anne Savage, Gertrude Spurr Cutts, Elizabeth Wyn Wood et Mary Wrinch. Cependant, les œuvres de ces femmes, acquises pour la plupart avant la fin des années 1960 (seules Wrinch et Biriukova n'étaient pas représentées dans la collection en 1969), ont été moins souvent reproduites ou commentées dans les textes sur l'histoire de l'art que celles de leurs collègues masculins. Les femmes – à l'exception de Carr et, plus récemment, de McNicoll, Heward, Wyn Wood, Clark et Robertson – n'avaient pas accédé au canon, car celui-ci, au début du xxe siècle, privilégiait davantage les représentations de la terre et du travail associées à l'édification du pays. Les œuvres réalisées par des femmes ont rarement été choisies pour les divers programmes de reproductions d'art canadien entre 1928 et les années 1960 — sauf celles d'Emily Carr et même dans ce cas, elles ne furent reproduites que plusieurs années après avoir été terminées.

55. Charles Hill, *Peinture canadienne des années trente*, Ottawa, Galerie nationale du Canada, 1975, p. 41.

56. Charles Hill, *Le Groupe des Sept. L'émergence d'un art national*, Ottawa, Musée des beaux-arts du Canada, 1995, p. 268.

57. E. W. Harrold (1931), cité dans Hill, *Le Groupe des Sept*, cat. 167, p. 336. Voir aussi *Peinture canadienne des années trente*, où Hill rappelle que Lyman fait une critique pénétrante de ce tableau dans son journal : « Lorsque l'idée devient explicite, écrit Lyman, elle meurt... ». Hill poursuit : « La végétation brossée à main levée à l'avant-plan isole le personnage central très soigné, presque trop travaillé, et le paysage à l'arrière-plan rappelle une toile de fond; l'œuvre possède cependant une qualité irrésistible. Les yeux grands ouverts, la tension musculaire du corps, les projections et les angles aigus qui entourent le personnage créent une aura de sexualité exaltée rappelant *La Perte du Pucelage* de Gauguin » (p. 40-41).

58. Edwin Holgate, « Prudence Heward », *Canadian Art*, vol. 4, n° 3 (1947), p. 161. Cité dans Natalie Luckyj, *L'expression d'une volonté : l'art de Prudence Heward / Expressions of Will: The Art of Prudence Heward*, Kingston, Agnes Etherington Art Centre, 1986, p. 38.

59. Brooke Claxton, tapuscrit, « Opening Remarks: Memorial Exhibition – Prudence Heward », 4 mars 1948, Ottawa, Archives du Musée des beaux-arts du Canada. Cité dans Luckyj, *L'expression d'une volonté*, p. 38.

60. Luckyj, *L'expression d'une volonté*, p. 50.

61. Le tableau a été reproduit dans Jerrold Morris, *The Nude in Canadian Painting*, Toronto, New Press, 1972, p. 55, fig. 34. Bien qu'il n'ait pas été présenté dans l'exposition organisée par Dorothy Farr et Natalie Luckyj, *From Women's Eyes: Women Painters in Canada*, présentée à l'Agnes Etherington Art Centre, à Kingston, en 1975–1976 (exposition où figuraient toutefois *Femme sur une colline* et *Portrait de Mme Zimmerman* de Heward), *Femme sous un arbre* faisait partie de l'exposition de Luckyj, *L'expression d'une volonté : l'art de Prudence Heward* (exposition itinérante montée par l'Agnes Etherington Art Centre en 1986), de l'*Exposition rétrospective Prudence Heward (1896–1947)* organisée par Janet Braide et présentée à la Galerie Walter Klinkhoff de Montréal en septembre 1980 (et accompagnée d'un petit catalogue), ainsi que de la très importante exposition itinérante montée en 1983 par Luckyj pour la London Regional Art Gallery, *Visions et triomphes : les œuvres de dix artistes canadiennes 1914–1945*. Joyce Millar a commenté ce tableau dans « The Beaver Hall Group : Painting in Montreal, 1920–1940 » (*Woman's Art Journal*, printemps–été 1992, p. 5), où elle soutient que Heward a « choisi la figure humaine comme incarnation de l'esprit canadien ». Millar déclare également que « la puissance et la tension émotive qui se dégagent des héroïnes peintes par Heward dans les années 1920 et 1930 constituent [...] une prise de position révolutionnaire sur la féminitude ».

62. Jerrold Morris sent dans cette œuvre un « malaise psychologique, peut-être un reflet des années 1930 – de la dépression et des bouleversements sociaux de cette époque troublée » (*The Nude in Canadian Painting*, p. 12). Plusieurs auteurs ont parlé de la sexualité latente du personnage et laissé entendre que, par ce tableau, Heward cherchait à transcender les stéréotypes sexistes; voir Luckyj, *L'expression d'une volonté*, p. 62, Barbara Meadowcroft, *Painting Friends: The Beaver Hall Women Painters*, Montréal, Véhicule Press, 1999, p. 117, ainsi que la notice de Meadowcroft dans le présent catalogue (cat. 63).

63. Pour des articles sur le rôle des reproductions dans l'art canadien, voir Joyce Zemans, « Establishing the Canon: Nationhood, Identity and the National Gallery's First Reproduction Program of Canadian Art », *Annales d'histoire de l'art canadien / Journal of Canadian Art History*, vol. 16, n° 2 (1995), p. 6–35 (résumé en français p. 36–39); « Envisioning Nation: Nationhood, Identity and the Sampson-Matthews Silkscreen Project: The Wartime Prints », *Annales d'histoire de l'art canadien*, vol. 19, n° 1 (1998), p. 6–47 (résumé en français p. 48–51); « Sampson-Matthews and the NGC : The Post-War Years », *Annales d'histoire de l'art canadien*, vol. 21, nos 1–2 (2000), p. 96–136 (résumé en français p. 137–139); et « The Canon Unbound », *Annales d'histoire de l'art canadien*, vol. 25 (2004), p.150–179. Pour une discussion des femmes artistes et de la constitution des collections dans les musées publics, voir « A Tale of Three Women: The Visual Arts in Canada / A Current Account/ing », *Revue d'art canadienne / Canadian Art Review*, vol. 25, nos 1–2 (1998), p. 103–122.

# Conservation d'un chef-d'œuvre canadien : Les techniques et les matériaux utilisés par Alex Colville pour son tableau *Cheval et train*

*Debra Daly Hartin*
*Restauratrice principale, Laboratoire des beaux-arts*
*Institut canadien de conservation, Ottawa*

Le tableau *Cheval et train* (cat. 85) de l'artiste Alex Colville exerce une influence considérable sur les observateurs. La juxtaposition troublante d'un cheval galopant vers un train venant en sens inverse, jumelée à la précision de la technique de l'artiste, font en sorte que cette image demeure imprégnée dans la mémoire de ceux qui ont vu soit l'original soit une reproduction. Un examen technique récent du tableau et la possibilité de l'étudier et d'en discuter avec l'artiste se sont traduits par une meilleure compréhension de son apparence, de son état et de la technique utilisée pour sa réalisation (fig. 78)[1].

Nous pourrions peut-être commencer par poser une question : Le souvenir que nous avons de ce tableau représente-t-il fidèlement l'apparence que l'artiste a bien voulu lui donner ? L'éclairage sous lequel nous observons le tableau et la précision de ses nombreuses reproductions jouent inévitablement sur le souvenir qu'il suscite. Lorsque les observateurs se trouvent pour la première fois devant l'original, plusieurs sont saisis par ses dimensions, lesquelles, d'après eux, sont plus petites que ce qu'ils envisageaient. Il exerce à coup sûr un énorme impact pour un tableau dont les dimensions sont relativement modestes (tableau : 41,5 cm x 54,3 cm; cadre : 58,6 cm x 71,7 cm). Les observateurs sont également portés à dire que l'original semble plus sombre. En effet, à cet égard, les reproductions représentent rarement le tableau avec précision. Elles sont incapables de capter la lueur distincte et calculée du phare frontal du train et sa réflexion sur les rails de métal, éliminant ainsi les zones de contraste frappant et dramatique faisant partie d'une scène nocturne. Les reproductions peuvent aussi mal représenter les teintes; les rendus chromatiques varient, le ciel pouvant parfois paraître d'un bleu clair et le gazon d'un vert vif. Le tableau paraît très différent sous des conditions d'éclairage diverses, ce qui constitue une difficulté lorsqu'il s'agit de le photographier. Ceci reflète l'habileté avec laquelle l'artiste a représenté les couleurs vues à travers le voile du crépuscule, qui est une période de lumière changeante.

En discutant de l'apparence générale du tableau, l'artiste a déclaré que « dès le début, ce tableau me paraissait sombre, du point de vue tant visuel que métaphysique »[2]. Rien, lors de l'examen technique, ne permet de conclure que le tableau soit devenu plus sombre; il est sombre car l'artiste l'a peint ainsi. Il est évident qu'il savait, d'après la technique qu'il a employée, que la peinture à l'huile devenait plus translucide avec le temps, une caractéristique qui aurait pu entraîner un changement de ton au fil des ans, si des sous-couches foncées avaient été utilisées. Cependant, Colville a appliqué une couche de préparation blanche avant une « première couche de couleur » – une couche intermédiaire de ton variable selon l'image sous-jacente. Il a pris soin de traiter certaines zones « en réserve »; c'est-à-dire que la couche de préparation blanche est apparente sous les zones les plus claires de la scène. Par exemple, il a pris la décision de ne pas peindre le train sous la fumée claire et transparente, car le train aurait pu devenir de plus en plus visible avec le temps. Au cours des dernières étapes d'exécution du tableau *Cheval et train*, l'artiste a utilisé des glacis aux standolies, et lorsque le tableau fut terminé, il a appliqué une fine couche de vernis de résine naturelle sur toute la surface. Les glacis à l'huile et le vernis dammar peuvent avoir légèrement jauni avec le temps, mais ce jaunissement ne serait guère notable sur les couches de peinture foncée. Il a sans doute conféré au tableau un ton légèrement plus chaud, mais ce changement ne serait que très légèrement visible sur le phare et les rails blancs. L'âge des matériaux et les altérations qu'ils ont subies au fil des ans n'ont donc pas modifié de manière importante l'apparence du tableau. Le ton a été créé grâce à un choix judicieux de peinture et de glacis pigmentés. En outre, l'artiste a renforcé son intention en concevant et en fabriquant un cadre qui accentue le ton sombre et obscur du tableau et qui contribue à lui conférer une impression obscure dans son ensemble.

L'apparence a peut-être été mal comprise, même après les premières années suivant son exécution. L'artiste se souvient que,

lorsque le tableau était à New York, avant que la Art Gallery of Hamilton (AGH) n'en fasse l'acquisition en 1957, quelqu'un a tenté de le nettoyer, croyant sans doute qu'il devait être plus clair. Cette tentative de nettoyage, entreprise lorsque la peinture et les glacis à l'huile utilisés par l'artiste étaient encore frais, peut avoir contribué à l'apparition des craquelures de séchage visibles aujourd'hui, un défaut rarement présent sur les tableaux de Colville.

## La technique de l'artiste

Alex Colville possède une technique minutieuse, méticuleuse et délibérée, et il s'efforce d'assurer la longévité de son œuvre. « Je souhaite réellement que mes tableaux durent. Il en a toujours été ainsi. Certains peintres aiment voir leurs tableaux vieillir et se transformer... et c'est justement ce que j'essaie d'éviter[4]. »

Colville commence par la réalisation de dessins préparatoires[5]. Afin de représenter fidèlement l'éclairage de cette scène particulière, il se souvient s'être rendu, un soir, à la voie ferrée, à Aulac, juste à l'extérieur de Sackville, là où la voie surélevée traverse le marais Tantramar. L'artiste raconte avec amusement, qu'afin d'éviter les soupçons, il avait « agi en coupable » en se cachant dans un fossé à côté de la voie ferrée pour attendre l'arrivée du train. Lorsque le train approcha, il se leva pour observer l'effet du phare frontal et de ses réflexions sur les rails en métal[6]. Dans l'œuvre, *Study for Horse and Train* (1954, Toronto, Musée des beaux-arts de l'Ontario), une esquisse en couleurs exécutée à la détrempe à la caséine, la position et la perspective du cheval et de la voie ferrée sont légèrement différentes de celles dans le tableau final. La technique de peinture de l'artiste est peu détaillée, mais les pigments utilisés reflètent déjà l'apparence sombre et obscure du tableau final. Il semble avoir éprouvé certaines difficultés avec la forme du cheval; il en a donc fait un modèle au moyen de broche à poule et de plâtre (ou de ciment). Après avoir peint le modèle en noir, il en a tiré plusieurs dessins. Ce modèle a accompagné le tableau à New York lorsque ce dernier a été exposé en 1955, mais personne ne sait ce qu'il en est advenu[7].

L'œuvre a été réalisée sur un panneau de 1/8 po d'épaisseur que l'artiste a soigneusement préparé en appliquant une couche de préparation lisse sur la face et une couche plus mince sur le dos (côté texturé), en vue d'éviter le gauchissement[8]. Il a ensuite poncé la surface avec soin pour obtenir un fini lisse. Il a également chanfreiné les bords du panneau pour éviter la formation d'écailles et d'autres lacunes – un autre exemple de l'effort constant dont il fait preuve dans le but d'assurer la stabilité et la permanence de son œuvre.

L'artiste s'est servi d'un carton de transfert pour transférer le dessin du cheval et de la voie ferrée sur le panneau préparé (1954, Toronto, Musée des beaux-arts de l'Ontario, fig. 79). Pour ce faire, Colville a tracé son esquisse du cheval (1954, Toronto, Musée des beaux-arts de l'Ontario, fig. 80) à l'encre et au crayon sur du papier-calque, en ajoutant les lignes représentant la voie ferrée et une boîte de perspective autour du cheval; au dos du carton de transfert, du graphite avait été appliqué en suivant les lignes du dessin. Il a utilisé deux crayons d'une dureté différente (ou possiblement un autre instrument pointu) pour tracer le motif sur la préparation sur la toile, à partir du carton de transfert. Lorsqu'on examine le tableau final au microscope, on peut voir les traces des fines lignes noires du dessin transféré là où de minuscules zones de la couche de préparation sont exposées. Le processus de transfert a laissé à la surface, le long du contour du cheval et de la voie ferrée, une fine rainure qui est visible sous un éclairage tangentiel (en biais).

Un examen au microscope a également permis de révéler diverses lignes du premier dessin et le lavis constituant la « première couche de couleur » sur la préparation blanche. On peut voir des marques de crayon et possiblement des lignes de l'esquisse réalisée au pinceau le long du contour du cheval et des rails. Une légère couche de lavis gris particulaire est visible sous certaines zones du ciel et sous le gravier et les rails. Ce lavis s'est accumulé dans les minces stries de ponçage de la couche de préparation – un effet également observé dans certains autres tableaux de la même période, notamment *Three Sheep* (1954, Ottawa, Musée des beaux-arts du Canada). On peut voir une sous-couche rouge directement sous le rail supérieur et une autre bleu clair sous la partie métallique du rail, tandis que les nuages et la fumée en volute qui s'échappe du train comptent parmi les zones où la préparation blanche a été laissée *en réserve*.

Quoique l'artiste ait construit l'image selon sa manière détaillée et précise habituelle, la technique d'application de la peinture est plus variée que dans plusieurs autres de ses tableaux. Des touches de peintures étendues se fondent ensemble dans le ciel, et les nuages ont été peints en de larges plans mats et réguliers qui ressemblent à des lavis de couleurs. On remarque clairement dans le gravier des zones circulaires de couleur mate et sans irrégularités qui se transposent en ombrages, demi-tons et rehauts. Toutefois, un examen attentif révèle clairement des couches de diverses couleurs réalisées à petits coups de pinceau : un rouge-noir intense, un rouge translucide, un bleu-gris clair, un gris-vert foncé et des rehauts d'ocre pâle, appliqués sous forme de minces coups de pinceau fluides, sans texture. Au fur et à mesure qu'il progresse vers l'horizon, il utilise une technique davantage pointilliste pour peindre le gravier, c'est-à-dire qu'il peint par points. Pour peindre le gazon, l'artiste a utilisé un mélange de couleurs fondues qu'il a appliqué en donnant de minces coups de pinceau, quoique ces coups de pinceau ne soient pas aussi fins que ceux que l'on observe pour peindre le gazon dans d'autres tableaux, y compris *Three Sheep*. Les coups de pinceau extrêmement fins, tellement typiques des tableaux de Colville, sont néanmoins évidents et, dans la lueur du phare frontal et dans le crin du cheval, deviennent de plus en plus fins (fig. 81) dans les rehauts.

Pour Colville, les années 1950 ont été une période de transition et d'expérimentation quant au choix des médiums. Si nous comparons *Cheval et train* à d'autres tableaux, les différences techniques que nous observons reflètent l'évolution des matériaux utilisés par l'artiste. L'artiste est passé de la peinture à l'huile, qu'il utilisait dans les tableaux qu'il a réalisés lorsqu'il était étudiant et dans ses tableaux de guerre, à un matériau qui sèche plus rapidement, qui lui permettait d'utiliser une technique par couches superposées et d'appliquer les couleurs au moyen de fins coups de pinceau distincts et juxtaposés. Il a employé la détrempe à la caséine dans plusieurs de ces esquisses et tableaux de cette période, mais il a également utilisé les glacis aux standolies pigmentées sur une couche d'émulsion de gomme arabique. Il croit que c'est la technique qui a été employée pour réaliser le tableau *Cheval et train*. Les notes écrites par Colville, dans l'édition de 1945 de l'ouvrage de Ralph Mayer, *The Artist's Handbook of Materials and Techniques*, décrivent les mélanges qu'il utilisait alors et les expériences qu'il menait avec des siccatifs, pour optimiser le temps de séchage et l'apparence de la surface[9]. Les glacis pigmentés sont facilement visibles sur la surface du tableau *Cheval et train*. Une analyse de minuscules échantillons prélevés sur ce tableau[10] révèle que le glacis pigmenté est essentiellement une standolie et renferme peut-être une petite quantité de dammar, ce qui serait compatible avec les recettes décrites dans le livre de Mayer. En discutant de son utilisation des glacis au cours de cette période,

Colville a mentionné que « parfois, j'utilise un glacis pour amal-gamer une certaine zone, pour la refroidir ou la réchauffer, pour neutraliser un rouge avec un jaune ou encore pour neutraliser une couleur trop intense avec un gris, en créant une sorte de voile transparent... Il y a des années que je n'ai utilisé cette technique [11] ». Les médiums utilisés lors de cette période sont décrits de dif-férentes manières, dont « détrempe avec glacis » et « ...émulsion d'huile avec glacis », mais seulement quelques tableaux présen-tent au dos les inscriptions de l'artiste confirmant cette information. Au dos du tableau *Cheval et train*, l'artiste a écrit « huile avec glacis. »

Outre ce qui est visible à l'examen de la surface du tableau, l'examen de coupes transversales révèle la présence d'une couche isolante (probablement de la résine ou de l'huile) sur la sous-couche ou la « première couche de couleur », ainsi qu'une variété de pigments dans le glacis (figures 82a et 82b). Dans une zone du gazon, la standolie contenait des pigments de terre verte, de noir d'os, de jaune ocre et de vert émeraude. Une coupe transversale du cheval révèle que la limite entre le glacis et la couche de peinture sous-jacente est indistincte, ce qui porte à croire qu'il y a eu appli-cation mouillé sur mouillé (application d'une couche de peinture ou d'autre médium sur une couche qui n'est pas encore sèche). On a décelé la présence d'une huile siccative dans les couches de pein-ture. À ce jour, l'analyse n'a pas permis de confirmer l'utilisation d'une émulsion gomme-huile. Toutefois, on ne peut éliminer la présence possible de petites quantités de gomme ou la présence de gomme dans des zones n'ayant pas encore fait l'objet d'un examen, comme dans le gravier, qui présente des différences de technique et de texture. Des études sont actuellement en cours.

L'artiste nous a avisé qu'après l'exécution du tableau, il a appliqué une mince couche de vernis de résine naturelle (dammar) sur la surface, à titre de couche protectrice qu'il serait possible d'enlever et d'appliquer à nouveau, au besoin, laissant le glacis sous-jacent intact [12]. Une analyse a confirmé la présence d'une mince couche de vernis dammar sur le tableau.

Le cadre, conçu et fabriqué par l'artiste, permet d'observer l'œuvre dans son ensemble, sans la présence dérangeante d'une bordure très contrastante, car il épouse le ton sombre du tableau. L'artiste a mentionné qu'il a sans doute utilisé des pigments blancs, noirs et jaune ocre, qui étaient, à l'époque, des couleurs assez courantes sur sa palette.

## État et traitement du tableau *Cheval et train*

Si l'on considère que le tableau *Cheval et train* célèbre ses cinquante ans d'existence en 2004, il vieillit très bien et son état général est bon. Néanmoins, on peut observer une mince craquelure à la surface, ce qui est inhabituel dans les œuvres de Colville. À quelques endroits où les glacis aux standolies sont les plus apparents, il n'y a aucune craquelure; par contre, à d'autres endroits, les couches supérieures de peinture et de vernis ont « rétréci » en se déplaçant sur les couches inférieures. Ce type de craquelure, souvent appelé « craquelure de séchage », peut être provoqué par les matériaux utilisés par un artiste et par la manière dont les couches ont été appliquées. Pour ce qui est de ce tableau, l'utilisation possible d'une émulsion de gomme arabique, de pein-ture à l'huile, de glacis aux standolies et de vernis peut avoir aggravé ce problème de séchage. Toutefois, le nettoyage qui a été tenté peu de temps après l'exécution du tableau a peut-être con-tribué au problème. Les pellicules de peinture et les couches de glacis appliquées depuis peu pourraient avoir gonflé en présence des solvants de nettoyage, puis s'être contractées en séchant,

entraînant ainsi la formation de telles craquelures. Les craquelures sont stables, il n'y a aucun signe de soulèvement de la peinture, de la couche de préparation ou des couches de glacis, et on note seulement des abrasions mineures et de petites lacunes dans la peinture.

Il y avait des signes de nettoyage antérieur et de perturba-tion de la couche de vernis. Un examen sous une lumière ultravio-lette a révélé la présence de certaines altérations dans le vernis au coin inférieur gauche et au coin supérieur droit (fig. 83). Ces zones ne sont pas visibles dans des conditions normales d'observation. Le lustre de la surface du tableau variait, et on pouvait observer, avant le nettoyage de la surface, d'importantes marques d'es-suyage.

Le tableau exigeait uniquement un traitement mineur. Un léger nettoyage de la surface a permis d'obtenir un lustre plus uniforme et plus intense. Il n'a pas été nécessaire d'enlever le vernis et cette mesure n'aurait pas été recommandée en raison de la présence de glacis d'huile et de résine sous le vernis. Avec la permission de l'artiste, on a retouché les abrasions mineures et les craquelures de séchage autour du phare frontal, afin de réduire la visibilité de la couche de préparation claire.

Après avoir examiné le tableau au laboratoire de restaura-tion, l'artiste était enchanté de son état et, selon lui, le tableau n'avait pas changé de manière notable. Depuis la fin des années 1950, Colville a souvent rédigé des notes détaillées au dos de ses tableaux, y indiquant les matériaux utilisés. « Il était important, pour moi, de fournir le plus d'information possible aux fins d'utilisation, entre autres, par des restaurateurs [13]. » Ce sont les tableaux qu'il a réalisés pendant cette période de transition, au cours des années 1950, qui présentent des défauts mineurs, tels que des craquelures et une légère décoloration des glacis. Ces changements sont néanmoins relativement mineurs si on les compare à ceux que présentent couramment les peintures à l'huile. Heureusement, en raison des choix que l'artiste a délibéré-ment pris en vue d'assurer la permanence de ses œuvres, nous sommes maintenant en mesure d'apprécier ses tableaux dont l'état actuel correspond tout à fait à celui dans lequel ils se trouvaient au moment de quitter son atelier.

## Remerciements

Je tiens à exprimer ma gratitude aux restaurateurs de diverses col-lections, qui m'ont permis d'examiner les tableaux d'Alex Colville et la documentation connexe : Stephen Gritt et Susan Walker Ashley du Musée des beaux-arts du Canada (MBAC); Sandra Webster-Cooke et John O'Neill du Musée des beaux-arts de l'Ontario; Catherine Stewart de la Collection McMichael d'art canadien; et Laurie Hamilton de l'Art Gallery of Nova Scotia. Je tiens également à remercier l'Art Gallery of Hamilton (AGH) de son appui lors de la visite d'Alex Colville à Ottawa, et Stephen Gritt, restaurateur en chef au MBAC, qui a fait les démarches néces-saires auprès du laboratoire de restauration du MBAC, pour que je puisse examiner les tableaux de l'artiste qui sont la propriété du MBAC, et en discuter. J'aimerais souligner le travail de Kate Helwig et de Jennifer Poulin, scientifiques en conservation à l'Institut canadien de conservation (ICC), qui ont procédé à l'échantillon-nage et à l'analyse de coupes transversales, et de Jeremy Powell et de Carl Bigras, technologues en documentation scientifique à l'ICC, pour la documentation photographique sur le tableau. En dernier lieu, je tiens à exprimer ma gratitude à Alex Colville et à sa fille Ann Kitz, qui ont bien voulu se rendre à Ottawa pour voir le tableau *Cheval et train* et nous donner de si précieux renseigne-ments. Ce fut une journée inoubliable. ~

## Description des figures

**Fig. 78 (page 190)**
Alex Colville discute du tableau *Cheval et train* avec le personnel de l'icc. Photo : Jeremy Powell.

**Fig. 79 (page 192)**
ALEX COLVILLE (né en 1920)
Carton de transfert pour panneau préparé *Horse and Train* 1954
Mine de plomb sur papier
39,1 x 27 cm
Musée des beaux-arts de l'Ontario, Toronto
Don de Helen J. Dow, Guelph, 1986

Ce carton semble avoir été tracé au papier-calque à partir de l'esquisse à l'encre du cheval montrée à la fig. 80.

**Fig. 80 (page 192)**
ALEX COLVILLE (né en 1920)
Étude pour *Horse and Train* 1954
Encre noire sur papier
32,5 x 25,2 cm
Musée des beaux-arts de l'Ontario, Toronto
Don de Helen J. Dow, Guelph, 1986

**Fig. 81 (page 193)**
Les coups de pinceau extrêmement fins de Colville sont visibles dans ce détail du cheval. Photo : Jeremy Powell.

**Fig. 82a et 82b (page 194)**
L'échantillon présenté dans ces deux images, où la couche de préparation est manquante, a été prélevé à un endroit du gazon où l'examen à la lumière ultraviolette révèle une application sélective ou plus épaisse de glacis. La largeur de l'image de la coupe transversale est de 270 micromètres. Photomicrographies par Kate Helwig.

82a. Sous un éclairage tangentiel, les couches suivantes sont visibles depuis la base vers la surface : un gris-vert clair pour la « première couche de couleur », une couche de gris-vert foncé et une couche épaisse de glacis pigmenté.

82b. Les couches résineuses deviennent très fluorescentes à l'examen sous une lumière ultraviolette, ce qui indique la présence d'une mince couche de résine entre les deux premières couches déposées sur le fond, ce qui accentue le glacis résineux et la mince couche de vernis sur le dessus.

**Fig. 83 (page 195)**
Étant donné que les résines naturelles deviennent fluorescentes sous une lumière ultraviolette, toute altération dans le vernis ou toute variante dans l'application des couches de surface devient visible lorsqu'on examine le tableau sous ce type de lumière. On peut voir des altérations dans le vernis au coin inférieur gauche et au coin supérieur droit. Photo : Jeremy Powell.

## Notes

1. Dans le but de se préparer à cette exposition, l'Art Gallery of Hamilton a envoyé le tableau à l'Institut canadien de conservation afin d'en faire évaluer l'état et de lui faire subir un traitement. Par la suite, en février 2004, l'AGH a invité l'artiste à se déplacer de sa résidence, à Sackville (Nouveau-Brunswick), jusqu'à Ottawa, pour une rencontre d'une journée en vue d'examiner le tableau et de discuter avec l'auteur et d'autres membres du personnel de l'ICC des techniques et des matériaux utilisés lors de l'exécution de l'œuvre, en 1954.

2. Alex Colville, en discussion, à Ottawa, le 16 février 2004.

3. L'artiste utilise de la standolie comme glacis ou médium de peinture. Il s'agit d'huile de lin polymérisée par chauffage, ce qui donne une huile possédant des propriétés différentes de celles de l'huile crue; cette huile tend à moins jaunir et forme une pellicule résistante et lisse.

4. Alex Colville, en discussion, à Ottawa, le 16 février 2004.

5. Dans son catalogue sur l'exposition des œuvres de Colville, monté par le Musée des beaux-arts de l'Ontario en 1983, David Burnett mentionne que l'idée du tableau *Cheval et train* a vu le jour dans une série d'esquisses datées du 16 mars 1954. Voir David Burnett, *Colville* (Toronto : Musée des beaux-arts de l'Ontario et McClelland et Stewart, 1983), p. 97.

6. Alex Colville, en discussion, à Ottawa, le 16 février 2004. Burnett décrit cet événement comme faisant partie du processus « d'authentification » de Colville, destiné à s'assurer que ses scènes sont le plus réalistes possible. Burnett, *Colville*, p. 97, 100, 105.

7. Alex Colville, en discussion, à Ottawa, le 16 février 2004.

8. Lors d'une conversation téléphonique avec l'auteur (février 2004), l'artiste a décrit comment il appliquait normalement trois couches de préparation sur la face et deux sur le dos. D'habitude, il utilisait du blanc de craie et de la colle de peau de lapin, quoiqu'il ait mentionné s'être servi de gélatine pendant un certain temps, lorsqu'il était impossible de se procurer de la colle de peau de lapin.

9. Voici plusieurs recettes écrites par Colville dans son exemplaire du livre de Mayer, qu'il s'est procuré en 1946. Des notes de l'artiste sont datées du mois de juin 1954, lorsqu'il était peut-être en train de travailler au tableau *Cheval et train*. (Le Nuodex est un siccatif utilisé pour accélérer le séchage de la standolie.)

<u>« le 8 juin 54</u>

médium à utiliser avec huiles Shiva sur dessous de « blanc pour dessous à l'huile Shiva »

    15 ml de standolie (Shiva)

    45 ml de térébenthine (Shiva)

    0,15 ml de Nuodex à 6 % (1 % du volume de standolie)

le 11 juin 1954 – Ce mélange a pris trop de temps à sécher – environ 2 à 3 jours.

<u>le 11 juin 1954</u>

médium à utiliser comme ci-dessus

10 ml $\begin{cases} 6 \text{ ml de standolie (Shiva)} \\ 4 \text{ ml de dammar (Shiva)} \end{cases}$

40 ml de térébenthine (Shiva)

0,2 ml de Nuodex à 6 % (2 % du volume de standolie et de dammar)

Ce mélange a séché en laissant une surface presque mate.

le 14 juin 1954 ai mélangé

20 ml $\begin{cases} 12 \text{ ml de standolie} \\ 8 \text{ ml de dammar} \end{cases}$

+ 20 ml de térébenthine + 0,4 ml de Nuodex à 6 % (2 % du volume de standolie et de dammar)

Ce mélange sèche en une seule nuit et laisse un fini lustré. »

Des notes additionnelles écrites en 1952 et en 1955 font état de variantes de ces médiums. Une note écrite à la main décrit une recette pour une émulsion de gomme :

<u>« Émulsion de gomme utilisée :</u>

    5 oz de solution de gomme

    1 oz de standolie

    1 oz de vernis dammar

    $3/4$ oz de glycérine »

Cette recette correspond, en fait, à celle de Mayer, décrite aux pages 192 et 193. « On obtient la solution de gomme en versant 5 onces liquides d'eau chaude sur 2 onces de gomme arabique broyée ou en poudre (2 onces de gomme arabique finement broyée correspondent à un volume d'environ 2 1/2 onces – légèrement moins). Le vernis dammar est le « 5 pound cut » mentionné à la rubrique traitant des vernis.

On verse lentement le mélange huileux dans la solution de gomme, en agitant constamment jusqu'à ce que le mélange devienne un liquide blanc visqueux et homogène, exempt de grosses gouttes d'huile. Si vous ne disposez pas d'un mélangeur, vous pouvez agiter les ingrédients dans une grande bouteille, en la remplissant aux trois-quarts, tout au plus. On y ajoute ensuite la glycérine et on mélange à fond après l'émulsion de la solution de gomme avec les ingrédients huileux. » Ralph Mayer, *The Artist's Handbook of Materials and Techniques* (New York : The Viking Press, 1945).

10. On a prélevé sur le tableau quelques échantillons plus petits que la taille d'un point sur une page imprimée pour élucider la structure des couches, examiner la composition des couches et déterminer la cause des craquelures de séchage. Les scientifiques en conservation ont préparé des coupes transversales qui ont été examinées et analysées au moyen de différentes techniques, dont la microscopie en lumière polarisée et la microscopie électronique à balayage couplée à la spectroscopie des rayons X à dispersion d'énergie. On a analysé d'autres échantillons microscopiques par spectrométrie infrarouge à transformée de Fourier (IRTF) et par chromatographie en phase gazeuse couplée à la spectrométrie de masse (CG-SM).

11. Alex Colville, en discussion, à Ottawa, le 16 février 2004.

12. Alex Colville, en discussion, à Ottawa, le 16 février 2004. Également documenté dans les dossiers du Laboratoire de restauration et de conservation du Musée des beaux-arts du Canada (écrits par S. W. Ashley) pour avoir été utilisé pour le tableau *Woman, Man and Boat*.

13. Alex Colville, en discussion, à Ottawa, le 16 février 2004.

# Translation of Entries / Traduction des notices

Cat. 1  (page 62)

**EUGÈNE BOUDIN** (French; 1824–1898)
*The Harbour at Trouville*  1884
oil on wood
23.7 x 32.8 cm
Bequest of Miss Muriel Isabel Bostwick, 1966

In 1884, Eugène Boudin was sixty years old. It was only then, however, with old age approaching, that his career truly began to flourish.

The previous year, 1883, had been a particularly auspicious one for the painter. On the first of February, the famous art dealer Durand-Ruel had inaugurated his new premises at 9, boulevard de la Madeleine with an exhibition of one hundred and fifty works by Boudin, which included paintings, pastels and watercolours. In April, the dealers Dowdeswell & Dowdeswell, who acted as Durand-Ruel's London agents, showed ten of his works in their gallery, in the flattering company of Manet, Degas and the Impressionists. Moreover, not content to simply exhibit Boudin, Durand-Ruel bought seventy-three of his paintings. In May, the artist presented two works at the Paris Salon, where he was awarded a second-class medal. And that year, as usual, he participated in exhibitions held in various provincial French towns, presenting works in Caen, Bordeaux and Le Havre.

It was thus in an optimistic frame of mind – and encouraged by his recent earnings – that the artist decided in 1884 to fulfil an old dream by building himself a villa in Deauville. He submitted two paintings to the Salon, one of which, *Low Tide* was purchased by the State. As the result of his recent successes, commissions flowed in: friends, art-lovers, dealers and exhibition organizers were all clamouring for pictures. Concerned above all to pay for his house, he had no choice but to work non-stop. As was his habit, he spent a month – from 11 June to 11 July – in Dordrecht and Rotterdam, in Holland, as well as making trips to the French towns of Berck, Le Havre, Boulogne, Trouville and Deauville.

*The Harbour at Trouville* was painted, then, in the vibrant atmosphere created by Boudin's official recognition as an artist. But for the reasons already touched upon he had been obliged to increase his rate of production, which led to a certain thematic repetitiveness and occasionally had a negative impact on his technique.

There exist five other pictures of Trouville by Boudin that (though all larger and later) are virtually identical to this one.[1] They offer the same view of Trouville harbour as seen from Deauville, and the various elements of the composition – boats, water, houses – are practically interchangeable. It is interesting to note that aside from the version belonging to the Art Gallery of Hamilton, two of the others are now also in Canadian collections, having entered the country through Montreal's Continental Galleries.[2]

Although Boudin introduced Monet to outdoor painting in 1858, and later, in 1874, took part in the first Impressionist exhibition, his career followed a path parallel to the Impressionists. His luminous painting, characterized by a restrained, delicate palette, and a brushstroke that is blended rather than fragmented, is closer to that of Corot and Jongkind, who followed no master but nature itself and no principle but its patient and methodical observation.

*Louise d'Argencourt*
*Art historian*
*Paris*

Notes _____

1. See Robert Schmit, *Eugène Boudin 1824–1898* (Paris: Robert Schmit), vol. 2 (1973), no. 23–94 (p. 410), vol. 3 (1973), no. 26–87 (p. 50), no. 35–79 (p. 367), no. 36–48 (p. 392), and second supplement (1993), no. 39–90 (p. 56).

2. Both works are titled *Trouville. Le port. Marée basse (The Harbour at Trouville, Low Tide)* and date respectively from 1896 and 1897. The first belongs to the Musée national des beaux-arts du Québec, and the other is in a private collection. See Schmit, *Eugène Boudin*, vol. 3, nos. 35–79 and 36–48.

~~~

Cat. 6  (page 68)

**WILLIAM BLAIR BRUCE** (1859–1906)
*Le chasseur fantôme*  1888
huile sur toile
151,1 x 192,1 cm
Don commémoratif Bruce, 1914

À n'en pas douter, voilà un chasseur en détresse. Dans l'immense désert de neige qu'il traversait tout seul (notez l'unique série d'empreintes), il a rencontré une force irrésistible. En pivotant sur lui-même, il a perdu l'équilibre et est tombé sur le sol glacé. L'apparition, elle, continue d'avancer, indifférente au sort du chasseur. Habillée de manière analogue, comme si elle voulait le dépouiller de sa vie, elle semble en prendre possession corps et âme. Ne dirait-on pas que la dernière heure du chasseur est venue ?

*Le chasseur fantôme* s'inspire d'un poème de C. D. Shanly, « Le marcheur des neiges », où il est question d'un chasseur qui, selon l'interprétation de William Blair Bruce, meurt de froid[1]. L'artiste exécuta ce tableau narratif en France, où il vivait. Il emprunta à un ami américain le texte du poème de Shanly et se fit envoyer par ses parents l'habillement et les raquettes dont il aurait besoin pour le personnage[2]. Dès la conception, Bruce avait en tête une toile au sujet typiquement canadien. C'était la première œuvre « nationale » qu'il présenterait aux Parisiens habitués des salons de peinture, un test pour évaluer la cote de tels objets exotiques nord-américains[3]. *Le chasseur fantôme* fut accepté en 1888 au Salon de la Société des artistes français; en dehors de cela, il suscita une indifférence quasi générale en Europe[4]. Au Canada par contre, il attira bientôt l'attention des rédacteurs artistiques du *Dominion Illustrated* qui, en 1890, en publièrent une reproduction pleine page dans le même numéro qu'une version abrégée du poème de Shanly[5]. Ironiquement, alors que Bruce avait espéré

plaire au public européen en misant sur l'exotisme, ce furent les arbitres du goût dans son propre pays qui adoptèrent *Le chasseur fantôme*, et le tableau finit par devenir un symbole de l'identité canadienne, par incarner l'idée du « Canada, espace nordique[6] ».

Pourtant, au-delà de sa valeur symbolique, *Le chasseur fantôme* semble dire quelque chose de l'ambivalence existentielle inhérente à la condition humaine. Sa puissance découle de la tension créée par l'accumulation des paradoxes picturaux qu'il contient. Comment devons-nous comprendre ses multiples contrastes – entre le costume du chasseur, rendu dans le détail, et son étrange équivalent, celui du messager de la mort, peint de manière spectrale, impressionniste; entre les tons bleu froid de la nuit de plein hiver et le soupçon de corail qui suggère le soleil; entre les coups de pinceau discrets du paysage et l'assurance avec laquelle l'artiste a posé les étoiles ? Plus poignante, peut-être, est la tension engendrée par l'espoir d'établir un lien affectif avec le chasseur et l'impossibilité d'y parvenir. Les yeux, ces « miroirs de l'âme » qui font si souvent partie intégrante d'un récit, n'offrent ici aucune révélation. Nous constatons bientôt que le regard du chasseur, dissimulé par le capuchon, est insaisissable. Bruce donne à voir, mais il soustrait aussi à la vue. Il invite le spectateur à entrer dans le tableau mais, en même temps, il frustre la quête d'une compréhension entière, d'une solution à l'énigme. Source d'une foule de sentiments contradictoires – espoir, désespoir, peur, délivrance, trahison, aliénation, solidarité, isolement –, *Le chasseur fantôme* est à la fois obsédant et provocant. Voilà pourquoi il exerce une telle fascination.

*Arlene Gehmacher*
*Conservatrice*
*Département des cultures du monde*
*Musée royal de l'Ontario, Toronto*

Notes _____

1. Bruce donne son interprétation du poème dans une lettre adressée à son père et datée du 13 novembre 1888. Voir Joan Murray (dir.), *Letters Home : 1859–1906. The Letters of William Blair Bruce*, Moonbeam, (Ontario), Penumbra Press, 1982, p. 167. Le titre original du tableau, donné par Bruce, est *The Phantom of the Snow (Canadian Legend)*; voir lettre de l'artiste à sa mère, 24 mars 1888 (*ibid.*, p. 162). Le tableau fut inscrit dans le catalogue du Salon de 1888 à Paris sous le titre abrégé *The Phantom of the Snow*.

2. Voir les lettres de Bruce à son père, 26 janvier 1893, et à sa mère, 22 janvier 1888 (*ibid.*, p. 185 et 161).

3. Voir la lettre de Bruce à sa mère, 24 mars 1888 (*ibid.*, p. 162).

4. Ce que la presse de Hamilton dit de la carrière de Bruce donne une très bonne idée de l'accueil reçu par son œuvre à l'étranger. Tout ce que l'on peut y lire, c'est que « le jury artistique a parlé en bien » du *Fantôme* (« A Canadian Artist Abroad », *Evening Times* [Hamilton], 14 avril 1888, p. 3). Voir Arlene Gehmacher, *William Blair Bruce : Painting for Posterity*, Hamilton, Art Gallery of Hamilton, 2000, p. 19.

5. Dans *The Dominion Illustrated*, vol. 4, n° 93 (12 avril 1890), le tableau est reproduit à la p. 237 sous le titre *The Walker of the Snow*. Le poème figure à la p. 231 et un survol de la carrière de Bruce, à la p. 230.

6. Voir Sherrill E. Grace, *Canada and the Idea of North*, Montréal, McGill-Queen's University Press, 2001, p. 3–4 et 104–120. Grace étudie les ambiguïtés du tableau et du poème de Shanly.

~~~

Cat. 12  (page 72)

**MAURICE CULLEN**  (1866–1934)
*Logging in Winter, Beaupré*  1896
oil on canvas
64.1 x 79.9 cm
Gift of the Women's Committee, 1956,
dedicated to the memory of Ruth McCuaig,
President of the Women's Committee, 1953–1955

In his seminal study of Canadian painting, published in 1966, John Russell Harper included a colour illustration of this small picture by Maurice Cullen, presenting it as a kind of manifesto, a "talisman" with the power to influence a whole generation of artists.[1] The work's fame is nevertheless quite recent, and can be attributed in large part to the revival of interest in Post-Impressionist painting that began in the 1970s.[2]

Cullen had returned in the summer of 1895 from France, where he had been introduced to outdoor painting. Particularly interested in the technique, he had been encouraged to explore it further by fellow countryman William Blair Bruce. The following year, William Brymner and Edmond Dyonnet persuaded Cullen to accompany them on a painting trip to the Côte-de-Beaupré region, north of Quebec City, where they rented lodgings from Anna Blouin, wife of general store owner Eugène Raymond. "Cullen and I shared the cost of models," Dyonnet wrote later. "We had farmers who came with their oxen to pose for us."[3]

Back in Montreal, Cullen exhibited the recent work that, as a *Gazette* reviewer explained, was "the result of an eight months' sojourn in the picturesque country around Ste. Anne de Beaupré." The journalist went on to add: "Mr. Cullen is undoubtedly a pronounced impressionist … evidently enthusiastic over that portion of the country where he has made such a long stay, for, as he says himself, he had never to go more than fifteen minutes' walk from the village to find a subject and in his many paintings there is quite a diversity of subject. His snow scenes are unusually fine and very pleasing to the eye."[4]

*Logging in Winter, Beaupré* was thus painted early in the winter of 1896, in a familiar setting, and most likely exhibited to the Montreal public almost immediately. It is first and foremost a study of brilliant light. The logging scene that is the source of the title is actually secondary, and even somewhat ill adapted to the picture's format. It seems almost like an afterthought, designed to add a touch of life to the landscape and introduce a narrative element. The true subject of the work is the unusual palette and the handling of the pigment, which has been applied in brushstrokes that are visible over the whole pictorial surface.

The low-angle viewpoint has the effect of flattening the foreground, reducing the craggy landscape of Côte-de-Beaupré to its simplest lines and exaggerating the scale of the trees that soar up beyond the edge of the canvas. The pure white of the snow and pale blue of the shadows have been combined to create the sky's bluish tint, while the diagonals of the hilly slopes are echoed in the movement of the road and the irregular pattern of sunlight gleaming on the ground. Upon this framework sit the verticals of the trees' massive trunks, rendered in a mix of greys, greens and browns that stand out against the sky. Painter and spectator alike are enveloped in a space created by the deep shade of the forest. Shafts of light form pale patches on the trunks that contrast with the dark evergreen foliage. A reiteration of the full range of greens, from yellowish to nearly black, closes the composition on the left.

*Laurier Lacroix*
*Professor*
*Department of Art History*
*Université du Québec à Montréal*

TRANSLATION OF ENTRIES / TRADUCTION DES NOTICES

276

Notes _____

1. J. Russell Harper, *Painting in Canada: A History* (Toronto: University of Toronto Press, 1966), p. 255, fig. 234, p. 258.

2. Sylvia Antoniou, *Maurice Cullen: 1866–1934* (Kingston: Agnes Etherington Art Centre, 1982), pp. 60 and 62.

3. Edmond Dyonnet, *Mémoires d'un artiste canadien* (Ottawa: Éditions de l'Université d'Ottawa, 1968), p. 67.

4. *The Gazette* (Montreal), 2 December 1896, p. 3.

~~~

Cat. 13 (page 74)

**JAMES WILSON MORRICE** (1865–1924)
*Un coin du palais des Doges, Venise*  vers 1901
huile sur bois
17,3 x 25,2 cm
Legs de Mlle Margaret Rousseaux, 1958

Parmi toutes les vues de Venise que l'on doit à James Wilson Morrice, celle-ci est l'une des plus saisissantes. Assis à la terrasse du Gran Caffè Chioggia, près de l'escalier de la bibliothèque Marciana, l'artiste s'est abandonné au plaisir de peindre et a capté l'atmosphère d'un après-midi. Devant une image aussi complexe et achevée, on ne s'étonne pas que ses collègues aient tellement admiré ses petits tableaux, d'autant plus qu'il les faisait en plein air et non en atelier. Personnification de l'« observateur passionné » dont parlait Baudelaire, Morrice a donné un caractère intime à l'un des panoramas les plus célèbres au monde. Intuitivement et avec audace, il en a imposé sa propre représentation. On croirait contempler avec lui la Piazzetta (l'extrémité est de la place Saint-Marc) et le Molo, en bordure du Bacino, et, de l'autre côté du Ponte della Paglia, la Riva degli Schiavoni, dont le prolongement aboutit à la pointe orientale de la ville.

Dans les scènes vénitiennes de Morrice, l'architecture est à la fois un fait et une idée, une armature qui soutient la jouissance et l'expression des aspects sensoriels de la peinture. De l'imposante extrémité sud-ouest du palais des Doges – appelée le « coin du Figuier » à cause de la sculpture d'Adam et Ève au jardin d'Éden, œuvre du XIV siècle tardif, qui coiffe la colonne d'angle –, il a fait une mosaïque de solides à l'aspect moelleux et de vides. La forme à peu près carrée de cet assemblage de motifs se répète dans le parallélogramme dessiné par le pavement de la Piazzetta et du Molo, puis dans le ciel limpide. La rangée compacte de bâtiments et de lampadaires le long de la Riva est la clé de la composition : elle arrime toute l'image. Les modules parallèles des profondes arcades du palais, le lampadaire plumeté et le paquebot ancré dans le bassin se présentent résolument de front, ce qui est typique du modernisme élégant de Morrice. De même, la taille et l'espacement des Vénitiennes drapées dans des châles témoignent de sa sensibilité à l'harmonie des positions et des proportions. Ces personnages ponctuent la moitié inférieure du tableau, telles les notes d'une partition pour flûte, cet instrument dont Morrice aimait jouer. Les rythmes entre les formes au contour accentué et les intervalles d'une forme à l'autre sont ordonnés avec grâce et extraordinairement palpables. L'équilibre entre tous les éléments se sent surtout dans la précision des couleurs et le jeu raffiné des nuances. Les tons soigneusement modulés et les répétitions subtiles de formes colorées donnent à l'ensemble cette lumière délavée qui est le propre de Venise.

Morrice se rendit plusieurs fois dans cette ville, et on peut relier *Un coin du palais des Doges* aux autres vues vénitiennes de l'artiste qui appartiennent à l'Art Gallery of Hamilton. Le lieu que l'on voit sur ce petit tableau se trouve entre celui qui est représenté dans *Le porche de l'église San Marco* (cat. 14), à l'autre bout de la Piazzetta, et celui d'*Étude, Venise* (fig. 57), peinte à l'hôtel Danieli sur la Riva degli Schiavoni, près du Ponte della Paglia. Le plaisir esthétique que procurent tous ces tableaux, probablement exécutés à l'aube du XXe siècle, prouve que, aux yeux de Morrice comme de Whistler, Venise était une « incroyable cité de palais – créée expressément, on dirait, à l'intention du peintre[1] ».

*Sandra Paikowsky*
*Professeure*
*Département d'histoire de l'art*
*Université Concordia, Montréal*

Notes _____

1. James McNeill Whistler dans une lettre non datée à sa mère, Anna Matilda Whistler, (mars–mai 1880, Venise), Collection Whistler, Glasgow University Library, Écosse.

~~~

Cat. 16 (page 78)

**JOHN SLOAN** (Américain; 1871–1951)
*Stein devant une presse*  1906
huile sur toile
81,3 x 66,3 cm
Don de M. et Mme J. A. McCuaig, à la mémoire
du père de celle-ci, Monsieur H. B. Hall, 1964

John Sloan était dans une période de transition quand il peignit *Stein devant une presse*. Parti de Philadelphie pour s'installer à New York en 1904, il trouverait, quelques années plus tard, ce sur quoi repose en grande partie sa renommée actuelle : une façon unique et moderne de représenter la ville. La femme du tableau, Eugenie Stein (connue aussi sous le nom de Zenka ou Efzenka), venait de Bohême et exerçait le métier de modèle. Elle apparaît dans plusieurs autres œuvres réalisées par Sloan à la même époque. L'une d'elles, *Eugenie Stein, profil* (1904–1905, localisation actuelle inconnue), est, croit-on, la première toile achevée par l'artiste à New York. Une autre, *La couchette* (1907, Brunswick, Maine, Bowdoin College Museum of Art), fut présentée en 1908 à New York à l'exposition des Huit, qui mit le réalisme cru de Sloan, Robert Henri et leurs collègues sur le devant de la scène de l'art contemporain aux États-Unis.

À la fin de 1905, Sloan et sa femme Dolly habitaient tout en haut d'un immeuble de cinq étages sans ascenseur dans la 23e Rue Ouest à Manhattan, non loin du quartier Tenderloin, lieu mal famé où le peintre découvrirait quelques-uns de ses sujets les plus mémorables. L'atelier de Sloan, une des deux pièces de leur appartement, forme l'arrière-plan de *Stein devant une presse* et vit naître certaines de ses toiles les plus célèbres. C'est là également que Sloan entreprit sa fameuse suite d'eaux-fortes sur la vie new-yorkaise. Il termina les dix premières gravures – la plus grande partie de la série – à la fin de 1905 et en 1906. L'imposante presse taille-douce au fond de notre tableau peut être considérée comme une allusion directe à ce travail.

John Sloan fit des portraits et des études de personnages tout au long de sa carrière, mais sa première et principale activité avait été, durant une douzaine d'années, l'illustration de journaux, de livres et de magazines, si bien que, de 1904 à 1907, c'est-à-dire dans les années où Eugenie Stein posa pour lui, il commençait à

peine à trouver son style en peinture. Au cours de cette période, il essaya diverses manières de traiter la figure et le portrait, en s'inspirant d'autres artistes. Son grand ami Robert Henri l'influença plus que quiconque; probablement est-ce par son entremise que Sloan et Eugenie Stein se rencontrèrent. Ici, Sloan a représenté le modèle en pied, comme le faisait souvent Henri, mais il a laissé de bonnes marges autour. Un critique de l'époque a d'ailleurs dit au sujet de ce tableau : « l'atmosphère et l'impression d'espace qui s'en dégagent [en font] une belle réussite[1] ». La toile plut aussi à Henri : le 19 octobre 1906, Sloan nota dans son journal que son collègue en pensait grand bien[2]. D'une conception particulière, *Stein devant une presse* rend compte d'un moment unique dans les débuts de Sloan en peinture.

*Laural Weintraub*
*Historienne d'art*
*New York*

Notes _____

1. *New York Times*, 11 novembre 1907.

2. Bruce St. John (dir.), *John Sloan's New York Scene*, New York, Harper & Row, 1965, p. 70.

~~~

Cat. 17 (page 80)

**ALBERT MARQUET** (French; 1875–1947)
*The Pont Marie Seen from the Quai Bourbon* 1906–1907
oil on canvas
65.0 x 81.0 cm
Bequest of Marion E. Mattice, 1958

Despite being a frequent traveller, the painter Albert Marquet never crossed the Atlantic, although he was known in the United States during his lifetime through his participation in a number of international exhibitions.[1] It was not until the 1950s that his art began to appear in Canada's public collections, which today feature about a dozen of his works. Only six of these are paintings – a fact that makes their presence all the more precious.

Marquet is best known for his views of the Seine, and of different ports of Europe and Africa. This very fine picture of the Pont Marie, in Paris, is one of the first canvases by Marquet to be purchased by a Canadian museum. On the verso of the work is an inventory number from the gallery run by Eugène Druet, the dealer and ardent supporter of Marquet who was largely instrumental in making his work known outside France. Druet had discovered the young painter when he was part of the group of artists represented by Berthe Weill who would soon become known as the "Fauves." But Marquet's works do not display the convulsive, often rather wild brushstroke seen in the paintings of Henri Matisse, André Derain and Maurice de Vlaminck, Fauvism's leading proponents. Nor do they employ the unadulterated colours – vivid, gleaming and totally unnatural – that became the trademark of that revolutionary new movement. Marquet never allowed himself to be overcome by the feelings experienced so keenly by the Fauves and the Expressionists that prompted them to break radically with pictorial convention.

During the early years of his career, before a certain financial success enabled him to travel freely, Marquet portrayed the quays and bridges of Paris, and he returned often to this theme throughout his life, creating a remarkable series of images of the Seine. Around 1903, he began regularly setting up his easel in front of a window and capturing in an almost bird's-eye view the broad outlines of the landscape spread out before him. The exquisite capacity for simplification and the sureness of eye reflected in these images are exceptional. Endowed with a subtle yet powerful artistic personality, he bathed his compositions in the particular light of each place, preferring damp, overcast atmospheres and skies full of mist or snow. Against these rarefied tonalities he added the movement of human activity, simply portrayed: a few, almost calligraphic strokes of clearly Japanese influence sufficed to suggest working people going about their daily business.

*The Pont Marie Seen from the Quai Bourbon* is an excellent example of Marquet's delicate yet vibrant art. The composition is structured by a series of diagonal and slanting lines that draw the gaze towards the horizon. The light is that of an autumn day, cold and cloudy, which the artist has "warmed up" with a few touches of colour – the green of the river, the orange of the wagon, the reddish trees. It is a view from a window of his riverside rooms, and in the foreground we see several *bateau-lavoirs*, whose dark rectangles lead to the brilliantly pale bridge and its shaded arches, the only curved forms in the image. Despite its rather summary rendering, the bridge's beak-shaped buttresses, each surmounted by a niche, are clearly depicted. The scene owes much of its vitality to the small black specks that depict pedestrians moving across the bridge to the right bank and the Quai des Célestins, leaving Île Saint-Louis behind them.[2]

*Michèle Grandbois*
*Curator of Modern Art*
*Musée national des beaux-arts du Québec*

Notes _____

1. His works were shown in New York, Cleveland and Pittsburgh. The magnificent *Pont-Neuf by Night* (1935–1939, Paris, Centre Georges Pompidou, Musée national d'art moderne / Centre de création industrielle) earned him a First Honorable Mention at the 1938 international exhibition in Pittsburgh.

2. Marquet painted countless views of Paris, most of them featuring his favourite neighbourhood – the quays around the Île de la Cité. This view of the Pont Marie is therefore unusual and, according to the exhaustive inventory drawn up by the Wildenstein Institute, is one of only two works painted from this window. The second picture shows the view in the opposite direction, minus the bridge and including Notre-Dame and the church of Saint-Gervais. I am grateful to Michèle Paret of the Wildenstein Institute in Paris for providing me with information concerning the viewpoints of these two paintings.

~~~

Cat. 18 (page 82)

**SPENCER GORE** (Britannique; 1878–1914)
*La chambre* 1908
huile sur toile
51,0 x 41,0 cm
Don du Comité féminin, à la mémoire de Mary (Molly) Proctor,
présidente du comité de 1960 à 1962, 1960

En 1904, Spencer Gore peignait en Normandie avec des collègues de la Slade School. Sa première rencontre avec Walter Richard Sickert, futur fondateur du groupe controversé de Camden Town, date de ce moment. De mai à octobre 1906, Sickert lui prêta sa maison de Neuville, aux abords de Dieppe. Gore profita de ces six mois en France pour se perfectionner dans la science picturale en étudiant les procédés des impressionnistes et néo-impressionnistes – Cézanne et Seurat, notamment. Lucien Pissarro, avec qui il se lia d'amitié, l'y aida.

Nourrie par les scènes de carnaval de Goya, la fascination de Gore pour le romantisme et l'exotisme du théâtre s'exprima dans des œuvres assez différentes des sombres tableaux – instants de vie captés dans la salle plutôt que sur la scène – que Sickert consacra à cet univers. Toutefois, Sickert orienta la carrière de Gore en l'emmenant dans les misérables garnis qui lui servaient d'ateliers à Camden Town et en l'initiant aux thèmes qui caractériseraient la peinture du groupe nommé d'après ce quartier londonien[1]. À compter de 1906, les deux artistes peignirent souvent le même modèle avec, en arrière-plan, l'un ou l'autre de ces ateliers sordides[2].

Leur thème de prédilection, « le nu dans la chambre », doit sa légitimité à Sickert, mais c'est à Lucien Pissarro, lui aussi du groupe de Fitzroy Street (précurseur du groupe de Camden Town), que Gore est redevable d'avoir exécuté des toiles ayant la facture et le coloris de notre tableau. Lucien Pissarro avait appris de son père, Camille Pissarro, à juxtaposer de petites touches de ton pur. À partir de 1907, Gore employa cette technique pointilliste, parfois appelée divisionniste, avec passablement d'assiduité, aussi bien dans ses intérieurs que dans ses paysages. Comme on le constate dans *La chambre*, elle crée une homogénéité qui comprime l'espace pictural. La tension évidente dans les toiles de Sickert – résultat d'un traitement plus recherché du sujet et d'un rendu sommaire des détails du fond – est ici absente.

Gore a peint *La chambre* dans son atelier du 31, Mornington Crescent. Construit à partir du lit de fer, le quadrillage avec lequel il a structuré la composition se répète dans les verticales de l'alcôve où se tient le modèle. L'artiste opterait pour le même type de cadrage dans *Nu sur un lit* (v. 1910, Bristol, City Art Gallery) et dans *La fenêtre de la nursery, Rowlandson House* (1911, collection particulière)[3].

La femme représentée ici debout en linge de corps est celle que Gore a peinte dans *Une fille du nord de Londres* (v. 1911), aujourd'hui à la Tate Gallery[4]. Il s'agit de la domestique qui servait le thé les samedis après-midi à l'atelier collectif de la rue Fitzroy. De plus, elle travailla pour Gore et sa femme quand ils vécurent à Houghton Place en 1912–1913. Elle figure dans un autre tableau de l'artiste, *Femme debout à la fenêtre* (v. 1908, fig. 58), aujourd'hui à la Galerie d'art Beaverbrook de Fredericton.

*Ian Lumsden*
*Historien d'art*
*Fredericton*

Notes _____

1. Wendy Baron, *The Camden Town Group*, Londres, Scolar Press, 1979, p. 10.

2. *Ibid.,* pl. 8 et 9.

3. *Ibid.,* pl. 20 et 125.

4. *Ibid.,* pl. 42.

~~~

Cat. 22 (page 86)

**JOHN SLOAN GORDON** (1868–1940)
*Première neige* 1909
huile sur toile collée sur panneau de fibres comprimées
35,7 x 31,0 cm
Don des héritiers de John et Hortense Gordon, 1963

À l'instar de ses amis, John Sloan Gordon allait souvent faire des croquis à Cootes Paradise. Vraisemblablement, c'est aux environs de ce marais proche de Hamilton qu'il trouva la matière de cette étude de maisons au bord de l'eau. D'un pinceau léger, il produisit une toile scintillante et pleine de vie, une composition unifiée aux contours adoucis, où les flocons en forme de prisme suggèrent davantage les ors de l'automne que le bleu de l'hiver. Avant tout, l'image fait ressortir combien une neige précoce peut donner un air magique à une scène banale.

Né à Brantford, Gordon passa une saison à Paris en 1895–1896 à étudier à l'Académie Julian et à l'École des beaux-arts. Une fois de retour au Canada, il expérimenta le pointillisme durant plus d'une décennie. Cette technique a donné des résultats éclatants dans son tableau des chutes du Niagara (1907, fig. 59)[1]. Gordon l'a employée aussi dans un nocturne intitulé *Le vieux moulin de Kirby, à Brantford* (1908, Ottawa, Musée des beaux-arts du Canada). *Première neige* illustre comment il arrivait à obtenir des effets de plein air en fractionnant les tons au moyen d'un procédé légèrement différent de celui de Georges Seurat ou de Paul Signac.

Dans sa ville, Hamilton, Gordon était connu comme un instituteur, un conteur et un bon vivant qui prenait part à toutes sortes de manifestations littéraires et artistiques. À la Hamilton Art School, puis au nouveau Hamilton Technical Institute – où il fut le premier directeur du département des arts –, il encouragea ses élèves à explorer l'impressionnisme et le post-impressionnisme et à dessiner d'après nature. L'un d'entre eux, Albert H. Robinson, qui travailla dans son atelier pendant un certain temps, devint un impressionniste réputé.

Adepte du narratif et du pittoresque, Gordon travaillait sur de petits formats. Chez lui, la sensibilité s'alliait à la maîtrise. Ses paysages à l'aquarelle et à l'huile comprennent à la fois des scènes du sud de l'Ontario et des vues exécutées au cours des voyages annuels qu'il fit en Europe de 1920 jusque vers 1935 en compagnie de sa femme, l'artiste Hortense M. Gordon. Il donna bon nombre de ses tableaux à des amis, quoique, à l'occasion, Hortense et lui aient organisé de petites ventes de leurs œuvres. Ses dessins au trait et au lavis ont servi à illustrer des articles du *Saturday Night,* du *Christmas Globe* et du *Canadian Magazine of Politics, Science, Art and Literature*, de même que des livres d'auteurs canadiens – romans sentimentaux et récits d'aventures – publiés à Toronto par la Musson Book Company et chez William Briggs dans les années 1898 à 1908.

Les meilleures œuvres de Gordon sont, pour la plupart, antérieures à 1910. Après avoir commencé à enseigner au Hamilton Technical Institute, l'artiste fit moins d'expériences

picturales. Doué pour rendre les atmosphères hors du commun et les aspects attrayants d'une scène, ce pointilliste à la palette claire se classe parmi des impressionnistes canadiens tels Ernest Lawson, Maurice Cullen et Robert Pilot.

*Grace Inglis*
*Historienne d'art*
*Uxbridge, Ontario*

Notes _____

1. Paul Duval, *Canadian Impressionism,* Toronto, McClelland & Stewart, 1990, p. 90–91.

~~~

Cat. 24 (page 88)

**WILLIAM BRYMNER** (1855–1925)
*Les sœurs Vaughan* 1910
huile sur toile
102,4 x 129,0 cm
Don de M^me^ Harold H. Leather, 1962

William Brymner peint *Les sœurs Vaughan* en 1909–1910. Il est alors au faîte de son prestige. À l'Art Association of Montreal où il enseigne depuis 1886, il a beaucoup élargi l'éventail des cours et fait augmenter le nombre d'inscriptions. Il vient d'entamer son premier mandat comme président de l'Académie royale des arts du Canada. Le gratin montréalais collectionne ses œuvres. Lorsque Victor Mitchell, avocat et professeur à l'Université McGill, lui commande un portrait des filles de sa sœur, il est donc une personnalité du milieu artistique. Irene Vaughan, douze ans, et Dorothy, sa sœur aînée, séjournent chez M. et M^me^ Mitchell avant de retourner en Angleterre. Elles posent dans l'atelier de l'artiste, rue Bleury, deux fois la semaine. Brymner est bourru, les deux jeunes filles ont la bougeotte, Irene s'ennuie – ce qui, dira-t-elle plus tard, explique pourquoi elle a l'air maussade sur la toile[1].

Les sœurs Vaughan révèle que Brymner recourt parfois à des effets associés à l'impressionnisme – courant à propos duquel il a déclaré avec une certaine sympathie, dans une conférence prononcée en 1897, qu'il favorise « le vivant et le senti » en art[2]. En 1902, Maurice Cullen et lui ont visité Giverny, la propriété de Claude Monet. Sans nul doute, les tableaux impressionnistes de Cullen ont incité Brymner à réaliser des paysages en plein air. Par ailleurs, tant dans son enseignement que dans sa production, Brymner attache beaucoup d'importance aux principes qu'on lui a inculqués à l'Académie Julian : maîtrise du dessin, observation attentive de la nature, composition bien structurée. En témoignent, dans *Les sœurs Vaughan,* la complexité des relations formelles, physiques et psychologiques entre les modèles, les fleurs au premier plan, traitées à la manière d'une nature morte, et le livre ouvert.

L'équilibre entre fraîcheur et « sobre gravité[3] » – expression employée à propos de Brymner par le critique et historien William Colgate – est mis en valeur à la grande exposition d'art canadien tenue en 1910 à la Walker Art Gallery de Liverpool. *Les sœurs Vaughan* y côtoie *La comtesse de Minto* (1903, Musée des beaux-arts de Montréal, fig. 60) de Robert Harris, le plus réputé des portraitistes canadiens, prédécesseur de Brymner à l'école de l'Art Association et à la présidence de l'Académie royale des arts du Canada. Superbe exemple de portrait officiel à l'anglaise, *La comtesse de Minto* fait ressortir à quel point, dans *Les sœurs Vaughan,* l'ordre académique se marie à de délicates harmonies tonales, à un éclairage subtil et à des touches souvent diaphanes.

Aussi la toile de Brymner plaît-elle davantage que celle de Harris, plus conventionnelle. Toujours en 1910, *Les sœurs Vaughan* fait partie d'une exposition du Canadian Art Club, dont les critiques attendent de l'art de facture « moderne », et Brymner a droit à des éloges pour son « audacieux conflit de lumières » et son « traitement libre, proche de l'impressionnisme[4] ». Plus tard dans le courant de l'année, un autre journaliste insiste non pas sur les expériences de Brymner avec la couleur et la lumière, mais sur les qualités qui enracinent ses portraits dans la tradition et qui, de l'avis même de l'artiste, comptent le plus à long terme : « Si vous avez la chance de vous faire portraiturer par Brymner, vous serez assuré d'avoir un dessin magistral et une bonne peinture, une étude qui révélera votre caractère et mettra en valeur sa note dominante… et enfin, ce qui n'est absolument pas accessoire, un tableau[5] ».

*Brian Foss*
*Professeur titulaire*
*Département d'histoire de l'art*
*Université Concordia, Montréal*

Notes _____

1. Irene Vaughan Menzies dans une lettre à T. R. MacDonald, directeur de l'Art Gallery of Hamilton, mars 1964, dossier d'acquisition, Art Gallery of Hamilton.

2. Janet Braide, *William Brymner, 1855–1925 : aperçu rétrospectif de l'artiste,* Kingston, Agnes Etherington Art Centre, 1979, p. 12.

3. William Colgate, *Canadian Art : Its Origin and Development,* Toronto, The Ryerson Press, 1943, p. 131–132.

4. « Notable Pictures at Art Club's Exhibition », *Globe* (Toronto), 15 janvier 1910, p. 6.

5. M. J. Mount, « Work », *Canadian Century,* vol. 1, n° 23 (11 juin 1910), p. 7.

~~~

Cat. 27 (page 92)

**EMILY CARR** (1871–1945)
*Village de Yan, Î. R.-C.* 1912
huile sur toile
98,8 x 152,5 cm
Don de Roy G. Cole, 1992

Emily Carr peint *Village de Yan, Î. R.-C.* à Vancouver après un voyage dans l'archipel de Haida Gwaii – le pays des Haïdas – à l'été de 1912. Baptisées îles de la Reine-Charlotte par les explorateurs et colons britanniques, ces îles du nord de la Colombie-Britannique sont situées à quatre-vingt kilomètres de la côte. Yan se trouve tout au nord, à l'embouchure de l'inlet Masset. Une vingtaine d'années auparavant, les dernières familles amérindiennes ont quitté leurs lointains villages décimés par les épidémies successives de variole pour se regrouper à Masset et à Skidegate. Mais les gens d'Yan traversent encore régulièrement l'inlet pour pêcher près de leur ancien village et y cultiver leurs carrés de pommes de terre. L'artiste nous montre ici l'imposante rangée de trente mâts totémiques et les cabanes de pêcheurs qui subsistent alors à Yan.

Pourquoi cette femme, née à Victoria dans une famille de colons anglais, entreprend-elle de partir seule au pays des Haïdas en 1912 ? Depuis son enfance, Emily Carr est fascinée par les Amérindiens, plus nombreux que les Blancs à l'époque. Après avoir suivi des cours d'art à San Francisco et en Angleterre, elle ressent le désir de représenter son coin de pays et commence à peindre le paysage de la côte nord-ouest et les Amérindiens qui

l'habitent. Sa vocation se confirme en 1910–1911 pendant ses études en France, où elle assimile la palette brillante des Fauves et découvre le « primitivisme » cher aux disciples de Gauguin et de Matisse. « Votre Indien silencieux, lui dit un de ses professeurs, vous en apprendra plus que tout le jargon artistique[1]. »

Carr rentre en Colombie-Britannique, et son intérêt pour les Autochtones et leur tradition sculpturale s'intensifie. C'est l'époque où, attirés par la construction ferroviaire et l'expansion du secteur des richesses naturelles, les colons affluent vers le nord, dans les territoires des Kwakwaka'wakw, des Gitksans et des Haïdas. Carr elle-même a une nièce qui travaille comme institutrice dans la petite localité de New Masset, fondée par les colons près du Masset des Haïdas, et ses sœurs aînées soutiennent les missionnaires dans leur action évangélisatrice. Les missionnaires remplissent un rôle utile auprès des premières nations : ils servent de médiateurs et dispensent aux Amérindiens l'éducation euro-canadienne dont ceux-ci ont besoin pour faire face à cette invasion de leur territoire. Mais ils considèrent aussi les traditions autochtones comme des superstitions nuisibles et, de ce fait, ne sont pas étrangers à l'attitude négative qu'adoptent les colons. Carr, par contre, se porte à la défense des cultures autochtones. Quand on lui demandera, en 1927, pourquoi elle a fait ses tableaux des villages amérindiens, elle répondra : « Pour l'honneur des Indiens ! C'est pour eux que j'ai entrepris ce travail. Je les aime. Ce sont mes amis[2] ! »

La grande toile lumineuse qu'est *Village de Yan, Î. R.-C.* s'inscrit dans un projet que Carr s'est donné dès 1907 et qui consiste à aller peindre les mâts à l'endroit même où ils ont été érigés. Au cours des années suivantes, Carr visite les villages kwakwaka'wakw d'Alert Bay, de Campbell River et de Cape Mudge. En 1912, après ses études à Paris, elle fait un long voyage jusqu'à la rivière Skeena et au Haida Gwaii. Ses guides haïdas, Clara et William Russ, membres de nobles familles de Skidegate, lui donnent des aperçus de l'histoire et des traditions amérindiennes. Ils l'emmènent dans de nombreux villages abandonnés, où se dressent encore les alignements de mâts totémiques et les charpentes des anciennes maisons communes.

Partout, Carr dessine : des vues du village entier quand c'est possible, et des études de chacun des mâts. Sachant que les animaux sculptés sur ces mâts – ours, épaulards, loups, aigles, corbeaux – représentent des armoiries familiales et des légendes, elle en note soigneusement les détails. Avant son départ, elle a lu des textes anthropologiques sur les cultures amérindiennes de la côte nord-ouest. Elle espère ajouter aux connaissances en ce domaine. À son retour, elle demande au gouvernement de la Colombie-Britannique de lui acheter ses tableaux pour le nouveau musée provincial en construction près des édifices du parlement. La récession économique dans la province empêche toutefois ce projet de se concrétiser. Carr a néanmoins établi des contacts avec des anthropologues tels que Charles F. Newcombe et le lieutenant George T. Emmons; elle en établira plus tard avec Erna Gunther de l'University of Washington. Il est fascinant de voir que, sans avoir jamais croisé l'éminent Franz Boas sur sa route, elle a visité les mêmes villages amérindiens que lui et demandé leur aide aux mêmes personnes. Un autre contemporain de Carr, le photographe étatsunien Edward S. Curtis, s'est donné pour projet de photographier toutes les tribus amérindiennes d'Amérique du Nord; il a non seulement l'aide financière du magnat des chemins de fer J. Pierpont Morgan, mais aussi l'appui du président Theodore Roosevelt. On comprend à quel point l'entreprise de Carr était ambitieuse quand on sait qu'elle et Curtis ont créé leurs images des villages kwakwaka'wakw et haïdas pendant les mêmes années, soit 1910–1913.

Ce qui anime Emily Carr, c'est une exceptionnelle capacité de s'identifier à la culture des premières nations et une conviction à toute épreuve. L'atmosphère qui règne dans les villages traditionnels, la monumentalité des mâts totémiques et des maisons communes, la magnificence des lieux face à la mer – tout cela la fascine. Elle exécute, rapidement, une multitude d'esquisses à l'aquarelle. Puis, rentrée à Vancouver, elle retravaille ces esquisses, les peaufine. Certaines lui inspirent de grands tableaux à l'huile dans lesquels elle recrée l'ambiance de chaque endroit et témoigne de l'imagination et du savoir-faire de ceux qui ont sculpté les mâts. *Village de Yan, Î. R.-C.* est un des plus grands de ces tableaux.

Carr décrit de manière vivante son voyage à Yan dans une conférence prononcée en 1913 : « J'y suis allée deux fois et j'ai passé de longues journées parmi les mâts totémiques. Yan se trouve sur l'île la plus au nord de l'archipel de la Reine-Charlotte, presque en face de Masset. Un large inlet sépare les deux villages, et la mer est parfois bien agitée en cet endroit, pleine de courants traîtres et de remous. J'ai fait la traversée dans une petite pirogue, en compagnie d'une Indienne et de ses deux enfants. La femme dirigeait l'embarcation, assise à l'arrière, le bébé sur les genoux. Sa petite fille de douze ans manœuvrait adroitement la voile – une voile faite de sacs à farine. Les Indiens sont si habiles pour piloter ces bateaux, cela semble inné chez eux. Le temps était très mauvais ce jour-là; il pleuvait beaucoup et je n'ai pu dessiner qu'entre les averses[3]. » En 1913 également, Carr organise à Vancouver une exposition de près de deux cents peintures (dont *Village de Yan, Î. R.-C.*) représentant les villages et mâts totémiques de la côte nord-ouest. Elle entend ainsi démontrer l'importance de ce patrimoine culturel menacé et en constituer en quelque sorte des archives, à l'intention des enfants des premières nations et des colons. À l'époque, elle passe pour une excentrique et bien peu de gens la prennent au sérieux. Mais aujourd'hui, sa vision, bien que teintée d'un romantisme colonial naïf, nous paraît prophétique. Et l'on célèbre la détermination avec laquelle des artistes haïdas contemporains comme Robert Davidson et le défunt Bill Reid ont renouvelé les motifs traditionnels, dessinés ou sculptés, pour les réadapter à un monde en mutation.

*Gerta Moray*
*Professeure*
*School of Fine Art and Music*
*University of Guelph*

Notes _____

1. Emily Carr, *Les maux de la croissance : autobiographie* [*Growing Pains: The Autobiography of Emily Carr*], traduit de l'anglais par Michelle Tisseyre, Saint-Laurent (Québec), Éditions Pierre Tisseyre, 1994, p. 239.

2. Cité dans Muriel Brewster, « Some Ladies Prefer Indians », *Toronto Star Weekly*, 21 janvier 1928.

3. « Lecture on Totems », Fonds Emily Carr, Archives de la Colombie-Britannique, Victoria.

~~~

**ARTHUR WATKINS CRISP** (1881–1974)
*Portrait de Mademoiselle X* 1912
huile sur toile
214,8 x 122,8 cm
Don de l'artiste, 1961

Arthur Crisp arriva à New York en 1900 pour étudier à l'Art Students League et y resta jusqu'en 1903. Beaucoup d'artistes canadiens désireux de parfaire leur formation choisissaient alors New York plutôt que Paris, et Crisp se mêla rapidement aux cercles artistiques de cette ville et à l'entourage du peintre Robert Henri[1]. C'est pourquoi son œuvre n'est pas représentatif de l'art canadien de l'époque et, bien qu'il ait de grandes affinités avec celui de la jeune École de New York, il s'en distingue par plusieurs aspects. Crisp puisa à diverses sources culturelles. Par exemple, son goût pour les choses de l'Orient se révèle dans les œuvres en matière textile et les batiks qu'il réalisa en collaboration avec sa femme, Mary Ellen, dans les années 1920 et 1930. Crisp ne délaissa jamais la peinture de chevalet, mais il est surtout connu pour son travail de muraliste, amorcé vers 1907 grâce aux commandes reçues de l'imprésario David Belasco pour un bâtiment alors à la fine pointe de la technologie, le Stuyvesant Theatre, renommé Belasco Theatre en 1910.

*Portrait de Mademoiselle X* est un portrait mondain qui comporte bien des caractéristiques du modernisme. Son titre est peut-être une allusion plaisante au portrait de Madame Gautreau, intitulé *Madame X*, avec lequel John Singer Sargent avait fait scandale en 1884[2]. Les deux tableaux se ressemblent par la composition, mais celui de Crisp nous montre une jeune fille « moderne », dans une pose plus proche de celle des portraits d'homme qui contraste avec la pose provocante utilisée par Sargent. Mademoiselle X regarde le spectateur, la main sur la hanche, les pieds écartés. Elle porte des vêtements pratiques et sobres, auxquels le superbe chemisier à la Byron et le collier de perles qui pend de travers confèrent une touche « artistique ». Le bonnet à plumes (purement décoratif, peut-être, puisqu'il semble trop petit pour elle) ainsi que les bottines sont typiques de la mode de l'époque. Ces chaussures, peu confortables pour le travail ou la marche, portent à croire qu'il s'agit d'une femme de la bourgeoisie[3]. Moderne à bien des égards, cette peinture fait aussi référence à l'histoire de l'art. La pose se compare à celle de certaines compositions de la Renaissance – plus particulièrement de la fin du XVe siècle – et la scène de chasse de la tapisserie à l'arrière-plan n'est pas sans évoquer le passé. Vers la fin de sa vie, toutefois, Crisp ferait remarquer que « l'art est comme toute chose, il doit se fonder sur le gros bon sens[4] ». Voilà qui témoigne d'une vision pragmatique et essentiellement moderne, dépourvue de romantisme ou de nostalgie[5].

D'abord exposé sous le titre *Miss Burnett*, ce *Portrait de Mademoiselle X* (qui prit ce titre à une date indéterminée) resta en possession de Crisp jusqu'à ce que celui-ci en fasse don à l'Art Gallery of Hamilton en 1961. Aucun document n'explique pourquoi l'artiste conserva ce portrait – s'il est vrai qu'il lui avait été commandé – ni pourquoi le titre en fut changé. L'identité du modèle n'a pas été confirmée, mais on pense qu'il s'agit de Mary Burnett (1895–1976), qui n'a que dix-sept ans ici, malgré son air plus âgé[6]. En septembre 1914, Mary épouserait William Grosvenor (1886–1972), (diplômé de Harvard en 1909). Famille bien en vue du Rhode Island, les Grosvener étaient apparentés aux Peabody et aux Gardner, deux familles connues pour leur mécénat. Mary était la fille d'Edward Burnett, architecte et paysagiste spécialisé dans l'aménagement d'exploitations agri-coles qui travailla au Rhode Island et à New York pour de riches clients liés au cercle des artistes soutenus financièrement par David Belasco.

*Ihor Holubizky*
*Historien d'art*
*Brisbane, Australie*

Notes _____

1. Crisp ne suivit pas les cours de Henri, mais il fut à même de constater son influence à l'Art Students League. De Henri, il dit qu'il était « un des meilleurs portraitistes de [notre] époque »; Arthur Crisp, *Art Students League 1900-1903*, Elmsford, New York, The Creative Team, Inc., 1975, p. 15 (copie dans le dossier Arthur Crisp, Art Gallery of Hamilton).

2. Crisp raconte avoir copié un Sargent pour la Society of American Fakers. L'Art Students League, qui organisa cette manifestation à quelques reprises, exigeait des droits d'entrée et vendait aux enchères les œuvres exposées à la fin de la semaine (*ibid.*, p. 7).

3. Je suis reconnaissant envers Mary Ellen Kelly, de New York, qui m'a fourni cette interprétation des vêtements de Mademoiselle X (correspondance personnelle avec l'auteur, 1996 et 2000), ainsi que des détails sur les premiers travaux commandés à Crisp pour le Stuyvesant Theatre.

4. Crisp dans une lettre à John Sheppard, Dominion Foundries and Steel Limited, Hamilton, 28 mars 1973, dossier Arthur Crisp, Art Gallery of Hamilton.

5. Il est intéressant de comparer ce portrait avec celui des *Sœurs Vaughan* de William Brymner (voir cat. 24). Brymner aussi a peint un fond neutre qui met ses modèles en valeur, mais il y a chez lui un lyrisme dans la couleur, les vêtements et les deux accessoires que l'on ne trouve pas ici.

6. La famille Burnett, avec laquelle nous avons communiqué, n'est pas d'accord avec cette hypothèse. Toutefois, nous n'avons encore découvert aucun document – un écrit de Crisp lui-même, ou une photographie d'époque de Mary Burnett, par exemple – prouvant que cette hypothèse est fausse.

~~~

**HELEN McNICOLL** (1879–1915)
*La robe victorienne* vers 1914
huile sur toile
107,1 x 92,0 cm
Don de Monsieur A. Sidney Dawes, M.C., 1958

Helen McNicoll est connue comme peintre de la féminité, peintre de femmes en robe blanche et de jeunes filles au soleil menant le genre d'existence oisive que l'on associe généralement aux tableaux impressionnistes, à la bourgeoisie et au règne d'Édouard VII en Angleterre, où l'artiste vivait. À première vue, la paisible scène d'intérieur qu'est *La robe victorienne* s'inscrit dans cette catégorie d'images : une jeune fille en robe de bal se penche sur sa lecture, dans la lumière filtrée du soleil qui se réfléchit sur sa clavicule et son épaule nue. L'atmosphère en est une de grâce discrète et de sérénité. Pourtant, quelques éléments du tableau viennent subtilement troubler cette quiétude. Dans cette toile d'une tonalité si délicate, le jaune citron et le vert strident des rideaux, au centre, choquent[1]. L'organisation spatiale aussi crée un étrange sentiment de malaise, car on ne sait trop quel rapport il y a entre le mobilier et la jeune fille; celle-ci ne semble ni assise ni debout, et elle est trop au centre pour être perchée sur l'accoudoir du canapé. Pire encore, on sent une certaine disjonction entre le corps et la robe du modèle. C'est précisément sur ce point que la peinture a été critiquée lors de sa première exposition à la Royal Society of British

Artists en 1914. Tout en félicitant McNicoll pour la manière dont elle avait traité « la ravissante jeune fille qui porte la robe », un critique du *Connoisseur* attira l'attention sur une certaine incohérence entre le beau modelé du personnage et le manque de nuance de la robe blanche : « La jupe à crinolines et à volants [...] n'a apparemment pas intéressé l'artiste, de sorte qu'elle forme une plaque peu attrayante dans un tableau par ailleurs joli[2]. » Le manque d'intérêt n'en était sûrement pas la cause. McNicoll peignait souvent – et fort bien – des étoffes blanches, et celles-ci connotent quelque chose d'essentiel dans son art : la fraîcheur et la pureté qui siéent à une « jolie fille », mais aussi une sorte de vacuité, un sentiment de vide qui se traduit ici sur le plan structurel. Bref, la jeune fille et la robe ne vont pas ensemble.

Il y a une dimension historique à cette incongruité formelle, car en 1914 les jeunes filles ne mettaient plus ces robes à multiples crinolines qui avaient été en vogue du temps de leurs grand-mères. Mais l'anachronisme n'est pas seulement d'ordre vestimentaire. Les tenues de soirée victoriennes étaient lourdes à porter, dans tous les sens du terme : elles enfermaient la femme tout aussi bien dans le carcan des convenances que dans un corset baleiné. Or, en 1914, ces entraves à la liberté étaient déjà contestées par les femmes qui revendiquaient haut et fort le droit de vote et l'égalité des chances en éducation. Helen McNicoll était l'une des nombreuses femmes à s'être bâti une carrière malgré la discrimination institutionnalisée. Pourtant, que ce soit en dépit ou à cause de ce mouvement d'émancipation, l'idéal symbolisé par la robe victorienne conservait son attrait. Élément de décor, cette robe séduisait l'imagination, même si (comme le critique du *Connoisseur* semble l'avoir pressenti) elle n'est pas un vêtement que le modèle du tableau porte avec conviction. Comme l'artiste elle-même, la jeune fille représentée sur la toile de McNicoll vit dans un milieu où la division des rôles selon le sexe l'empêche de se sentir à l'aise. La féminité, telle qu'on la conçoit à l'époque, ressemble beaucoup à cette robe victorienne : plus qu'un simple vêtement, mais pas tout à fait une seconde peau.

*Kristina Huneault*
*Professeure agrégée*
*Département d'histoire de l'art*
*Université Concordia, Montréal*

Notes _____

1. Cet effet est perdu dans la reproduction.

2. *Connoisseur*, vol. 40 (1914), p. 229.

~~~

Cat. 36 (page 104)

**MARION LONG** (1882–1970)
*L'éventail*  1914
huile sur toile
41,6 x 32,1 cm
Don du Dr J. S. Lawson, 1961

Bien qu'elle porte un kimono, la femme que l'on voit dans *L'éventail* de Marion Long n'est pas une Japonaise, mais une Occidentale habillée à la japonaise. Les détails de son costume sont bien dans l'esprit du japonisme, cet engouement pour les choses japonaises que connaît l'Amérique du Nord à la fin du XIXe et au début du XXe siècle. Plus qu'un simple élément décoratif utilisé par les artistes, le kimono est alors un vêtement d'intérieur très à la mode, tant sur le continent nord-américain qu'en Europe. L'éventail noir qui complète la tenue est l'élément central de l'œuvre et lui donne son titre. L'intérêt pour la culture matérielle du Japon a perpétué l'usage de cet accessoire qui non seulement évoque la féminité pour les Occidentaux, mais renvoie à un langage secret, un code compris par les seuls initiés.

À la différence des portraits de militaires aux traits bien reconnaissables qui ont fait la notoriété de Long, ce tableau dans lequel le visage du modèle reste flou n'est pas un portrait, mais plutôt la représentation d'une idée. Devant une telle image, le spectateur de l'époque aurait vraisemblablement compris qu'ainsi vêtue, cette femme se trouvait chez elle, dans sa chambre; la voyant seule et inactive, il aurait facilement conclu qu'elle était perdue dans une rêverie. Les images de femmes songeuses, absorbées dans leurs pensées, étaient en effet populaires au moment où le tableau fut réalisé[1]. Long n'était pas la seule femme artiste à mettre en scène de tels personnages pensifs, et elle l'a fait dans d'autres peintures du même genre, dont *Le bocal à poissons rouges* (1916, Toronto, Musée des beaux-arts de l'Ontario). Ainsi, réunit-elle ici un certain nombre d'éléments qui font de cette toile une œuvre représentative des préoccupations des femmes peintres du Canada tout autant que de l'esthétique de la fin du XIXe et du début du XXe siècle.

Critiques littéraires et historiens d'art ont vu, dans l'omniprésence du thème de la rêverie, la quête personnelle de bien des femmes désireuses de donner un nouveau sens à leur vie dans une société en mutation. Il y a toutefois ici une deuxième interprétation possible. Si son visage demeure flou, c'est peut-être que la femme de *L'éventail* éprouve un instant le sentiment de ne plus se reconnaître elle-même et que, ayant perdu son identité, elle appréhende la solitude. Vivant à une période où seraient transgressées les règles de l'époque victorienne et édouardienne, et qui la plongerait, elle et ses semblables – sans doute trop vite – dans l'inconnu, cette femme ne sait peut-être plus très bien quelle est sa place dans la société. Et son dilemme se refléterait dans son costume : doutant de son identité, elle s'habille en étrangère. Souhaite-t-elle qu'on continue de l'admirer surtout pour sa beauté, ou veut-elle trouver au plus profond d'elle-même le sens de sa propre valeur ? Dans son langage secret, l'éventail qu'elle tient dans la main pose la question sans fournir la réponse.

*Janice Anderson*
*Conservatrice des ressources visuelles*
*Faculté des beaux-arts*
*Université Concordia, Montréal*

Notes _____

1. Pour en savoir plus sur la représentation des femmes dans diverses attitudes rêveuses, voir Julia Gualtieri, « The Woman as Artist and Subject in Canadian Painting (1890–1930) : Florence Carlyle, Laura Muntz Lyall, Helen McNicoll », mémoire de maîtrise, Queen's University, Kingston, 1989, p. 81–133.

Cat. 32 | 39 | 42 | 46 | 50 | 62

Lawren Harris (1885–1970) dans la collection
de l'Art Gallery of Hamilton

Cat. 32 (page 107)

*L'orgue de Barbarie* 1913
huile sur toile
75,8 x 86,6 cm
Don de Roy G. Cole, 1992

Cat. 39 (page 107)

*Dans le « Ward » à Toronto* vers 1919
huile sur panneau de fibres
26,7 x 35,4 cm
Don du Lillian & Leroy Page Charitable Trust, 1964

Cat. 42 (page 108)

*Chute, Algoma* vers 1920
huile sur toile
120,2 x 139,6 cm
Don du Comité féminin, 1957

Cat. 46 (page 109)

*Glacière, Coldwell, lac Supérieur* vers 1923
huile sur toile
94,1 x 114,1 cm
Legs de Monsieur H. S. Southam, C.M.G., LL.D., 1966

Cat. 50 (page 112)

*Jour de grisaille en ville* 1923, retravaillé au début des années 1930
huile sur toile
82,3 x 97,7 cm
Legs de Monsieur H. S. Southam, C.M.G., LL.D., 1966

Cat. 62 (page 113)

*Icebergs et montagnes, Groenland* vers 1930
huile sur toile
92,2 x 114,4 cm
Don de Monsieur H. S. Southam, C.M.G., LL.D., 1948

Lawren Stewart Harris a exercé une influence considérable sur l'évolution de la peinture canadienne dans la première moitié du XXᵉ siècle. Fils d'une famille riche, il a pu se consacrer à la peinture et soutenir plusieurs autres artistes. Après des études en Allemagne, il est rentré au Canada et a entrepris une série importante de vues torontoises. Elles sont particulièrement lumineuses, et la couleur, souvent utilisée à l'excès, y possède parfois des qualités expressives. *L'orgue de Barbarie* (1913, cat. 32) en est un superbe exemple. On peut l'associer aux œuvres des Scandinaves – Gustav Fjaestad, entre autres – que Harris avait vues à Buffalo en janvier 1913. Parmi tous ses tableaux, c'est peut-être celui qui doit le plus à l'impressionnisme. La légèreté de touche et l'atmosphère de mouvement sont remarquables. On croirait entendre le bruissement du vent dans les feuilles.

*Dans le « Ward » à Toronto* (v. 1919, cat. 39) est une toile beaucoup plus paisible. Cependant, la palette est encore plus expressive, peut-être parce que, après la Première Guerre mondiale, Harris se souciait davantage du message contenu dans chacune de ses œuvres. Cette description saisissante de taudis torontois témoigne sans doute d'une conscience grandissante des écarts entre classes sociales. Cela dit, les personnages du tableau n'ont guère de quoi nous toucher. Harris, dirait-on, les a placés là comme de simples repères dans l'espace et non pour susciter un sentiment quelconque. L'intensité dramatique provient plutôt du jeu des couleurs : le rouge chaud de la maison à droite, le blanc éclatant de la maison voisine, le jaune vif des feuilles d'automne. L'ensemble de la composition baigne dans une lumière égale qui laisse aux tons tout leur éclat.

Harris, donc, a joué un rôle déterminant dans la peinture canadienne. En 1913–1914, avec le Dʳ James MacCallum, il fait construire à Toronto le Studio Building, foyer de la peinture moderne. Le type de modernisme que l'on y pratique, bien qu'il s'inspire des artistes scandinaves et du post-impressionnisme français, privilégie le paysage. Harris contribue à l'essor de ce genre en organisant en 1918 la première des expéditions au cours desquelles lui-même et ses collègues parcourent la région de l'Algoma, en Ontario, à bord d'un wagon de marchandises. Ces excursions débouchent sur la production d'un ensemble d'œuvres qui sont montrées pour la première fois à l'Art Gallery of Toronto en mai 1920. Cette exposition inaugurale des artistes désormais rassemblés sous le nom de « Groupe des Sept » marque un tournant dans l'histoire de la peinture au pays.

*Chute, Algoma* (v. 1920, cat. 42), créé vers le moment de la première exposition du Groupe, a été peint à Toronto d'après un croquis fait à l'automne 1919 au cours d'un autre voyage en wagon de marchandises. Il indique de manière frappante que, de plus en plus, l'artiste entend révéler des vérités sur la nature en simplifiant le paysage et en se servant de la lumière. La composition n'a rien de « joli ». Les couleurs sont presque choquantes et le motif linéaire qui définit la chute est hautement stylisé. En fait, cette toile est un véritable manifeste sur le paysage canadien. Dans une perspective résolument nationaliste, Harris met l'accent sur la puissance et la simplicité des formes naturelles et donne une image de la terre qu'il connaît et qu'il aime.

L'Algoma dans son entier signifiait beaucoup pour l'ensemble du Groupe des Sept, mais Harris avait une prédilection pour la rive nord du lac Supérieur. Il a peint plusieurs de ses toiles les plus marquantes d'après des croquis dessinés dans cette région qu'il a visitée pour la première fois en 1921. *Glacière, Coldwell, lac Supérieur* (v. 1923, cat. 46) est l'une des plus intéressantes. Non seulement présente-t-elle une grande rigueur formelle, mais elle est imprégnée des convictions théosophiques de l'artiste. En étudiant les idées de Mᵐᵉ Blavatsky, fondatrice de la théosophie,

Harris a acquis la certitude que la peinture pouvait être une source d'inspiration métaphysique. Avec des dégradés, des formes épurées, des motifs très linéaires et une lumière surnaturelle, il a créé des scènes d'une grande profondeur spirituelle. Celle-ci est à la fois théâtrale et émouvante. De toute évidence, les détails de l'architecture et du paysage étaient secondaires pour lui. Si nous éprouvons un sentiment de transcendance en voyant ce tableau, Harris a atteint son but.

Tout en continuant d'occuper une place importante au Groupe des Sept, Harris a progressivement abandonné ses visées nationalistes pour approfondir sa quête spirituelle. Une image plus tardive de maisons torontoises, *Jour de grisaille en ville* (cat. 50), témoigne de cette nouvelle orientation. Exécutée en 1923 mais retouchée par la suite, probablement au début des années 1930, cette toile contraste avec *L'orgue de Barbarie* et même avec *Dans le « Ward »*. En voyant la porte close, les fenêtres aveugles, les maisons dont la lumière blafarde fait ressortir la pauvreté, on ne se sent guère le bienvenu. Ce tableau est l'expression d'une conscience sociale plus que la représentation d'un coin de Toronto.

L'idée du Nord, lieu de pureté et domaine de l'esprit, obsédait de plus en plus Harris. D'abord présente dans ses tableaux du lac Supérieur, puis dans des scènes des Rocheuses comme *Pics Goodsir* (v. 1924–1929, fig. 61), elle s'incarne on ne peut mieux dans la série de tableaux que l'artiste a peints à la suite de son seul voyage dans l'Arctique.

À l'été 1930, encouragé par A. Y. Jackson, qui était déjà allé dans le Grand Nord, Harris s'est rendu dans l'île de Baffin et au Groenland à bord d'un navire gouvernemental de ravitaillement, le *Beothic*. À partir de ses croquis, il a réalisé certains de ses tableaux les plus puissants et les plus imprégnés de spiritualité. Des œuvres comme *Île Bylot* (v. 1930, fig. 62) ou *Icebergs et montagnes, Groenland* (v. 1930, cat. 62) montrent un univers éloigné du tumulte des villes, un monde où l'esprit peut contempler le sublime en toute liberté. Dans *Icebergs et montagnes,* la majestueuse progression dans l'espace témoigne de l'importance que la maîtrise formelle conservait pour l'artiste. L'équilibre des formes des icebergs au premier plan et au plan médian, leurs masses sombres qui se détachent sur la blancheur des montagnes dans le lointain et la voûte dessinée dans le ciel ont tous été pensés pour façonner notre lecture de l'image. La lumière, immatérielle à l'intérieur des icebergs ou intense sur les montagnes de l'arrière-plan, joue aussi un rôle essentiel. Notre imagination nous transporte dans cette lointaine région immaculée, mais Harris voulait avant tout évoquer un voyage spirituel dans de pures régions isolées, et il en a fait le thème central de sa peinture de l'époque.

Le degré de stylisation évident dans des toiles telles *Île Bylot* et *Icebergs et montagnes, Groenland* indique que l'artiste se désintéressait de plus en plus du paysage lui-même. Dès le début des années 1930, sa quête esthétique et spirituelle le menait à l'abstraction, à la différence de ses collègues du Groupe des Sept. C'était comme si le paysage ultime, l'Arctique, avait fait perdre toute pertinence à n'importe quel sujet basé sur la nature. Moins populaires que ses paysages, les œuvres abstraites de Harris, dont la collection de l'Art Gallery of Hamilton comporte deux beaux exemples – *Abstraction (verticale)* (v. 1939, fig. 63) et *Peinture (Abstraction horizontale)* (v. 1948, fig. 64) – sont l'aboutissement logique de sa démarche. D'une grande rigueur intellectuelle, enracinées dans ses convictions théosophiques et dans ses recherches sur l'abstraction au sein du Groupe de peinture transcendantale au Nouveau-Mexique, ces œuvres représentaient pour Harris un nouveau type de peinture, une peinture d'idées, détachée de toute relation avec le terrestre.

La collection des œuvres de Lawren Harris à l'Art Gallery of Hamilton est particulièrement riche. Non seulement compte-t-elle plusieurs tableaux majeurs, mais elle nous permet de suivre les grandes étapes de l'évolution esthétique du peintre.

*Ian Thom*
*Conservateur principal*
*Musée des beaux-arts de Vancouver*

~~~

Cat. 37 (page 114)

TOM THOMSON (1877–1917)
*Bosquet de bouleaux, automne* 1915–1916
huile sur toile
99,0 x 115,4 cm
Don de Roy G. Cole, à la mémoire de ses parents,
Matthew et Annie Bell Gilmore Cole, 1967

*Bosquet de bouleaux, automne*, une des grandes toiles peintes par Tom Thomson pendant l'hiver 1915–1916, se classe parmi les œuvres les plus modernes de cet artiste. Par la négation délibérée de la profondeur, les taches bien nettes de couleurs pures et l'importance accordée à la matière et au geste plus qu'à la délimitation des formes, Thomson s'éloigne ici de l'approche picturale encore en vogue à la fin de l'époque victorienne, qui privilégie la représentation de l'espace par plans successifs. Cependant, Thomson ne rompt pas définitivement avec ce type de représentation spatiale. Le même hiver, par exemple, il exécute *Débâcle* (1915–1916, Ottawa, Musée des beaux-arts du Canada) et, un an plus tard, *Le pin* (1916–1917, Musée des beaux-arts du Canada). Cependant, quand on regarde ce grand symbole de l'identité canadienne qu'est devenu *Le pin*, on y voit davantage d'affinités avec la gestuelle de *Bosquet de bouleaux* qu'avec le fluide enchaînement des plans de *Débâcle*. *Bosquet de bouleaux* annonce les audacieuses petites esquisses à l'huile – fleurs sauvages et feuillages d'automne – de 1916, remarquables par la primauté accordée à l'acte de peindre. Ce sont ces œuvres qui démontrent le mieux combien fut rapide, chez Thomson, le passage à la modernité.

Comme la plupart des œuvres de Tom Thomson, *Bosquet de bouleaux* donne à voir un coin du parc Algonquin. Après sa première excursion en 1912, Thomson passe de plus en plus de temps dans ce parc, loin de Toronto et de son travail dans les ateliers d'arts graphiques (Grip Limited, puis Rous and Mann), isolé aussi (par la distance et les répercussions de la Première Guerre mondiale) du cercle des artistes qui formeraient plus tard le Groupe des Sept. Jusque-là, il avait surtout vécu en ville. Quoiqu'en dise la légende, Thomson n'était ni un artiste sans formation ni un « homme des bois », et le « Nord » qu'il parcourait n'avait rien d'une forêt « vierge ». Le parc Algonquin avait déjà été transformé par l'exploitation forestière puis, plus tard, par le tourisme, deux activités encore florissantes à l'époque, et Thomson, qui travaillait dans le parc comme guide de pêche et guetteur d'incendies, nous montre des traces de ces activités humaines dans beaucoup de ses peintures. Les bouleaux et les pins gris, fréquents dans son œuvre, sont parmi les premières essences d'arbre à pousser dans les zones déboisées; dans le parc Algonquin, ce déboisement résultait habituellement de l'abattage massif des pins blancs et des nombreux feux attribuables aux méthodes peu sécuritaires d'exploitation forestière.

Comprendre l'histoire du parc est essentiel pour comprendre Thomson, car on a beaucoup identifié l'artiste au « pays nordique » et à l'image populaire du Canadien idéal. Étant donné le mythe

qui entoure une grande partie de sa vie et de son art, il est capital de réexaminer l'artiste et son œuvre en fonction de ce que l'on sait aujourd'hui sur le paysage où il a vécu et peint. Thomson a lutté, avec un remarquable succès, pour définir par la peinture un sentiment d'appartenance. Des œuvres majeures comme *Bosquet de bouleaux, automne* invitent à un tel réexamen : elles mettent en évidence les phénoménales réalisations de Tom Thomson en tant que peintre, tout en témoignant de sa remarquable faculté de communier avec l'environnement complexe qui était le sien.

*Andrew Hunter*
*Artiste, écrivain et conservateur indépendant*
*Dundas, Ontario*

~~~

Cat. 38  (page 116)

### FLORENCE H. McGILLIVRAY  (1864–1938)
*Hiver à Rosebank, lac Ontario*  1917
huile sur carton
46,1 x 61,5 cm
Don de Kathleen Hillary, 1957

Florence H. McGillivray fait partie des post-impressionnistes canadiens les plus nettement influencés par Vincent Van Gogh. Après ses études à la Central Ontario School of Art and Design auprès de l'artiste d'origine écossaise William Cruikshank, elle suit des cours dans divers ateliers, dont celui du portraitiste J.W.L. Forster, puis, part pour Paris. C'est là, à l'Académie de la Grande Chaumière en 1913, qu'elle découvre le post-impressionnisme. Elle en donne une interprétation enthousiaste et d'une belle intensité lyrique dans un tableau représentant une religieuse française, *Contentement* (Toronto, Musée des beaux-arts de l'Ontario), où elle traite les couleurs par masses, au couteau à palette, et accentue les contours des formes en noir. La même année, elle expose ce tableau au Salon des Beaux-Arts. La puissance de cette œuvre lui vaut d'être rapidement acceptée dans la communauté internationale. Toujours en 1913, McGillivray est élue présidente de l'International Art Union, groupe qui serait dissout au déclenchement de la Première Guerre mondiale. En 1917, année où elle peint *Hiver à Rosebank*, elle est élue à l'Ontario Society of Artists ainsi qu'à la Society of Women Painters and Sculptors de New York. À ces deux importantes distinctions s'ajoutera, en 1925, son entrée à l'Académie royale des arts du Canada en qualité de membre associée. La notoriété n'empêche nullement McGillivray de donner généreusement de son temps à de jeunes artistes contemporains talentueux. Tom Thomson, à qui elle rend visite en 1917 dans la cabane près du Studio Building de Toronto où il peint, voit en elle une « âme sœur », et l'intérêt que McGillivray porte à son travail lui est précieux. Il confiera à une de ses connaissances, le garde forestier Mark Robinson : « Elle fut la seule à comprendre tout de suite ce que je cherchais à faire[1] ».

McGillivray peint *Hiver à Rosebank* dans un lieu de villégiature, très fréquenté par les pique-niqueurs en été, qui se trouve à l'embouchure de la rivière Rouge à Pickering, entre Whitby (où vit sa famille) et Toronto (où elle a de nombreux amis). Le tableau donne une excellente idée du genre de peinture descriptive qu'elle pratique. L'artiste réalise plusieurs toiles et aquarelles à la Rivière Rouge, et Rosebank est sans contredit l'un de ses endroits préférés pour peindre. D'après le point de vue – le même que sur une carte postale de l'époque (fig. 65) –, elle s'est placée sur un escarpement pour saisir cette vue hivernale de la plage et du lac Ontario.

*Hiver à Rosebank* est un tableau impressionnant, tumultueux. McGillivray y condense le monde en des empâtements vibrants d'énergie et de riches couleurs. Dans les eaux houleuses du lac Ontario, dans le ciel lavande et jaune du couchant, elle fait sentir la turbulence de la nature, et l'on décèle l'excitation que lui procure le travail de la matière tout autant que l'attention vigilante qu'elle porte à la surface. Le tronc du bouleau au premier plan à gauche témoigne de cette maîtrise de la forme et de cette vigueur de la touche par lesquelles McGillivray, avec d'autres post-impressionnistes, a préparé l'avènement du modernisme au Canada.

*Joan Murray*
*Directrice exécutive par intérim*
*Collection McMichael d'art canadien*
*Kleinburg, Ontario*

Notes _____

1. Mark Robinson dans une lettre à Blodwen Davies, 11 mai 1930, Fonds Blodwen Davies, MG30 D24, Archives nationales du Canada, Ottawa.

~~~

Cat. 40  (page 118)

### ROCKWELL KENT  (Américain; 1882–1971)
*Chute d'eau gelée, Alaska*  1919
huile sur toile collée sur panneau de fibres
86,5 x 71,2 cm
Don du Comité féminin, 1971

J'ai besoin de montagnes aux cimes enneigées [...] et de la cruelle mer septentrionale [...] Ici, les ciels sont plus clairs, plus profonds et, par les plus grandes merveilles qu'ils révèlent, mille fois plus éloquents que l'éternel mystère des ciels qui s'étendent au-dessus de terres plus clémentes[1].

Rockwell Kent

« Non ! Non ! Trois fois non ! cria-t-il d'une voix forte en passant la main sur sa barbe – *cela* je le sais mieux que toi ! Il y a encore des îles Fortunées[2] ! »

Friedrich Nietzsche

Installé pour l'hiver 1918–1919 dans l'île Fox, au large de Seward, l'Américain Rockwell Kent peignit cette composition aux formes puissantes, à la lumière cristalline et aux riches tons de bleu dont l'intensité, à première vue, masque la profondeur spirituelle[3]. Kent était un individualiste, un artiste qui cherchait le sens de la vie en affrontant la nature brute et les climats du Grand Nord. Amateur de lieux retirés, il avait vécu à l'île Monhegan, dans le Maine, et dans le village terre-neuvien de Brigus avant d'aller en Alaska. Dans les années 1929 à 1935, deux de ses trois séjours prolongés au Groenland se dérouleraient dans une île minuscule, Igdlorssuit.

L'île Fox, où Kent peignit *Chute d'eau gelée, Alaska* et passa l'hiver avec son garçon de neuf ans, était presque inhabitée. Père et fils y vivaient à la manière de Robinson Crusoé. Leur unique compagnon était un trappeur solitaire nommé Olson, leur guide dans cet endroit que Kent, plus tard, appellerait le paradis. Loin de l'agitation urbaine qui ne lui était que trop familière, l'artiste trouvait la solitude dont il avait besoin pour clarifier sa vision esthétique.

Depuis longtemps, les mythes et les sagas nordiques passionnaient Kent. Dans l'île Fox, il lut deux grands récits d'exploration

– *Voyage autour du monde, fait dans les années* MDCCXL, *I, II, III, IV,* de George Anson, et *Le Nord dans le brouillard,* de Fridtjof Nansen. En outre, il passa des heures dans *Ainsi parla Zarathoustra,* de Friedrich Nietzsche. Ce long ouvrage rempli de prophéties obscures l'émouvait à tel point qu'il s'en inspira pour une série d'illustrations intitulée *L'ermite fou,* qu'il annexa à son autobiographie illustrée, *Wilderness : A Journal of Quiet Adventure in Alaska.* Dans ce livre, on peut suivre le récit de sa vie quotidienne et comprendre sa vision au moyen de textes et d'images qui décrivent les splendides montagnes, paysages maritimes et chutes d'eau de son « île Fortunée ».

> Zarathoustra conduisait lui-même par la main le plus affreux des hommes, pour lui montrer [...] les chutes d'eau argentées qu'il y avait près de sa caverne[4].

En regardant *Chute d'eau gelée,* on imagine Kent en acteur et metteur en scène d'un drame wagnérien. Debout sur les rives de l'île Fox, il lève un rideau de glace d'un bleu vert iridescent et révèle ainsi une scène grandiose : la baie de la Résurrection, le glacier de l'Ours et les monts Chugach. Depuis les coulisses à l'extrémité gauche, le soleil doré du solstice d'hiver illumine la base du glacier et transforme les méplats des montagnes en pyramides sculptées, en totems symboliques. Au fil de son expérience nordique, Kent a créé une iconographie très personnelle, imprégnée de spiritualité.

La similitude entre *Chute d'eau gelée* et les tableaux nordiques de Lawren Harris est trop forte pour être le fruit du hasard. Les deux hommes étaient amis. Harris avait tous les livres illustrés de Kent et bon nombre d'estampes gravées d'après ses toiles[5].

*Constance Martin*
*Historienne d'art*
*Institut arctique de l'Amérique du Nord*
*University of Calgary*

Notes _____

1. Introduction à son livre *Wilderness : A Journal of Quiet Adventure in Alaska,* Hanover, New Hampshire, University Press of New England, [1920] 1996, p. xxvii.

2. *Thus Spoke Zarathustra,* cité dans David Traxel, *An American Saga : The Life and Times of Rockwell Kent,* New York, Harper & Row, 1980, p. 100. La version française de la citation provient de Friedrich Nietzsche, *Ainsi parla Zarathoustra,* traduit de l'allemand par Maël Renouard, Paris, Rivages poche / Petite bibliothèque, 2002, p. 384.

3. Il existe au moins une autre version, identique si ce n'est de la lumière et des nuages. Elle s'intitule *Chutes gelées, Alaska* (1919, Plattsburgh State Art Museum). Au sujet des autres tableaux représentant des chutes et peints par Kent en Alaska, voir Fridolf Johnson (dir.), *Rockwell Kent : An Anthology of His Work,* New York, Alfred Knopf, 1982, p. 263–265.

4. Kent a fait de cette citation de Nietzsche (*Ainsi parla Zarathoustra,* p. 495) la légende d'un dessin de *Wilderness,* p. 5. D'autres illustrations de chutes figurent aux pages 111, 114, 149, 151, 153, 169 et 190 de *Wilderness.*

5. Constance Martin, *Distant Shores : The Odyssey of Rockwell Kent,* Berkeley, University of California Press, 2000, p. 27.

~~~

Cat. 45  (page 122)

**EMILY COONAN** (1885–1971)
*Jeune fille en robe à pois*  vers 1923
huile sur toile
76,0 x 66,4 cm
Don du Hamilton Spectator, 1968

Ce tableau montre combien Emily Coonan savait donner de l'expression à une scène banale. Il possède une éloquence qui tient moins à son contenu qu'à la poétique de l'articulation formelle. En ce sens, il reflète l'affinité de Coonan avec le langage post-impressionniste qu'une génération d'artistes canadiens était en train d'assimiler au début du XXᵉ siècle. Coonan fut l'une des premières artistes professionnelles du pays à embrasser le modernisme naissant. Son œuvre se caractérise par une interprétation hardie et précoce des récentes innovations stylistiques.

D'emblée, la critique reconnut en Coonan une voix originale, « le genre d'artiste dont le talent est manifestement inné[1] ». Même si sa carrière professionnelle coïncida avec l'ascension des Sept, elle n'adhérait pas au propos nationaliste de ce groupe. Ses sources d'inspiration étaient plutôt le modernisme international et l'esthétique raffinée de James Wilson Morrice. À l'instar d'autres membres du Groupe de Beaver Hall à Montréal, auquel elle fut associée un moment, elle puisait dans un vaste répertoire iconographique qui englobait des scènes urbaines, des tableaux d'intérieur et des paysages. Toutefois, on admirait surtout ses figures, et c'est en elles que le caractère unique de son œuvre se voit le mieux.

Peint peu de temps après un deuxième voyage en Europe et présenté à la British Empire Exhibition en 1924 à Wembley, en Angleterre, *Jeune fille en robe à pois* illustre à merveille comment Coonan abordait la figure. L'artiste a comprimé l'espace pictural et utilisé une palette claire, assez excentrique, ce qui témoigne de son intérêt pour les techniques nouvelles. Une atmosphère poignante et introspective, souvent présente chez Coonan, tempère la vigueur que donnent à l'image l'immédiateté architectonique, la solide conception interne et la virtuosité de l'exécution. L'élégance de la touche, la subtilité des tons et le lyrisme des détails décoratifs sont remarquables. Sur un fond neutre, où l'on ne voit guère autre chose que des coups de pinceau, le modèle, sans référents sociaux ou personnels, est traité presque à la manière d'un motif ou d'un « sujet trouvé ». Pourtant, une forte présence habite la toile. Cette jeune inconnue n'est pas aussi sereine qu'il y paraît. Son expression insaisissable suscite notre attention et pique notre curiosité.

Cette qualité énigmatique, commune à toutes les toiles de Coonan mais particulièrement évidente dans ses représentations de personnages, est peut-être l'élément qui différencie ses tableaux de ceux de ses contemporaines Mabel May, Prudence Heward et Lilias Torrance Newton. Bien que, tout comme elles, Coonan ait eu le souci de renforcer la syntaxe moderniste au moyen de la figuration, son œuvre se distingue de la leur. Contrairement à la *Femme indienne, Oka* de May (cat. 55) ou à la *Femme sur une colline* de Heward (1928, Ottawa, Musée des beaux-arts du Canada), ses personnages évitent le face-à-face. Leur regard est rarement révélateur et les décors demeurent anonymes – ils ne sont ni descriptifs ni symboliques. En fait, Coonan ne poursuit jamais une démarche thématique (elle n'a que faire du portrait ou de la vérité historique). Elle cherche plutôt le potentiel expressif de la « forme signifiante ». Ainsi, *Jeune fille en robe à pois* annonce le modernisme qui parviendra à maturité à Montréal dans les années 1930. Hélas, Emily Coonan quittera mystérieusement la scène artistique de la métropole à un moment qui aurait

pu être des plus propices sur le plan professionnel : elle exposera pour la dernière fois en 1933.

*Karen Antaki*
*Historienne d'art*
*Montréal*

Notes _____

1. « 27th Annual Spring Exhibition », *The Standard* (Montréal), 25 mars 1911.

~~~

Cat. 52 (page 126)

**J.E.H. MacDonald** (1873–1932)
*Pluie dans les montagnes* 1924
huile sur toile
123,5 x 153,4 cm
Legs de H.L. Rinn, 1955

En août 1924, J.E.H. MacDonald part de Toronto à destination du lac O'Hara, dans le parc national Yoho, en Colombie-Britannique. Descendu du train sur une voie de garage au lac Wapta, il monte ensuite sur un cheval de bât et gravit, sur une distance de onze kilomètres, un sentier qui mène à une petite cabane en rondins bâtie en 1911. La cabane se niche dans un pré idyllique, au pied des sommets Wiwaxy et du mont Odaray, dans les chaînes continentales des Rocheuses canadiennes. Dans ce lieu de haute altitude, amphithéâtre où se concentre une beauté exceptionnelle, l'artiste trouve le réconfort, la sérénité et une réserve inépuisable de matière. Sa santé, toujours fragile, s'améliore. Il passe trois semaines à faire des croquis dans sa retraite rustique. Il y retournera six ans d'affilée pour à peu près la même période. En tout, il exécutera plus d'une centaine de croquis pendant ces séjours.

La plupart des scènes de montagnes de MacDonald sont des pochades qui illustrent les métamorphoses du panorama : effets de lumière, phénomènes atmosphériques, couleurs toujours changeantes des rochers, des arbres et des lacs. *Pluie dans les montagnes* est la première du nombre assez limité de toiles qu'il produit à partir de ses croquis du lac O'Hara. Il l'a peinte dans son atelier torontois peu après sa première expédition en 1924. Plus qu'un paysage, elle est un amalgame des trésors – expériences, souvenirs – que l'artiste a rapportés de son voyage.

Elle est aussi l'œuvre d'un graphiste accompli et d'un peintre subtil. Au graphiste, on doit la forêt, simple motif, et le lac, représentation épurée des reflets du soleil dans l'eau. La mosaïque des lichens sur les rochers de la rive, la forme stylisée du glacier Odaray et les taches de lichen sur le tronc courbé contribuent toutes à l'harmonie de l'ensemble. MacDonald le peintre a su rendre – par exemple en orientant ses coups de pinceau du coin supérieur gauche au coin inférieur droit de la toile – la force et la soudaineté des bourrasques de pluie qui caractérisent cette région. Par beau temps, souvent presque sans prévenir, des nuages venus du sud et de l'ouest s'avancent sur le mont Biddle et déversent dans la vallée une pluie drue, tandis que, déjà, le soleil recommence à luire dans le lointain. Attentif à saisir l'essence même du lac O'Hara, l'artiste nous offre le spectacle de la pluie et nous livre ses souvenirs des montagnes.

En fait, la toile présente un même paysage vu de deux points différents. Elle montre le lac O'Hara et le mont Odaray tel qu'on les voit en se tenant à l'extrémité sud-ouest du lac et tels qu'on les voit en montant cent mètres plus haut, sur le plateau Opabin. Pour visiter ces lieux et faire de la randonnée dans la

région du lac O'Hara comme MacDonald l'a fait dans les années 1920, se rendre au parc national Yoho et s'adresser au bureau de renseignements.

*Lisa Christensen*
*Conservatrice des objets d'art*
*Whyte Museum of the Canadian Rockies, Banff*

~~~

Cat. 55 (page 130)

**H. Mabel May** (1877–1971)
*Femme indienne, Oka* 1927
huile sur toile
67,0 x 54,0 cm
Legs de Josephine M. Magee, 1958

Parmi les multiples figures peintes par Henrietta Mabel May entre 1910 et 1930, *Femme indienne, Oka* se distingue par la manière et le sujet. L'approche stylistique reflète la personnalité et la condition du modèle. Sans doute sous l'influence du fauvisme, l'artiste a opté pour des couleurs franches, des formes simples et des aplats. Bien que la femme occupe la plus grande partie du tableau, le traitement du fond suggère que l'abri derrière elle a son importance. Par le jeu des contrastes – tons sombres pour le personnage, couleurs claires pour l'arrière-plan –, May a pu faire ressortir également, mais de façon différente, les deux éléments. Dans des toiles précédentes, elle avait employé plutôt des couleurs sourdes qui donnaient aux sujets féminins un air plus passif[1].

Bon nombre des portraits antérieurs de May représentaient des personnes de sa connaissance, et leur nom figurait dans le titre. C'était le cas de *Doris et Ruth* (v. 1916, localisation actuelle inconnue), où l'on voit deux de ses nièces. Par son thème, *Femme indienne, Oka* s'apparente peut-être davantage à *Immigrants, gare Bonaventure* (1914, localisation actuelle inconnue) et aux souvenirs de guerre peints par May dans les années ultérieures – par exemple, *Femmes fabriquant des obus* (1918, Ottawa, Musée canadien de la guerre) –, qui mettent en évidence les changements sociaux à l'œuvre dans un pays en expansion[2].

On peut aussi placer cette *Femme indienne* dans un contexte plus large, à savoir l'iconographie des peuples autochtones dans l'art canadien, qui, historiquement, tendait à les présenter comme une « race en voie d'extinction », à les confondre en une entité homogène, à les regrouper sous le type du bon sauvage attaché aux valeurs spirituelles ou du primitif assoiffé de sang[3]. Le tableau de May, lui, est manifestement le portrait d'un individu à part entière. Les traits accusés de l'Indienne et son regard intense, dirigé tout droit vers le spectateur, dénotent fierté et résolution.

À une époque où, par crainte de voir disparaître le mode de vie des Autochtones au Canada, bien des gens s'affairaient à l'inventorier, May choisit de représenter une Autochtone en particulier, une femme en chair et en os, devant sa maison. Pourtant, on ne sait trop si l'artiste entendait ainsi remettre en question une perception à son avis erronée ou si elle tentait, elle aussi, de « capter » le sujet avant qu'il ne cesse d'exister. L'absence de nom dans le titre renforce l'altérité du personnage : par cette omission, May éclipse l'identité du modèle au profit de celle de tout un « groupe ethnique[4] ».

Depuis la crise d'Oka en 1990, il est difficile de regarder ce portrait et d'en lire le titre sans revoir en pensée les guerrières mohawks qui ont tenu bon pendant cet affrontement. Dans le film d'Alanis Obomsawin, *Kanehsatake : 270 ans de résistance*,

Ellen Gabriel explique quelle a été la réaction instinctive des femmes quand les policiers ont donné l'assaut : « Nous avons compris que les femmes aussi devaient être en avant. C'est notre devoir de protéger la terre, de protéger notre mère[5] ». À des décennies d'écart, ces propos et le regard de défi de la *Femme indienne* ne livrent-ils pas le même message : autonomie et défense du foyer ?

*Maura Broadhurst*
*Historienne d'art*
*Toronto*

Notes _____

1. Karen Antaki, « H. Mabel May (1877–1971) : The Montreal Years, 1909–1938 », mémoire de maîtrise, Université Concordia, Montréal, 1992, p. 46. Antaki suggère que, même dans ces autres portraits, May pourrait avoir contesté les structures de pouvoir en place dans la société. Néanmoins, *Femme indienne, Oka* est différent en ceci que le sujet est plus ouvertement conflictuel et que l'on ne peut éviter le regard du modèle.

2. Par l'entremise du Fonds des souvenirs de guerre canadiens, le gouvernement fédéral a engagé des artistes canadiens et britanniques pour qu'ils rendent compte, par la peinture, la sculpture et la photographie, de l'effort de guerre au Canada et de l'impact des hostilités au pays.

3. Daniel Francis, *The Imaginary Indian: The Image of the Indian in Canadian Culture*, Vancouver, Arsenal Pulp Press, 1992.

4. Charmaine Nelson, *Le regard de l'autre, artistes canadiens blancs – sujets féminins noirs / Through An–other's Eyes: White Canadian Artists – Black Female Subjects* Oshawa, The Robert McLaughlin Gallery, 1998, p. 8.

5. Alanis Obomsawin, *Kanehsatake : 270 ans de résistance*, Office national du film du Canada, 1993.

~~~

Cat. 57 (page 134)

**ADRIEN HÉBERT** (1890–1967)
*Elevator No. 1* c. 1929
oil on canvas
104.7 x 63.8 cm
Gift of The Hamilton Spectator, 1962

At a time when the Group of Seven was relentlessly making a northern landscape iconography the symbol of "Canadian" painting, Adrien Hébert set himself apart by portraying an icon that could rather be seen as the quintessential image of urban and industrial modernity: the huge, portside grain elevator.

When Hébert began painting the port of Montreal regularly in 1924, it had just been classed for the fourth year running as the largest grain exporter in the world. Elevator no. 1, built between 1901 and 1904 by Steel Storage and Elevator Construction of Buffalo, was considered one of the most up-to-date and best equipped of its type. Fifty-nine metres high, it rose above the skyscrapers that were beginning to appear on the city's skyline.[1] The next two decades saw the construction of additional grain elevators, soon cited as models of the genre by modernist architects Walter Gropius and Le Corbusier.[2] These structures, together with the port's high wharves, permanent steel-and-concrete sheds, refrigerated warehouses and sophisticated conveyor system made the Montreal harbour and its railway network Canada's principal transport centre, rivalling the major Atlantic ports of the United States. From the early 1920s on, the port, the locomotives that serviced it, its elevators and the steel-hulled liners that docked there embodied Quebec's economic, architectural and industrial modernity.

Formally speaking, *Elevator No. 1* was somewhat unusual for the time. While the vast majority of the landscapes that then typified "Canadian modern art" were dominated by natural motifs rendered in brilliant colours and a heavy impasto, Hébert was developing an entirely different approach. The picture's natural elements (sky, water, clouds) occupy a very small area and are powerfully framed by its industrial components. The paint layer is thin and smooth, and the complex image decidedly rectilinear, with a composition that emphasizes the monumentality of the port architecture. The painting's framework is formed by the geometric shapes of the elevators and conveyor bridges, and even the human figure becomes part of this tightly constructed world. The man in *Elevator No. 1* is integrated into the structure of the metal gate, just as the conveyor is into that of the sheds. Moreover, the man's position and the angle of his bent left leg echo (in reverse) the line of the conveyor and its shadow: the industrial engulfs the human, the human replicates the industrial.

*Elevator No. 1* has been exhibited many times, much reproduced and much analyzed. It can be seen as an archetype of modernity as depicted in Hébert's work of the late 1920s. It pays tribute to the functionalist, engineering aesthetic that was hailed in 1918 by several of the artist's friends in the avant-garde journal *Le Nigog* and that he himself defended in both his art and his writings.[3] It also reaffirms Hébert's role as a precursor of those artists who, like his friend T. R. MacDonald, made the representation of Montreal one of their regular preoccupations during the 1930s. Interestingly, it was MacDonald – by that time director and curator of the Art Gallery of Hamilton – who in 1962 purchased *Elevator No. 1* for the museum's collection, using funds donated by *The Hamilton Spectator*.

*Esther Trépanier*
*Professor*
*Department of Art History*
*Université du Québec à Montréal*

Notes _____

1. Claude Bergeron, *Architectures du XXe siècle au Québec* (Quebec City: Musée de la civilisation and Éditions du Méridien, 1989), p. 22.

2. See Melvin Charney, "The Grain Elevators Revisited," *Architectural Design*, vol. 37 (July 1967), pp. 328–331.

3. See Esther Trépanier, "Sens et limites de la modernité chez Adrien Hébert et ses critiques," in Pierre L'Allier, ed., *Adrien Hébert* (Quebec City: Musée du Québec, 1993), pp. 85–102.

~~~

Cat. 61 (page 138)

**RODY KENNY COURTICE** (1895–1973)
*Petite ville ferroviaire du nord* vers 1929–1935
huile sur toile
86,6 x 102,2 cm
Don du Russell Nelson Eden Fund, 2000

Quand Rody Kenny Courtice et Yvonne McKague peignaient sur la rive nord du lac Supérieur en 1929, elles savaient très bien qui était passé par là avant (fig. 66). À la fin d'une séance de croquis infructueuse, les deux amies décidèrent de

> « ... faire un Lawren Harris ! » Nous sommes allées ramasser un arbre mort et l'avons appuyé contre un rocher. Il y avait le lac Supérieur au loin et un de ces spectaculaires ciels gris traversés de nuages [...] nous avons travaillé avec beaucoup d'énergie et, en moins d'une heure, nos esquisses étaient terminées. Puis, nous avons remballé nos affaires et sommes rentrées au Y.M.C.A. de Schreiber[1].

Depuis 1922, Lawren Harris exposait des paysages du lac Supérieur. À la fin de la décennie, majestueux nuages, lumière franche, collines chauves et lac immobile s'étaient cristallisés en symboles du Nord, de la frontière sauvage du Canada. Tous ces éléments, Courtice les incorpora dans *Petite ville ferroviaire du nord*. Elle qui travaillait dans un genre de plus en plus défini par les peintres du Groupe des Sept (dont plusieurs lui avaient enseigné à l'Ontario College of Art et étaient devenus ses amis) savait cependant que c'est d'eux qu'elle devait se distinguer. Aux représentations emblématiques du lac Supérieur que contenait son « faux Harris[2] », elle ajouta ici des détails cocasses. De plus, elle prit pour sujet Schreiber – la gare de la Compagnie du chemin de fer canadien du Pacifique où elle logeait – , plutôt que Rossport, Jackfish ou Coldwell, villages de pêcheurs plus populaires auprès des artistes (voir cat. 46).

Partagée entre le désir de construire le paysage et de le représenter tel qu'il est, Courtice simplifia son sujet. Pour accentuer l'impression d'isolement de la petite ville nichée dans la vallée, elle peignit une seule église (alors il y en avait plusieurs) et disposa en cercle un nombre réduit de rues et de maisons. Elle dégagea la perspective et créa un effet esthétique en accentuant la nudité des collines – même si celles-ci devaient être passablement nues à l'époque puisque, depuis des années, on abattait des arbres pour faire du bois de chauffage. Elle ajouta aussi une vue du lac Supérieur qu'elle ne pouvait avoir de l'endroit où elle se trouvait[3]. La voie ferrée, qui part de sous la saillie rocheuse au premier plan et serpente entre les collines, dirige notre regard vers le lointain. Elle nous rappelle également que le chemin de fer était le seul moyen d'accès à Schreiber par voie de terre[4].

Il ne se dégage cependant pas de cette œuvre toute simple l'impression d'éternité qui émane d'un Lawren Harris. La magnifique lumière n'annonce pas un phénomène mystique, mais un matin d'automne. Les fenêtres sont vides et les rues, désertes; seuls quelques lève-tôt vaquent à leurs occupations quotidiennes. Courtice a manifestement pris plaisir à peindre les menus détails : les formes convolutées de la fumée et des arbres, beaucoup de minuscules fenêtres, le château d'eau juché sur ses pattes grêles, les carrés de fleurs près de la gare. Elle les a peints d'une manière délibérément sommaire, naïve même. Dans cet environnement austère et parmi les maisons aux silhouettes bien découpées, le train a l'air d'un jouet[5]. Par le jeu des détails intimes et des différences d'échelle, Courtice nous offre ici une vision bien à elle de la région du lac Supérieur : un aperçu du quotidien dans un décor grandiose.

*Alicia Boutilier*
*Conservatrice indépendante*
*Bowmanville, Ontario*

Notes

1. Yvonne McKague Housser, citée par Margaret Gray et Margaret Rand dans une biographie manuscrite (dossier 24, vol. 1, Fonds Yvonne McKague Housser, MG30 D305, Archives nationales du Canada, Ottawa). La même anecdote est racontée dans Yvonne McKague Housser, « North Shore of Lake Superior », *Northward Journal : A Quarterly of Northern Arts*, n° 16 (juin 1980), p. 29. Dans *A Painter's Country* (Toronto, Clarke, Irwin & Company Ltd., 1958), A.Y. Jackson révèle que le tronc d'arbre brisé du célèbre *Rive nord du lac Supérieur* de Harris « était presque perdu dans les buissons, à un endroit d'où on ne voyait pas le lac Supérieur. Harris l'a isolé et lui a donné un arrière-plan plus digne » (p. 48).

2. Voir McKague Housser, « North Shore of Lake Superior », p. 29.

3. Je remercie la Schreiber Archives and Historical Society de m'avoir aidée à trouver cet endroit et fourni des précisions sur l'histoire de Schreiber.

4. La route Transcanadienne, en construction, n'avait pas encore atteint Schreiber.

5. Soulignons que Courtice a souvent peint des natures mortes représentant des jouets de son fils et d'autres enfants. À partir de la fin des années 1930, elle atteignit une certaine notoriété comme peintre humoriste et fantaisiste.

~~~

Cat. 63 (page 140)

**PRUDENCE HEWARD** (1896–1947)
*Femme sous un arbre* 1931
huile sur toile
122,5 x 193,7 cm
Don de la famille de l'artiste, 1961

En 1931, le nu féminin était un sujet inhabituel pour une femme peintre au Canada[1]. À l'époque, les musées publics répugnaient à exposer des nus, de crainte de froisser la susceptibilité puritaine de certains de leurs visiteurs. L'Art Gallery of Toronto interdit d'accrocher *Nu* (aussi appelé *Nu dans un atelier*, fig. 67) de Lilias Torrance Newton (1933, Toronto, The Thomson Collection) à l'exposition du Groupe des peintres canadiens en 1933, bien que deux ans plus tôt, il ait accepté que *Femme sous un arbre* de Prudence Heward fasse partie de l'exposition du Groupe des Sept[2]. Les chaussures à talon haut portées par le modèle du tableau de Newton, soutenait-il, allaient à l'encontre de l'idéal de beauté féminine. La plupart des artistes canadiens se pliaient encore aux conventions de la peinture de nu (établies pour marquer la distinction entre grand art et pornographie), alors que beaucoup de peintres européens s'adonnaient déjà à peindre la « nudité[3] ». *Femme sous un arbre* de Prudence Heward est à la frontière de ces deux genres.

Dans ce tableau, Heward place les membres du modèle de manière à dissimuler les poils, suivant en cela les conventions de la peinture de nu. Elle n'en propose pas pour autant un idéal de beauté féminine, mais une image d'une femme reconnaissable du XX$^e$ siècle[4]. Cette femme a la tête tournée vers le spectateur et le fixe de ses grands yeux, affirmant par le fait même son individualité. Son regard ainsi que l'allusion au désir sexuel qu'elle exprime dans son long corps tendu font de ce tableau une œuvre qui dérange, contrairement, par exemple, à *Femme endormie* de Randolph Hewton (v. 1929, Ottawa, Musée des beaux-arts du

Canada). Chez Hewton, le modèle n'est pas conscient du regard du spectateur, de sorte que le corps, ainsi objectivé, se prête aux fantasmes érotiques des hommes.

Le nu féminin dans un paysage est un sujet traditionnel dans l'art de l'Europe occidentale, particulièrement dans les tableaux mythologiques ou historiques, mais Heward le traite ici d'une manière fort personnelle. Le décor pastoral de *Femme sous un arbre* est coupé, au plan intermédiaire, par des formes en aplat qui suggèrent une ville. Dans deux œuvres précédentes, *Au café* (v. 1928, Musée des beaux-arts de Montréal) – un portrait de la peintre Mabel Lockerby – et *Au théâtre* (1928, Musée des beaux-arts de Montréal), Heward a associé les femmes à la ville et à la culture. Ici, les triangles créés par le genou et le bras levés du modèle renvoient aux formes géométriques des édifices – des édifices que certains critiques ont qualifié de « cézannesques[5] ». La femme allongée est alors associée non seulement à la nature sauvage, mais aussi à la vie urbaine, au modernisme et à la culture. *Femme sous un arbre* peut s'interpréter comme une tentative pour libérer le corps féminin des fantasmes réducteurs des hommes et se le réapproprier en tant que moyen d'expression des désirs et projets de la femme.

*Barbara Meadowcroft*
*Associée de recherche*
*Institut Simone de Beauvoir*
*Université Concordia, Montréal*

Notes _____

1. *Femme sous un arbre* de Prudence Heward est le plus ancien nu peint par une femme mentionné dans Jerrold Morris, *The Nude in Canadian Painting*, Toronto, New Press, 1972.

2. Voir Donald W. Buchanan, « Naked Ladies », *Canadian Forum*, vol. 15 (avril 1935), p. 273–274; et Natalie Luckyj, *L'expression d'une volonté : l'art de Prudence Heward / Expressions of Will : The Art of Prudence Heward*, Kingston, Agnes Etherington Art Centre, 1986, p. 62 et 63.

3. Pour la distinction entre « nudité » et « nu », voir Kenneth Clark, *Le nu*, traduit de l'anglais par Martine Laroche, Le Livre de Poche, 1969, tome 1, p. 19.

4. « Je reconnais le modèle puisque je l'ai moi-même peint », écrit T. R. MacDonald dans une lettre à Ross W. Heward, datée du 28 juin 1961 (dossier d'acquisition, Art Gallery of Hamilton). Cette remarque prouve que l'œuvre n'est pas un autoportrait, comme l'ont suggéré Luckyj et d'autres.

5. Voir Hedwige Asselin (dir.), *Inédits de John Lyman*, Montréal, Bibliothèque nationale du Québec, 1980, p. 107; ainsi que Luckyj, *L'expression d'une volonté*, p. 60.

~~~

Cat. 65 (page 144)

**E. GRACE COOMBS** (1890–1986)
*La cabine du monte-billes*   vers 1933
huile sur carton contrecollé
26,7 x 21,5 cm
Fonds d'acquisition du directeur, 1959

Durant une courte période de sa carrière, avant de se borner à peindre interminablement des tableaux de fleurs, Grace Coombs semblait avoir trouvé son équilibre. Ayant toute liberté de voyager et de créer, et encouragée par l'intérêt que J.E.H. MacDonald portait à son travail – continuez et « soyez vous-même », lui avait-il dit –, elle parcourut le continent nord-américain et peignit tout ce qui l'émouvait, avec exaltation et vigueur.

De passage dans un parc à bois d'Haliburton, en Ontario, au début des années 1930, elle fut témoin d'une scène (à moins qu' elle l'ait imaginée ?) qui satisfaisait son amour du plein air tout en lui permettant de traiter, d'un point de vue résolument féminin, un sujet familier en art canadien. Elle en tira *La cabine du monte-billes*. Devant cette esquisse, notre attention se porte alternativement sur le solide gaillard représenté, jambes écartées, dans la partie supérieure du tableau et sur les deux enfants qui, plus bas, s'amusent tranquillement à l'ombre des barges de drave, les « pointus ».

Le paysage exerçait une telle fascination sur la conscience nationale que, dans les années 1910 et 1920, les œuvres mettant en scène des personnages étaient devenues à la fois moins populaires et moins fréquentes. Le draveur et son frère le bûcheron faisaient toutefois exception, parce qu'ils étaient de fiers conquérants du territoire et parce qu'ils entretenaient d'étroits rapports avec la véritable vedette de l'art et de l'industrie au Canada : l'arbre.

Quand Arthur Lismer, J.E.H. MacDonald et Clarence Gagnon peignaient des draveurs, ils les montraient toujours en pleine action, descendant les rivières, seuls ou en bandes. Dans *La cabine du monte-billes*, Coombs ramène ces athlètes à des dimensions plus humaines en suggérant la présence de femmes dans leur entourage. Elle laisse entendre que ces pittoresques hommes des bois ont une vie en dehors de leur métier, qu'ils ont aussi des relations sociales et des responsabilités comme maris et pères. On voit ici que, de retour au camp, ils doivent continuer leur travail tout en gardant un œil sur leurs enfants.

Coombs ne revint jamais à ces audacieuses juxtapositions ni à ce traitement alerte que l'on trouve dans *La cabine du monte-billes*. Peu de temps après avoir terminé cette peinture, elle décida de se retirer du monde de l'art contemporain et délaissa ses amis. Continuer de voir Yvonne McKague ou Arthur Lismer, par exemple, l'aurait sans doute mise au défi d'innover, forcée à évoluer. Au lieu de cela, elle gravita vers la communauté évangélique de l'Emmanuel College, à l'université de Toronto, où elle commença à fréquenter Jim Lawson, étudiant au doctorat en théologie et artiste de réputation internationale. Lawson, qui était sculpteur de fruits en cire[1], l'amena à s'intéresser davantage à la vie des fleurs et des plantes. Ils commencèrent à peindre ensemble, s'offrirent leurs œuvres en cadeau[2] et finirent par se marier en 1942, après plus de quinze années de fréquentations.

Bien qu'elle n'ait pas été élevée dans la religion méthodiste, Coombs décida, à l'âge adulte, de se laisser conduire par la « douce Lumière » de l'Esprit-Saint, inspirée en cela par les paroles d'un hymne du cardinal Newman. Humblement, elle renonça à poursuivre la route qui, dans sa jeunesse, l'avait menée à travers le Grand Canyon et jusqu'aux falaises venteuses de l'Algoma.

*Alison Garwood-Jones*
*Auteure indépendante*
*Toronto*

1. Beaucoup de pommes, vrilles de pois grimpants et champignons vénéneux sculptés par Lawson se trouvent à la New York State Agricultural Experiment Station de l'université Cornell, où l'artiste travailla plusieurs étés. Admiré pour les couleurs et les textures minutieuses de ses œuvres, Lawson avait, dit-on, arraché des poils de ses bras et les avait coupés à la bonne longueur pour façonner le duvet de ses framboises.

2. Des centaines d'œuvres de Coombs sont aujourd'hui conservées à l'Art Gallery of Hamilton.

~~~

Cat. 68  (page 148)

**Yulia Biriukova** (1895–1972)
*Prospecteur (Peter Swanson)*  1934
Huile sur toile
114,2 x 92,0 cm
Don de Thoreau MacDonald, 1973

Peter Swanson était l'image même de la virilité : un solide gaillard, aux bras massifs, au regard perçant. Dans ce saisissant portrait, l'artiste d'origine russe Yulia Biriukova nous présente un personnage hors du commun, qui semble avoir causé tout un émoi dès qu'il débarqua dans le groupe d'artistes et d'amis gravitant autour du Studio Building de Lawren Harris, à Toronto.

Peu après son arrivée à Toronto en novembre 1929, Biriukova (qui est venue de Vladivostock en passant par Rome) obtient un atelier au fameux Studio Building. C'est là qu'elle rencontre Swanson, un prospecteur minier qui, avec son associé Keith MacIver (fig. 35), tente de faire fortune dans le nord de l'Ontario et du Québec. En novembre 1933, MacIver et Swanson logent tous deux dans la « cabane de Tom Thomson » derrière le Studio Building, tout en se servant de l'atelier d'A.Y. Jackson comme quartier général temporaire[1].

Bien que ses séjours à Toronto soient brefs et irréguliers, Swanson impressionne beaucoup de gens, qui lui trouvent une aura de romantisme et de force. Pendant une courte période à l'automne de 1933 – celle où Biriukova travaille vraisemblablement à son portrait –, il est « en grande demande socialement[2] ». On dit qu'il a le don de double vue et qu'il peut lire l'avenir dans les feuilles de thé, ce qui, allié à un certain charme masculin, en fait un invité recherché dans les réunions d'artistes. Au départ de Swanson pour le Nord avec MacIver au début de janvier 1934, Jackson écrit : « Toutes leurs amies les ont accompagnés à la gare... Jamais Pete n'avait été autant embrassé de sa vie, mais il dit que ces histoires de femmes le fatiguent et qu'il en a assez[3]. » L'arrogance de Swanson avait son côté sinistre, toutefois. Plus tard l'année suivante, Jackson racontera : « Il a agi comme un sale type ici l'hiver dernier, et il est étonnant qu'il n'ait pas abouti en prison[4]. »

Aux dires de la plupart des gens, Swanson avait tout du mauvais garçon, à la fois charmant et explosif, et dans son tableau Biriukova a réussi à rendre ce double aspect de son caractère. Bien que, dans l'ensemble, la composition tienne de la tradition picturale du portrait dans un paysage – celle, perfectionnée par Edwin Holgate dans les années 1920 et 1930, où le panorama sert de contexte à différents « types » humains (fig. 68) –, Biriukova a cherché à saisir la personnalité de son prospecteur, à capter quelque chose de son tempérament, au-delà du métier qu'il exerce. Alors que dans tant de portraits de ce genre, le personnage se fond dans le décor et perd son identité au profit des objets reliés à son travail (billes de bois, pagaies, canots), il ne fait aucun doute qu'ici, Biriukova peint l'homme qu'elle a croisé sur sa route.

Biriukova attire l'attention sur le visage de Swanson, à la fois plus travaillé et plus intense que toute autre partie de l'image. Elle applique la peinture par plans de couleurs qui façonnent les traits burinés du prospecteur et rendent à la fois la forme et le teint de sa figure. Toute l'image se concentre dans les yeux, tous les éléments formels mènent à ce regard sombre et foudroyant. Voilà un homme qui sait ce qu'il veut et n'hésitera pas à le faire savoir. Yulia Biriukova réussit à en brosser un portrait aussi mémorable et impressionnant que Swanson lui-même.

*Tobi Bruce*
*Conservatrice principale*
*Art Gallery of Hamilton*

1. Lettre d'A.Y. Jackson à Anne Savage, 23 novembre 1933, dossier 14, vol. 1, Fonds Anne Savage, MG30 D374, Archives nationales du Canada, Ottawa. Jackson lui-même a fait de la prospection minière et investi de l'argent dans plusieurs projets de MacIver.

2. A.Y. Jackson dans une lettre à Anne Savage, 8 décembre 1933, *ibid.*

3. A.Y. Jackson dans une lettre à Mme H.P. DePencier, 9 janvier 1934, vol. 1, Fonds Norah Thomson DePencier, MG30 D322, Archives nationales du Canada, Ottawa.

4. A.Y. Jackson dans une lettre à Mme H.P. DePencier, 30 octobre 1935, *ibid.*

~~~

Cat. 70  (page 152)

**Bertram Brooker** (1888–1955)
*Femme assise*  1935
huile sur toile
101,6 x 101,6 cm
Don du Marie Louise Stock Fund, 1996

Laura ouvrit les yeux au moment même où le soleil se levait. Elle s'étira avec sommeil et regarda les couleurs emplir lentement le ciel pâle. De l'horizon caché, un large rayon grimpa soudain au zénith, puis un autre à côté, et la première lueur rosée d'un matin glorieux flotta dans la chambre[1].

*Femme assise* est un tableau intime. Une femme s'est glissée sans hâte sur une plate-forme couverte d'une ample draperie et lève la tête, songeuse. La lumière franche donne à son corps un modelé bien net. Le rouge à lèvres, le fard à joues et le hâle autour de son cou accentuent sa nudité. Devant cette étude d'après nature, notre regard se porte vers les formes pleines de son torse et de ses jambes, sculpturales contre la toile de fond des rideaux. Cette femme ordinaire, que l'artiste emploie comme modèle dans son atelier, se redresse dans une sorte d'extase. Elle annonce « Laura », personnage principal de *Think of the Earth*, roman qui valut à Bertram Brooker le Prix du gouverneur général en 1936.

Le soleil réchauffait lentement la chambre. Elle se coula dans une position plus confortable, tourna son corps vers la fenêtre [...] et cueillit de tout ce qui s'était passé les plus doux moments[2].

Après avoir quitté l'Angleterre pour émigrer au Manitoba avec sa famille à l'âge de dix-sept ans, Bertram Brooker exploita une salle de cinéma avec son frère à Neepawa, au nord-est de Brandon. Chaque jour, quand les rideaux s'ouvraient et que le film commençait à tourner, il a dû ressentir l'imminence de cette révélation

qu'il décrirait en 1936 comme « la première lueur rosée d'un matin glorieux ». Établi à Toronto en 1921, Brooker chercha la toujours fuyante expérience de la révélation dans l'art et l'écriture. Dans *Think of the Earth*, exploration de l'éveil esthétique à l'« unité » des êtres humains, l'ouverture des rideaux métaphoriques de la conscience apparaît comme le plus puissant symbole de l'expérience spirituelle. À « When We Awake ! » – essai visionnaire sur l'unité publié dans le *Yearbook of the Arts in Canada* de 1929 – succéderont des textes de plus en plus forts sur « la prise de conscience de l'harmonie entre l'homme et l'univers ». Brooker était convaincu que l'artiste avait une exceptionnelle faculté de « voir des relations nouvelles entre les choses, détachées de ses basses préoccupations et de ses médiocres désirs, de sorte qu'elles prennent valeur de symboles – symboles de mouvements, de changements et de lois qui ont une portée universelle, transcendent le temps et l'espace, et sont liés seulement au Tout infini qui est le mystère central de la vie[3] ». *Femme assise* incarne la promesse d'une révélation.

En 1931, Brooker dit de l'exploration esthétique des « beautés du corps nu » qu'elle est l'expression libératrice des « pulsions sexuelles[4] ». Tant devant le personnage de « Laura » que devant l'inconnue qui pose pour *Femme assise*, nous sommes en présence d'un sujet qui a « une intuition profonde de ce Tout, de ce mystère premier que nous avons pressenti, auquel nous aspirons et par la connaissance duquel nous pourrions parvenir à l'unité[5] ».

*Anna Hudson*
*Professeure adjointe, Département des arts visuels*
*York University, Toronto*

Notes _____

1. Bertram Brooker, *Think of the Earth*, Toronto, Brown Bear Press, 2000, p. 197.

2. *Ibid.*, p. 203.

3. Bertram Brooker, *Yearbook of the Arts in Canada, 1936*, Toronto, MacMillan, 1936, p. xxviii.

4. Bertram Brooker, « Nudes and Prudes », dans William Arthur Deacon et Wilfred Reeves (dir.), *Open House*, Ottawa, Graphic Publishers, 1931, p. 105.

5. *Ibid.*, p. 106.

~~~

Cat. 73  (page 156)

**SARAH ROBERTSON** (1891–1948)
*Couronnement*  1937
huile sur toile
84,4 x 60,9 cm
Don de Monsieur H. S. Southam, C.M.G., LL.D., 1951

La porte noire au centre n'est pas la première chose que l'on remarque dans *Couronnement* de Sarah Robertson. Ce qui a généralement retenu l'attention, ce sont les éléments par lesquels l'artiste recrée l'atmosphère de fête dans laquelle se déroule le couronnement du roi George VI après l'abdication de son frère Édouard VIII : la touche hardie, les couleurs éclatantes et les branches dont le mouvement reprend celui des drapeaux qui flottent. Membre du Groupe de Beaver Hall et active dans la communauté artistique montréalaise, Robertson a souvent peint la ville où elle passa toute sa vie. Les célébrations du 12 mai 1937 furent, d'après les journaux de l'époque, les plus grandes et les plus réussies que l'on ait jamais vues à Montréal[1]. Les édifices rutilaient, parés des couleurs de la royauté – rouge, bleu, blanc et or. Partout flottait l'Union Jack. Tôt le matin, des milliers de personnes

avaient convergé vers le parc Jeanne-Mance pour entendre, en français et en anglais, le reportage radiophonique transmis par haut-parleurs depuis l'abbaye de Westminster. Dans la soirée, la foule put admirer un spectaculaire feu d'artifice, gracieuseté du quotidien *La Presse*.

Parce que tant de gens s'étaient rassemblés dans le parc et les rues au pied du Mont-Royal, il est tentant de voir, dans la porte noire et l'absence de personnages du tableau de Robertson, une représentation du centre-ville qui, ce jour-là, « avait [...] l'aspect dominical : rues désertes dans la section commerciale ». Cette porte fait toutefois soupçonner quelque chose de menaçant. Bien qu'elle soit placée au centre et que le mât à gauche soit braqué sur elle, le spectateur se laisse facilement distraire par les décorations exubérantes qui l'entourent. Même le sentier la contourne. La population ne pressentait pas encore l'éclatement d'une guerre mondiale en 1937, mais Montréal sortait à peine de la Crise et l'on parlait de la guerre civile d'Espagne aux bulletins de nouvelles. Robertson semble avoir interprété les festivités du couronnement comme une distraction bienvenue, et l'enthousiasme avec lequel les Montréalais y ont participé comme un signe de leur volonté d'oublier qu'ils vivaient des temps difficiles.

Malgré son titre, le tableau n'évoque pas vraiment un couronnement. Les drapeaux sont peints de manière si libre qu'ils en perdent presque leur sens de symboles de l'Empire, et les couleurs de la royauté, surtout à l'arrière-plan, remplissent une fonction plus esthétique qu'idéologique. En 1937, bien qu'il conservât des liens étroits avec la Grande-Bretagne, le Canada aspirait de plus en plus à l'autonomie. Flous et dispersés, les emblèmes qui colorent ce paysage urbain reflètent la politique isolationniste adoptée après la Crise sous le régime libéral du premier ministre Mackenzie King.

*Couronnement* semblait un choix tout indiqué pour Harry Stevenson Southam, un homme dont l'imprimerie familiale possédait ou contrôlait plusieurs grands journaux du Canada. H. S. Southam, éditeur du *Citizen* d'Ottawa et président du conseil d'administration du Musée des beaux-arts du Canada, acheta le tableau de Robertson peu après que celle-ci l'eut peint. Collectionneur passionné, il apporta un soutien particulier aux artistes canadiens contemporains pendant et après la Crise. Le fait qu'il ait choisi *Couronnement* montre bien son intérêt pour l'art considéré comme moderne au Canada dans les années 1930; en effet, cette peinture marque un changement par rapport au style qu'avait antérieurement adopté Robertson sous l'influence du Groupe des Sept. Southam commença à donner des œuvres à l'Art Gallery of Hamilton en 1948 et lui légua plus tard le reste de sa collection par testament. Lui qui avait grandi à Hamilton espérait que ces dons « plaisent au public [de cette ville] et incitent d'autres collectionneurs à faire de même[3] ». Néanmoins, après avoir eu *Couronnement* en sa possession durant plus d'une décennie, il se sépara à regret de cette œuvre qui était devenue l'une de ses préférées[4].

*Alicia Boutilier*
*Conservatrice indépendante*
*Bowmanville, Ontario*

Notes _____

1. « Quant à la parade militaire, dit *Le Devoir*, on estime que c'est le plus considérable qu'on ait jamais vue à Montréal » (« La journée d'hier à Montréal », 13 mai 1937, p. 10). *The Gazette* déclare que « jamais dans son histoire, Montréal n'a connu une journée comme celle-là » (« Loyal Thousands Eagerly Awaiting Coronation Fetes », 12 mai 1937, p. 15). Enthousiaste, *La Presse* annonce que 300 000 personnes ont assisté aux festivités de la soirée : « "Jamais foule pareille n'avait envahi la montagne", déclare le surintendant des parcs » (« Un grand jour fini en apothéose », 13 mai 1937, p. 1).

2. « La journée d'hier à Montréal », *Le Devoir*, 13 mai 1937, p. 10.

3. H.S. Southam dans une lettre à T.R. MacDonald, 2 mars 1948, H.S. Southam Source File, Art Gallery of Hamilton.

4. H.S. Southam dans une lettre à H.O. McCurry, 6 mars 1951, 9.2S Southam, H.S., 1951—78, dossier 10, Fonds MBAC, Archives du Musée des beaux-arts du Canada, Ottawa.

~~~

Cat. 74  (page 158)

**PAUL-ÉMILE BORDUAS** (1905–1960)
*Spring Morning*  1937
oil on canvas
30.5 x 39.3 cm
Gift from the Alfred Wavell Peene
and Susan Nottle Peene Memorial, 2001

This figurative painting by Paul-Émile Borduas is in a style reminiscent of Renoir or Pascin, two artists for whom he expressed admiration during his first Paris sojourn, in 1929–1930. It thus reflects the early influences on a painter who was to become a leading figure of Canadian abstract art. But the work has greater significance. When Borduas painted it, he was living at 953 Napoléon Street, in Montreal, and renting a studio very close by, at 3940 de Mentana Street. *Spring Morning* pictures the view from his apartment of the entrance to the studio – one of the dark doorways on the right. It was in this same studio that a few years later Borduas would regularly gather around him the handful of students – some of his own, from the École du Meuble, others from the École des beaux-arts – with whom he would later found the group known as the Automatistes. It can be claimed, then, that in executing *Spring Morning* Borduas was unwittingly sewing the seeds of the Automatiste movement, which was to have such a profound impact on the development of painting in Canada.

The question of when the work was first exhibited is not an easy one, and in fact represents an interesting case study in the matter of provenance. Given that there is a label from the Art Association of Montreal's 55th Spring Exhibition on the back of *Spring Morning*, it seemed reasonable to assume that the picture was shown at this salon, even though the Borduas that appears as number 12 in the catalogue is titled *Young Girl* (1937, fig. 69).[1] I imagined that the artist had simply changed his mind at the last minute and swapped the paintings after the catalogue was printed. But this theory raises a number of difficulties. Since the Spring Exhibition was a juried show, it seems more likely that Borduas submitted two paintings, of which only *Young Girl* was selected. Both pictures would have been given labels by the Art Association: the *Spring Morning* label should have been removed or crossed out, while the *Young Girl* one probably fell off.[2]

This matter of labels is less trivial than it may appear, for it was on seeing the painting by Borduas included in the 1938 Spring Exhibition that John Lyman felt impelled to meet its author. The painting that so attracted Lyman's attention was thus *Young Girl*, and not *Spring Morning*. This seems to be confirmed by the fact that Lyman detected an "influence of Maurice Denis" – a remark far more readily applicable to the former work than to the latter.

Was it perhaps at the Contemporary Arts Society exhibition held in December 1939, at Montreal's Frank Stevens Gallery, that *Spring Morning* was first shown to the public? The only Borduas listed in the catalogue of this exhibition is a *Landscape*, which Jacques de Tonnancour described as being the size of a "pocket handkerchief" – most likely one or other of the small landscapes

Borduas had made the previous year in the Gaspé Peninsula. So *Spring Morning* did probably not appear in public until the major retrospective of Borduas's work mounted by the Montreal Museum of Fine Arts in 1962, where it was presented under the title *Montana Street* (a misspelling of Mentana).

*François-Marc Gagnon*
*Director*
*Institute for Studies in Canadian Art*
*Concordia University, Montreal*

Notes _____

1. See F.-M. Gagnon, *Paul-Émile Borduas* (Montreal: The Montreal Museum of Fine Arts, 1988), p. 274, cat. 78.

2. I am grateful to Alicia Boutilier of the Art Gallery of Hamilton for having pointed this out to me.

3. John Lyman, "Borduas and the Contemporary Arts Society," in Evan H. Turner, *Paul-Émile Borduas 1905–1960* (Montreal: The Montreal Museum of Fine Arts, 1962), p. 40.

~~~

Cat. 76  (page 160)

**PAUL NASH** (Britannique; 1889–1946)
*Le rivage Fantôme*  1939
huile sur toile
71,2 x 91,5 cm
Don du Comité féminin, 1966

Toute sa vie, le paysagiste anglais Paul Nash sera préoccupé par la mort, cette force qui tout à la fois le terrifie et le rassure. En même temps, il est envoûté par les mystérieuses présences, annonciatrices de l'immortalité, qui errent en bordure de l'existence quotidienne. Avant lui, au XIXe siècle, Blake, Palmer et Rossetti ont manifesté des intérêts semblables. Nash exprime le legs de ces trois hommes dans un langage bien du XXe siècle. Très tôt, il s'enthousiasme pour le surréalisme, car cette approche lui permet d'intégrer dans son art l'illogisme des rêves et le subconscient.

Le surréalisme qui électrifie alors l'atmosphère intellectuelle a, selon Nash, ses racines en Grande-Bretagne. Il est né, dit-il, dans l'univers créé par des poètes tels que Wordsworth, Coleridge et, bien sûr, Blake[1]. Surtout, Nash y voit un moyen de rester fidèle au romantisme anglais tout en explorant un courant majeur de l'art européen de son époque.

Au milieu des années 1930, Nash se laisse fasciner par une autre idée chère aux surréalistes : « l'objet trouvé ». En juin 1938, pendant un séjour à Madams, une petite maison dans le Gloucestershire où ses amis Clare et Charles Neilson viennent de s'installer, il est subjugué par les longues perspectives que l'on voit de la terrasse et croit que des esprits hantent le petit jardin d'arbustes taillés. Non loin de là, il découvre un champ, à Carswalls Farm, près de Newent. Cet endroit qui semble n'avoir ni commencement ni fin, il le nomme le champ Fantôme, en l'honneur de deux objets qu'il y trouve : les restes de deux ormes. Dans les dépouilles de ces arbres, il voit « deux objets qui ne sont plus de l'ordre des phénomènes naturels », qui sont « passés » dans une autre dimension[2].

Les troncs d'arbre symbolisent souvent la mort dans l'œuvre de Nash, et ils remplissent cette fonction dans *Le rivage Fantôme*, qui est une « vue » du champ Fantôme. L'image des marches en tant que lieu de passage d'une sphère de l'existence à une autre est également un dispositif privilégié par l'artiste à sa

maturité. Ici, les souches occupent la gauche et la droite de la composition, mais les marches, telles celles d'une scène de théâtre, dirigent le regard vers la forme spectrale qui a quitté le monde de la finitude pour accéder à l'infini. Dans cette toile, Nash regarde la mort en face et donne à espérer que l'accueillir, c'est la vaincre.

En 1939, Nash, qui souffre d'asthme chronique, a la certitude que ses jours sont comptés (il mourra dans son sommeil en juillet 1946, à l'âge de cinquante-sept ans). Durant toute sa carrière, il aura cherché à comprendre et à accepter le caractère éphémère de l'existence humaine, à se faire à l'idée de la mort. *Le rivage Fantôme* marque une étape de plus dans cette quête.

*James King*
*Professeur*
*McMaster University, Hamilton*

Notes _____

1. Paul Nash, « A New Poetry », *News Chronicle* (Londres), 7 juin 1937.

2. Paul Nash, *Monster Field : A Discovery Recorded by Paul Nash*, Oxford, Counterpoint Publications, 1946, p. 4.

~~~

Cat. 77  (page 162)

**CARL SCHAEFER** (1903–1995)
*Une ferme au bord de la voie ferrée, Hanover*  1939
huile sur toile
87,0 x 117,8 cm
Don du Comité féminin, 1964

J'essaie d'analyser mon sujet pour ce qu'il présente, d'abord sa signification en termes d'atmosphère et de caractère et tout ce qui s'en dégage immédiatement, sur le coup, en retenant toutes ces émanations dans un temps assez court, c'est maintenant ou jamais, sinon tout est perdu, le résultat d'un processus exsangue. L'important, c'est de retenir cette première impression et de l'exprimer de manière qu'elle soit vitale, vivante; souvent je tourne le dos au sujet et je le peins pour ce qu'il m'a donné.[1]

Ainsi Carl Schaefer décrivait-il à la fois sa méthode de travail et sa philosophie. À l'instar de son ami David Milne, il cherchait à saisir ses premières réactions. Ces émotions s'enracinaient dans un solide attachement à ses origines, un amour profond du métier, le respect de la tradition et l'émerveillement devant le mystère de la nature.

Pour Schaefer, donc, la transformation d'une expérience en œuvre d'art était un processus qui engageait à la fois l'intellect et la sensation. Il devait bien connaître son sujet avant de pouvoir en maîtriser les représentations. Après l'avoir étudié longuement, il avait assez de liberté pour s'en dégager – parfois en lui tournant carrément le dos. « Si on connaît vraiment ce qui est là, devant soi, l'espace au-delà de la vision de l'œil entre en jeu[2] », expliquait-il. Connaître le sujet en détail, disait-il aussi, ouvre le « vaste espace au-delà de la vision de l'œil, là où il n'y a aucun objet, uniquement du mystère. Une peinture dépourvue de mystère ne signifie rien, [elle n'est] qu'un travail machinal[3] ». L'inconnaissable fait contrepoids au connu.

*Une ferme au bord de la voie ferrée* résume brillamment le credo de Schaefer. Cet artiste que l'on peut considérer comme un

régionaliste a noté l'emplacement précis de la ferme : « à 1¹/₄ mille à l'est de Hanover et à environ 1 mille au nord, du côté sud de la voie ferrée du Canadien Pacifique, près du bras nord de la rivière Saugeen[4] ». Espiègle, il n'a « pas pu résister à la tentation d'inclure et de mettre en valeur les latrines, qui étaient placées dans un joli coin bien abrité[5] ». Néanmoins, le tableau est triste : il « reflète ma vie pendant la Dépression des années trente[6] », a dit Schaefer. Autour de la ferme et des dépendances, une clôture décrépite, des rails, un poteau électrique tordu, un arbre noueux et un signal de passage à niveau. Le potager et la rangée de peupliers atténuent à peine l'ambiance de mort et de destruction. Nous comprenons tout de suite quelles émotions contradictoires Schaefer a éprouvées devant la scène et nous pouvons les ressentir indirectement.

*Ann Davis*
*Directrice*
*The Nickle Arts Museum*
*University of Calgary*

Notes _____

1. Carl Schaefer dans une lettre à l'auteure, 8 janvier 1982.

2. Carl Schaefer, « Personal Reminiscences », *Carl Schaefer Retrospective Exhibition Paintings from 1926 to 1969*, Montréal, Sir George Williams University, 1969, p. 8.

3. Schaefer à l'auteure, 8 janvier 1982.

4. Carl Schaefer dans une lettre à Myra Davis, 8 juin 1975 (copie en possession de l'auteure).

5. Schaefer à l'auteure, 8 janvier 1982.

6. Schaefer à Myra Davis, 8 juin 1975.

~~~

Cat. 79  (page 166)

**JOHN SLOAN** (1890–1970)
*Rosie la riveteuse*  début des années 1940
Plâtre
49,8 x 31,0 x 50,1 cm
Don de l'artiste, 1965

Au cours de la Seconde Guerre mondiale, des affiches de propagande américaines marquées du slogan « We Can Do It » mettaient en vedette l'insolente et expansive Rosie la riveteuse. Les Canadiens connaissaient bien ce personnage grâce aux images imprimées et aux films de recrutement. La sculpture de John Sloan constitue un hommage beaucoup plus sobre aux femmes qui ont quitté leurs rôles traditionnels pour travailler en usine pendant que les hommes allaient combattre.

Vêtue d'un pantalon ample et d'une chemise, un foulard noué autour de la tête, Rosie, penchée sur sa machine, accomplit sa tâche avec détermination. Elle incarne la force consacrée à l'effort de guerre sur le front intérieur, la contribution de tous les civils, en particulier les femmes employées dans l'industrie. L'esprit de cette œuvre rappelle celui des quinze figures de bronze – des ouvrières d'usines de munitions – exécutées en 1918–1919 par Frances Loring et Florence Wyle pour le Fonds des souvenirs de guerre canadiens.

La statue en plâtre de Sloan appartient au réalisme social, style pratiqué par plusieurs sculpteurs canadiens, dont Elizabeth Wyn Wood, dans les années 1930 et 1940. Bien que son attitude statique et ses dimensions soient loin d'être héroïques, elle

possède une telle véracité qu'elle apparaît comme un emblème de l'ouvrière. Son visage aux traits classiques lui donne un caractère universel, intemporel et anonyme. Pourtant, l'inclinaison de la tête et la position naturelle des jambes confèrent à cette femme une certaine individualité. Sloan a donné noblesse et dignité à sa *Rosie* en traitant ce sujet moderne dans une veine naturaliste, essentiellement classique. Il a adopté la même approche dans beaucoup d'œuvres, par exemple *Quarante sous zéro* (cat. 67) et *Le soudeur* (fig. 70). Certes, la forme sombre et masquée du *Soudeur* a quelque chose d'inquiétant que l'on ne trouve pas dans *Rosie*, mais les volumes simplifiés et les lignes ciselées en surface évoquent aussi l'ouvrier humble et stoïque. Quant au personnage de *Quarante sous zéro* – un homme emmitouflé veillant auprès d'un chien de traîneau qui dort, roulé en boule –, il ne se laisse pas abattre par les épreuves qui l'attendent. À l'instar de *Rosie*, ces deux figures sont des portraits profondément humains, des symboles d'un pays au travail et aux aguets.

L'époque des monuments publics et commémoratifs a atteint son apogée à la fin du XIX$^e$ siècle et au début du XX$^e$. Au moment de l'exécution de *Rosie*, il n'était plus nécessaire de placer une sculpture sur un piédestal pour en rehausser le prestige. La sculpture était devenue une forme d'art autonome. Réalisée dans un langage plastique qui reflète cette transition, *Rosie la riveteuse* annonçait l'avènement du modernisme au Canada.

*Joyce Millar*
*Directrice*
*Galerie d'art Stewart Hall*
*Pointe-Claire, Québec*

~~~

Cat. 85  (page 172)

**ALEX COLVILLE** (né en 1920)
*Cheval et train*  1954
huile avec glacis sur panneau dur
41,5 x 54,3 cm
Don de la Dominion Foundries and Steel Limited (Dofasco), 1957

Alex Colville est le plus célèbre des artistes canadiens vivants. Même ceux qui ignorent son nom auront eu dans leurs poches des pièces de monnaie qu'il a dessinées pour le centenaire de la Confédération en 1967. Beaucoup de gens gardent, gravées dans leur esprit, certaines de ses images. Les amateurs de musique folk connaissent *Cheval et train* parce qu'ils l'ont vu sur la pochette d'un disque de Bruce Cockburn. Bien que Colville en doute parfois, ses tableaux plaisent à un vaste public.

*Cheval et train* a été acheté pour l'Art Gallery of Hamilton trois ans après que l'artiste l'eut terminé. Colville écrivit à son collègue artiste T.R. MacDonald, alors directeur de ce musée, qu'il était ravi de savoir sa peinture à Hamilton. Il estimait que son tableau était « plutôt bon », mais se rendait compte que « peu de gens l'achèteraient pour l'accrocher chez eux (la plupart semblent le trouver trop morbide)[1] ». Maintes images de Colville rappellent la stratégie surréaliste de l'association insolite – la fusion du rêve et de la réalité – et l'on éprouve, à les regarder, le sentiment aigu d'une catastrophe imminente. Ils dérangent, peut-être parce que, depuis son service comme artiste de guerre (1944–1946), Colville est préoccupé par la mort – la mort omniprésente dans chaque conflit armé, mais qui a pris des proportions particulièrement monstrueuses dans les camps de l'Holocauste. À la fin de la guerre,

Colville, comme nombre de ses contemporains, s'est penché sur les questions éthiques soulevées par le phénomène nazi et l'Holocauste.

*Cheval et train* s'inspire d'un distique du long poème « Dedication to Mary Campbell » publié en 1949 par le poète sud-africain Roy Campbell :

Contre un régiment j'oppose un cerveau
Et un sombre cheval contre un train blindé.

Le rapport d'équivalence établi entre le cerveau humain et le sombre cheval dans le poème rend plausible l'interprétation selon laquelle le tableau illustrerait la résistance que, par sa créativité, l'individu peut opposer aux réglementations et idéologies sur lesquelles s'appuient les systèmes d'enrégimentement des masses. Lors de sa tournée en Amérique du Nord en 1953, Campbell avait fait une lecture de ses poèmes à Sackville, au Nouveau-Brunswick, où Colville, professeur à l'université Mount Allison, aurait eu l'occasion de le rencontrer[2].

La clé pour interpréter cette image nous est donnée dans la lettre de Colville à MacDonald. L'artiste, versé en philosophie, a lu tout autant les écrits des existentialistes de l'après-guerre que les travaux plus récents d'Iris Murdoch sur la métaphysique et la morale. Sa lettre nous apprend qu'il a aussi étudié la pensée du psychologue Carl Gustav Jung et qu'il était alors « porté à croire » à l'existence de « l'inconscient collectif [...] Les chevaux et les trains ont, ou éveillent dans notre esprit (du moins dans le mien), des échos symboliques que nous ne saisissons que vaguement[3] ».

Le cheval de Colville est un symbole du « pouvoir innocent ». L'artiste continue de croire que les animaux possèdent « l'innocence » et il le dit dans ses images. Les animaux, symboles d'harmonie, sont essentiellement inconnaissables. Nous ne pouvons pas *connaître* le cheval, mais l'image nous incite à construire des histoires qui prennent leur source dans cet espace fécond entre imagination et réalité.

*Michael Bell*
*Professeur agrégé*
*Carleton University, Ottawa*

Notes _____

1. Alex Colville dans une lettre à T.R. MacDonald, 8 février 1957, dossier d'acquisition, Art Gallery of Hamilton.

2. Dans sa lettre à T.R. MacDonald, Colville cite (incorrectement) de mémoire les deux vers du poème de Campbell et décrit le cerveau comme un cerveau « humain ». Pour un commentaire exhaustif sur cette peinture, voir la publication accompagnant la rétrospective Colville présentée en 1983 au Musée des beaux-arts de l'Ontario : David Burnett, *Colville*, Toronto, Art Gallery of Ontario et McClelland & Stewart, 1983, p. 96–105.

3. Colville à MacDonald, 8 février 1957.

~~~

Cat. 87  (page 174)

**PHILIP SURREY** (1910–1990)
*Les amants*  vers 1957
huile sur toile
61,3 x 45,8 cm
Legs de Josephine M. Magee, 1958

Le jeune Philip Surrey prit goût à la description des états d'âme et des atmosphères et à l'utilisation expressive de la couleur auprès de son ami F. H. Varley à Vancouver. Puis, au cours de ses voyages et de ses études aux États-Unis, il s'intéressa à l'aspect imagé et narratif du régionalisme, ce qui l'amena à puiser son inspiration dans des lieux, des événements et des mythes américains. L'influence de William Gropper et de Martin Lewis sur son évolution ultérieure est indubitable. Montréal, où il s'établit en 1937, lui offrit un vaste théâtre urbain et une profusion de sujets.

Surrey était un être ironique, renfermé et peu enclin à nouer des liens affectifs. Le plus souvent, ses personnages sont aussi des solitaires dont les rapports se limitent, à peu de chose près, à fréquenter les mêmes rues et les mêmes cafés. Lorsque ses tableaux mettent en scène des relations, elles sont plutôt tourmentées, sinon violentes. Il a peint beaucoup de nocturnes où abondent recoins obscurs, formes ambiguës et ombres menaçantes.

*Les amants* date de 1957 environ. Parvenu au sommet de son art, Surrey produisait alors ses toiles les plus raffinées et les plus ambitieuses. Celle-ci dénote une observation attentive et se caractérise par la complexité de l'organisation spatiale, par des zones de couleur bien différenciées, par une touche dansante et par des nuances subtiles. Tel n'est pas toujours le cas : bon nombre de ses tableaux frôlent la caricature.

Les amants se tiennent au premier plan, à gauche, devant une vitrine éclairée par une faible lumière verdâtre. Penché vers la femme, qu'il presse contre la vitrine, l'homme plaide ardemment sa cause. La femme, le regard froid, le tient à distance. Leur relation semble être en crise. Peut-être est-elle illicite : le décor sombre, le panneau d'arrêt et les autres personnages au dos tourné le suggèrent. Les formes ovoïdes et courbes que l'on voit par la vitrine portent à croire que la femme pourrait être enceinte. L'élément le plus troublant est le visage de la femme : on dirait celui de l'épouse du peintre, Margaret.

L'homme au dos tourné fait-il partie d'un triangle amoureux ? À ce sujet, nous en sommes réduits aux conjectures. Cependant, la présence de ce troisième personnage rappelle une œuvre que F. H. Varley peignit après avoir passé le week-end de Pâques à Montréal avec Surrey : *Traversier de nuit, Vancouver* (1937, Kleinburg, Collection McMichael d'art canadien, fig. 71). Dans ce tableau, deux amoureux, sous un clair de lune, s'appuient au bastingage d'un traversier. Non loin d'eux, un homme debout, les jambes écartées, nous tourne le dos. C'est l'alter ego de Varley, le loup solitaire. Les amoureux n'existent que dans son imagination. Ils incarnent son idéal romantique, une relation faite de confiance et de sincérité. Par comparaison, la vision que Surrey présente de l'amour – chargée de méfiance et d'anxiété – est beaucoup plus crédible et familière.

*Christopher Varley*
*Marchand de tableaux et consultant en art canadien*

~ ~ ~

| | |
|---|---|
| AAM | Art Association of Montreal (auj. Musée des beaux-arts de Montréal) |
| AGH | Art Gallery of Hamilton |
| AGO | Art Gallery of Ontario / Musée des beaux-arts de l'Ontario, Toronto |
| AGT | Art Gallery of Toronto (auj. Musée des beaux-arts de l'Ontario) |
| AGW | Art Gallery of Windsor |
| ARC | Académie royale des arts du Canada |
| CNE | Canadian National Exhibition, Toronto |
| GNC | Galerie nationale du Canada, Ottawa (auj. Musée des beaux-arts du Canada) |
| GPC | Groupe des peintres canadiens |
| MBAM | Musée des beaux-arts de Montréal |
| MBAC | Musée des beaux-arts du Canada, Ottawa |
| OCA | Ontario College of Art, Toronto (auj. Ontario College of Art and Design) |
| OSA | Ontario Society of Artists |
| SAC | Société d'art contemporain |
| SSC | Société des sculpteurs du Canada |

# Biographies d'artistes

*Préparées par Alicia Boutilier*

## BIRIUKOVA, Yulia (née en 1895 à Vladivostok, Russie; décédée en 1972 à Toronto, Ontario)
### Voir cat. 68

Biriukova étudie à l'Académie impériale des beaux-arts de Petrograd (aujourd'hui Saint-Pétersbourg), puis à l'Académie royale des beaux-arts de Rome, où sa famille s'installe après la Révolution russe. En 1929, après le krach boursier, elle arrive à Toronto avec sa sœur Alexandra (architecte qui, l'année suivante, dessinera la maison de Lawren Harris). Biriukova prend un atelier au Studio Building et se lie d'amitié avec beaucoup d'artistes qui y travaillent et s'y réunissent, dont J.E.H. MacDonald. Après la mort de MacDonald, elle va habiter chez lui, dans sa maison de Thornhill qu'elle partage avec son fils l'artiste Thoreau MacDonald. En 1932, elle commence à travailler à la Central Technical School, où enseignent également Carl Schaefer et Elizabeth Wyn Wood. C'est vers cette époque qu'elle peint ses personnages grandeur nature sur l'iconostase de l'église orthodoxe russe Christ the Saviour à Toronto. Biriukova, qui est surtout portraitiste, reçoit de nombreuses commandes et expose régulièrement dans les années 1930, en particulier à l'OSA. À l'Upper Canada College où elle enseigne de 1942 jusqu'à sa retraite en 1963, elle organise des excursions de peinture dans le sud de l'Ontario et aide les élèves dans la création des décors de leur spectacle annuel. En 1968, le College rendra hommage à cette merveilleuse pédagogue en donnant son nom à une galerie d'art contemporain.

## BORDUAS, Paul-Émile (né en 1905 à Saint-Hilaire, Québec; décédé en 1960 à Paris, France)
### Voir cat. 74

Borduas commence son apprentissage comme décorateur d'églises auprès d'Ozias Leduc en 1922. Diplômé de l'École des beaux-arts de Montréal en 1927, il est embauché comme professeur par la Commission des écoles catholiques de cette ville; un an plus tard, il part pour Paris étudier aux Ateliers d'art sacré de Maurice Denis. De retour au Canada en 1930, il continue à travailler pour Leduc et à enseigner; en 1937, il accepte un poste à l'École du Meuble. Sa participation au Salon du printemps de l'AAM en 1938 l'amène à faire la connaissance de John Lyman, avec qui il fonde la SAC en 1939. Peu après, il produit ses premières peintures non figuratives, influencées par l'écriture automatique des surréalistes. Les conflits à l'intérieur de la SAC le poussent à se dissocier de ce groupe et, dès 1946, Borduas expose avec d'autres artistes — ses disciples — qui prendront bientôt le nom d'« automatistes ». En 1948, il est congédié de l'École du Meuble pour avoir publié le manifeste *Refus global* dans lequel il s'élève contre le conservatisme québécois. Après un séjour de deux ans à New York, il retourne en 1955 à Paris, où il peint les toiles abstraites en blanc et noir qui feront sa renommée. L'année de sa mort, le prix Guggenheim lui est décerné pour son tableau *L'étoile noire*. La première rétrospective de ses œuvres a lieu au Stedelijk Museum d'Amsterdam l'année suivante et la première rétrospective canadienne, au MBAM, à la GNC et à l'AGT en 1962.

## BOUDIN, Eugène (Français; né en 1824 à Honfleur, France; décédé en 1898 à Deauville, France)
### Voir cat. 1

Après avoir tenu une boutique de papeterie au Havre (où sa famille s'est établie en 1835), Boudin part en 1847 pour Paris étudier par lui-même au Louvre. En 1851, il reçoit de la municipalité du Havre une pension qui lui permet de poursuivre ses études durant trois ans. Plutôt que de s'inscrire dans un atelier, il choisit de copier les œuvres des paysagistes hollandais du XVII$^e$ siècle. Boudin aime la mer et, toute sa vie, il peindra les côtes de sa Normandie natale et d'autres régions de France, de Belgique, de Hollande et d'Italie. Corot, Millet et plusieurs autres artistes de Barbizon l'encouragent à adopter une touche plus libre pour représenter la lumière. Boudin expose régulièrement au Salon des artistes français à compter de 1859 et au Salon de la Société nationale des beaux-arts à compter de 1890. Le marchand parisien Paul Durand-Ruel organise sa première exposition solo en 1883 et fait connaître son œuvre en Grande-Bretagne et en Amérique du Nord. Pour attirer l'attention sur les murs encombrés des Salons, Boudin produisait de grands tableaux, mais préférait travailler les petits formats. Sans être lui-même un impressionniste, il exposa avec Manet et Monet, et participa à la première exposition des impressionnistes en 1874.

## BROOKER, Bertram (né en 1888 à Croydon, Angleterre; décédé en 1955 à Toronto, Ontario)
### Voir cat. 70

Brooker immigre au Manitoba en 1905. En 1921, il s'établit à Toronto afin de travailler pour une revue de publicité, qu'il quitte pour devenir journaliste indépendant et se consacrer à l'art abstrait. Cet autodidacte, admirateur de Kandinsky, tient sa première exposition en 1927 à l'Arts and Letters Club de Toronto, cercle exclusivement masculin où se rencontrent artistes et intellectuels. L'année suivante, il est invité à exposer avec le Groupe des Sept. Brooker commence aussi à écrire sur les arts et la culture : dans sa chronique « The Seven Arts » de 1928 à 1930 et comme rédacteur du *Yearbook of the Arts in Canada* (en 1928-1929 et en 1936). Après sa rencontre avec l'artiste réaliste de Winnipeg Lionel LeMoine FitzGerald en 1929, il abandonne la peinture abstraite durant presque une décennie. En 1933, il devient un des membres fondateurs du GPC – issu de la volonté d'expansion du Groupe des Sept – bien qu'il en désapprouve le nationalisme. Homme aux multiples talents, il retourne travailler en publicité pendant la Crise et produit deux livres sur le sujet. Son premier roman, *Think of the Earth*, remporte le Prix du gouverneur général en 1936.

**BRUCE, William Blair (né en 1859 à Hamilton, Ontario; décédé en 1906 à Stockholm, Suède)**
**Voir cat. 2, 3, 6**

À Hamilton, Bruce suit des cours privés de Henry Martin, qu'il appellera plus tard son « vieux maître », et peut-être aussi des cours de dessin au Mechanics Institute. En 1881, il se rend à Londres, puis à Paris où il étudie à l'Académie Julian auprès des peintres académiques Tony Robert-Fleury et William Bouguereau. La même année, l'État cède la direction du Salon de Paris à la Société des artistes français et, en 1882, le premier envoi de Bruce est accepté et exposé. Bruce ne reviendra au Canada que deux fois : en 1885 dans sa famille pour une cure de repos et en 1895 avec sa femme, la sculpteure suédoise Caroline Benedicks, qu'il avait épousée en 1888. Le couple vit à l'île de Gotland, dans la mer Baltique, à compter de 1899 et y fonde une colonie d'artistes. Bruce envoie régulièrement des toiles au Canada pour qu'elles soient exposées, mais en 1885, un grand nombre de ses peintures disparaissent dans le naufrage d'un vapeur qui avait quitté Liverpool, le *Brooklyn*. Excellent peintre de figures, Bruce préfère néanmoins le paysage. Vers la fin de sa vie, il peindra à maintes reprises la vue qu'il a de la mer depuis sa maison, dans un style lumineux et naturaliste inspiré de l'école de Barbizon, qui frôle parfois l'impressionnisme.

**BRYMNER, William (né en 1855 à Greenock, Écosse; décédé en 1925 à Wallasey, Cheshire, Angleterre)**
**Voir cat. 19, 24**

Après avoir étudié l'architecture à Ottawa, Brymner se rend à Paris en 1878, instaurant ainsi ce qui deviendrait une coutume chez les artistes canadiens. Inscrit à l'Académie Julian, il suit des cours de William Bouguereau et de Tony Robert-Fleury. Il revient de temps à autre au Canada et s'établit finalement à Montréal en 1886 pour diriger l'école de l'AAM. Bien que de formation académique, Brymner encouragera l'exploration chez ses élèves et en inspirera plusieurs – dont Helen McNicoll, A. Y. Jackson, Sarah Robertson, Prudence Heward, Anne Savage et Mabel May jusqu'à sa retraite en 1921. En 1897, il donne une conférence très remarquée sur l'impressionnisme à l'AAM. Pendant ses vacances, Brymner peint en plein air dans la campagne québécoise avec ses amis Maurice Cullen et J.W. Morrice. En 1905, il construit avec Cullen un atelier à Saint-Eustache. Toute sa vie, Brymner s'intéresse à la figure humaine, mais vers la fin de sa carrière, les paysages atmosphériques retiennent de plus en plus son attention. En 1909, il est élu président de l'ARC (dont il est membre depuis 1886) et se joint au Canadian Art Club, qui vise à intéresser le public aux œuvres canadiennes plutôt qu'aux importations hollandaises. Grand voyageur, il mourra pendant un séjour dans la famille de sa femme en Angleterre. L'AAM tiendra une exposition à sa mémoire l'année suivante.

**CARR, Emily (née en 1871 à Victoria, Colombie-Britannique; décédée en 1945 au même endroit)**
**Voir cat. 27**

Carr étudie à la California School of Design de San Francisco de 1891 à 1893 puis, à compter de 1899, à la Westminster School of Art de Londres. Elle passe également huit mois à St. Ives, en Cornouailles, auprès de Julius Olsson et d'Algernon Talmage. De retour en Colombie-Britannique en 1904, elle va dessiner dans les villages des premières nations le long de la côte. En 1910, à l'âge de trente-huit ans, elle part pour Paris et fréquente l'Académie Colarossi, puis l'atelier de John Duncan Fergusson, qui lui fait découvrir la palette et la technique des Fauves qu'elle reprendra plus tard dans ses tableaux amérindiens. Après une période improductive dans les années 1920 (pendant laquelle elle tient une maison de chambres à Victoria), Carr est invitée à participer en 1927 à l'exposition *Canadian West Coast Art : Native and Modern* à la GNC. En route vers Ottawa pour assister au vernissage, elle fait la connaissance de certains membres du Groupe des Sept; Lawren Harris, avec qui elle correspondra par la suite, l'inspire particulièrement. Dès le début des années 1930, Carr a adopté des couleurs sourdes et des formes sculpturales pour représenter la forêt profonde. Vers la fin de la décennie, utilisant l'essence comme diluant de l'huile et prenant pour sujets le littoral et les clairières créées par l'abattage des arbres, elle peint des œuvres de plus en plus dégagées, empreintes de spiritualité. Elle écrit également plusieurs livres autobiographiques dans les années 1940.

**CASSON, A. J. (Alfred Joseph) (né en 1898 à Toronto, Ontario; décédé en 1992 au même endroit)**
**Voir cat. 82**

Casson revient dans sa ville natale après avoir étudié auprès de John Sloan Gordon à la Hamilton Technical and Art School et travaillé à la Laidlaw Lithography. À Toronto, il suit des cours de dessin d'après modèle à la Central Technical School avec Alfred Howell de 1915 à 1917, puis à l'OCA avec J.W. Beatty. À partir de 1916, il étudie également le paysage avec Harry Britton, qui encourage les excursions en plein air. En 1919, Casson est employé chez Rous and Mann en 1919 comme assistant de Franklin Carmichael, qui lui fait connaître l'Arts and Letters Club et avec qui il va souvent faire des esquisses dans la campagne ontarienne. En 1925, il fonde la Canadian Society of Painters in Water Colour avec Carmichael et Fred Brigden. En 1926, il devient le septième membre du Groupe des Sept (remplaçant Frank [Franz] Johnston qui est parti en 1921). La même année, il entre à la Sampson-Matthews, où il participera à la production de sérigraphies d'œuvres canadiennes destinées aux écoles et aux casernes de militaires. Membre fondateur du GPC en 1933, Casson est élu président de l'OSA en 1941 et président de l'ARC en 1949. Il quitte la Sampson-Matthews en 1958 pour peindre à plein temps et s'essaie pendant une courte période à une manière plus moderne. La galerie d'art de l'université McMaster lui consacre une rétrospective en 1971; une autre rétrospective sera organisée conjointement par l'AGW et l'AGO en 1978.

**CLARK, Paraskeva (née en 1898 à Saint-Pétersbourg, Russie; décédée en 1986 à Toronto, Ontario)**
**Voir cat. 71**

Clark (née Plistik) commence à étudier le paysage en 1916 sous la direction de Savely Seidenberg à l'Académie des beaux-arts de Petrograd, puis, dans la même école, renommée Svomas (Ateliers d'art libres de l'État), elle étudie le portrait et la nature morte auprès de Kouzma Petrov-Vodkin, dont elle partage l'intérêt pour Cézanne. Après l'obtention de son diplôme en 1921, elle peint des décors de théâtre. Installée à Paris en 1923 après la mort de son premier mari, elle travaille comme décoratrice d'intérieur et rencontre son deuxième mari, le Canadien Philip Clark, avec qui elle immigrera à Toronto en 1931. Le fait que Philip soit membre de l'Arts and Letters Club facilite son intégration dans les milieux artistiques de cette ville. En 1932, Clark expose à l'ARC, puis en 1933, avec le nouveau GPC dont elle deviendra membre en 1936. Amie de Norman Bethune, elle prône la responsabilité sociale de l'artiste par la gravure et la peinture. *In Aid of Russia*, en 1942, est sa deuxième exposition solo à la Picture Loan Society. En 1944,

Clark est élue vice-présidente de la Federation of Russian Canadians et commanditée par la GNC pour peindre les activités du Service féminin de l'Aviation royale du Canada. Elle peint aussi des paysages pendant ses vacances en famille dans le nord de l'Ontario et au Québec. Passablement marginalisé à la fin des années 1950 et dans les années 1960 par les nouveaux mouvements artistiques, son œuvre suscite l'intérêt d'un nouveau public dans les deux décennies suivantes.

## COLVILLE, Alex (né en 1920 à Toronto, Ontario)
Voir cat. 85

La famille de Colville se fixe à Amherst, en Nouvelle-Écosse, en 1929. À l'âge de quatorze ans, le jeune Alex commence à suivre des cours d'art à Sackville, au Nouveau-Brunswick, et en 1938 il s'inscrit à l'université Mount Allison, où son professeur Stanley Royle lui fait apprécier la peinture de la Renaissance italienne. Après avoir obtenu en 1942 un baccalauréat en beaux-arts (un des premiers diplômes de ce type décernés au Canada), il épouse sa camarade d'études Rhoda Wright et s'enrôle dans l'armée. Devenu artiste de guerre officiel en 1944, il se rend en Hollande et en Allemagne, et passe quelques jours au camp de concentration de Bergen-Belsen, qui vient d'être libéré. Ces années au front marqueront son art. De retour au Canada, Colville enseigne à Mount Allison à compter de 1946. En 1963, il quitte l'université pour se consacrer à la peinture. En 1965, il dessine les pièces de monnaie du Centenaire et, en 1966, il représente le Canada à la 23ᵉ Biennale de Venise. Désormais, sa renommée internationale ira croissant. En 1973, l'artiste s'établit à Wolfville, où il vit toujours. Une décennie plus tard, l'AGO organise la première rétrospective Colville et la met en tournée au pays et à l'étranger. De nombreuses expositions Colville ont été présentées partout dans le monde. Une rétrospective de ses cinquante années de production a eu lieu au MBAC en 2000. La manière de Colville, parfois qualifiée de « réalisme magique », se caractérise par une touche néo-pointilliste et une structuration géométrique de l'espace.

## COMFORT, Charles (né en 1900 à Édimbourg, Écosse; décédé en 1994 à Ottawa, Ontario)
Voir cat. 60

Arrivé à Winnipeg en 1912, Comfort travaille dans l'atelier d'arts graphiques de Fred Brigden et fréquente la Winnipeg School of Art. Après un an d'études à l'Art Students League de New York auprès de Robert Henri, il se fixe à Toronto en 1925, ouvre un atelier d'arts graphiques avec Will Ogilvie et Harold Ayres en 1931 et peint sa première grande murale en 1932 (pour la North American Life Assurance). Beaucoup d'autres murales suivront, dont celles de la Bourse de Toronto en 1937 et de la Bibliothèque nationale du Canada en 1966. Actif dans la communauté artistique, Comfort participe à la fondation du GPC en 1933 et préside l'ARC de 1957 à 1960. Il abandonne sa carrière de graphiste pour enseigner à l'OCA en 1935, puis se joint au département d'art de l'université de Toronto en 1938. Dès 1936, il peint au Studio Building à côté d'A. Y. Jackson, avec qui il va faire des esquisses dans la baie Georgienne. En 1937, il remporte le premier prix à la *Great Lakes Exhibition*, exposition canado-américaine visant à faire connaître l'art de la région des Grands Lacs. Artiste de guerre officiel de 1943 à 1946, il racontera ses années au front dans *Artist at War* (1956). Comfort retourne à l'université de Toronto après la guerre. En 1960, il quitte l'enseignement pour devenir directeur de la GNC, poste qu'il occupera jusqu'en 1965.

## COOMBS, E. (Edith) Grace (née en 1890 à Hamilton, Ontario; décédée en 1986 à St. Catharines, Ontario)
Voir cat. 47, 51, 65, 66

À l'OCA où elle étudie de 1913 à 1918, Coombs se mérite les encouragements de George Reid, J.E.H. MacDonald, Robert Holmes et Emanuel Hahn. À l'été de 1929, elle ira également étudier à la New York School of Fine and Applied Art. Après avoir été chef du département des arts durant un an à l'Edgehill College de Windsor, en Nouvelle-Écosse, puis professeur d'art au Havergal College de Toronto, elle commence à enseigner à l'OCA en 1920. Même si elle fait quelques sculptures pendant ses années d'études, Coombs travaille principalement à l'huile, à l'aquarelle et au pastel. Ses premiers paysages audacieusement colorés s'inspirent du Groupe des Sept, dont plusieurs membres sont ses collègues de travail à l'OCA. Coombs peint aussi de délicates natures mortes aux fleurs sauvages. À la fin des années 1930, elle s'essaie à l'abstraction. Elle expose régulièrement à l'OSA, à l'ARC et à la CNE, et elle est membre du Heliconian Club de Toronto, pendant féminin de l'Arts and Letters Club. Elle peint et donne des cours d'été à Camp Charmette, maison d'été qu'elle partage avec son mari James Sharp Lawson dans la région de Parry Sound. Après avoir pris sa retraite de l'OCA en 1956, elle fait plusieurs expéditions de peinture et de dessin à l'étranger, dont un voyage en Russie et en Scandinavie en 1961.

## COONAN, Emily (née en 1885 à Montréal, Québec; décédée en 1971 au même endroit)
Voir cat. 45

Née dans le quartier de Pointe-Saint-Charles à Montréal, Coonan habitera dans la maison familiale jusqu'à la fin des années 1960. Encouragée par sa mère, elle étudie au Conseil des arts et manufactures vers 1898 puis, vers 1905, s'inscrit à l'école de l'AAM où elle suit les cours de William Brymner et se mérite une bourse dans le cours de dessin d'après modèle en 1907. En 1912, elle part pour l'Europe (nord de la France, Belgique, Hollande) avec Mabel May, mais rentre au pays au début de 1913 tandis que May poursuit son voyage en Angleterre et en Écosse. L'année suivante, elle reçoit la première bourse de voyage jamais offerte par le conseil d'administration de la GNC mais, à cause de la guerre, cette bourse ne lui est remise qu'en 1920, année où elle part de nouveau pour l'Europe. Au début de sa carrière, Coonan s'intéresse au post-impressionnisme et elle est, avec Lilias Torrance Newton, la première femme à exposer avec le Groupe des Sept, lors de la deuxième tournée américaine de ce groupe (1923). Bien qu'elle loue pendant quelque temps un atelier sur la côte du Beaver Hall, elle ne sera jamais très impliquée dans les activités du Groupe de Beaver Hall. Déjà à la fin des années 1920, elle a cessé d'exposer régulièrement à la CNE, à l'ARC et à l'OSA, et entretient peu de contacts avec la communauté artistique montréalaise. Sa dernière exposition a lieu à l'AAM en 1933. Coonan continuera néanmoins jusqu'à la fin de sa vie de peindre en plein air avec des membres de sa famille.

**COURTICE, Rody Kenny (née en 1895 à Renfrew, Ontario; décédée en 1973 à Toronto, Ontario)**
Voir cat. 61

Courtice étudie à l'OCA de 1920 à 1925 environ, auprès de George Reid, J.W. Beatty, Arthur Lismer et J.E.H. MacDonald. En 1927, elle va étudier la figure humaine auprès de Karl Buehr à l'Art Institute of Chicago; elle suit également les cours du marionnettiste Tony Sarg au Goodman Theatre, qui est rattaché à cet institut. Durant les années 1930, elle donne les cours du samedi matin aux enfants à l'AGT; plus tard, elle enseignera aux enfants chez elle. Courtice partage son temps entre Toronto, où elle joue un rôle actif dans le Heliconian Club (cercle artistique et littéraire exclusivement féminin fondé en 1909), et sa maison de campagne près de Markham. Membre fondatrice du GPC en 1933, elle va faire des esquisses avec Yvonne McKague Housser et Isabel McLaughlin (également du GPC) sur la rive nord du lac Supérieur et dans les villes minières du nord de l'Ontario à la fin des années 1920 et au début des années 1930. Ses sujets sont variés : outre des paysages, elle peint les animaux et la vie sur la ferme autour de sa maison de campagne, de même que les jouets de son fils, appliquant parfois dans le traitement de l'espace une multiplicité d'angles de vue inspirée du cubisme. En 1950, elle fréquente l'école d'été de Hans Hofmann à Provincetown, au Massachusetts. Son œuvre tendra de plus en plus vers l'abstraction dans les années 1950 et 1960.

**CRISP, Arthur Watkins (né en 1881 à Hamilton, Ontario; décédé en 1974 à Biddeford, Maine)**
Voir cat. 28

Crisp étudie à la Hamilton Art School auprès de John Sloan Gordon et, de 1900 à 1903, à l'Art Students League de New York auprès de Bryson Burroughs, Frank DuMond et John Twachtman. Dans les années 1910 et 1920, il enseigne dans des écoles d'art de New York, entre autres à son *alma mater*, mais sa principale occupation sera celle de muraliste. Crisp remplit de nombreuses commandes pour des édifices publics et privés à New York et dans le New Jersey, et réalise six murales pour la salle de lecture de la nouvelle Chambre des communes à Ottawa. Il est membre de plusieurs sociétés artistiques américaines, dont l'Architectural League of New York, la National Society of Mural Painters et l'American Watercolor Society. En 1956, il s'établit à Biddeford, dans le Maine, mais ses problèmes de vision rendent son travail de plus en plus difficile. Il parvient à terminer sa dernière murale en 1963 grâce à l'aide de sa femme Mary Ellen, avec qui il dessine également des tapisseries. Bien qu'il ait vécu presque toute sa vie à l'étranger, Crisp n'oublia jamais sa ville natale. Il fit don de plusieurs de ses peintures et études préparatoires à des murales à l'AGH qui, à cette occasion, tint en 1963 une rétrospective des œuvres des Crisp.

**CULLEN, Maurice (né en 1866 à St. John's, Terre-Neuve; décédé en 1934 à Chambly, Québec)**
Voir cat. 12, 21

Arrivé à Montréal avec sa famille en 1870, Cullen étudie à l'école d'art de l'abbé Chabert (de 1884 jusqu'à la destruction de cette école par le feu en 1887) de même qu'auprès du sculpteur Louis-Philippe Hébert. En 1888, il part pour Paris et fréquente l'Académie Colarossi et l'Académie Julian (avec George Reid et William Brymner). En 1890, il est accepté à l'École des beaux-arts, où il aura comme professeurs Jules-Élie Delaunay et, plus tard, Alfred Roll. La même année, plusieurs artistes quittent la Société des artistes français (qui exerçait son emprise sur le Salon annuel) pour former la Société nationale des beaux-arts. Cullen est le premier Canadien à devenir membre associé de cette société en mai 1895. Impressionniste réputé, Cullen rentre au Canada trois mois plus tard et commence à peindre dans la région de Québec, principalement à Beaupré. Il enseigne à l'école de l'AAM de 1911 jusqu'à la fermeture de cette école en 1923; tous les ans – sauf durant son service comme artiste de guerre officiel pour les Archives de guerre du Canada entre 1918 et 1920 –, il emmène ses élèves en excursion pour faire des esquisses. Les cours privés qu'il donne dans son atelier du square du Beaver Hall sont à l'origine de la fondation de l'Arts Club de Montréal en 1912. De 1923 à 1934, le marchand d'art William Watson organise chaque année des expositions Cullen (où sont également présentées des œuvres de son beau-fils Robert Pilot). Une rétrospective Cullen est organisée par le gouvernement du Québec en 1930.

**GORDON, John Sloan (né en 1868 à Brantford, Ontario; décédé en 1940 à Hamilton, Ontario)**
Voir cat. 22

Avant son départ pour Paris en 1895, Gordon travaille pour la Howell Litho Company et comme illustrateur indépendant à Hamilton. Dans la capitale française, il étudie à l'Académie Julian auprès de Jean-Paul Laurens et de Benjamin Constant, ouvre un atelier et participe à la fondation du magazine artistique et littéraire *Quartier Latin* (1896–1898); il collabore également à des publications de Londres, de New York et de Boston. De retour à Hamilton en 1896, Gordon continue à recevoir des commandes pour illustrer d'importants magazines et livres canadiens. En 1898, il participe à la mise sur pied de l'Art League of Hamilton (qui succède à l'Art Students' League of Hamilton) et y enseigne la peinture et le dessin. En 1904, la League fusionne avec la Hamilton Art School, où Gordon continue d'enseigner. En 1909, à la fusion de cette école avec la Board of Education's Technical School (qui prendra le nom de Hamilton Technical Institute en 1923), Gordon devient chef du département d'art, poste qu'il occupera jusqu'à sa retraite en 1932. Pendant sa carrière, il eut pour élèves Arthur Crisp, John Sloan et Albert Robinson, de même que Hortense Mattice, qu'il épousa en 1920. Gordon, qui a beaucoup voyagé aux États-Unis et en Europe, commença à élaborer une forme personnelle de pointillisme dès les années 1900 et fut reconnu comme le premier artiste canadien à employer cette technique.

**GORE, Spencer** (Britannique; né en 1878 à Epsom, Angleterre; décédé en 1914 à Richmond, Angleterre)
**Voir cat. 18**

De 1896 à 1899, Gore fréquente la Slade School of Art de Londres, où il fait la connaissance d'Albert Rothenstein (plus tard Rutherston), Harold Gilman et Wyndham Lewis. En 1904, il va avec Rothenstein rendre visite à Walter Sickert à Dieppe. Les artistes qui se réunissent dans l'atelier londonien de Sickert prennent en 1907 le nom de groupe de Fitzroy Street. C'est dans ce groupe que Gore rencontre Lucien Pissarro et apprend à mieux connaître l'œuvre de son père Camille, ce qui influence sa technique pointilliste. Plus tard, il intégrera les influences de Gauguin, de Matisse et de Cézanne, et participera à la deuxième exposition post-impressionniste mise sur pied par Roger Fry en 1912. Reconnu pour ses qualités d'organisateur et de médiateur, Gore prend part à la fondation de l'Allied Artists' Association en 1908 et se joint au New English Art Club en 1909. En 1911, il devient membre fondateur et premier président du groupe de Camden Town, du nom du quartier ouvrier du nord-ouest de Londres où il habite. Gore va peindre dans la campagne presque chaque été, mais il commence aussi à réaliser ces scènes londoniennes et études de personnages pour lesquelles le groupe de Camden Town est connu. Après trois expositions à la Carfax Gallery, le groupe fusionne avec d'autres pour former le London Group en 1913. La même année, Gore se fixe à Richmond, où il peint ses dernières œuvres avant de succomber à une pneumonie à l'âge de trente-cinq ans.

## HAGARTY, Clara S. (Sophia) (née en 1871 à Toronto, Ontario; décédée en 1958 au même endroit)
**Voir cat. 44**

Hagarty commence ses études à Toronto avec Wyly Grier et Sydney Strickland Tully. L'été, elle fréquente également l'école d'art créée par William Merritt Chase à Shinnecock, Long Island. Plus tard, elle va étudier en Hollande et à Paris, sous la direction de Luc-Olivier Merson, Henri Caro-Delvaille et Claudio Castelucho. Quand la Première Guerre mondiale éclate, Hagarty quitte Paris et travaille pour la Croix-Rouge en Angleterre. À son retour à Toronto peu après l'ouverture d'une nouvelle aile à l'AGT, elle commence à tenir les archives de ce musée; elle y sera conservatrice adjointe jusqu'en 1928. Membre de l'OSA à compter de 1899, membre associée de l'ARC à compter de 1903, elle partage un atelier pendant quelques années avec Mary Wrinch. Elle expose souvent dans le rayon des tableaux de la T. Eaton Co., notamment en 1927 des paysages italiens et écossais inspirés de ses deux voyages en Europe en 1921 et en 1925. En 1930, la T. Eaton Co. inaugure la galerie d'art de son nouveau magasin de la rue College, à Toronto, par une exposition d'œuvres de Hagarty, Wrinch et Marion Long. D'abord peintre de paysages, d'intérieurs et de figures, Hagarty est surtout connue pour ses études de fleurs.

## HARRIS, Lawren (né en 1885 à Brantford, Ontario; décédé en 1970 à Vancouver, Colombie-Britannique)
**Voir cat. 32, 39, 42, 46, 50, 62**

De retour au Canada après ses études à Berlin (1904–1908), Harris devient membre fondateur de l'Arts and Letters Club de Toronto, où il fait la connaissance de J.E.H. MacDonald et, par son intermédiaire, de F. H. Varley, Frank (Franz) Johnston, Arthur Lismer et Franklin Carmichael. Avec A. Y. Jackson, ces artistes formeront en 1920 le Groupe des Sept, pour promouvoir ce qu'ils considèrent comme un art national. Dans les années qui précèdent la formation du Groupe, Harris joue un rôle actif dans l'élaboration d'une vision commune, le financement (avec le D<sup>r</sup> James MacCallum) du Studio Building sur la rue Severn (achevé en 1914) et l'organisation d'expéditions d'esquisses dans l'Algoma, en Ontario. En 1933, le Groupe des Sept se dissout dans le GPC, dont Harris devient le premier président. Peu après, il part pour le New Hampshire avec sa deuxième femme Bess, une artiste intéressée comme lui par la spiritualité et la théosophie. Son formalisme pictural, qui s'accentue à compter des années 1920 dans ses tableaux de la rive nord du lac Supérieur, des Rocheuses et de l'Arctique, le mènera finalement à l'abstraction pure. En 1938, Harris va vivre au Nouveau-Mexique et se joint au Groupe de peinture transcendantale. Il revient au Canada en 1940 pour s'établir à Vancouver.

## HÉBERT, Adrien (né en 1890 à Paris, France; décédé en 1967 à Montréal, Québec)
**Voir cat. 57**

Adrien Hébert étudie à Montréal au Conseil des arts et manufactures auprès d'Edmond Dyonnet, Joseph Saint-Charles et Joseph Franchère de 1904 à 1906, puis fréquente l'école de l'AAM où il suit les cours de William Brymner jusqu'en 1911. Encouragé à devenir artiste par son père Louis-Philippe qui l'emmène à Paris étudier à l'École des beaux-arts, il fera pendant sa vie de nombreux voyages en France. Revenu à Montréal en 1914, Adrien Hébert enseignera d'abord au Conseil, puis à la Commission des écoles catholiques de 1917 à 1954. Il participe souvent aux Salons du printemps de l'AAM en tant qu'exposant ou membre du jury; deux fois, il remporte le prix Jessie Dow. Il produit également des illustrations pour *Le Nigog*, revue d'avant-garde fondée en 1918, et devient membre du Groupe de Beaver Hall en 1920. Pendant les années 1920, Hébert commence à s'intéresser plus particulièrement au port et aux rues de Montréal. En 1931, il présente ses scènes montréalaises dans des expositions solos à la Galerie Bareiro de Paris et à l'Arts Club de Montréal (où il rencontre fréquemment T. R. MacDonald, Edwin Holgate et Robert Pilot). Célèbre pour ses paysages urbains, il a également peint dans la région de Chicoutimi et du rocher Percé.

## HÉBERT, Henri (né en 1884 à Montréal, Québec; décédé en 1950 au même endroit)
Voir cat. 58

Henri Hébert étudie à Montréal au Conseil des arts et manufactures auprès d'Edmond Dyonnet ainsi qu'à l'école de l'AAM auprès de William Brymner. Il étudie également à Paris, à l'École du soir de la Ville de Paris et à l'École nationale des arts décoratifs entre 1898 et 1902, puis, à compter de 1904, à l'École nationale et spéciale des beaux-arts auprès du sculpteur Gabriel Thomas. Établi à Montréal en 1909 dans l'atelier de la rue Labelle qu'il partage avec son père Louis-Philippe Hébert, il fait néanmoins de fréquents retours à Paris. Il enseigne le modelage à la nouvelle école d'architecture de l'université McGill de 1910 à 1921 ainsi qu'au Conseil des arts et manufactures à compter de 1923. Collaborateur à la revue d'avant-garde *Le Nigog* en 1918, Hébert préconise un art qui privilégie la forme plutôt que le sujet et plaide en faveur de l'intégration de la sculpture à l'architecture. Contrairement à ses contemporains Alfred Laliberté et Marc-Aurèle de Foy Suzor-Coté, Hébert évitera les thèmes régionalistes dans ses œuvres de maturité. Pendant ses quarante années de carrière, il réalise de nombreux monuments publics et funéraires, collabore à maints projets d'architecture et participe aux expositions annuelles de l'AAM, de l'ARC, de l'OSA et de la GNC. En 1928 dans son atelier de la rue Labelle, Hébert fonde avec Frances Loring, Florence Wyle, Emanuel Hahn et Elizabeth Wyn Wood, la SSC qui vise la reconnaissance publique de la sculpture moderniste.

## HÉBERT, Louis-Philippe (né en 1850 à Sainte-Sophie-d'Halifax, Québec; décédé en 1917 à Westmount, Québec)
Voir cat. 11

Après avoir servi dans un détachement de zouaves pontificaux à Rome, Hébert entre en 1872 à l'atelier d'Adolphe Rho à Bécancour, au Québec. L'année suivante, il devient l'apprenti de Napoléon Bourassa à Montréal. Son nom figure en 1875 sur la liste des professeurs du Conseil des arts et manufactures, où il enseignera de temps à autre jusqu'à la fin du siècle. Ayant entamé en 1879 une collaboration avec l'architecte Georges Bouillon pour la cathédrale Notre-Dame d'Ottawa, il exécute une soixantaine de sculptures sur bois pour la décoration du chœur. Hébert reçoit ensuite d'autres commandes de décoration d'églises, dont celle de Notre-Dame de Montréal, ainsi que des commandes de monuments. Ainsi réalisera-t-il au cours de sa carrière une cinquantaine de monuments à travers le Canada, le dernier étant celui d'*Édouard VII* à Montréal en 1914. En 1886, on lui commande des statues de personnages historiques pour le nouvel Hôtel du Parlement de Québec, travail pour lequel il retourne étudier à Paris. Il passe plusieurs années dans cette ville à raffiner ses techniques, mais revient au Canada fréquemment. Passionné par l'histoire du Canada et les sujets amérindiens, il produit également des bustes, des statuettes et des médailles qui représentent des personnages historiques et des contemporains, dont lui-même et des membres de sa famille. Plusieurs distinctions confirment sa renommée et son talent : médaille de la Confédération, médaille Bene Merenti (Vatican), Légion d'honneur (France) et Ordre de Saint-Michel et de Saint-Georges (Grande-Bretagne).

## HENDERSHOT, Rae (née en 1921 à Hamilton, Ontario; décédée en 1988 au même endroit)
Voir cat. 81

Diplômée en 1939 du programme technique de la Westdale Secondary School de sa ville natale, où Ida G. Hamilton était directrice du département des arts, Hendershot expose en tant que membre de la section de Hamilton de la Women's Art Association of Canada. Elle étudie ensuite au département de peinture et dessin de l'OCA à Toronto auprès de John M. Alfsen, Rowley Murphy, Manly MacDonald et Archibald Barnes, et obtient son diplôme en 1946. C'est son professeur de peinture de figures, Alfsen, qui aura le plus d'influence sur elle. Hendershot s'intéresse aussi au réalisme américain. De retour à Hamilton, elle suit des cours de dessin d'après modèle à l'AGH auprès de John Sloan et loue un atelier. Elle peint des portraits et des scènes de genre urbaines, où figurent surtout des femmes et des enfants, et qui se caractérisent par leur coup de pinceau moelleux et leurs riches couleurs. En 1948, elle est l'une des treize membres fondateurs du groupe Contemporary Artists of Hamilton. Moins militante dans les sociétés d'art après son mariage avec l'artiste et directeur de l'AGH T. R. MacDonald en 1950 et la naissance de leur fille Katherine en 1953, Hendershot continue néanmoins à présenter des œuvres aux expositions annuelles de l'AGH et de l'AGW. Elle peint souvent avec MacDonald et les deux artistes s'inspirent mutuellement. Hendershot tient sa première exposition solo en 1961 à la Westdale Gallery de Hamilton.

## HENRI, Robert (Américain; né en 1865 à Cincinnati, Ohio; décédé en 1929 à New York, New York)
Voir cat. 29

Henri entre à la Pennsylvania Academy of Fine Arts en 1886 et suit les cours de Thomas Anshutz, influent défenseur du réalisme social. En 1888, il part pour Paris étudier à l'Académie Julian et à l'École des beaux-arts. Rentré aux États-Unis en 1891, Henri retourne pour une courte période à la Pennsylvania Academy et enseigne à la Philadelphia School of Design for Women. Après de longs voyages à Paris, en Belgique et en Hollande, il se fixe définitivement à New York, où il enseigne à la New York School of Art (1902–1908), à la Modern School of the Ferrer Society (1911–1916) ainsi qu'à l'Art Students League (1915–1928). De 1909 à 1912, il a également sa propre école, que fréquentent Rockwell Kent, Guy Pène du Bois, Edward Hopper et George Bellows. Devenu membre à part entière de la National Academy of Design en 1906, Henri est de plus en plus mécontent des jurys de cet organisme, qu'il trouve conservateurs. En 1908, il organise une exposition d'indépendants, les Huit, aux Macbeth Galleries de New York. Le cercle d'artistes (dont certains sont ses élèves) qui se forme autour de lui prendra le nom d'Ashcan School. En 1910, Henri monte l'*Exhibition of Independent Artists* qui se tient, sans jury ni prix, en même temps que le Salon du printemps de la National Academy. Peintre de la vie urbaine et des ouvriers, Henri a fait de nombreux voyages à travers les États-Unis et en Europe, surtout en Espagne et en Irlande.

**HEWARD, Prudence** (née en 1896 à Montréal, Québec; décédée en 1947 à Los Angeles, Californie)
Voir cat. 63

Native de Montréal où elle passera presque toute sa vie, Heward commence à suivre des cours de dessin dès l'âge de douze ans et, en 1912, se mérite une bourse dans le cours élémentaire supérieur à l'école de l'AAM. Elle interrompt toutefois ses études afin de travailler pour la Croix-Rouge en Angleterre de 1916 à 1918. À Paris en 1925, elle étudie à l'Académie Colarossi auprès de Charles Guérin et à l'École des beaux-arts auprès de Bernard Naudin. Elle retourne dans cette ville en 1929 et s'inscrit à l'Académie scandinave avec l'artiste Isabel McLaughlin. En 1936, elle fait un premier voyage à la maison de vacances des McLaughlin aux Bermudes, dont le paysage l'inspirera. Associé au Groupe de Beaver Hall, Heward invite les artistes à venir dessiner et peindre à la maison d'été de sa famille à Fernbank (près de Brockville, en Ontario). Trois fois, elle expose avec le Groupe des Sept. En 1933, soit un an après sa première exposition solo chez William Scott and Sons à Montréal, elle participe à la fondation du GPC. En 1939, elle devient également membre de la SAC, instituée par John Lyman pour promouvoir l'art moderne. À cette époque, elle s'est déjà méritée des éloges dans des expositions d'art canadien à l'étranger et commence à être connue pour ses portraits et nus monumentaux. La GNC présentera une exposition à sa mémoire en 1948.

**HILLIER, Tristram** (Britannique; né en 1905 à Pékin, Chine; décédé en 1983 dans le comté de Somerset, Angleterre)
Voir cat. 75

Après un bref apprentissage comme comptable, Hillier étudie auprès de Henry Tonks à la Slade School of Art en 1926, et, le soir, auprès de Randolph Schwabe et Bernard Meninsky à la Westminster School of Art. Deux ans plus tard, il va à Paris étudier avec le cubiste André Lhote. Plusieurs années durant, il parcourra l'Europe et enverra ses peintures à Londres. Sa première exposition solo, à la galerie Lefevre en 1931, fait l'objet d'une critique favorable de Paul Nash dans *The Listener*. Hillier est alors invité à se joindre à Unit One (formé en 1933 par Nash, Henry Moore et d'autres pour promouvoir l'art moderne britannique) et participe à la première exposition de ce groupe à la galerie Mayor en 1933. Il peint souvent avec Edward Wadsworth, autre membre du groupe. De 1935 jusqu'aux années 1970, Hillier expose régulièrement à la galerie Arthur Tooth & Sons de Londres. Rentré à Londres en 1936, il monte un atelier à Chelsea. Après avoir servi dans la Royal Naval Volunteer Reserve (1940–1944), il s'établit avec sa deuxième femme, Leda, dans le Somerset, en Angleterre, et publie son autobiographie, *Leda and the Goose*, en 1954. Pendant sa carrière, Hillier se désintéressa du cubisme et du surréalisme pour devenir un réaliste, mais il conserva toujours le style net et précis qui lui est propre.

**HOLGATE, Edwin** (né en 1892 à Allandale, Ontario; décédé en 1977 à Montréal, Québec)
Voir cat. 83

En 1910, Holgate s'inscrit à plein temps à l'école de l'AAM, où il étudie auprès de William Brymner, et suit les cours d'été de Maurice Cullen à Beaupré. Deux ans plus tard, il fréquente l'Académie de la Grande Chaumière à Paris. Après avoir servi dans une unité d'artillerie de campagne de 1916 à 1919, il participe à la fondation du Groupe de Beaver Hall à Montréal, puis retourne à Paris étudier sous la direction d'Adolf Milman. De cet artiste russe, Holgate retiendra la puissance du trait et la combinera, dans ses célèbres portraits et nus, à une structure cézannesque. Revenu à Montréal en 1922, il loue un espace dans l'immeuble où Alfred Laliberté a son atelier, avec Cullen, Robert Pilot et Marc-Aurèle de Foy Suzor-Coté. En 1926, il se rend avec A. Y. Jackson et l'anthropologue Marius Barbeau à la rivière Skeena étudier la culture des premières nations. Trois ans plus tard, il s'inspirera des motifs amérindiens de la côte nord-ouest pour la décoration d'une nouvelle aile du Château Laurier, à Ottawa. De 1928 à 1934, Holgate enseigne la gravure à l'École des beaux-arts de Montréal. Avec Lilias Torrance Newton, il relance l'école de l'AAM en 1934–1936 et en 1938–1940. Holgate devient le huitième membre du Groupe des Sept en 1929 et participe à la fondation du GPC en 1933. Après avoir servi comme artiste de guerre officiel dans l'Aviation en 1943–1944, il s'établira dans les Laurentides et peindra surtout des paysages.

**HOO, Sing** (né en 1909 à Canton [auj. Guangzhou], Chine; décédé en 2000 à Toronto, Ontario)
Voir cat. 84

Arrivé au Canada en 1922, soit un an avant l'adoption de la *Loi d'exclusion* qui interdirait l'immigration chinoise jusqu'en 1947, Hoo étudie auprès d'Emanuel Hahn, J.W. Beatty et Frederick Challener à l'OCA et obtient son diplôme en 1933. Il fréquente également la Slade School of Art de Londres et se rend à Paris ainsi qu'à Rome. De 1934 à 1942, il travaille au département de paléontologie du Royal Ontario Museum, où il sculpte des répliques et donne des conférences sur l'art occidental et oriental. Il commence à exposer ses sculptures en 1933 à l'OSA et à la CNE. Il expose aussi régulièrement à la SSC ainsi qu'à l'ARC, dont il deviendra membre associé en 1948, puis membre à part entière en 1966 après avoir déposé comme morceau de réception un buste de sa femme, Norah Chambers. En 1984 et en 1992, il retournera en Chine à l'invitation du gouvernement pour donner des conférences sur l'art canadien dans les écoles. Hoo a assisté Emanuel Hahn dans la réalisation du monument de sir Adam Beck (Toronto) et Elizabeth Wyn Wood dans celle du monument de Georges VI (Niagara Falls). Il a également dessiné le cadran solaire du cimetière Mount Pleasant, à Toronto. Dans son travail personnel, il préférait sculpter des animaux et des bustes. La SSC a tenu une rétrospective de son œuvre sculpté en 1999.

## JACKSON, A. Y. (Alexander Young) (né en 1882 à Montréal, Québec; décédé en 1974 à Kleinburg, Ontario)
**Voir cat. 25, 35**

Jackson travaille en lithographie tout en suivant les cours de William Brymner à l'école de l'AAM. Passé à l'emploi d'une entreprise de Chicago en 1906, il suit des cours à l'Art Institute le soir. L'année suivante, il fréquente pour une courte période l'Académie Julian à Paris. Inspiré par l'impressionnisme français, il reviendra en Europe pour peindre en Bretagne et à Assise de 1911 à 1913. Peu après ce voyage, il fait la connaissance de J.E.H. MacDonald, Arthur Lismer, F.H. Varley et Lawren Harris, et décide de s'établir à Toronto. L'exposition de ses esquisses de la baie Georgienne à l'Arts and Letters Club en 1913 déclenche la première attaque contre le nouveau modernisme. Enrôlé dans l'armée en 1915, Jackson devient l'année suivante le premier Canadien chargé de peindre pour le Fonds des souvenirs de guerre canadiens. En 1920 se forme le Groupe des Sept, dont il est membre fondateur. Chef de file dans la communauté artistique, il est également président du Groupe de Beaver Hall en 1920 et participe à la fondation du GPC en 1933. Professeur durant un an à l'OCA (1924), il abandonne l'enseignement parce que cette occupation l'empêche de partir en excursion pour faire des esquisses. Bien qu'il peigne partout au Canada – dans la région de la rivière Skeena en 1926, dans l'Arctique en 1930, en Alberta à la fin des années 1930 et dans les années 1940 –, Jackson préférera toujours la campagne québécoise.

## KENT, Rockwell (Américain; né en 1882 à Tarrytown Heights, New York; décédé en 1971 à Plattsburgh, New York)
**Voir cat. 40**

Étudiant en architecture à l'université Columbia, Kent passe trois étés (1900–1902) à suivre des cours de William Merritt Chase, qui lui accorde une bourse pour la New York School of Art. Un été, il assiste également Abbot H. Thayer dans son atelier du New Hampshire. Encouragé par son professeur Robert Henri, il se rend pour la première fois à l'île Monhegan dans le Maine en 1905. Il y construit une maison en 1907, année de sa première exposition solo à la galerie Claussen de New York. Il participe à l'*Exhibition of Independent Artists* en 1910 mais se détache progressivement du cercle de Henri; au tumulte urbain, il préfère les gens et les paysages des régions isolées. Il vit à Terre-Neuve de 1913 à 1915, puis en Alaska avec son fils en 1918–1919, après quoi il publie *Wilderness*, le premier de ses journaux illustrés. Influencé par le réalisme visionnaire de William Blake, il se met vers cette époque à la gravure sur bois. Il voyage à la Terre de Feu (1922) et au Groenland (1929, 1931–1933, 1934–1935). Son édition de *Moby Dick*, parue chez R.R. Donnelley & Sons en 1930, est vite épuisée, et Random House en publiera une réédition dans un plus petit format. Fervent socialiste, Kent est cité à comparaître devant la Commission McCarthy en 1953. En 1960, il fait don d'une grande partie de ses œuvres à l'Union soviétique.

## LALIBERTÉ, Alfred (né en 1878 à Sainte-Élisabeth de Warwick, Québec; décédé en 1953 à Montréal, Québec)
**Voir cat. 56**

Bien qu'il sculpte sur bois dès 1894, Laliberté en viendra à préférer le modelage. En 1898, il entreprend ses études à Montréal au Conseil des arts et manufactures; il s'y mérite le premier prix de sculpture en 1900 et en 1901. En 1902, il s'inscrit à l'École des beaux-arts de Paris, où il étudie sous la direction de Gabriel-Jules Thomas et, plus tard, de Jean-Antoine Injalbert. À Paris, il rencontre un autre artiste québécois, Marc-Aurèle de Foy Suzor-Coté. Après son retour à Montréal en 1907, Laliberté enseigne la sculpture au Conseil des arts et manufactures et obtient ses premières commandes pour la réalisation de monuments publics (dont plusieurs pour l'Hôtel du Parlement de Québec), de médailles et médaillons. De retour à Paris en 1910, il installe son atelier dans l'impasse Ronsin, mais revient au Québec l'année suivante. En 1923, il commence à donner des cours de modelage le soir à l'École des beaux-arts de Montréal et termine le monument funéraire de sir Wilfrid Laurier pour le cimetière Notre-Dame d'Ottawa. À cette époque, Laliberté se fait également remarquer pour ses représentations du Québec d'autrefois. En 1932, il a terminé une série de plus de deux cents sculptures, « Légendes, métiers et coutumes disparus du Canada », qui sera achetée par le gouvernement du Québec.

## LISMER, Arthur (né en 1885 à Sheffield, Angleterre; décédé en 1969 à Montréal, Québec)
**Voir cat. 48**

Après ses études à la Sheffield School of Art de 1898 à 1905, Lismer s'inscrit à l'Académie royale des beaux-arts d'Anvers en 1906. Arrivé au Canada en 1911, il travaille d'abord à la Grip Limited de Toronto (où il fait la connaissance de J.E.H. MacDonald, Tom Thomson, Franklin Carmichael et Frank [Franz] Johnston). L'année suivante, il passe à l'emploi de Rous and Mann et retourne brièvement à Sheffield pour épouser Esther Mawson et convaincre F.H. Varley d'émigrer au Canada. Son intérêt pour le paysage canadien date de ses expéditions à la baie Georgienne en 1913 et dans le parc Algonquin en 1914 avec Thomson, A. Y. Jackson et Varley. Lismer fera une longue carrière de pédagogue et préconisera avec une ferveur particulière l'enseignement des arts aux enfants, sujet sur lequel il donne des conférences un peu partout dans le monde. De 1916 à 1919, il est directeur de la Victoria School of Art and Design à Halifax (ville dont il peint également l'activité portuaire pour les Archives de guerre du Canada), puis, de 1919 à 1927, directeur adjoint de l'OCA à Toronto. Il supervise l'enseignement des arts et les cours pour enfants à l'AGT (1927–1938), à la GNC (1939–1940) et à l'AAM – qui deviendra le MBAM (1941–1967). Il enseigne également à l'université McGill de 1941 à 1955. Membre du Groupe des Sept et du GPC, Lismer représente souvent les petits détails du paysage dans ses œuvres : un sous-bois, une paroi rocheuse, les débris laissés sur les grèves. L'AGT tient une rétrospective de sa production en 1950.

**LONG, Marion (née en 1882 à Toronto, Ontario; décédée en 1970 au même endroit)**
Voir cat. 36

Après ses études à l'OCA sous la direction de George Reid et des cours privés de Laura Muntz (Lyall), Long étudie à New York auprès de Robert Henri et de William Merritt Chase probablement pour deux hivers (1907–1908), puis à Provincetown, au Massachusetts, auprès de Charles Hawthorne durant l'été de 1913. Elle s'installe au Studio Building sur la rue Severn à Toronto vers 1915 et occupe l'atelier d'AY. Jackson et Tom Thomson (le « Studio One ») après le départ de ceux-ci. En 1933, après dix ans comme membre associée, elle devient la première femme à être élue membre à part entière de l'ARC depuis Charlotte Schreiber en 1880 (année de la fondation de l'ARC). Pendant la Seconde Guerre mondiale, elle peint une série de portraits du personnel des armées, y compris de l'aviation norvégienne, pour lesquels le gouvernement de Norvège lui décerne la Médaille de la libération du roi Haakon VII. En 1943, l'Imperial Tobacco lui commande pour sa campagne sur la Player's Navy Cut onze portraits de marins, dont quatre sont utilisés dans des affiches et des publicités. Long a également illustré plusieurs couvertures et articles du *Canadian Home Journal* au début des années 1920. Dans sa production personnelle, elle préférait le portrait et représenta souvent des femmes pensives dans des intérieurs, mais elle peignit également des natures mortes aux fleurs et des vues de Toronto.

**MacDONALD, J.E.H. (James Edward Hervey) (né en 1873 à Durham, Angleterre; décédé en 1932 à Toronto, Ontario)**
Voir cat. 33, 43, 52

Arrivé à Hamilton, en Ontario, en 1887, MacDonald prend des cours du soir à la Hamilton Art School. Deux ans plus tard, il poursuit ses études à la Central Ontario School of Art and Design de Toronto (qui deviendra l'OCA) auprès de George Reid. Il travaille à la Grip Limited de 1894 jusqu'à son départ pour l'Angleterre en 1903. Cette année-là, il se joint également à l'Art Students' League de Toronto (modelée sur celle de New York), dont les membres vont faire des esquisses dans la campagne environnante. À son retour d'Angleterre en 1907, MacDonald est réembauché comme concepteur-graphiste principal chez Grip, où le rejoignent successivement Tom Thomson, Arthur Lismer, Franklin Carmichael, Frank (Franz) Johnston et F.H. Varley. MacDonald tient sa première exposition solo en 1911 à l'Arts and Letters Club; la même année, il quitte la Grip pour se consacrer à sa propre production. Inspiré par l'exposition d'art scandinave tenue en 1913 à l'Albright Art Gallery de Buffalo, il donne du nord de l'Ontario une interprétation de plus en plus hardie par la couleur et le coup de pinceau. À compter de 1924, il passe ses étés à peindre au lac O'Hara, dans les Rocheuses. Après la formation du Groupe des Sept, MacDonald commence en 1921 à enseigner à l'OCA, où il remplacera George Reid comme directeur en 1928.

**MacDONALD, T. R. (Thomas Reid) (né en 1908 à Montréal, Québec; décédé en 1978 à Paris, France)**
Voir cat. 86

De 1928 à 1930, MacDonald suit des cours privés d'Adam Sherriff Scott (dont il deviendra l'assistant) et, de 1930 à 1933, les cours d'Edmond Dyonnet en dessin d'après modèle offerts par l'ARC à l'AAM (dont l'école est temporairement fermée depuis 1924). Peintre et photographe, il s'inspire des réalistes américains dans ses premières scènes urbaines et études de figures. À l'Arts Club de Montréal, dont il est membre, MacDonald se lie d'amitié avec plusieurs artistes de cette ville; il participe également aux expositions annuelles de l'AAM à compter de 1929 et à celles de l'ARC à compter de 1931. Enrôlé en 1941, il est nommé artiste de guerre officiel en 1944. En Italie, il peint quelques portraits de militaires, mais il a par ailleurs toute latitude pour représenter à sa façon les activités des troupes et le paysage dévasté, ce qu'il fait surtout à l'aquarelle. Après la guerre, MacDonald dirige pendant un an l'Owens Art Gallery et le département des beaux-arts de l'université Mount Allison de Sackville, au Nouveau-Brunswick. En 1947, il accepte le poste de directeur de l'AGH, qu'il occupera jusqu'à sa retraite en 1973. Il épouse l'artiste Rae Hendershot en 1950. En 1968, la galerie d'art de l'université McMaster organise une rétrospective de son œuvre.

**MARQUET, Albert (Français; né en 1875 à Bordeaux, France; décédé en 1947 à Paris, France)**
Voir cat. 17

De 1891 à 1893, Marquet fréquente l'École nationale des arts décoratifs de Paris, où il fait la connaissance d'Henri Matisse. À compter de 1894, il étudie avec Matisse à l'École des beaux-arts sous la direction de Gustave Moreau jusqu'à la mort de celui-ci en 1898, puis dans une académie privée sous la direction d'Eugène Carrière; il travaille à partir de modèles vivants et fait des esquisses dans les rues et jardins de Paris. En 1899, Marquet expose pour la première fois au Salon de la Société nationale des beaux-arts, mais après le rejet de son envoi en 1901, il ne soumettra plus jamais d'œuvre à ce Salon qu'il juge trop bourgeois. Il expose plutôt au Salon des indépendants à compter de 1901 et au Salon d'automne (dont il est membre fondateur) à compter de 1903. Deux ans plus tard, avec d'autres exposants du Salon d'automne, Marquet est qualifié de « Fauve » par le critique Louis Vauxcelles. De 1904 jusqu'à la fin de sa vie, il sera associé à la Galerie Druet, où il tient sa première exposition solo en 1907. Connu comme peintre des quais et des ponts de Paris, il commence aussi à peindre des nus vers 1909. À partir de 1920, ce grand voyageur passe ses hivers en Afrique du Nord, région où il vivra toute l'année durant, avec sa femme Marcelle Martinet, pendant la Seconde Guerre mondiale. Au style fauve de ses débuts succédera dans ses dernières années une production plus naturaliste.

**MAY, H. (Henrietta) Mabel (née en 1877 à Montréal, Québec; décédée en 1971 à Vancouver, Colombie-Britannique)**
Voir cat. 55

Encouragée par son père, May commence à suivre des cours de dessin dès l'âge de douze ans. Vers 1902, elle s'inscrit à l'école de l'AAM, auprès de William Brymner, où ses frais de scolarité seront plus tard payés grâce à des bourses du cours de dessin d'après modèle. En voyage en Europe avec Emily Coonan en 1912–1913, elle admire (et commence à assimiler) les effets de lumière des impressionnistes, ainsi que le traitement hardi de la couleur et des motifs chez les post-impressionnistes. May remporte le prix Jessie Dow au Salon du printemps de l'AAM deux fois : en 1914 pour l'aquarelle et en 1918 pour l'huile. En 1918 également, elle est l'une des quatre femmes artistes appelées par le Fonds des souvenirs de guerre canadiens à illustrer l'effort de guerre sur le front intérieur – dans son cas, les travailleuses de l'usine de munitions de la Northern Electric à Montréal. Peu après, May délaisse les tableaux de figures pour les paysages urbains et ruraux, et peint en Nouvelle-Angleterre et dans l'est du Québec ainsi qu'à Montréal. Elle participe à la fondation du Groupe de Beaver Hall en 1920 et à celle du GPC en 1933. May s'installe à Ottawa pendant la Crise et enseigne les arts à l'école Elmwood (1936–1947); elle supervise aussi les cours pour enfants offerts le samedi à la GNC. Elle retourne à Montréal pour une courte période et tient une exposition solo à la galerie Dominion en 1950 avant de s'établir à Vancouver.

**McGILLIVRAY, Florence H. (Helena) (née en 1864 dans le canton de Whitby, Ontario; décédée en 1938 à Toronto, Ontario)**
Voir cat. 38

McGillivray étudie à la Central Ontario School of Art (qui deviendra l'OCA) auprès de William Cruikshank et suit des cours privés de W.L. Forster, Lucius O'Brien et F. McGillivray Knowles. Elle enseigne les arts à l'Ontario Ladies' College de Whitby (aujourd'hui Trafalgar Castle School) et présente des critiques d'œuvres au Pickering College jusqu'à la destruction de cette école dans un incendie en 1905. En 1913, elle étudie à Paris auprès de Lucien Simon et d'Émile-René Ménard, et voyage en Angleterre ainsi qu'en Italie. La même année, elle est élue présidente de l'International Art Union (Paris), association qui sera dissoute au début de la guerre. En 1917, McGillivray est élue membre de l'OSA et de la Society of Women Painters and Sculptors de New York. Toute sa vie, McGillivray sera une grande voyageuse : elle dessine et peint au Québec, à Vancouver, en Alaska, en Nouvelle-Angleterre, à Terre-Neuve et au Labrador, ainsi que dans les Antilles (Trinidad, Jamaïque, Bahamas). En 1935, elle se retire à Toronto et s'implique dans la Guild of All Arts, collectif d'artistes établi sur les falaises de Scarborough. À ses débuts, McGillivray a incorporé des éléments de l'Art nouveau avant même que ce style ne devienne populaire au Canada. Elle s'intéressa plus tard aux couleurs audacieuses et aux contours sombres des Fauves.

**McNICOLL, Helen (Galloway) (née en 1879 à Toronto, Ontario; décédée en 1915 à Swanage, Dorset, Angleterre)**
Voir cat. 34

Devenue sourde des suites de la scarlatine pendant son enfance à Montréal, McNicoll est encouragée par ses parents à étudier les arts. Issue d'une riche famille, elle fréquente l'école de l'AAM sous la direction de William Brymner, puis la Slade School of Art de Londres, où elle prend des cours de dessin d'après modèle et de peinture. À la fin de 1905 ou au début de 1906, après un séjour de trois mois à Paris (entrecoupé de voyages), elle s'inscrit à la School of Landscape and Sea Painting de Julius Olsson à St. Ives, en Cornouailles (qu'Emily Carr a également fréquentée). Elle y étudie auprès d'Algernon Talmage qui, comme Brymner, insiste sur l'importance d'aller sur le motif. Aux œuvres influencées par l'école de Barbizon succèdent alors des tableaux impressionnistes, emplis de lumière et d'une touche assez libre, dans lesquels McNicoll représente surtout des femmes et des enfants, souvent en plein air. C'est vraisemblablement à la populaire colonie d'artistes de St. Ives qu'elle fait la connaissance de l'artiste britannique Dorothea Sharp, avec qui elle voyagera en Europe et vivra en Angleterre. À compter de 1906, McNicoll envoie régulièrement au Canada des œuvres destinées à être exposées à l'AAM, à l'ARC, à la CNE et à l'OSA. En 1908, elle remporte, ex aequo avec W. H. Clapp, le premier prix Jessie Dow au Salon du printemps de l'AAM. Son élection à la Royal Society of British Artists en 1913 fait la une des journaux de Montréal. En 1925, soit dix ans après sa mort de complications diabétiques, l'AAM lui rendra hommage par une exposition commémorative.

**MORRICE, James Wilson (né en 1865 à Montréal, Québec; décédé en 1924 à Tunis, Tunisie)**
Voir cat. 13, 14, 26, 31

Né dans une famille de marchands montréalais qui approuve ses ambitions artistiques, Morrice part en 1889 pour l'Europe après avoir terminé ses études de droit. Il fréquentera l'Académie Julian de Paris, mais son séjour y sera, semble-t-il, de courte durée, car il est plus intéressé par le paysage que par la peinture académique. Les tonalités subtiles et les préoccupations formelles de ses premières œuvres rappellent Whistler. Plus tard, Morrice fait la connaissance de Matisse qui le surnomme « l'artiste à l'œil délicat » et avec qui il fait des esquisses lors de deux voyages au Maroc (1911–1913). Progressivement, sous la double influence des chauds climats et des Fauves, sa palette s'éclaircit, son coup de pinceau se fait plus léger. Bien qu'il passe presque toute sa vie à l'étranger – à Paris surtout, mais avec de fréquents voyages ailleurs en Europe, dans les Antilles et en Afrique du Nord –, Morrice envoie régulièrement des œuvres à exposer au Canada et revient au pays à plusieurs reprises pour peindre le paysage québécois avec Brymner et Cullen. Sa santé ravagée, surtout par l'alcool, il cesse de peindre en 1922 après un voyage à Alger où il a rejoint Marquet. L'année suivante, on annonce prématurément sa mort dans le catalogue du Salon d'automne, où Morrice a exposé depuis 1907.

## MORRIS, Kathleen Moir (née en 1893 à Montréal, Québec; décédée en 1986 à Rawdon, Québec)
Voir cat. 69

Morris est encouragée dans ses premières recherches artistiques par un cousin de sa mère, le peintre Robert Harris, qui a fait un portrait d'elle en 1901. Vers 1906, elle commence à suivre les cours élémentaires à l'école de l'AAM; elle parlerait chaleureusement, plus tard, du cours de peinture en plein air donné au printemps par Maurice Cullen à Carillon, au Québec. Morris termine ses études à l'AAM en 1917. Sans être membre de l'éphémère Groupe de Beaver Hall, elle s'associe aux femmes artistes qui en font partie et expose avec elles. De 1923 à 1929, elle habite à Ottawa avec sa mère (passant ses étés à Marshall's Bay près d'Arnprior, en Ontario) et se lie d'amitié avec le directeur de la GNC, Eric Brown, et sa femme Maud. En 1924, elle prend part à la British Empire Exhibition à Wembley. La section canadienne de cette exposition soulève une controverse, d'abord parce que c'est la GNC plutôt que l'ARC qui en assume l'organisation, ensuite parce que les critiques britanniques ignorent les académiciens du Canada pour faire l'éloge des peintres plus modernes, dont Morris. En 1929, Morris devient membre associé de l'ARC et, en 1940, membre du GPC. Elle adore peindre l'activité communautaire – les rues, les marchés, les rassemblements à l'heure de la messe – surtout l'hiver, période où elle part en expédition d'esquisses à Québec et à Berthierville.

## NASH, Paul (Britannique; né en 1889 à Londres, Angleterre; décédé en 1946 à Boscombe, Hampshire, Angleterre)
Voir cat. 76

Nash s'inscrit en 1910 à la Slade School of Art, où il rencontre Stanley Spencer, Mark Gertler et Christopher Nevinson. Il quitte la Slade en 1912 et, à l'invitation de Roger Fry, s'associe aux Omega Workshops en 1914. En 1917, il expose à la galerie Goupil les paysages dévastés par la guerre que lui ont inspiré son service à Ypres (où il a été blessé). À l'automne, Nash retourne à Ypres, comme artiste de guerre officiel cette fois. Il peindra plus tard à Vimy pour les Archives de guerre du Canada (à l'instar de plusieurs artistes britanniques) et sera de nouveau recruté comme artiste de guerre en 1940. Bien qu'il s'essaie aux scènes d'intérieur et à l'abstraction, il n'abandonnera jamais ses paysages oniriques, influencés par le peintre métaphysique Giorgio de Chiroco. En 1933, il fonde Unit One (avec Henry Moore, Barbara Hepworth, Ben Nicholson, Edward Burra et Edward Wadsworth), un groupe qui durera deux ans et cherchera à revitaliser l'art britannique en se tournant vers l'avant-garde européenne. Nash fait également partie du comité de l'exposition internationale surréaliste tenue à Londres en 1936 et participe dans les années subséquentes à d'autres expositions surréalistes. En 1938, il fait le premier de nombreux séjours à « Madams », une maison où vivent des amis dans le Gloucestershire et qui lui inspirera bien des œuvres.

## NEUMANN, Ernst (né en 1907 à Budapest, Hongrie; décédé en 1956 à Vence, France)
Voir cat. 78

Neumann immigre au Canada avec ses parents en 1912 à l'âge de cinq ans. Vers 1924, il fréquente l'École des beaux-arts de Montréal, ouverte l'année précédente. Il suit également des cours de dessin d'après modèle offerts par l'ARC à l'AAM (qui a dû fermer sa propre école à cause de la gratuité des cours de l'École des beaux-arts). Dès avant 1932, il est apprenti dans un atelier d'arts graphiques où il en vient à s'intéresser à la lithographie, à la gravure sur bois et à l'eau-forte. Entre 1936 et 1938, il partage un atelier et donne des cours avec Goodridge Roberts, ancien élève de l'École des beaux-arts comme lui. Inspiré par Goya et Daumier, il est attiré par la condition humaine et les scènes urbaines, et représente durant la Crise les chômeurs de Montréal. Bien qu'il accepte des commandes de portraits et fasse de la sculpture, il gagne surtout sa vie grâce à ses estampes, qu'il vend apparemment de porte à porte. Il expose régulièrement à l'ARC et au Salon du printemps de l'AAM, mais tient aussi des expositions solos et participe à plusieurs petites expositions collectives. En 1955, Neumann reçoit de la Société royale du Canada une bourse pour étudier en Europe. Installé à Paris, il meurt d'une défaillance cardiaque lors d'un voyage dans le sud de la France. Un an après sa mort, la GNC parraine une exposition de ses œuvres qui sera mise en tournée à travers le Canada; l'avant-propos du catalogue est écrit par son grand ami T.R. MacDonald, directeur de l'AGH.

## PÈNE DU BOIS, Guy (Américain; né en 1884 à Brooklyn, New York; décédé en 1958 à Boston, Massachusetts)
Voir cat. 72

En 1899, Pène du Bois s'inscrit à la New York School of Art (alors la Chase School) où il devient assistant dans le cours de Robert Henri. En 1905, il part pour Paris étudier à l'Académie Colarossi et suivre des cours privés de Théophile Steinlen. De 1906 à 1912, il travaille comme reporter puis comme critique d'art à temps plein pour le *New York American*. En 1912, il adhère à l'Association of American Painters and Sculptors, qui organisera en 1913 l'Armory Show, exposition d'art moderne américain et international destinée à faire opposition à la solennelle National Academy of Design. Tout de suite après, la scission entre réalistes et modernistes amènent Pène du Bois, Robert Henri et John Sloan à se retirer de l'Association. En 1918, année de la fondation du Whitney Studio Club, Pène du Bois y tient sa première exposition solo. Après avoir travaillé pour diverses publications et enseigné à l'Art Students League, il s'établit avec sa famille en France en 1924; commence alors sa période la plus productive, durant laquelle il représente dans ses œuvres les réunions que tiennent les Américains expatriés. Il revient à New York en 1930 et, de 1932 à 1950, dirige la Guy Pène du Bois Summer School au Connecticut. En 1940, il publie *Artists Say the Silliest Things*. Bien qu'il continue de s'intéresser à la belle société, il peint aussi à partir des années 1930 des modèles et des nus.

## REID, George A. (Agnew) (né en 1860 à Wingham, Ontario; décédé en 1947 à Toronto, Ontario)
Voir cat. 4, 5, 7, 8, 10

Après son apprentissage en architecture, Reid étudie à l'Ontario School of Art auprès de Robert Harris (1879–1880 et 1882), à la Pennsylvania Academy of Fine Arts de Philadelphie auprès de Thomas Eakins (1883–1884) ainsi qu'à l'Académie Julian et à l'Académie Colarossi à Paris (1888–1889). De retour à Toronto, il continue d'envoyer des peintures de genre au Salon de Paris. En 1891, Reid commence à enseigner à la Central Ontario School of Art and Design (ancienne Ontario School of Art, qui deviendra l'OCA en 1912) et en sera le directeur de 1909 à 1928. Il y instituera les stages d'été en plein air (offerts à Port Hope à compter de 1922) et sera l'architecte en chef de l'immeuble que l'OCA fait construire sur la rue McCaul (1919). Membre fondateur de plusieurs sociétés artistiques, dont la Society of Mural Decorators (1894), la Toronto Guild of Civic Art (1897) et la Canadian Society of Painters in Water Colour (1926), Reid est également président de l'OSA de 1897 à 1901 et président de l'ARC en 1906-1907. Après son retour à l'Académie Julian en 1896, il essaie d'appliquer une technique plus impressionniste à sa manière académique de modeler les formes par les ombres et la lumière. Il commence aussi à accepter des projets de murales à Toronto, notamment pour l'hôtel de ville (1897–1899) et le Royal Ontario Museum (1934–1938). Après le décès de sa première femme, l'artiste Mary Hiester, en 1921, Reid épouse Mary Wrinch en 1923.

## ROBERTSON, Sarah (née en 1891 à Montréal, Québec; décédée en 1948 au même endroit)
Voir cat. 73

En 1910, Robertson se mérite une bourse dans le cours élémentaire supérieur à l'école de l'AAM, où elle étudie plusieurs années. Elle se joint à l'éphémère Groupe de Beaver Hall en 1921 et expose avec lui l'année suivante. On la considère comme l'animatrice de la « bande » de femmes artistes qui se sont connues dans ce groupe et à l'école de l'AAM. Robertson peint surtout des paysages, tant urbains que ruraux, mais se spécialise dans les scènes montréalaises et réalise des vues du Séminaire des sulpiciens, situé au bout de la rue du Fort, où elle vit à compter de 1927. Bien qu'elle s'en tienne, dans ses excursions d'esquisses, à des pique-niques d'une journée ou à des visites aux maisons de campagne de ses amies (Prudence Heward près de Brockville et Nora Collyer dans les Cantons de l'Est) et de sa famille (dans le Vermont), elle fait néanmoins un voyage aux Bermudes avec Collyer vers 1929. Son coup de pinceau devient plus vigoureux à la fin des années 1930. Pendant la Crise, Robertson peint aussi quelques murales dans des résidences privées. Comme plusieurs anciennes du Beaver Hall, elle participe à la fondation du GPC en 1933. Très proche de Heward, elle aide à organiser l'exposition présentée par la GNC à sa mémoire en 1948. Elle meurt peu après d'un cancer des os. La GNC tiendra une exposition commémorative en son honneur en 1951.

## ROBINSON, Albert (né en 1881 à Hamilton, Ontario; décédé en 1956 à Montréal, Québec)
Voir cat. 30, 49

Robinson étudie auprès de John Sloan Gordon à la Hamilton Art School de 1901 à 1903, tout en travaillant comme illustrateur en chef au *Hamilton Times*. Entre 1903 et 1906, il étudie auprès de William Bouguereau et de Marcel-André Baschet à l'Académie Julian de Paris, puis auprès de Gabriel Ferrier à l'École des beaux-arts; il suit également des cours privés de T.W. Marshall. Établi à Montréal en 1909 ou avant, il commence à peindre le paysage québécois avec le soutien de ses mécènes M. et M^me William Davis. En 1911, il est élu au Pen and Pencil Club, dont William Brymner et Maurice Cullen sont membres, et peint en France (Saint-Malo et Carhaix) avec A.Y. Jackson. Après avoir illustré la construction navale à Montréal pour les Archives de guerre du Canada en 1919, Robinson est invité à participer à la première exposition du Groupe des Sept et élu membre à part entière de l'ARC. En 1921, Jackson, qui dira plus tard être influencé par ses effets de lumière, l'encourage à se joindre à lui pour le premier des nombreux voyages qu'ils feront ensemble, l'hiver, dans le Bas-Saint-Laurent. Robinson sera surtout connu pour ses scènes hivernales québécoises, vivement colorées. Membre fondateur du GPC, il participe à plusieurs expositions internationales d'art canadien. Une rétrospective de ses œuvres est organisée par l'AGH et présentée là ainsi qu'à la GNC l'année avant sa mort.

## RODIN, Auguste (Français; né en 1840 à Paris, France; décédé en 1917 à Meudon, France)
Voir cat. 9

Après avoir fréquenté de 1854 à 1857 une école spéciale de dessin et de mathématiques appelée la « Petite École », Rodin essaie par trois fois de se faire admettre à l'École des beaux-arts de Paris. Il assiste les sculpteurs Albert-Ernest Carrier-Belleuse (à compter de 1864) et Antoine-Joseph Van Rasbourgh (à compter de 1873), et visite l'Italie en 1875 pour étudier les œuvres de Michel-Ange. Deux ans plus tard à Paris, il expose *L'âge d'airain* au Salon des artistes français. Radicale par son naturalisme, cette œuvre est achetée en 1880 par l'État, qui commande à l'artiste une porte pour un projet de musée. De cette *Porte de l'Enfer*, jamais tout à fait achevée, seront issues les célèbres sculptures du *Penseur* et du *Baiser*. En 1890, Rodin devient membre fondateur de la Société nationale des beaux-arts. Suivent plusieurs grandes expositions internationales, ainsi que des commandes de monuments, dont *Les bourgeois de Calais*, dévoilé à Paris en 1895. Son monument à Balzac, commandé en 1891, ne sera finalement érigé qu'en 1939 en raison des protestations contre son manque de fini. Un pavillon est consacré à l'œuvre de Rodin à l'Exposition universelle de Paris en 1903 et une galerie Rodin est ouverte en 1912 au Metropolitan Museum de New York. Réputé pour l'expressivité et l'énergie de ses bustes et statues (dont certains ont un caractère érotique, et beaucoup sont des fragments), Rodin a fait don de sa collection à la France, qui a ouvert le Musée Rodin à Paris en 1919.

**RUSSELL, John W. (Wentworth) (né en 1879 à Binbrook, Ontario; décédé en 1959 à Toronto, Ontario)**
Voir cat. 23

Russell étudie à la Hamilton Art School et, entre 1898 et 1904, à l'Art Students League de New York, où il habite avec Arthur Crisp. Installé ensuite à Paris, il maintient néanmoins des liens avec le Canada et expose à l'ARC ainsi qu'au Canadian Art Club, dont il devient membre en 1909. Ses premiers tableaux de la côte de Bretagne se caractérisent par des couleurs pastel et des tons subtils. Il vit à New York pendant son bref mariage avec l'illustratrice Helen Dryden, qui dessine des couvertures pour le magazine *Vogue*. En 1912, le couple habite aussi à Ottawa, où Russell peint le portrait de Wilfrid Laurier. En 1927, l'exposition de son nu *A Modern Fantasy* à la CNE provoque une vive controverse à Toronto. Revenu de Paris une fois de plus en 1931 pour exposer aux Eaton's Fine Art Galleries, il saisit l'occasion de parler à Hamilton de la nécessité d'un musée d'art public. L'année suivante, il fonde à Toronto la Russell School of Fine Arts, qui fermera ses portes au début de la guerre. Après le refus de ses envois à la CNE en 1933, Russell décide d'y exposer lui-même ses œuvres et loue pendant quelques années un étage dans l'Automotive Building. Russell, qui a fait de nombreux voyages à l'étranger, revient à Toronto peu avant sa mort.

**SAVAGE, Anne (née en 1896 à Montréal, Québec; décédée en 1971 au même endroit)**
Voir cat. 41

Savage perd son frère jumeau Donaldson, mort au champ d'honneur, pendant ses études à l'école de l'AAM auprès de William Brymner et de Maurice Cullen (1914-1918). Après avoir obtenu son diplôme, elle partage un atelier avec Nora Collyer sur la côte du Beaver Hall et devient membre fondatrice du Groupe de Beaver Hall en 1920. Elle sera également membre fondatrice du GPC en 1933 et de la SAC en 1939. Savage enseigne les arts au Commercial and Technical High School durant un an avant de devenir en 1922 la première professeure d'art du Baron Byng High School, où elle enseignera jusqu'en 1948. Après sa retraite, elle supervise l'enseignement des arts à temps plein pour la Commission des écoles protestantes de Montréal jusqu'en 1953 et enseigne aux futurs professeurs d'art à l'université McGill de 1954 à 1959. Savage dirige également les cours d'art offerts le samedi matin aux enfants à l'AAM de 1937 jusqu'à son remplacement par Arthur Lismer en 1941. Même si l'enseignement l'accapare beaucoup, elle trouve le temps de faire des voyages pour peindre : en 1927 à la rivière Skeena avec Florence Wyle (une expédition organisée par l'anthropologue Marius Barbeau en vue d'étudier la culture des premières nations) et en 1933 à la baie Georgienne avec son amie de toujours A. Y. Jackson. Surtout, elle peint à la maison de campagne de sa famille au lac Wonish, au nord de Montréal, où elle se construit un atelier dans les années 1930.

**SCHAEFER, Carl (né en 1903 à Hanover, Ontario; décédé en 1995 à Toronto, Ontario)**
Voir cat. 77

Schaefer s'inscrit à l'OCA en 1921 pour étudier sous la direction d'Arthur Lismer et de J.E.H. MacDonald, mais quitte cette école en 1924. Il travaille ensuite à la pige et assiste notamment MacDonald dans la décoration des Claridge Apartments et du Concourse Building à Toronto. À l'occasion d'un contrat avec l'atelier d'arts graphiques Brigden's Limited, il se lie d'une longue amitié avec Charles Comfort, qui peindra son portrait trois fois. Embauché par René Cera comme étalagiste pour la T. Eaton Co. en 1929, il est licencié l'année suivante à cause de la Crise. Pendant les années 1930, il devient membre du GPC et enseigne à temps partiel à la Central Technical School et à la Hart House de Toronto, ainsi qu'au Trinity College à Port Hope. De 1932 à 1940, Schaefer passe ses étés avec sa famille à Hanover, en Ontario, chez ses grands-parents qui l'avaient élevé, et y peint la campagne dans un style régionaliste. Dans les années 1930, il se met aussi à l'aquarelle, qui sera son moyen d'expression préféré. Devenu en 1940 le premier Canadien à se mériter une bourse Guggenheim, il s'établit au Vermont pour peindre durant un an. Nommé artiste de guerre officiel trois ans plus tard, il illustre les activités de l'Aviation royale du Canada au Royaume-Uni et en Islande. Il enseignera ensuite à l'OCA de 1948 à 1970.

**SLOAN, John (Américain; né en 1871 à Lock Haven, Pennsylvanie; décédé en 1951 à Hanover, New Hampshire)**
Voir cat. 16

Graveur autodidacte, Sloan étudie à la Pennsylvania Academy of Fine Arts à compter de 1892 (sous la direction de Thomas Anshutz) tout en travaillant comme illustrateur pour l'*Inquirer* de Philadelphie. En 1893, il forme le Charcoal Club avec son camarade d'études Robert Henri et d'autres qui feraient plus tard partie de ce qu'on appelle l'Ashcan School. Sloan quitte l'*Inquirer* pour la *Press* de Philadelphie en 1895 et commence bientôt à peindre sérieusement des huiles, influencé par le style d'observation directe du reportage journalistique. En 1904, il a quitté la *Press* et s'est établi à New York. En 1908, il est l'un des Huit qui exposent aux Macbeth Galleries et, en 1910, il participe à l'*Exhibition of Independent Artists*. De 1918 à 1944, il est président de la Society of Independent Artists. Militant dans le parti socialiste, il illustre des publications et se présente deux fois comme candidat aux élections. Après avoir tenu sa première exposition solo au Whitney Studio (la première galerie de Gloria Vanderbilt Whitney) en 1916, il entame la même année avec la Kraushaar Gallery une association qui durera toute sa vie. En 1949, il est élu président de la New Mexico Alliance for the Arts, à Santa Fe où il passe presque tous ses étés depuis 1919. En 1952, le Whitney Museum of American Art tient une rétrospective de ses œuvres, choisies tout juste avant sa mort.

## SLOAN, John (né en 1890 à Aberdeen, Écosse; décédé en 1970 à Hamilton, Ontario)
### Voir cat. 67, 79

Avant d'immigrer à Hamilton en 1914, Sloan a fait son apprentissage dans l'atelier d'un sculpteur et fréquenté la Gray's School of Art à Aberdeen. Peu après son inscription à la Hamilton Technical and Art School, il devient l'assistant de John Sloan Gordon. En 1915, il fait partie du corps professoral de cette école où il enseignera jusqu'à sa retraite en 1956. En 1936, année de son élection comme membre associé de l'ARC, l'Académie lui accorde une subvention pour donner des cours du soir à l'AGH; ces cours, qu'il dispensera durant quinze ans, sont gratuits pour les artistes admis et les élèves de Hamilton. Très actif dans la communauté artistique de cette ville, Sloan est de 1934 à 1946 membre du comité directeur du Hamilton Art Club, qui tient ses réunions et ses expositions annuelles à l'AGH. Ce club, d'abord exclusivement masculin (sous le nom de Men's Art Club) admet les femmes en 1938. Sloan participe aux expositions annuelles de l'AGH ainsi qu'à celles de l'OSA, de la CNE et de l'ARC. Sloan est surtout un sculpteur, dont les œuvres réalistes deviennent de plus en plus formalistes dans les années 1940, mais il fait également de la peinture, ayant étudié auprès de John Beatty, l'été, à l'école de l'OCA à Port Hope. Une rétrospective de ses sculptures a lieu à l'AGH en 1959.

## SPURR CUTTS, Gertrude (née en 1858 à Scarborough, Angleterre; décédée en 1941 à Port Perry, Ontario)
### Voir cat. 20

Après ses études à la Scarborough School of Art auprès d'Albert Strange ainsi qu'à la Lambeth School of Art de Londres auprès de John H. Smith, Spurr Cutts va peindre en Belgique et en Hollande. Elle expose déjà à la Royal Society of British Artists et à la Society of Women Artists quand, en 1890, elle immigre au Canada et ouvre son atelier à Toronto, où vivent ses parents. Rapidement, elle s'implique dans la communauté artistique; elle devient membre de l'OSA dès l'année suivante et secrétaire correspondancière à la Toronto Art Students' League en 1896. Fondée dix ans plus tôt sur le modèle de celle de New York, la League encourage les artistes à aller sur le motif. Vers 1900–1901, Spurr Cutts fait un stage d'été auprès de George Bridgman et de Birge Harrison à l'école de l'Art Students League de New York à Woodstock. Elle étudie également avec le paysagiste John F. Carlson, qui a sa propre école à Woodstock. En 1909, elle épouse l'artiste William Cutts, avec qui elle partage un atelier à Toronto et peint en plein air. Le couple voyage en Angleterre et habite dans la colonie d'artistes de St. Ives, en Cornouailles, pendant un certain temps vers 1912 avant de s'établir à Port Perry, en Ontario, en 1915.

## SURREY, Philip (né en 1910 à Calgary, Alberta; décédé en 1990 à Montréal, Québec)
### Voir cat. 87

Surrey travaille à l'atelier d'arts graphiques de la Brigden's à Winnipeg tout en suivant les cours de Lionel Lemoine FitzGerald à la Winnipeg School of Art (1926–1927). En 1929, il s'installe à Vancouver où il prend des leçons de F.H. Varley. Il étudie aussi pendant une courte période en 1936 l'Art Students League de New York (auprès de Frank Vincent Dumond et Alexander Abels) et y est influencé par le réalisme social américain. L'année suivante, il s'établit à Montréal et commence une longue carrière comme journaliste et photographe éditeur au *Montreal Standard* et au *Weekend Magazine*. La ville deviendrait un fréquent sujet de ses tableaux. En 1939, il épouse l'écrivaine Margaret Day et remplace Jack Humphrey comme sixième membre de l'Eastern Group of Painters, organisé par John Lyman à l'appui des mouvements artistiques internationaux. La même année, il participe à la fondation de la SAC. En 1943 et 1944, la SAC boycotte le Salon du printemps de l'AAM, estimant son jury trop académique; l'AAM fera une concession en 1945 en créant deux sections au jury, dont une composée de membres de la SAC. Surrey présente plusieurs expositions solo, dont une au Musée d'art contemporain de Montréal en 1971 et au Centre culturel canadien à Paris en 1972.

## SUZOR-COTÉ, Marc-Aurèle de Foy (né en 1869 à Arthabaska, Québec; décédé en 1937 à Daytona Beach, Floride)
### Voir cat. 53

Suzor-Coté fait son apprentissage auprès du peintre-décorateur Joseph-Thomas Rousseau de 1886 jusqu'à son départ pour la France en 1891. Dans ce pays, il étudie avec Léon Bonnat et le paysagiste Henri Harpignies avant d'entrer à l'École des beaux-arts. Revenu à Paris en 1897, il fréquentera l'Académie Julian et l'Académie Colarossi, et exposera régulièrement au Salon de la Société des artistes français. De retour dans son atelier d'Arthabaska en 1907, Suzor-Coté se concentre sur le paysage canadien – employant des couleurs vives et une touche souvent impressionniste – de même que sur les portraits de gens de la campagne québécoise. La même année, il expose sa première sculpture connue, *Le trappeur*, au Salon de la Société nationale des beaux-arts. Il reçoit aussi des commandes de portraits, dont un de sir Wilfrid Laurier en 1909. De plus en plus connu pour son talent de peintre et de sculpteur, Suzor-Coté expose fréquemment à l'AAM (où il remporte le prix Jessie Dow deux fois), à l'ARC et à l'OSA. En 1913, il est invité à se joindre au Canadian Art Club. Il expose ses premiers nus en 1915 et, quatre ans plus tard, emménage dans un atelier de Montréal construit par Alfred Laliberté. Au milieu des années 1920, il embauche des modèles de la réserve mohawk de Caughnawaga (aujourd'hui Kahnawake). Un accident vasculaire cérébral, dont il souffre en 1927, l'amène à s'installer à Daytona Beach, en Floride. Le gouvernement du Québec tient une grande rétrospective de ses œuvres à l'École des beaux-arts de Montréal en 1929.

**THOMSON, Tom (né en 1877 près de Claremont, Ontario; décédé en 1917 au lac Canoe, Ontario)**
**Voir cat. 37**

Après avoir fréquenté pendant une courte période le Canada Business College de Chatham, en Ontario, et l'Acme Business College de Seattle, dans l'État du Washington, Thomson exerce le métier de graveur. Dès 1909, il travaille à la Grip Limited de Toronto pour J.E.H. MacDonald. En 1912, il fait le premier de ses nombreux voyages dans le parc Algonquin, et quitte la Grip pour la Rous and Mann Press Limited. Bientôt toutefois, il décide de consacrer son temps à la peinture; il travaille occasionnellement comme guide ou comme guetteur d'incendies dans le parc Algonquin et ne revient à Toronto que l'hiver pour reprendre dans des tableaux quelques-unes de ses nombreuses esquisses. Après avoir partagé un atelier avec A. Y. Jackson dans le nouveau Studio Building en 1914, il emménage l'année suivante dans une cabane située derrière cet immeuble. En 1915-1916, il termine les panneaux d'une murale pour le chalet du Dr James MacCallum à la baie Go Home, dans la baie Georgienne, commande qu'il partage avec MacDonald et Arthur Lismer. En juillet 1917, son corps est retrouvé dans le lac Canoe. Thomson, qui n'avait pas fréquenté d'école d'art et ne connut qu'une brève carrière de six ans, avait appris la peinture auprès de ses collègues. Ses tableaux, dans lesquels se manifeste le souci décoratif qu'il tenait de son expérience comme dessinateur commercial, étaient devenus de plus en plus libres et vibrants vers la fin de sa vie.

**WADSWORTH, Edward Alexander (Britannique; né en 1889 à Cleckheaton, Yorkshire, Angleterre; décédé en 1949 à Londres, Angleterre)**
**Voir cat. 80**

Tout en faisant ses études d'ingénieur à Munich en 1906-1907, Wadsworth suit des cours d'art à l'école privée de Heinrich Knirr. De retour dans le Yorkshire, il s'inscrit à la Bradford School of Art, puis, en 1908, remporte une bourse pour étudier à la Slade School of Art de Londres, où il restera jusqu'en 1912. Après avoir participé en 1912 à la deuxième exposition post-impressionniste organisée par Roger Fry aux Grafton Galleries, il est invité à se joindre aux Omega Workshops, fondés par Fry en 1913. Il quitte peu après ce groupe avec Wyndham Lewis et adhère au groupe rival, le Rebel Art Centre, formé par Lewis en 1914 pour promouvoir un style cubo-futuriste. Wadsworth signe le manifeste vorticiste dans le premier numéro de *Blast* (juin 1914) et expose avec le groupe vorticiste en 1915. Pendant la Première Guerre mondiale, il sert dans la Royal Naval Volunteer Reserve en Méditerranée jusqu'en 1917, puis passe un an à peindre du camouflage miroitant sur des navires. Après la guerre, toujours intéressé par les sujets relevant de l'industrie et de la marine, il sera de plus en plus influencé par le surréalisme; il relancera aussi l'utilisation de la détrempe. En 1933, année où les Éditions Sélection d'Anvers publient une monographie sur lui, il devient membre fondateur de Unit One, avec Paul Nash. En 1940, son œuvre est choisie pour représenter la Grande-Bretagne à la Biennale de Venise.

**WALKER, Horatio (né en 1858 à Listowel, Ontario; décédé en 1938 à Sainte-Pétronille, île d'Orléans, Québec)**
**Voir cat. 15**

L'OSA tient sa première exposition au studio de photographie de Notman et Fraser à Toronto en 1873, soit l'année même où Walker y est embauché pour colorier des photographies. En grande partie autodidacte, Walker s'instruit au contact de ses collègues, notamment Robert F. Gagen et John A. Fraser, le premier président de l'OSA. En 1876, il part pour les États-Unis et habite d'abord à Rochester puis à New York. Il passe régulièrement ses étés au Québec, où il peint les travailleurs des champs et les animaux de ferme dans un style sombre influencé par les artistes de Barbizon. Vers la fin du XIXe et le début du XXe siècle, il est au sommet de sa carrière. Membre de l'American Water Color Society, de la Society of American Artists et de la National Academy of Design de New York, Walker remporte de nombreux prix et médailles. Après avoir participé en 1908 à la fondation du Canadian Art Club, dont il sera président en 1915, Walker expose plus fréquemment au Canada. Il prend part aux expositions annuelles de la CNE et de l'ARC, qui modifie tout spécialement sa constitution en 1913 pour qu'il en devienne membre (bien qu'il soit considéré comme non-résident). Walker s'installe définitivement à l'île d'Orléans, au Québec, en 1928. L'année suivante, l'AGO et l'École des beaux-arts de Montréal tiennent une rétrospective de son œuvre.

**WARRENER, Lowrie (né en 1900 à Sarnia, Ontario; décédé en 1983 à Toronto, Ontario)**
**Voir cat. 54**

Après trois ans à l'OCA sous la direction d'Emanuel Hahn et d'Arthur Lismer, Warrener interrompt ses études en 1924 et se rend en Europe. Il s'inscrit à l'Académie royale des beaux-arts d'Anvers, mais part en 1925 pour Paris où il fréquente l'Académie de la Grande Chaumière. De retour à Toronto en 1926, il est invité à exposer avec le Groupe des Sept et s'installe au Studio Building. Cet été-là, il fait des esquisses à la rivière Pickerel avec Carl Schaefer. Vers cette époque, Warrener commence à peindre des paysages abstraits. Il s'intéresse également à la scénographie et collabore avec le dramaturge Herman Voaden, avec qui il se rend dans l'Ouest en 1930 grâce à un laissez-passer du Chemin de fer Canadien Pacifique pour écrire un drame canadien. De retour dans l'Ouest l'été suivant (cette fois grâce à un laissez-passer obtenu par l'entremise de Marius Barbeau), il peint à Kitwanga, en Colombie-Britannique. Revenu à Toronto, il se lance (mais sans succès) dans le commerce de la peinture et travaille comme inspecteur de fusils antichars. En 1944, il est embauché à la Eagle Pencil Company, où il demeurera jusqu'à sa retraite en 1968. Ayant cessé d'exposer régulièrement dans les années 1940, Warrener s'en tiendra à faire des esquisses pendant ses vacances d'été et à imprimer des cartes de Noël gravées sur linoléum.

**WOOD, Elizabeth Wyn** (née en 1903 à Orillia, Ontario; décédée en 1966 à Toronto, Ontario)
**Voir cat. 64**

Wood étudie à l'OCA auprès d'Arthur Lismer, de J.E.H. MacDonald et du sculpteur Emanuel Hahn de 1921 à 1926 (y restant une année après l'obtention de son diplôme). Elle épouse Hahn en 1926 et fréquente l'Art Students League de New York sous la direction d'Edward McCarton et de Robert Laurent. À son retour, inspirée par le Groupe des Sept, l'Art déco et les voyages qu'elle fait tous les ans dans le nord de l'Ontario, elle commence à interpréter le paysage en sculpture. En 1928, Wood devient membre fondatrice de la SSC, société dont elle assumera la présidence après son mari en 1935. De 1928 à 1961, elle enseigne la sculpture à la Central Technical School. La plupart de ses œuvres des années 1930 et 1940 sont des figures modernistes et des bustes. Elle remporte de nombreux concours de sculpture, dont celui du Monument aux morts de Welland et Crowland (1934–1939), du Monument de Simcoe à Niagara-on-the-Lake (1951–1953) et du monument de Georges VI à Niagara Falls (1955–1961). Elle participe à l'organisation de la section sculpture de plusieurs expositions internationales d'art canadien. Elle s'occupe aussi de représentation politique des artistes en tant que membre de la Fédération des artistes canadiens, de secrétaire de l'Arts Reconstruction Committee, ainsi que de présidente du comité des relations extérieures du Conseil canadien des arts, qui remplace l'Arts Reconstruction Committee en 1945. Après la mort de Hahn, Wood s'intéresse de plus en plus à la conception de médailles et de pièces de monnaie. Elle fonde la Canadian Society of Medallic Art en 1963.

**WRINCH, Mary E. (Evelyn)** (née en 1877 à Kirby-le-Soken, Essex, Angleterre; décédée en 1969 à Toronto, Ontario)
**Voir cat. 59**

Wrinch arrive en Ontario avec sa famille après la mort de son père. À compter de 1893, elle étudie à la Central Ontario School of Art and Design auprès de George Reid et de Robert Holmes, et suit des cours privés à l'atelier de Reid (où enseigne également Laura Muntz [Lyall]). En 1897, elle va à Londres étudier le dessin d'après modèle sous la direction de Walter Donne à la Grosvenor Life School, ainsi que la miniature avec Alyn Williams. Elle continue d'explorer la miniature (appliquant une technique de pointillé, à l'aquarelle sur ivoire) auprès d'Alice J. Beckington à l'Art Students League de New York, mais en vient finalement à réaliser des paysages à l'huile après son premier voyage à Muskoka en 1906. Quatre ans plus tard, Wrinch construit son propre atelier sur le lac des Baies, en Ontario, où elle passe ses étés. En 1923, elle épouse George Reid, avec qui elle ira peindre en pleine nature dans l'Algoma, à Temagami, dans la vallée de l'Outaouais et au Québec. Première femme élue au comité directeur de l'OSA, elle est vice-présidente et trésorière de cette société en 1924–1925. Vers 1928, Wrinch commence à faire de la linogravure. Travaillant à partir de petites esquisses à l'huile et inspirée par Gauguin, elle réduit un paysage ou un arrangement floral à un motif plat, sur lequel elle joue avec les contrastes de couleurs.

~~~

# Alphabetical list by Artist of Works in the Exhibition
## Liste alphabétique par ordre d'artistes des œuvres de l'exposition

The following indicates where works in the exhibition appear in the colour plate section and the Catalogue.
La liste suivante indique où figurent les œuvres de l'exposition dans la section des planches couleur ainsi que dans le catalogue.

## Catalogue Credits

DESIGN/PRODUCTION
~ Branka Vidovic, NeoGraphics

EDITING:
~ Danielle Chaput and Judith Terry

TRANSLATION:
~ Danielle Chaput and Judith Terry

All translation of English to French was carried out by Danielle Chaput, with the exception of Debra Daly Hartin's essay which was translated by Linda Leclerc of the Canadian Conservation Institute.

All Edwin Holgate images appear with thanks to David Rittenhouse, Executor, Estate Edwin Holgate

Printed and bound in Canada by Kromar Printing Ltd.

## Photography Credits

Institution precedes photographer's name, where known.

All photographs are by Cheryl O'Brien with the following exceptions:

Art Gallery of Hamilton: cat. 7, 9, 12, 15, 32, 34, 37, 45, 52, 56, 68, 77; fig. 2–7, 11, 16, 17, 19-21, 23, 24, 27–34, 38, 40, 42, 48, 49, 51, 52, 56, 57, 61–64, 70, 74

Art Gallery of Ontario: fig. 67, 72; Carlo Catenazzi, fig. 79, 80; James A. Chambers, fig. 46; Larry Ostrom, fig. 36

The Beaverbrook Art Gallery: fig. 58

Lloyd Bloom: fig. 26

Boston Museum of Fine Arts: fig. 8

Canadian Conservation Institute: Jeremy Powell, cat. 85; fig. 78, 81–83, and cover detail. Reprinted with permission from the Canadian Conservation Institute.

Gallery Lambton: Charles Hupé, fig. 68

Hart House, University of Toronto: fig. 76, 77

McMichael Canadian Art Collection: fig. 71

Bob McNair: fig. 45

Montreal Museum of Fine Arts: Brian Merrett, fig. 60

National Gallery of Canada: fig. 66, 73, 75; Charles Hupé, cat. 50, 63

Roy Timm of Wavelength: cat. 49; figs. 1, 9, 10, 12–15, 18, 44, 65

## Staff

Janine Belzak, *Manager, Hospitality Services*

Erin Bitner, *Co-op student*

Christine Braun, *Registrar*

Carlos Brieiro, *Manager, Building and Security*

Julie Bronson, *Exhibitions Coordinator*

Tobi Bruce, *Senior Curator / Curator of Canadian Art*

Patrick Shaw Cable, *Curator of European Art*

Katja Canini, *Media Programmer*

Barbara Carter, *Exhibitions Coordinator*

Larissa Ciupka, *Director, Marketing and Communications*

Trevor Code, *Gallery Attendant*

Greg Dawe, *Chief Preparator*

Tina Destro, *Assistant Educator*

Steve Denyes, *Manager, Communications*

Alison Devine, *Officer, Finance and Administration*

Louise Dompierre, *President and C.E.O.*

Tina Eidukaitus, *Manager, Membership*

Paula Esteves Mauro, *Preparator*

Vince Franco, *Manager, Marketing*

Carole Gardiner, *Director, Retail Operations*

James Girt, *Gallery Attendant*

Helen Hadden, *Volunteer Librarian*

Margaret Hayes, *Director, Finance and Administration*

Arlene M. Lee, *Executive Assistant*

Shirley Madill, *Vice President and C.O.O. / Director of Programming*

Jennifer Matotek, *Programming Assistant*

Alex Moroz, *Manager, Special Events*

Sharada Seemala, *Interim Officer, Finance and Administration*

Brett Simonton, *Educator*

Julie Smith, *Officer, Finance and Technology*

Ryan Thompson, *Manager, Tourism Development*

Jessica Tubman, *Administrative Assistant*

Robin Waters, *Gallery Attendant*

Ola Wlusek, *Volunteer Curatorial Intern*

## Board of Directors 2004–2005

Robert Beckerson

T. L. (Terry) Bedard

Bryan Bennett

Wynn Bensen

Bob Bratina

Linda Brown

Maggie Carr

Jim Cimba

Patrick J. Collins

Andrea DeSantis

Marie Di Silvestro

Brent Foreman

Chip Holton

John D. Hutton

Janice Locke

Karen Mills

Maria Pearson

E. Robert Ross

Michael Schwenger

John A. Soule

Robert Wade

Shendal Yalchin

ART GALLERY OF HAMILTON | 123 KING STREET WEST | HAMILTON, ONTARIO  L8P 4S8